GIORGIONE DA CASTELFRANCO
PITTORE VINIZIANO

INDEX COMPILED BY BARBARA MELLOR
PICTURE RESEARCH BY CORINNE POINT AND SÉGOLÈNE MARBACH

PHOTOENGRAVING BY PRODIMA SA, BILBAO
TYPESETTING BY WYVERN 21, BRISTOL
PRINTED BY I G CASTUERA SA, PAMPLONA

FLAMMARION
26 RUE RACINE
75006 PARIS

200 PARK AVENUE SOUTH
SUITE 1406
NEW YORK
NY 10003

ORIGINALLY PUBLISHED IN FRENCH AS
GIORGIONE: PEINTRE DE LA "BRIEVETÉ POÉTIQUE"
© ÉDITIONS DE LA LAGUNE — PARIS — 1996
PUBLISHED WITH THE SUPPORT OF THE CENTRE NATIONAL DU LIVRE.

ISBN: 2-08013-644-5

DÉPÔT LÉGAL: SEPTEMBER 1997

PRINTED IN SPAIN

Library of Congress Cataloging-in-Publication Data

Anderson, Jaynie.
 [Giorgione. English]
 Giorgione : the panter of "poetic brevity" / Jaynie Anderson.
 p. cm.
 Translated from the French.
 Includes bibliographical references.
 ISBN 2-08-013644-5
 1. Giorgione, 1477–1511—Criticism and interpretation.
 2. Giorgione, 1477–1511—Catalogues raisonnés. I. Title.
ND623.G5A8913 1997
759.5—DC21 97-33012

JAYNIE ANDERSON

GIORGIONE

The Painter of 'Poetic Brevity'

INCLUDING CATALOGUE RAISONNÉ

Flammarion

Paris - New York

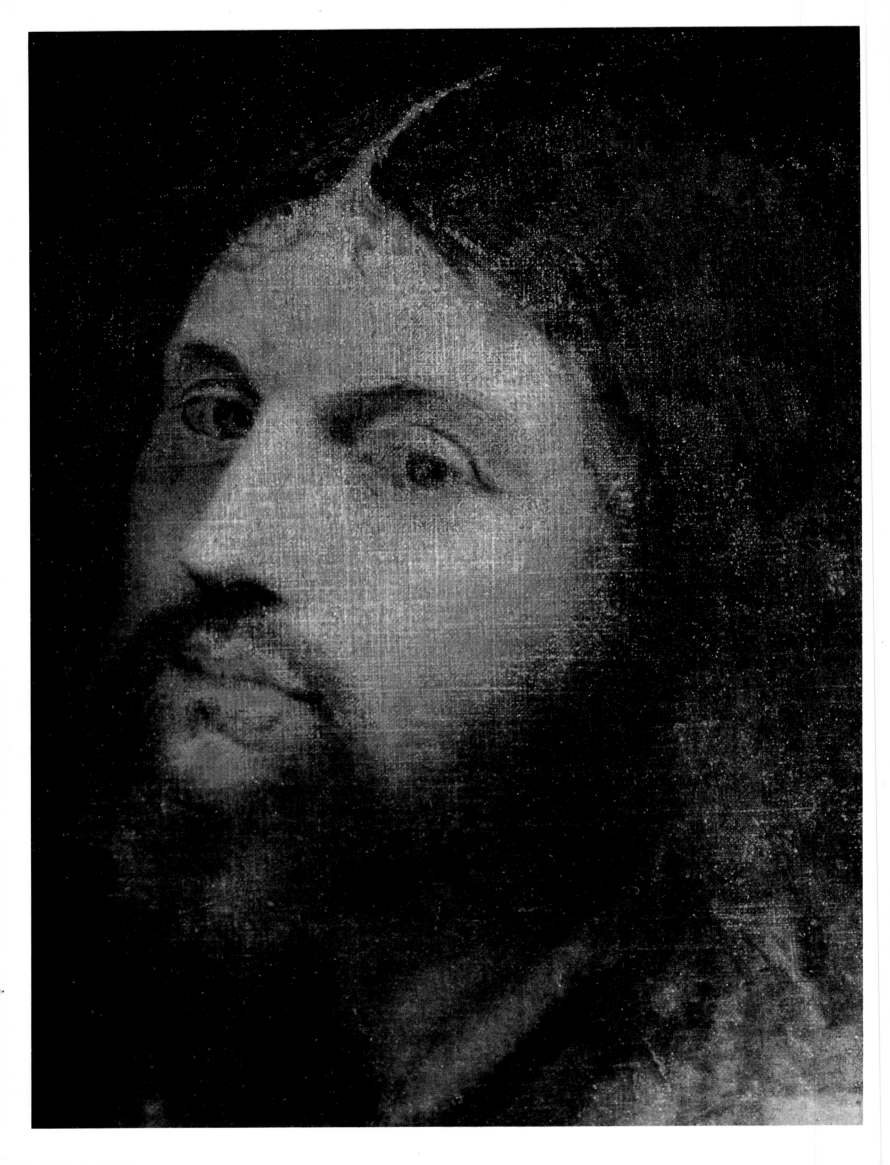

CONTENTS

1. GIORGIONE. *Christ Carrying the Cross*. Detail of Fig. 15.

For Richard and Alicia

Over the last decade there have been a number of remarkable exhibitions on sixteenth-century Venetian painting, the last of which, *Le siècle de Titien*, was held in Paris in the spring of 1993. The exhibition was the most interesting ever mounted on Venetian painting of that period. The second room, curated by Alessandro Ballarin, purported to contain only Giorgione's works. At a conservative estimate, there were at least eight other artists grouped under Giorgione's name–some would say more. In a later section of the same catalogue, devoted to 'the problem of works from Titian's youth', at least several works, universally given in part to Giorgione, such as the Dresden *Venus*, which was not exhibited, were confidently reproduced under Titian's name alone, without a reasoned analysis. In a further section on Giorgione's drawings, Konrad Oberhuber presented another list of attributions in Giorgione's name, most of which contradicted those advanced in the painting section. Thus, between the two sections of the catalogue, one curated by Ballarin and the other by Oberhuber, there was no agreement on what Giorgione had painted, or what the problems were. Despite the wealth of the exhibition, *Le siècle de Titien* never received the scholarly attention it deserved. But newspapers discussed the confusion openly, and one historian, Paul Joannides, went so far as to say that Giorgione was the 'black hole' of the show.

What form of art historical writing would allow us to escape from the confusion in which Giorgione studies have now fallen? There are dangers in allowing the polemics of exhibitions to dictate how a subject is developed. Exhibition catalogues are rarely the right forum to debate such complex issues as have arisen, because all the pictures are never present, and catalogues may be written in haste. The most important exclusions from the Paris exhibition catalogue were the results of the scientific examinations of Giorgione's paintings that had been undertaken before the works travelled to Paris.

If catalogues are open to criticism, the monograph on a single artist is also often ridiculed. Yet in Giorgione's case, the monograph is a necessity, for how can we talk about Giorgione's significance unless we know what he painted? This book attempts to be a monograph of a new kind, one which emphasizes the myths and realities created by the scientific examination of paintings associated with Giorgione's name. It has been necessary to reevaluate past conservation as well as the recent results of scientific research, and in this task I have been greatly helped by generous

colleagues and conservators in museums who have authorised me to reproduce the documentation relating to their restorations.

Since Karl Popper, we know that scientific research may be as fallible as historical research, and limited by the period during which it took place. Attributions, too, are opinions, which may be arrived at with good reason but may not be capable of proof. Only when a general consensus is reached can an attribution be accepted. For these reasons, it was necessary to retain the traditional features of a monograph, such as a catalogue, where each attribution is argued. In the catalogue raisonné, a group of works is attributed to Giorgione, followed by a short selection of problematic works, some of which may be attributed to him with reserve, as well as an account of paintings attributed to him in the past.

One of the keys to understanding the confusion that has arisen in Giorgione studies concerns the condition of his works. All the recent evidence points to the fact that Giorgione applied paint thinly, and that his technique could be imperfect. The condition of works of art, whatever their quality, can explain why their present appearance may differ from their original state. Only experience can determine why a detail seems wrong, why a section in a work of art appears weak, or how to evaluate the deterioration of colours in paintings, a task that is always complex with works of art which have survived almost five hundred years. Sometimes pupils and assistants in a studio can contribute to uneven execution, but in Giorgione's case he does not appear to have had a workshop like that of the Bellini until near the end of his life when he worked on the Fondaco frescoes. For these reasons, the most important criteria for evaluating Giorgione's corpus is the state of conservation of his paintings.

In his celebrated monograph, published in 1969, Terisio Pignatti was unconcerned with problems of condition, and this lack of interest has influenced successive literature. For my own part, in order to reevaluate earlier opinions and reputations, I reproduce unpublished archival material relating to what might be called the historical study of connoisseurship. This sort of material is exemplified by photographs of Giorgione's paintings taken during conservation (from the Duveen archives), and the various opinions of German and English museum directors in Italy in the nineteenth century, when Giorgione's pictures were being seriously evaluated for acquisition by major national museums. Such nineteenth-century material from the working notebooks of connoisseurs helps prove that the first modern

account of Giorgione's *Tempesta* was Lord Byron's *Beppo*.

Contrary to the view proposed by Konrad Oberhuber at the Paris exhibition, it is unlikely that Giorgione drew very much on paper, but infrared reflectography reveals that he drew a great deal on the surface of his canvasses. Sometimes the drawings are doodles and seemingly unrelated to the final composition, while at other times they are on the way to what we see on the surface. None of this is really very surprising since it conforms to what Titian told Vasari about Giorgione's working method. Giorgione's underdrawing can now be compared with what may be attributed to him on paper, and in future comparisons between underdrawings and drawings on paper will become more frequent.

My catalogue of Giorgione's works contains new material on provenances, collections and conservation history. Only the essential bibliography is given, for it is more important to provide the crucial references than to rehearse a sterile repetition of every recorded opinion. A new edition of the documents and sources relating to Giorgione is reproduced in an appendix. It includes some previously unpublished inventories, such as one concerning the collection of Taddeo Contarini, compiled at the time of the death of his son Darius in 1546. Another is a Medici list of works of art for sale in Venice in 1681, which includes many works by Giorgione, among them *La Vecchia*.

My fascination with Giorgione began when I was an undergraduate at the University of Melbourne, studying Venetian Renaissance portraiture with Franz Phillip, one of the last Viennese pupils of Julius von Schlosser, whom I have always considered an intellectual grandfather. I continued my doctoral studies at Bryn Mawr College, Pennsylvania, completing a Ph.D. thesis on Giorgione in 1972, supervised by the late Charles Mitchell and Charles Dempsey. Parts of my dissertation were published in articles as well as in the publications of the Giorgione quincentenary celebrations at Castelfranco and Venice in 1978. After this I was engaged with other subjects, notably the historical study of connoisseurship, but returned to Giorgione in 1991 as a Paul Mellon Fellow at the Center for Advanced Studies in the Visual Arts at the National Gallery of Art, Washington, D.C. Some of the chapters in the book developed from lectures for a course on sixteenth-century Venetian art and architecture at the University of Cambridge in the winter of 1996.

For many years I have discussed Giorgione with a number of scholars, to whom I owe a great deal, not only in terms of their scholarly publica-

tions, but also for their dialogues, namely, David Bomford, David Alan Brown, Jill Dunkerton, Charles Hope, Paul Joannides, Peter Meller, the late Joyce Plesters, David Rosand, and Wendy Stedman Sheard. Almost certainly we will not all be in agreement on everything, but then it is only with our best friends that we can agree and disagree.

One of the novelties of this book is the integration of material from conservation, and I am indebted to the conservators who have generously discussed their work with me. In Washington I learnt much from David Bull during his restoration of the *Allendale Adoration* in 1989, as I did from Yvonne Szafran of the J. Paul Getty Museum concerning the *Terris Portrait* in 1992. I am grateful to the conservation department of the National Gallery in Washington for permission to discuss so many previously unpublished underdrawings revealed by infrared reflectography with the help of Elizabeth Walmsley. Christopher Lloyd and Viola Pemberton-Piggott generously made available to me the results of their restoration on the Hampton Court *Singers* in the Royal Collection. For advice on particular problems I am grateful to Sylvie Béguin, Gianluigi Colalucci, James Dearden, Colin Eisler, Klara Garas, Burton Fredericksen, William Hauptman, Deborah Howard, Peter Humfrey, Alastair Laing, Mauro Lucco, Stefania Mason-Rinaldi, Mitchell Merling, Alessandra Mottola Molfino, Giovanna Nepi-Scirè, Serena Padovani, Joyce Plesters, Roger Rearick, Erich Schleier, Tilmann von Stockhausen, Carol Togneri, Francesco Valcanover, and many others.

Jaynie Anderson

2. GIORGIONE. *Self-Portrait as David.* Detail of Fig. 34.

NOTES TO THE READER

References to books and articles are given in full in the Bibliography at the end of the volume. In the notes to the essay and the literature sections of the catalogue, two forms of abbreviation are keyed to the Bibliography: works cited by author's surname and date appear in the Books and Articles section of the Bibliography; those cited by title and date are in the section concerning Exhibition Catalogues and Conference Proceedings. In the notes to the essays, a third form of abbreviation is used for repeat citations to references not in the Bibliography: the use of an author's surname and the title of the work indicates an earlier citation in the same chapter.

An explanation of the order of works in the catalogue raisonné is given at the beginning of that section.

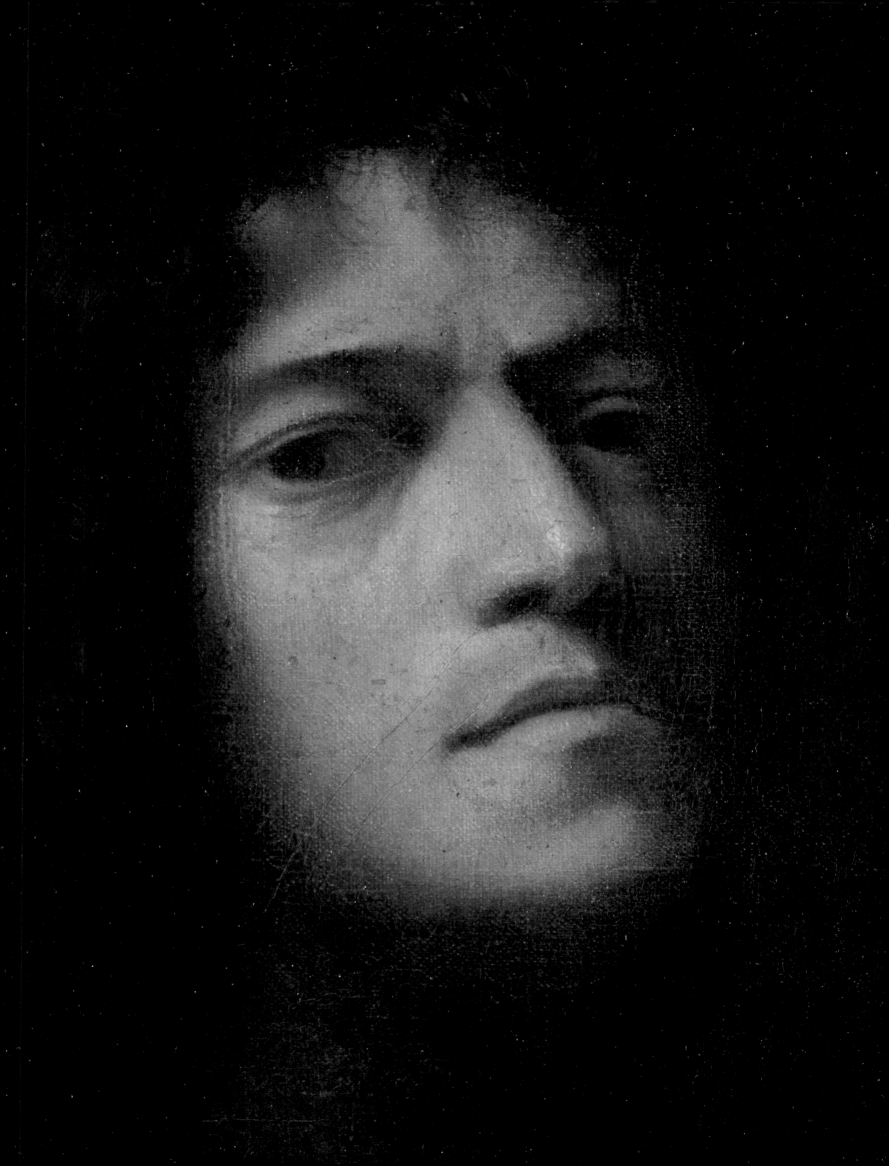

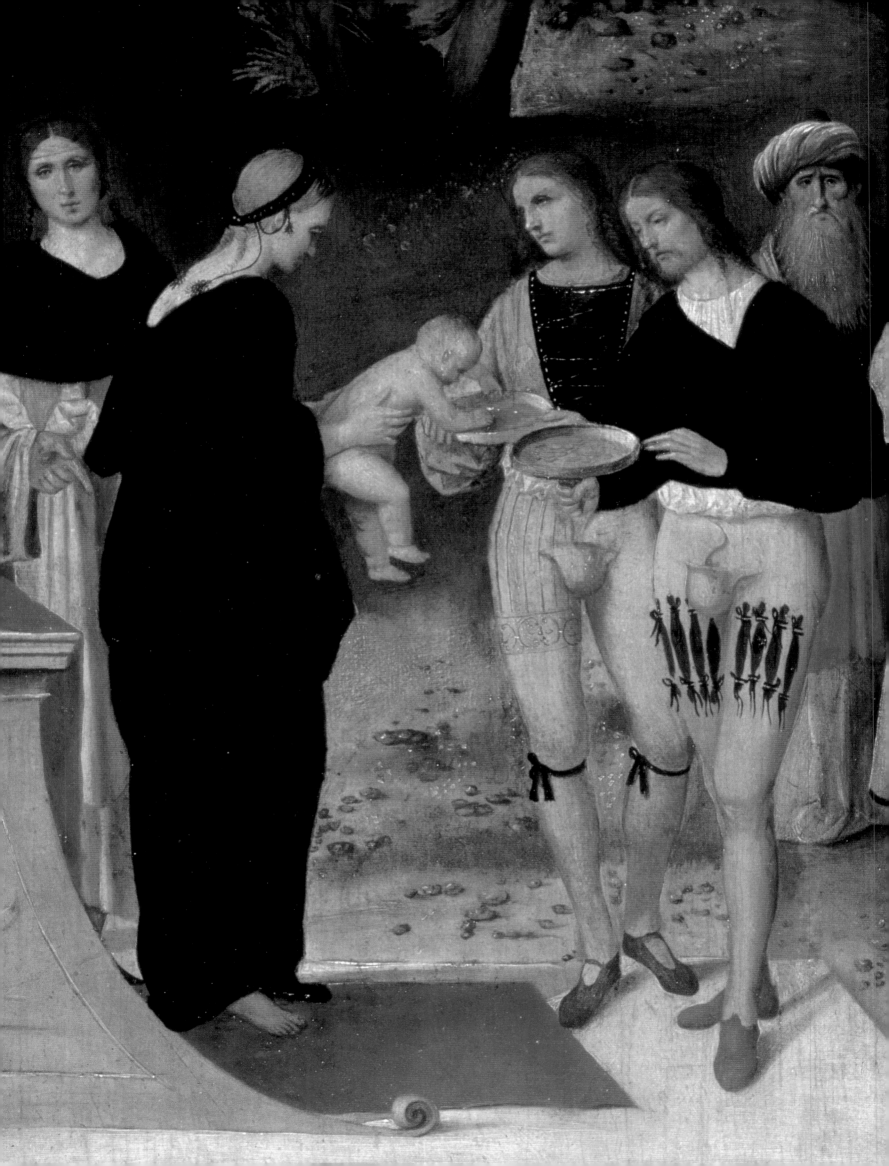

Chapter

I

A Poetic Style
of Brevity

I n late October 1510, the most resolute collector of the Northern Italian Renaissance wrote to her Venetian agent asking him to buy a painting of a night scene from the estate of Zorzo from Castelfranco, whom she described as 'a painter'. She had heard that Zorzo da Castelfranco's *Nativity*, the *Notte*, was an exquisite object, and she wanted to have it above all else. Yet Isabella d'Este was destined to be frustrated. Her agent Taddeo Albano replied that the painting in question was not in the artist's studio at the time of his death, but had been sold in two different versions to Venetian collectors. These collectors, one a seriously rich patrician, Taddeo Contarini, and the other a less well-known *cittadino*, Victorio Bechario, had debated as to which version was better conceived and better finished ('meglio designo e meglio finito'). Whatever the result of the ongoing debate as to the merits of the two versions, Albano's cultivated friends informed him that neither collector would sell his version of the *Notte* at any price, even to Isabella, because each had commissioned it for his own pleasure.[1]

This exchange of letters is often cited as the first reference to Giorgione's death, but more important it is also the earliest correspondence about the collecting of Giorgione's paintings. Like much of Isabella d'Este's correspondence, it is genuinely revealing. Here stated for the first time are all the constants about an artist who became known in succeeding decades as 'big George' or Giorgione. Immediately we know of the rarity of Giorgione's works, of the affinity between their subject matter and the intellectual enjoyment of a few patrons, of the extraordinary reputation for quality that the artist enjoyed, and that there was a debate about finish and design relating to the evaluation of a particular work. All these facts indicate that there was a greater demand than Giorgione could supply in the local art market, and that collecting and connoisseurship were intimately related to the production of his paintings. Giorgione's works may have always been rare, for they were copied early on, perhaps even forged. Even in 1510 no other Renaissance artist was so elusive, or in such demand. Unlike other Renaissance artists, who wrote treatises, letters and poems, like Dürer, Michelangelo or Leonardo, there is not enough literary evidence to write a biography in the modern sense of the word. Yet there is enough material to outline a minimal chronology.

The span of Giorgione's life, some thirty years or so, was established by Isabella d'Este and Giorgio Vasari. Giorgione's birthdate was 1478,

Page 14: 3. GIORGIONE. *Trial of Moses*. Detail of Fig. 6.

according to the corrected date in the second edition of Vasari's *Lives*. This date should be taken as a guideline; after all, Vasari gave Giorgione's date of death as 1511, wrong by merely a year. If he followed the traditional rules of apprenticeship, Giorgione should have become an independent painter at least by the age of twenty, that is, by 1498, or even earlier. There is no indication as to when he left his birthplace, Castelfranco, but according to Vasari he was brought up in Venice, where he studied with Giovanni Bellini at an early date. It was from Venice, according to Carlo Ridolfi, that Giorgone sent the *Castelfranco Altarpiece* back home. It had been executed for one of his first patrons, a Cypriot *condottiere*, Tuzio Costanzo, who had established residence in the Veneto in 1488, in proximity to Caterina Cornaro, a Cypriot queen in exile. Yet most scholars have been reluctant, for no good reason, to attribute anything to Giorgione before 1500.[2] There is an even more curious reluctance to attribute much to Giorgione after his frescoes on the Fondaco dei Tedeschi, in 1508, a year in which he received a number of official commissions. The frescoes on the German Customs House must have been the most important and discussed commission given to any Venetian artist in the first decade of the Cinquecento. Even the few sources we have are uniform on this matter. The German merchants in Italy were to be encouraged, but as a military presence they were to be controlled. Such a commission was thus a matter of concern for the Council of Ten.

One scholar argues for an even more extreme case, squeezing Giorgione's career into a few years and suggesting that the first indication of his existence is the Laura portrait in Vienna (Fig. 131), datable to 1506, and the last the Fondaco frescoes.[3] But how can Giorgione not have executed anything afterwards, especially since the early sources consistently testify to his continuing fame? Strangest of all, the contemporary documents about the Fondaco do not mention Titian's name, and yet he has been credited with the frescoes on the side of the building facing the Calle del Buso (now called the Calle del Fondaco), according to the testimony of his friend Lodovico Dolce.

How a young artist from Castelfranco, of humble birth ('nato di umilissima stirpe'), managed to find favour with a considerable number of wealthy patrician patrons for modish paintings without any earlier precedent requires some explanation. After an apprenticeship in Giovanni Bellini's workshop, Giorgione must have met a dealer, or more likely a

patron, someone like Pietro Bembo, who seems to have known almost all
of Giorgione's patrons, or the very wealthy Taddeo Contarini, or the subal-
tern bachelor Gabriel Vendramin. Any one of these men could have acted
as a go-between to facilitate a series of remarkable commissions from their
patrician friends within Giorgione's short life span. No other Venetian
artist before or after had a comparable career. Other Venetian artists, such
as Giovanni Bellini or Titian, may have lived longer, but their patronage
was of a more conventional kind. Giorgione must have been considered
the right kind of artist for such unusual subjects. His genial personality
can only have been an asset, for he was cultivated ('gentile') and endowed
with all manner of good habits in his life ('buoni costumi in tutta la sua
vita'), according to Vasari. His civilized manners were accompanied by a
handsome presence and an intriguing personality, as is testified by his self-
portrait. His self-image as David (Fig. 34) is not a mere likeness, but an
allegorical interpretation of himself as a boyish Old Testament hero. In
another self-portrait as Orpheus, surviving only in a painted copy by
Teniers (p. 317 below), Giorgione portrays himself as the ancient poet and
musician at the moment he loses Eurydice. There was something of the
dandy about him, with fashionable long hair worn down to the shoulders,
a style known as *zazzera*, and he was renowned for playing madrigals on
a lute, a social accomplishment that Pietro Bembo made fashionable. And
most intriguing of all, he was committed to 'le cose d'amore'. Vasari makes
Giorgione one of the earliest artists about whom it is legitimate to ask
questions about his sexuality.

Within the Venetian tradition, easel painting, such as Giorgione
invented for his private patrician patrons, implied a reduction of the
normal relationship between architectural space and the paintings.
Whereas an altarpiece inhabited and dominated a surrounding spatial
area in a church, Giorgione's small cabinet pictures were for rooms in
Venetian palaces. They may sometimes have been kept under painted
covers, as in the collection of Gabriel Vendramin at Santa Fosca, to be
opened and perused for private enjoyment with a few friends. Their
novelty when compared to the staid traditions of the altarpiece must have
been considerable. Earlier precedents for secular painting in Florence
were of a monumental kind, such as Botticelli's *Primavera*, or they
were associated with domestic furniture painting on wedding chests,
cassoni. Alternatively, there were precedents in the court culture of

Mantua, where Isabella d'Este commissioned paintings from such artists as Perugino and Mantegna. Such small portable pictures as Giorgione invented did initiate new fashions in collecting, for his patrician patrons could buy or swap them, weary of them, or decide to sell them, should they wish to profit. Unlike Isabella d'Este's commissions, these private works do not appear to have been precisely positioned within programmatic *studioli*, rooms that assembled paintings by different artists in a meaningful arrangement. Marcantonio Michiel's notes about early collections in Venice reveal the chic vogue of collecting pursuits among patricians. The refinement of Michiel's vocabulary concerning connoisseurial questions, copies, overpainting, and what we now call condition reflects the lost conversations of these patrician collectors. The paintings were valued not only for their content, but also for their style, one which Paolo Pino later defined in 1548 as 'poetic brevity'.

Within Giorgione's oeuvre, two paintings, half-figure compositions, are unparalleled representations of the humanistic education of young men: the so-called *Three Ages of Man* or the *Education of the Young Marcus Aurelius*, in the Palazzo Pitti (Fig. 106), and *Giovanni Borgherini and his Tutor* (Fig. 89). Did education mean something to Giorgione himself, or can we tell something about Giorgione's education from these paintings? Although Giorgione may not have been an intellectual, he was clearly an artist who was responsive to humanist themes and subjects, such as the education of young men, and philosophical and musical themes appear in a number of his pictures. Even though he may not have been 'learned', as some art historians would have wished him to be, the originality of his treatment of the subjects he was chosen to represent demonstrates that he must have been considered the right kind of artist for such themes, unlike his teacher Giovanni Bellini. His own self-image as David presents the first allegorical portrait of an artist within Venetian art. For the cut version in Braunschweig (Fig. 34), Giorgione reused an old canvas with an earlier image by his friend Catena on it, to create an original and spontaneous view of who he was. One doubts from the poverty of the materials used that it can have been commissioned; it therefore constitutes an autobiographical statement. The painting probably once belonged to Cardinal Marino Grimani, which suggests that the Grimani knew Giorgione. His self-portrait was extraordinarily popular, as many variants and copies confirm. The existence of so many self-images of a long-haired

artist with a furrowed brow attests to a contemporary fascination with the cult of his artistic personality, within and after his lifetime.

Giorgione's early work was informed by the court culture of Asolo, a small hill town near Castelfranco, where he found one of his earliest patrons, Tuzio Costanzo, a loyal retainer of the Queen of Cyprus in exile, Caterina Cornaro. In 1472 the Republic of Venice consolidated an alliance with Cyprus by adopting Caterina as a daughter of the Republic, and by arranging her marriage to Giacomo Luisignano, King of Cyprus. The groom died shortly after the wedding and Caterina was recalled to the Veneto. At Asolo, Caterina Cornaro resided at the *Barco*, a villa that no longer survives, but which in the past exerted a beguiling magic, not the least on Pietro Bembo, who took it for the setting of his book on the nature of courtly love, *Gli Asolani* (1505). Bembo's *Asolani* was published in a tiny format, resembling those small books held by long-haired young men in Venetian portraiture. Written for the wedding of one of the ladies-in-waiting at the court of Caterina Cornaro in Asolo, *Gli Asolani* created a pictorial provocation about the nature of love. Of the many interpretations proposed for two masterpieces, Giorgione's *Concert Champêtre* and Titian's *Sacred and Profane Love*, different passages in Bembo's book have proved among the most convincing sources.[4]

Large, conspicuous and important erotic Venetian paintings such as these have no early provenances, and do not appear in the inventories and descriptions of collections before the seventeenth century. It has frequently been suggested that they may have been commissioned for *studioli*, Isabella d'Este having been proposed as a likely patron of the *Concert Champêtre*. Yet of all patrons she is among the best documented, and nothing in these documents is revelatory about the picture in question. Moreover, the *Concert Champêtre* could have been inspired by the same debates at Asolo that inspired Bembo. Caterina's *Barco* was a unique example of a court in the Veneto, to some degree imitative of Mantua, a potent reminder of Central Italian culture, and the forerunner of the later Palladian fashion of building villas on the *terraferma*, or enjoying *la dolce vita pastorale*. Even at Urbino, Mantua, and elsewhere, there may have been dukes and duchesses, but never kings and queens. Caterina Cornaro was a queen, in a city state that forbade queens, that is, within the oligarchy of Venice; further, there was no royalty within the Italian peninsula. Whatever the reality of Caterina's patronage — for some have denied

that she commissioned works of great quality — her mere presence attracted attention, as is shown by the large number of portraits of her in comparison to those of other Venetian women of the period. Caterina's visibility, in contrast to other contemporary women, is a proof of the fascination she exerted.

Castelfranco was located in the Trevigiana, a small lush region of the Veneto, where humanist culture flourished.⁵ Treviso, the capital of the region, was the location for an erotic antiquarian love story, the celebrated *Hypnerotomachia Poliphili*, set in what was then a recent past, the month of May 1467. The book, known colloquially as the *Dream of Poliphilo*, was published by Aldus Manutius in 1499.⁶ It represents the Trevisan antiquarian world in which Giorgione was nurtured, and some of the sensual woodcut illustrations in the book were to inform Giorgione's imagery. In the story, a young man, Poliphilo, goes on a pilgrimage in search of antiquity, which, after many adventures, eventually presents itself in female

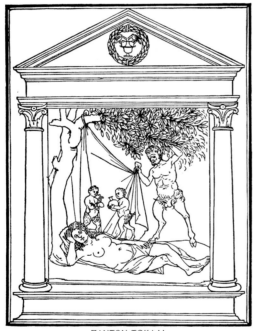

4. *Representation of a Fountain with Venus and a Satyr.* Woodcut from the *Hypnerotomachia Poliphili*, Venice, 1499.

ΠΑΝΤΩΝ ΤΟΚΑΔΙ

form as a young woman called Polia, whose name in Greek means antiquity, and whom he chases through ancient palaces and beautifully decorated convents. The narrative begins with Poliphilo falling asleep, and then dreaming about an ancient world within his dream. In this second dream world he encounters many challenges, travels to ancient sculptural and architectural monuments, and encounters gods and goddesses, all of whom encourage him to go further in his quest.

One of the monuments that he encounters is a fountain with a sculpture of a sleeping female figure watched by a lascivious satyr accompanied by two baby satyrs frolicking with snakes and a vase (Fig. 4). The woodcut in which the sculpture is depicted has often been recognized as having informed Giorgione's Dresden *Venus* (Fig. 139). The author and illustrator of the *Hypnerotomachia* suggest various possibilities about the erotic sleeping woman's identity. At first

sight she appears to be one of the numerous nymphs on garden fountains,[7] because she is on a fountain, and in proximity to satyrs, but the Greek inscription ΜΑΝΤΩΝ ΤΟΚΑΔΙ, meaning the 'mother of all things', reveals that she can only be *Venus genetrix*. In the text she is initially described as a carved and very beautiful sleeping nymph ('bellissima nympha . . . interscalpta'). There follows a complex account of how water gushes fervidly from her breasts, to be collected in vases, all of which emphasize the functional nature of the sculpture. The spectator/reader is stimulated to examine the woodcut, where not all the erotic details discussed in the text are represented. The anthropomorphic fountain is then compared to Praxiteles' *Venus* at Knidos, a statue which excited men to make love to it ('in lascivia pruriente et tutto commoto'). Further details of the woodcut are explained. The satyr, with a hybrid face, half-goat, half-human, is breaking a branch of the tree with his left hand, a gesture which denotes a violent rape, while with his right hand he pulls a curtain to shade Venus. There is always a playful relationship between the text and imagery of the *Hypnerotomachia Poliphili*, in which classical sources are manipulated and recreated, suggesting a close relationship between the author and illustrator. The attribution of the woodcuts is problematic, but one of the more convincing suggestions is that they are by Benedetto Bordon, a miniature painter, although they are far superior in quality to his usual productions.[8]

The story is told in exuberant, even intoxicating language, a mixture of Venetian dialect and Latin, and sometimes the text imitates in satirical manner the language of ecclesiastical oratory, as if a priest were preaching. Annibale Caro, Vasari's literary friend, later pronounced that it was written in 'provençal', whereas Castiglione remarked in his *Cortegiano* that it had become fashionable among women to speak and write like Poliphilo. Dürer is said to have bought the volume on his second visit to Venice. The stunning illustrations, primarily of sculptures and buildings rather than paintings, were to influence generations of artists for centuries. The author's imagination was triggered by classical descriptions of lost buildings, and he describes partly made-up monuments of architecture and sculpture. Despite the prominent and pioneering role that the Aldine Press occupied in Venetian humanism, only two Aldine books were fully illustrated, one of which was the *Hypnerotomachia*, and the illustrations became better known than the text. The expensive

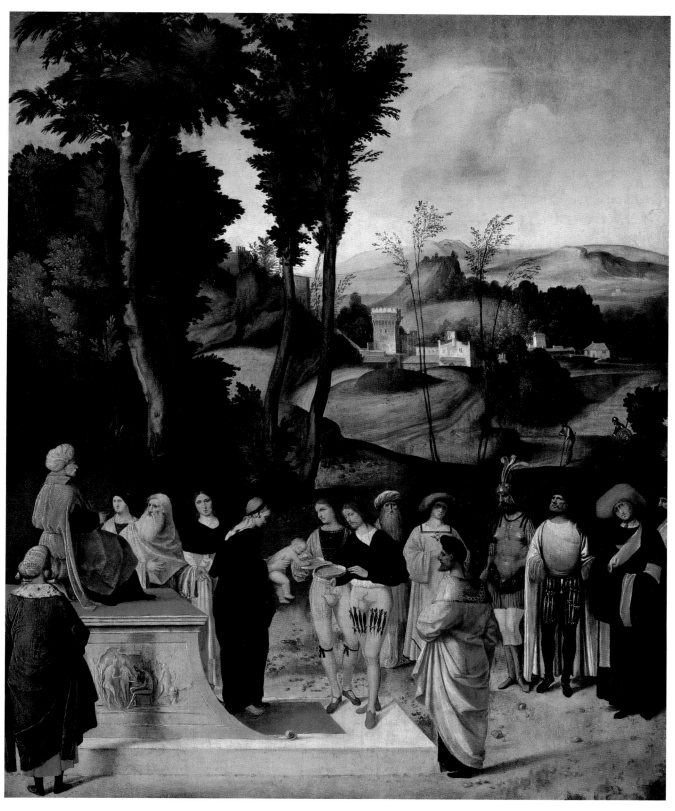

Above: 6. GIORGIONE. *Trial of Moses*, c. 1496. Oil on panel. 89 x 72 cm. Florence, Galleria degli Uffizi.
Left: 5. GIORGIONE. *Trial of Moses*. Detail.

publication was financed by a wealthy Veronese lawyer and entrepreneur, Lodovico Crasso,[9] who undertook to have the manuscript published at his own expense by the great Aldus in Venice, 'lest', as he advises us in his Latin dedication to the Duke of Urbino, the manuscript 'should hide longer in oblivion'. In many ways the book's most important novelty was that it discussed classical stories in the vernacular, and placed recently rediscovered Roman antiquities within the context of a Trevisan love story.[10]

In the cathedral at Treviso, Giorgione could not have failed to be impressed by the sculpture of Tullio and Antonio Lombardo, especially the sarcophagus on the tomb of Bishop Giovanni Zanetto (1485–88), decorated with a relief of marine creatures bearing gorgeously brittle foliage. Indeed, it may have instilled in him a sense of competition, later to bear fruit in his concern with the *paragone*, the debate on the relative merits of the arts, which in Giorgione's case focussed on whether sculpture or painting was the greater art. Some of the more interesting works of art to be seen locally in the Trevigiana were sculptural, which led Giorgione to a stubborn reaction in favor of the power of painting. Might he have witnessed, at the age of ten, or at least heard of, the 1488 procession which Pomponius Gauricus describes in his treatise on sculpture some sixteen years later? As Gauricus recounts it, the Trevisans 'bore aloft elements of cornices, that he [Tullio Lombardo] had carved as a young man, with all sorts of foliage ornaments, in a sort of triumphal procession'. It appears to have been a sculptor's triumph, for Andrea Rizzo was present; according to Gauricus, Rizzo remarked 'that never before had architectural elements been worked like sword hilts'.[11] In these circumstances the Trevigiana where Giorgione grew up can hardly have been a provincial backwater, with Caterina's court resident at Asolo and the Lombardi creating a sensation in Treviso.

According to Vasari's second edition of the life of Giorgione, one event placed the *paragone* on Giorgione's artistic agenda: the unveiling of the equestrian monument to Bartolomeo Colleoni by Andrea Verrocchio in front of San Giovanni e Paolo (Fig. 30), recorded by Marino Sanudo in his diaries on 21 March 1496.[12] According to Vasari, Giorgione entered into a debate with some sculptors, who maintained that sculpture was superior to painting because it enabled viewers to walk around it, thus showing many different aspects and gestures of a body. Giorgione coun-

tered that history painting was superior because it could show you at one glance the figure of a man from all sides. His demonstration piece was a nude male figure turning his back; a frontal view of the man was reflected in a limpid fountain at his feet, one of his profiles was seen in a brightly polished piece of armour, and his other side was reflected in a mirror. This story places Giorgione in Venice in the late 1490s, a likely date for an artist born c. 1477. More important, it shows him as an active member of the Venetian artistic community and, since Verrocchio was Leonardo da Vinci's master, also suggests an early indirect contact before Leonardo's visit to the Veneto. Giorgione's relationship with Leonardo and his theories has been much debated, but it seems to have been one of constant concern. Throughout his life, Giorgione was attracted to motifs taken from Leonardo's imagery, and he was also involved in developing Leonardo's theories about the power of representation, principally in portraiture.

What was to be seen in Venice during Giorgione's formative years is conveniently outlined in Marino Sanudo's *List of Notable Things in Venetian Churches* (1493), a guide to Venetian art before Giorgione.[13] Sanudo is usually thought of as a mere diarist, who has left us an account of daily life in richly detailed and succinct prose. But he also collected works of art, and composed some forty-seven lists (surprisingly unpublished) of the sights, institutions, rituals and customs of Venice. The thirteenth of these lists concerns tombs and alterpieces in Venetian churches. Here he makes more value judgements as to what was beautiful than he ever did afterwards in his diaries. Foremost among the thirty-nine tombs listed was Tullio Lombardo's tomb of Doge Andrea Vendramin, described by Sanudo in an uncharacteristic fit of hyperbole as 'the most beautiful monument on earth'. The combination of elusive sadness and sensuality in the young men Tullio sculpted, exemplified by the figure of *Adam*, from the Vendramin tomb (Fig. 9), then in the church of Santa Maria dei Servi (and now detached in the Metropolitan Museum of Art, New York), was to be later reflected in the free-standing monumental figure paintings that Giorgione created in the Fondaco frescoes. Nor was Giorgione alone in feeling the impact of Tullio's sculpture, for Michelangelo visited Venice in October 1494, and his *Bacchus* of about 1496 reveals the impact of the figures on the Vendramin tomb.

A few paintings were also singled out by Sanudo for praise in his list,

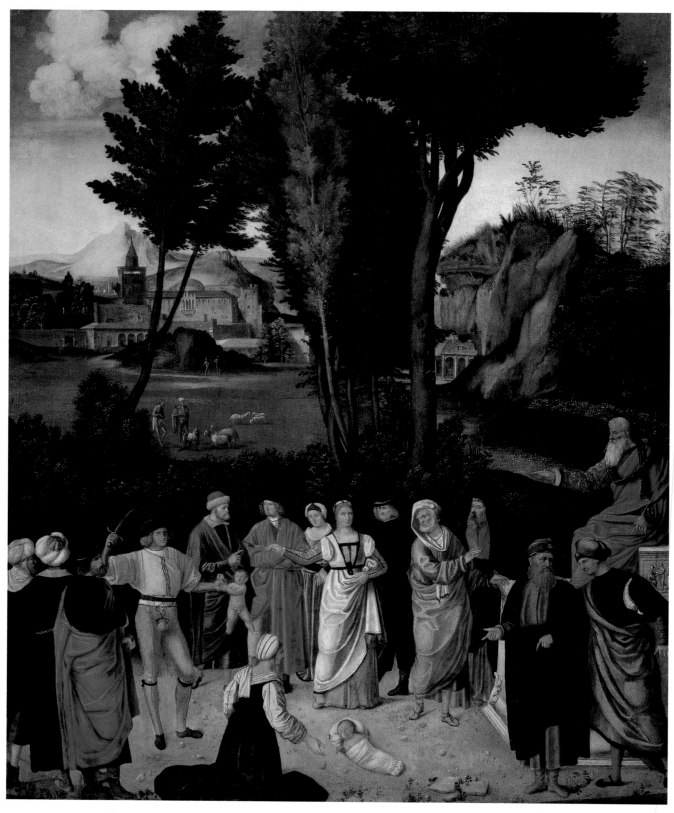

Above: 7. GIORGIONE. *Judgement of Solomon*, c. 1496. Oil on panel. 89 x 72 cm. Florence, Galleria degli Uffizi.
Right: 8. GIORGIONE. *Judgement of Solomon*. Detail.

including two recent altarpieces by Giovanni Bellini, his 'altar bellissimo', the *Polyptych of San Vincenzo Ferreri*, in the church of San Giovanni e Paolo, and the altarpiece of the Virgin and saints with musical angels then in San Giobbe (now in the Gallerie dell'Accademia). Near the end of the list came Antonello da Messina's *San Cassiano Altarpiece* (1475–76), com-

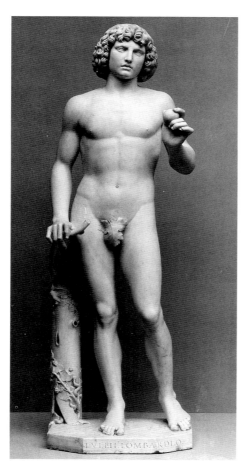

9. TULLIO LOMBARDO. *Adam*, from the tomb of Andrea Vendramin. Marble. Height 193 cm. New York, The Metropolitan Museum of Art; Fletcher Fund, 1936.

missioned by a patrician of the Bon family. Sanudo described the figures in this work as only lacking a soul to be fully alive ('e queste figure e si buone che appariscono vivente, & non li manca se non l'anima'). A surviving fragment of Antonello's altarpiece (Kunsthistorisches Museum, Vienna) reveals how the Madonna was isolated on top of a high throne, a motif which Bellini in the *San Giobbe Altarpiece*, and later Giorgione in his *Castelfranco Altarpiece*, were to develop in different ways.

Although undocumented, one may suppose that Giorgione was early acquainted not only with the Trevigiana, but also with the region of Padua. For the identification of the celebrated drawing by Giorgione in Rotterdam as a representation of the Castel San Zeno at Montagnana (Fig. 61), a small walled city not far south of Padua, reveals that he was in the region at an early date in his career. Art historians are notoriously reluctant to allow artists to have travelled, but in this instance Giorgione appears to have gone beyond these imposed confines. Could he have been en route to the Emilia, to Bologna, where he might have encountered altarpieces by Francia and Costa, whom some have argued was one of Giorgione's earliest teachers;[14] or could he have met Giulio Campagnola in the Padovano?[15] He may also have been in contact with Garofalo, described by Vasari as 'l'amico di Giorgione', for there are early reflections of the *Allendale Adoration* in Ferrarese painting.

The notes of the patrician collector Marcantonio Michiel identify Giorgione's early works as being paintings like Taddeo Contarini's *Finding of the Infant Paris*, the appearance of which is recorded in Teniers' engraved and painted copies (Fig. 93). From the beginning, the pastoral landscape of the *terraferma* is introduced as the background to both religious and classical subject matter, as in the early Uffizi panels, the *Trial of Moses* and *Judgement of Solomon* (Figs. 6, 7), which take place against a Veneto landscape, irrespective of any textual justification. These early works, together with the Allendale group of paintings, demonstrate an approach to the construction of figures within a landscape setting very different from anything seen before in Venetian painting. The same concerns develop gradually in the *Three Philosophers in a Landscape*, the *Tempesta*, and the *Venus Sleeping in a Landscape* in Dresden (Figs. 49, 108, 139). In almost every work that may be attributed to Giorgione, with the exception of portraiture, landscape is explored in a novel fashion. Landscape was not discussed in Alberti's treatise *On Painting* (1435), but it was taken up in architectural treatises by Alberti and by his model, the ancient Roman Vitruvius, where landscape painting is introduced as an appropriate form of architectural decoration. In Italian theory, landscape was first introduced as subservient to architecture, but Leonardo elevated its status, arguing that the artist possessed a god-like power when he was able to depict nature. Significantly, it is in Venetian literature that pastoral landscapes are first explored, notably in Jacopo Sannazaro's *Arcadia*, first published in 1504, but written decades earlier. Giorgione drew on the rich literary and artistic traditions developed by Leonardo and Sannazaro to create a new form of Venetian pastoral painting.

In his first edition of the *Lives*, Vasari discusses Giorgione as the equal of Leonardo da Vinci and Correggio, the three together identified as the first exponents of the modern style of the sixteenth century, *la maniera moderna*. In the second edition, Vasari defines more precisely the impact of the art of Leonardo on Giorgione. He writes that Giorgione had seen 'some things' ('alcune cose') by Leonardo's hand that were very soft, frighteningly dark, shadowy and hidden; this style pleased Giorgione so much that he pursued it, particularly in oil painting. For Vasari, Giorgione was fascinated with Leonardo's personality, beginning, we may add, at least in March 1500, when Leonardo is documented as being briefly in Venice. Since Vasari wrote about Leonardo's impact on Venetian art, the topic

has always been controversial,[16] partly because Leonardo is only known to have visited Venice briefly in March 1500, engaged by the Venetian Republic on a hydraulic project, and partly because it is difficult to know which works by Leonardo were in Venice. On the one hand, there are a number of precise borrowings that Giorgione made from Leonardo's drawings, which may be documented from his earliest to his late works; on the other hand, the issue of which paintings could be seen by Leonardo's hand has proved until now more elusive.

Giorgione's indebtedness to the imagery of Leonardo's drawings is overwhelming, not only in terms of precisely derived motifs, but also in concept and theory. It is known that Leonardo brought with him to Venice at least one drawing, a portrait of Isabella d'Este, a full-scale cartoon now in the Louvre, and he showed it to Isabella's agent in Venice, Lorenzo da Pavia. But there were presumably others, for the head of the young man on the right in the *Education of the Young Marcus Aurelius* or *Three Ages of Man* (Fig. 10) is derived from Leonardo's preparatory chalk drawing now at Windsor for the head of the Apostle Philip in Leonardo's *Last Supper* (Fig. 11).[17] The convincing supposition is that Leonardo arrived in Venice with a portfolio of preparatory drawings for his recently completed Milanese masterpiece, which immediately made an impact on Venetian artists; this in turn suggests an early date of c. 1500 for Giorgione's Pitti painting.[18] The many drawings by Leonardo that present effective physiognomic contrasts between beauty and ugliness inspired confrontational poses in Giorgione's portraits and religious pictures. The celebrated Leonardo drawing, also at Windsor, of the profile of an elderly man surrounded by four grotesque heads (Fig. 12) was adopted by Giorgione for the confrontation between a noble Venetian patrician and a menacing servant in the *Portrait of a Young Soldier with his Retainer*, said to be a portrait of Girolamo Marcello (Fig. 13).[19] In the San Rocco *Christ Carrying the Cross* (Fig. 15), the contrasting profiles of youth and age, nobility and ignobility, between Christ and his executioner are directly inspired by a motif well known in Leonardo's drawings of the heads of Christ and Judas, exemplified by a metalpoint drawing of the head of Christ alone, now in Venice (Fig. 14). Copies after Leonardo's drawing show that there was once a figure of Judas grasping Christ's hair on the left side, allowing us to infer that Giorgione saw the composition intact.[20] We may never know in what precise circumstances Giorgione saw Leonardo's drawings, nor in which

10. GIORGIONE.
Education of the Young Marcus Aurelius (Three Ages of Man).
Detail of Fig. 106.

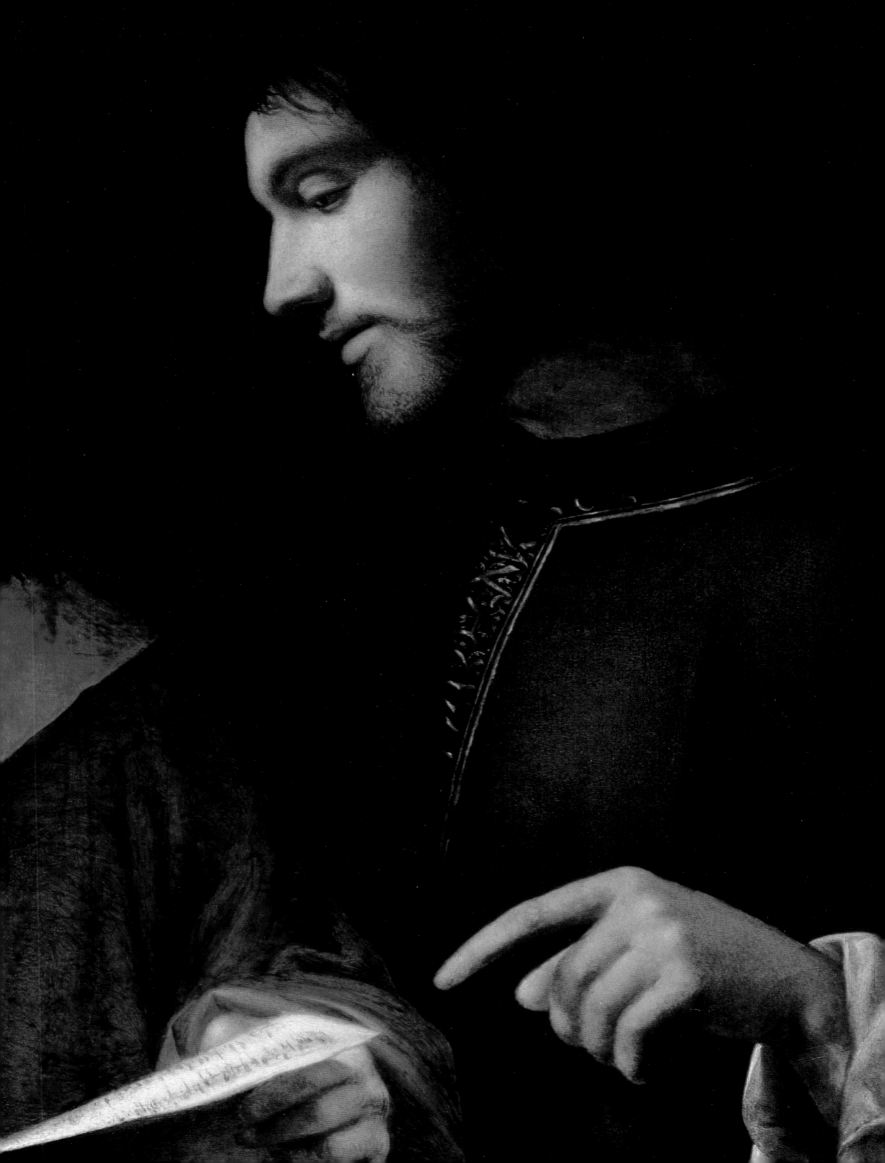

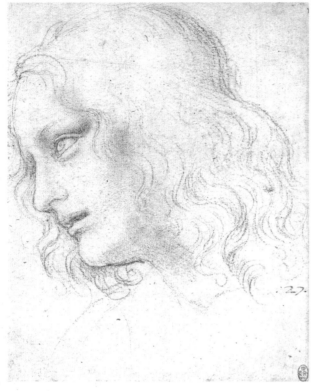

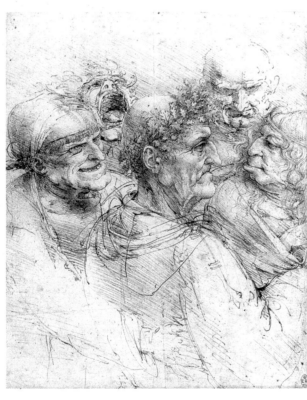

collections or artists' workshops they may have been, but the derivations from drawings seem to be consistently about one theme: how male beauty is portrayed more effectively when contrasted with ugliness, a visual foil invented by Leonardo.

The heavy chiaroscuro under-modelling of Leonardo's technique in painting made a strong impression on Giorgione, especially evident in the deep iridescent glow of the chiaroscuro undermodelling in Giorgione's *Portrait of a Woman* (*Laura*), where the contours are all suggested by inner modelling rather than by schematic outlines (Fig. 131). Giorgione could have learnt about Leonardo's painting technique from a direct acquaintance, for there were at least three paintings by Leonardo in Venetian collections, the most important being the *Madonna Litta*, described by Michiel as in the collection of Michele Contarini (now State Hermitage Museum, St Petersburg). Two other paintings by Leonardo in one of the most important Venetian collections of the early Cinquecento, that of Cardinal Marino Grimani, were described in an inventory he made of the pictures he took to Rome following his election to cardinal in October 1528.[21] Marino Grimani's paintings were largely inherited from his uncle, the legendary Cardinal Domenico Grimani, with whose

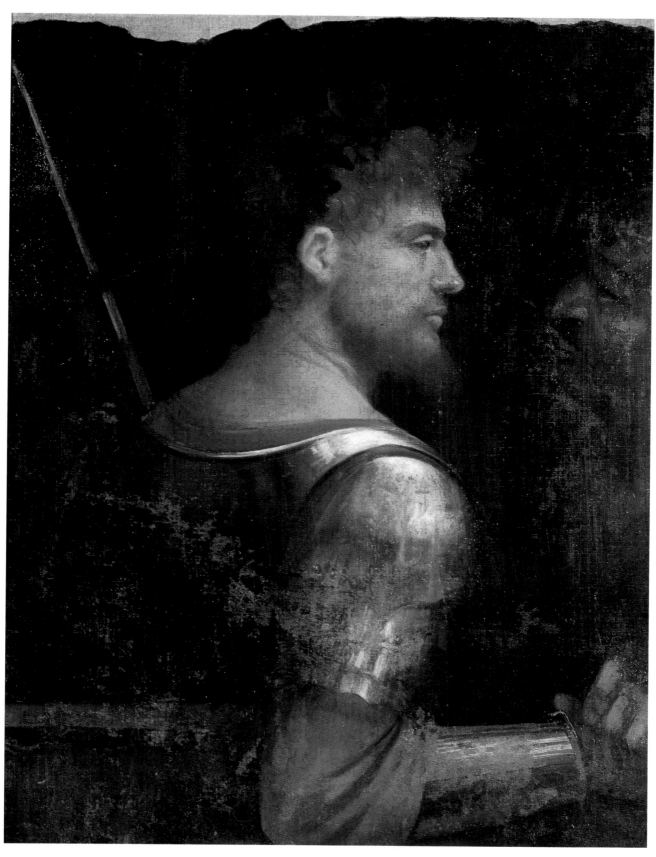

13. GIORGIONE. *Portrait of a Young Soldier with his Retainer (Portrait of Girolamo Marcello)*.
Canvas. 72 x 56.5 cm. Vienna, Kunsthistorisches Museum.

permission Leonardo appears to have made copies of Grimani antiquities.[22] In the Grimani collection there were works by Giorgione, including his self-portrait, suggesting that he could have even met Leonardo through their mutual patron. The two works by Leonardo were 'a head with a garland'[23] and 'the head of a young boy'.[24] Both may be identified with works described in the inventory of Leonardo's pupil Salaì.[25] The first was a painted version of the profile bust of a young woman with a garland of

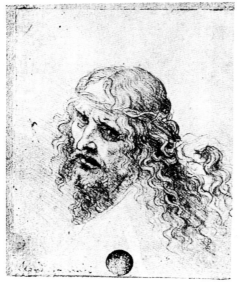

14. LEONARDO DA VINCI. *Head and Shoulders of Christ.* Silverpoint on grey prepared paper. 11.6 x 9.1 cm. Venice, Gallerie dell'Accademia.

ivy, represented in the celebrated engraving inscribed with the name of Leonardo da Vinci's academy (Fig. 16). The other may be the *Christo Giovinetto*, age ten to twelve, that Isabella d'Este continually asked Leonardo to make for her in these very years, but which Domenico Grimani may have been lucky enough to obtain. This unique invention of a youthful Christ is reflected in a Leonardesque picture in Madrid (Museo Lazzaro Galdiano) which has the faintest sign of a cross defined in light to indicate the divine identity of the boy.

A conspicuously Leonardesque picture by Giorgione, known as the *Young Boy with an Arrow* (Fig. 17), is first recorded in the house of Giovanni Ram, a Spanish merchant in Venice. It may be better to describe this androgynous youth as a young man in the guise of St Sebastian, a subject which emerged in Leonardo's workshop in Milan during the last decade of the Quattrocento, most notably in those portraits of young men, crowned with laurel, ivy and jewels, created by Giovanni Antonio Boltraffio, a pupil of Leonardo beginning in 1490.[26] Boltraffio's bejewelled youth as St Sebastian (Fig. 18) gives the impression of being a real portrait of someone dressed up in gorgeous costume, decorated with lilies, for a religious play or theatrical festival.[27] Of all Boltraffio's portraits, it appears closest to Giorgione's androgynous youth. Many of the exquisite details of Giorgione's picture — the youth's heavy curls, the delicately smocked pink shirt, and seductive glance at the spectator as he points an arrow at himself — are predictive of some of the early works of Caravaggio. There has been

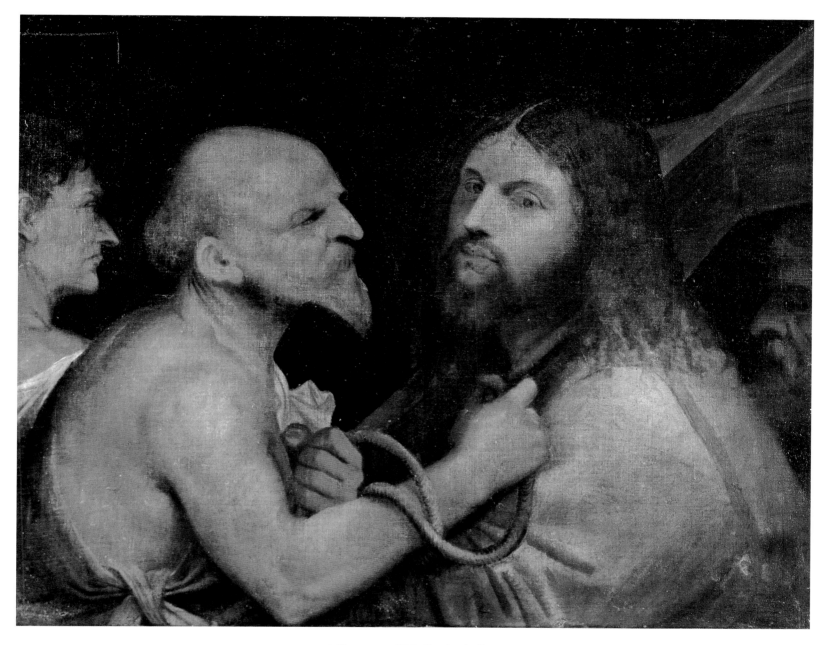

15. GIORGIONE. *Christ Carrying the Cross.*
Oil on canvas. 70 x 100 cm. Venice, Scuola di San Rocco.

much speculation about how Giorgione could have been acquainted with Leonardo's paintings and drawings, for many Venetian writers, such as Boschini, have denied it. The evidence assembled here should leave us in no doubt about Giorgione's indebtedness to a genius, even though his model is guilty of being Florentine.[28]

16. School of LEONARDO DA VINCI. *Profile of a Young Woman with a Garland of Ivy*. Engraving. London, British Museum.

In accounts of Giorgione's chronology, two dates inscribed on the reverses of two portraits have always been thought canonical. One is the famous inscription on the reverse of *Laura*, dated 1 June 1506, when the portrait was made for Messer Giacomo, and where Giorgione is identified as a colleague of Vincenzo Catena ('1506 adj. primo zugno fo fatto questo de man de maistro zorzi da chastel fr[ancho] cholega de maistro vizenzo chaena ad instanzia de misser giacomo'). The portrait was virtually ignored in all the Giorgione literature before 1931, when the inscription was published for the first time. Laura, her head outlined against laurel leaves,

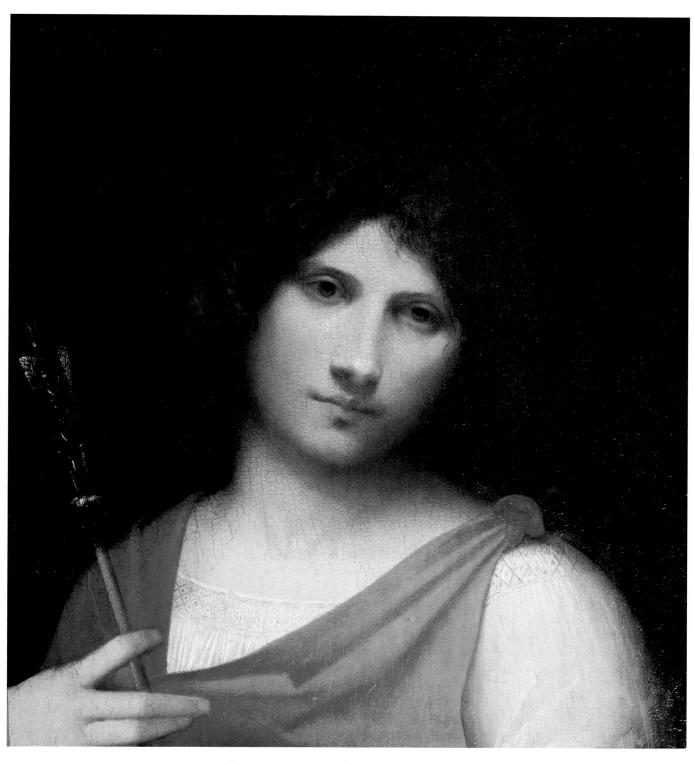

17. GIORGIONE. *Young Boy with an Arrow*. Poplar. 48 x 42 cm.
Vienna, Kunsthistorisches Museum.

is again a witness to Giorgione's concern with Leonardesque inventions, in this case his *Portrait of Ginevra dei Benci* in Washington.

The second date is on the reverse of the *Terris Portrait* at San Diego (Fig. 68). It has proved more problematic to read, even illegible, since the last two numbers are almost destroyed. Yet since Pignatti in 1969 read the date as 1510, the *Terris Portrait* has always been considered a late work and a key to understanding Giorgione's style in his last years, after the Fondaco frescoes. In 1992, the reverse of the panel

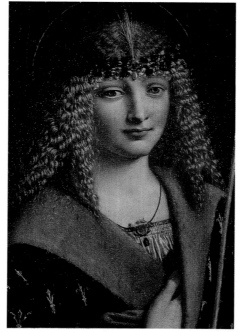

18. GIOVANNI ANTONIO BOLTRAFFIO. *Portrait of a Young Man as St Sebastian.* Panel transferred to canvas. 48 x 36 cm. Moscow, Pushkin Museum.

was examined with infrared reflectography, which did little to render the date less ambiguous, but did reveal an underdrawing which Giorgione had begun on the reverse (Fig. 67).[29] He had applied gesso as a ground and had then made drawings of small figures in a landscape, which he had begun to inpaint, before abandoning that side of the panel. Thereafter, someone applied a layer of paint to the reverse and the date. The newly revealed drawings look rather like those in the underdrawing of the *Education of the Young Marcus Aurelius*, thus placing the painting within the first years of the Cinquecento. Once the validity of the date has been questioned, the debate is reopened as to where the *Terris Portrait* should be placed in Giorgione's chronology and, more important, what should be attributed to him after the Fondaco frescoes. The portrait has also suffered considerable discoloration. The sitter's clothes were once bright purple against the green background, suggesting that it may be an earlier work, just as the drawing revealed on the reverse is an early drawing. All this points to a reading of the date on the reverse as probably 1500, or even 1506, but not 1510.

Vasari describes a stylistic change in Giorgione's work in 1507, when he became displeased with the current mode and began to give his work more softness and greater relief, painting with many layers of colour and dispensing with drawing on paper. What did Vasari mean when he chose

this date? The year 1507 was one in which Giorgione received an impor-
tant commission for the Audience Hall in the Palazzo Ducale, Venice.
The canvas, now lost and of unknown subject, was the first occasion in
which Giorgione was commissioned to paint a major work for an impor-
tant public space. There has been much speculation as to how he moved
from the small patrician circle, for whom he painted works with small
figures, to such a commission. In the documents recording the commis-
sion, one name stands out, that of Nicolò Aurelio, Secretary to the Council
of Ten in these years.[30] One might argue that this is simply because as
secretary, Aurelio signed everything, but nonetheless Aurelio is well known
as a patron, for he commissioned Titian's *Sacred and Profane Love*, his coat-
of-arms being conspicuously represented on the sarcophagus in that famous
idyll.[31] There has been much speculation as to who may have recommended
Giorgione to the Council of Ten, but Aurelio's name should be suggested.
Would he not, more than others, have been particularly susceptible to a
style of large figure painting, such as he was to later commission from
Titian? Giorgione's canvas for the Palazzo Ducale was probably in the style
of the large flaming red nude figures that he devised for the facade of the
Fondaco dei Tedeschi (Fig. 173). His lost canvas was commissioned when
the Palazzo Ducale was undergoing a radical restoration and was part of a
series of commissions from artists like Gentile and Giovanni Bellini,
Carpaccio, Perugino, and many others. The architect, Giorgio Spavento,
also supervised the building of the Fondaco until 1505, while the sculp-
tural decoration for the room where Giorgione's canvas was located was
by Tullio and Antonio Lombardo, presumably old friends and rivals from
Treviso. Nothing survives of what must have been one of the most excep-
tional rooms in Renaissance Venice.

Giorgione's new style was exemplified by the frescoes on the Fondaco
dei Tedeschi, one of the most prominent facades along the Grand Canal,
near the Rialto bridge, and certainly one of the most delicate of political
commissions. What can be deduced from the surviving fragments, and
from the hand-coloured copies by Zanetti after the frescoes, is that they
represented huge, flaming red coloured sculpture, suggesting that the
unusual imagery was intended to demonstrate that polychrome painting
could represent the visual world better than white marble sculpture. The
Fondaco is also the first commission for which we know Giorgione had a
workshop, which included at least one of his pupil 'creatures' ('creati', as

Vasari called them), that is, Titian, along with Giovanni da Udine and Morto da Feltre, now usually identified with Lorenzo Luzzo. There is no contemporary documentation about Giorgione's relationship with his pupils, other than the testimony half a century later of Vasari and Dolce. In the second edition of the *Lives*, Vasari's testimony about Giorgione, recorded in Titian's life, is based on his conversations with Titian.

Giorgione's other famous pupil was Sebastiano del Piombo, who has been mistreated by Venetian historians since he left Venice for Rome with the Sienese banker Agostino Chigi in 1511. As he was chosen by such a discerning patron as Chigi in preference to other Venetian artists, he must have been an exceptional artist, then considered even more remarkable than Titian. Was he ever apprenticed to Bellini as Vasari suggested? There is little evidence of Bellini's impact on the young artist in Sebastiano's earliest surviving Venetian works, though this is also true of Giorgione's early paintings. There is, however, considerable evidence of a deep relationship between Sebastiano and Giorgione, exemplified in many paintings, especially in the saints' heads in the organ shutters of San Bartolomeo, and also in some figures, but conspicuously in the executioner in the *Judgement of Solomon* at Kingston Lacy (Fig. 77).

When Sebastiano left Venice he was faced with a dilemma, one that helps define Giorgione's legacy. At the beginning of his life of Sebastiano, Vasari tells how the Venetian arrived in Rome, fresh from Giorgione's studio, and was employed by Chigi to paint lunettes in the loggia of the Villa Farnesina. These murals Vasari called 'poesie' and described them as painted in that style which Sebastiano had brought from Venice, one very different from the manner employed by the eminent painters in Rome at the time. This new style derived from Giorgione. Vasari's passage is preceded by a long preamble to the effect that Sebastiano left his first master Giovanni Bellini to follow the more advanced style of Giorgione, which he imitated so perfectly that some people — including Vasari himself — were deceived as to who had painted the altarpiece in the church of San Crisostomo (Fig. 19). What especially impressed Roman artists, Vasari says, was Sebastiano's Giorgionesque kind of soft colouring — 'un modo di colorire assai morbido'. In the Farnesina, one of the most sumptuous of Roman palaces, Sebastiano painted episodes from Ovid's *Metamorphosis* relating to wind gods, Dedalus and Icarus, Zephyr, and many others. These pastel-coloured fables by Sebastiano look very different from anything

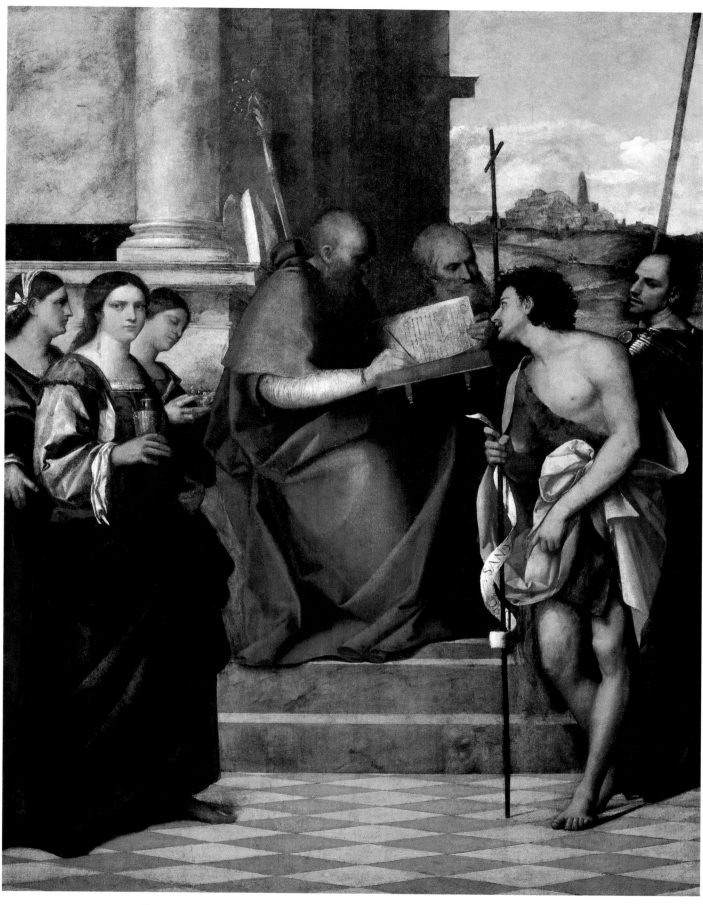

19. SEBASTIANO DEL PIOMBO. *St John Chrysostom between Sts Catherine of Alexandria, Mary Magdalen,*
Lucy, John the Baptist, John the Evangelist (?) and Theodore (?). Canvas. 200 x 165 cm.
Venice, San Giovanni Crisostomo.

Roman, but on the other hand as *poesie* they do not appear very Venetian either; they show Sebastiano trying to be Roman in his style and failing wonderfully, such was the depth of his Venetian education in Giorgione's studio.

The most explicit text we have concerning Giorgione's poetic inventions is the *Dialogue on Painting* by Paolo Pino (1548), written from a frankly Giorgionesque viewpoint after the artist's death.[32] Pino came from Noale, a small village in the Trevigiana, close to Giorgione's birthplace, Castelfranco, and was a pupil of the Brescian Gerolamo Savoldo, an artist at the forefront of the Giorgionesque revival in the decade of the 1530s. The treatise testifies to the independence of Venetian taste against other regional areas, but especially against the Tusco-Roman tradition of Alberti, who, as Pino says, wrote more about mathematics than painting, even though he promised the contrary. Pino's dialogue was unknown to Vasari, and appears to have had little impact beyond the Veneto, a fate shared by the writings of Antonfrancesco Doni and the treatise on sculpture by Pomponius Gauricus, for which reason, these Venetian views have never entered the mainstream of art history.

Yet Venetian theories antedated Vasari's famous Aristotelian definition of *disegno* as an intellectual activity in the second edition of the *Lives*: 'disegno ... procedendo dall'intelletto cava di molte cose un giudizio universale simile a una forma overo idea di tutte le cose della natura'.[33] *Disegno* for Pino was also an intellectual activity, something to be divided into four component parts: judgement, circumscription, practice, and composition ('giudizio, circumscrizione, practica, and composizione'). Judgement implied an innate ability to learn *disegno*, circumscription was about defining the boundaries of forms, while practice included the arrangement of compositions, and the final realization of the whole work. In one of the best-known passages in his *Dialogo*, Pino argues that perfection in painting may have been achieved when the *disegno* of Michelangelo was combined with the *colorito* of Titian, which some have taken to be evidence of eclecticism, but which may be a reflection of actual studio practice. In 1511 Titian was already precociously adapting motifs from Michelangelo's compositions in the Scuola del Santo frescoes. In the fresco of the *Jealous Husband* (Fig. 169), he reversed the figure of Michelangelo's recumbent Eve, to portray the innocent wife, sprawling backwards beneath her husband's arm.[34]

In contrast to Alberti, Pino associates painting with poetry and imaginative invention. He uses a terminology recalling Isabella d'Este's when she referred to a 'fantasia' as a poetic invention in her famous letter about Perugino's *Battle between Chastity and Love*, which she was in the process of commissioning for her *studiolo*.[35] Pino wrote that painting is truly poetry ('la pittura è propria poesia, cioè invenzione'), that is to say, invention, which makes appear that which does not exist.[36] It would be useful, Pino argues, to observe some rules chosen by poets, who in their comedies and other compositions introduce the rule of brevity. Painters should observe the rule of brevity in their inventions, and should not wish to crush all the facts of this world into a single picture. Nor should artists draw on their panels with that painstaking accuracy associated with Giovanni Bellini, because it is wasted effort, and in the end everything is covered up with colour. It is even less useful to have that insipid invention of Alberti's, a grid, to transfer drawings.

Here in one eloquent paragraph is the essence of Giorgione's new style of brevity, placed in contrast to the Florentine way of making a picture, and also in contrast to the narrative style of the confraternity painters, Carpaccio and Giovanni Bellini. Pino has enlivened the conventional rhetorical formulae of treatise writers with his experience of Venetian studio practice, formulated in a tradition that stems from Giorgione. Brevity was a term that related not only to invention, but also to technique. Giorgione's interpretation of subject matter was about poetic brevity. Subjects were defined without excessive detail. Allied with Pino's observation about the subject was Giorgione's rather 'brief' technique, for he had a spare way of applying paint to canvas, which resulted in innumerable problems in conservation in later centuries.

Pino's equation of poetry with invention places his dialogue within a group of art treatises (including even the famous one on painting written by Alberti, the Florentine Pino professes to hate, as well as Gauricus' work on sculpture) which use a terminology derived from ancient rhetoric. The notion of invention as Pino explains it was derived from an ancient rhetorical term, *inventio*. When applied to painting, *inventio* signified the finding of subject matter, as well as the decorum and style with which the subject is expressed. Or as Pino puts it, it was necessary to distinguish, order and compare things said by others, accommodating the subjects to the actions of the figures ('il ben distinguere, ordinare e compartire le cose dette dagli

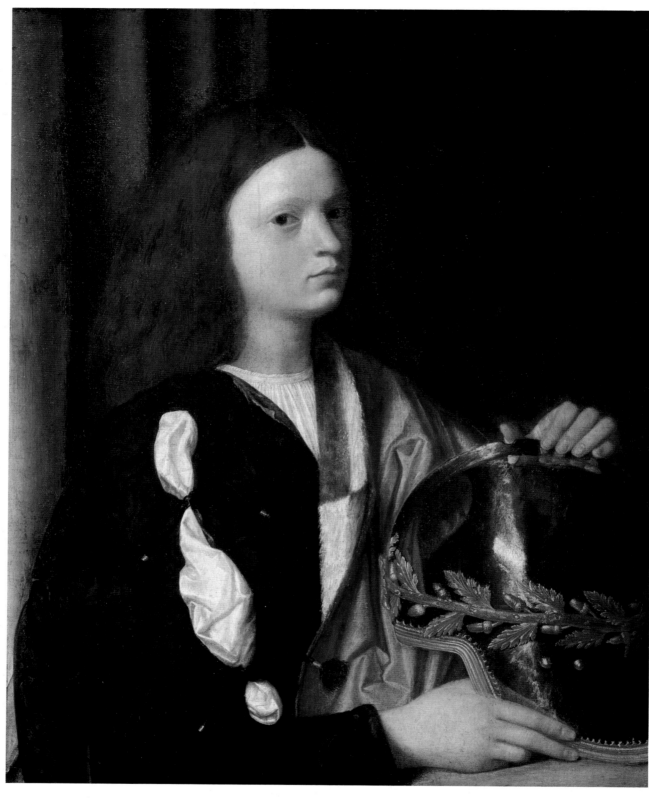

Above: 20. Attributed to GIORGIONE. *Portrait of a Young Boy with a Helmet, said to be Francesco Maria I della Rovere, Duke of Urbino.* Wood transferred to canvas. 73 x 64 cm. Vienna, Kunsthistorisches Museum.
Right: 21. Attributed to GIORGIONE. *Portrait of a Young Boy with a Helmet.* Detail.

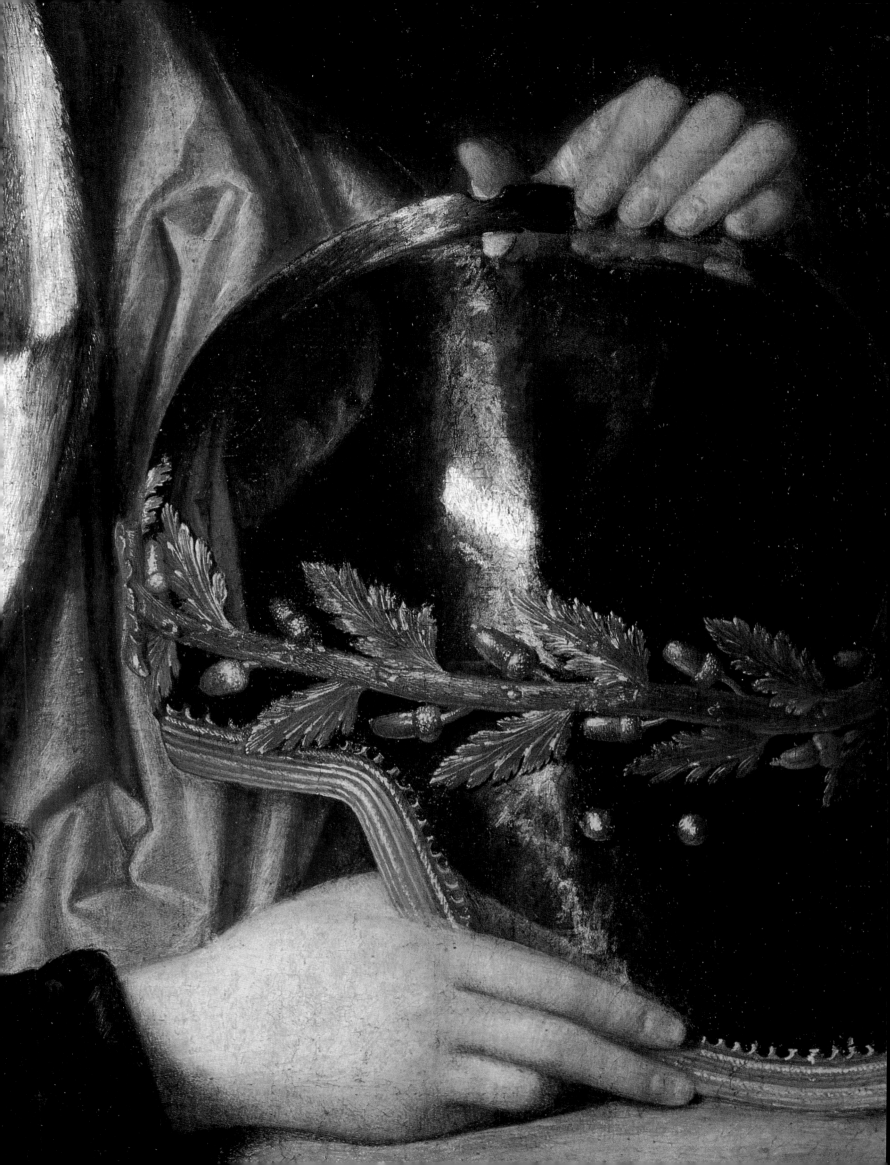

altri accommodando bene li soggetti agli atti delle figure'). His notion of brevity was similarly derived from antique rhetoric.[37] The alternative — to abbreviate or to amplify ('breviare', 'amplificare') — comes from Plato's *Phaedrus* (267B), wherein Socrates says of Tisias and Gorgias that they had invented the art of expressing themselves either briefly or at endless length upon any subject. This distinction is adopted by Pino to differentiate between the copious or meticulous style of the pre-Giorgionesque gener-ations of Bellini and Alberti, what has been called by Patricia Fortini-Brown 'the eye witness style',[38] and the new style of poetic brevity associated with Giorgione. Hence Giovanni Bellini was criticized for squeezing too many objects into his paintings and for an overelaborate preparation of the canvas with underdrawing. Pino's prejudice in favour of the Venetian custom of painting without making preliminary drawings on paper well preceded Vasari's criticism of the same practice.

The earliest writer to equate *poesia* with *invenzione* was the artist Jacopo dei Barbari. In his curious and delightful letter of 1501, addressed to the Elector of Saxony, Frederick the Wise, *De la eccelentia de la pictura*, Barbari praised the necessary accomplishments of the learned painter, ending with the request that the Elector of the Roman Empire should raise the status of painting to become the eighth Liberal Art. Among the painter's accomplishments, Barbari listed 'poetry for the invention of works [la poesia per la invention de le hopere], from which is born grammar, rhetoric and dialectic'.[39] Much of Barbari's other comments are conven-tional wisdom, such as his insistence that painters be familiar with the sciences of astronomy, physiognomy and chiromancy, as artists need to distribute the signs of men according to what they express in their history or poetic paintings ('bisognia che pitori intenda per distribuir i segni nelli homeni secondo che hanno a exprimere nelle *historie* over *poesie*').[40] But to differentiate between one kind of painting as *poesie* and another as *historie* was new in Renaissance art criticism, although the distinction between the subject matter of history and poetry has its foundation in Aristotle's theory of ideal imitation as formulated in the *Poetics* (IX, 2–4). Barbari's letter shows the background to Pino's later Venetian formulation of a local tradition.

It is also Paolo Pino who first testifies to Giorgione's interest in the theoretical dispute known as the *paragone*, one that emerges naturally from his Trevisan upbringing. Pino describes a painting by Giorgione of

a standing, armed St George, leaning on the shaft of his lance, the whole figure reflected in foreshortening in the water at his feet. Behind St George was a mirror in which the other side of the saint was reflected, thereby, in Pino's view, showing that at one glance an entire figure could be represented, unlike sculpture, where the spectator had to walk around. As noted earlier, Vasari described a similar Giorgione demonstration piece of a nude. A number of paintings attributed to Giorgione survive that clearly relate to the dispute about the *paragone*, one being a *Portrait of a Young Boy with a Helmet* (Fig. 20). The helmet, decorated with oak leaves, shines brightly, and the page's fingers are reflected on the polished surface, as is the head of an older man reflected from a much further distance (Fig. 21). The identity of the head in the reflection is ambiguous; is it the artist, knight, spectator or father? Certainly it is a *tour de force* to represent objects from different viewpoints reflected on a single surface; painting of such considerable virtuosity is unparalleled before the seventeenth century.

Although art historians have made a veritable industry of denying that Giorgione had an existence or, alternatively, giving him at least sixteen different personas, these early sources present an image of a major artist with a consistent personality, decisively committed to the theory of art, one who had an artistic vision which Pino perceptively called 'poetic brevity'.

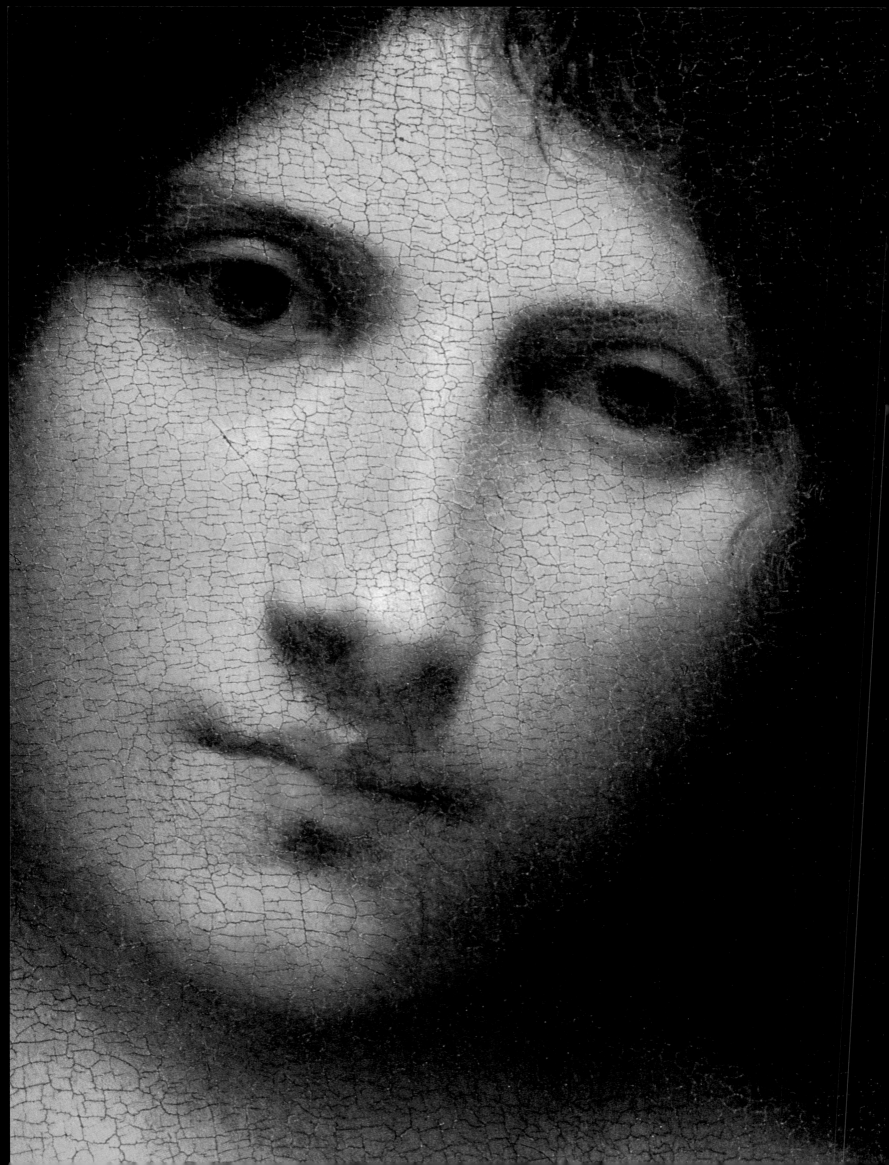

CHAPTER

II

GIORGIONE'S
BIOGRAPHERS
AND CONNOISSEURS

Were it not for the existence of Marcantonio Michiel's notes on Venetian painting, cynical twentieth-century historians might not have allowed Giorgione to exist. For art historians are reluctant to believe in the existence of artists unless their works are soundly documented. In Venice, contracts were made for pictures commissioned for public buildings like the Palazzo Ducale, or confraternities like San Rocco, that is, in situations where patrons were accountable to a patrician oligarchy or to a confraternity. Private patrons commissioning secular works had no need for contracts, so that these works appear only in inventories or informal documents.

Marcantonio Michiel was a Venetian patrician and antiquary who, between 1525 and 1543, kept a notebook in which he described works of art in collections in Venice and the Veneto.[1] He was born c. 1486 and educated with Marcantonio Contarini in classical studies at the famous school of Battista Egnazio. His marriage to Maffetta Soranzo was without dowry, suggesting that he was wealthy and married for love; they had five sons.[2] He had no intention of ever publishing his notes on paintings, but since their publication in 1800, centuries after his death in 1552, we can document a large proportion of Giorgione's works. Michiel's correspondence attests that he was admired and respected by other patricians and scholars, such as Pietro Aretino, Pietro Bembo, Jacopo Sannazaro, Sebastiano Serlio, Andrea Navagero, and many others, who all testify to his value as a witness to the Venetian art world in the early sixteenth century.[3]

Scholars usually consult Michiel's book in one of five modern editions, each with its own commentary, printed under the title *Notizia dei pittori*, whereas Michiel's own title on the first page of his manuscript is more eloquent and less pretentious: *Pittori e pitture in diversi luoghi*. He did not write in the inflated manner of an art theorist, nor did he lapse into the garrulousness of Vasari. Instead he wrote naturally in the laconic manner of his famous contemporary, the diarist Marino Sanudo, whose clear and pithy style he imitated, not only in his notes on painters but also in an earlier diary. It would be impossible to overemphasize the originality of Michiel's notebook in relation to other art writing of the period elsewhere in Italy, even though his views are given merely as notes and thoughts. He is not a historian, and was never interested in writing about famous men in a biographical way, such as became commonplace after Vasari's *Lives*.

Page 50: 22. GIORGIONE. *Young Boy with an Arrow*. Detail of Fig. 17.

∎

His intellectual orientation was ahistorical, a characteristic of all connoisseurs, who are concerned with the centrality of looking rather than biographical anecdote or gossip. The essentials of Michiel's descriptions of works of art have a timelessness about them which continues to intrigue every admirer of Venetian art, exemplified by his description of the *Tempesta*, written in 1530: 'The little landscape on canvas, representing a storm and a gypsy woman [*cingana*] with a soldier, is by Giorgio di Castelfranco'.

Michiel begins his description of each city and collection with a new page. His handwriting is untidy, even emotional, and many spaces are left, either as lines of dots or as large white gaps. His descriptions are tantalisingly incomplete. Sometimes there are gaps where there should be names and dates, which may mean that he had every intention of returning to describe what he had seen more precisely. Often the blank spaces are for Flemish names, as in the case of a painting in the collection of Andrea Odoni: 'The canvas, representing various monsters in the Infernal Regions, in the Flemish manner, is by. . . .' Was it due to laziness or honesty that he never returned to fill in the blank? More annoying to a twentieth-century reader is the description of a copy after a work by Giorgione, where the copyist's name is forgotten: 'St Jerome, nude, sitting in the desert by moonlight, was painted by . . ., from a picture on canvas by. . . .' More complete are the notes on Giorgione's *Three Philosophers*, which Michiel saw in the house of Taddeo Contarini in 1525; here the manuscript shows signs that he returned to amplify his few lines: 'The canvas of three philosophers in a landscape, two standing and one seated who contemplates the solar rays'; to which he then adds that the canvas is executed 'in oil' (Fig. 26).

Between 1525 and 1543, Michiel described fourteen paintings by Giorgione in Venetian collections, including one in his own, a nude in a landscape. For this reason he has always been considered a source particularly partial to the art of Giorgione and his circle, and to a few others artists such as Giovanni Bellini and Lorenzo Lotto, while ignoring, for example, the early paintings of Titian. To some degree the exclusion of Titian must have been a value judgement. Yet even with Giorgione he is much more selective than has been realized. Take, for instance, the collection of Gabriel Vendramin, a collection we can document in other sources. If we compare what Michiel described in 1530 with what was listed in the later inventories of 1567–69 (compiled by Tintoretto, Orazio Vecellio and Alessandro Vittoria),[4] and 1601 (compiled by lawyers),[5] the result is

surprising, even if we allow that Gabriel could have made acquisitions after 1530 and before his death in 1552. Michiel described seventeen paintings out of a possible forty-nine in the Vendramin collection. He chose eleven that were Flemish, and only two by Giorgione, the *Tempesta* and the much discussed 'Un Christo morto sopra un sepolcro'. The latter was never again mentioned in the Vendramin inventories, perhaps because Gabriel sold or swapped it. Of the attributions made by Tintoretto and Orazio Vecellio in 1567–69, there were five other works by Giorgione that Michiel might have been able to describe. Of these, only one can be identified today, *La Vecchia* (Fig. 23), while the other four remain obscure: 'una Madonna', 'uno quadreto con do figure dientro de

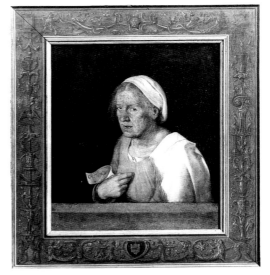

23. GIORGIONE. *La Vecchia* (Fig. 110), in its sixteenth-century frame. Venice, Gallerie dell'Accademia.

chiaro scuro', 'tre testoni che canta', and a 'quadreto con tre teste che vien da Zorzi ... alla testa de mezo ha la goleta'. In addition, the Vendramin collection contained another work that has been attributed to Giorgione in modern times, the *Education of the Young Marcus Aurelius* (Fig. 106), which Michiel did not attribute to Giorgione. Giorgione's most celebrated easel painting, the *Tempesta* (Fig. 108), was inaccessible for centuries, together with the rest of Gabriel Vendramin's collection, which after Gabriel's death was kept under lock and key in the family palace at Santa Fosca, Venice, while the Vendramin heirs bickered over their inheritance. The collection was finally dispersed in 1657 when the paintings were sold for the price of a 'bit of bread' on some painters' stalls in the Venice market; one artist-dealer fortunate enough to acquire some works by Giorgione at this time was the Fleming Niccolò Renieri.

As a guide to Venetian collections, Michiel's notes represent the tip of an iceberg. In some cases, as with the Vendramin family, we can compare his descriptions with later inventories — for example, the collection of the Cardinals Grimani and that of Mantova Benavides.[6] These collections were vast, but Michiel mentions only a few items. There were many other distinguished collections which did not even rate a mention, such as

one belonging to Michele Vianello, who owned a version of Giovanni Bellini's *Supper at Emmaus*, a classical agate vase (now in Braunschweig), a portrait of himself by Antonello da Messina, as well two paintings by Van Eyck, a self-portrait and a *Submersion of Pharaoh in the Red Sea*. At Vianello's death, his creditors auctioned his collection, and a number of works were bought by Isabella d'Este, who had visited Vianello's palace in 1506.[7] Another strange omission in Michiel's notebook is any mention of portrait busts or much contemporary sculpture, although we know that the collections he saw were full of such things,[8] and he himself commissioned works from contemporary sculptors, such as Antonio Minello's 1527 statue of *Mercury* (Fig. 24).[9] Indeed, in his own collection Michiel appears to have been particularly partial to bronze sculpture, although little of what he actually owned may be identified today.[10]

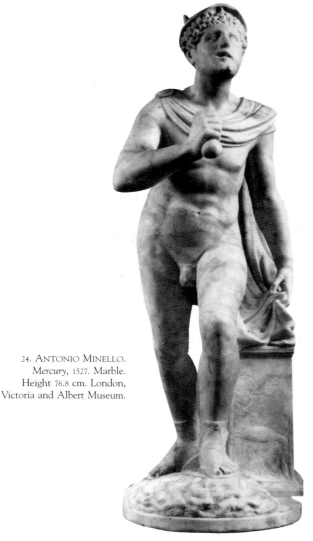

24. Antonio Minello. *Mercury*, 1527. Marble. Height 76.8 cm. London, Victoria and Albert Museum.

In Venice itself, Michiel gives us precious insights into patrician collectors and the nature of the art market in early sixteenth-century Venice when he mentions episodes of buying and selling between friends that essentially went unrecorded in notarial documents. Michiel's vocabulary demonstrates that connoisseurship — how to distinguish between copies and various versions of the same painting, how the condition of a painting affected its legibility — was highly developed. In turn, these insights allow us to realize the impossibility of reconstructing this world by conventional historical methods; put another way, we know from the outset that we can only discover a small part of it. Why were so many copies of Giorgione's works made relatively early and why was there so much confusion as to what he painted?

Already in 1532 there was substantial uncertainty as to which version of Giorgione's *Young Boy with an Arrow* was original. A Spanish merchant had bought two variants and had kept the version he considered superior, but to Michiel's eye, Giovanni Ram had been mistaken and had sold the better of the two. How were their different qualities evaluated? Was it according to Isabella d'Este's criteria of finish and *disegno*? Unfortunately, we do not know whether the exquisite painting in Vienna (Fig. 17) was the one kept by Ram or not; if we could determine which it was, then we would be able to assess the supposed infallibility of Michiel's eye. Enviably, Michiel has gained a reputation for accuracy, whereas Vasari has not. Yet how reliable was he?

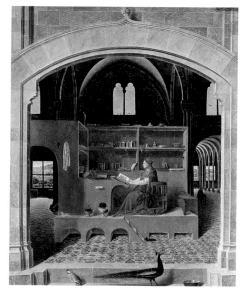

25. ANTONELLO DA MESSINA. *St Jerome in his Study*. London, National Gallery.

In 1529, at the house of Antonio Pasqualigo, Venice, Michiel described one of the best-known masterpieces by Antonello da Messina, a small painting of *St Jerome in his Study* (Fig. 25). In his lengthy description of the work, Michiel has difficulty over the attribution. He writes that it is 'ascribed by some to Antonello da Messina, but the great majority, with more probability, ascribe it to Jan Van Eyck or to Memling, old Flemish painters; and it really shows their manner, though the face may be finished in the Italian style, and seems to have been painted by Jacometto. . . . Some believe that the figure has been repainted by Jacometto Veneziano'.[11] In this particular instance, Michiel appears to be the passive communicator of received opinions, which he is unable to verify; and the idea that the work was repainted by Jacometto Veneziano is not borne out by recent scientific examination. Antonello's *St Jerome* is all of a piece, but Michiel perceived a conflation of styles and explained it as the product of two hands. The fanciful absurdity of his suggestion throws doubt on Michiel's canonical status in similar statements about other pictures. In the case of Giorgione, he describes two pictures that were 'finished' by other artists, namely the *Three Philosophers in a Landscape* (Fig. 49), which he says was finished by Sebastiano del Piombo, and the *Venus Sleeping in a Landscape* (Fig. 139), which was finished

by Titian. Despite considerable scientific investigation, the *Three Philosophers* has never shown a discontinuity in the handling of the paint which would prove Michiel's assertion, although the Dresden *Venus* has been quite clearly shown to have been 'finished' by Titian.

Michiel's testimony as a connoisseur in such matters as repainting is more open to question than one might believe, as is his ability to describe subject matter with reasonable accuracy. Michiel began to describe works of art in his (as yet unpublished) diaries,[12] which he began in 1511, years earlier than his notes on painting. During a Roman sojourn (1518–21), Michiel became increasingly interested in works of art, especially Raphael's achievements — the Vatican tapestries and the decoration in the Logge — and also in Sebastiano del Piombo's success in Rome with the favourable critical reception of the *Raising of Lazarus*.[13] In all these writings, subjects are described rather casually, a sort of hit-and-miss affair, as they are in Michiel's later Venetian notes. Philosophers, whether they are Bramante's philosophers in green chiaroscuro, formerly on the facade of the Palazzo del Podestà, Bergamo,[14] or those represented by Giorgione in Taddeo Contarini's collection, are always philosophers, not named individuals. Altarpieces are described simply as *pale*, with their location and the artist's name, but Michiel is indifferent about the identity of the saints accompanying the Virgin or about liturgical matters. This is of some importance when considering his descriptions of Giorgione's works, because in these he often gives more detail than elsewhere and is sometimes attentive to subject matter, as in the description of the *Finding of the Infant Paris* (Fig. 93) and *Hell with Aeneas and Anchises*, both in the Contarini collection. Michiel may simply have been more interested in secular subjects. However, is Giorgione's *Young Boy with an Arrow* in the Ram collection merely that, or is it a portrait of a boy

26. Manuscript of MARCANTONIO MICHIEL, *Pittori e pitture in diversi luoghi*, Biblioteca Marciana, Venice. Page describing the collection of Taddeo Contarini; at top, the *Three Philosophers*.

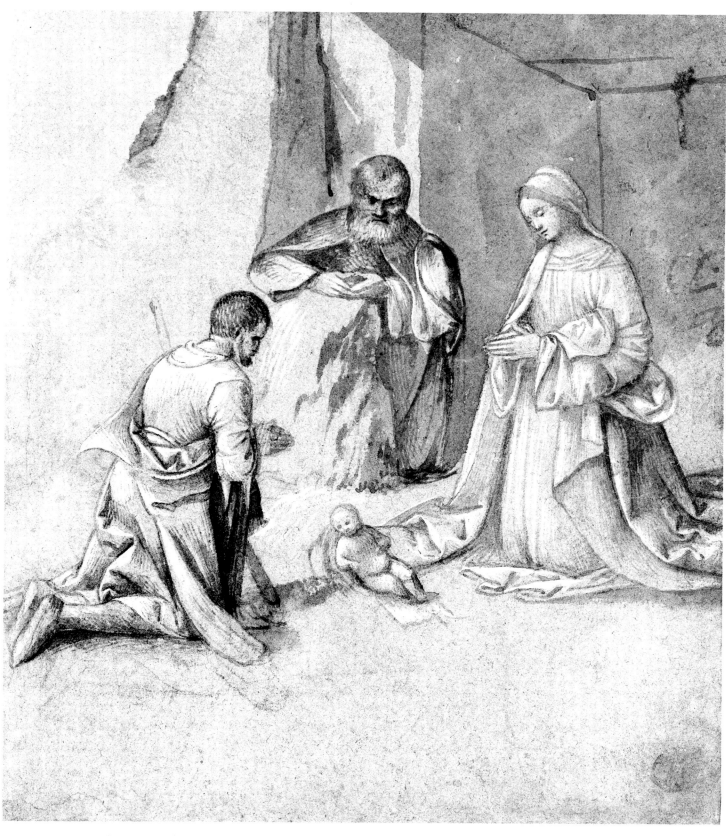

27. GIORGIONE. *Adoration of the Shepherds*. Point of brush with brown ink and wash over black chalk on blue paper, heightened with white body colour. 22.7 x 19.4 cm. Windsor Castle, Royal Library, Collection of Her Majesty the Queen.

dressed up as St Sebastian, as one finds frequently represented in the work-shop of Leonardo, or is it a depiction of Eros?

What are we to make of the famous description of the *Tempesta* (Fig. 108), where a nude female, suckling her infant in an open landscape, is identified as a gypsy — 'la cingana'. The word 'cingana' was rare in Italian at the time, the first instance occurring in Pulci's *Morgante* in the 1460's, which suggests that it was not casually chosen. Yet Giorgione's gypsy looks less like a gypsy than those by other artists; she does not resemble the famous Roman sculpture known as *La Zingara* in the Capitoline Museum, Rome; neither does she look anything like Leonardo da Vinci's deformed gypsy king, Scaramuccia;[15] nor is she engaged in any of the traditional activities associated with gypsies, such as fortune telling, except that she is feeding her baby in a casual way, such as gypsies were believed to do.[16] What did Michiel mean by his use of the word? Like all connoisseurs, he was not as interested in subject matter as we would like him to have been, and although Giorgione and his patrons may have been deeply interested in what was represented, Michiel, alas, chose to record only the briefest of impressions.

A FLORENTINE BIOGRAPHER OF GIORGIONE

Giorgio Vasari may have known fewer works by Giorgione than earlier Venetian writers like Michiel, but he had a network of informants, artists conversant with Giorgione and the Venetian art world, who provided him with information.[17] Vasari was writing to a particular biographical formula, and he asked questions of his informants different from those Michiel asked of his patrician collectors. As one of the few non-Venetians to have written about Venetian art, Vasari's judgements have often been subjected to greater criticism than those of Venetian writers, especially in the seventeenth century. In the first edition of the *Lives* (1550), Vasari gives importance to Giorgione's role within the wider context of Renaissance art, a judgement he freely acknowledges to have been derived from the oral testimony of Giorgione's excellent contemporaries ('molti di quegli che erano allora eccellenti'). Giorgione is placed next to Leonardo da Vinci and Correggio as one of the earliest leading exponents of *la maniera moderna*. Unlike Michiel, who could conceivably have met Giorgione (although such a meeting is unrecorded), Vasari can never have known the artist;

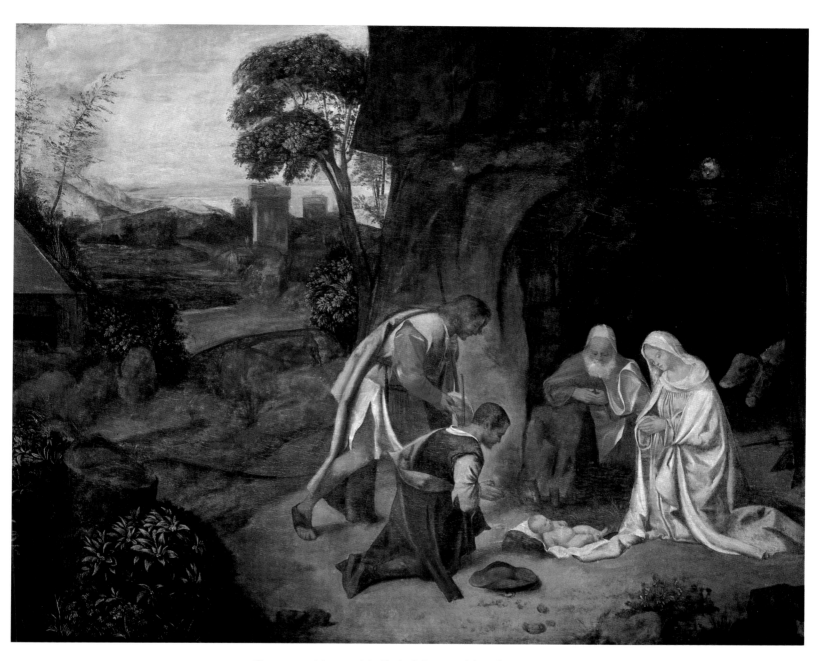

28. GIORGIONE. *Adoration of the Shepherds* (variant of the *Allendale Adoration*).
Oil on poplar. 92 x 115 cm. Vienna, Kunsthistorisches Museum.

and Vasari's judgements were formed during a visit to Venice in 1541–42. At least two of Vasari's sources are acknowledged in the second edition (1568), one being Titian himself, whom Vasari says he had met in Venice in 1566. Indeed, much additional information about Giorgione occurs at the beginning of the *vita* of Titian, so that the reader can infer that this information comes from Titian. Elsewhere Vasari speaks of Sebastiano del Piombo as one of his informants, an artist he would have known outside Venice; and there were other artists to whom Vasari spoke, such as Giovanni da Udine, Garofalo, and Morto da Feltre, in whose biographies Giorgione is mentioned.

In the first edition, Vasari's life of Giorgione is brief, but some essentials are given: he is born in 1477 at Castelfranco of humble parentage, but brought up in Venice ('fu allevato in Vinegia'). In the second edition, the birthdate is corrected to 1478, the year Giovanni Mocenigo became Doge.[18] At what age Giorgione left Castelfranco for Venice is unstated, but it was at least before his apprenticeship to both Gentile and Giovanni Bellini. Vasari says that at the beginning of his career Giorgione made many paintings of Madonnas, such, we might add, as the *Allendale Adoration* and the *Benson Madonna* (Figs. 28, 56). He also praises Giorgione's portraits of this early period. Giorgione's style receives high praise for its lifelikeness, vivacity and softness ('morbidezza'), principally in reference to Giorgione's public works, frescoes on the facades of buildings such as those on the Fondaco dei Tedeschi. In his painting, Giorgione is described as softening contours, endowing figures with an awesome movement, and adding a certain obscurity to intense shadows. Giorgione also emerges as a charming personality. He is a musician, who often played at patrician gatherings, and someone who continually delighted in amorous pleasures ('e dilettosi continovamente delle cose d'amore'), a point which later biographers developed, especially Vasari's final reference to the woman from whom Giorgione caught the plague and died. In at least one fact, the date of Giorgione's death, Vasari is accurate to within a year, the story confirmed by Isabella d'Este's correspondence in 1510. If the birthdate of 1478 that Vasari gives in the second edition is accurate, then Giorgione was about thirty-two years old when he died.

In 1550 Vasari refers to a number of paintings by Giorgione, some of which cannot be identified, such as frescoes and portraits. But three works in public and prominent locations are still in situ, and in all instances

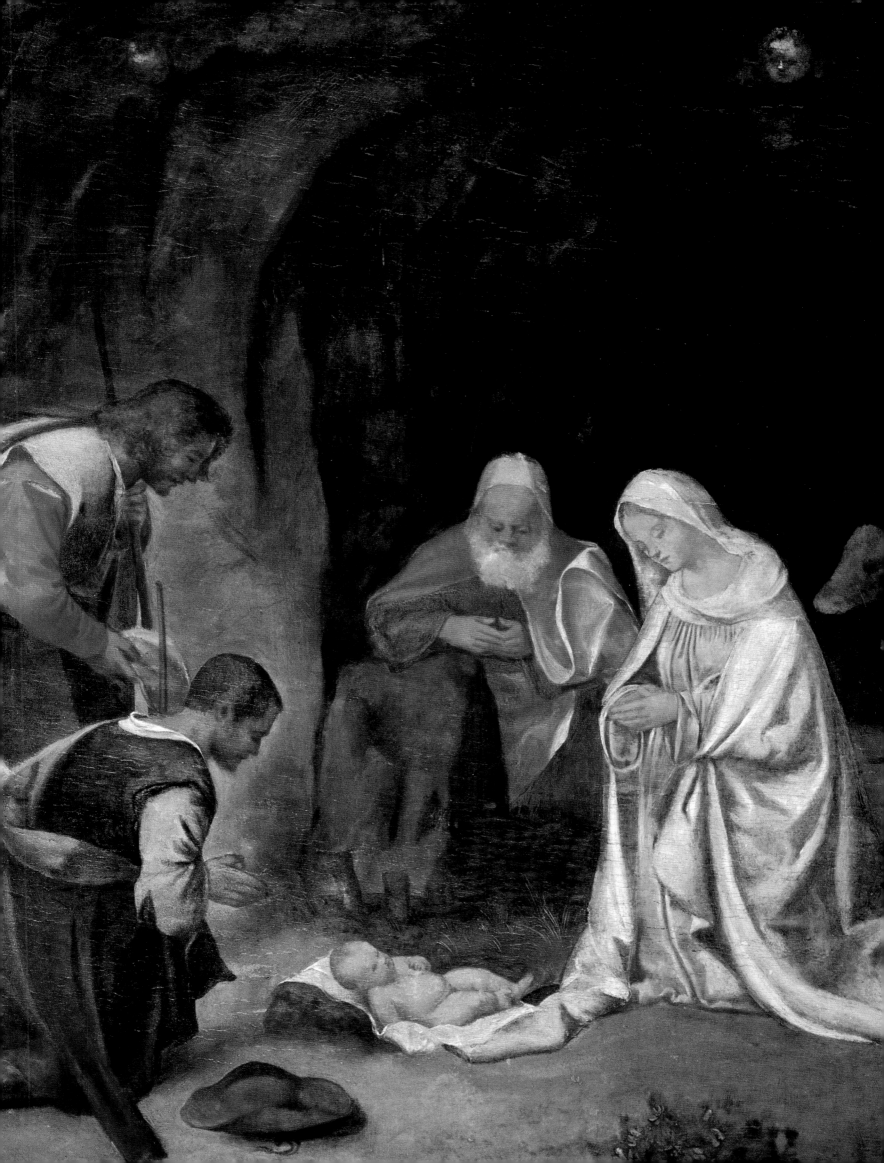

Vasari's attributions to Giorgione have been questioned. One was the much praised altarpiece in the church of San Giovanni Crisostomo, now given to Sebastiano del Piombo (Fig. 19), because archival discoveries concerning the patron suggest that the commission was executed after Giorgione's death.[19] Another was the *Christ Carrying the Cross* (Fig. 15), a miracle-working picture belonging to the Confraternity of San Rocco, which Vasari attributes for the first time to Giorgione, and which is now disputed, although documents show that it was executed in Giorgione's lifetime. The third, a painting for which Vasari himself demonstrates a personal liking, was the *Tempest at Sea*, now attributed to Palma Vecchio, in the Scuola di San Marco. Vasari describes this particular *Tempest* at some length as a most frightening representation, a passage which reveals that he responded to Venetian art with the taste of a Central Italian Mannerist. Indeed the painting which he thought was the most beautiful in Venice ('la più bell'opera di pittura che sia in tutta Venezia') was an octagon by his friend, also a Mannerist, Francesco Salviati, representing the *Adoration of Psyche*, which he had made for the palace of Giovanni Grimani at Santa Maria Formosa. The Grimani palace was a conspicuous monument to Central Italian taste and decoration, a building to display a Roman collection of ancient sculpture. The octagon is now lost, but a companion octagon, also by Salviati, is still in situ. This example reveals how essentially unsympathetic Vasari must have been to Venetian art. A further restriction on his understanding of Venetian art was his dislike of portraiture, which he makes eminently clear in his autobiography, when he remarks that he was forced against his very nature to make portraits. Portraiture was an important part of Giorgione's career, and that of other Venetian artists, especially Titian; thus it is a disappointment that Vasari's descriptions of Venetian portraits are sometimes perfunctory.

In the second edition, Vasari is responsive to criticism of his earlier book, rewrites the life of Giorgione, revises his birthdate, discusses more paintings, and adds a considerable

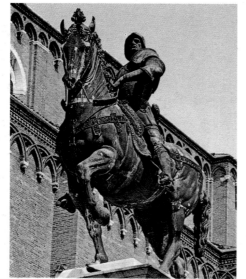

Right: 30. VERROCCHIO. *Equestrian Statue of Bartolomeo Colleoni*, 1496. Bronze, originally partly gilt, on a marble base. Height 395 cm. Venice, Campo Santi Giovanni e Paolo.

Far right: 31. GIORGIONE. *Christ Carrying the Cross*. Detail of Fig. 15.

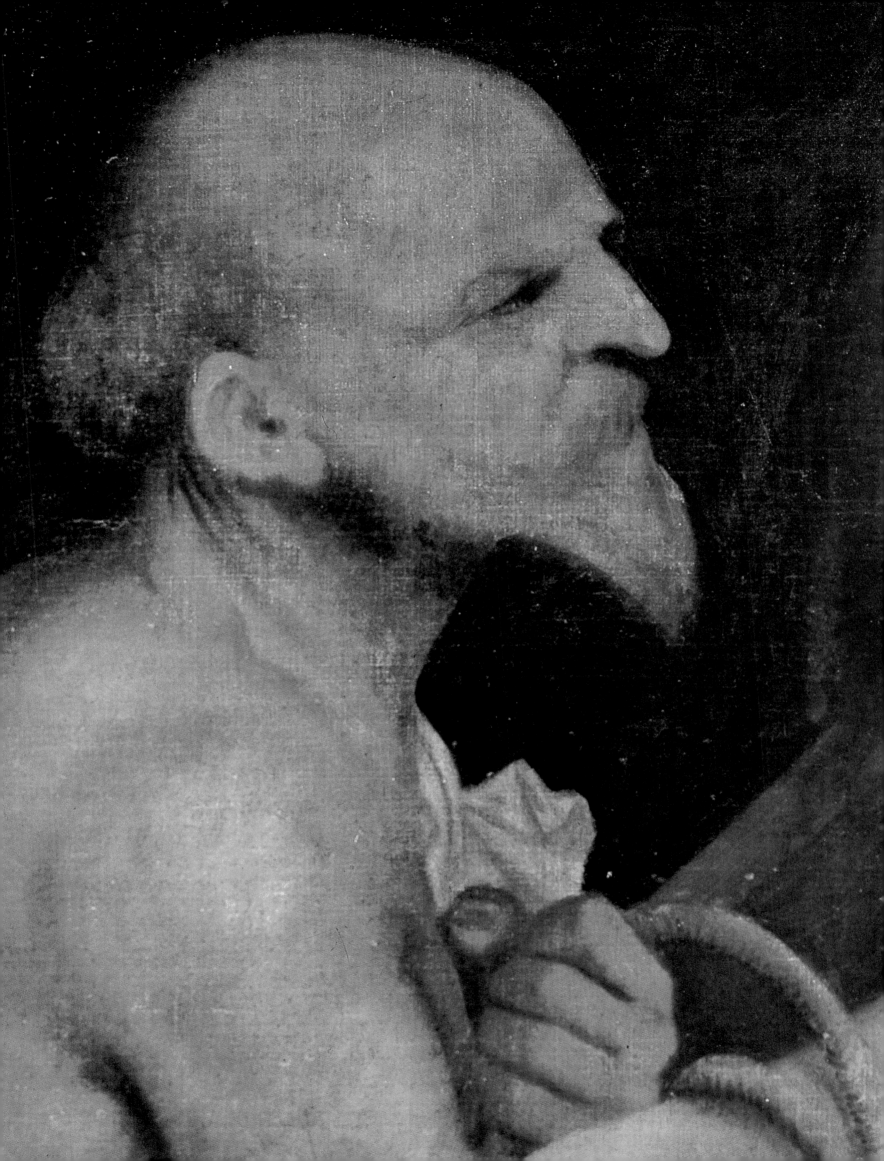

section on Giorgione's concern with theoretical debates on the relative merits of painting and sculpture, stimulated by Andrea Verrocchio's equestrian monument to Bartolomeo Colleoni (Fig. 30). This last section concerning Verrocchio is based on hearsay ('dicesi'), and if the debates really took place in Verrocchio's lifetime, they would have occurred between 1486 and 1488, the dates of Verrocchio's arrival and death in Venice. At Verrocchio's death, Giorgione could have been only ten, at the most a *garzone* in the Bellini workshop. More likely the debates mentioned by Vasari took place later, when the monument was cast in 1490 by Alessandro Leopardi, or at the unveiling in March 1496, for Vasari refers to the sculpture as a bronze horse ('cavallo di bronzo'), rather than to the clay model which Verrocchio left. In the mid-1490s, Giorgione would have been a youth of about twenty and, we may assume, extremely articulate, if his

32. GEROLAMO SAVOLDO. *Portrait of a Man in Armour, said to be Gaston de Foix,* c. 1548. Canvas. 91 x 23 cm. Paris, Musée du Louvre.

views were remembered and repeated some sixty years later. Vasari's section on the *paragone* appears to be quite independent of the anecdotes related by Paolo Pino in his earlier dialogue of 1548, where Giorgione's contribution to similar debates is mentioned (p. 49 above), a guarantee

that both record something authentic. Among the 1568 additions to Giorgione's *vita* are Vasari's references to pictures in private collections, only one of which was in Venice, that owned by Giovanni Grimani, the Patriarch of Aquilea, in his palace at Santa Maria Formosa. There Vasari describes Giorgione's self-portrait as David with Goliath, together with two other works by Giorgione, an imposing portrait of a general with a fur collar, a vest *all'antica* and red beret in his hand, as well as a very beautiful picture of a young boy ('bella quanto si può fare'). Then Vasari moves abruptly to Florence, where he describes a double portrait by Giorgione of Giovanni Borgherini and his Venetian tutor, in the collection of the Borgherini heirs, an important collection Vasari knew well, for he returns to describe paintings in it quite frequently in other parts of the *Lives*,

particularly in connection with Pontormo's bedroom decorations for
Pierfrancesco Borgherini. This double portrait (Fig. 89), and Giorgione's
Self-Portrait as David (Fig. 34), are the only paintings discussed by Vasari in
this section which may be now identified with certainty. Vasari then
describes a portrait of an armed captain, in the house of Anton de' Nobili,
presumably also in Florence, but otherwise unmentioned in the Giorgione
literature. He then discusses the portrait of Gonzálvo de Córdoba, described
as 'cosa rarissima e non si poteva vedere pittura più bella che quella', which
has also eluded identification, despite
arousing discussion.[20]

In 1568 Vasari also adds a novel
section about Giorgione in Titian's *vita*.
Here he poses some of the great prob-
lems relating to Giorgione for the first
time with an uncanny prophetic accu-
racy. In a famous passage concerning
the frescoes on the facade of the
German Customs House in Venice,
a plum commission for a supremely
important site, Vasari admits his inabil-
ity to comprehend the meaning of

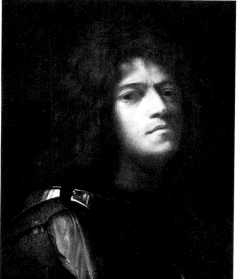

34. GIORGIONE. *Self-Portrait
as David.* Canvas. 52 x 43
cm. Braunschweig, Herzog
Anton-Ulrich Museum.

Giorgione's paintings, a difficulty in which he has not been alone. He also
comments for the first time on the lack of drawings on paper in Venetian
art, and defines Giorgione's painting as 'senza disegno' — a concept with

which we are still coming to terms. Vasari notes as well a stylistic change in Giorgione's art in 1507, when he began to give his work greater softness and relief ('cominciò a dare alle sue opere più morbidezza e maggiore rilievo con bella maniera'); this stylistic shift must have occurred just after the completion of the *Laura* (Fig. 131). It is a style that is present in the *Tempesta* and develops in the Fondaco frescoes and the Dresden *Venus*.

There are a series of well-known discrepancies between the two editions of Vasari's *Lives*. The *Miracle of St Mark*, credited to Giorgione in 1550, is attributed to Palma Vecchio eighteen years later; *Christ Carrying the Cross* in San Rocco occurs in both the lives of Giorgione and Titian in the second edition, whereas it only appears under Giorgione's name in the first; the altarpiece of San Giovanni Crisostomo is ascribed to Giorgione in the first edition, and then in the second to Sebastiano del Piombo, with the hilarious remark that those who know very little about art have given it to Giorgione's hand. In the first and last case, Vasari's corrections represent improvements on the 1550 edition, improvements presumably made following conversations with the artists concerned, Palma Vecchio and Sebastiano. The same cannot be said of Titian, who appears to have been an unreliable witness in his old age, especially about his youth.[21] Vasari was only as good as his Venetian informants — and he had the honesty to admit it.

In the same year Vasari published his second edition, a Venetian writer attempted to re-baptize Giorgione. The Vicentine poet Giambattista Maganza referred to 'Le belle teste di Barba Zorzon' in a poem among his rustic verse, dedicated to Giacomo Contarini.[22] In a slightly later poem, in which he gave advice to Titian on how to paint his mistress, he referred to the age of Giorgione as 'ieri al tempo de barba Zorzon'.[23] This affectionate and intimate dialect nickname, 'grandpa Giorgione', failed to become fashionable.

ART HISTORY AND THE SEVENTEENTH-CENTURY ART MARKET

Venice has always been a city for foreigners, and in the second half of the sixteenth century Francesco Sansovino published a series of guidebooks to the city, primarily addressed to tourists, principally his *Venezia città nobilissima et singolare descritta* (1581), which was reissued in several editions. Sansovino follows Vasari to some extent, attributing the San

Giovanni Crisotomo altarpiece to Giorgione and the Scuola di San Marco *Storm* to Palma Vecchio. He also refers to the collection of Gabriel Vendramin, but without reference to its contents (p. 368 below). There is some concordance between the collections mentioned by Sansovino and those in Michiel's earlier notes, so close a concordance that it has been suggested that one was based on the other,[24] but the similarities may be explained by the fact that the same collections were famous, and perhaps open to select visitors.

Art historical writing in Venice lagged behind that in other regional cities until the middle of the seventeenth century, when Carlo Ridolfi produced a Venetian equivalent of Vasari's *Lives* — *Maraviglie dell'arte* (1648) — and slightly later Marco Boschini published his *Carta del navegar pitoresco* (1660), a spirited dialogue in verse between a senator and a Venetian artist.[25] Both books were written by authors who were unsuccessful as artists, but who had brilliant careers in the marketing of art. The audience for these books was complex, because they are the products of an interrelationship between collecting and the art market in which the authors have multiple roles as historians, dealers, and artists.[26] Whereas Michiel's notes were written for himself, and Vasari was writing for an artist public, both Ridolfi and Boschini have European art collectors in mind. The volumes were used by foreign collectors, who not only wanted to admire Venetian art, but also acquire it. By the beginning of the seventeenth century, Amsterdam had become the centre of the European art market, and numerous Italian masterpieces were acquired by collectors, especially the brothers Gerard and Jan Reynst, to whom Ridolfi's album is dedicated.[27] The Reynst brothers were said to have bought intact the collection of Andrea Vendramin (c. 1565–1629), which survives only in manuscript drawings, with a few intriguing copies after lost works by Giorgione (Fig. 35).[28] The European enthusiasm for collecting Venetian art was paralleled by the development of a Venetian approach to art history, one which was proclaimed by these authors to be anti-Vasarian. Yet despite his polemic, Ridolfi adopted the Vasarian biographical formula for his work. Significantly, his book is only about Venetian painting, for his project to write the history of Venetian sculpture and architecture came to nothing. Ridolfi was not just a dealer, but also ambitious as a historian; unlike Boschini, he attempted to discuss Quattrocento art seriously, and provided invaluable descriptions of cycles that are now lost.

In Ridolfi's *Maraviglie*, Giorgione acquires nobility, a new biograph-ical background, and innumerable works. Ridolfi is the first to propose that Giorgione was an illegitimate son of a nobleman named Barbarella and a peasant woman from Vedelago, a tiny village near Castelfranco. The tradi-tion may have started when Ridolfi, in order to escape the plague, spent most of the year 1630 at Spineda (Trevigana), a small town between Asolo and Castelfranco, also in close proximity to Riese, where the Costanzo, descendants of Giorgione's patron Tuzio I, had their villa.[29] There Ridolfi was a guest in Ca' Stefani, and it is also possible that he could have met the descendant of Giorgione's patron, Tuzio Costanzo III (1596–1678). Ridolfi is the first writer to discuss the *Castelfranco Altarpiece*, and in these circumstances the Costanzo themselves could have drawn the altarpiece to his attention, as it is unlikely he was aware of the sixteenth-century descriptions recorded in a series of pastoral visits to the chapel in which the altarpiece was originally placed.[30] When Ridolfi visited Castelfranco, he would have seen an epitaph formerly on the tomb of the Barbarella family between the altars of St Mark and St John the Baptist in the *chiesa antica* of San Liberale, which may have prompted his thesis concerning Giorgione's origins.[31] On other occasions, Ridolfi mentions that he talked to the descendants of artists, as in the life of Cima da Conegliano, and his use of inscriptions has frequently been remarked upon.[32]

Another novelty in Ridolfi's life of Giorgione is his assertion that Giorgione began his career as an artist by producing furniture paintings. As has been noted by historians of furniture, it is remarkable that very few painted marriage chests, such as *cassoni*, survive in Venice, whereas many more Florentine examples have come down to us. However, a high proportion of the Venetian examples that do survive are what we might call 'Giorgionesque' in style. Of all Giorgione's works, only one painting, the St Petersburg *Judith* (Fig. 123) decorates a cupboard door. Other works, such as the painted box cover with *Venus and Cupid* (Fig. 75), are shown to have been drawn in a very different style from that in which they were later painted, which leads one to conclude that they were made to match a particular fashion; in other words, they were made to look like works by Giorgione. Presumably, Ridolfi's statement reflected many such works with anodyne renderings of Giorgione's subjects.

Ridolfi describes a vast number of pictures by Giorgione, not only in churches, but also in Venetian houses and palaces. This great accretion

of attributions suggests that Ridolfi was advertising what was for sale. Merely from reading his descriptions of paintings (a considerable number cannot be identified) some of the attributions to Giorgione appear implausible. Among the most unbelievable are a series of twelve paintings of the story of Cupid and Psyche, for which no location is given, and which occupy three of thirteen pages.[33]

As a guide to Venetian collections, both in Venice itself and in the *terraferma*, Ridolfi is extraordinary. He travelled widely to make portraits and frescoes for many a wealthy patron. In this capacity he describes nine collections in Bergamo, nineteen in Brescia, sixteen in Padua, fifteen each in Treviso and Verona, six in Vicenza and one hundred and sixty in Venice.[34] Paintings from the late Quattrocento and early Cinquecento were already designated *antichi maestri* and cost international collectors like Lord Arundel and Leopoldo de' Medici a considerable amount. Only one of the collections described by Michiel (the Marcello collection at San Tomà), is referred to, although others, such as the Contarini collection, were inherited by

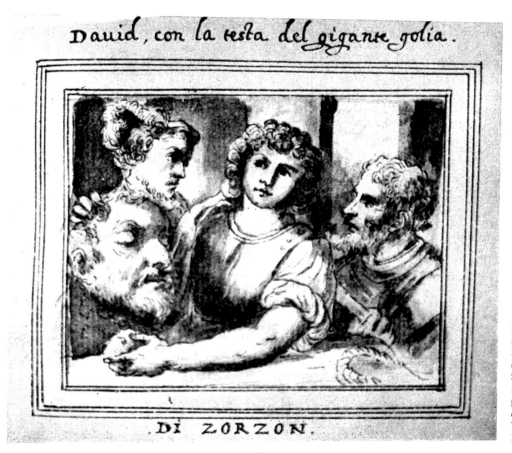

35. After GIORGIONE. *Self-Portrait as David with the Head of Goliath, accompanied by King Saul and Jonathan.* Seventeenth-century inventory drawing after a painting formerly in the collection of Andrea Vendramin. London, British Library.

descendants. Sometimes collections are described that had already left Venice, such as that of Bartolomeo della Nave. At one point near the end of the life of Titian, Ridolfi remarks that he has described as many paintings in private collections as he was allowed to see, or which had come to his attention, but that these works could easily change location. He continues by mocking those collectors who wish that excellent pictures would spring up in their galleries like grains of wheat in a field, and concludes passively that he will let everyone express their opinion.[35]

Ridolfi collected albums of drawings, now in the Picture Gallery, Christ Church, Oxford, which have always been considered the equivalent of Vasari's *Libro dei disegni*, that is, an illustration of the graphic development of Venetian art. Yet the attributions of many of the drawings are quite surprising, such as a Carpaccio drawing of four ladies, two gentlemen and a child walking on a quayside, which has an old attribution in Ridolfi's hand on the paper to 'Antonio Vandijch d'Anversa' (Van Dyck). How could Ridolfi have made such a howler when the drawing is related to a prominent painting in a principal confraternity, *The Reception of the English Ambassadors* in the Scuola di Sant'Orsola, which Ridolfi mentions in his life of Carpaccio? Some of Ridolfi's attributions to Tintoretto in the same album at Christ Church appear equally strange. Unlike Vasari, Ridolfi never mentions his own collection of drawings, and the Capello coats-of-arms found in the volume suggest that the albums may have been made for sale.[36] Even in these circumstances, the attribution of a drawing by Carpaccio to Van Dyck can only call into question Ridolfi's reputation as a connoisseur of Quattrocento Venetian drawing and painting.

In contrast to Ridolfi, Marco Boschini in *La Carta del navegar pitoresco* (1660) is more aggressively Venetian in both language and polemics. He was indifferent to the Vasarian view of the biographical development of art history, accused Aretino of having misled Vasari about Venetian art, and was only concerned with the excellence of Venetian painting. In his book, a Venetian senator and collector, called *Eccellenza*, is escorted around Venice in a gondola on a series of guided tours by a painter named Boschini, and the principal monuments of the city are explained in exuberant Venetian dialect. Boschini's inventive vocabulary defines the characteristics of Venetian painting and provides invaluable insights. Like Ridolfi, he was hazy about Quattrocento artists. Although a passionate admirer of Giovanni Bellini, whom he saw as the 'primavera del mondo', he knew

36. TITIAN. *The Bravo*
(The Assassin),
c. 1515–20. Canvas.
77 x 66.5 cm. Vienna,
Kunsthistorisches Museum.

little about artists before Bellini, whom he considered dry and sterile. With Giorgione, 'a giant in art', the great Venetian style is born, with soft colours and shaded outlines ('quell'impasto di pennello così morbido e lo sfumar de' dintorni'). Indignantly, Boschini refutes Vasari's idea that Leonardo da Vinci may have stimulated the development of 'lo sfumato giorgionesco'.

Of Giorgione's works, Boschini is most familiar with portraits and frescoes, many of which are now unidentifiable. There are few points of comparison between those paintings described by Michiel and those Boschini selects, such as the sleeping Venus in Ca' Marcello (Fig. 139). In contrast to Michiel's few succinct words describing pictures, Boschini writes flamboyant febrile passages, as when he describes a bravura confrontation

between two men, whom he calls Claudius and Caelius Plotius, in Titian's *Bravo (The Assassin)* (Fig. 36). In 1648 the painting had been in a Venetian collection, where Ridolfi mentioned it, but by 1659 it had become one of the most treasured possessions of Archduke Leopold Wilhelm of Austria. Boschini and Ridolfi were the first authors to attribute the *Dead Christ Held by Angels* in the Monte di Pietà, Treviso, to Giorgione. Unlike the *Bravo*, the *Dead Christ* was never to appeal to foreign writers. It was frequently described by travellers, but considered ineligible for purchase by all those who bought for national galleries in England and Germany in the mid-nineteenth century, until Giovanni Morelli rejected the attribution to Giorgione. Boschini has much to say about the commercial activities of foreigners in Venice and complains about how much is sold abroad, although his book is dedicated to Archduke Leopold Wilhelm, whose gallery is described at length, and whose gold chain Boschini wore, as he was one of his Venetian agents.

Boschini was involved in the connoisseurship of Giorgione's works, not only as a writer, but also as a dealer and adviser in the contemporary art market. He described his great friend, the artist Pietro della Vecchia (1602–1676), as Giorgione's ape ('sima di Zorzon'), and praised della Vecchia's imitations of Giorgione's style as 'perfect'. To a twentieth-century reader, this may sound as though della Vecchia were a perfect forger, but in reality his imitations of Giorgione's works appear to be harmless exercises in bravura painting, or free variations in the style of the *Bravo*.[37] Boschini's correspondence reveals that della Vecchia had painted a Giorgione self-portrait which deceived an artist-dealer, Francesco Fontana, who was creating a collection for Cardinal Leopoldo de' Medici, one of the greatest connoisseurs of the seventeenth century (the collection is now in the Palazzo Pitti, Florence). Leopoldo's agents in Venice were Paolo del Sera and Boschini, who were asked to value the paintings that Fontana was offering to the cardinal. Fontana made it difficult for them to have access to self-portraits by Titian and Giorgione. Eventually, when they were permitted to examine the Giorgione, the reason became clear. As Boschini explained to Leopoldo de' Medici: '. . . having seen it della Vecchia at once asked me how it seemed to me, and I replied that he knew better than I what that portrait was. He then commanded me to tell him my opinion, and I told him, smiling, that it was unnecessary for him to ask me such a thing, since he knew that he had made it himself.

Then he also began to laugh, and confessed that it was from his hand. He recounted that he had made it at the behest of the late Signor Niccolò Renieri thirty-two years ago, and that in truth to satisfy that painter he laboured hard to put all his knowledge into it, painting it from his own head without using anything for a model, much less copying it directly from Giorgione. Rather, he intended to emulate that singular artist, as in such a way Vecchia has done numerous things that give thought and have also tricked many'.[38]

The cardinal then commissioned a modern 'Giorgione' from della Vecchia to hang with other Old Masters, but declined the self-portrait Fontana had offered him. Della Vecchia, whose very name implies that he imitated the Old Masters, was an artist, dealer, restorer, pupil of Alesssandro Varotari, known as Padovanino (1588–1648), and was married to a woman artist, Clorinda Renieri, daughter of the artist-dealer Niccolò Renieri. Della Vecchia was directly acquainted with authentic Giorgiones, as he had restored the *Castelfranco Altarpiece* between 1643 and 1645, but there is little of the style of the altarpiece in his imitations. Boschini, in a slightly later work in Venetian prose, *Breve instruzione* (1664), redefines Giorgione, or rather provides a synthesis of his earlier thoughts on an artist whom he refers to as the 'diamond' of Venetian art. Here Boschini describes depictions of young men in dresses of striped velvet, damask and satin, with slit jackets and bizarre plumes, as being representative of Giorgione's genius, all of this being based on the attribution to Giorgione of the *Bravo*.[39] Following a lengthy discussion of the *Bravo*, he then praises della Vecchia's creations in a Giorgionesque style, which he says are not copies in the literal sense, but 'astratti del suo intelletto', intellectual abstractions. These splendidly dressed assassins sound more like variations on the work of Caravaggio than anything that resembles a Giorgione, as we define the œuvre today.

It is in connection with della Vecchia's imitations of Giorgione that Boschini invents the word 'Giorgionesque',[40] a term used by most art historians today to denote an approximation of Giorgione's style by artists closely related to him in time and who imitate him more closely than della Vecchia. It is rarely used now, in Boschini's sense, to denote free variations on Giorgione's compositions.

In all this dealing and Boschini's intoxicating verbosity, one may wonder whether the real Giorgione was lost from view in the seventeenth century. One could also imagine that Boschini was attempting to sell della

Above: 37. GIORGIONE. *Concert champêtre*. Canvas. 105 x 136.5 cm. Paris, Musée du Louvre.
Right: 38. GIORGIONE. *Concert champêtre*. Detail.

Vecchia's imitations because there was a lack of the real thing. But if we look at the inventories of what was for sale, it is apparent that real Giorgiones were recognized and described as such, and that works by him were still available. In at least one collection in Venice, that of Bartolomeo della Nave, there were a number of works that we would attribute to Giorgione today, including the *Laura* and the *Three Philosophers*, which Basil Feilding, British ambassador to Venice, acquired for the 3rd Marquis of Hamilton in Venice between 1637 and 1639.[41] Della Nave's collection, which is mentioned frequently in Ridolfi's *Maraviglie*, even after it had left Venice, came on the market after della Nave's death in 1636. These well-known masterpieces were only briefly in England before being bought by Archduke Leopold Wilhelm in Brussels, and eventually they were to provide the nucleus for what is now the Kunsthistorisches Museum in Vienna. Cardinal Leopoldo de' Medici bought at least one work which has a claim to be by Giorgione, the *Education of the Young Marcus Aurelius*.

What was for sale in seventeenth-century Venice? Inventories, such as a Medici sales list of 1681, all testify to the extraordinary wealth of Venetian collections in this period, especially in works attributed to Giorgione. This particular inventory, previously undiscussed in the Giorgione literature, was sent by the Tuscan ambasssador in Venice, Matteo del Teglia, to Apollonio Bassetti, Secretary to the Grand Duke, accompanying a letter in which he mentions a series of paintings by great Venetian artists that were for sale with a merchant in that city.[42] One of the pictures on the list was Giorgione's *La Vecchia* (Fig. 110): 'Quadro il ritratto di una vecchia di mano di Giorgione che tiene una carta in mano et è sua madre', accompanied by what was said to be a self-portrait of the artist with a horse's skull. There were nine other works on the same list attributed to Giorgione, compared to three by Titian, as well as pictures by Pordenone, Bonifazio Veronese and Veronese. The letter does not give the dealer's name, nor any indication of provenance, nor were they bought by the Grand Duke of Tuscany.

Two of the paintings were of pastoral subjects resembling the *Concert Champêtre* (Fig. 37): the first, a painting of a shepherd with a *lira da braccio* and two nude women in a landscape ('Quadro di Giorgione con un Pastor con una lira e doi donine in paese al naturale'); the other was a panel picture of two nude women, one sleeping, the other watching, with a shepherd playing a flute ('Quadro di Giorgione in tavola con due donine nude una

dorme e l'altra vigila con un pastore che suona un flauto al natural et dele pecore in paese'). Neither description is close enough to the *Concert* to supply the lost early provenance for the work, and the descriptions are surprisingly unspecific as to who is represented.[45] A further panel painting on the list, said to be by Giorgione, may in fact be the early Lorenzo Lotto panel in Washington, known as a *Maiden's Dream* ('Quadro in tavola di Giorgione, con una dona sedente che guarda il cielo tiene un drapo nelle mani qual sono Danae in piogia d'oro').[44] There was also a *Europa* by Giorgione, presumably related to the well-known composition copied by Teniers (p. 316 below), as well as two furniture paintings. One of these latter, representing *Leda and the Swan*, could be the little panel of the same subject in the Museo Civico, Padua (Fig. 39); the other, a panel depicting Apollo playing a *lira da braccio* and a satyr playing pipes, describes two of the principal figures in the composition now in Houston (p. 328 below), and may provide an early provenance for this mysterious work.

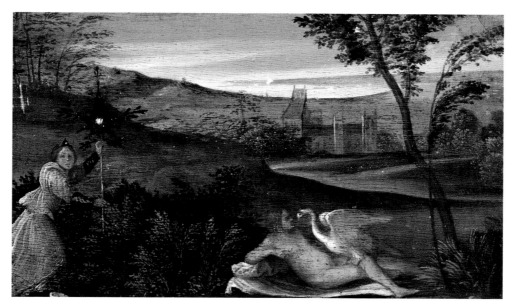

39. ANONYMOUS SIXTEENTH-CENTURY VENETIAN. *Leda and the Swan*. Panel. 12 x 19 cm. Padua, Museo Civico.

Such lists, besides yielding a surprising number of new provenances, are genuinely revealing about what Giorgione's biographers missed, and show, contrary to popular opinion, that the real Giorgione was to some extent never lost sight of, even in the succeeding centuries after his untimely death. Ironically, it may have been the compilers of catalogues and inventories, who patiently recorded traditions, rather than the more flamboyant theorists, such as Ridolfi and Boschini, who remained closer to the personality whom we now call Giorgione.

■

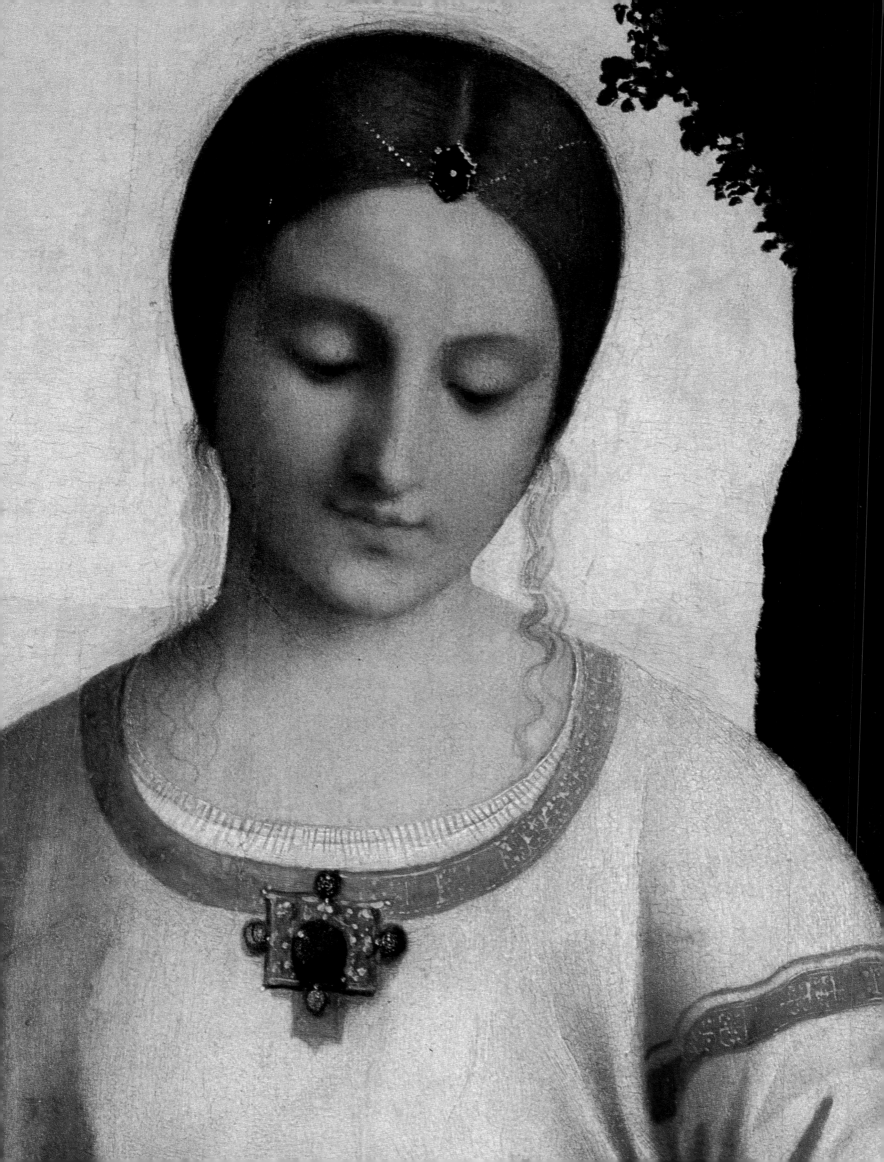

CHAPTER
III

MYTHS AND REALITIES
CREATED BY SCIENTIFIC
ANALYSES OF PAINTINGS

I t is unlikely that we will find much more in Venetian archives to add to the new archival documents about Giorgione presented here. By contrast, we are still discovering significant evidence from the examination of Giorgione's paintings, aided by the latest scientific means, and particularly from advances in infrared imaging technology. Such discoveries have not always elicited constant truths, for the interpretation of scientific evidence is often related to the prevailing art historical view of Giorgione. Whatever the art historical orthodoxy, scientific analyses can be weapons used to confirm or question authenticity. Technical examinations, such as X-rays or infrared reflectography, which reveal new images, require a kind of connoisseurship. We ask whether the new image fits in with others revealed by the same process, as well as how it relates to what can be seen on the surface. Conclusions made following conservation are often accepted as certainties, but the data should be subject to reassessment. In this process, the amount of comparative information about individual works is variable. Many paintings have not been X-rayed or examined with infrared reflectography, and those that have may have been examined in different conditions. Before the scientific analysis of pigments was developed by Joyce Plesters in her pioneering work at the National Gallery, London, there was no reliable means of knowing what colours were beneath the surface. Nevertheless, X-rays were occasionally misinterpreted as denoting colour, which led to a misunderstanding in the case of Giorgione's *Three Philosophers*.

When radiography was invented in the late nineteenth century, a paint box was X-rayed and it was shown which pigments were amenable to analysis — lead white, lead tin yellow and vermilion (mercuric sulphide). It was not until the 1930s that X-rays were used for the scientific study of painting.[1] It was immediately apparent that X-rays were ravishing images in their own right, as exemplified here by the various placements of the head of the adulteress in Titian's Glasgow painting (Figs. 41, 44). They could enhance the appreciation of a painting by indicating changes in its execution and show how a composition evolved. At first it was believed that this new form of analysis would contribute to our cognizance of an artist's style by revealing the underlying brushwork. But a comparison of X-rays is only a comparison of the application of X-ray dense pigments, and it is a simpler comparison than that of the complex morphology of brushstrokes visible on the surface of a painting. Yet it was

Page 80: 40. GIORGIONE. *Judith with the Head of Holofernes*. Detail of Fig. 123.

41. TITIAN. *Christ and the Woman Taken in Adultery*. Canvas. 139.2 x 181.7 cm. Glasgow, Corporation Art Gallery and Museum.

hoped that X-rays, like drawings, would be closer to an artist's first thoughts. At that time, art historians did not understand the physical properties of X-rays; nor was it understood how X-rays related to conservation; nor did anyone have the slightest interest in Renaissance techniques. Giorgione was one of the first artists whose works were X-rayed, and the radiographic evidence was intriguing.

These interpretations of X-rays obscured as well as clarified how Giorgione worked, beginning with Hans Posse's publication of an X-ray of the Dresden *Venus* in 1931.[2] The painting is identifiable with the sleeping Venus with Cupid that Michiel described in the collection of Girolamo

42. Attributed to GIOVANNI CARIANI. *Christ and the Woman Taken in Adultery*. Canvas. 149 x 219 cm. Bergamo, Accademia Carrara.

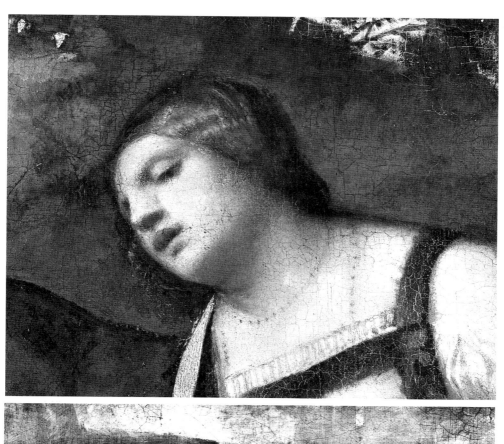

Top: 43. TITIAN. *Christ and the Woman Taken in Adultery*. Detail.
Above: 44. TITIAN. *Christ and the Woman Taken in Adultery*. X-ray showing Titian's
various positionings of the head of the adulteress.

Marcello. Later Ridolfi described the same painting, but mentioned that the Cupid held a bird in his hand. It had always been recorded in the Dresden catalogues that when Martin Schirmer restored Giorgione's painting in the early nineteenth century he covered up the Cupid, because that area of the painting had been extremely damaged. Posse made a drawing of what he believed could be seen in the X-ray (Fig. 45). Until 1994 this has always been accepted as the correct interpretation.[3] One detail, the bird in Cupid's hand, is impossible to see in an X-ray now, and it is likely that Posse's reconstruction was informed by Ridolfi's testimony.[4] The newest reconstruction by Marlies Giebe suggests that the Dresden Cupid once held an arrow in his hand, similar to a painted fragment of a Cupid above the contour of a female thigh, now in the Akademie der bildenden Künste, Vienna.[5] Giebe's research throws light on the vexed question of how Titian finished the picture (p. 227 below).

45. GIORGIONE and TITIAN. *Venus Sleeping in a Landscape.* Hans Posse's reconstruction of the overpainted Cupid, published in the *Jahrbuch der Preußischen Kunstsammlungen,* 1931.

During Johannes Wilde's years at the Kunsthistorisches Museum, he collaborated with the restorer Sebastian Isepp, and began to use X-rays systematically as data for the physical condition of paintings and as a guide to an artist's creative process. By 1928, he was using the facilities of the Röntgenologisches Institut, Vienna; two years later he had established a laboratory in the museum for taking X-rays of paintings; and by 1938 he had made X-rays of more than a thousand works in the collection. In 1932 he published the famous X-rays of Giorgione's *Three Philosophers* and Titian's *Gypsy Madonna.* Those of the *Three Philosophers* (Fig. 49) revealed dramatic changes in the earliest stages of the composition, which differ from what we see on the surface. These changes remain of fundamental significance, both for determining the painting's iconography and for discerning where the young Sebastiano may have intervened. Despite the importance of Wilde's pioneering role, his publication has contributed to a misunderstanding of the subject of the painting.[6]

The evidence published by Wilde revealed that in Giorgione's first conception the eldest philosopher had been depicted in profile, and had worn a startling sun crown with pointed spokes, which all commentators on the painting have since tried to explain (Fig. 46). On the basis of the X-ray, Wilde also argued that the face of the turbaned philosopher was originally black, and consequently that the subject was the Three Magi, an interpretation that has become almost canonical in recent literature. So persuasive was Wilde's reading of the radiographic evidence that even Salvatore Settis in 1978,[7] and Ernst Gombrich in 1986[8] were misled, claiming that no other interpretation of the subject is possible. Examination of the radiograph shows that the head of the central philoso-

46. GIORGIONE. *Three Philosophers in a Landscape.* X-ray showing the solar crown worn by the eldest philosopher in Giorgione's underdrawing.

pher is more transparent to X-rays than the head of the old philosopher, and hence appears dark or exposed (Fig. 47). Presumably Wilde assumed that the central figure lacked an X-ray opaque pigment such as white lead, which was used for the head of the old man. But to the eye, the colour of the turbaned philosopher's face on the surface is not dissimilar to that of the old philosopher. The light flesh colours on the turbaned philosopher's face are produced by pigments which are X-ray transparent, for X-rays do not discriminate between pigments on the surface and those at deeper levels. It is impossible without pigment analysis to determine whether the X-ray transparent material on the central figure was originally dark but later changed. The X-rays of the *Concert champêtre* (Fig. 37) reveal a similar contrast between the two women. One woman is X-ray transparent, the other not. No one has argued — at least as yet — that Giorgione first conceived one as black and the other white on the basis of the radiographic evidence.

Michiel claims that the *Three Philosophers* was completed by Sebastiano del Piombo. Despite the fact that many Giorgione scholars deny that Sebastiano played any part in the painting, Hirst, following an observation made by Wilde, revived the idea that Sebastiano's hand may be detected in the youngest seated philosopher (Fig. 50). Although Wilde

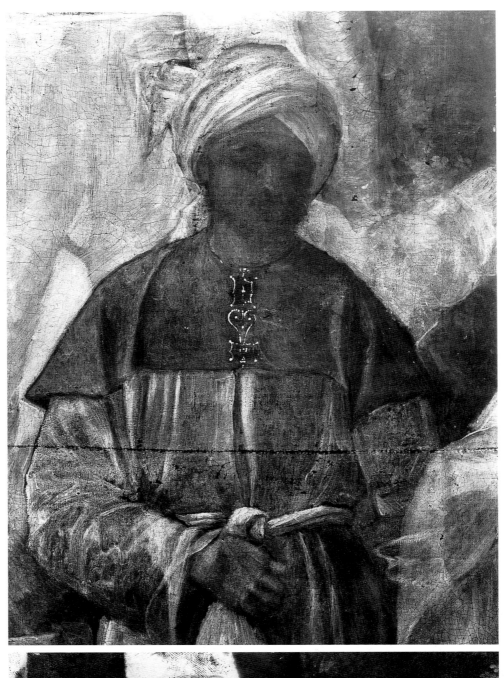

Top: 47. GIORGIONE. *Three Philosophers in a Landscape*.
X-ray of the middle philosopher.
Above: 48. GIORGIONE. *Three Philosophers in a Landscape*. Infrared reflectogram
of the underdrawing on the face of the middle philosopher.

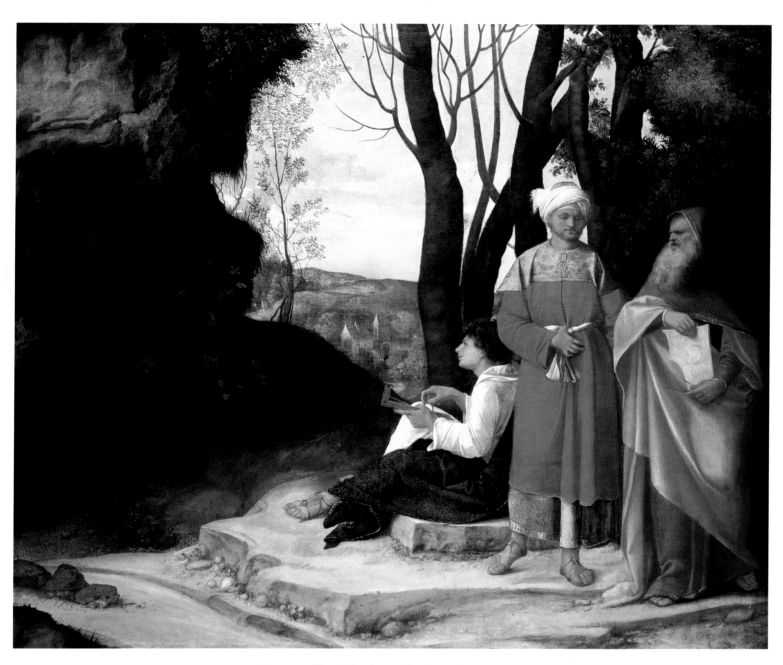

49. GIORGIONE. *Three Philosophers in a Landscape*. Canvas. 123 x 144 cm.
Vienna, Kunsthistorisches Museum.

himself abandoned the idea, Hirst revived his mentor's suggestion on the basis of a more recent X-ray, published by Klauner in 1955, where he saw a difference in stylistic facture between the seated and standing figure in the X-ray,[9] although Klauner did not.

One picture that had been the subject of controversy in the 1930's, the *Allendale Adoration* (Fig. 52), was X-rayed when it reached the National Gallery of Art in Washington in the hope that new evidence would answer old questions. But only in the 1990's was underdrawing on the *Adoration* revealed by reflectography to show painted drawings characteristic of Giorgione's other works. They are published in this volume for the first time (Figs. 63–65). Many art historians had problems analyzing the 'shadowgraphs', as they were called in the 1940's. The then director of the National Gallery in Washington, John Walker, wrote to a friend about Berenson's difficulties, for Berenson admitted he could 'make nothing of the shadowgraphs': 'B. B., between you and myself, does not really believe in the usefulness of X-rays in determining attributions, and consequently almost always complains that they are obscure. In fact, I agree with him about their limited value, and much prefer to base my judgment on enlarged details'.[10] Walker later published an X-ray of Giovanni Bellini's *Feast of the Gods* in a pioneering publication which attempted to show, following Vasari's testimony, which parts of the painting Bellini had made, and which parts Titian may have completed.[11] But as has recently been demonstrated, the radiographic evidence was difficult to interpret without pigment analyses.[12] Walker argued that Titian had eroticized Bellini's conception of the painting by revealing the nymphs' breasts and adding other sensual details. It was only in 1990 that Joyce Plesters revealed, by means of the analysis of pigment cross-sections, how these erotic details were apparent in the earliest layer of the preparatory paint surface. Walker's reading of the scientific evidence, such as was then available, was coloured by his conception of Bellini's personality. He, following Vasari, saw Bellini as a banal painter of Madonnas, unable to encompass the novelties of humanistic painting. The publication in 1988 of a poem by Bartolomeo Fuscus (Leonico Tomeo's brother), which describes the octogenarian Bellini in bed with a beautiful apprentice, 'an ideal model with limbs better proportioned than a Greek statue', seems destined to change his reputation.[13]

50. GIORGIONE.
Three Philosophers in a Landscape.
Detail of Fig. 49.

·

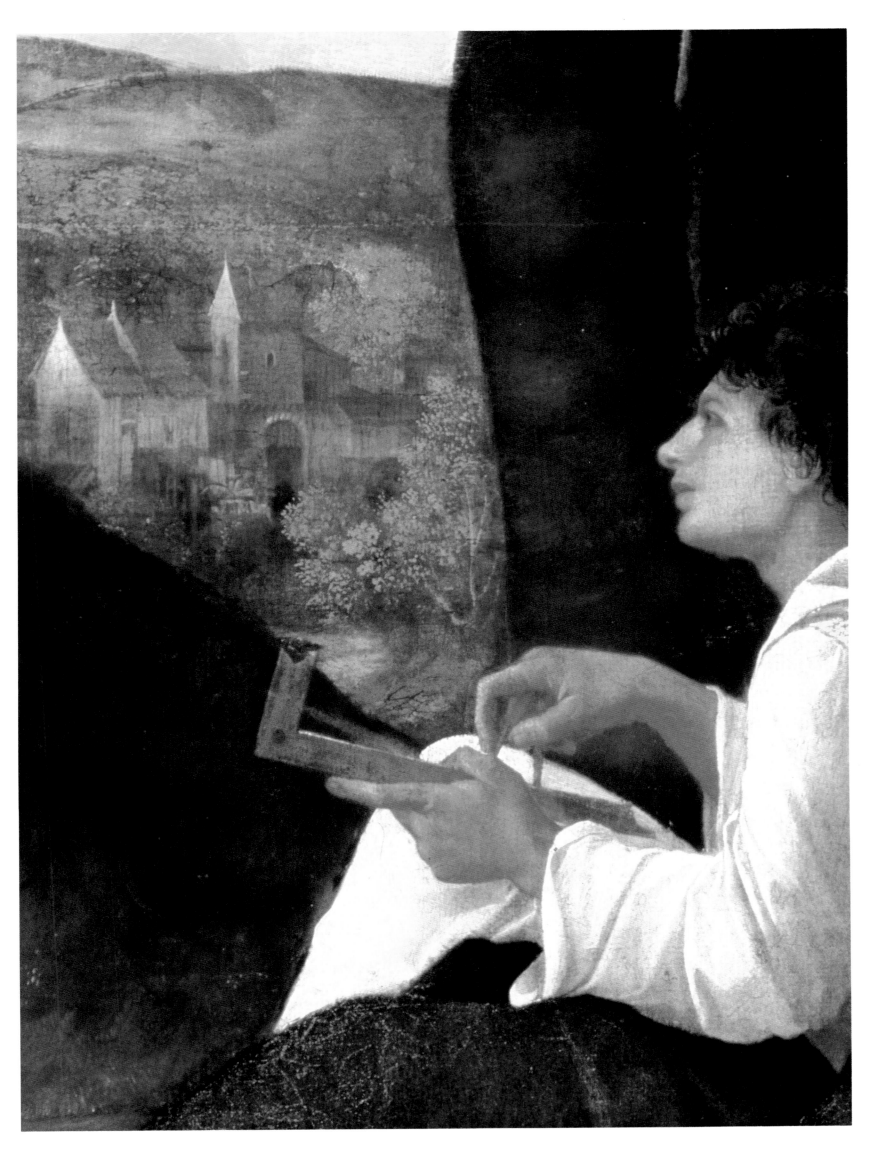

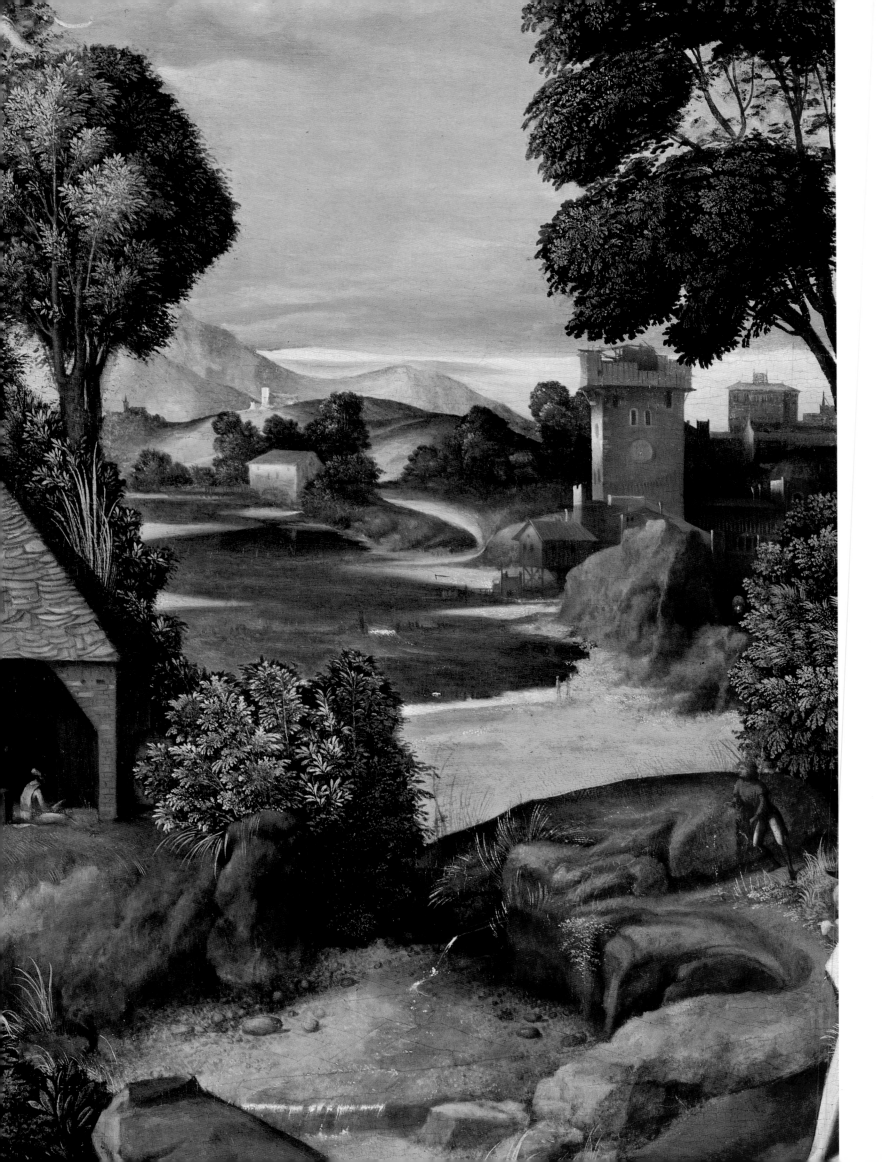

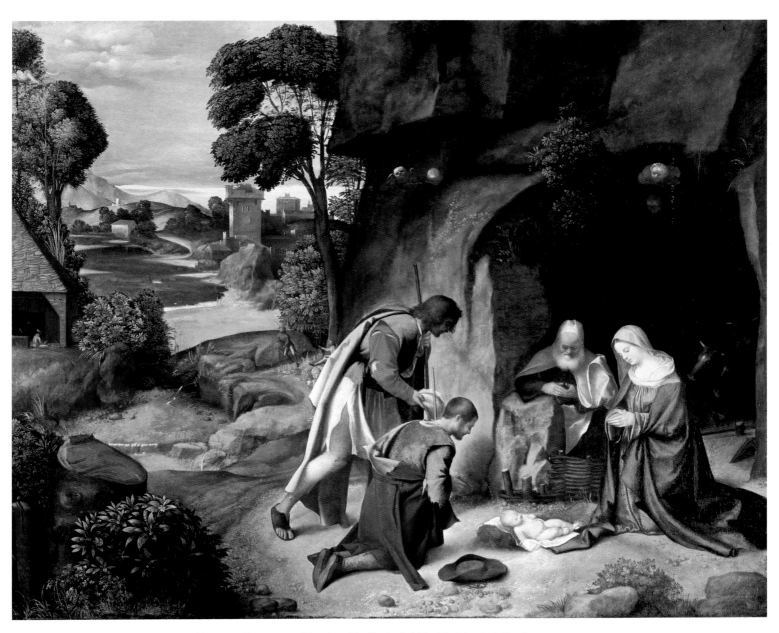

Above: 52. GIORGIONE. *Adoration of the Shepherds (Allendale Adoration)*. Panel. 91 x 111 cm.
Washington, D.C., National Gallery of Art; Samuel H. Kress Collection.
Left: 51. GIORGIONE. *Adoration of the Shepherds (Allendale Adoration)*. Detail.
Following double page: 53. GIORGIONE. *Adoration of the Shepherds (Allendale Adoration)*. Detail of Fig. 52.

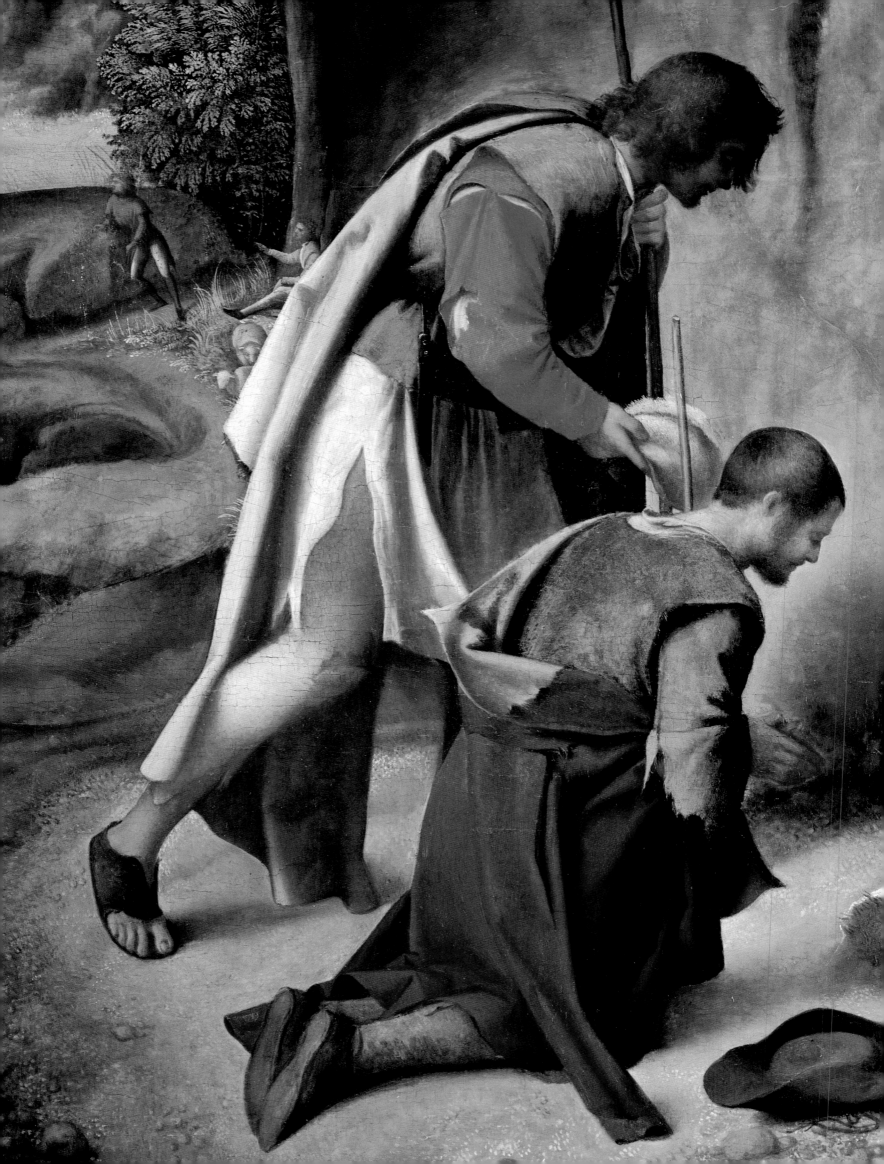

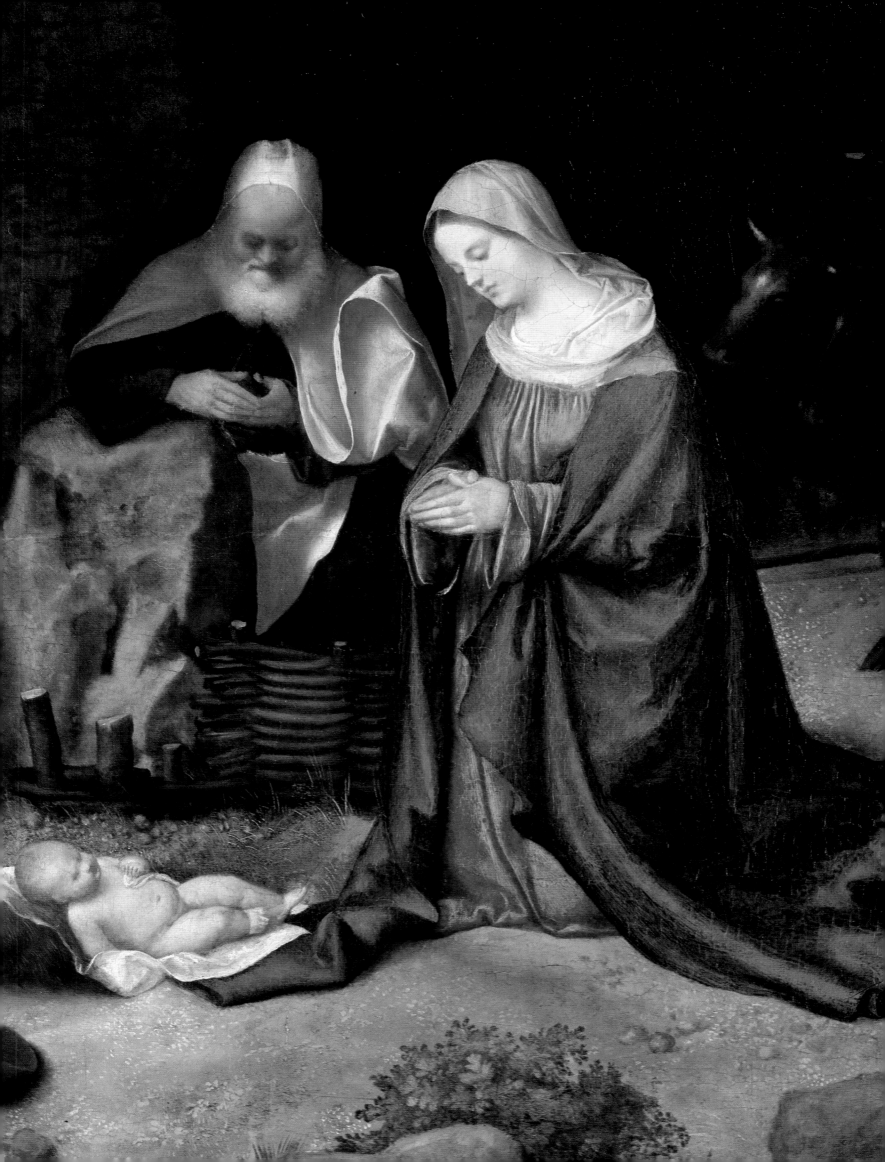

In 1939, Antonio Morassi published the first X-rays of the *Tempesta*, where the presence of another woman was revealed, seated on the river bank beneath the soldier (Figs. 54, 108).[14] The restorer Mauro Pellicioli believed that the seated female figure beneath the soldier was an earlier version of the female figure on the right. Yet it is impossible to tell from the X-ray, or indeed from the infrared reflectogram, whether or not Giorgione intended to place a baby in the woman's arms, for the figure is unfinished. Even with the analysis of pigment samples, it is difficult to determine whether the women were initially conceived in the same first layers of the paint structure.[15]

In conformity with the prevailing doctrine of formalism in the 1940s, the presence of the second woman was, for scholars like Lionello Venturi and Ugo Oggetti, a confirmation that Giorgione had painted a picture without a subject. This perception culminated in the classic definition proposed in Creighton Gilbert's 1952 article 'On Subject and Non-Subject in Italian Renaissance Pictures'. Gilbert introduced the idea that there

54. GIORGIONE. X-ray of the *Tempesta* (Fig. 108), showing the presence of a second woman in the left corner.

was an actual word for a painting without a subject: *parerga*. In this he may have gone too far, as *parerga* is more usually interpreted as a landscape motif that fills in a background. In point of fact, the more convincing interpretation of the X-ray by Mauro Pellicioli suggests that Giorgione began the composition by outlining the woman on the river bank, and then changed his mind to place her on the other side. Kenneth Clark summarized current thinking in his memorable 1949 study, *Landscape into Art*: 'there is little doubt that it is a free fantasy, a sort of Kubla Khan, which grew as Giorgione painted it — for X-rays have shown us that Giorgione was an improviser, who changed his pictures as he went along.'

In 1986 a computer-processed infrared reflectogram revealed a new detail in the underdrawing of the landscape in the *Tempesta*, above the two broken columns. Here at an earlier stage of the composition a square tower had been set behind the truncated columns; only the very top with the cupola remains visible in the final painted version.[16]

Leaving aside what may be revealed beneath the surface of the *Tempesta* by scientific investigation, it is worth reconsidering once again what may be seen on the surface. In chapter VI, I publish the critical reactions of some of the greatest nineteenth-century connoisseurs and museum directors to the *Tempesta* — Waagen, Mündler, Eastlake, Bode, Meyer and Morelli; the first four refused to acquire the work. What was it about the appearance of the picture that led them to say it was a 'ruin' and ineligible for a national collection? What was it about Cavenaghi's restoration of the painting in the 1870s that led to a changed view? Neither of these important questions is really answerable in the present state of knowledge about the painting's condition.

The scientific study of Giorgione's works received a new impetus during the Giorgione quincentenary exhibitions in Castelfranco, when Ludovico Mucchi organized a novel radiographic exhibition with a comparative display of radiographs of paintings to scale — *Caratteri radiografici della pittura di Giorgione*.[17] Mucchi claims, in a way that is reminiscent of 1930's thinking, that there are radiographic characteristics peculiar to Giorgione's paintings which distinguish them from those of his contemporaries. He defines three periods in Giorgione's development, each with its own peculiar radiographic traits, while throughout one constantly observes the use of low density pigments and grounds and light strokes of the brush. In the radiographs, only brushstrokes made in X-ray opaque

pigments are shown, and while this makes the connoisseur's task of comparing the morphology of brushstrokes easier, the comparison of brush-strokes on the surface of a painting is no different. There are no surprises in Mucchi's catalogue, for his conclusions all support the findings in Pignatti's monograph of 1969.

A substantial amount of data concerning the analysis of Giorgione's pigments was first presented by Lorenzo Lazzarini at the Castelfranco exhi-bitions in 1978, where Giorgione's reputation as a colourist was given serious scientific consideration and proved to be as revolutionary as the early sources claimed.[18] Paolo Pino once said that Venetian colour was so complex it could not be defined in words, but this is no longer the case. The *Castelfranco Altarpiece* (Fig. 84) was examined in relation to other works by Giorgione and his contemporaries found in Venetian collections between 1500 and 1510. On the *Castelfranco Altarpiece* itself, Giorgione drew the principal architectural outlines of the throne in relation to the landscape with a pointed stylus on the gesso preparatory ground, and then painted in the backgrounds and details without complex underdrawings. No traces of an extensive preparatory drawing in charcoal or other media, such as was habitual in Bellini's studio, were found. All this confirmed what Titian told Vasari, that he and Giorgione painted 'senza disegno' in the Florentine sense, that is, without preparing compositions in works on paper and without making cartoons. Giorgione really worked out his compositions on the canvas as he went along, beginning with some outlines of the major shapes. He used a rich variety of colours and applied a mixture of coloured glazes in conjunction with related undercolours. Comparing samples from a number of key works, Lazzarini argued that after the *Castelfranco Altarpiece*, progressing to works like the *Tempesta* and *La Vecchia*, Giorgione became surer of his techniques and used fewer pigments to greater effect. For example, three yellows are used in the *Castelfranco Altarpiece*, ochre, orpiment and lead tin yellow, only two in the *Tempesta*, ochre and probably lead tin yellow to denote the lightning, while there are none in *La Vecchia*.[19] Pigment samples have never been published for many of Giorgione's works, including the important group in the Kunsthistorisches Museum, Vienna.

Pigment samples from Giorgione's paintings, in comparison to those of the generation of the Bellini and Carpaccio, were immediately more complex in their layer structure. Both Giorgione's pupils, Titian and

Sebastiano del Piombo, adopted Giorgione's techniques, and with them the mixtures of pigments became more complex and the palettes richer. Titian ground pigments to varying degrees of subtlety in order to achieve different hues and brightness. The chromatic habits of Venetian artists are to some degree individual, and for Lazzarini the technique of the San Rocco Christ was more Giorgionesque than Titianesque, especially when the pigment samples are compared with those taken from Titian's *Altarpiece of St Mark and Saints* from Santa Maria della Salute (1510).[20] In 1983 Lazzarini gave a progress report on Venetian pigments in a classic survey that examined the chromatic habits of Venetian painters between 1480 and 1580, but his conclusions relating to Giorgione remained the same.[21]

Scientific photography can provide a new view of a painting and can also play an important part in how we attribute and assess the condition of paintings. Old photographs of restorations should be used more frequently. One such example is provided by the *Benson Madonna* (Fig. 57). A recent infrared reflectogram reveals a magical brush underdrawing (Fig. 62), but could not be expected to show considerable problems in condition. The painting was last cleaned in 1936 by William Suhr[22] when it was at Duveen's. Duveen commissioned photographs of Suhr's restoration, one of which reveals damage due to a previously unrecorded act of vandalism (Fig. 55): scratched drawn circles as though made by a compass in several parts of the picture, especially on the Madonna's robe. There are also scratchings on Joseph's eyes, mouth and nose, as well as on the Madonna's features. In his notes, Suhr remarks that Duveen's assistant, who revelled in the name of Bogus, 'directed that the Madonna's face be made more complete'. The features of the Holy Family, especially the Madonna, all have a kind of Estée Lauder appearance, the result of the great cosmeticians Suhr and Bogus. It is in these parts that art historians have seen the hand of Sebastiano del Piombo, or other artists, to whom they would misattribute the work. Once the difficulties with the faces are known, the real qualities of the painting become clearer. Photographs of this kind are extremely important documents, and Duveen was aware of their scientific value. He preserved them carefully, and today they reveal how the changing appearance of paintings and their conservation history should play an essential role in Giorgione studies.[23] If only the early photograph of the *Tempesta*, taken before restoration in the late nineteenth

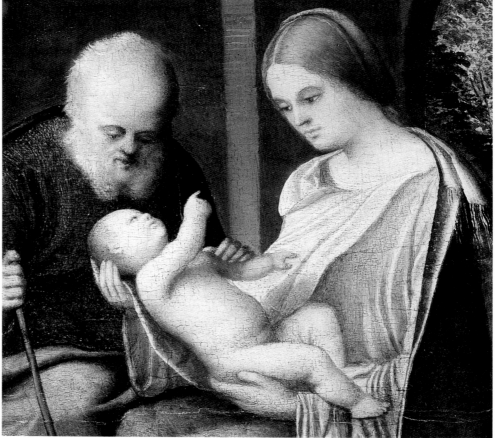

Top: 55. GIORGIONE. *Holy Family (Benson Madonna)*. Detail. Photograph taken in 1936 when the painting was in conservation with William Suhr at Duveen's, New York.
Above: 56. GIORGIONE. *Holy Family (Benson Madonna)*. Detail. Photograph taken in 1936, showing the inpainting after the painting was in conservation with William Suhr at Duveen's, New York.

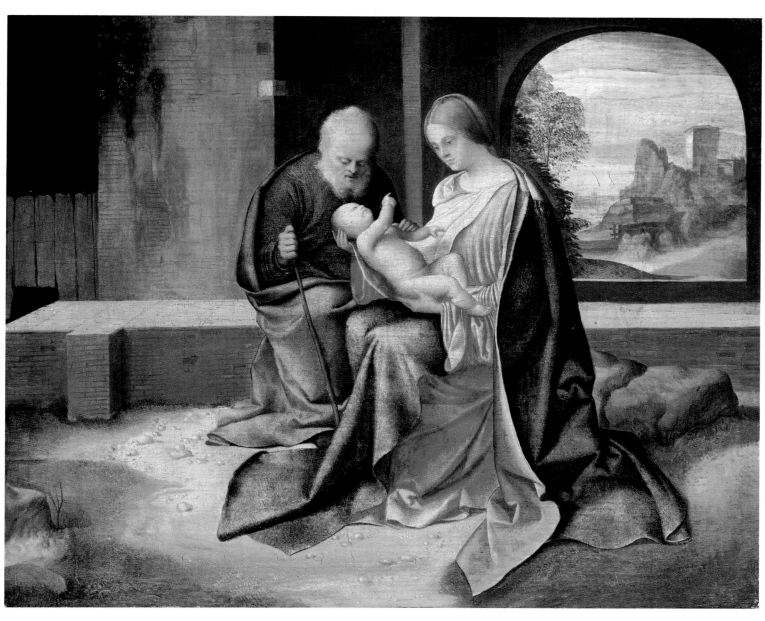

57. GIORGIONE. *Holy Family (Benson Madonna).* Panel transferred to masonite. 37.3 x 45.6 cm.
Washington, D.C., National Gallery of Art; Samuel H. Kress Collection.

century for Bode and Meyer to send to the trustees of the Berlin museum, had survived.

One of the most interesting developments in recent years concerning the scientific study of Venetian paintings has been the discovery of underdrawing, principally by means of infrared reflectography, the drawing often being more adventurous in style than what we see on the surface of paintings and panels. Infrared reflectography, which utilizes an electronic sensing device, is more sensitive than infrared photography using film. Charles Hope and J.R.J. van Asperen de Boer published an innovatory study of a number of underdrawings by Giorgione and his circle in 1991. They revealed that the entire composition of the *Three Philosophers* was drawn on the ground before the artist began to paint, and this drawing established a basis for comparison with other works. They also argued that the seated philosopher has the best claim to be the work of Sebastiano, since he does not appear in the underdrawing, but this need not necessarily be so, as it is always dangerous to argue in the absence of evidence. Their examination of the *Laura* portrait, for example, revealed no underdrawing, which does not mean that Giorgione did not begin with some preliminary marks on the canvas.

Hope and van Asperen de Boer also published infrared drawings of the London *Adoration of the Magi* (Fig. 59) and the *Benson Madonna* to conclude that they were by a different hand. In a lecture published in 1994, which looked at a wide range of material relating to the physical examination of painting, including pigments and infrared reflectography, Jill Dunkerton refuted their claims by means of a persuasive argument. She found that the two underdrawings were more similar than the others supposed. She remarked on the 'schematic rendering of the lowered eyelids of the central philosopher [in the *Three Philosophers*] and of the Christ child in the National Gallery picture [*Adoration of the Magi*, London] as

58. GIORGIONE.
Adoration of the Magi.
Detail of Fig. 59.

semicircles, like lunettes. Moreover the distinctive way that a line was drawn along the central ridge of the nose so that it meets the eyebrow at right-angles is a feature shared by both the philosopher and the Virgin; and in both paintings and drapery folds are outlined with an angular sequence of linked, only slightly curved strokes of the brush, a linear reduction of Giorgione's style of drapery painting that in the core works, at least, suggests stiffened almost papery fabrics that fall into broad and often interconnected triangular shapes. The National Gallery [London] painting

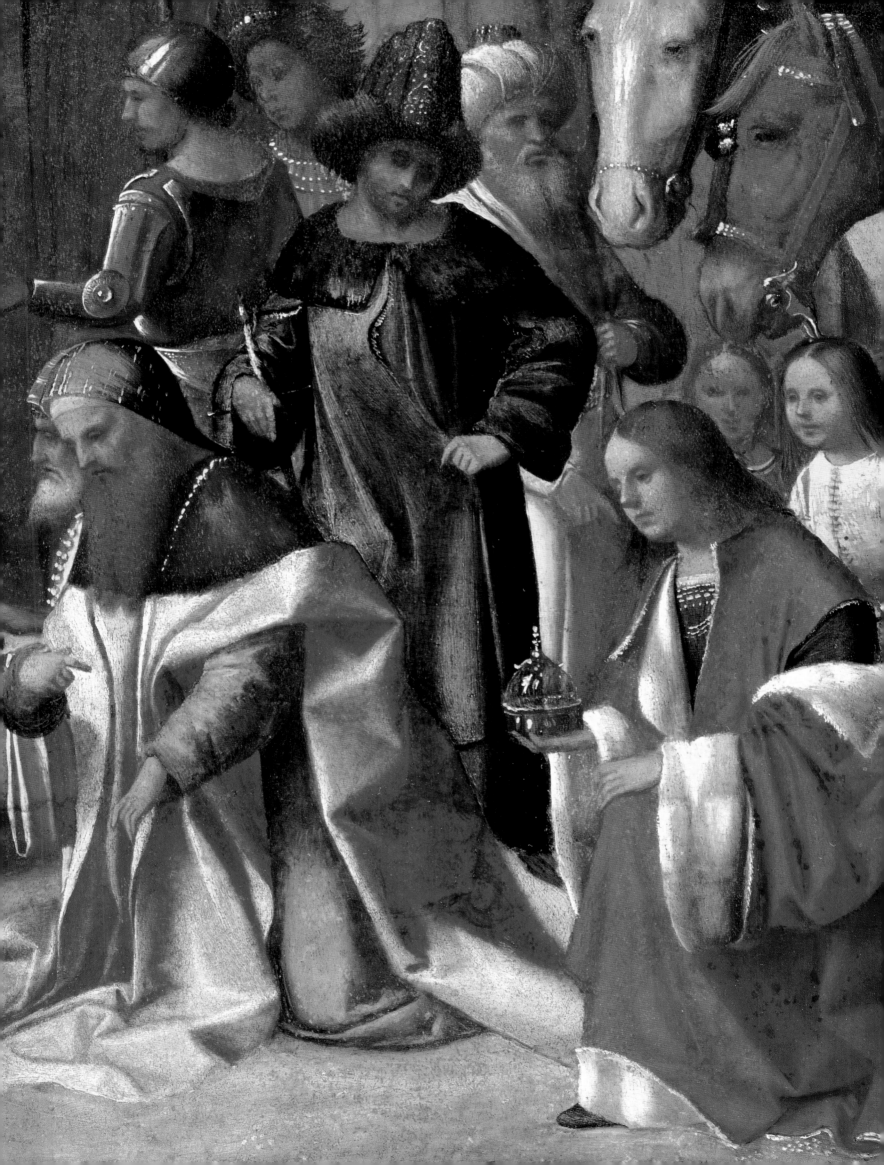

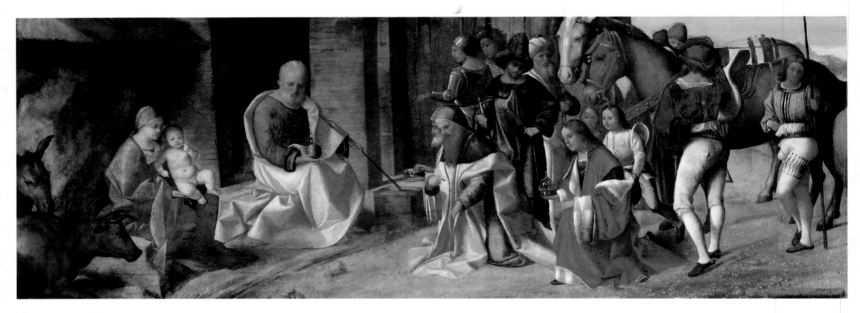

Above: 59. GIORGIONE. *Adoration of the Magi*. Panel. 29 x 81 cm. London, National Gallery.
Right: 60. GIORGIONE. *Adoration of the Magi*. Detail.

lacks the careful shading of the Vienna *Three Philosophers*, but then it is on a much smaller scale. However, it does have an initial free sketch (apparently by the same hand) of the figures and horses on the right, legible only when the image is inverted, suggesting an artist of some flexibility of approach to picture making'.[24]

Paintings attributed to Giorgione have so far shown underdrawings in a variety of media, but very frequently in brush. They almost always give the immediate impression of being more adventurous and freer than Venetian painting at the same period, just as Jacopo Bellini's sketchbooks always appeared to represent imagery that was more stylistically advanced than contemporary history painting in Venetian *scuole* and architectural compositions that seemed more adventurous than structures actually built. These more adventurous images underneath the surface teach us a lot about how compositions evolved and the techniques of Venetian artists. In some cases, where the condition of a painting is poor, the drawing revealed can sometimes uncover the quality of the conception of an image, which has been obscured by subsequent restorers' overpainting. One of the difficulties about assessing such evidence is that we do not have equal information about a large number of Venetian paintings of the same period. Increasingly, however, images of underdrawing should be brought into the debates about how attributions are assessed and how drawings on paper are attributed. The underdrawings revealed by infrared reflectography establish a new corpus of Giorgione drawings, allowing us to understand how he drew on the material support in different ways, and also suggesting comparisons with two drawings, at Windsor and Rotterdam, which may be attributed to him (Figs. 27, 61). These latter offer well worked out compositional structures (the one in Windsor representing a compositional formula that was modified for the *Allendale Adoration*), whereas the underdrawings revealed by reflectography are first ideas to be reworked, the earliest steps in an organic, additive painting process. On the final canvas, Giorgione paints with a stippling technique which hides what has happened underneath, whereas his student Titian lets us see the magical process of addition with a mesh of interlaced colours that is finished only when the artist says so.

One Vasarian cliché, frequently repeated by art historians today, is that Giorgione and the Venetian artists who followed him did not know about good *disegno*. In his conviction that *disegno* was superior to *colore*,

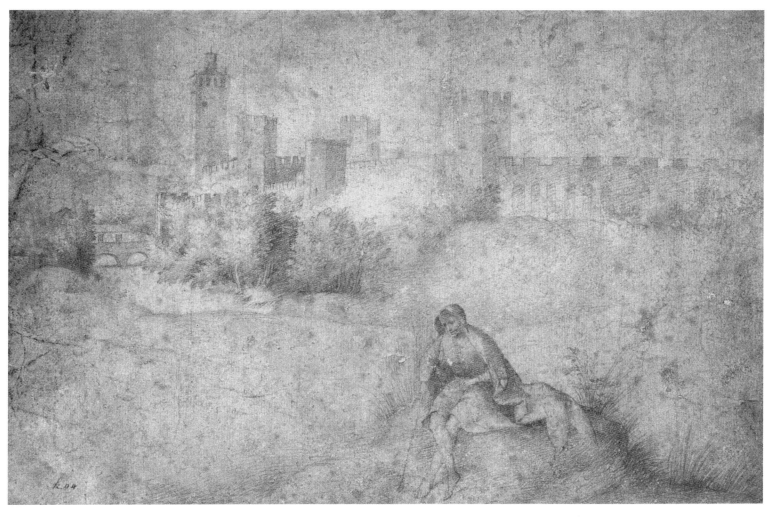

61. GIORGIONE. *View of Castel San Zeno, Montagnana, with a Seated Figure in the Foreground.*
Red chalk. 20.3 x 29 cm. Rotterdam, Museum Boijmans Van Beuningen.

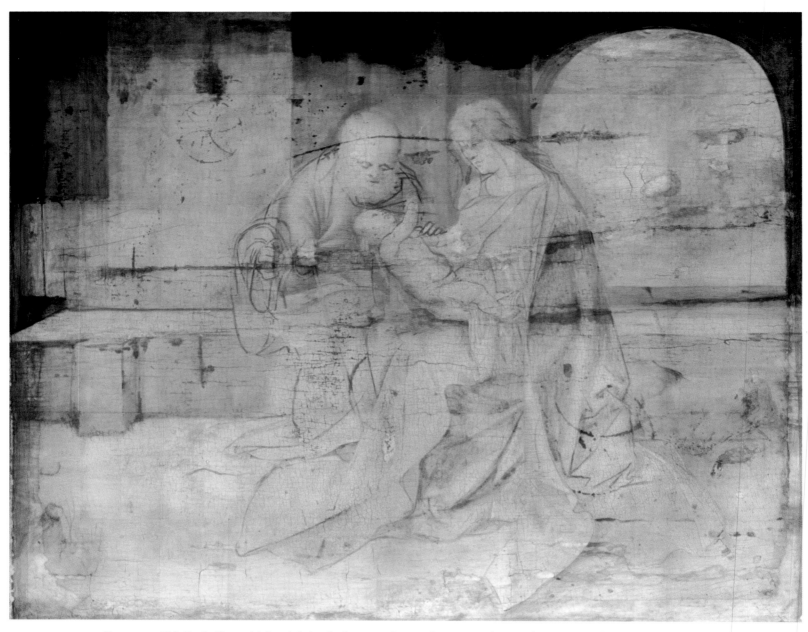

62. GIORGIONE. *Holy Family* (*Benson Madonna*). Infrared reflectogram showing Giorgione's preliminary drawing executed with the point of the brush.

Vasari stood in the mainstream of Tuscan art theory, which went back to Aristotle's statement that the most beautiful colours laid on confusedly will not give as much pleasure as the chalk outline of a picture. In a more practical sense, Vasari's statement may have appeared true, since few actual drawings on paper survived, either by Giorgione or Titian. The common-sense refutal of Vasari's prejudice came from one of the Carracci brothers. They kept a copy of Vasari, which they annotated, often with pro-Venetian statements. One annotation at the beginning of the Titian *vita* came from their real knowledge and enthusiasm of Venetian painting. What was wrong, Annibale Carracci interjected angrily, if an artist were to try out various possibilities on board, reworking and remaking his conceptions, rather than wasting all that paper on preliminary versions?[25] And Annibale Carracci was right. Confirmation of frequent changes in the course of execution on some of Giorgione's pictures is shown by the scientific examination of what is underneath the surface.

An examination in 1994 of both the *Allendale Adoration* and the related *Benson Madonna* at the National Gallery, Washington, with the platinum silicide camera developed by the gallery, with a generous donation from Eastman Kodak, for the examination of Renaissance paintings, reveals much delicate preliminary drawing of extraordinary high quality in the earliest conception of the paintings (Figs. 63, 64).[26] The brush underdrawing of the *Benson Madonna* as shown in the infrared image is of great delicacy and competence (Fig. 62). Giorgione begins by placing the principal figures with fluid brushstrokes on the prepared surface. The holy couple is first depicted as psychologically much closer. Great care has been taken with the placement of the stiffened drapery of the Virgin and the hands of Joseph — one of his hands is drawn twice. The arch behind them foreshadows the contour of the cave in the *Allendale Adoration*. The style of the preparatory brush drawing, and of the facture of the original surface of the painting, is very close to the *Allendale Adoration*.

Giorgione began the *Allendale Adoration* with some doodling, just playing around with forms, before drawing with a pointed brush. He placed the main elements of the landscape (taking particular care with the outlines of the rock) and the principal figures before the cave (especially the Virgin). In many aspects of the drawing, there are echoes of Leonardo's techniques and language, such as in the geological forms of the landscape and the artificial stiffness of the Virgin's drapery. The sophisticated beauty

of the figures, the psychological intimacy of Mary and Joseph, stands out against the landscape. The cherubs' heads, the single partings of their hair, and the light on their faces were carefully drawn in at this early stage. There is also a Florentine feel about how the foliage masks the contours of the caves in relation to the delicacy of the cherubs, reminiscent of Filippo Lippi in the Medici Chapel. No preliminary indications of the baby were found, but an infant is a small presence to be placed at the end. Great care was taken with how the Virgin's robes fall on the ground, as is shown by the delicate washes and drawn lines in the underdrawing. Similarly, the robes of the kneeling shepherd and the position of his feet are carefully delineated. Beneath the standing shepherd there was a simplified ovoid head, drawn again with a pointed brush, as was the drapery on his shoulders, perhaps from a mannikin rather than a model (Fig. 65).

Giorgione had some difficulty in placing the line of the cave against the landscape — there are three attempts registered — and in relating the landscape to the figures. In the main, the brush-painting of the trees and trunks looks uncannily like that on the surface of the *Tempesta*. There are many differences in the landscape underdrawing from the surface features, and the explanation is not always clear. The tower was not part

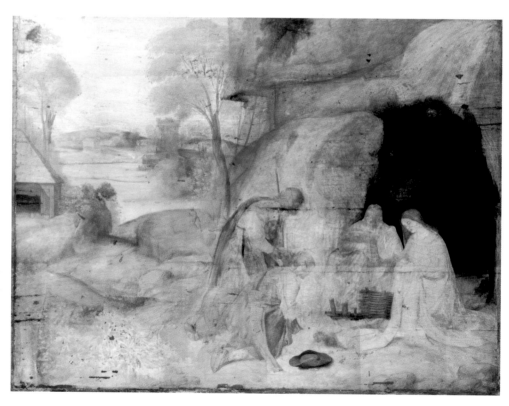

63. GIORGIONE. *Adoration of the Shepherds* (*Allendale Adoration*). Infrared reflectogram showing the underlying drawing.

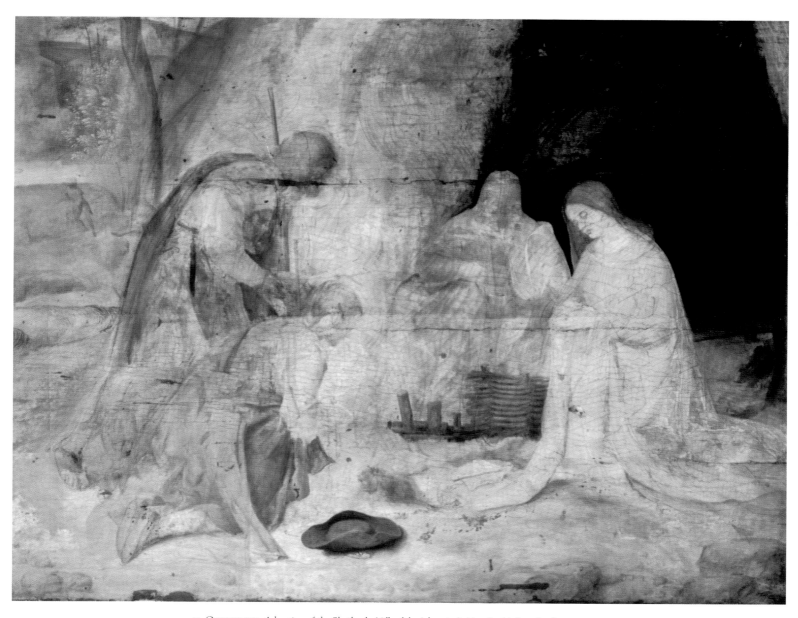

64. GIORGIONE. *Adoration of the Shepherds (Allendale Adoration)*. Detail of infrared reflectogram.

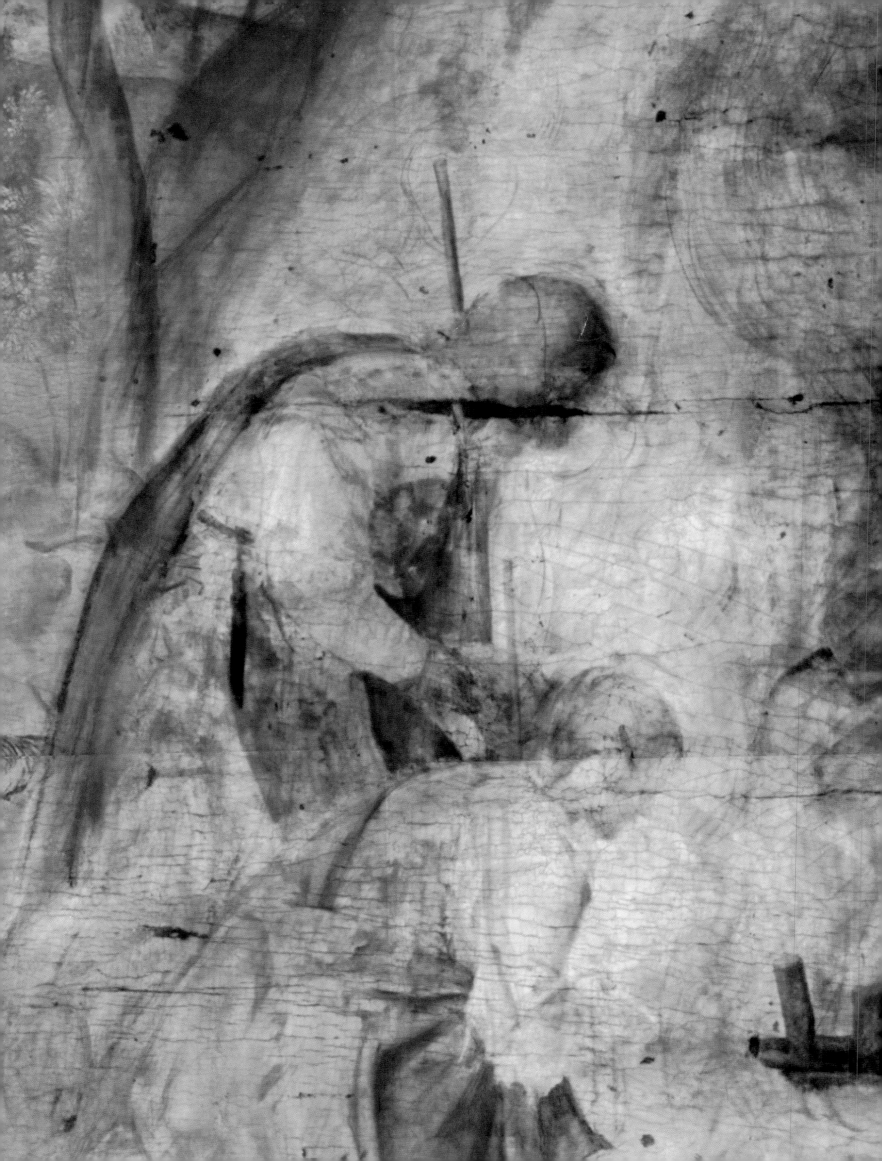

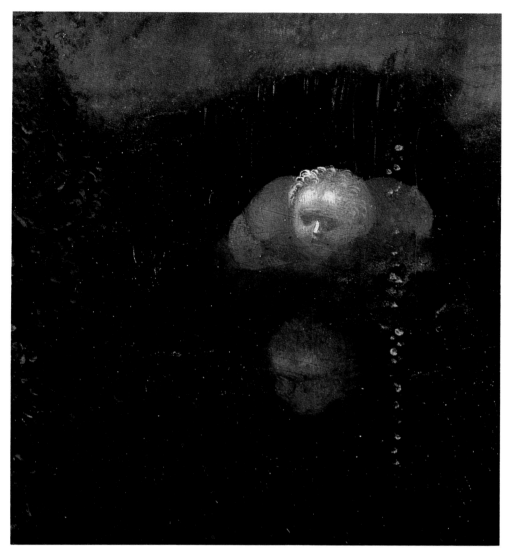

Left: 66. GIORGIONE.
*Adoration of the Shepherds
(Allendale Adoration)*. Detail
of Fig. 52.

Far left: 65. GIORGIONE.
*Adoration of the Shepherds
(Allendale Adoration)*. Detail
of infrared reflectogram.

of the original conception, and the scene in the little hut was very
different. In the first conception there are two partly hidden figures lying
along the base line of the rural dwelling. The underdrawing shows a rough
fringe along the edge of the thatch, implying that thatch was not origi-
nally intended. To the right of where the tower appears on the surface,
there is some very beautiful drawing of stilt constructions in the landscape
which differ from what we see on the surface.

Giorgione's changes in the landscape suggest a second reworking of
the painting at some time after its execution, particularly at the left, that
is, in the area of the composition which has provoked the most contro-
versy concerning its attribution. There is a strange difference between the
niggling precision with which the bushes on the surface of the painting
are rendered, and the fact that there is no indication of their placement
in the earliest layers of the painting. Are they part of a second reworking

by Giorgione at some time after the picture was completed? Or is it a reworking concurrent with the addition of the announcing angel, later in the sixteenth century (Fig. 66)? These questions are difficult to evaluate in the absence of pigment samples.

A most dramatic drawing was discovered on what we consider the reverse of the *Terris Portrait* at San Diego by Yvonne Szafran of the J. Paul Getty Museum in 1992. The reverse of the portrait had been much discussed in connection with a partially legible date which had been confidently read by Pignatti as 1510 (Fig. 67), even though the last two numbers are missing, only a lower loop of the last being legible. For this reason, Pignatti made the *Terris Portrait* (Fig. 68) one of the key works for Giorgione's last years. However, Yvonne Szafran found on the reverse an ink underdrawing,

67. Reverse of the *Terris Portrait*, showing the date and an inscription with the name of the artist.

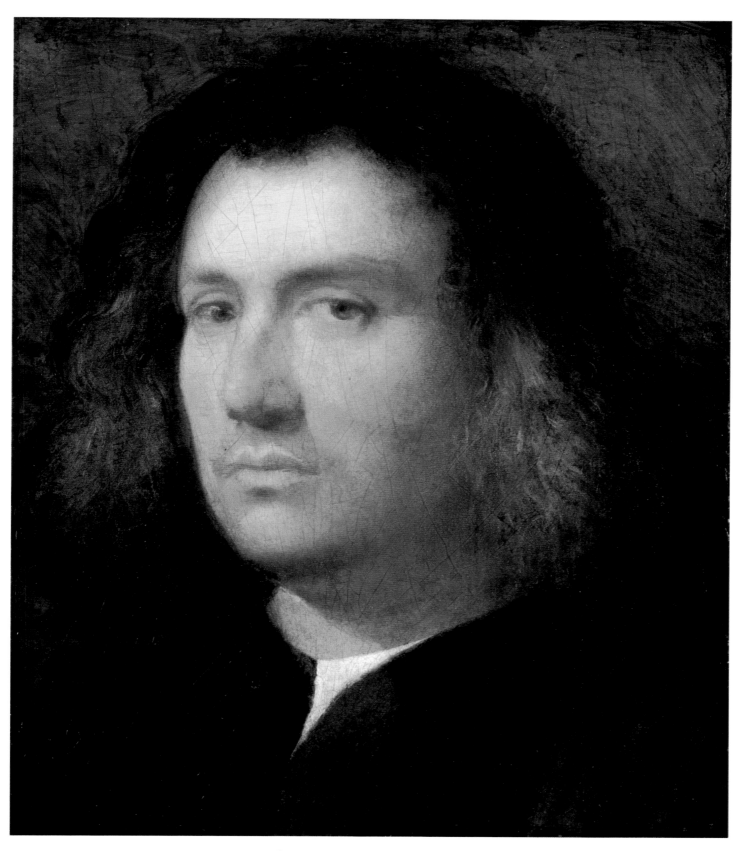

68. GIORGIONE. *Portrait of a Man (Terris Portrait)*.
Oil on poplar. 30.1 x 26.7 cm. San Diego Museum of Art.

69. GIORGIONE. *Terris Portrait*. Infrared reflectogram of the reverse of the panel, showing various drawings representing Mary and Joseph, various personages and a torso of a man.

made on a prepared ground and partly painted in, probably of Joseph and Mary, as well as other figures, including a male torso (Fig. 69). The component parts of the drawing, if it is one composition rather than doodling, are difficult to understand. The iron gall ink drawing is unrelated to the portrait on the reverse of the panel. The individual figures are partly painted in, which does suggest that it was begun as a coherent composition, and then for some reason abandoned. The style of the drawing is characteristic of the beginning of the first decade of the Cinquecento. The portrait does not have to date from the same time as the drawing on the other side, but questions can still be raised about the date, for which variant readings would be 1506, or even 1500. Moreover, the portrait has darkened with age, there being a layer of black paint under much of the skin colouring, and the sitter's clothes were once purple.[27]

Mauro Lucco's publication of underdrawings on the *Education of the Young Marcus Aurelius* (Figs. 70, 71), drawings that show the Virgin kneeling to adore the Christ Child and a bucket on a wooden fire, make a revealing comparison with the San Diego portrait, as this drawing seems similarly disconnected from what we see on the surface.[28] Although the underdrawings on the Pitti painting are easier to read — the Madonna kneels in an architectural surround, either a cave or a thatched hut — they seem to date from the early years of the Cinquecento, like those on the reverse of the San Diego portrait. Moreover, the iconography of the underdrawing on the Pitti painting recalls the *Allendale Adoration* of approximately this date. Giorgione, when young, appears to have experimented even more freely than Vasari would have us believe. Perhaps it was a shortage of money that led him to play around so freely with compositions.

Another group of paintings, such as the Widener *Orpheus* (p. 344 below), are even more problematic, in terms of attribution and dating, than the Allendale group. Here as well the platinum silicide camera proved helpful in explaining the differences of opinion concerning the condition and attribution of a work that has hovered around Giorgione's name. In the last serious consideration of the Widener *Orpheus*, the invention was attributed to Giorgione himself, while the execution on the surface was believed to be by a later hand, or by someone like Previtali.[29] A magnificent underdrawing was revealed of the complete composition, but the drawing is entirely characteristic of the energy and humour of Giovanni Bellini, at his best in such paintings as the *Feast of the Gods*, and different

70. GIORGIONE. *Education of the Young Marcus Aurelius (Three Ages of Man)*. Infrared reflectogram showing a drawing of the Virgin and Child. Detail of the Virgin in prayer.

71. GIORGIONE. *Education of the Young Marcus Aurelius (Three Ages of Man)*. Infrared reflectogram showing a drawing of the Virgin and Child. Detail of the Child resting on the ground.

from any of the underdrawings by Giorgione. Circe and Apollo were originally conceived as in a glade, the woodland background being an important part of the composition. Bellini began by drawing the curtains of trees in the landscape, and then improvised details. The tender sensual expression on the satyr's face, as he holds the conch shell towards his female companion, is very like a painted version of Riccio's bronze satyrs. On the painted surface, the subtlety of these expressions has been lost. Although some art historians, such as Berenson, have always believed the attribution to Bellini, the condition has led to doubts. The beautiful fluency of

the underdrawing and the slightly more old-fashioned technique suggest that the invention was entirely by Giovanni Bellini's hand, even though what we see on the surface is heavily restored. The composition postdates the *Feast of the Gods*, and shows how Bellini in his last years was responsive to Giorgione's inventions.

Another small Giorgionesque panel with an Orphic subject in the Phillips Collection, Washington, has been shown to have a fascinating underdrawing, different in style from any of the others, but one which reveals a more emblematic configuration of objects than the final painting (Figs. 72, 73). The underdrawing shown in the infrared reflectogram reveals that the musician, sometimes identified as Apollo and sometimes

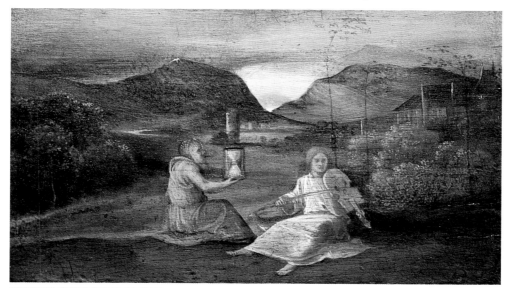

72. ANONYMOUS SIXTEENTH-CENTURY VENETIAN. *Father Time and Orpheus (The Astrologer)*. Furniture panel. 12 x 19.5 cm. Washington, D.C., Phillips Collection.

73. ANONYMOUS SIXTEENTH-CENTURY VENETIAN. *Father Time and Orpheus (The Astrologer)*. Infrared reflectogram showing a confrontation between a buck deer and a hind in the preliminary composition.

as Orpheus, was first placed near two deer, a buck and a hind, who confront one another. This detail is more appropriate to Orpheus, who charmed

74. ANONYMOUS SIXTEENTH-CENTURY VENETIAN. *Father Time and Orpheus (The Astrologer)*. Infrared reflectogram, showing the preliminary drawing of a hind and the tower.

the animals with his music, than to Apollo. In the painting, only the buck is visible, the hind having been covered by the figure of the elderly man holding an hourglass. The position of the tower in the background was an element of some importance in the composition from the beginning. It first consisted of a tower on top of a pedestal, and was placed dramatically beneath the setting sun. The idea of Time, personified by the figure of Chronos holding an hourglass, was added later to a scene that was primarily conceived as Orphic.

Other problematic paintings can be more interesting if they are taken away from Giorgione and examined on their own terms, such as the Giorgionesque panel of *Venus and Cupid* in Washington (Fig. 75). It once decorated a box for some precious treasure, perhaps jewels, as indicated by the presence of a keyhole. Here a powerful expressionist underdrawing is revealed in an infrared reflectogram. The underdrawing (still unpublished) is in an entirely different style, reminiscent of Pordenone, from that on the surface, which has always provoked an attribution to Giorgione's name. Basing his design for the figures on a plaquette by Riccio (Fig. 76), the artist placed Venus and Cupid in a landscape. He then repainted the composition in a style that would intentionally look Giorgionesque, suggesting that such subjects were much in vogue for a

whole range of decorative objects. The changes between the reflectogram
and the surface painting show how a Venetian artist made a design more
Giorgionesque to accord with current fashion.

Of all Venetian paintings of the first decade of the
Cinquecento, the *Judgement of Solomon* at Kingston Lacy
(Figs. 77, 78), once firmly attributed to Giorgione, has
the most complex underdrawing, revealing several
compositions, some of which are clearly, even
disturbingly, apparent to the eye, while others are
only perceptible in an infrared photograph (Fig.
79). At some stage, the picture was considerably
overpainted, or rather an unfinished picture of
the Venetian Renaissance was finished, perhaps
in the eighteenth century, either before or after
the picture reached the Marescalchi collection,
Bologna.[30] Canon Luigi Crespi (1709–1779), son of the
ingenious and eccentric Giuseppe Maria Crespi, has much
to say in his critical essay on the restoration of oil painting in
Bologna, protesting against the free way in which his contemporary
restorers overpainted Renaissance pictures. It was always apparent that the
Kingston Lacy *Judgement* was unfinished, as the unclothed executioner was
only painted in dark undercolour, and the infants were missing. But in
conservation in 1984, the whole surface was shown to be incomplete, with
the exception of the clothes of the evil mother. On the right side of the
picture, several underlying figures are visible to the naked eye, all
conceived on a much smaller scale than in the final version: the head of
an old man, a headless green vest, and a floating white loincloth near the

Top: 77. SEBASTIANO DEL PIOMBO. *Judgement of Solomon*. Canvas. 208 x 315 cm.
Kingston Lacy, Wimborne, Dorset.
Above: 78. SEBASTIANO DEL PIOMBO. *Judgement of Solomon*. After restoration.

79. SEBASTIANO DEL PIOMBO. *Judgement of Solomon.* Infrared reflectogram showing the different stages of the underdrawing on the right side.

executioner. The infrared photograph shows the old man clearly, as well as an underdrawing of a horse's head and torso. The position of the missing infants is revealed only in the X-radiograph. The living child is held in the executioner's left hand while the dead infant is placed just before Solomon at the base of the podium.

The first version of the subject, partly drawn and partly painted, was conceived on a smaller scale with a different architectural background. Some figures in this first version were completed to a high degree of finish. The difference in scale is best understood when the figure of the executioner is compared to his shadowy *pentimento* at his right. Presumably, the other figures were enlarged in the same way. Traces of blue paint in the oculus on the upper left suggest a landscape, and there may have been a

landscape behind the horseman on the right. The floor was first designed with a square tiling. As a consequence of the restoration, both architectural backgrounds are visible at the same time. Above Solomon's head there is a pink canopy and a white Romanesque arch with gilded spandrels from the first solution. A thin layer of grey paint has been applied over the lower part of the canopy to suggest stonework. The second architectural scheme is an antique basilica, much more appropriate to the subject.

In conclusion, some methodological points emerge from all this novel data. The scientific examination of the physical condition of paintings does enrich our appreciation of many aspects of the art of Giorgione and his contemporaries, but more important, it is the way forward to understanding issues of attribution and chronology. The most significant discovery is that the delicate brush underdrawing on the *Allendale Adoration* helps establish a link between the Allendale group of paintings and the *Tempesta*. The evidence of the underdrawing on the *Education of the Young Marcus Aurelius* and the *Terris Portrait* opens up new arguments about Giorgione's chronology. When combined with archival research, the analysis of old photographs may provide a new understanding of the condition and iconography of individual works such as the *Benson Madonna*. How art history should be rewritten as the result of the changing appearances of Renaissance works is becoming an increasingly important subject, one in which all kinds of evidence should be brought into play. The study of pigments, infrared reflectography and X-radiography have enriched our vocabulary and understanding of Giorgione's works and techniques. In many ways, they have not altered Vasari's picture of Giorgione's way of working out compositions, but we can now describe it in rich detail.

80. SEBASTIANO DEL PIOMBO. *Judgement of Solomon*. Detail of Fig. 78.

CHAPTER

IV

PATRONS OF
'LA MANIERA MODERNA'

As Taddeo Albano informed Isabella d'Este, those fortunate enough to possess Giorgione's versions of the Notte had ordered them for their own enjoyment and refused to sell them (p. 362 above). This has been seen as proof that the early collectors, whose identities are known to us mostly from Marcantonio Michiel, not only owned paintings with secular subjects, but also commissioned them. It has always been recognized that Giorgione's patrons form a special group.[1] Insofar as we can trace the genealogy of collections, those who inherited works by Giorgione also declined to sell them until the beginning of the seventeenth century, when a large number of collections formed in the sixteenth century left Venice. Giorgione's patrons include a wider cross-section of Venetian society than has been acknowledged, one which goes beyond the patrician oligarchy described by Michiel. Some non-patricians, like Victorio Bechario, who owned the Notte, sometimes identified as the *Allendale Adoration*, remain mysterious. Among those who have previously been ignored is the Florentine Republican intellectual Salvi Borgherini, who commissioned from Giorgione a portrait of his son with the Venetian tutor Niccolò Leonico Tomeo, the first Renaissance Italian in Venice to read Aristotle in Greek (Fig. 89). Salvi is a barometer of Giorgione's fame beyond the Veneto, and it is significant that we know of his existence from a non-Venetian source, Vasari. The Grimani have similarly been strangely neglected in accounts of Giorgione's patronage. An inventory made of the Grimani painting collection by Cardinal Marino himself suggests that the most important of all Venetian cardinals, Domenico Grimani, could have been in contact with Giorgione.

Archival discoveries allow us to assemble some essentials of a patron's biography, but there is rarely a statement of personal opinion or belief, such as may be found in the *ricordanze* that Florentines kept.[2] As we shall see, Gabriel Vendramin's will represents an exception, for in that eloquent document he discusses at length the personal qualities necessary for a successful patrician existence. It is amusing to note that Girolamo Marcello, who commissioned as his wedding picture one of the most sensual depictions of Venus ever conceived (Fig. 139), was later to occupy the office of Censor of the Venetian Republic and to translate one of the most pessimistic antique treatises on marriage.

Page 126: 81. GIORGIONE. *Castelfranco Altarpiece*. Detail of Fig. 84, showing a ruined tower and the flag of the Knights of Malta.

TUZIO COSTANZO (c. 1450–1517)
AND CATERINA CORNARO (1454–1510)

For at least 150 years after it was painted, Giorgione's *Castelfranco Altarpiece* (Fig. 84), the largest surviving composition in oils that the artist ever produced, remained shut off and virtually ignored in the funerary chapel dedicated to St George on the right side of the atrium of the ancient church of San Liberale, Castelfranco.[3] Commissioned by Tuzio Costanzo, a Cypriot *condottiere* in the Veneto, it was originally in the *chiesa vecchia* of San Liberale, an edifice demolished in the mid-eighteenth century. The present chapel in the new church, designed by Francesco Maria Preti, does not correspond to the one described in early documents.[4] The saints represented, St Francis,[5] and St George, who significantly holds the banner of the Order of the Knights of St John, *gueules a croix argent* (Fig. 81),[6] were chosen because they participated in the crusades against the Turks, in which successive generations of *condottieri* in the Costanzo family had made their fortunes in Sicily and Cyprus.[7] For a century and a half, the strange composition of the Madonna on a high throne, isolated against a landscape, seems to have made little impression in the provincial ambiance of Castelfranco, with the exception of a painted panel derived from the St George figure, owned by Gabriel Vendramin (p. 330 below). Following its restoration in 1635, and Carlo Ridolfi's description of it in the *Maraviglie dell'arte* (1648), the altarpiece became one of the few known works to be correctly attributed to Giorgione in the seventeenth century. The Costanzo coat-of-arms is prominently displayed on the base of the Madonna's throne (Fig. 83). The top of the escutcheon bears the lion rampant, awarded to the Costanzo by Emperor Frederick II, and on the lower half are six silver human rib bones, to record hardships the family had undergone. The rib bones are a gruesome pun on the surname, the Italian word for rib being *costa*, a suitable emblem for a family of military adventurers. Heraldry is prominent, and, on a tower in the background, the presence of the lion of St Mark is a reminder of Tuzio's fidelity to Venice. The abandoned military constructions suggest a period of peace between the many wars in which Tuzio was engaged on behalf of the Republic. Behind St Francis, there is an arcadian setting with two warriors holding lances, one seated, the other standing, in peaceful discourse (Fig. 82), a poetic interpretation

82. GIORGIONE. *Castelfranco Altarpiece.* Detail of Fig. 84.

83. GIORGIONE. *Castelfranco Altarpiece.* Detail of the Costanzo coat-of-arms, six rib bones and a lion rampant.

of St Francis' traditional message: *pax et bonum*. The theme of war and peace is a truly appropriate one for a *condottiere* in the service of the Venetians in the Trevigiana.[8]

Genealogists agree that the Costanzo fled from Constance, Germany, in the twelfth century to become *condottieri* in Italy; and by 1182, two brothers, Giordano and Guglielmo, had been admitted to the Neapolitan nobility.[9] In 1430, a branch of the Costanzo family transferred to Messina, Sicily, and were occupied with military commissions in the Mediterranean. In 1462, Muzio Costanzo won an important naval battle at Famagusta on behalf of the bastard Giacomo Luisignano, King of Cyprus.[10] Luisignano was disinterested in administration. In reward, Muzio received the title of Vice King of Cyprus and became responsible for much of the government of the island.[11] Giorgione's patron was Muzio's eldest son, Tuzio, born in Messina in the 1450s, who accompanied his father to Cyprus, with the

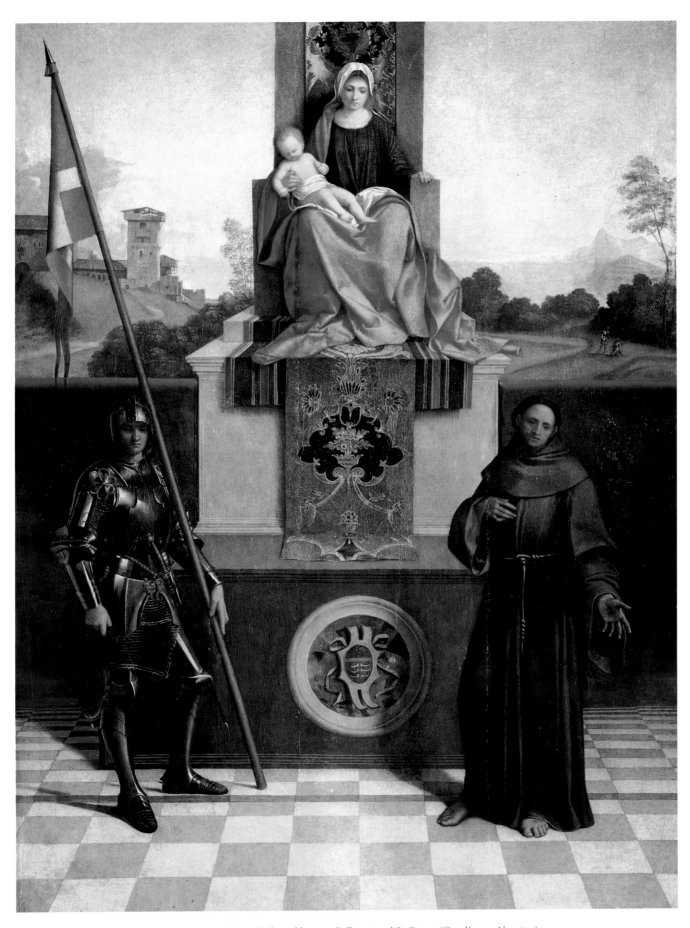

84. GIORGIONE. *Virgin Enthroned between St Francis and St George (Castelfranco Altarpiece).*
Panel. 200 x 152 cm. Castelfranco, Cathedral of San Liberale.

intention of inheriting his rich legacy, while his younger brother, Mattheo, a Knight of the Order of St John, remained in Messina, where he became prior.

In 1472, Venice consolidated an alliance with Cyprus and adopted a beautiful young woman from a patrician family as a daughter of the Republic: Caterina Cornaro,[12] whom they married to Giacomo Luisignano.[13] A few months after the wedding, Luisignano died, leaving Caterina a widow and pregnant. Their son died in infancy, and Caterina governed the island with some difficulty, until she was finally recalled to Venice in 1488. The Venetians did not wish the title of Vice King to become hereditary, and so Tuzio moved to the Veneto and entered the service of the Republic as a *condottiere*. He had married Isabella Vernina, daughter of the Chancellor of Jerusalem, who brought a considerable dowry, with which he was able to buy extensive estates.[14] Tuzio was resident in the Veneto by 1475,[15] in which year Caterina Cornaro had written to the Venetian Republic to request that Tuzio be allowed to return to Cyprus, a request that was denied.[16] One reason may have been that the Council of Ten feared Tuzio would support Caterina's interests — principally to help her in her plan to remarry — against those of Venice.[17] Even in 1479, when his father Muzio died, Tuzio was forbidden to return to Cyprus.

Caterina was recalled to Venice in October 1488, and she arrived at Asolo on 20 June 1489, when it was formally given to her as her dominion. She entered Asolo on 9 November to be welcomed by the people of her small principality, who bore olive branches and crowns; later in the day there was jousting in which Tuzio took part. The Costanzo family codex,[18] a collection of documents about family property, suggests that Tuzio's patronage of his chapel in San Liberale was part of his sustained attempt to satisfy the Republic that he had assumed residence in Castelfranco. The codex commences on 2 January 1488, when Tuzio acquired an important house within the walls of Castelfranco. He then began a systematic campaign to acquire properties in Castelfranco and the surrounding district until his death in 1517. Only in 1500 did Tuzio manage to satisfy the Venetian government of his intention to reside in the Trevigiana, at which time his son was finally allowed to inherit the title of Vice King of Cyprus.[19]

Sanudo's *Diaries* record Tuzio's commands during the French invasion

and the war of the League of Cambrai.[20] The most important was in 1495, when he led 160 lances under Francesco Gonzaga, General of the League, against King Charles VIII of France. Among less reputable episodes, it is said that Tuzio was employed by the Podestà of Treviso, Gerolamo Contarini, in 1499 during his feud with Bishop Bernardo de Rossi, whose features we know from Lorenzo Lotto's famous portrait.[21] It was rumoured that Contarini looked to Tuzio for support when preparing to have the bishop assassinated.[22] (Years later Tuzio's descendants were to behave badly towards Lorenzo Lotto, for they refused to pay him for a portrait of Tuzio's son.[23] The events are perhaps unconnected, for Lotto seems to have often suffered at the hands of his eccentric patrons, unlike Giorgione.) In 1509 Tuzio was governor for the Republic in the Romagna during the pontificate of Julius II, and after the siege of Novara he was praised by his adversary, Louis XII, as the finest lance in Italy. One may conclude that his military career was of note, even if undistinguished.

It can hardly have been coincidental that Tuzio established his family in Castelfranco near Asolo, since Tuzio's loyalty to Caterina was one of the reasons why he was refused permission by the Republic to inherit the title of Vice King of Cyprus. Whenever a courtly ceremony was described, Tuzio is mentioned rendering homage to his queen. Tuzio had a villa, *La Costanza*, at Riese, some four and a half miles from Caterina's *Barco*; the name of the latter villa, built c. 1490 at Altivole, signified 'paradise'.[24] There Giorgione could have come into contact with Caterina's court as her portraitist, for Vasari describes Giorgione's portrait of Caterina as being in the collection of her relative Giorgio Cornaro. The *Barco* was an early example of a Venetian villa on the *terraferma*. Little survives, but the style of the architect, Graziolo Lombardo, may be judged by his own home in Asolo, the *Casa Longobarda*, a precocious rustic masterpiece that fore-shadows Serlio.[25] Caterina's court provided the setting for one of the most celebrated Venetian Renaissance books, Pietro Bembo's *Gli Asolani*, printed by Aldus Manutius in 1505, a text which announces itself as a pictorial provocation. It has often been suggested that there is a parallel develop-ment between the bucolic landscape painting associated with Giorgione and Bembo's introduction of pastoral themes into Venetian literature and music. Giorgione's *Concert champêtre* (Fig. 37) evokes a mood of rural peace and pastoral learning as found in the opening passages of Bembo's

Asolani, a dialogue that takes place during the festivities of a marriage at Asolo. Bembo's idealized landscape, a pleasance at the border of Caterina's garden, near a lush meadow, with a cluster of trees, a fountain, and herds of sheep, is the traditional Virgilian pastoral setting, known as the *locus amoenus*, for a bucolic contest between singers and poets. The eclogue as a painted landscape was paralleled by the developing form of the sung eclogue, the madrigal. Bembo was the authority on the new sixteenth-

Right: 85. RAPHAEL. *Portrait of Pietro Bembo*. Panel. 54 x 69 cm. Far right: Attributed to TITIAN. *Cardinal Pietro Bembo*. Canvas. 57.5 x 43.5 cm. Both Budapest, Szépművészeti Múzeum.

century madrigal, defined as a short free poem not bound by a number of lines or set rhythm, but a song to be composed freely as a poet pleased.[26] Bembo's description of how to compose a madrigal is very similar to the way in which he described Giovanni Bellini's compositions to Isabella d'Este in 1506. In an often quoted letter, he wrote: '. . . the invention [*invenzione*] which you write I am to choose for the picture must be adapted to the painter's imagination [*fantasia*], for he does not care to have his composition bound by innumerable instructions [*molti signati termini*]. He is accustomed, as he says, to wander at will in his pictures [*vagare a sua voglia nelle pitture*] and is confident that in this way he can produce the best effect'.[27]

When Caterina returned to the Veneto, Marino Sanudo described her as a very beautiful woman ('donna bellissima'), a description that hardly corresponds to the sad and weary expression conveyed in Gentile Bellini's portrait now in Budapest (Fig. 88). Among Venetian women, the

queen in exile is more often portrayed than any other in her time, as in the portraits by Albrecht Dürer (Fig. 86) and Floriano Ferramola. She was a figure of fascination, especially in 1496, when we find her prominently visible among other women spectators in Bellini's *Miracle of the Holy Cross* (Fig. 87). Dürer was so taken by her image that he copied her portrait in Gentile Bellini's studio, as well as a detail of three Turks from Bellini's *Procession in St Mark's Square.*[28] Royalty in Italy was

86. ALBRECHT DÜRER. *Portrait of Caterina Cornaro.* Chalk and watercolour. 25.9 x 20.5 cm. Formerly Kunsthalle Bremen.

unknown before the seventeenth century, and to be a queen in a city like Venice was an exotic and unique phenomenon, accentuated by the romantic tragedy of the story.

What was the reality of Caterina Cornaro's court? Some have questioned whether it amounted to very much, especially when Caterina is compared to extraordinary women patrons like Isabella d'Este.[29] Furthermore, it has been shown that a painting at Attingham House, Berwick, which pretends to represent Giorgione's life at Caterina's court, is a nineteenth-century creation, a sentimental view of the life Giorgione was believed to have led, conceived with Robert Browning's poem 'Asolando' in mind.[30] But the authenticity of this picture is not the point at issue. Caterina's role was so exceptional within Renaissance society that she may not have had to do very much to inspire artists and poets. As a widow, prevented from remarrying, she seems to have taken generous pleasure in marriage festivities for younger women at her court.[31] It was such a marriage — that of Caterina's favourite lady-in-waiting Fiammetta — that inspired Bembo in 1495 to create *Gli Asolani*. There may also have been a host of minor artistic personalities in the Asolan entourage, such as those described in Tuzio Costanzo's codex, where a surprising number of artists witnessed his legal documents, including the sculptor Giorgio Lascaris, who was admired by Gauricus and assumed the name of a famous sculptor in antiquity, Pyrgoteles.[32]

One incident suggests that the Venetian government exercised

Above: 88. GENTILE BELLINI. *Portrait of Caterina Cornaro*. Panel. 63 x 49 cm. Budapest, Szépmüvészeti Múzeum.
Left: 87. GENTILE BELLINI. *Miracle of the Holy Cross*, 1500. Transferred to canvas, 323 x 430 cm.
Venice, Gallerie dell'Accademia.

some control over the magnificence of Caterina's court. On 4 December 1497, there was a fabulous festival at Brescia to welcome Caterina on her first visit to her brother, Giorgio Cornaro, then Podestà.[33] Tuzio expressed his allegiance to her symbolically with the presentation of a *bonbonnière* at dinner before the Venetian patriciate. The festivities lasted four days and were depicted by Floriano Ferramola in a fresco, now in the Victoria and Albert Museum, London. The Council of Ten's reaction was to dismiss Giorgio Cornaro from his office, fearing that he and his sister had aspirations to establish the Cornaro family as a permanent royal dynasty. In such circumstances, Caterina's court at Asolo, until her death in 1510, had to be one of public restraint. Giorgione may well have enjoyed court life at Asolo in the 1490s, before the incident at Brescia. Venetian women later attempted to emulate Caterina's architectural patronage, such as the heiress Agnesina Badoer Giustinian, who commissioned the Villa Giustinian at Roncade (1511–13) from Tullio Lombardo.[34]

SALVI BORGHERINI (1436–1515)

Borgherini patronage is an important, but as yet relatively unexplored subject, both in Venetian and Florentine art history. Giorgione's portrait of Salvi Borgherini's younger son Giovanni was commissioned when Salvi was on banking business in Venice (Fig. 89). Vasari knew Giovanni Borgherini's collection well, was friendly with the Borgherini heirs, and describes pictures in the Borgherini palace, Florence, at least several times in the *Lives*. The double portrait has been little discussed, partly because it entered the National Gallery in Washington relatively recently, and partly because a repaint still conceals what one suspects to be a genuine painting by Giorgione's hand, or what remains of one. The brush underdrawing of the ovoid shape of Giovanni's head and the astronomical instrument (more scientifically rendered in the underdrawing than on the surface) confirm that this is the picture Vasari mentioned.

'Intelligence is worthless unless the deeds that flow from it will be worthy' ('NON VALET IGENIUM NISI FACTA VALEBUNT') reads the inscription on the scroll. Giovanni's childish lack of interest in what his tutor is saying suggests that here we have a paternal commission from Salvi with

89. Attributed to GIORGIONE. *Giovanni Borgherini and his Tutor (Niccolò Leonico Tomeo)*. Canvas. 47 x 60.7 cm.
Washington, D.C., National Gallery of Art; Gift of Michael Straight, 1974.

90. *Giovanni Borgherini and his Tutor*. X-ray of the young Borgherini.

a weighty recommendation about education. The child's boredom may in fact be a realistic observation of his own contradictory personality. Later in 1529, when he had grown up and become a successful banker, he was described by the historian Benedetto Varchi as someone who loved learning, a cultivated and courteous person, but who gambled huge sums of money.[35] Giovanni grew up to commission works of art such as Andrea del Sarto's *Holy Family with the Infant St John* (Fig. 91), which has been convincingly interpreted as a political allegory of Florentine republicanism.[36] The counsel given him by his father and tutor must have included politics. The inscription on Sarto's painting, 'King of the Florentine People' ('REX POPULI FLORENTINI') is a contemporary slogan, one precisely connected to events which took place on 28 February 1528,

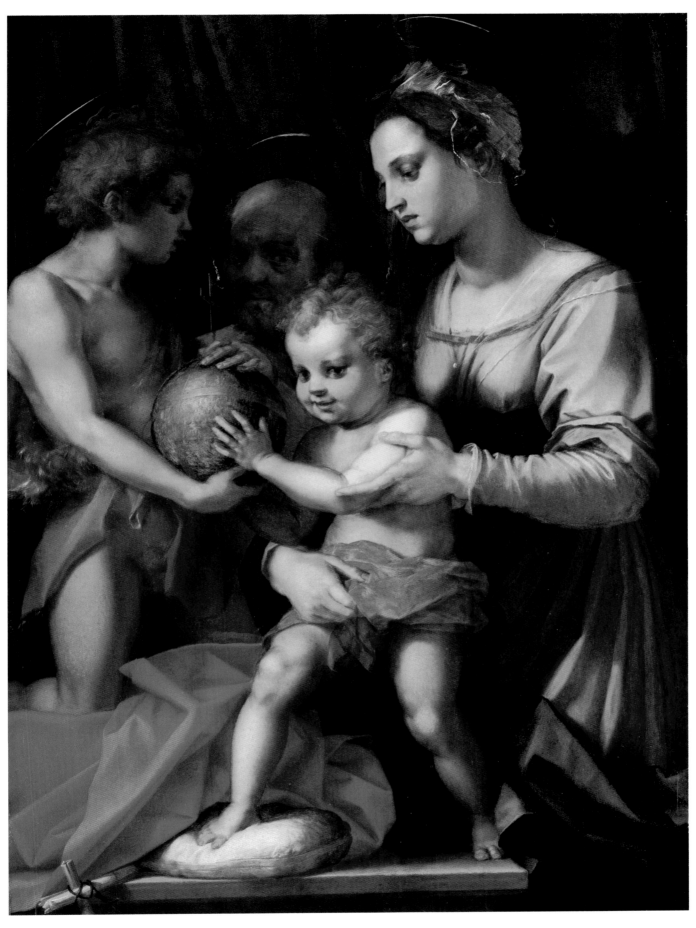

91. ANDREA DEL SARTO. *Holy Family with the Infant St John.* Oil on wood. 135.9 x 100.6 cm.
New York, The Metropolitan Museum of Art.

when Christ was proclaimed King of Florence, and became joint custodian of Florentine republicanism with St John the Baptist. It has been argued that the painting was executed in recognition of the right of republican freedom, and that the Christ Child is cast in the role of *Salvator Mundi*.

Giovanni's espousal of republicanism was well known, since he was one of the principal participants in a celebrated dialogue, Donato Giannotti's *Della Repubblica de' Veneziani*,[37] which contains the most laudatory account of the Venetian constitution and oligarchy ever written. Although printed as late as 1543, it was actually written between 1525 and 1527,[38] when, as Giannotti writes in the preface, he was called to Venice by Giovanni Borgherini 'a dare opere in compagnia sua alle buone lettere'. In 1526, Giovanni had married Selvaggia, daughter of Nicolò Capponi, with whom he had nine children. Shortly after their marriage, between 1527 and 1530, Capponi became *gonfalonier* of the Florentine Republic. At the time of the composition of the dialogue, Giovanni had written to his father-in-law, recommending Giannotti for employment as a man 'buono, virtuoso e povero',[39] and it was with this dialogue that Giannotti made his political debut.[40] Unlike his elder brother Pierfrancesco, Giovanni had demonstrated republican sympathies from his youth. In Giannotti's dialogue, Giovanni is a visitor to Venice, who asks a philosopher to explain to him the republican and Aristotelian customs of the Venetians. What is not said in the dialogue is that Borgherini is returning to a place where he had received some instruction as a child. The setting for the dialogue is the home of Pietro Bembo in Padua. Giovanni Borgherini asks Trifone to give an account of the virtues of the Venetian constitution, which he envisages as a model for Florence. At the end of the conversation, they all go to the garden, where they find their host in discourse with some gentlemen. Afterwards they proceed to Venice to meet Girolamo Quirino, who defines the Venetian magistracy; and, last but not least, they meet the greatest living Greek scholar in Venice, Niccolò Leonico Tomeo,[41] for the final exposition.[42] Leonico was the first Renaissance scholar to teach Aristotle from the original Greek text, and his fame was such that he was visited by Erasmus and other distinguished scholars when they came to Venice.

The models in Giorgione's double portrait anticipate the two protagonists in Giannotti's dialogue, where the adult Giovanni Borgherini

receives a lesson on Venetian government, as though he were a Florentine pupil of Venetian republicanism. Trifone was too young to have been Borgherini's tutor in the double portrait, but Leonico was not. In fact he could well have taught Latin and Greek to Giovanni, when the young Florentine was in Venice after 1504. Leonico was such a distinguished teacher, with a knowledge of art, that it would have been appropriate to include his portrait with one of his pupils. Born of Greek parents in Venice in 1456, Leonico studied at the *Studio* of Padua until 1504. In that year, most likely on 27 December, he assumed the classical chair at San Marco (occupied by Benedicti Brognoli until 1502) to train future lawyers in Latin and other pupils in humanist studies. Leonico taught in Venice from 1504 to 1506, presumably the years in which Giorgione's portrait was painted. A portrait of Leonico himself was made shortly before his death on 28 March 1531 on a medal attributed to Riccio (Fig. 92). The medal depicts a bald-headed old man, whereas the tutor is younger, but the resemblance is nevertheless close — the same heavy Greek features, nose, curly hair, chin, etc. Both Giovanni Borgherini and his brother were friends, bankers and correspondents of Pietro Bembo. On more than one occasion, Bembo writes to Giovanni Borgherini of their intellectual father Leonico ('nostro padre'), who continues to have a kindly regard for messer Giovanni ('M. Leonico ne tiene M. Giovanni ben conto').[43] Bembo's teasing references to the paternal figure of Leonico add weight to the hypothesis that it is Leonico who is represented as Giovanni's tutor in Giorgione's double portrait. The armillary sphere could be a reference to Leonico's scholarly interest in Ptolemy, which later reached fruition in his published translation of 1516: *Claudii Ptolemaei inerrantium stellarum significationes per Nicolaum Leonicum Thomaeum e Graeco translatae.*

It has been asked how the Borgherini could have chosen Giorgione as a portraitist, when most of his works were hidden in Venetian patrician collections. The answer may well be provided by Leonico, who seems the ideal intermediary between the Florentine bankers and the Venetian art world. For Leonico was an *amateur*, who amassed antiquities in a

92. Attributed to ANDREA RICCIO. *Portrait of Niccolò Leonico Tomeo.* Bronze medal. Diameter 5.5 cm. Milan, Castello Sforzesco.

collection described by Marcantonio Michiel, some parts of which are now in the Museo Archeologico, Venice.[44] He was a correspondent of Giulio Campagnola,[45] and appears as one of the principal interlocutors in Pomponius Gauricus' *De Sculptura* (1502).[46] Leonico was far from being merely a tutor, and would have appeared to the Borgherini as a personality in the Venetian art world. As a youth, he had had his portrait painted by Giovanni Bellini, described by Michiel ('Lo ritratto di eso M. Leonico, giovine, ora tutto cascato, inzallito et ofuscato, fu di mano di Zuan Bellini'), together with a portrait of his father by Jacopo Bellini. Masterpieces in Leonico's collection included an illustrated manuscript, the Joshua Roll, now in the Biblioteca Vaticana, and Van Eyck's much discussed, but lost, *La chasse à la loutre*.

Salvi Borgherini also commissioned the decorations for the most famous bedroom in Renaissance Florence[47] as a wedding present for his eldest son Pierfrancesco and his wife Margherita Acciaiuoli, a daughter of Roberto Acciaiuoli. Pierfrancesco was born in 1480 and married Margherita in 1515, the year the cycle is usually dated; he was buried in San Francesco, Florence, in November 1558. Michelangelo's banker and friend from about 1515 on, he also knew artists from the Michelangelo circle, such as Sebastiano del Piombo, from whom he commissioned frescoes in a chapel in San Pietro in Montorio, Rome, and Andrea del Sarto, whose *Madonna and Child*, now in the Pitti Palace, he owned. Vasari says that Granacci and some other artists had been summoned to Rome to work with Michelangelo, who had then shut them out of the Sistine Chapel, and they went back to Florence to work for Pierfrancesco. Given his character, Pierfrancesco may have expressed his views to his father about who should execute the commission for his bedroom; on the other hand, his father had quite firm views about a son's education.

Fourteen of the panels (now divided between the National Gallery in London, the Galleria Borghese in Rome, and the Uffizi and the Pitti in Florence) tell the story of Joseph with unprecedented detail, based on Genesis (46:1–6, 13–26; 47:1–14). The series was executed, according to Vasari, by Andrea del Sarto, Pontormo, Granacci and Bacchiacca, while the carpentry of the whole ensemble was attributed to Baccio d'Agnolo. A reconstruction of the decorative ensemble as bedroom furniture, and of the panels on an actual bed, has never been satisfactorily attempted.

At first sight the story appears inappropriate for a bedroom, or to celebrate a marriage, especially since Granacci's representation of *Joseph and Potiphar's Wife* is prominent. Yet Margherita is remembered for her dramatic defence of her bedroom, which occurred during the siege of Florence in 1529–30: with her husband in exile, she outwitted every attempt to appropriate the paintings in her bedroom. The story is told by Vasari, who relates that Margherita denounced Giovanni Battista della Palla, the agent of the French King François I, as a vile dealer in secondhand goods who wanted to dismantle respectable men's bedrooms.

On the banner in Pontormo's representation of Joseph's brothers begging for help is inscribed 'ECCE SALVATOR MUNDI', which identifies Joseph as a precursor of Christ. The colours of Joseph's clothes throughout the cycle are those usually worn by Christ. Was Joseph conceived as a model for the young Pierfrancesco, who, at the time of his marriage, was a young banker, recently returned from the Vatican? Without knowing as much as one would like about Pierfrancesco's relationship with his brothers when he was away, perhaps Pierfrancesco's Roman sojourn was thought comparable with Joseph's success in Egypt with Pharaoh. The most prominent, beautiful and problematic panel of the series concerns Joseph's relationship with his father Jacob, and in turn with his own son, that is, Pontormo's *Jacob and Joseph in Egypt*.

The subject was depicted in an unconventional manner and confused Vasari, as well as many later art historians. One could see the panel as a tribute to a son's economic success, and as a reminder of his filial responsibilities to his elderly father, as well as to his own sons. A patriarchal theme underlies the four episodes in this panel concerning the relation of one generation to another. On the left, Joseph presents his father Jacob, on his arrival in Egypt, to Pharaoh. To the right, Joseph, his arm on his son's shoulder, probably listens to men who demand bread in a famine and present a petition (Genesis 47:13–26). The central image shows Joseph leading one of his sons up the stairs, while another is embraced by his mother at the top. (The women at the top of the staircase and around the column wear clothes with high waists and oversleeves typical of c. 1515). This all leads to the upper right side of the panel, where Joseph presents his sons to the dying Jacob. This may suggest an invitation to the couple to conceive and educate children. One of Vasari's observations about Pontormo's panel has always been

accepted (although every commentator asks why): that represented on the stairs was the youthful Bronzino, 'allora fanciullo e suo discepolo'. Pontormo's autobiographical addition could be seen as a statement concerning his own artistic legacy in favour of an adopted apprentice son. Salvi Borgherini's patronage, whether in Florence or Rome, seems to have been remarkably consistent, with different artists and with different sons.

TADDEO CONTARINI (1466–1540)

Of the three Venetian patricians who bore the name Taddeo Contarini during Giorgione's lifetime, the one whose collection was described by Michiel in 1525 has been identified as the son of Niccolò di Andrea and Dolfinella Malipiero.[48] He was presented at his maturity to the Balla d'Oro on 15 November 1484 at the age of eighteen years. In 1495 he married Marietta Vendramin, Gabriele Vendramin's sister, at which date he probably went to live in a house belonging to the Vendramin, which had been made for him ('per lui fabrichada'), adjacent to the Vendramin palace at Santa Fosca.[49] The Vendramin also owned a house at Sant'Eufemia on the Giudecca, where their brother-in-law Taddeo went to relax, and for which he paid no rent.[50] Taddeo was a wealthy humanist merchant who borrowed books from the Marciana library, and one of his four sons, Pietro Francesco, was a philosopher who wrote a commentary on Aristotle's *Physics* and who was elected Patriarch of Aquilea (1554–55). Sanudo described Taddeo as one of the eighty richest men of Venice ('80 di primi richi di la terra'). His considerable fortune was based on maritime commerce and agriculture, for he owned real estate in the countryside around Padua and Verona, as well as many Venetian houses, and he was forced to make continual loans to the Republic of Venice. He was a relative of Doge Andrea Gritti, and participated in Gritti's investiture on 19 March 1523, together with Gabriele Vendramin. He died intestate on 11 October 1540, and was buried in Santa Maria dei Miracoli beneath a marble altar with a painting of St Jerome, which he had commissioned.[51]

Proof that this Taddeo Contarini was the collector visited by Michiel is found in an unpublished inventory of the possessions of his eldest son Dario, made between 12 and 23 November 1556 (p. 365 below).[52] The

collection appears to have remained much as he had inherited it, and it is easy to identify, in the principal reception room on the first floor, the *portego grande di sopra*, the three works by Giorgione which Michiel mentioned. 'Un quadro grande con do figure depente in piedi pusadi a do arbori et una figura de un homo sentado che sona de flauto', records the *Finding of the Infant Paris*, which survives in the Teniers copy (Fig. 93). 'Un quadro grande di tela soazado sopra il qual e depento l'inferno' is Giorgione's lost painting of *Hell with Aeneas and Anchises*. The *Three Philosophers* (Fig. 49), which Michiel described at some length ('La tela a oglio delli 3 phylosophi nel paese due ritti e uno sentado che contempla

93. DAVID TENIERS THE YOUNGER. *Finding of the Infant Paris.* Copy after a lost Giorgione. Panel. 23 x 31.5 cm. London, private collection.

li raggi solari cum nel saxo finto cusi mirabilmente, fu cominciato da Giorgio da Castelfranco et finita da Sebastiano Viniziano'), is reduced in the Contarini inventory to: 'Un altro quadro grandeto de tella soazado di nogara con tre figuri sopra'. The famous *Notte* described in the correspondence between Isabella d'Este and Taddeo Albano is surprisingly not in the inventory, nor was it mentioned by Michiel, which might suggest that one of the other two Taddeo Contarini could have been the collector or, alternatively, that it is not a Nativity, but one of the lost Giorgiones, such as 'l'inferno'.

In the first room, where the inventory began, there were several works by Giovanni Bellini. One is the Frick *St Francis*, mentioned as 'Un quadro

grande con sue soazze indorado con l'immagine di san Francesco'. The only painting described with an artist's name was Bellini's 'Un quadro fatto de man de Zuan Bellin con una figura d'una Donna', presumably the portrait of a woman mentioned by Michiel ('El quadretto della donna retratta al naturale insino alle spalle fu de mano de Zuan Bellino'), but which is difficult to identify as there are no surviving portraits of women by Giovanni Bellini. In the same room there were two profane paintings, one perhaps identifiable as Bellini's late masterpiece of a woman looking at herself in the mirror (Fig. 94): 'Un quadro grandeto con sue soazze intorndo dorado con una Donna che si [g]uarda in specchio'. Bellini's *Woman at her Toilet* has no earlier provenance than the collection of Leopold Wilhelm in the seventeenth century.[53] It has always been assumed that Bellini was commissioned to paint such a work after Giorgione's death in a style that was his version of the Giorgionesque. It should come as no surprise that one of Giorgione's patrons may have commissioned it.

Another painting in the same room may depict the *Three Graces*: 'Uno altro quadro grandeto con tre figure di donna nude con sue soazze dorade', but by whom can it have been painted, as no Venetian version of the subject is known? Michiel describes a tempera painting of horsemen by Romanino, which may be identified with the following item in the inventory: 'Un quadro vecchio strazado soazado con . . . figure a cavallo'. Did it look 'older' than other pictures because it was in tempera, as it alone is said to be an Old Master? The lengthy inventory describes other paintings, some simple images of Christ and the Virgin Mary,[54] as well as many other items of luxury clothing and linen. Even though it is difficult to identify some of the pictures today, it is impressive that in the same domestic space — reception room or bedroom — images of Christ and the Virgin were hung next to profane paintings, Bellini's Frick *St Francis* in close proximity to his *Woman at her Toilet*.

Dario owned two chests full of books and manuscripts about the humanities and philosophical subjects, unfortunately not described in detail ('Nelle altre do case libri diversi de humanita, et filosofia de grandi, et de piccoli, stampadi, et scritti a penna'). Taddeo frequented the circle of Aldus Manutius. Both Aldus' Greek editor, Marcus Musurus,[55] and Pietro Bembo knew Taddeo in connection with manuscripts that he and his son Girolamo[56] borrowed from the library bequeathed by Bessarion to the

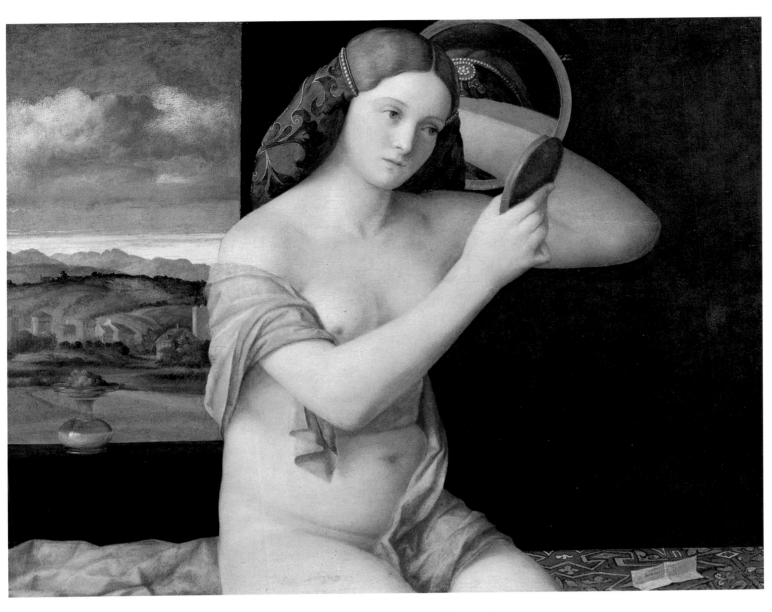

94. GIOVANNI BELLINI. *Woman at her Toilet*, 1515. Oil on panel. 62 x 79 cm.
Vienna, Kunsthistorisches Museum.

Venetian Republic, and had failed to return. On 8 May 1517, Musurus noted that Andrea Navagero (the first librarian appointed to look after Bessarion's gift) had accused him of having taken to Rome a codex of the works of Homer;[57] Musurus explained that Navagero had not lent the codex to him, but to Taddeo's son Girolamo, who presumably still had it.[58] Musurus must have been reasonably well acquainted with Taddeo and his son to remember which manuscripts they had borrowed from Bessarion's library.

In 1531, Girolamo refused to return an illustrated manuscript of Ptolemy[59] for Pietro Bembo's use, even though Bembo had requested that the head of the Procurators of San Marco force Contarini to give back the codex, but his request was refused ('quel bon gentil homo par che non si curi di renderlo'). Bembo was then forced to write to Giambattista Ramusio, Secretary to the Council of Ten, asking him to go to Taddeo's house with his son's *confesso*, the signed declaration that he had taken the book, in order to make him return it.[60] Other authors borrowed by Taddeo from Bessarion's library include Appianus (*Historia Romana*), Gallienus (*Opere*) and a manuscript of Philo Judaeus in Greek. All this evidence of the reading habits of Taddeo and his sons, their obsession with Greek and Latin manuscripts, suggests that Giorgione's *Three Philosophers* was a significant picture in a house where classical philosophical culture was a part of daily life.

For many years the interpretation of the *Three Philosophers* was coloured by the misinterpretation of the X-ray proposed by Wilde in 1932, where the three men were said to be the Three Magi, because he thought the radiographic evidence showed that the central man was black, and hence Melchior (p. 88 above) — despite Michiel's description of Taddeo's painting as representing philosophers. The theory that the figures represent the Three Magi, the most frequently discussed interpretation of the picture, was first proposed in Christian Mechel's catalogue of the Kunsthistorisches Museum and revived by Wilde. Wilde suggested that the text for the painting was the apocryphal Book of Seth,[61] a commentary on St Matthew's Gospel, which described how the Magi assembled in front of a cave to await the appearance of a star on Mons Victorialis. Inconveniently, the Book of Seth describes twelve magi rather than three.[62]

Given the intellectual interests of the Contarini family, Michiel's

suggestion that they are philosophers seems both plausible and preferable. Giorgione certainly intended to represent particular philosophers, although it may be impossible to discover their actual identities. (Similar difficulties occur with the philosophers represented by Raphael in his *School of Athens*; Plato and Aristotle are easily recognizable, but their companions less so.) The eldest of Giorgione's philosophers is dressed in a cowl, edged with blue, and holds in his hand a pair of dividers and a sheet of vellum with astronomical calculations (Fig. 95). The turbaned swarthy philosopher is dressed in red and blue with three curious jewels on his chest. The seated philosopher, whom Michiel describes as 'looking at the rays of the sun', gazes not in the direction of the sun itself, but at a patch of light above the cave. He holds in his hands a pair of dividers and a set square.

The eldest bearded philosopher holds a piece of parchment on which is drawn a large quarter moon, a circular disc with spokes, and the numbers one to seven, reminiscent of astronomical diagrams that represent lunar computation. As John North has suggested to me, the spoked disc may be a lunar volvelle, a rotating disc made from parchment or wood and used to calculate the occurrence of an eclipse. It is frequently found in astronomical manuscripts from the mid-fourteenth to the late fifteenth centuries, such as in Ms. Digby 46 in the Bodleian Library, Oxford (Fig. 96).[63] The numbers one to seven represent a quarter of the lunar calendar. Beneath the philosopher's hand some have seen a word in Greek, but it could also be interpreted as the date 1505. During a lunar eclipse, the earth is interposed between the sun and the moon, the earth's shadow falls on the body of the moon, and the moon is deprived of light from the sun. This is the key to one of the central themes of the painting, the contrast between light and darkness in relation to philosophy.[64]

A contemporary popular print, the *Astrologer* (Fig. 97), by Giorgione's imitator Giulio Campagnola, reflects in popular fashion Giorgione's composition of the *Three Philosophers*. Campagnola shows a single philosopher, with

96. Lunar volvelle. Ms. Digby 46. Oxford, Bodleian Library.

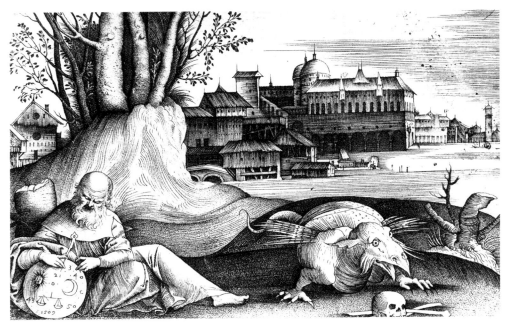

97. GIULIO CAMPAGNOLA.
The Astrologer. Engraving.
9.9 x 15.2 cm.

a pair of dividers poised above a sphere or disc, with calculations relating to the moon and sun and resembling diagrams in Sacrobosco's *Sphaera mundi* (1488), together with the date 1509. The dragon in the print is a phenomenon often seen on diagrams of lunar eclipses, which all suggests that here too is a representation of a prognostication of a lunar eclipse.[65]

The landscape of Giorgione's *Three Philosophers* is conceived as a series of contrasting patterns of light and darkness. The picture is divided between the obscurity of the cave and the world outside, lit by the rays of the rising sun. When the painting was first created, the cave was more prominent, the whole entrance having been depicted; in the eighteenth century, at least 18 centimetres were cut from the left side. The bare black trunks frame the verdant foliage bathed in sunlight around the mill, and in the foreground a mysterious golden light shines from an unknown source on the philosophers. The rising sun is a continual proof of the sun's power to create night and day, to give and take away light. A most credible interpretation proposed by Peter Meller suggests that the painting represents the education of philosophers, as described in book VII of Plato's *Republic*, in the famous allegory concerning the cave, the sun and the dividing of the line.[66] Plato's myth was occasionally illustrated in the Renaissance. An artist of the School of Fontainebleau illustrated that passage where Plato compares the most unenlightened state of existence to the condition of men born prisoners in a subterranean cave (Fig. 98). The prisoners are dressed in classical togas, their legs and necks fettered (*Republic*, 514A). They can only

look in one direction, at shadows cast on the wall by human images and animal shapes.

A more complex allegory of the *Antrum Platonicum* was made by Cornelis Cornelisz of Haarlem for the Dutch humanist H. L. Spiegel for his home at Meerhizen, where it hung as a pendant to a painting illustrating the *Tabula Cebetis*.[67] The composition survives only in a print by

98. SCHOOL OF FONTAINEBLEAU. *Allegory of Plato's Cave.* Musée de Douai.

99. After CORNELIS CORNELISZ OF HAARLEM. *Antrum Platonicum.* Engraving by Jan Saenredam, 1604.

Jan Saenredam (1604), dedicated to Spiegel's nephew Pieter Paaw (Fig. 99). At the top is a line from John 3:10: 'Light is come in to the world and men loved darkness rather than the light'; while the inscription below states that most men prefer to look at cast shadows, the appearance of truth, although the better eleven (perhaps Christ's Apostles) are in the light.[68]

Both Cornelis of Haarlem and the School of Fontainebleau artist represented part of Plato's allegory fairly literally, whereas a more poetic allusion can be found in a fifteenth-century Venetian manuscript of Petrarch's *Trionfi* (Ms. Addit. A. 15, Bodleian Library, Oxford). A miniature illustrates the opening lines of the Triumph of Death:

> *La Nocte che seguì l'orribil caso*
> *che spense il sol, anzi il ripose en cielo,*
> *on dio so qui come huom cieco rimaso* Triumphus Mortis, II

Nine monks are seated in a cave representing night and darkness, whilst above them their four companions are in various stages of spiritual contemplation. This curious Platonic elaboration was stimulated merely by the mention in Petrarch's text of the night, sun and blindness.

In these examples, which envisage Plato's myth in Christian terms, mankind only sees the shadows. This essentially pessimistic view of human existence is in contrast to Giorgione's men, who are philosophers outside the cave, where they contemplate the light. It is tempting to identify the triad as Plato, Arisototle and Pythagoras, Plato represented as an elderly bearded man, Aristotle as an Eastern, and Pythagoras as the inventor of geometry and the right angle. Together these three ages of philosophy represent a genealogy of ancient wisdom. But since representations of these men varied considerably during the Renaissance a definitive identification would be hazardous.

In Plato's *Republic*, the sun was the visible offspring and image of the Supreme Good in the world; and a philosopher's perception of it is related to two ways of seeing the sun. At the beginning of his education, Giorgione's young philosopher contemplates the visible sun and works empirically as a geometer, using models and instruments as a sort of bridge to help the mind proceed from the visible object to the intellectual reality (*Republic*, 510C–511E). At a second stage, corresponding to Giorgione's elderly sage, a philosopher can contemplate the *verus sol*, the intellectual

sun, with the inner thought of the eye of the soul (*Republic*, 529A–530B). In this final stage, the philosopher can dispense with diagrams and models, and it is noticeable that the calculations for a lunar eclipse on the diagram are torn and cancelled out. Between the philosopher-geometer's contemplation of the visible rays of the sun and the philosopher-astronomer's contemplation of the intelligible sun, there is an intermediary world governed by an intellectual sun, which is represented by the trance-like expression on the face of the Eastern philosopher. The X-ray shows that Giorgione first invented a solarian crown for the eldest philosopher, and that he was originally shown facing the sun, his eyes open.[69] The sun crown may have been eliminated because it was too prominent or archaeologically incorrect.

Within Contarini's collection there was a Christian counterpart to Giorgione's philosophical picture, Bellini's *St Francis*, painted some twenty years earlier (Fig. 100). The subject of Bellini's picture has been much debated. Michiel simply called it *St Francis in the Desert*. Millard Meiss

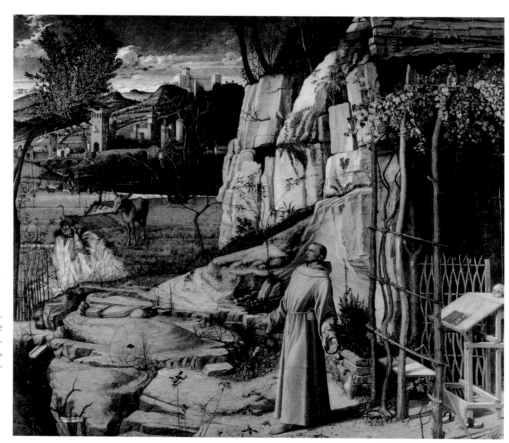

100. GIOVANNI BELLINI. *St Francis Singing the Canticle of Creation*. Oil on wood. 125 x 141 cm. New York, Frick Collection.

suggested it was a representation of *St Francis Receiving the Stigmata*,[70] although the saint is not represented as kneeling to receive the stigmata, there are no stigmata, and the seraph is omitted. These omissions, Meiss argued, are understandable because of the increasing naturalization of religious phenomena in the late fifteenth century. He also describes a rare tradition for the representation of standing figures of St Francis, for example, Bartolomeo della Gatta's *Stigmatization of St Francis* (Castiglione Fiorentino), although in this representation traditional features survive: brother Leo is present and the seraph conspicuous. In another of the examples Meiss refers to, Titian's *St Francis* at Ascoli Piceno, there is a risen Christ with rays descending from his wounds in

place of the seraph, and again Leo witnesses the event. An alternative reading was suggested by Richard Turner, who sees Bellini's picture as a representation of *St Francis Singing the Canticle of Creation*.[71] St Francis has a sheet of paper in his girdle, perhaps even to be identified as the text of the canticle, and he seems to be singing to the heavens. Meiss considered this possibility, but rejected it on the grounds that such a subject was unknown. I should like to bring one new item of evidence to the debate. A black cowled friar singing on the title page of Franchino Gafforio's *Practica musicæ* (Venice, 1512; Fig. 101) shows the gesture in which a friar sings, his arms spread wide and mouth open, the same gesture which Bellini used for his representation of St Francis singing, exulting in the discovery of the mystical communion between God and nature. St Francis deemed that the sun was fairer than all other created things and often likened it to Christ, who in Scripture is called the 'Sun of Righteousness' and for that reason St Francis called his canticle 'The Song of Brother Sun'.[72]

101. Woodcut of friars singing, from FRANCHINO GAFFORIO, *Practica musicæ*, Venice, 28 July 1512.

The existence of two pictures with solarian imagery in the Contarini collection suggests patronage of a philosophical kind. A family who owned and read philosophical texts, was acquainted with Musurus, then editing the first edition of Plato's works for the Aldine Press, is all consistent with Michiel's assertion that the *Three Philosophers* is a painting about philosophy — to which I would add Platonic philosophy in the dawn of a new Renaissance.

GABRIELE VENDRAMIN (1484–1552)

Of all Giorgione's patrons, Gabriele Vendramin is the most discussed,

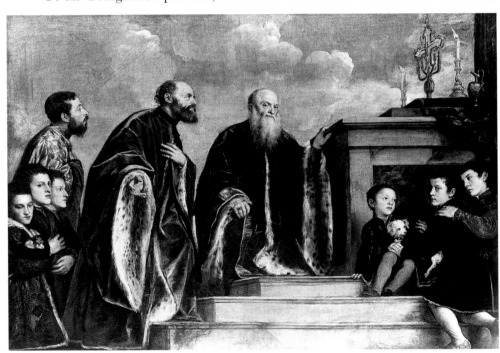

102. TITIAN.
The Vendramin Family, c. 1547.
Canvas. 206 x 301 cm.
London, National Gallery.

because he owned one of the greatest and most varied collections in Renaissance Venice, including the *Tempesta*, and left in his will the most individual testimony of any Venetian collector of the period about the personal and intellectual value of his collection.[73] Gabriele is depicted in a family portrait by Titian, together with his brothers and nephews (Fig. 102). The portrait was described as in Gabriele's *studiolo* in the Vendramin palace at Santa Fosca (Fig. 103) in an early inventory made by Titian's son Orazio Vecellio and Jacopo Tintoretto: 'a big painting in which is portrayed the miraculous cross with Andrea Vendramin with his seven sons and Gabriele Vendramin'.[74] Gabriele was not the eldest son, nor was

he ever married, but as the only surviving uncle he is depicted in the family portrait of c. 1547. Gabriele's portrait has frequently been identified as that of the oldest bearded man, close to the crystal cross, but it would be more judicious to identify him as the standing procurator dressed in rich velvet robes lined with ermine,[75] his hand outstretched to his collection below. The description of the portrait in the inventory begins with Andrea, the head of the family, followed by Andrea's sons, and then Gabriele, three years younger than his brother.

Andrea (1481–1542) had seven sons and four daughters — the latter omitted from the portrait, but not from their father's will, where he expresses his concern that some were married, while others were not.[76] The eldest son, Leonardo (1523–1547), is behind his father and uncle, while his six younger brothers, Luca (1528–1601), Francesco (1529–1547), Bartolomeo (1530–1584), Giovanni (1532–1583), Filippo (1534–1618) and Federigo (1535–1583), are portrayed as rather restless children in the foreground. Perhaps the death of both Francesco and Leonardo in 1547 prompted Gabriele to commission the work. They were to inherit Gabriele's collection, and they squandered their inheritance on gambling

103. Vendramin palace, Santa Fosca, Venice.

and frquenting courtesans, finally selling the collection piecemeal, against Gabriele's instructions. The Vendramin are represented venerating a reliquary of the True Cross, which had played an important part in their family's history in the fourteenth century. In 1360 the reliquary had been presented to Andrea Vendramin, then *guardiano* of the Scuola di San Giovanni Evangelista, by Philippe de Maizières, Chancellor of the Kingdom of Cyprus, who in turn had received the relic from the Patriarch of Constantinople, an event commemorated in a picture painted by Lazzaro Bastiani in 1494.[77] Five years after Andrea had received it on behalf of the Scuola, the reliquary was dropped into the canal while a procession was crossing a bridge. Several members of the confraternity tried to rescue the precious object, but it eluded their grasp. Then Andrea Vendramin jumped into the water and was allowed to rescue the miraculous cross by divine

intervention. The incident was commemorated in a notable painting by Gentile Bellini (Fig. 87). In their commission to Titian, the members of the family chose to be represented adoring the reliquary, not only in deference to their ancestor, but also to invoke continual protection for their interests.[78]

Gabriele was the son of Lunardo Vendramin and Isabella Loredan. In 1495 his sister Marietta married Taddeo Contarini, who came to live in a house adjacent to the Vendramin palace at Santa Fosca. Contarini's presence can only have stimulated the young man. Gabriele participated in the cultural life of Venice in a palace that was frequented by other patricians, and we can hypothesize, following Vasari, that Giorgione came to sing and play in meetings of a Compagnia della Calza. At his majority, Gabriele was presented to the Balla d'Oro by Bernardo Bembo (father of Pietro) and Ermolao Barbaro, his cousin, the famous humanist. Documents reveal that Gabriele was also in contact with other Venetian collectors, especially those who owned works by Giorgione. According to Michiel, he gave to Antonio Pasqualigo the (Hellenistic?) marble head of a woman with an open mouth ('la testa marmorea di Donna che tien la bocca aperta') in exchange for an ancient marble torso ('torso marmoreo antico'). Michiele Contarini, who lived at San Marcilian, in close proximity to Santa Fosca, mentions Gabriele in a codicil to his testament of 24 May 1550 as a most dear relative and patron ('carissimo patron et compare'), to whom he leaves some marble sculptures, including a faun, and fifteen carpets to repay a debt.[79] Although a younger unmarried brother, Gabriele occupied some distinguished positions in Venetian government, especially at the end of his life, when he was Censor and Consigliere della Città. He was occupied in the lucrative family soap business and owned numerous estates, including some in the Padovano 'sul Piovego', and the Castello di San Martino, near Cervarese, a point of some interest since the coat-of-arms of the Paduan patrons of Petrarch, the Carrara family, is represented on the *Tempesta*.

In Gabriele's lifetime, his collection was highly praised by his contemporaries in guidebooks, especially by the witty and irreverent journalist Anton Francesco Doni, who, as early as 1549, in his *Disegno*, lists the most important works of art to be seen in Venice (p. 363 below): pictures by Giorgione, four divine horses on San Marco, history painting by Titian in the Palazzo Ducale, a frescoed facade by Pordenone on a palace on the

Grand Canal, and Dürer's *San Bartolomeo Altarpiece*. Doni also mentions the *studioli* of Pietro Bembo and of Gabriele Vendramin, by whom he says he is employed ('al quale io son servidore'). Such a reference suggests that the Vendramin collection was accessible to a cultivated *amateur* and that Doni, a man who had escaped from an ecclesiastical career and had led a varied life, was an adviser or curator at some stage. This impression is reinforced by Sansovino's guidebooks to Venice, where he refers to Gabriele's collection as among the most remarkable, first in relation to his drawings in *Delle cose notabili in Venezia* (1565), and then in his *Città nobilissima* (1581; p. 368 below), where he refers to pictures by Giorgione, Giovanni Bellini, Titian, Michelangelo and others in Gabriele's *studiolo*.

Doni's dialogues concerning sculpture, *I Marmi*, were set in the Piazza del Duomo, Florence, and in Vendramin's palace at Santa Fosca. Published in 1552, the year of Gabriele's death, Doni included a portrait which was almost an obituary: 'Gabriele Vendramin, a Venetian gentleman, is truly courteous, naturally noble, and wonderfully intelligent, has fine manners and is a paragon of virtue. Once I was in his treasury of stunning antiquities, and among his divine drawings, which his magnificence has gathered together with expense, effort and genius. We went to see his rare assembled antiques, and among many things he showed me a cupid on a lion. We discussed at great length the beautiful invention, and finally praised it for the fact that love triumphs over great ferocity and awesomeness [*terribilità*] in people'.[80] Doni may have recorded an actual conversation with Gabriele, as one of the inventories of the Vendramin collection describes an ancient bronze that could have provoked Gabriele's discourse on the power of love to tame savageness, a bronze of a cupid who crushes a lion by clinging to his head.[81] Doni also referred to Gabriele's collection in *Il Petrarca di Doni* (1564), his work on pictorial inventions based on Petrarchan triumphs. Here he describes a cameo in Gabriele's studio of an elaborate allegory of fortune, so complex that it would appear to be too exaggerated even for a sixteenth-century cameo.[82] Gabriele's conversations may have been recorded more often than we realize in Doni's engaging writings, for, as Doni warned his friends, his books would be read before they were written, and printed before they were conceived.

Gabriele himself does not appear to have published under his own name, although he is recorded in October 1545 as having versified Aretino's *Vita di San Tommaso*.[83] But there were numerous occasions when Gabriel's

judgements concerning works of art were publicly recognized. In 1539, he was asked, together with Jacopo Sansovino, to evaluate the figural decoration by Jacopo Fontana and Danese Cattaneo for Sebastiano Serlio's altar in the church of the Madonna di Galliera, Bologna.[84] During his lifetime, he was praised by Serlio as an authority on ancient Roman building and on Vitruvius.[85] Michiel described his painting collection, but other contemporaries were more impressed by his vast collection of antique sculpture and coins, which were cited in early publications on numismatics by Hubrecht Goltz and Enea Vico.[86] Only one item is identifiable today, a bronze sestertius, the largest coin of Emperor Pertinax, whose coins were rare because he only reigned for three months (Fig. 104). Pertinax became emperor on 28 March 193, and was murdered by the Praetorian Guard, who then put the Empire up for auction. With such a short reign, his

104. Bronze sestertius of the Emperor Pertinax that belonged to Gabriel Vendramin.

coins were sought by many collectors, and Vico mentions that specimens of this rare sestertius were owned by Gabriele Vendramin, as well as by Pietro Bembo, Andrea Averoldo of Brescia and by the Paduan Marc'Antonio Massimo.

In his much cited will of 3 January 1548, Gabriele left most of his estate to his nephews, and was concerned with their moral welfare and education.[87] He advised them to love their homeland, to be law abiding, but above all to be engaged in three activities: navigation and the navy, humanistic studies (which were never to be abandoned), and commerce. Such pedagogical instructions may inform the novelty of Giorgione's *Education of the Young Marcus Aurelius* (Figs. 105, 106), which is an unusual

subject about the education of a future emperor and his philosophical and humanistic apprenticeship with the stoic Apollonius of Chalcedon.[88] According to the *Historia Augustae* (Marcus Antoninus, II–III), the young Marcus Aurelius was the archetypal stoic swat, just the kind of role model Gabriele would have wished for his nephews.

Gabriele's life exemplified the virtues described in Ermolao Barbaro's treatise, *De coelibatu* (c. 1472). Barbaro justified the life of a celibate bachelor-scholar as an alternative to that of the patrician father. This hierarchy was opposed to the classic account in *De re uxuoria*, written by his ancestor Francesco Barbaro in 1415–16, which showed how Venetian families were subject to government and their individual members to fatherly direction. Ermolao believed that personal fulfilment would be attained in a life devoted to classical learning; one might add that for Gabriele personal fulfilment was to be found in his classical collection. In Venetian Renaissance society, Gabriele was a patrician bachelor, or unmarried patriarch.[89] Nearly half the male nobles who reached adulthood in fifteenth-century Venice appear to have remained bachelors, a much higher statistic than elsewhere in Italy. Bachelors occupied at least a fifth of the offices in the Venetian government, and they characteristically — like Gabriele — directed their beneficence to their families.

The few documents concerning Gabriele's life are revealing in relation to the most discussed question in Giorgione studies, the identity of the figures in the *Tempesta* (Fig. 108). Despite a vast number of readings, no single analysis has stood the test of time, least of all that of Marcantonio Michiel, for his 'gypsy woman with a soldier' appear to resemble no others of this type (see p. 60 above). Despite the rarity of the word 'cingana' ('gypsy') in the Italian language at that date, in Venetian dialect one of the meanings of the expression 'to look like a gypsy' ('el me par cingano'), is to have one's hair rumpled or disarranged ('essere scapigliato, rabbuffato ne' capelli').[90] Could Michiel's description of the woman as a gypsy be an ironic observation about her disarrayed hair?

Some art historians, like Sandra Moschini Marconi,[91] who were more concerned with the analysis of technique than with iconography, recognized that the male figure on the left side was dressed like a *compagno* of the Confraternity of the Sock, the Compagnia della Calza (Fig. 107), his stockings being in red and white, even though this is slightly obscured as his left leg is in shadow. *Compagni* were also represented on the Merceria

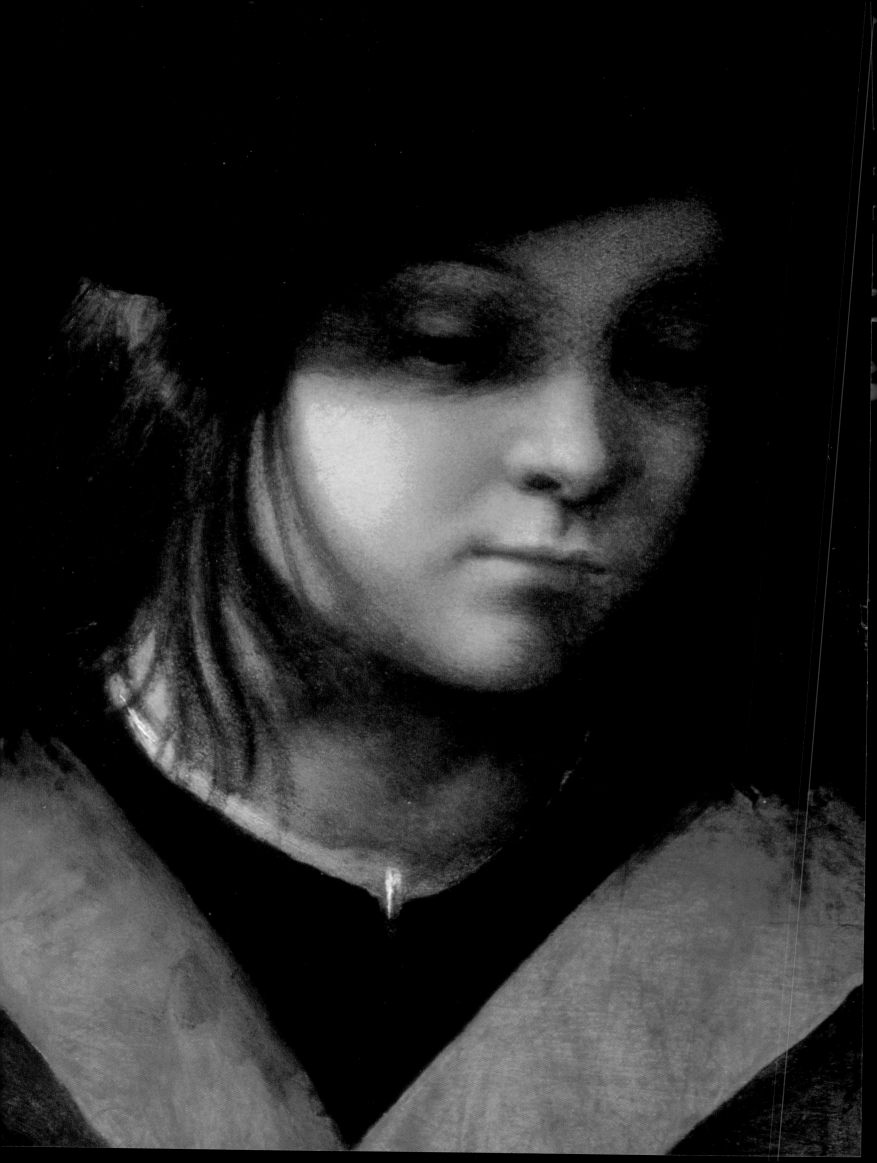

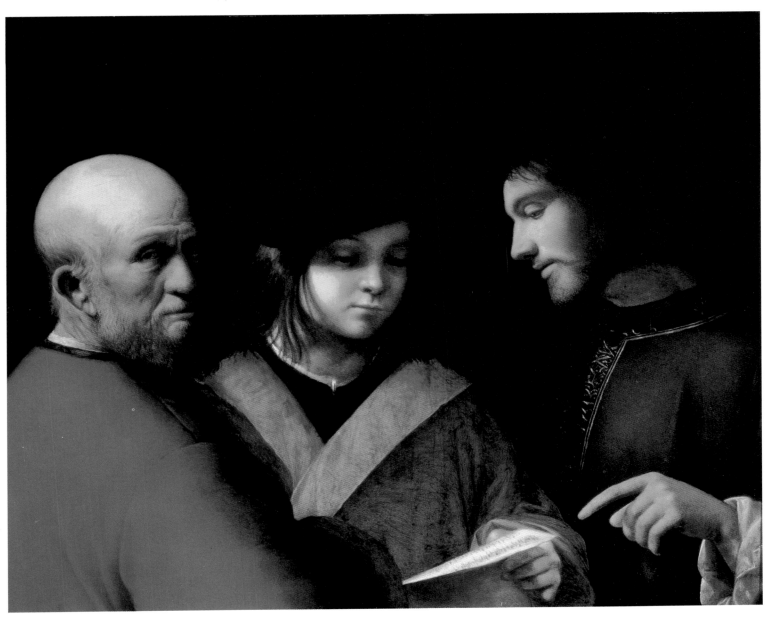

Above: 106. GIORGIONE. *Education of the Young Marcus Aurelius (Three Ages of Man)*. Panel. 62 x 77 cm. Florence, Palazzo Pitti.
Left: 105. GIORGIONE. *Education of the Young Marcus Aurelius (Three Ages of Man)*. Detail.

facade of the Fondaco dei Tedeschi. The Compagnie della Calza were special clubs for young unmarried men, who organized feasts, banquets, and plays, often of an erotic kind, in which young boys took the parts of women.[92] The subject matter of Venetian theatre was often secular, and praised the virtues of rural life, a practice to some degree paralleled in Giorgione's secular *poesie*. The emotional division between the man and

107. GIORGIONE. *The Tempesta*. Detail.

the woman in the *Tempesta*, emphasized by the stream that divides them permanently, might be taken to indicate a division between a male spectator-actor and a divine presence, or theatrical image. More than anything else, the *Hypnerotomachia Poliphili* represented the changing conception of women and of erotic love in Venetian society in this period, and by far the most convincing interpretation of the *Tempesta* is that it represents the young hero Poliphilo when he encounters a deity in his search for antiquity.

Saxl was the first writer to associate Giorgione's picture with the antiquarian dream of Poliphilo,[93] a comparison developed in much greater depth by Stefanini.[94] Several analogies can be found between the imagery described in the *Hypnerotomachia* and the *Tempesta* — the broken columns, the miraculous appearance of Venus suckling Cupid, and the fantastic architecture (Fig. 109). X-radiography shows that the columns were first conceived twice as high in the underdrawing. The column is especially significant as it alludes to the surname of the author of the *Hypnerotomachia* — Colonna.[95] In an acrostic made of the chapter initials of the book, it is stated that 'Fra Francesco Colonna was Polia's

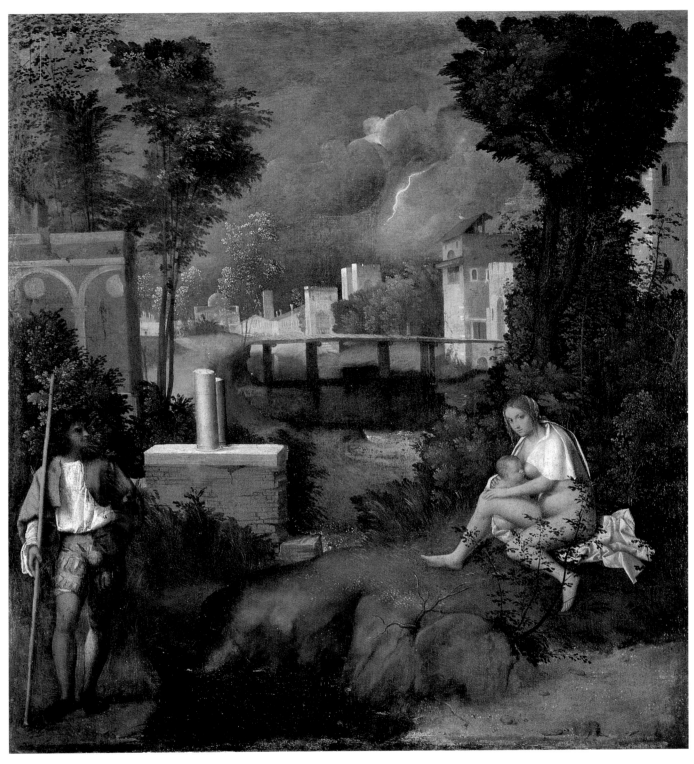

108. GIORGIONE. *The Tempesta*. Oil on canvas. 82 x 73 cm. Venice, Gallerie dell'Accademia.

lover'. Polia's name is derived from the Greek *polios*, meaning hoary with age, a clear indication that Poliphilo's search for Polia was also a quest for antiquity. Polia becomes herself an antique object, a column, which Poliphilo refers to as 'Mia firmissima columna et colume pila et sublica constantissima'. Polia refers to Poliphilo as the robust column of her life — 'tu sei quella solida columna et columne della vita mia' — when, in an ecstasy of passion, she finally embraces him. On another occasion Poliphilo finds two superb columns in ruins ('due magne et superbe columne fino alla sua crepitudine di scabricie di ruina sepulte'). The image of lovers as columns freqently occurs in Petrarch's poetry as a metaphor for Petrarch's love for Laura, as in his *Triumph of Death*:

> *Quella leggiadra e gloriosa donna*
> *Ch'è oggi ignudo spirito e poca terra*
> *E fu già di valor alta colonna.*

Poliphilo's search for antiquity leads him to discover the religion of Venus, goddess of the generative forces of nature. Significantly, a woodcut in the *Hypnerotomachia Poliphili* representing *Venus genetrix* also informed Giorgione's Dresden *Venus* (Fig. 139). Poliphilo discovers Venus feeding her infant son Cupid with tears. In the *Tempesta* as in the *Concert Champêtre*, there is an emotional divide between the sexes, emphasized by the distance in the landscape between them. The miraculous appearance of a deity was a common *topos* in allegorical romances, and usually the occasion for imparting good advice to the hero, as in Boccaccio's novel *L'Ameto*, where Venus appears to the hero, rather like she does to Poliphilo, nude but with a little piece of drapery on her shoulders: ('Ella era nuda, benché piccola parte del corpo fosse da sottilissimo velo purpureo coperta, con nuovi ravvolgimenti sopra il sinistro omero ricadenti su doppia piega'.)

109. GIORGIONE.
The Tempesta.
Detail of Fig. 108.

The curious mixture of classical towers and Venetian rural buildings in the background of the *Tempesta* seems to illustrate the *Orto del destino* of Poliphilo's dream. When Gabriele commissioned the *Tempesta* from Giorgione, he must have been inspired by his reading of the newly published romance, which was exactly the sort of text Gabriele would have understood as a young man in search of antiquity and the meaning of Vitruvius. At the end of his third book on architecture, Serlio wrote that there was no man more charmed by the ruins of ancient Roman buildings, nor more impressed by the soundness of Vitruvius' doctrines

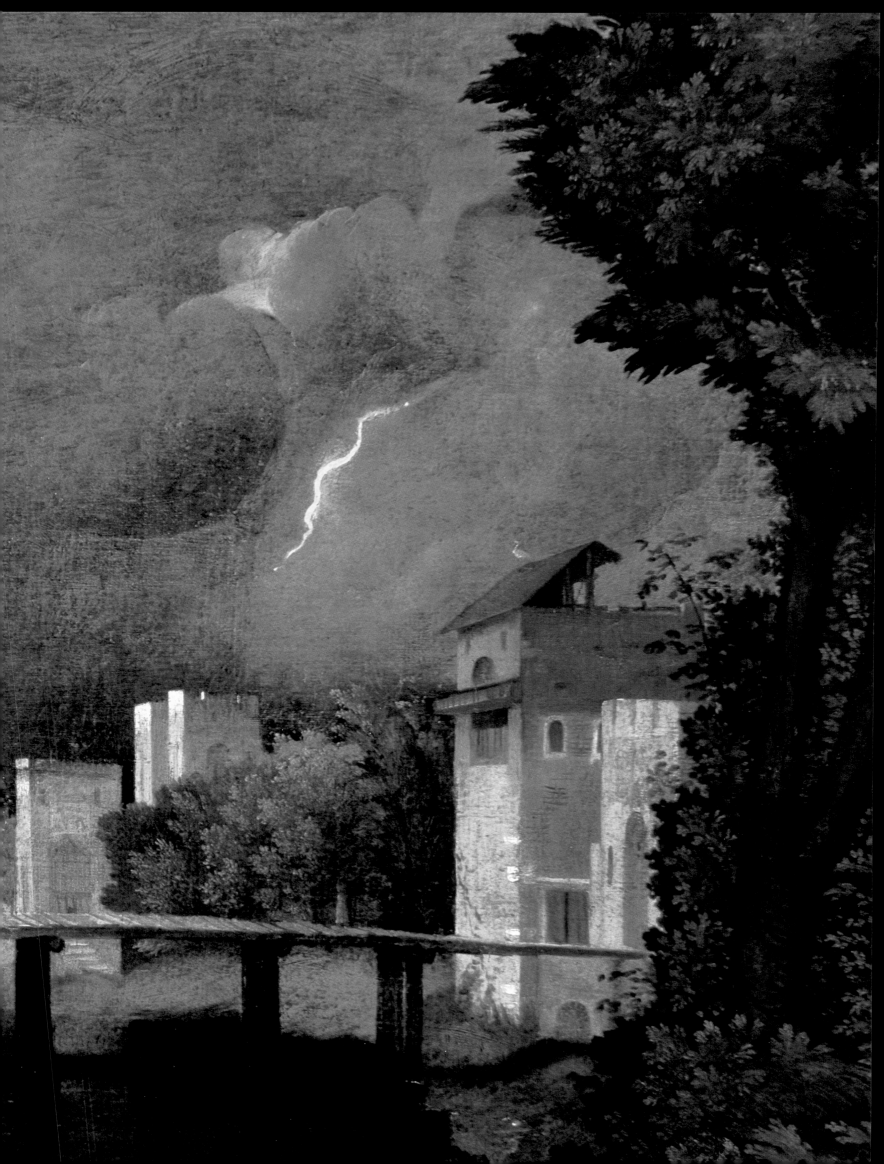

than Gabriele Vendramin, who was a severe critic of irregular classical architecture.

Gabriel possessed other works by Giorgione, notably *La Vecchia* (Fig. 110), which originally had a painted cover with a representation of a man with a fur coat, since lost. In all descriptions of Giorgione's image of female senility, the elderly woman is described as the mother of the artist, and to have owned such a work the collector would have known the artist. A further proof of their acquaintance is revealed by Gabriele's ownership of a variation of the St George in the *Castelfranco Altarpiece* (p. 330 below), even though the *Castelfranco Altarpiece* does not seem to have been imitated much. The saint in armour is heavily repainted, so it is difficult to argue an attribution, but Gabriele presumably commissioned the replica. Other works described as by Giorgione in the collection have not been identified.

Gabriele owned a number of Flemish paintings, only one of which can be identified with certainty, the diptych attributed to Mabuse (Galleria Doria Pamphilj, Rome). The left wing is a copy after Jan van Eyck's *Virgin in the Church* in Berlin, and the right wing shows St Anthony with a kneeling donor. Michiel attributed it to Rogier van der Weyden. It appears in the 1569 Vendramin inventory, but not in 1601, even though it is later described in the collection of Renieri, where the main panel is correctly attributed to Mabuse, and the right wing to Heinrich Aldegrever.

Self-portraits of artists constituted another nucleus of Gabriel's collection. He owned a coloured drawing by Parmigianino, a painted self-portrait by Giovanni Bellini, a portrait drawing by Raphael, a portrait of Dürer (now identified as a portrait of a man by Dürer, Palazzo Rosso, Genoa), and one of Titian. These last three portraits were eventually acquired by Renieri. Gabriele also had a great drawing collection, including one of the famous albums by Jacopo Bellini as well as Central Italian drawings, all of which he kept in large albums.

The inventories of the Vendramin collection were so detailed that the interior architecture of Gabriele's *camerino* in the Vendramin palace at Santa Fosca may be reconstructed. It was a large, high room (7.6 x 5.4 m) on the *piano nobile*, overlooking the canal. The room must have been dominated by Titian's *Vendramin Family* portrait. There were five other paintings in the room, including Giorgione's three singing heads,

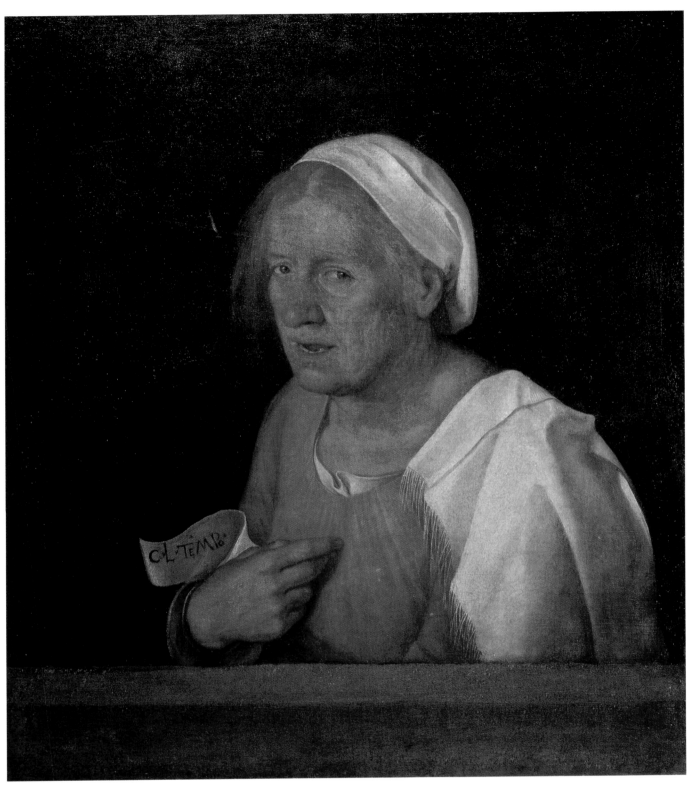

110. GIORGIONE. *Portrait of an Old Woman (La Vecchia or Col Tempo)*. Board transferred to canvas. 68 x 59 cm.
Venice, Gallerie dell'Accademia.

a portrait by Palma Vecchio, and a Madonna with St Margaret and St John. The room contained a vast collection of objects, mostly antique, and the location of each object is described in the inventory. Above the cornice (*soazon*) there were over thirty busts and vases, as well as a deer and a rhinoceros with a bent horn. The *soazon* had *timpani* painted by Titian. There was a frieze with twelve metopes. Sixteen antique statues and busts were above the bases (of columns?). There were thirty-six busts and torsos in the room. Eighteen tabernacles (*capitelli*) on the sides contained small objects — bronzes, pewters, bas-reliefs, fragments of marble statues, lamps and vases, medals, an animal's tooth and two horns. Thirty-two other objects — small torsos, masks, figures, and a tiny picture — were on the bases of the cupboards below, and in the cupboards there were books, medals, painted and carved boxes, small pictures by Titian, Mantegna, and seven by Giovanni Bellini, and drawings and prints by Dürer, Mantegna, Raphael and Giulio Campagnola. Drawers below contained other small objects, including three small pictures, two by Bellini, and a chiaroscuro painting with two figures by Giorgione. Between the cupboards were cases full of porcelain, terracotta and bronze vases. Cases in the middle of the room contained hundreds of medals and coins.

There was not enough for all the paintings in the *camerino* itself; they were in adjacent rooms. In 'the most beautiful room', the *camera per notar*, adjacent to the *camerino*, there were over twenty pictures, and this room was presumably the principal picture gallery. There were five works by Giorgione — the *Tempesta*, *La Vecchia*, a small painting with three heads, a portrait head with an iron goleta, and a Madonna; also a self-portrait by Dürer, a Raphael portrait, a Vivarini, and a woman by Palma Vecchio.

In his testament, Gabriele described the extent of his vast collection of paintings — all by excellent artists and of great value — of drawings, engravings, woodcuts, ancient marbles and bronzes, heads, torsos, Greek vases, ancient and modern coins, a unicorn's horn and other rarities. To his nephews and heirs, the five surviving sons of his brother Andrea, he stipulated that the collection remain intact for some future member of the family who shared his passion and that an inventory be made immediately after his death. Some of Gabriele's recommendations to his nephews — urging them, for instance, to keep a check on their appetites and to

live quietly — suggest that he feared the worst. When Gabriele died in 1552 his nephews divided their rich inheritance of real estate, money and the family soap business, the source of their fortune, but the collection remained in the celebrated *camerino* and the adjoining rooms of the family palace at Santa Fosca, specifically, the part of the palace inherited by the eldest nephew, Luca.[96]

In 1565 relations between the brothers deteriorated when Federigo learned from his friend Alessandro Contarini that Luca was secretly selling some of the antique coins and drawings to dealers in Venice. The younger brothers then instituted legal proceedings against Luca, and demanded that an inventory be made of the collection as Gabriele had instructed. Their real intention does not seem to have been to preserve the collection, but to sell it to Albrecht V of Bavaria, who was creating a new *antiquarium* in Munich. Albrecht employed agents, including Jacopo Strada and Niccolò Stoppio, to ferret out collections that were for sale, to bring pressure on collectors or their heirs, to make inventories, and to have the collections sent to Munich. On 14 June 1567, Strada wrote to Albrecht from Mantua, alerting him that the collection was for sale, and again, some days later, to say that inventories were being made.[97] When in Venice in August, he reported that the Vendramin were no longer in a position to sell, being prevented by Gabriele's will. Nevertheless, between 1567 and 1569, the younger brothers Federigo and Filippo had inventories made in an attempt to sell the collection to Albrecht of Bavaria, while their brother Luca, in whose part of the palace the *camerino* was located, tried to sell items individually on his own behalf. Some thirty-six paintings were described by Jacopo Tintoretto and Titian's son Orazio Vecellio over six days, while the antiquities were described by Alessandro Vittoria, Sansovino and Tomaso de Lugano.[98]

Although the inventories were completed and Albrecht's agents wished to buy the collection, each side of the family blocked the other. After Luca's death on 19 December 1601, another inventory was made by notaries, rather than artists, with measurements, which gave further descriptions of the collection.[99] In 1615, Scamozzi remarked that the collection was one of the most remarkable still in Venice, but was kept under lock and key, until someone in the family would take pleasure in it.[100] Some of the paintings are recorded in 1666 in the collection of Niccolò Renieri, by which time the Vendramin inheritance must have been broken up.[101]

■

CARDINAL DOMENICO GRIMANI (1461–1523)

Of all Venetian sixteenth-century patrons, Domenico Grimani is the most celebrated because his sculpture collection, a bequest to the city of Venice, is permanently visible in the Museo Archeologico.[102] In the last year of his life, he was incurably ill and composed a will in which he wished to be remembered by the collection that he had formed. He left to the city a public museum, with not only the marbles, but also paintings, precious stones, and the famous Breviary. He was a complex and fascinating personality, who moved between the worlds of the Roman Curia and the Venetian patriarchy with consummate ease, whether he was involved in diplomatic politics or in the culture of humanism.[103] His father, Antonio Grimani, was born a patrician, but in some ways was a self-made man, having created a fortune with enviable rapidity. Antonio became one of the most respected senators of the Venetian Republic, not only for his wealth, but also for his wisdom and learning. Domenico was created a cardinal by Alexander VI in 1493, and four years later was elected Patriarch of Aquilea. Among his many benefices was the Duomo at Castelfranco, for which Giorgione's altarpiece was commissioned.[104]

In 1499 the family suffered disgrace when Antonio Grimani, then captain-general of a large Venetian fleet engaged in a significant naval battle against the Ottoman Turks, lost the battle badly; in 1500 he was imprisoned on a remote Dalmatian island for cowardice, having been made a scapegoat for the Venetian defeat. Domenico returned incognito to Venice from Rome and helped his father escape; they went back to Rome, where together they built the famous Grimani villa on the Quirinale. Cardinal Domenico's principal Roman residence was the Palazzo Venezia. In the excavations for the villa on the Quirinale, much ancient sculpture was discovered, including colossal statues of Marcus Agrippa and Augustus, which went into the Grimani collection at the Palazzo Venezia. On 5 May 1505, Sanudo mentions that Girolamo Donato and other Venetian ambassadors to the papal court were received in a room against the background of a great collection of Roman antiquities.

At the time of the war of the League of Cambrai (December 1508– July 1509), Antonio and Cardinal Domenico were loyal ambassadors to Venice in Rome, for which reason Antonio was able to return triumphantly to Venice. On at least two occasions, the Venetians hoped that Domenico would become pope — at the time of the elections of Julius II and Leo

X — but his greatest disadvantage in the Roman College of Cardinals was that he was a Venetian. In 1521, Antonio was made Doge of Venice at the age of eighty-seven.

Cardinal Domenico enjoyed the friendship of humanists such as Pietro Bembo, Francesco da Diaceto, Lorenzo de' Medici, Poliziano, Guido Steuchus and, most of all, Pico della Mirandola. He assembled a great library, which in 1498 he enriched with the acquisition of Pico's own library. At Domenico's death, it was bequeathed to the convent of Sant'Antonio in Castello, but it was destroyed in a fire in the seventeenth century, for which reason this important bequest to Venice, primarily of Platonic manuscripts, has been strangely forgotten. Erasmus of Rotterdam met Domenico Grimani in 1509 when he was travelling across Italy, and later in 1517 Erasmus dedicated his paraphrase of St Paul's Epistle to the Romans to Domenico. Erasmus recorded his visit to the Grimani palace in Rome in a memorable letter to Guido Steuchus, written on 27 March 1531, from Freiburg.[105] Like Sanudo's description of the impact that the Roman sculpture made on Venetian ambassadors in 1505, at a period when Antonio was in disgrace, Erasmus' letter suggests that the Grimani collection, together with an incomparable library, had a political point — that it was an impressive installation in which to convince ambassadors of the humanistic virtues of those who possessed them.

Domenico's picture gallery, and what he may have owned by Giorgione, is more difficult to establish than his political career or his relations with humanists. This is partly because we have to reconstruct his collections through the collections of his nephews, Marino and Giovanni, who both inherited works from their uncle, but who were also impressive patrons themselves. In 1521 Marcantonio Michiel described some of Domenico Grimani's collection, then in his house at Venice, and was only impressed by paintings by Northern artists, Bosch (now in the Palazzo Ducale, Venice) and Memling.[106] Michiel, as we have noted with other collections, only described a selection of what Domenico owned. When describing the collection of Zuanantonio Venier in 1528, Michiel also mentioned that Domenico possessed a large Raphael cartoon of the *Conversion of St Paul*, one which we know was made in preparation for the tapestries in the Sistine Chapel, and would have been the only one to have returned from Flanders. Domenico must have known Raphael to have owned such an object, and it is later recorded in Marino's collection.

In June 1523, Domenico attempted to commission something from Michelangelo, no matter what, irrespective of the price, as he longed to have something from the master's hand, either a little picture for his *studiolo* ('quadretto per uno studiolo'), or a sculpture, or a 'fantasia'.[107] In July of the same year, the cardinal's agent continued to insist and, finally, Domenico wrote to Michelangelo on 11 July, reminding him of his promise to send him a little painting for his *studiolo*.[108] That Michelangelo may have made something for Domenico before the cardinal's death on 27 August 1523, or given him something from an earlier period, is suggested by a notice in Sanudo. On 2 February 1526, when the doge made his annual visit to the church of Santa Maria Formosa, the diarist described among the decorations for the festival a number of paintings and other precious works on loan from the heirs of Cardinal Domenico Grimani, the paternal family palace being in close proximity. They included very beautiful paintings made by Michelangelo in Rome, and bronze busts of the cardinal and his father Antonio.[109] Which of the rare pictures by Michelangelo might have been seen by Sanudo is impossible to say, and they seem to have been ignored in the Michelangelo literature.[110]

No complete inventories exist of the Grimani collection from Domenico's lifetime and even its location or locations are unclear, but much of his collection was left in the safe keeping of the nuns at the monastery of Santa Chiara, Murano. In his will of 16 August 1523, Domenico mentions a number of treasures, including an image of St Jerome by Bellini, which he bequeaths to a bishop. He left the small antiquities to his nephew Marino. To his brother Vincenzo, he left 4,000 ducats and some very beautiful paintings ('certi bellissimi quadri'). One suspects that important pieces may have gone back and forth between Rome and Venice to furnish rooms of state. A summary inventory of Domenico's possessions in 1523 records 'un quadretto de un garzon de man italiana, in una cassetta', which could be the head of the beautiful boy ('testa del putto'), later described by Vasari.

Domenico's *quadreria* was in part inherited by Marino, and described in an inventory which Marino made himself when he left for Rome at the time of his election to a cardinalship in 1528.[111] At that time, many important paintings were in Venice. In a case with twenty paintings, there were three works by Giorgione, the famous *Self-Portrait as David* (Fig. 34) the head of a young boy ('testa di putto'), sometimes identified as one of

the *Pages* (p. 311 below), and the *Portrait of a Man with a Red Helmet in his Hand*, probably recorded by Federico Zuccaro in a drawing made when he was working in the Grimani palace at Santa Maria Formosa (Fig. 111). These three works were described many years later by Vasari in the second edition of the *Lives* as being in the collection of Giovanni Grimani at Santa Maria Formosa. They may have been first acquired by Cardinal Domenico during Giorgione's lifetime, later to become treasured possessions, handed down from generation to generation. If Domenico possessed Giorgione's *Self-Portrait* then he must have known him rather well.

Pietro Marani has revealed that Leonardo da Vinci had the cardinal's secretary's Roman address in his notebook and made copies from antiquities in the Grimani collection, namely, of two marble candelabra bases from Tivoli decorated with bacchic revellers which reappear in a late drawing by Leonardo of *Three Dancing Nymphs* at Venice.[112] One of the ancient maenads wears a solarian spoked basket crown, which is reminiscent of what is seen in the underdrawing of the headdress of the eldest of Giorgione's *Three Philosophers* (Fig. 46). Marani suggests that when Leonardo was briefly in Venice in March 1500 he may have come into contact with the cardinal's entourage, who proposed that he visit the cardinal's collection the following year in Rome. Could Giorgione have known the Hellenistic pieces that were in Rome, could they have been in Venice at some time during his life?[113]

111. FEDERICO ZUCCARO. *Portrait of a General with a Red Helmet*. Copy after a lost Giorgione from the Grimani collection. Black and red chalk. 19.9 x 14.5 cm. Staatliche Museen zu Berlin-Preussischer Kulturbesitz, Kupferstichkabinett.

From these tantalizing traces in contemporary documents, Domenico appears as a lively patron, commissioning and buying works by Michelangelo, Raphael, Leonardo and Giorgione, as well as having a taste for Flemish art. As with other sixteenth-century Venetian collections, except for that of Gabriele Vendramin, we know little about how the pictures in the collection were later displayed, even though the Grimani

palace at Santa Maria Formosa was visited by royalty — Alfonso, Duke of Ferrara, Henry III of France in 1574 — and by scholars and antiquarians — Stefanio Vinando, Spon, Montfaucon, Maffei, Pococke, Bocchi, Paciaudi and Winckelmann, who all raved about it, but neglected to leave detailed accounts of what they actually saw.

In 1564 Federico Zuccaro worked for Giovanni Grimani in the palace at Santa Maria Formosa, where the *Portrait of a Man with a Red Helmet* was kept, and also in the Grimani chapel at San Francesco della Vigna, where Cosimo Bartoli reported to Vasari that Federico was working on 19 August 1564.[114] All this evidence suggests that Zuccaro, when working for the Grimani, made a copy of one of the most famous portraits in Venice, which very plausibly is the Giorgione described by Vasari, so close is the description with the image.

In the seventeenth century, Boschini and Ridolfi refer to many pictures in the palace, as well as to paintings in the Palazzo Ducale from the Grimani collections. The first detailed description of the decorations comes as late as 1815 with Marcantonio Moschini's guidebook to Venice, by which stage many of the paintings had been taken down from the walls and replaced with copies. In 1819, Moschini published a substantially revised edition of his guidebook with a more critical account of the decorations. In the nineteenth century, when the Grimani palace was an antique dealer's premises (Fig. 117), it was reputed to have works by Giorgione. One English collector, William John Bankes, bought a ceiling there which he believed to be by Giorgione. It now hangs above the marble stairs at Kingston Lacy (p. 328 below), and it has frequently been attributed to Giorgione, together with Giovanni da Udine, since Bankes bought it from the Palazzo Grimani at Santa Maria Formosa,[115] on 6 February 1850.[116] Earlier, on 24 September 1843, the restorer Giuseppe Girolamo Lorenzi wrote a *perizia* in which he declared that he had cleaned an octagonal painting, representing *Autumn*, some 2 metres in diameter, for the dealer Consiglio Ricchetti, from whom Bankes acquired the ceiling.[117] He had it adapted by a carpenter to fit an oval shape.

Despite the many traditions that link Giorgione's name with the Palazzo Grimani, no sources tell us the location of Giorgione's works within Giovanni Grimani's palace. The building remains a conspicuous monument to Roman taste within Venice, with stucchi by Giovanni da Udine, and ceiling paintings by Salviati and the Zuccaro brothers.[118] Giovanni

Grimani's *studiolo* was the most beautiful room in Renaissance Venice (Fig. 112). Opinions differ as to the identity of the architect, but Giovanni himself may have played a significant role in its creation, as it was attributed to him by Muzio Sforza in 1588.[119] Vasari and others who discussed the palace earlier gave no architect's name.

One evaluation of Giovanni Grimani's pictures by Paris Bordone, made between 1553 and 1564, suggests that Grimani may have owned the

112. The *studiolo* of Giovanni Grimani. Palazzo Grimani, Santa Maria Formosa, Venice.

Benson Madonna, for an inexpensive *presepio* by Giorgione is mentioned ('Uno quadro de uno prexepio de man de zorzi da Chastel Franco per ducati 10').[120] The unusual iconography of the devotional painting and the Northern stylistic elements suggest a patron like Domenico Grimani. All narrative aspects of the scene have been omitted, and the difference in age between the holy couple is accentuated.[121] The Christ Child points upwards, as if emphasizing that he is the Incarnation of God. There is a meditative quality to the scene, with both Joseph and Mary engaging in reverent contemplation of the Child. The configuration of forms in the landscape seen through a window in the background echoes the foreground figures, suggesting that the earth too is part of the Incarnation.

Another religious painting by Giorgione, the *Tramonto* (Fig. 113), has no early provenance, although it was discovered in the Villa Garzone at

Ponte Cassale, which had once belonged to the Michiel family. Some of the thematic elements in this painting, the monsters in the landscape combined with the presence of St Anthony, could suggest that Giorgione's subject was inspired by works in the Grimani collection. Marcantonio Michiel records a large canvas of the 'Inferno with diverse monsters by the hand of Bosch', a further canvas of 'Dreams' by the same hand, and a canvas of 'Fortuna with a whale swallowing Jonah', also by Bosch. Cardinal Marino Grimani later owned several paintings by Bosch, among which there were two *Temptations of St Antony*.[122] The Grimani family were patrons of the Antonite hospice in Venice, the monastery of Sant'Antonio Abbate in Castello, from the time of its foundation in the fourteenth century until its dissolution in 1807.[123] St Anthony appears as a tiny bearded hermit in a cave, accompanied by a pig, while St George is depicted in his traditional battle with a dragon (Fig. 115). The two foreground figures are engaged in an act of healing, such as was common among the Antonites, an order established to heal those inflicted with 'St Anthony's fire'. Treatment of the disease consisted of prayers and offerings to the saint, as well as bathing limbs in wine to heal ergotism. There is a small cask in the painting that could be interpreted as containing the holy wine of St Anthony used in such treatments.

The only contemporary representation of such a subject was the panel of the *Temptation of St Anthony* from Grünewald's *Isenheim Altarpiece* (Colmar), executed around 1515 for the church of an Antonite hospice. Grünewald depicted an afflicted person in a state of extreme suffering, possibly even experiencing the hallucinations said to accompany the disease, whereas Giorgione has depicted a scene of healing and compassion in a pastoral setting. The life of St Anthony, as told by Athanasius in the fourth century, describes how Anthony at the age of twenty became a hermit in the desert, where he suffered continual temptations at the hands of the Devil. Later, the spiritual state of St Anthony in the desert was compared to the hallucinations experienced by a sufferer from ergotism. In Giorgione's *Tramonto*, the fantastic animals, the aquatic bird with a viciously opened beak, and the dark, lurking rhinoceros shape reflect the imagery of Bosch. Even the pig, traditionally a tame attribute, is depicted in a sinister manner as the inhabitant of a watery crevice. The *Tramonto* introduces the sentiment of Northern fantasy into Venetian pastoral painting, not merely in the adaptation of single motifs, like Bosch's

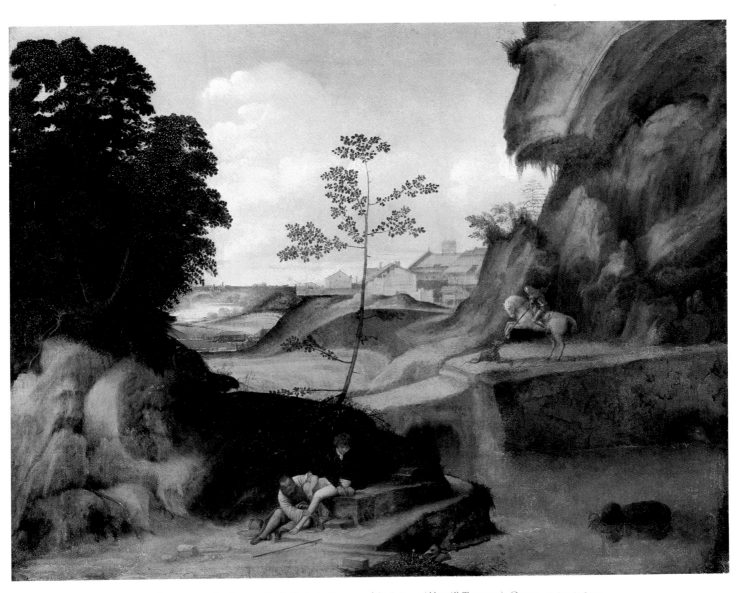

113. GIORGIONE. *Landscape with St Roch, St George and St Antony Abbot (Il Tramonto)*. Canvas. 73.5 x 91.5 cm.
London, National Gallery.

monsters, but in the strange suggestive forms of the landscape. In contrast to the hard Istrian stone in the *Three Philosophers*, Giorgione has covered his rocks with feathery tussocks of grass; he beards them to destroy their contours and to suggest other forms. The gnarled roots of a large tree are exposed, while St Anthony's cell lurks within a murky, jagged spiky cliff. The whole landscape vibrates with suggestiveness, heightened by the extraordinary sunset. Only the background and the blue monochrome vista of the *pianura* with another distant hamlet belong to the Veneto.

It has always been thought, although there is no documentary proof, that one of the most enigmatic compositions of Marcantonio Raimondi, an engraving called *The Dream*, is a reflection of a lost Giorgione, which itself could have been informed by the Flemish painting in the Grimani collection. The Marcantonio has alternatively been identified as a print after the painting of the lost *Hell with Aeneas and Anchises*, described by Michiel in the collection of Taddeo Contarini, or as one of the night pieces (*Notte*) mentioned in Isabella d'Este's correspondence with Taddeo Albano. A more plausible explanation of the two *Notte* is that they refer to the two versions of the *Adoration of the Shepherds*, one in Washington, the other in Vienna (Figs. 52, 28). Marcantonio's print depicts two heavy-limbed women sleeping, in type reminiscent of Giorgione's Dresden *Venus* (Fig. 139). In the background, a city burns and Flemish monsters cavort on the banks of the river. In the doorway of the tower illuminated by the fire are two figures, one on the shoulders of another, the traditional iconography for Aeneas and Anchises leaving Troy. One of the more convincing interpretations of the print is that Dido is represented sleeping next to her sister Anna, and that the background in flames is her nightmare, a prediction that Aeneas will desert her.[124] As many of the motifs in the engraving are taken from other works, doubt has been cast on whether Raimondi was really copying an actual work by Giorgione. For the climbing man in the right background is from Michelangelo's *Battle of Cascina*, the sleeping woman seen from the side is close to Giulio Campagnola's famous print of a reclining nude, while the other woman resembles the sleeping figure in a painting attributed to Girolamo da Treviso in the Borghese.[125] This is an engraving which should be included in any discussion of Giorgione's works, but it does not as yet have canonical status.

Turning from the difficulties of identifying particular pieces, the

Right: 114. GIORGIONE.
Il Tramonto.
Detail of Fig. 113.

Following double page: 115.
GIORGIONE. *Il Tramonto.*
Detail of Fig. 113.

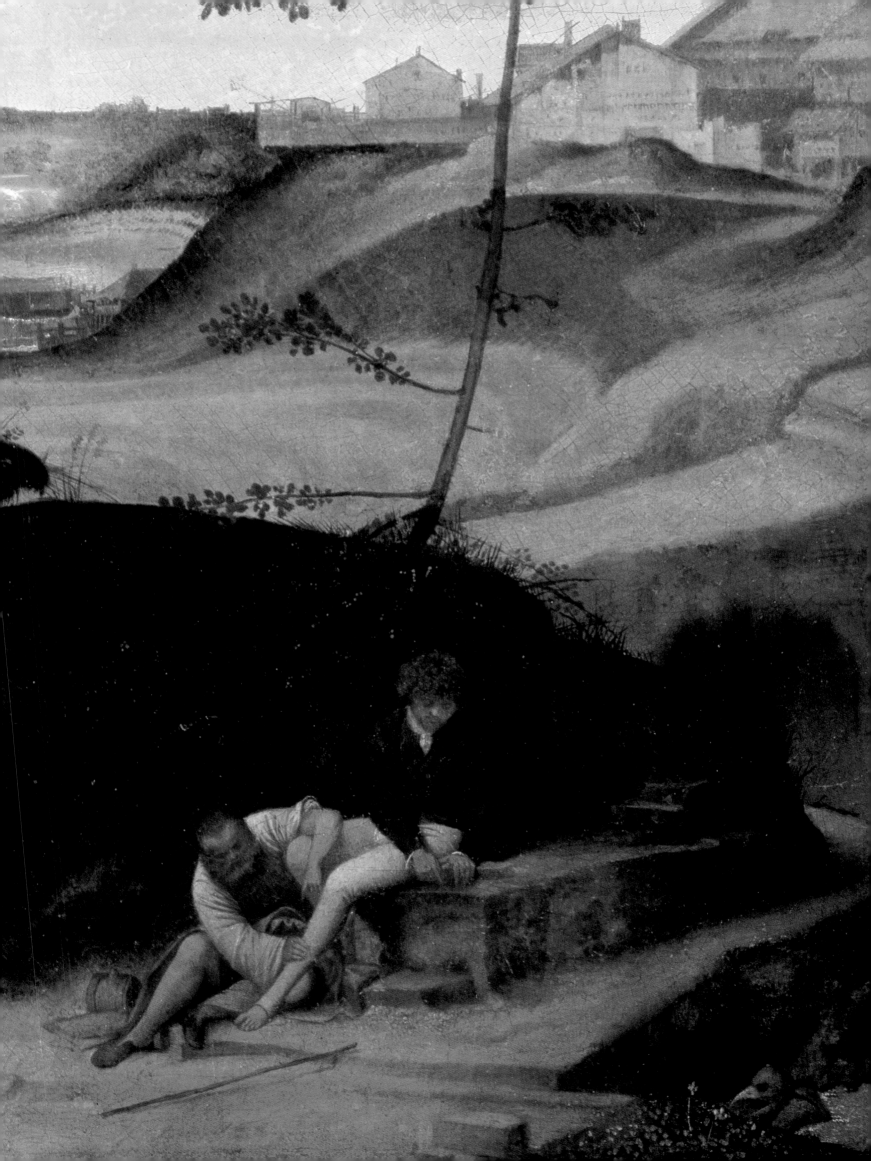

central role played by the Grimani family within the history of Venetian collecting suggests guidelines for a future history of Venetian collections. In past scholarship, Venetian collecting has sometimes been explained in an anodyne manner merely as an expression of taste.[126] It is true that at one level Venetian collections by individuals were an expression of the wealth and magnificence of patrician culture. They were also a declaration of piety and of humanistic and classical learning. Some collectors, like Gabriel Vendramin and Cardinal Domenico Grimani, wished for their collections to remain intact after their death and to be open to visitors. Works by Giorgione were treasured and rare possessions, and in the context of the Grimani collection were privileged to be seen as the Venetian equivalent of masterpieces by Central Italian artists. Collections of works of art were usually accompanied by great libraries, where guests and ambassadors were received. The atriums of Venetian palaces were decorated with arms, naval banners and trophies recording the origins of families and their triumphs. Venetian collections were also about collective and individual patrician politics. The Roman nature of the Grimani collection made apparent the family's success within the papal Curia. Whether in Rome or Venice, the Grimani collections were magnificent installations in which to receive ambassadors and foreign royalty, both on behalf of the Serenissima and the family.

116. Palazzo Grimani. Entrance on the canal. Santa Maria Formosa, Venice.

There was also an interrelationship between public and private patronage, demonstrated by the case of Nicolò Aurelio, who played a major role as a private patron, commissioning such works as Titian's *Sacred and Profane Love*. But as Secretary to the Council of Ten, he may also have played a crucial role in commissioning Giorgione for the Fondaco frescoes. Gabriele Vendramin was praised by Serlio and others for his knowledge of architecture, and in the last two years of his life he occupied the office of *Provveditore sopra la fabbrica del Palazzo*, that is to say, he was one of the supervisors of the rebuilding of the Palazzo Ducale from

March 1550 until his death in 1552.[127] Within the Grimani family there is a similar duality. Giovanni and his brother, the procurator Vettore, who both inhabited the family palace at Santa Maria Formosa (Fig. 116), not only brought Central Italian artists to Venice for their palazzo and parish church, San Francesco della Vigna, but also played a major part in the direction of public works in Venice, such as the Library, the Zecca, and the Loggetta of San Marco, showing a predilection for the architecture of Sansovino, who had been brought to the Serenissima by Cardinal Domenico.

117. Interior view of the Palazzo Grimani, as an antique dealer's shop in the nineteenth century.

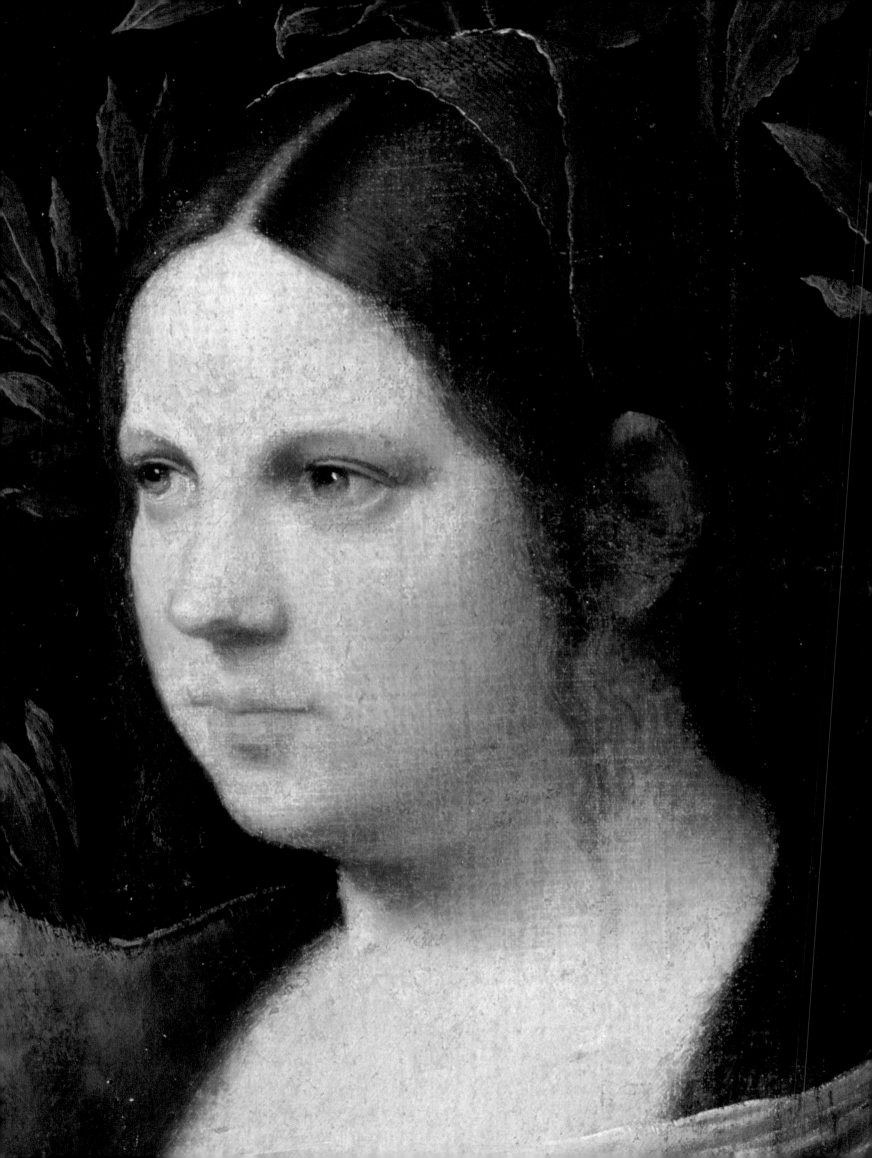

Chapter

V

Giorgione's Imagery of Women

In Venetian art of the Quattrocento, women are often marginalized in pictorial representations of contemporary history — with some revealing exceptions, such as the presence of Queen Caterina Cornaro and her female companions in Gentile Bellini's *Miracle of the Holy Cross* (Fig. 87). Until the middle of the Cinquecento, women are rarely represented in individual portraits. In Central Italy (at the courts of Urbino, Ferrara, and Rimini), the crucial role that women played in dynastic succession and inheritance was perceptibly demonstrated with portraits of married aristocratic couples, sometimes with their children. Why did this not happen in Venice until the 1540s? Why were Venetian dogaressas so rarely represented?[1] Why was visibility problematic for women in Renaissance Venice?

Such questions are important in relation to Giorgione, because in his small corpus of works the converse is true, for there are at least two portraits of women, *La Vecchia* (Figs. 110, 119) and *Laura* (Fig. 131), a seemingly high proportion. His portraits of men are equally unusual within the context of Venetian art, principally because their dress contravenes the sumptuary laws. As for other Venetian artists, few surviving portraits, either of men or women, may be attributed to Gentile and Giovanni Bellini, although literary sources suggest that the most important may not have survived. Titian lived longer than Giorgione, but portraits of women in his œuvre are statistically even rarer.[2] He portrayed women who were foreign rulers, or his own daughter, or noted beauties such as Flora. Painted portraits of individual men exist, but Venetians preferred large history paintings with group portraits, so that the patriciate were seen collectively in situations of group patronage, witnessing miracles in a social group or as confraternity patrons, rather than as individuals. Of all Italian city states, the Venetian Republic was famous for its stability and commitment to liberty. In order to maintain this ideal, personal power was distrusted and terms of office were constitutionally limited by a non-hereditary dogeship and by short tenures as well as other means. (As mentioned, one of Giorgione's sitters, Giovanni Borgherini, though a Florentine, was among the principal participants in Donato Giannotti's dialogue *Della Repubblica de' Veneziani*, the most laudatory account of the Venetian constitution and oligarchy ever written.)

Two related explanations for the relative paucity of individual portraits are possible, both based on the commemorative and documen-

tary role of images in relation to the society that produced them. The first is that the patrician oligarchy of Venice did not allow a single family to visibly represent itself as greater than its peers — for example, in familial situations, such as group portraits, where they would portray their children as their political successors. In Bergamo, by contrast, families could be represented in group portraits that included both men and women. Lotto brought this fashion to Venice with the *cittadini* family della Volta in their portrait of c. 1545 (National Gallery, London). Shortly thereafter, Titian's Vendramin family portrait (Fig. 102) became one of the few attempts to portray generations of a Venetian patrician family; unlike Lotto's portraits, however, women are absent. Or as James Grubb, a historian who recently tried to explain the absence of personal writing and imagery in Venice, explains: 'Women figure prominently in Florentine memoirs, as links between generations and links between families, as sources of shame or honour, as providers of moral and spiritual instruction of children, and as domestic managers; the ruthlessly patrilineal Venetian texts nearly exclude women altogether, except as possible contaminants of nobility'.[3]

A second, related consideration is the considerable testimony about the conspicuous presence of courtesans on the Venetian streets. Were patrician women worried about being confused with them? It has long been recognized that Venetians were relatively disinclined to write about themselves and preferred to demonstrate collective oligarchic solidarity. It may have been the early impact of Caterina Cornaro's court at Asolo on the young Giorgione that made him see the imagery of women in a way more analogous to Central Italian culture and stimulated him to develop some of the most sensual images of women ever created, images which were seminal for the development of Venetian painting.

119. GIORGIONE. *La Vecchia.* Detail of Fig. 110.

DECOLLATIONS

Giorgione's earliest image of a woman is of *Judith with the Head of Holofernes* (Fig. 123). It is also the first time Giorgione depicted a heroic biblical figure triumphing over a severed head. The theme of decapitation was later to become of autobiographical significance when Giorgione explored his own self-image as *David Meditating over the Head of Goliath* (Fig. 128). The Jewish heroine of the Apocrypha, Judith was a novel subject

in Venetian painting in the late 1490s. The work is also Giorgione's only known furniture painting: the door to a cupboard, either a sacristy cupboard, or more probably a secular piece of furniture, such as a writing cabinet.[4]

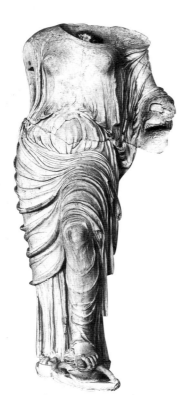

There are precedents for the subject in Venetian sculpture which Giorgione knew, such as the *Judith* on Tullio Lombardo's Vendramin tomb (c. 1493). He may also have known an even earlier bronze associated with Donatello's Paduan workshop, the first known image of a nude Judith (Fig. 121). Donatello's lost original represented an attempt to create a feminine analogue to the heroic nudity of his *David*.[5] For Judith's arresting pose, Giorgione was inspired by an ancient statue by Phidias, the *Aphrodite Ourania*, showing Aphrodite with her left foot on a tortoise and known in innumerable Hellenistic versions (Fig. 120).[6] Giorgione placed Judith's bare left foot on Holofernes' head, her toes resting on his curls (Fig. 124) — an extraordinarily sensual detail, especially when we recall that in the biblical text Judith wears sandals, meant to ravish Holofernes' eyes. The *Judith* is intended to rival the sculptural prototypes on which she depends, for Giorgione has introduced innumerable other effects to which sculpture cannot aspire, such as the mists, mountains and valleys in the landscape background (Fig. 122). Leonardo considered these motifs to be a demonstration of the intellectual qualities of painting and suggestive of the subject's inner thought, 'the motions of the mind'. Unlike her sculptural prototypes, *Judith* is also represented in brilliant colour. The shape of her features, the arrangement of her hair, the enigmatic smile, all bring to mind Leonardo's studies for the figure of *Leda*.

There were several other Florentine precedents which Giorgione may have known, perhaps indirectly through drawn copies, each one illustrating a radically different interpretation of the subject: Donatello's bronze statue of the clothed *Judith* (Palazzo Vecchio, Florence, c. 1455) and Botticelli's two small furniture panels, *Judith and her Maid*

Above: 120. Attributed to PHIDIAS. *Aphrodite Ourania*. Marble. Height 158 cm. Berlin, Staatliche Museen-zu Berlin-Preussischer Kulturbesitz.

Right: 121. Workshop of DONATELLO. *Judith with the Head of Holofernes*. Bronze. Height 8.4 cm. Formerly Kaiser Friedrich Museum, Berlin.

Far right: 122. GIORGIONE. *Judith with the Head of Holofernes*. Detail of Fig. 123.

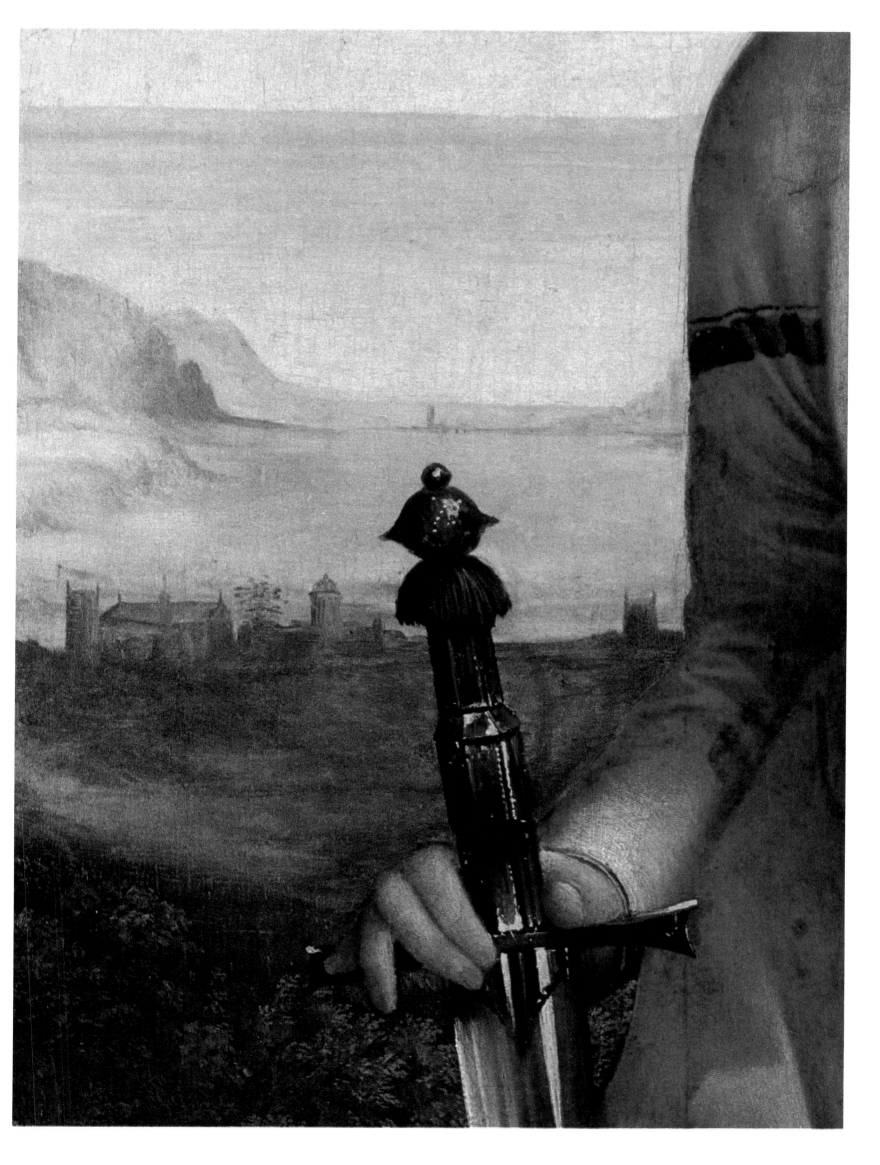

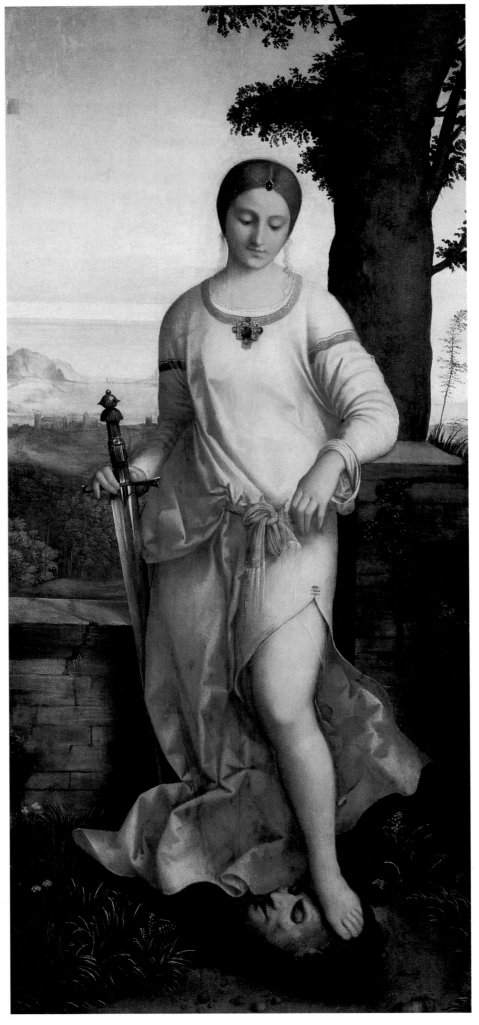

Above: 123. GIORGIONE. *Judith with the Head of Holofernes*.
Canvas, transferred from panel. 144 x 68 cm. St Petersburg, State Hermitage Museum.
Right: 124. GIORGIONE. *Judith with the Head of Holofernes*. Detail.

and the *Discovery of the Dead Holofernes* (Uffizi, Florence). Both Donatello and Botticelli were attentive to many of the details of the story of Judith. Donatello chose the most brutal moment, when Judith holds her falchion aloft and grasps Holofernes' head of hair as she is about to strike him (Judith 13:6–8), while Botticelli represents Judith as a graceful young girl, sprightly journeying home to Bethulia, accompanied by her maid and jauntily holding not only Holofernes' sword, but also an olive branch, symbolic of the peace she brings to the Israelites (13:10). Judith's character and her actions were interpreted in two ways in the Renaissance: either she was seen as a heroine who had overthrown a tyrant, and therefore representative of civic virtue and republican freedom, or she was considered a *femme fatale*, an enchantress who lured men to their destruction. There is no doubt as to which tradition Donatello alludes, since his statue of Judith was once accompanied by an inscription proclaiming her civic virtue,[7] whereas Botticelli's diptych, a century after it was created, was given by Ridolfi Siringatti to Lady Bianca Cappello de' Medici to adorn her writing cabinet; in this context, it was intended to complement the lady's beauty and power.[8] Functionally, Giorgione's *Judith* seems closer to Botticelli's diptych, both originally serving as a painted door cover.

Giorgione's painting is not a literal interpretation or narrative representation of an episode in the Book of Judith. Although the scene chosen follows the decapitation of the tyrant, Judith is not hurrying home to Bethulia, nor is she accompanied by her maid. Instead she stands immobile like a sculpture, dressed in a flowing diaphanous pink robe, which is open to show her bared left thigh as the pivotal point of the composition.[9] Her foot rests languidly on Holofernes' brow, the smiling severed head surrounded by wild flowers, white grape hyacinths, sylvan tulips and a rare *Columbina japonica*, a plant then only recently introduced into Italy. (These flowers are unusual in Giorgione's œuvre for their botanical accuracy.) No one could doubt the conscious sexual allegory, the severed head lying beneath Judith's plump leg, a spent force in a field of lush flowers. For this reason, some scholars have imagined that the severed head bears Giorgione's features, but there is little resemblance between this Holofernes and Giorgione's known self-image as David, as shown in Hollar's engraving (Fig 125).[10] Furthermore, Giorgione never lived long enough to be as old as the man depicted at Judith's feet or in the Goliath head. But in both

the *Judith* and the self-portrait, the severed head is the same person. So if he is not Giorgione himself, who is represented in these two very different contexts? Could this be merely a male model, or is the spectator meant to recognize the repetition of the likenesses and speculate about its implicit connotation of bisexuality? In the *Judith*, the context is heterosexual, whereas in the self-portrait the context could be construed as homosexual — as male jealousy, of the kind that appears in Giorgione's other variations on the David theme (Fig. 35), and in view of the later tradition as developed by Caravaggio and other seventeenth-century artists (discussed below).

VERO RITRATTO DI GIORGONE DI CASTEL FRANCO da luy fatto come lo celebra il libro del VASARI

125. After GIORGIONE. *David Meditating over the Head of Goliath.* Engraving by WENZEL HOLLAR, 1650.

That the thematic relationship between Judith and David, as well as other virtuous decapitators, must have been discussed in early sixteenth-century Venice is suggested by a curious sculpture of 1502–09 attributed to Severo da Ravenna, depicting *Queen Tomyris with the Head of the Persian King Cyrus* (Fig. 126).[11] Tomyris was Queen of the Massagetae in ancient Greece and, like Judith, a widow who saved her people from a tyrant. King Cyrus, wishing to subjugate her country, proposed marriage to her. Tomyris indignantly rejected his offer, realizing that he was wooing not herself but her dominions. Cyrus then engaged in a battle with her troops, made them drunk through subterfuge, and captured and killed her son, Spargapises, the general of the Massagetae army. Tomyris threatened a bloody revenge, and eventually Cyrus was defeated and slain. Tomyrus found his dead body on the battle field, severed his head and placed it in a leather bag full of blood to fulfil a sworn threat (Herodotus, I, 205–14; Valerius Maximus, IX, 10).

126. SEVERO DA RAVENNA. *Queen Tomyris with the Head of the Persian King Cyrus,* c. 1502–09. Bronze. Height 30.8 cm. New York, Frick Collection.

Severo's bronze depicts the widow's gruesome revenge. Like Donatello's lost *Judith*, Tomyris is a heroic nude figure, but in dialogue with the severed head, which she holds high, as if conversing with it. Severo was praised by Pomponius Gauricus as 'the perfect sculptor', greater than any other in the past or

present, both for the excellence of his technique in many media, and for his knowledge of literature.[12] He may well have made his bronze in response to Giorgione's *Judith*, as part of that continual debate about the superiority of sculpture to painting. When Signorelli depicted Judith, nearly nude, in a fresco in the San Brizio Chapel, Orvieto, between 1500 and 1503, she is a simulated sculpture, part of a painted keystone. Giorgione's *Judith* was conceived in response to the classicizing sculpture of the Lombardi, but it engendered an ongoing debate.

Much of the documentation that we have for the symbolism of decapitation comes from seventeenth-century sources. The most dramatic and fully documented example of the fatal *Judith* is by Cristofano Allori, a Florentine Mannerist artist and *bon viveur*, who painted two versions of the subject, the superior variant now believed to be at Hampton Court Palace, the other in the Palazzo Pitti, Florence. The best account of Allori's life, and of his *Judith*, is given by Filippo Baldinucci in his *Notizie de' professori del disegno* (1681–1728), a chronological account of the lives of the Florentine artists, modelled on the Vasarian prototype. According to Baldinucci, Allori was conspicuously addicted to pleasure, but then joined a devotional confraternity, which led to a brief period of exemplary moderation. 'But at last, tempted perhaps by all the varied entertainments and pleasant pastimes with which his mind had always been filled, he abandoned prayers and the brotherhood. He returned to his amusements until he fell deeply in love with a very beautiful woman called La Mazzafirra. With her he used to squander all his considerable earnings, and what with jealousy and the thousand other miseries which such relations usually bring with them, he led a thoroughly miserable life. Since we have mentioned La Mazzafirra, we should also tell that he made use of her face, portrayed from the life, to represent Judith in one of the oddest pictures which ever came from his hand'.[13] Baldinucci goes on to relate that La Mazzafirra holds a bloody sword in her right hand, while in the other she holds aloft the head of Holofernes, in which the artist's bearded features are represented, and that the maidservant was a portrait of Mazzafirra's mother. In the Hampton Court version, dated 1613, Holofernes' bed is inscribed in gold with the artist's signature.

Allori must have been conversant with several versions of the Judith subject by Jacopo Ligozzi, an antiquarian painter, court artist to the Grand Duke of Tuscany, and superintendent of the Medici collections at Florence.

Giorgione *p.* *5 Alta. 4 Lata.* L. *Vorsterman iunior ſ.*

127. After GIORGIONE. *David Meditating over the Head of Goliath.* Engraving by
LUCAS VORSTERMAN for Teniers' *Theatrum pictorium,* 1658.

In several versions of his *Judith* (the best is in the Palazzo Pitti), Ligozzi gives Raphael's features to the sleeping head of Holofernes, who awaits decapitation at the hands of Raphael's mistress, La Fornarina. The picture is a self-conscious bit of antiquarianism, a seemingly imaginary episode from the life of the most famous artist of the preceding century, and quite different in mood from the various versions of decapitation by Caravaggio

128. After GIORGIONE.
David Meditating over the Head of Goliath. Poplar.
65 x 74.5 cm. Vienna, Kunsthistorisches Museum.

and his followers, which must have also been known to Allori, and which have often been interpreted as having very personal associations. In some, there are self-portraits in which Caravaggio depicts himself both as victim and executioner. The most famous is the *David and Goliath* in the Galleria Borghese, Rome, where at least one contemporary observer, Bellori, noted that Caravaggio had represented himself as the severed head held aloft by the youthful hero. Caravaggio's own life was notoriously violent — he is known to have committed murder on at least one occasion — and it is difficult not to interpret these subjects as having a psychological and autobiographical meaning. Howard Hibbard has made much of these severed heads, with streaming blood and horror-stricken faces, which he sees as reflecting Caravaggio's fears and fantasies and relates to the view

of decapitation as symbolic castration, proposed in Freud's *Medusa's Head* (1922).[14] In point of fact, the sexual symbolism of decapitation may have been much more complex in the Renaissance.

Artemisia Gentileschi, one of the most successful women artists in seventeenth-century Italy, worked in a pictorial language drawn from Caravaggio, with whom her father Orazio had studied.[15] One incident in her life, the trial of her father's apprentice Agostino Tassi for allegedly raping her in 1612, has provoked much comment. Tassi had been employed by her father as a perspective artist, and is said to have forced himself upon Artemisia during a lesson. Artemisia painted at least four versions of the Judith subject, which seem to reflect the trauma of the trial, and her self-portrait has been identified in both the Jewish heroine and the maidservant, while the violator Tassi's features appear in the head of Holofernes. By contrast, representations of Judith by Bolognese women, Fede Galizia and Elisabetta Sirani, depict a bland and chaste figure, assisted in conspiratorial fashion by her maidservant.[16] The identification of portraiture in such paintings, though not open to definitive proof, carries conviction within the tradition. What light does such seventeenth-century documentation throw on Giorgione's decapitation scenes, about which the contemporary Venetian sources are silent?

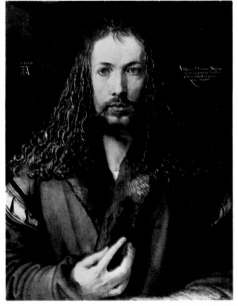

129. ALBRECHT DÜRER. *Self-Portrait as Christ*, 1500. Panel. 67 x 49 cm. Munich, Alte Pinakothek.

130. BERNARDO LICINIO. *Young Man with a Skull*. Canvas. 76 x 62 cm. Oxford, Ashmolean Museum of Art and Archaelogy.

Among the more curious and rarer conventions of Italian sixteenth-century painting is a form of disguised portraiture in which contemporary persons are represented in the guise of Old Testament figures, such as David,

Judith, or Salome, each with a severed head, usually containing a further likeness. The earliest instance of a disguised allegorical portrait occurs in the famous self-portrait by Giorgione of himself as David with the severed head of Goliath (Fig. 128). Allegorical self-portraiture was unknown in Venetian art before Giorgione's self-representation as an Old Testament hero. The only near-contemporary parallel that can be found is Albrecht Dürer's bold depiction of himself as Christ in a painting in Munich (Fig. 129). Both pictures may be interpreted as autobiographical statements about the divine power of an artist to create. The original portrait by Giorgione is often identified as the fragment in Braunschweig (Figs. 2, 34), where the giant's head has been cut, leaving only the self-portrait as David; but the entire composition is faithfully recorded in Hollar's engraving. In the few documents that refer to Giorgione during his own lifetime, his name is given in Venetian dialect as Zorzi da Castelfranco, or George from Castelfranco; significantly, it is in an inventory description of this portrait in 1528 that he is first given the name Zorzon (Giorgione in Venetian), or 'big George', the nickname by which he has become known to posterity. Hollar's engraving of the picture, made before it was cut, shows that the artist had portrayed himself as giant-sized, the features of David being the same size as the head of the Philistine giant.

In his allegorical self-portrait, Giorgione has chosen to be represented as a soldier rather than a shepherd. For his fight with Goliath, David refused to wear Saul's armour (I Samuel 17:38–39), but after his victory, he accepted clothes and weapons from Saul's son Jonathan (I Samuel 18:4). Giorgione's choice of clothes, particularly the iron gorget, indicates a moment in time, the period after David's victory over the Philistine, when he was perturbed by Saul's envious persecution. The analogy suggests that the artist, like David, is subject to melancholy and self-doubt even at the moment of his greatest triumph. This interpretation is enforced by another self-portrait composition by Giorgione of himself as David, which survives only as a reproductive drawing in an illustrated inventory of the Andrea Vendramin collection (Fig. 35). Here David is accompanied by Jonathan, who gazes searchingly at him, suggestive of his enduring love for David, and by Saul, who holds a concealed weapon, a threatening indication of his attempts on David's life. The inventory sketch is so rough that it is impossible to say whether the composition contains more portraits than the self-portrait, and Ridolfi, who described the painting, is unhelpful (see

p. 372 below). This lost narrative version of the subject confirms that Giorgione identified his own artistic personality with David's suffering during his flight from Saul's persecution. It is a unique representation of the theme of male jealousy masquerading as a biblical subject.

The idea of a biblical slayer as a contemporary portrait was disseminated among Giorgione's pupils in slightly varying forms, adapted to representations of both Judith and Holofernes and Salome and John the Baptist. Giorgione's half-length portrait of Judith, presumably of the same date as the *Laura* portrait (Fig. 131), is conveyed in a reproductive engraving by Lucas Vorsterman, made for Teniers' 1658 *Theatrum pictorium* (p. 318 below). Judith stands before a cloud-swept landscape, the locks of her hair in disarray. She gazes at the viewer, while the severed head of Holofernes rests on a parapet beneath the sword hilt. On the evidence of Vorsterman's print, Giorgione's lost representation was the model for a version made by his friend Vincenzo Catena, now in the Pinacoteca Querini-Stampalia, Venice (p. 318 below). Here again Judith stares fixedly at the viewer as if conveying a statement of some importance, and the severed head, acutely foreshortened, is a strongly expressive element in the composition. In the middle of the decade, Andrea Solario became fascinated with the subject of Salome and John the Baptist, and produced for his French patrons a number of half-figure compositions in which the executioner hands Salome the head of St John (Metropolitan Museum of Art, New York), as well as isolated portrait studies of the head on a charger.[17] In 1512 Lorenzo Lotto painted a small half-figure panel of *Judith and her Maidservant*, now in the collection of the Banca Nazionale del Lavoro, Rome. Lotto's conception of Judith as a virtuous heroine has a portrait-like quality, suggesting that it may also be a disguised portrait.[18] The most striking derivation of this Giorgionesque tradition is Titian's *Salome* in the Galleria Doria Pamphilj, Rome, where Titian's own likeness is represented in the severed head of St John,[19] although Paul Joannides has argued that the woman may be another Judith.[20]

What category do these images fall into? Are they portraits of Venetian women called Judith, or are they history pictures? The same compositional formulae are interchangeable for male and female images of decapitation, and they are also used for portraits of warriors, the configuration of the helmet and warrior's head replacing the sitter and the severed head. We are perhaps looking at an intentional ambiguity between genres,

as if Giorgione were developing Leonardo's prescriptions to enliven portraiture by applying the principles of history painting.

LAURA

As Vasari noted, Giorgione was deeply influenced by Leonardo's style, and 'while he lived always followed it' ('mentre visse, sempre andò dietro a quella'). This is particularly apparent in Giorgione's images of women, which reflect both Leonardo's portraits and also his often quoted theories about portraiture. Nowhere is this more manifest than in Giorgione's *Portrait of a Woman* (*Laura*), dated on the reverse 1506, and in her relationship, both formal and intellectual, with Leonardo's portrait of *Ginevra dei Benci* in Washington. The title of Giorgione's work is suggested by the laurel leaves that frame the sitter's head, which echo the juniper leaves behind the head of Ginevra. Leonardo's *Ginevra* precedes Giorgione's *Laura*, but there are even earlier antecedents for such an image, among them Pisanello's *Portrait of Ginevra d'Este* in the Louvre, where juniper leaves frame the princess's head.

There has been a considerable debate about the character of the woman portrayed by Giorgione.[21] Is this a marriage portrait of a known individual, in which case the male companion piece is missing, or is she an idealized image of Petrarch's Laura, or is she one of the first portraits of a courtesan? Of some importance are Teniers' replications, as seen in his paintings of the interiors of the gallery of Archduke Leopold William (principally those in Madrid and Munich, Figs. 151–153). The Prado version shows a three-quarter-length Laura, her hand held on an enlarged stomach, suggesting pregnancy, like the woman in Van Eyck's *Arnolfini Marriage*. Consequently, it has sometimes been argued that Teniers' copy reproduces the portrait as it was in the seventeenth century, before it was presumably cut. Another Teniers copy in Munich represents the figure waist length, as she is in the surviving portrait.[22] Most important, the measurements of the actual portrait are the same today, allowing for the frame, as they were in the inventory of Leopold Wilhelm's collection in the seventeenth century.[23] The inevitable conclusion is that the copy by Teniers of the pregnant Laura is a mocking fantasy, rather like the irreverent copy Teniers made of the *Three Philosophers*, now in Dublin, where the philosophers are transformed into down-and-out rustics, one carrying a soup plate

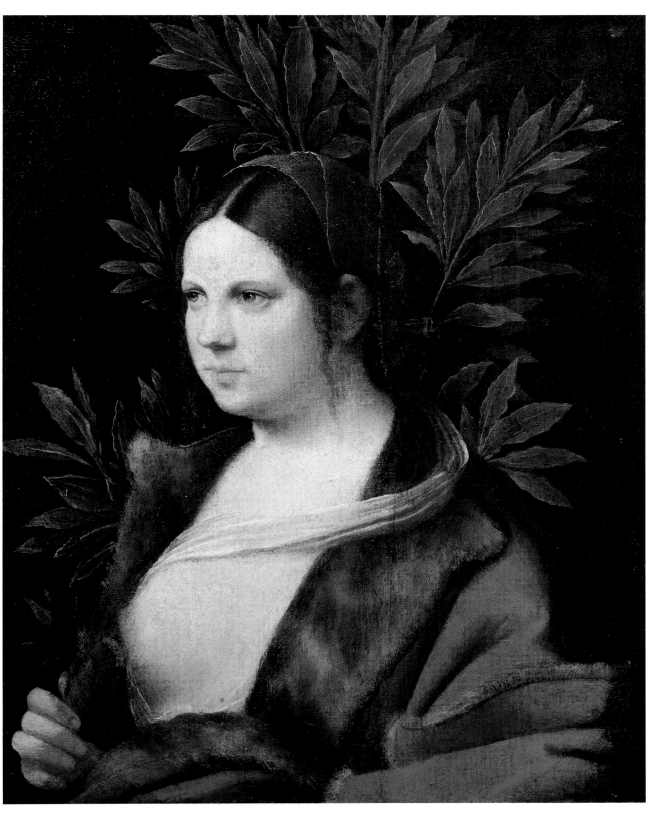

131. GIORGIONE. *Portrait of a Woman (Laura)*. Canvas affixed to spruce panel. 41 x 33.6 cm.
Vienna, Kunsthistorisches Museum.

rather than a set square (p. 316 below). Once Teniers' *copie libre* is eliminated from the discussion, the question as to Laura's identity can only be answered by reference to the actual surviving portrait.

Laura's one bare breast (Fig. 132) would be interpreted as an emblem of chastity had she belonged to a cycle of idealized beautiful women, such as were depicted in Renaissance courts, or if she were one in a series of famous women, such as Petrarch's Laura.[24] In other contexts, heroines of unblemished chastity, such as Diana, were often depicted with a bare breast, but so too were women swooning, underdressed, and mortal; in the latter cases, the woman may perhaps be identified with portraits of courtesans mentioned in Renaissance texts and inventories of collections.[25] Although a few representations of Flora with her breast bared by Titian and Palma Vecchio show a ring on the model's left hand — the hand that carries emblematic flowers — this does not necessarily mean that a bared breast is characteristic of a wedding portrait, nor that the ring is a betrothal ring.[26]

If Giorgione's *Laura* is compared to portraits of married women, she fails to join their company. There are representations of married couples, notably by Lorenzo Lotto, where chastely and magnificently dressed women are portrayed with their husbands in the act of exchanging a ring, such as the famous portrait of Antonio Marsilio and Faustina Cassotti in the Prado. In 1523, Antonio Marsilio ordered, as a wedding present, two pictures from Lotto for his bedroom, one a double portrait, a painted record of his marriage, in which he places a ring on his wife's finger, as Cupid joins them with a yoke from above. (The other was the *Mystic Marriage of St Catherine with Saints*, among them St Antony Abbot, namesake of the patron. Neither picture pleased Antonio, and so Lotto gave them as payment for his rent to his Bergamo landlord, Zannin Cassotto, in whose home, a building by the Bergamo Renaissance architect Alessio Agliardi, they are recorded by Michiel, merely as 'due quadri', yet another example of Michiel's disinterest in subject matter.) Another double portrait by Lotto (Fig. 133) shows a married couple accompanied by a squirrel and a little dog. Here Lotto represents a moment in the life of a married couple who have been together for some time. The inscription held in the man's hand, HOMO NUMQUAM, alludes to fidelity in marriage, as do the animals. Every detail of the couple's dress suggests domestic comfort. To a seventeenth-century Italian observer, Carlo Ridolfi, this was a portrait of a 'marito e moglie'.

When Dürer visited Venice he made drawings and paintings of

132. GIORGIONE. *Laura.*
Detail of Fig. 131.

Venetian women with the eye of a foreign observer. In one drawing, he compared a Nuremberg *Hausfrau* with a Venetian *gentildonna* (Fig. 134). The Venetian woman has a fashionably deep cleavage, but scarcely a bared breast. Similarly, Dürer's 1495 drawing of *Two Venetian Women* (Fig. 135) presents a brilliant caricature of their fashionability. But their garments approximate the luxurious Venetian fashions worn by patrician women as described in Sanudo's *Diaries* much more closely than the bare-breasted Floras of Titian and Palma Vecchio. Dürer's drawings and Lotto's portraits give us a glimpse of fashionable married patrician women, and their image is very different from Giorgione's *Laura*.

Context is all important, and the clearest indication of context is provided by the inscription on the reverse of the Laura portrait: 'On 1 June 1506 this was made by the hand of Giorgio of Castelfranco, colleague of Vincenzo Catena, on the instruction of Messer Giacomo . . .' (see p. 361 below). Giacomo's surname is missing, and his relation to the sitter uncertain. The model for Giorgione's portrait, Leonardo's *Ginevra dei Benci*, was traditionally believed to have been made about 1474, the year of Ginevra's marriage to Luigi di Bernardo di Niccolini. However, the recent identification of the personal emblem of Bernardo Bembo on the reverse of Leonardo's painting, a laurel branch intertwined with a juniper stem, suggests a new possibility concerning the commission: that Bernardo Bembo could have ordered the portrait of a noted beauty and woman poet whom he had admired.[27] However, the collections of Bernardo and his son Pietro Bembo were described by Michiel and others, and there is no evidence that they owned the portrait, although Pietro Bembo's collection did contain masculine friendship-portraits, notably one by Raphael of the poets Andrea Navagero and Agostino Beazzano (Galleria Doria Pamphilj, Rome).[28] The exchange of portraits between friends is a subject that emerges quite naturally from Renaissance sources; it is a tradition to which Giorgione's and Leonardo's portraits of women belong.

Alternatively, the laurel branch on the reverse of the Leonardo portrait and the laurel behind Giorgione's sitter's head have been interpreted as an artist's response to Petrarch's challenge, issued in his two sonnets on Simone Martini's portrait of Laura, wherein he states that perfect beauty could not be realized in a pictorial image.[29] Yet Leonardo's own writings often mocked Petrarchan traditions, as when he wrote: 'If Petrarch was so fond of laurel, it was because it has a good taste with sausages and roast thrush:

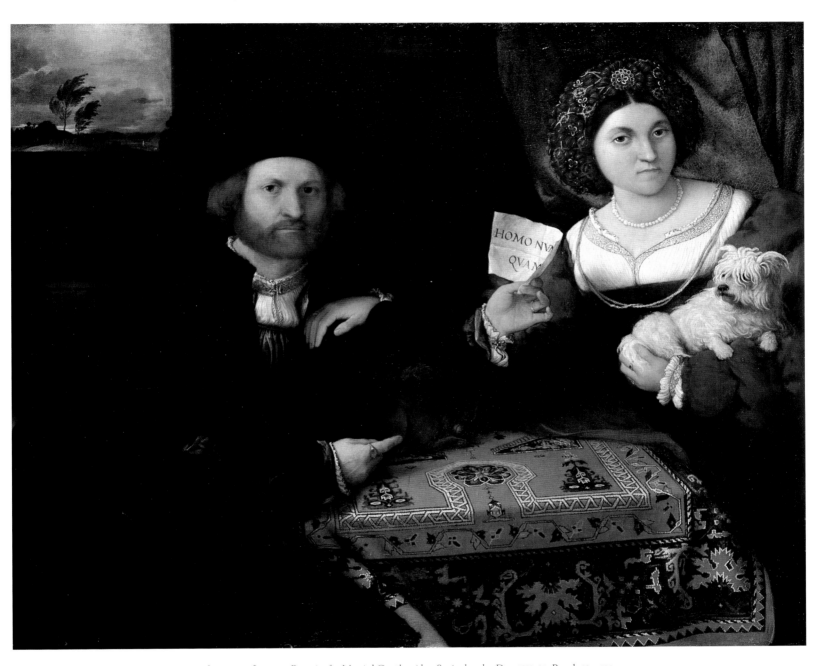

133. LORENZO LOTTO. *Portrait of a Married Couple with a Squirrel and a Dog*, 1523–24. Panel. 98 x 118 cm.
St Petersburg, State Hermitage Museum.

134. ALBRECHT DÜRER. *A Hausfrau from Nuremberg and a Gentildonna from Venice.*
Pen and dark brown ink. 24.7 x 16 cm. Frankfurt, Städelsches Kunstinstitut.

I cannot set any store by their twaddle'.[30] All Renaissance readers knew that Petrarch's Laura, as portrayed by Simone Martini, was blonde, that she had blue eyes, that she was chaste, that she was an ideal beauty, and that she was unlike Giorgione's *Laura*, who is dark-haired, dark-eyed, whose beauty is unidealized, and whose chastity is questionable. The reference to Petrarch in both portraits is not a simple one, and suggests an ironic *paragone*, both painters surpassing the poet's description.

The laurel wreath in both Giorgione's *Laura*, and Leonardo's *Ginevra* may be a tribute to the poetry composed by the sitter, for Ginevra was a poet.[31] Her personal emblem was the juniper which, when intertwined with the laurel of poetry, could become an emblem of her literary accomplishments. Only one feisty line of Ginevra's poetry survives — 'I ask your forgiveness and I am a mountain tiger'[32] — but it is not improbable that her achievements could have been recorded in this way. Sometimes the laurel can refer to the intellectual and poetic pretensions of the courtesan, as in Correggio's presumed portrait of Veronica Gambara in St Petersburg. Another example is the portrait of a woman, with laurel leaves behind her head, by Moretto da Brescia of c. 1540 (Fig. 136). Traditionally said to represent Tullia d'Aragona, one of the most famous sixteenth-century courtesans, the subject is also playing the role of

135. ALBRECHT DÜRER. *Two Venetian Women*, 1495. Pen and watercolor.. 29 x 17.3 cm. Vienna, Graphische Sammlung Albertina.

136. MORETTO DA BRESCIA. *Presumed Portrait of Tullia d'Aragona as Salome*, c. 1540. Brescia, Pinacoteca Civica Tosio Martinengo. Parapet inscribed: QUAE SACRVM IOANNIS/ CAPVT SALTANDO/ OBTINVIT.

Salome, underlined by the inscription on the parapet: 'while dancing she obtained the sacred head of John'. Here the laurel leaves that frame Tullia's head may complement her poetry.

Giorgione's *Laura*, like Moretto's Tullia, wears a fur-lined robe, beneath which she is nude.[33] The sensuality of the image is extraordinary. It is the first depiction in the history of art of a single bare breast nestling in fur. A fur-lined robe was a typical winter costume for courtesans ('vestida da verno, con veste foderata di bellissime pelli di gran valore'), according to one authoritative source on Venetian costume, Cesare Vecellio's *Habiti antichi e moderni* (1590).[34] Vecellio also notes that a yellow scarf was a mark of a courtesan. Laura's scarf is white, whereas a very clear example of a woman wearing a courtesan's yellow scarf is found in Giovanni Battista Tiepolo's *Woman with a Parrot* (Ashmolean Museum, Oxford).

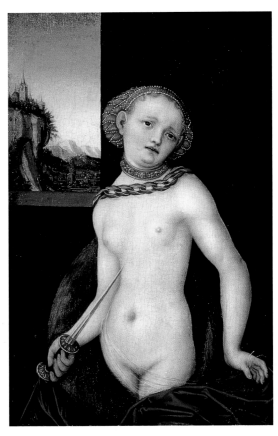

The reputation of courtesans increased by the mid-Cinquecento when their poetry, mostly about love, described in vivid and confessional tones, was first published.[35] Their rise to prominence coincided with an increase in the portraiture of women as well as courtesans in Venetian art. Even though historians cannot agree as to which portraits depict actual courtesans, Renaissance writers discussed courtesan portraits, as when Cardinal Pietro Bembo described a picture of his mistress by Giovanni Bellini in a sonnet.[36]

137. LUCAS CRANACH THE ELDER. *Lucretia*, 1530. Panel. 38 x 24.5 cm. Helsinki, Museum of Foreign Art.

There is often an intentional ambiguity about Renaissance images of women. Laura's red, fur-lined coat has been much discussed, but it has not been noticed that a similar garment appears in the work of Lucas Cranach the Elder. A small painting of *Lucretia*, acquired in 1994 by the Museum of Foreign Art, Helsinki (Fig. 137), depicts the young heroine, usually an emblem of chastity, on the point of taking her own life. Her fur-lined red coat, a somewhat more luxurious version of Laura's, has slipped down to

reveal and frame one of the most sensual bodies Cranach ever depicted. There is a considerable play between the sexuality of the image and the chastity of the heroine who committed suicide to preserve her virtue. But Cranach's depiction heightens the eroticism of the subject in provocative ways. In many of Cranach's works, he seems to have had a surprising knowledge of Giorgione's inventions, and to have understood their implications.

Giorgione's *Laura* is not a beauty, she is not seductive, she is not young. Her modernity consists in the total absence of sentimentality — an absence even more apparent in Giorgione's *La Vecchia*, which is constantly described in the earliest inventories as an image of the artist's mother. The compiler of a 1681 list of Medici paintings, previously unpublished, again describes her in this way: 'Quadro il ritratto di una vecchia di mano di Giorgione che tiene una carta in mano et è sua madre' (p. 376 below). A comparison has been made between Giorgione's figure and a Leonardo drawing of an old woman, but the veristic Venetian image is entirely independent of Leonardo.[37] Leonardo makes an ironic comment on the senility of old age, while the Giorgione portrait has a surprising verism.

THE VENETIAN TRADITION OF
EROTIC RECLINING FEMALE FIGURES

On the fifth day of Boccaccio's *Decameron*, the story of Cymon and Iphigenia is related. Cymon, a problem youth who is disinterested in women, abusive to his parents, and who hates education, sees a nearly naked sleeping beauty near a fountain, her body only lightly clothed in a diaphanous garment; whereupon his life and his very nature are transformed. The act of contemplating a sleeping woman changes Cymon from a country bumpkin to a connoisseur of beauty. From that moment on, he is committed to marriage with Iphigenia, an enterprise in which he succeeds, after many adventures, by abducting her on the high seas. Although the story purports to be about two ancient Cypriots, and was written in the fourteenth century, it is predictive of how a sixteenth-century Venetian would have looked at a painting of a nymph or sleeping Venus, such as Giorgione first created in his picture in Dresden (Fig. 139).

A sleeping Venus had never before been represented. For centuries, those who wrote about the painting claimed that Giorgione had invented a new mythological subject for the sixteenth century. Even someone as

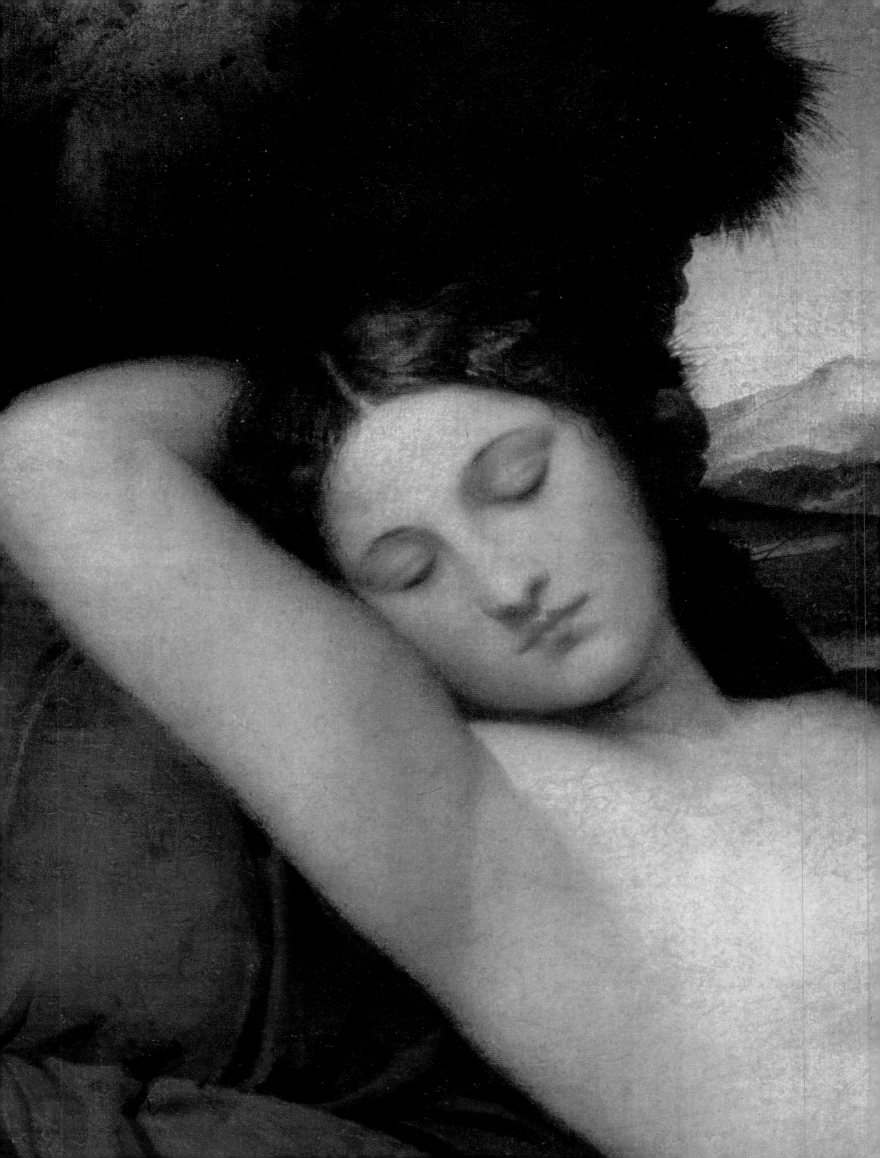

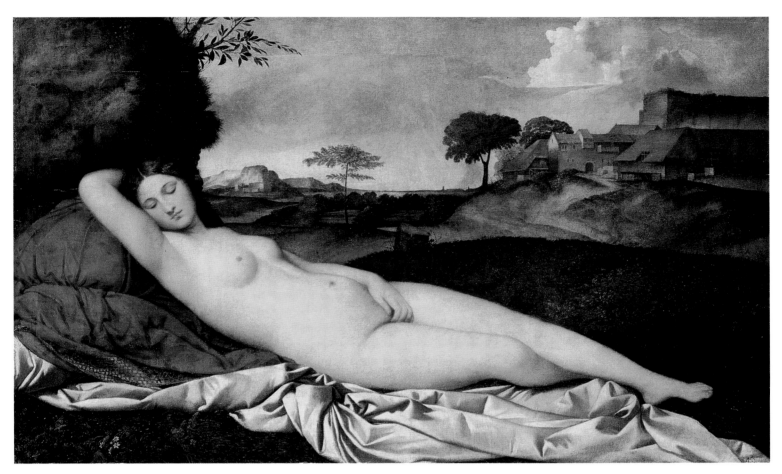

Above: 139. GIORGIONE and TITIAN. *Venus Sleeping in a Landscape*. Canvas. 108 x 174 cm. Dresden, Gemäldegalerie.
Left: 138. GIORGIONE and TITIAN. *Venus Sleeping in a Landscape*. Detail of 139.
Following double page: 140. GIORGIONE and TITIAN. *Venus Sleeping in a Landscape*. Detail of 139.

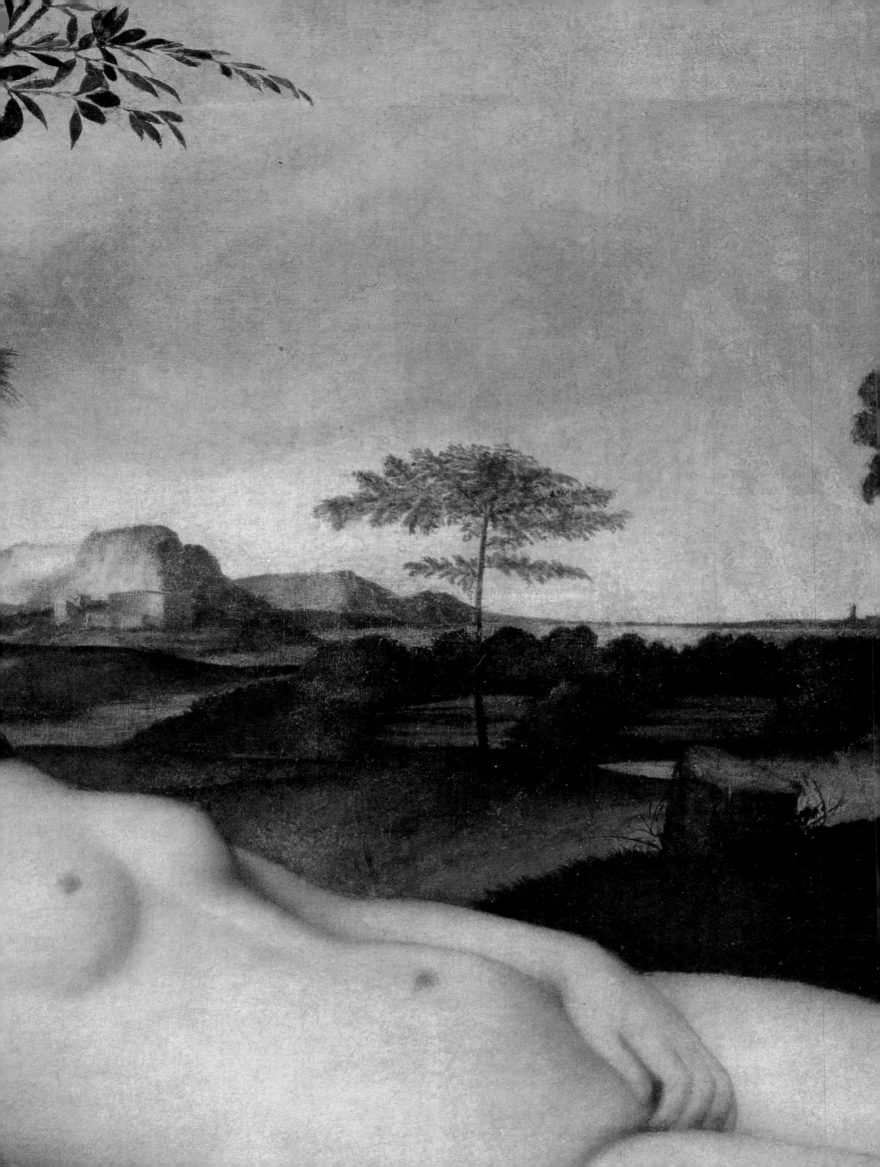

conversant with the classical tradition as Fritz Saxl proclaimed Giorgione's Venus 'startling and unclassical';[38] and he assumed that it was merely inspired by the sleeping nymph as represented in the woodcut of a fountain in the *Hypnerotomachia Poliphili* (Fig. 4). In a delightful lecture on the representation of 'Sleep in Venice', Millard Meiss went even further, maintaining that although Giorgione's painting 'was no doubt represented as a mythological subject all'antica, Venus is never represented lying asleep in Graeco-Roman art, and no such conception in ancient literature has ever been cited'.[39] It was highly symptomatic of Giorgione studies of the 1960s that no one believed Giorgione could have represented a recognizable classical subject. But not only did he depict a sleeping Venus as a monumental subject, he also introduced a metaphoric background for her body, the hills and distant rolling landscape echoing her curves (Fig. 140).

There was, in fact, an ancient literary source that described Venus as sleeping: in 399, the last of the Roman poets, Claudian, wrote an epithalamium for the wedding of two friends, which he began with a description of the goddess sleeping.[40] The epithalamium, or marriage poem, originated in antiquity as a song sung by young men and maidens before the bridal chamber.[41] As it developed in later Latin literature, the epithalamium became a kind of rhetorical panegyric whose theme was the glorification of love personified by Venus and Cupid,[42] in which form it passed into medieval and Renaissance literature. Claudian's invention of the sleeping Venus was modelled on the first of these rhetorical epithalamia, the *Epithalamion in Stellam et Violentillam* by Statius, which begins with a long description of Venus wearily resting on her couch in a bower, following the departure of Mars.[43] After Statius and Claudian, it became traditional for Latin writers, namely Sidonius Apollinaris[44] and Ennodius,[45] to begin epithalamia with an account of Venus, either sleeping or resting in her garden, a sacred landscape where spring is said to reign eternally.[46] Whilst Venus is sleeping, she is usually surrounded by a troop of cupids who play aimlessly, awaiting instruction about where to shoot their arrows. Venus' slumber is always disturbed by the god of love, who arrives bearing arms and urges his mother to a course of action. She then prepares herself for a journey to the wedding, where she will act as *pronuba*, the patroness of marriage.

Although the conceit of the sleeping or resting Venus is firmly embedded in the literary genre of the epithalamium — it occurs no less than four times in this context — Giorgione's painting cannot be consid-

ered a literal illustration of any one of the ancient epithalamia by Statius, Claudian and their imitators. To take one example. In the passage from Claudian, Venus is described as asleep on a green bank in a landscape setting, and in the heat of the midday sun has let fall her covering — all of which might be said to briefly summarize what is represented in the picture. Yet the details of the description do not correspond. There is no cave; Venus rests her head on a sumptuous red cushion propped against a bank rather than on a heap of flowers; nor is there a leafy bower of vine leaves and grapes. In some respects, Giorgione is much closer to Statius than Claudian, but even here Statius describes Venus as resting rather than sleeping. Similar points could be made about the descriptions of Venus in the epithalamia of Sidonius Apollinaris and Ennodius. Some of the details are strikingly similar, notably Sidonius' characterization of the pose assumed by the sleeping Venus as the one traditionally used to represent Ariadne when Bacchus discovered her on Naxos.[47]

141. *Venus and Cupid*. Roman topaz. Staatliche Museen zu Berlin-Preussischer Kulturbesitz, Antikenmuseum.

A more significant difference is that in each of these epithalamia Venus is surrounded by a crowd of *erotes*, whereas in the Dresden *Venus* Giorgione chose to represent only one, Cupid himself, now completely obscured by overpainting.[48] In searching for a visual formula to depict Venus, Giorgione selected the pose that is most commonly associated with the sleeping Ariadne. Nevertheless, the pose was not Ariadne's exclusive prerogative, and had been used by ancient artists to depict other sleeping beauties, notably Rhea Silvia and the numerous nymphs that adorn garden fountains. It appears, for example, on an ancient Roman topaz (Fig. 141); such a gem, or something similar, could easily have supplied Giorgione with a prototype.[49] Many of these small ancient gems, easily portable antiquities, provided inspiration for Venetian artists, who, as Vasari was only too eager to suggest, lacked ancient monuments in their own city. In antiquity a specific name was used to designate pictures of 'women at rest', *anapauomenai*,[50] as if in recognition of the easy adaptability of this languid sleeping stance to any goddess who aroused desire in the beholder.

Giorgione's rediscovery of an ancient literary theme was probably inspired by a search for a subject to celebrate a particular occasion — perhaps the marriage of his patron Girolamo Marcello to Morosina Pisani, which took place on 9 October 1507.[51] The impetus to find an epithalamic subject

connected with Venus may not only have been suggested by the role of the goddess as patroness of marriage, but also by the fact that she was the tutelary goddess of Marcello's family house. Ingenious genealogists had traced the Marcello family's descent from the Roman family of the same name, who in turn were descended from Venus, the mother of Aeneas.[52] The only precedent before Giorgione for such a subject occurs on a pair of Florentine marriage *cassoni*, where Venus is depicted in the Statian manner, resting, before the adoring gaze of a clothed mortal, the groom.[53]

Only a sketchy biography of Girolamo can be gleaned from Venetian archives. Girolamo entered the Maggior Consiglio in 1494, presented to the Senate by an august group of humanists, Bernardo Bembo, Leonardo Grimani and Girolamo Donato.[54] He married Morosina Pisani in late 1507, and fought in the war of the League of Cambrai, where Sanudo mentions him briefly;[55] at this time, Giorgione may have executed Girolamo's portrait (Fig. 13). He was appointed Censor of the Venetian Republic in 1542.[56] His only extant tax return suggests that he was wealthy.[57] Much more is known about Girolamo's distinguished brother, Cristoforo Marcello, a theologian and orator, who is famous as the author of the earliest anti-Lutheran tract in Italy,[58] of an enthusiastic panegyric to Julius II delivered at the Lateran Council,[59] and of a controversial book on papal ceremonial which Paris de Grassis tried to censor.[60] He died in 1527 at Gaeta, where he had been imprisoned by the Spanish for a huge ransom during the Sack of Rome. A very moving letter to his brother Girolamo, printed by Sanudo, describes his imprisonment.[61]

When Girolamo Marcello's son Antonio married the daughter of Piero Diedo on 23 May 1530, there was a magnificent ceremony on the Canal Grande; it took place on a ceremonial boat on which forty women danced. The event, according to Sanudo, was arranged for everyone to see ('che tutti poté veder').[62] The boat left Ca' Marcello at San Tomà, went as far as San Marco, then returned to the Rialto bridge, turned around, and at two in the morning everyone went back to Ca' Marcello to dine. Sanudo's lengthy description shows how Girolamo Marcello believed in celebrating weddings, especially that of his son, with true magnificence.

About thirty years after the Dresden *Venus* was painted, Lodovico Dolce published a curious tripartite work on marriage, which was prefaced by a lengthy dedication to Titian.[63] The first part is a summary paraphrase of the sixth satire of Juvenal, one of the most bitter and obsessive condemnations of matrimony ever written, while the third is a free verse trans-

lation of Catullus, LXIV, an epithalamium justly renowned as an epic cele-
bration of the glory of marriage (the opening lines are the source for
Titian's *Bacchus and Ariadne* in the National Gallery, London). Sandwiched
between them is a dialogue written by Dolce on how to choose a wife
and keep her chastely hidden. The masculine point of view in the debate
is given by a certain Messer Marcello, a middle-aged man who is learned
and noble ('un'huomo di buona etade, tra'l vecchio è 'l giovane nobile
sopra tutto e letterato, quanto si convenga e savio per se e per altri'). He
declines to give his first name, because women may never speak to him
again should they learn his true identity.

Giorgione's *Venus* has never been easy to understand in terms of attri-
bution, since Michiel described parts of the painting, namely the Cupid
and landscape, as having been finished by Titian. Ridolfi and Boschini also
remarked that Titian had finished the Marcello *Venus*. Since she was the
first sleeping Venus in a landscape ever painted, and hence seminal for a
new Venetian tradition, scholars have squabbled over whether the priority
of the invention should be given to Giorgione or Titian. Without dwelling
too much on the errors of the past, it may be sufficient to recall that some
scholars have even gone so far as to attribute the Venus, her features and
her body to Titian, while Giorgione has been grudgingly given some minor
role as the initiator of the composition.[64]

In 1992, the Gemäldegalerie in Dresden reexamined the painting with
modern scientific means. Giebe's analysis of the new X-radiographs,
published the same year, in conjunction with the pigment samples of the
strata, allow us to distinguish Giorgione's original conception of the *Venus*
from Titian's later additions.

The results of the investigation reveal that the conception of the figure
of Venus in a landscape originated with the picture's creation, the ground
being exactly prepared in a light colour for that part where the body of
Venus was confidently placed. With Giorgione's compositions there are often
many *pentimenti*, but here they are few, such as a slight change in the posi-
tioning of the turn of Venus' head. This suggests that the complex pose of
the figure was drawn in some way before the composition was begun. The
original paint is thicker in the body area, especially on the mounds of the
breasts and where the outline of the body is differentiated from the left
hand. Scientific photography reveals beautiful underdrawing in the land-
scape, a plain across the central background very like the one in the back-

ground of the *Tramonto* (Fig. 113). This original landscape is now obscured by overpainting, while the landscape we see on the right side is the work of two hands. The outlines of the composition of the fortress and town were devised early on. A path reaching almost to the body of Venus is now obscured with green paint. The refinement and retouching in the details of the landscape on the right side indicate Titian's hand.

One major change between the two versions of the composition concerns the white drapery. In the first version of the painting, the drapery was much more extensive, especially on the right, where Cupid sat on it; and it provided a backdrop to the goddess' feet. In Giorgione's version, the white drapery was a bed-like construction on which Venus lay in front of the landscape; whereas Titian covered up a lot of the white sheet by introducing the red drapery under Venus' head, by abbreviating the white sheet at the edges, and by increasing the grassy area. Titian also introduced a dark area behind Venus' head, to suggest that she was sleeping in a rocky bower, whereas in Giorgione's version her head was silhouetted against a clear landscape. All of Titian's alterations show that he was concerned with depicting Venus within a landscape, the forms of her body being more closely related to the landscape itself. Titian was responsible for introducing much of the green grass and the plants in the left foreground. It is difficult to be precise about his alterations to the Cupid, as this is a much damaged part of the painting, and in some instances there is nothing left of the original paint surface. It is likely that Cupid resembled another such figure in a fragment, now in the Akademie der Bildenden Künste, Vienna, who holds an arrow in one hand. The old reconstruction of Cupid holding a bird in Giorgione's painting is not confirmed in these analyses.[65]

All this confirms the reports of Michiel, Ridolfi and Boschini that there are two hands in the painting. But in what circumstances may we presume that Titian 'finished' the picture? Nothing in the technical examination shows that a particular area was left unfinished by Giorgione. One of the conclusions was that Giorgione prepared the canvas badly, which led to considerable problems. In other works, we know that Giorgione's paint layer is always very thin and chalky. Could Titian have been called in to rework the painting because of problems with its condition, shortly after Giorgione's death? In other instances, notably Bellini's *Feast of the Gods*, we know that Titian received just such a commission after Dosso Dossi had attempted (or failed) to modernize Bellini, or rather after Dosso made adjustments so that

the painting would fit in with the other paintings in Alfonso d'Este's *camerino*. The alterations to Bellini's *Feast of the Gods* have never been satisfactorily explained, but they do show Titian working in a situation we can compare to the Dresden *Venus*. In both cases, Titian was reworking a masterpiece made by one of his masters. In the case of the Bellini, Titian's alterations cannot have been made for conservation reasons. If my hypothesis is correct, then the first date for Giorgione's creation of the Dresden *Venus*

142. DOMENICO BECCAFUMI. *Venus and Cupid.* Panel. 57 x 126 cm. Birmingham, Barber Institute of Art.

would be about the time of Marcello's wedding in late 1507, even early in 1508. The date of Titian's intervention would be after 1510, and the work would have been done to conserve the painting.

Another vision of Venus lying in a landscape was executed about a decade after Giorgione by Domenico Beccafumi (Fig. 142). It was also commissioned for a matrimonial context. Beccafumi's *Venus* was made in 1519 to decorate a bedroom in the home of Francesco Petrucci at Siena. The painting was part of an elaborate bedroom decoration, of which seven panels can be identified. Two *cassoni* fronts depict the cults of Vesta and Lupercalia (Casa Martelli, Florence), while four virtuous and famous women, Martia, Tanaquilla (National Gallery, London), Cornelia (Galleria Doria Pamphilj, Rome) and Penelope (Galleria del Seminario, Venice), are the remaining heroines from a group of righteous women. The theme celebrates the virtues necessary in marriage, their meaning enunciated in Latin inscriptions. The Lupercalian rites are about fecundity, while Vesta is a goddess who protects domestic virtue. Cornelia is an exemplary mother, Penelope a model of patience and fidelity, Tanaquilla a woman who counsels, while Martia is the exemplary wife. In this virtuous company, Venus has often been thought to be the odd woman out,[66] but in fact, in her role

as marriage broker she is entirely appropriate. The context of Beccafumi's *Venus* confirms that the motif of a Venus reclining was recognized as having an epithalamic meaning. Whether Giorgione's Dresden *Venus* hung in a bedroom is not known, but Michiel does describe a nude figure by Savoldo in the bedroom of Andrea Odoni's house ('La Nuda grande destesa da drietto el letto fu de man de Ieronimo Savoldo Bressano').

After 1513, and during his sojourn in Bergamo, Lorenzo Lotto painted an extraordinary epithalamic painting of *Venus and Cupid* (Fig. 143). Lotto painted fewer mythological pictures than other artists; indeed, the novelty of such subjects for him might be characterized by one entry in his account book, 2 September 1542: 'For undressing a woman only to look . . . 12 soldi' ('per spogliar femina nuda, solo veder'). Unlike any other Venetian Venuses of the sixteenth century, the features of Lotto's goddess are individualized, so that she looks like an ancient Roman sculpture with a portrait head. Both she and her son are enjoying the humour of the situation. Cupid urinates on his mother through a wreath of myrtle, an augury of good fortune and fecundity. Nothing is known of the circumstances in which the painting was commissioned, but Lotto's nephew Mario d'Armano, who commissioned some of his uncle's mythological paintings, is named in the *Libro di spese*, Lotto's account book, as the recipient of a painting of Venus, usually identified as *Venus Adorned by the Graces* (private collection, Bergamo); he could equally have commissioned this painting. Many of the details of the iconography — the incense burner, the crown and veil that Venus wears, the shell, the rose petals scattered on her body — point to a particular marriage, perhaps one for one of Mario d'Armano's children.[67]

The invention of a sleeping Venus inspired not only generations of Venetian artists, but also created a European following, principally in Spain and Germany. Rather undistinguished variants and copies of Giorgione's prototype, attributed to Pordenone, found their way to Spain to provide a companion to Velázquez's *Rokeby Venus* and later inspired Goya's clothed and naked majas.[68] Lucas Cranach's versions of nymphs by fountains suggest that Giorgione's invention of a sleeping Venus was also known in Germany in the decade after its creation.

In a collection belonging to the brothers Franz and Bernhard von Imstenraedt at Cologne, there were recorded three works by Giorgione in 1670, one of which was a Venus in a landscape. Descriptions of the work suggest that it was a variant of the Dresden *Venus*, which also contained

143. LORENZO LOTTO. *Venus and Cupid*. Canvas. 92.4 x 114 cm. New York, The Metropolitan Museum of Art; Mrs. Charles Wrightsman Gift, 1986.

144. Lucas Cranach the Elder. *Sleeping Nymph.* Panel. 34.5 x 56 cm. Kunsthalle Bremen. Inscription: FONTIS NYMPHA SACRI SOMNIVM/NE RUMPE QVIESCO.

hunting scenes in the background.[69] The Imstenraedt *Venus* was probably destroyed by fire at the castle at Kroměříž (now in the Czech Republic), in 1752, along with almost all the collection. A version of this type of Giorgione *Venus* could well have reached Saxony as early as 1518, when Cranach created fountain nymphs with deer in the background. Cranach's deer have been seen as an attribute of Diana, denoting chastity, but they may be an echo of their lost Giorgione prototype. Cranach's nymph in Bremen (Fig. 144) lies supine on a discarded red dress. The garment is aggressively contemporary and of *haute couture* — the sleeve rendered with a degree of legibility and detail that is unparalleled in any Venetian version.[70] She also wears a flirtatious veil. Her hand is almost in the gesture of concealment of a *Venus pudica*, but not quite. It attracts the spectator, and makes no attempt to conceal what is in fact covered by a transparent veil. There is a slight suggestion of pubic hair, in the form of dark shadows in the curve of her thighs. Water from the fountain jets down. The arrows are a token of a male presence, as are the pair of quail in the foreground. Like all Cranach's erotic nymphs, this one appears to be informed by Giorgione's Dresden *Venus* as well as the famous woodcut from the *Hypnerotomachia Poliphili* (Fig. 4).

The celebration of marriage and how it is commemorated in visual form has become of the greatest relevance to the interpretation of Venetian Renaissance painting. In recent decades, marriage has replaced Neoplatonism as the key to understanding the sexuality of secular painting in Venice.[71] The validity of this approach is worth testing in relation to current interpreta-

tions of Titian's *Sacred and Profane Love* (Fig. 145). It was always known that Nicolò Aurelio, Secretary of the Council of Ten, commissioned the painting, as his coat-of-arms is prominently represented on the sarcophagus at which the two women sit. In the 1980s and 1990s, Harold and Alice Wethey first identified Laura Bagarotto's coat-of-arms in the silver bowl (Fig. 146);[72] they were followed by Charles Hope[73] and Rona Goffen,[74] both independently proposing, in a series of books and articles, that the painting celebrates the 1514 marriage of Nicolò Aurelio and Laura Bagarotti, the evidence being that both their coats-of-arms are seemingly on the painting.

Hope went so far as to identify the woman seated at the fountain as a portrait of Laura Bagarotti herself. She is dressed in a white dress, although what colour wedding dress was worn in sixteenth-century Venice is far from certain. For Sansovino, a late sixteenth-century writer, Venetian brides dressed in white and their hair flowed freely ('vestita per antico uso di bianco, et con chiome sparse giù per le spalle'), whereas, according to Sanudo, in various accounts of Venetian weddings, some wore white, but others wore a combination of white and golden embroidery ('restagno d'oro'), or even crimson velvet, like Lotto's Faustina Casotti, bride to Messer Marsilio.[75]

One of the most significant results of Anna Marcone's restoration in 1993–94 was to render the imagery of Titian's picture more legible, and to show that Laura Bagarotto's coat-of-arms on the silver bowl had never been present. Despite the problems raised by this new evidence, or rather the lack of evidence, the previous interpretations of the picture continue to inform readings of the radiographic evidence. For example, in the context of an exhibition following the conservation of *Sacred and Profane Love*, it has been argued that Titian had to rework a picture already in progress for another patron, because of the forthcoming marriage between Aurelio and Bagarotto. For this reason, he made a series of corrections on the evening of the marriage.[76]

The reason why it is so difficult to dismiss this interpretation is partly because of the romantic story of Laura Bagarotto's own life. Her first husband, Francesco Borromeo, supported the Imperial troops in 1509, and was subsequently condemned for treason and presumably executed — though the circumstances of his death are unknown. Her own family were similarly involved, her father executed for treason in 1509 at Padua. The Venetian Republic confiscated her dowry, yet somehow, against all odds, she married one of the highest ranking officials of the Venetian Republic, Nicolò Aurelio,[77] after which her dowry was released. Usually it is argued

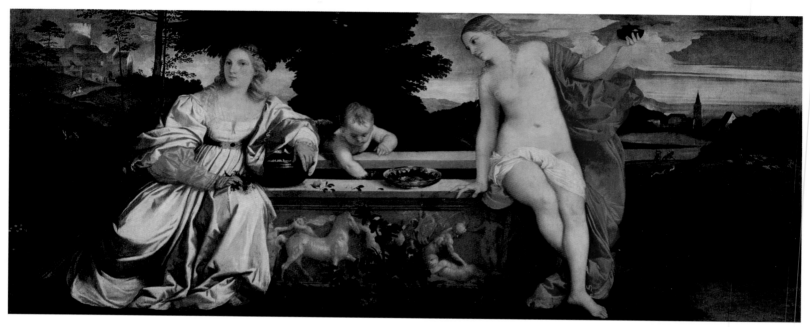

145. TITIAN. *Sacred and Profane Love*. Oil on canvas. 118 x 278 cm. Rome, Galleria Borghese.

146. TITIAN. *Sacred and Profane Love*. Detail of Cupid and the silver bowl, where some have imagined the coat-of-arms of Laura Bagarotto.

that 'Aurelio himself could not have afforded this painting; only Laura Bagarotto's dowry can have paid for it'.[78] Yet it is Aurelio's coat-of-arms which is depicted so prominently on the painting, not Laura's. Nor is it difficult to see Aurelio as the *commitente*. In the transcriptions of the documents relating to Giorgione's frescoes on the Fondaco dei Tedeschi, Nicolò Aurelio is always the signatory. In his role as Secretary to the Council of Ten, he was at the least conversant with the public patronage of the Venetian state, in which capacity he certainly met Titian, who could well have supplied him with an original composition for what Italians call 'prezzo d'amico'. But as Secretary to the Council of Ten, he could also have played a considerable role in the public patronage of the Venetian Republic, an interpretation which seems justified by his commission to Titian of such an important painting. After all, according to no less an authority than Sansovino, Aurelio was a man of great learning ('persona di molte lettere'). One most significant detail, the black band along the margins of the painting, of unequal dimensions, was added by Titian himself — to make the painting fit a particular space, hanging high on a cornice or placed above a bed as a *spalliere*. Whatever conclusions are reached about the interpretation of this famous Renaissance painting — and much remains to be discovered — the role of Aurelio as patron should play some part in their elucidation. Aurelio's taste was initially formed by Giorgione's large nudes on the Fondaco, well before he met Laura. The revolution that Giorgione began with his imagery of women came to fruition in this magnificent composition by Titian, which has antecedents in Pietro Bembo's innovatory dialogue on the nature of love, *Gli Asolani*.[79]

Chapter
VI

Giorgione's Critical Fortunes and Misfortunes

During the eighteenth century, Giorgione's reputation was not only subject to misinterpretation but, more seriously, his works were sometimes misplaced, or lost, or on occasion altered to fit new systems of framing. Between 1772 and 1782, a number of paintings attributed to Giorgione, some engraved by Teniers, disappeared from the Imperial collections at Vienna. The 1772 inventory of Schloß Stallburg,[1] describes them, but Mechel's catalogue of 1782 does not.[2] How could such well-documented paintings disappear at such an advanced stage in the history of collecting, and why has it hardly been remarked upon ever since? In 1765, Empress Maria Theresa sent from Vienna to the castle at Bratislava a number of paintings to decorate the castle where her daughter and son-in-law, Archduchess Marie-Christine and Archduke Albert, Prince of Saxony and Teschen, were to become governors. Later consignments of works of art were sent back and forth between Vienna and Bratislava, and finally a large number went to the Royal Castle at Buda (Hungary), some inventoried, others not. Some of these paintings were later to return to Vienna. In this process, a group of paintings, all very plausibly by Giorgione, such as the *Self-Portrait as Orpheus* (pp. 317–18 below), the *Judith* (Fig. 123), the painting known as *The Rape* (pp. 316–17 below), and the *Rape of Europa* (Fig. 150), all disappeared from the Imperial collections, leaving only a trace of their former presence in the Teniers engravings.

Maria Theresa occupies a very special place in the history of collecting because she had little respect for the original physical context of a painting. It was she who first had the idea of creating museums by suppressing monastic institutions and taking their works of art to form new galleries. In this practice, she was later imitated by Napoleon in Italy and, after Italian unification in 1866, by Italians themselves. Most of all, she was responsible for the new galleries at Schloß Stallburg, at which time Giorgione's paintings, as well as many other Italian Renaissance masterpieces, were wilfully altered to fit a new framing installation. For example, the portrait of Laura was converted into a roundel (Fig. 151), while the *Three Philosophers* (Fig. 49) lost a third of its surface. Her actions were considered an act of gross vandalism by European artists and collectors, but especially by Count Francesco Algarotti, who expressed his views in a letter to Jacopo Barolommeo Beccari in Bologna on 10 August 1756: 'I know very well what the government has

Page 234: 147. GIORGIONE. *Castelfranco Altarpiece.* Detail of Fig. 84.

Above: 149. DAVID TENIERS THE YOUNGER. *The Picture Gallery of Archduke Leopold Wilhelm.*
Canvas. 123 x 163 cm. Vienna, Kunsthistorisches Museum.
Left: 148. DAVID TENIERS THE YOUNGER. *The Picture Gallery of Archduke Leopold Wilhelm.*
Detail showing Giorgione's *Three Philosophers*, in the upper left corner, before it was cut.

150. DAVID TENIERS THE YOUNGER, after Giorgione. *Rape of Europa*. Oil on panel. 21.5 x 32 cm. The Art Institute of Chicago.

done to the Titians in the Gallery at Vienna. Would you believe that in order to accommodate them to the shape of their bizarre frames, they have added pieces to the paintings, and cut bits from others? *Quaque ipse miserrima vidi*'.[3] There were earlier precedents for such behaviour in the sixteenth and seventeenth centuries, when collectors became obsessed with decorative schemes and pictures were accordingly modified, enlarged or cut, and sometimes mutilated in the interests of the general appearance of the framing in a gallery.[4] A famous example is provided by Leonardo's *Mona Lisa*. When she was in the French royal collection, probably during the reign of Louis XIV, the painting lost two classical columns that originally flanked the portrait and were especially important for the landscape background.[5]

151. Right: DAVID TENIERS THE YOUNGER, copy of *Laura*; far right: the original in an oval eighteenth-century frame.

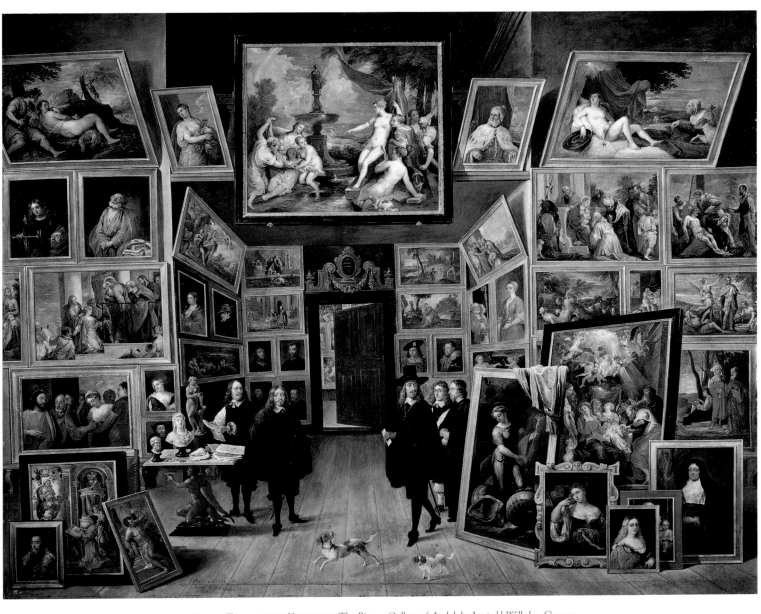

152. DAVID TENIERS THE YOUNGER. *The Picture Gallery of Archduke Leopold Wilhelm.* Canvas.
106 x 129 cm. Madrid, Museo del Prado.

ANTONIO CANOVA'S FORGERY OF A GIORGIONE

Biographers of Canova relate that about 1792, the sculptor forged a Giorgione self-portrait to deceive his Roman friends, having been inspired by a similar (but unspecified) forgery produced in Venice a few years earlier. Canova had the idea of playing a comparable joke when his friends were reading to him a passage in Carlo Ridolfi's *Maraviglie* (1648) about a Giorgione self-portrait in the Widmann collection, Venice. (Ridolfi actually refers not to a self-portrait, but to paintings of Ovidian fables by Giorgione, then in the possession of the Signori Widmann.)[6] Canova then bought a sixteenth-century canvas of a *Holy Family*, scratched away the surface, and painted a Giorgione self-portrait, imitating the style of the master from Castelfranco. Canova was aided by his friends, the Princes Rezzonico and d'Este: Rezzonico announced to their Roman circle that his nephew, a member of the Widmann family, had had a Giorgione self-portrait restored. His nephew had decided to send it to Rome to be evaluated at one of the dinners they enjoyed with artists and writers. Two weeks later, at a dinner attended by Angelica Kauffmann, Gavin Hamilton, Giovanni Volpato, Gian Gherardo dei Rossi, the painter Cavallucci and a celebrated picture restorer, Burri, the Prince d'Este brought in a sealed and dusty box. The canvas was unpacked, and there was a definite roar, 'Giorgione, Giorgione, Giorgionissimo'! Only Burri questioned the validity of the attribution, because he could see a defect in the restoration of the right eye of the sitter. Canova arrived late, and pronounced that it seemed to him a good picture, but that he knew nothing about painting; if only it were a sculpture then he could make a judgement. Dei Rossi, director of the Portuguese School in Rome, asked permission to have a copy made by a Portuguese artist. Permission given, the copy was sent to Lisbon, while the original remained in Prince Rezzonico's possession; Rezzonico left it in his will to dei Rossi as a memento of the prank.[7] Canova's forgery has disappeared, and the collection of Gian Gherardo dei Rossi is now dispersed.[8]

153. DAVID TENIERS THE YOUNGER. *The Picture Gallery of Archduke Leopold Wilhelm*. Detail of Fig. 152, showing Giorgione's *Laura* and the Budapest *Self-Portrait*.

THE ANONYMOUS JOURNALIST OF THE *QUOTIDIANO VENETO*, 1803

On 2 December 1803, an anonymous journalist wrote an article on the *Castelfranco Altarpiece* (Fig. 84) for the *Quotidiano Veneto*, in which he invented the story that the painting was commissioned by Tuzio Costanzo in 1504 to commemorate the death of his son Mattheo, whose tomb, inscribed

with the date, was in the Costanzo chapel in San Liberale. The journalist stated that the saint in armour (Fig. 154) was a portrait of Mattheo, and that the altarpiece was placed in an architectural relationship with the tomb, the Virgin looking down mournfully at the departed youth. He also affirmed that there was a romantic inscription on the reverse, in which Giorgione declared that he was waiting impatiently for his mistress Cecilia: 'Vieni, vieni, Cecilia t'aspetti'. The inscription to Cecilia has never been found, and no twentieth-century art historian would seriously entertain that it ever existed, or that the saint was really a portrait of Mattheo. Yet the other romantic suggestion — that the altarpiece was commissioned by Tuzio for Mattheo — still lingers on, despite the discovery of Tuzio Costanzo's will,[9] where it is clearly stated that Mattheo's tomb was placed high on the wall of the chapel, not on the ground where the Virgin's eyes would have fallen. By the time the article was published, the ancient church of San Liberale, for which the altarpiece had originally been made, had been replaced. The location of the tomb the journalist saw was what we see today, not the original setting. The local journalist does not appear to have considered that Mattheo's burial in the chapel presupposed the chapel's prior completion.

155. Mauro Pellicioli during the 1934 restoration of the *Castelfranco Altarpiece.*

In nineteenth-century Venice, Italian scholars such as Giovanni Morelli and Giovanni Battista Cavalcaselle attempted to establish Giorgione's identity more securely. At Castelfranco in the second half of the nineteenth century, a statue of Giorgione by Augusto Benvenuti was erected at a corner of the castle. Giorgione is depicted in Quattrocento costume, just like one of Carpaccio's youths, long hair escaping from his beret, his head raised in observation, a pencil in one hand, a palette in the other. There were attempts by Urbani di Gheltof to locate the house of Giorgione, which had been mentioned by Ridolfi as being in Campo San Silvestro,[10] but they have failed to convince, and we have no real idea where Giorgione's studio was in Venice.

Far left: 154. GIORGIONE. *Castelfranco Altarpiece.* Detail of Fig. 84.

■

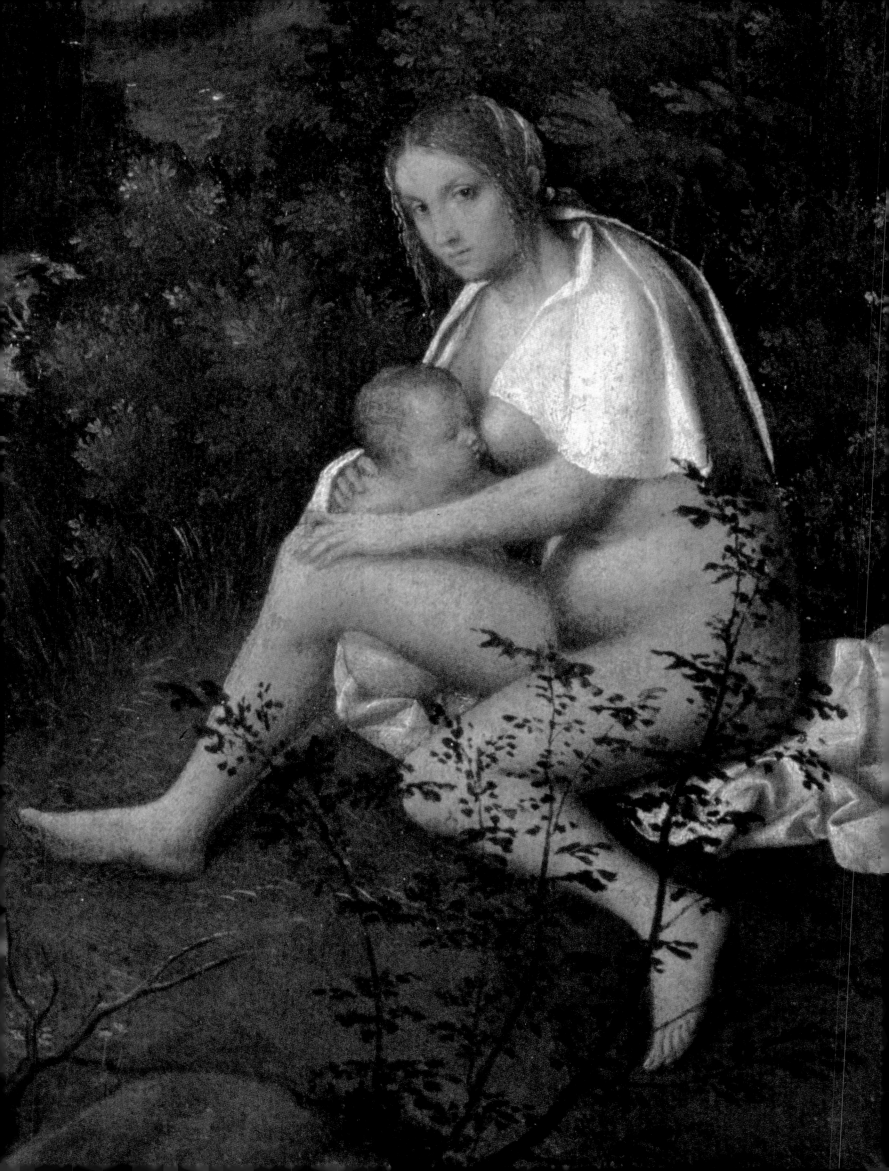

LORD BYRON'S TEMPESTA

Giorgione's images of women have elicited more comment than those of any other Venetian artist, yet it has only recently been realized that the earliest modern writer to pen an appreciation (though an eccentric one) of the enigmatic woman in Giorgione's *Tempesta* (Fig. 108) was Lord Byron (Fig. 157).[11] Despite Byron's avowed dislike of all Renaissance painting, his fascination with Giorgione is expressed in his descriptions of the most visited private collection in nineteenth-century Venice, the Manfrin Gallery,[12] where there was a painting then called the *Family of Giorgione*, which we know as the *Tempesta*. On 14 April 1817, in a letter to his publisher John Murray, Byron wrote: 'What struck me most in the general collection [i.e., the Manfrin Gallery] was the extreme resemblance of the style of the female faces in the mass of pictures — so many centuries or generations old — to those you see and meet everyday amongst the existing Italians. — The Queen of Cyprus and Giorgione's wife — particularly the latter — are Venetians as it were of yesterday — the same eyes and expression — and to my mind there is none finer. — You must recollect however that I know nothing of painting — and that I detest it — unless it reminds me of something I have seen or think it possible to see — for which [reason] I spit upon and abhor all the saints & subjects of one half the impostures I see in the churches & palaces — & when in Flanders I was never so disgusted in my life as with Rubens & his eternal wives & his infernal glare of colours'.

In September and October of the same year, Byron wrote his poem about the Venetian carnival, *Beppo*, and was still enchanted by 'Giorgione's wife' (Fig. 156) and by the notable lack of idealism with which she was represented. His extraordinary poem is the first modern exegesis proposed

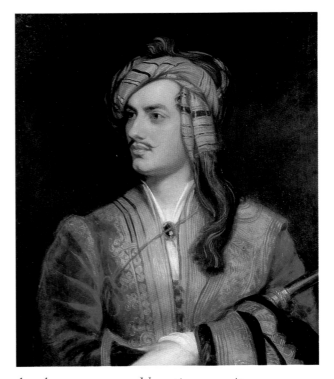

157. THOMAS PHILLIPS. *Portrait of Lord Byron*. Canvas. 76.3 x 63.9 cm. London, National Portrait Gallery.

Far left: 156. GIORGIONE. *The Tempesta*. Detail of Fig. 108, the woman Byron thought was Giorgione's wife.

for the picture, and he wrote it in the belief that it really represented Giorgione's own family:

> And when you to Manfrini's palace go,
> That picture (however fine the rest)
> Is loveliest to my mind of all the show;
> It may perhaps be also to *your* zest,
> And that's the cause I rhyme upon it so,
> 'Tis but a portrait of his son, and wife,
> And self; but *such* a woman! love in life!
>
> Love in full life and length, not love ideal,
> No, nor ideal beauty, that fine name,
> But something better still, so very real,
> That the sweet model must have been the same;
> A thing that you would purchase, beg, or steal,
> Wer't not impossible, besides a shame:
> The face recalls some face, as 'twere with pain,
> You once have seen, but ne'er will see again. . .

Not all visitors to the Manfrin Gallery were convinced of the value Byron placed on the painting. One nineteenth-century traveller, a numismatist and antiquary who visited Italy in 1851 with Byron's poetry as his unconventional guidebook, professed to disagree. He was an English minister, the Reverend Henry Christmas, and wrote: 'I cannot echo the opinion of Lord Byron on the picture by Giorgione in the Manfrin palace. He speaks most enthusiastically of it. . . . This picture represents Giorgione himself in a dress somewhat brigand-like, looking on his wife and child, dressed in — nothing at all. It is beautifully executed, and there is much loveliness in the female figure, seated on the ground, but the face is in no wise remarkable for expression'.[13] Byron's fascination with Giorgione continued and was to leave an even more permanent legacy in England. In a letter of 26 February 1820, Byron encouraged William John Bankes, a friend from his undergraduate days at Cambridge who was putting together a collection at Kingston Lacy, Dorset, to buy Sebastiano del Piombo's *Judgement of Solomon* (Fig. 77), then firmly attributed to Giorgione: 'I know nothing of pictures myself, and care almost as little; but to me there are none like the Venetian — above all, Giorgione. I remember well his *Judgement of Solomon* in the Marescalchi [Gallery] in Bologna. The real mother is beautiful, exquisitely beautiful. Buy her, by all means, if you can, and take her home with you: put her in safety'. In point of fact, Bankes had already bought the painting a month earlier on his own judgement,

as a receipt for 11 January 1820 in the Bankes papers confirms.[14] Bankes later continued to buy works he believed to be by Giorgione, but with less success, such as a ceiling painting now at Kingston Lacy, which hangs above the marble stairs (p. 328 below). The octagon has optimistically been attributed to Giorgione, working with Giovanni da Udine, since Bankes bought it from the Palazzo Grimani at Santa Maria Formosa, Venice, where there had been other works by Giorgione described in the Grimani *studiolo* by Vasari.[15]

Byron was not an attentive reader of Vasari, but his contemporaries were, particularly those producing the first scholarly editions of the *Lives*. Some realized that the *Family of Giorgione*, the traditional title of the *Tempesta*, did not make sense with the artist's biography, for Giorgione was not known, unlike Byron, to have ever been married. Some visitors to the gallery — like the Scottish artist Andrew Geddes — were confused, and suggested that the picture described by Byron was not in fact the *Tempesta*, but a rather undistinguished Titian School painting, a triple portrait, now at Alnwick Castle, which Geddes copied.[16] There were in fact a number of works attributed to Giorgione in the Manfrin collection and travellers' references were often imprecise.[17] But there can be no doubt that the painting Byron described was the *Tempesta*, for the following reason. In the 1850s, the London National Gallery as well as the Gemäldegalerie in Berlin were offered the Manfrin collection intact for a very small sum of money. All declined it, but the travelling agent of the gallery, Otto Mündler, describes the painting of the *Family of Giorgione* with the exact measurements of the *Tempesta*, and he was preparing a careful evaluation of the collection rather than writing an impressionistic travel guide like the other sources for the Manfrin collection.[18]

At least a decade earlier, museums had become interested in the acquisition of the *Tempesta*. On 25 October 1841, Gustav Friedrich Waagen, on a picture buying trip to Italy for Berlin, wrote from Venice to the general director of the Prussian museums, Ignaz von Olfers, concerning his experiences with the Manfrin collection at Palazzo Venier, Cannaregio. At that date, the Manfrin collection was owned by Countess Julie-Jeanne Manfrin Plattis, who had inherited it from her brother Pietro Manfrin, who in turn had been left the collection by his father Girolamo Manfrin, a self-made millionaire who had accumulated a fortune from tobacco holdings in Dalmatia. She wished to sell all the paintings in the collection

together, and would not agree to give Waagen only the two Giorgiones and Titian that he wished to buy. She had made an exception for the Prince of Orange, whom she had allowed to buy a single painting of a Magdalen. Waagen reported with his habitual cynicism that Plattis was old and rich, and her heirs thought quite differently about how the collection should be sold, so the situation could change with time.[19] (Waagen was unsuccessful in his efforts to purchase the three pictures. He then went to see a Giorgione in the Monte di Pietà, Treviso, about which Passavant had enthusiastically informed him in conversation and letters. Waagen found it ineligible and disappointing, a misguided attempt to imitate Bellini with strong foreshortenings.)[20] The Swiss painter Charles Gleyre made a copy of Giorgione's *Tempesta* when he was in Venice between October and November 1845, which he inscribed as by 'Georgione', a copy that he can only have made after the original.[21] Although it has been argued by Francis Haskell that the *Tempesta* was lost sight of between 1530 and 1855,[22] it is now apparent that it was in the public domain from the moment it entered the Manfrin collection around 1800. By the time Burckhardt mentioned the painting in the *Cicerone* (1855), Giorgione's *Family* was well known to enthusiasts of Byron's verse, and to artists, connoisseurs and international museum directors.

For most of the nineteenth century, the *Tempesta* remained in the Manfrin collection, one of the most celebrated private galleries, referred to in every guidebook and visited by almost every traveller to the city. For several decades, however, the newly forming national galleries declined to buy it, apparently because the subject did not appeal and because of the painting's condition. It was considered a ruin and very overpainted by an earlier restorer. Gleyre's copy does not tell us as much about the condition of the work as we should like to know. Sir Charles Eastlake, the first director of the National Gallery in London, reveals in his travel diaries that he did not like the work and rejected it for the National Gallery, while his contemporaries, such as Sir Austen Henry Layard, realized that not buying the entire Manfrin collection was one of Eastlake's greatest mistakes.[23] Mündler was also disparaging about the quality of the *Tempesta* and recorded that some thought it was by Savoldo.

The correspondence of the great connoisseur, patriot and politician Giovanni Morelli reveals that he had successfully persuaded a number of English collectors *not* to buy the picture, for he believed it

was a masterpiece that should remain in Italy. On 25 May 1871, for example, he wrote to Sir James Hudson: 'The little picture on canvas by Giorgione (at least that is what the connoisseurs call it) is now for sale in the Manfrin collection, Venice. . . . It is a very beautiful thing, nor is the state of conservation too bad, but the price that they have asked, Lire 30,000 is exaggerated. . . . The subject of the painting is too intellectual for people, and then it is a little picture that would never be appreciated except by true connoisseurs'.[24] Hudson took Morelli's advice and bought instead a less intellectual painting, a portrait by Moroni, known as the *Gentile Cavaliere*, now in the National Gallery, London. Morelli's statement is the first occasion when the subject of the *Tempesta* is referred to as 'intellectual', the first recognition of the ambiguities of interpretation that would follow. Although Morelli may have successfully dissuaded British collectors and museum directors from acquiring the painting, the Germans reentered the international arena of collecting in 1872, with museum directors who were not artists, but art historians possessed with a more eclectic taste.

In his autobiography, Wilhelm von Bode gives a dramatic account of the Berlin museum's failed attempt in 1875–76 to acquire the *Tempesta*.[25] Still in the Manfrin collection and available for a mere 27,000 lire, the painting was reserved for Berlin; but, according to Bode, Giovanni Morelli (still trying to keep the painting in Italy) bribed the Italian banker acting on behalf of the Berlin gallery not to release the money for payment until after the contractual date had expired. In the version of the story told in his autobiography, Bode exaggerates the importance of his own role in negotiations for Berlin at this date, to the detriment of his superior Julius Meyer, a man of self-destructive instincts who, although director of the Gemäldegalerie from 1872 to 1890, allowed himself to be written out of history, subsumed by Bode's massive ego.[26] The letters and telegrams exchanged between Berlin and the Prussian commissioners in Venice, now available in the Berlin museum's central archives, reveal a slightly different story, in which Bode emerges as being rather sceptical that the painting was worth acquiring in view of its bad condition (just like Eastlake), while his superior Meyer was responsible for the negotiations, pursued enthusiastically with two Venetian intermediaries, Girolamo dalla Bona and Count Sardegna, presumably agents for the Manfrin heirs.[27]

On 11 May 1875, Bode wrote from Florence to the general director of the Prussian royal museums, Count Guido von Usedom, to report on

important works that were to be offered for sale, among which was Giorgione's *Family in a Landscape*, as he called the *Tempesta*. This painting had not been sold, according to Bode, because it was strongly overpainted, and it was not clear what was underneath the overpainting. Moreover, it was expensive, and the Dresden Gemäldegalerie was considering acquiring it.[28] On 9 October 1875, Bode wrote again to Usedom from Brescia. He reported that Meyer was to travel to Venice in order to see Giorgione's *Tempesta*, which would shortly be sold to a rich Russian count. The cost was only 150,000 lire for the *Tempesta* and other paintings in the Manfrin collection, but Bode thought little of the collection, while Giorgione's *Tempesta* he described as a ruin. Bode's letter belittles Meyer's judgement,[29] but Meyer was still determined to have the painting, increasingly becoming aware of the picture's haunting beauty. A telegram on 10 October 1875 from Julius Meyer advises Usedom that the Giorgione in the Manfrin collection is still available. Again on 25 October, Meyer in Florence wrote to Usedom that the Giorgione in the Manfrin collection was still unsold, and described the beauty of the landscape, thereby making a passionate plea for the acquisition of the work. He referred to two important discussions of the painting in the newly developing art historical literature, the first by Crowe and Cavalcaselle in their *New History of Painting in North Italy* (II, pp. 135–37), and the second in an 1866 essay by H. Reinhart, which reproduces the *Tempesta* in an engraving after a drawing by Reinhart himself. Meyer enclosed with his letter a photograph (now lost) of the painting, which he explains fails to render the deep tone of the picture, although the aerial perspective and the beauty of the landscape is recognizable. The asking price had become reasonable in view of the picture's condition, which had had an 'italienische Restaurierung', by which Meyer meant a repainting.[30]

Usedom, whose appointment was political rather than art historical, was unimpressed, and replied by telegram that Baron Schack had told him that in the winter the Giorgione could be had for a mere 15,000 francs. On 23 November, Meyer sent a telegram to Usedom informing him that he had offered 25,000 lire. A flurry of telegrams followed between Usedom and Meyer and Bode, in which a purchase price of 27,000 lire was agreed to on 22 December 1875, with a gratuity of 1,000 lire to be given to the agent in Venice, Girolamo dalla Bona. Negotiations eventually failed because Usedom, reluctant to pay the sum, was slow to make the money

available. Morelli's name is not mentioned in the Berlin documents, but in April 1876, the German artist Friedrich Nerly was asked to find out why the painting had not been sold to Berlin; his investigations revealed that Morelli had persuaded one of his Venetian friends, Prince Giuseppe Giovanelli, to buy it.[31]

Giuseppe Giovanelli acquired the picture and it was shortly afterwards restored by Luigi Cavenaghi, at Morelli's suggestion, for both were in charge of the Giovanelli collection. The collection was located in the Palazzo Giovanelli (formerly Donà), a distinguished fifteenth-century Gothic building near the church of Santa Felice.[32] Morelli described Giovanelli's acquisition of the *Tempesta* in a letter of 16 January 1876, from Rome, to his lifelong friend Sir Austen Henry Layard:[33] 'My government, having learnt from Mr Barozzi that Prussia wished to buy paintings by Giorgione from the Manfrin collection, begged the Prince Giovanelli to forestall the Prussian delegates, to secure the picture for the gallery in Venice. Giovanelli, then bought the picture for 30,000 pounds — now it is in the hands of Cavenaghi, who has already cleaned it, and finds it in a much better state of conservation than expected. But the price was too high'. Layard replied that the 'Italian government [in whose interests Morelli was acting] has bought the little Giorgione in the Manfrin palace, although they paid too much for it. Under the able hands of Cavenaghi, something will emerge and paintings of this great master are so rare in Italy that no one could allow a painting by an artist to pass into other hands, whose authenticity was accepted by all the best authorities'.[34]

At Giovanelli's death, Morelli commented to Layard in a letter from Milan, dated 12 September 1886: 'He has suffered enough and I am happy to hear of his death. He was a good man who did much for his country. Poor people in Venice will feel his loss. I hope that he will have left his collection to the Accademia in Venice, where he was President'.[35] He was quite unprepared for Giovanelli's will, as is shown by his letter to Layard of 6 October 1886: 'Prince Giovanelli's will is a gross scandal, and everyone is indignant about it. Have you read it? Those, who do not belong to his religion may not attend his funeral; he leaves everything to his adulterous son; nothing to the friends who cared for him during his last illness, no pension to his dependants, nothing to the academy — a paltry sum to the poor. I would not have realized that the Prince was such a bigot or so despicable!'[36]

The *Tempesta* remained in the Giovanelli palace, out of sight, but very much in the minds of ambitious collectors, such as Mrs Isabella Gardner, who wrote to Berenson of her dream to possess the Giovanelli Giorgione. 'It is presumably in that shut up Palace in Venice. Disagreeable, very disagreeable people own it. But perhaps they are not entirely dogs in the manger and might be willing to let me pull out that beautiful plum'.[37] Eventually, in 1932, the *Tempesta* came to the Accademia in Venice, where it has become one of the most discussed paintings of the twentieth century.

OTHER GIORGIONES IN THE NINETEENTH CENTURY

Even if the *Tempesta* was not to be had, other paintings by Giorgione were available on the nineteenth-century art market, and a significant group, now in the Museum of Fine Arts, Budapest, were acquired by a Hungarian bishop: Johann Ladislaus Pyrker (1772–1847), who first visited Venice at the age of fifteen and who later returned to become Patriarch of Venice. He had considerable opportunities to acquire paintings, including the *Broccardo Portrait* (Fig. 158), and the fragment depicting two shepherds from the *Finding of the Infant Paris* (p. 323 below), both now in Budapest. In his biography, he mentions his friendship with Cicognara and many Venetian painters and dealers, on whose advice he presumably acquired these pictures.[38]

A significant group of problematic Giorgiones, such as the Bergamo *Madonna and Child* (p. 322 below) and the Borgherini double portrait in Washington (Fig. 89), were in the collection of Francis Cook (1817–1901) and his grandson Sir Herbert Cook (1868–1939), who wrote a book on Giorgione which inspired the term 'Pan-Giorgionesque'. The collection was housed at Doughty House, Richmond, south of London. Some works by Italian painters were acquired in Rome in the 1840s, but the majority of Cook's collection was bought for him by J. C. Robinson (1824–1913).[39] The collection was broken up in the 1940s, and the magnificent Titian portrait, misidentified by Cook as Giorgione's long-lost portrait of Caterina Cornaro, was bequeathed to the National Gallery, London.

Robinson worked during Sir Henry Cole's directorship as the super-intendent of the art collections of the South Kensington Museum, now the Victoria and Albert Museum. He is today idolized within the history of collecting because he bought a very great collection of Italian

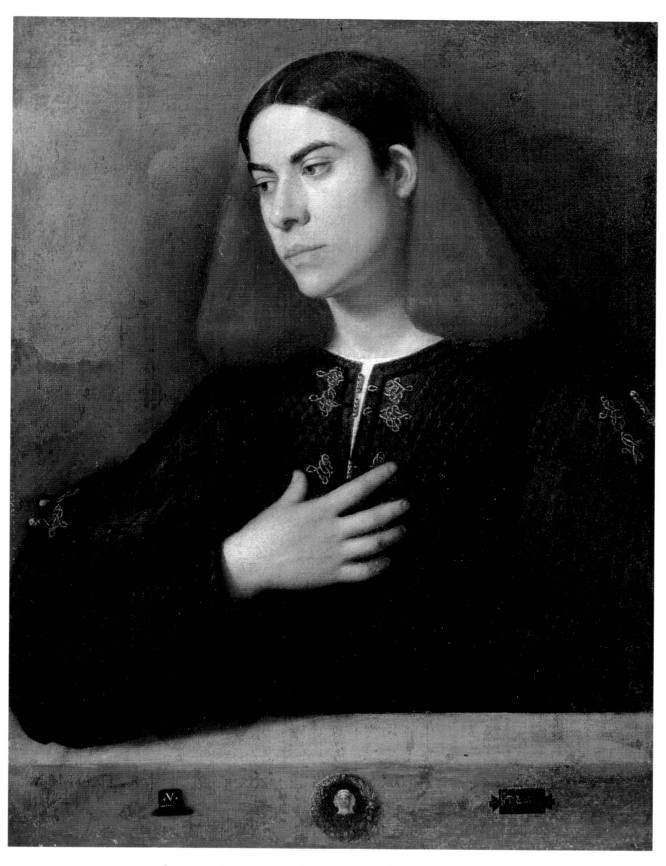

158. GIORGIONE. *Portrait of a Young Man (The Broccardo Portrait)*. Canvas. 72.5 x 54 cm.
Budapest, Szépmüvészeti Múzeum.

Renaissance sculpture for a London museum, in advance of the formation of sculpture museums. However, despite the fact that he worked for a national museum, he continued to buy and sell for many private clients, which was unusual (but not unknown) among British museum men, and this brought him into constant conflict with Cole, who as director was publicly accountable. An example of how Layard judged Robinson is given in the following letter to Sir William Gregory, an Irish politician and fellow trustee of the National Gallery, with whom Layard often acted: 'Robinson is a clever and active little fellow — but I have very little faith in his judgement and he is the last man I should like to see as sole referee at South Kensington. He is now, I think, doing himself much harm by running down and disparaging all that is purchased for the Museum unless he is the author of the purchase. This is not wise or just — and has lowered him a great deal in the estimation of those who know his good qualities and would have willingly supported him to a considerable extent if not in all his pretensions'. Robinson was eventually dismissed, and became surveyor of the Queen's collection, where he continued to deal.[40]

GIORGIONE CONTROVERSIES RELATING TO NATIONAL MUSEUMS

In England and America in the 1930s, national collections were created by art historians, and with this novel phenomenon in the history of collecting there came considerable changes. Significant controversies occurred concerning the acquisition of a number of Giorgione paintings when they were being considered for national collections. These examples provide material — at least in two cases — about one touchy subject in art history, that is, of the relationship of the art market to art history, and of art historians' involvement in the art market. The first example concerns the *Allendale Adoration* (Fig. 52) and Joseph Duveen's sale of the picture in relation to the opinions given by art historians.

Duveen (Fig. 162) was rightly convinced of Giorgione's authorship of the *Allendale Adoration*, which he wanted to purchase in 1937 from Lord Allendale for £60,000.[41] Although in a private collection, the painting had been frequently discussed and often exhibited, notably at the Royal Academy in 1873, 1892, 1912 and 1930. As was his habit, Duveen consulted a number of leading art historians who specialized in Venetian painting:

Detlev von Hadeln, August Mayer, George Martin Richter, Lionello Venturi, Wilhelm Suida, and Georg Gronau. All these scholars, whose books are still authoritative, agreed with Duveen, and wrote *perizie* in favour of the attribution; in addition, Gronau consented to write an article on the attribution of the painting for *Art in America*.[42] Richter had published the painting in his monograph in 1937, not as a Giorgione, but 'by an assistant who had originally been a follower of Giovanni Bellini';[43] he later revised his opinion, with some encouragement from Duveen.[44]

Duveen's only problem, and it was a considerable one, was with his principal adviser, Bernard Berenson, who obstinately stated that the picture was by Titian, and affected to despise the excellent authorities whom Duveen had consulted. The tension became so extreme that Berenson refused to see him, and on 7 August 1937 wrote: 'If I do not take the greatest care I shall have a complete breakdown. In the present state I must not see anyone on business, no matter how pressing. I must not even see you. Still less am I in a condition to go into a question so supremely delicate as the authorship of the *Allendale Nativity*'. Two days before, Duveen had bought the painting with the expectation of selling it to Andrew Mellon. However, Mellon died on 17 August, and the picture was shipped to Paris, to be cleaned by the Swiss restorer Madame Helfer-Brachet, and then photographed.

Berenson's narcissistic opinion of his own role in relation to Duveen's firm, and to the art market, is conveyed in a letter from his personal assistant, Nicky Mariano, to Duveen's associate, Edward Fowles, written on 7 September 1937 from Poggio allo Spino, Florence: 'In the thirty or more years in which B.B. has been the adviser of the Firm, Lord Duveen has always flattered him into feeling that for him, Lord Duveen and for his clients there was only one authority, his, B.B.'s. B.B. does not choose to climb down at the end of his career from that height and to submit to the opinion of critics whose competence he respects no more than he and Lord Duveen's clients have respected it hitherto. If, therefore, Lord Duveen insists on selling the Allendale picture as a Giorgione on his own authority or on that of other critics, B.B. no longer sees any reason for retaining his position as the adviser of Lord Duveen. It would be utterly below his self respect let alone his dignity to be kept as a pet and not as an unquestioned authority. Lord Duveen by doing this leaves B.B. no alternative but

to offer his resignation, to take effect within the terms of their agreement in six month's time. B.B. begs me to add that this of course will happen on his part with the friendliest feelings.'

Mariano's letter reveals Berenson's naïveté in relation to the brilliance of Duveen's manipulative techniques and very real knowledge of art, and his calculated reliance on the best experts in Venetian paintings, who despite any financial remuneration received, were still the best judges of the attribution. As Berenson was being difficult, Duveen asked Kenneth Clark (Fig. 161), then director of the National Gallery, London, for his opinion, also in the hope that the Gallery might acquire it. Clark had earlier attributed the painting to Titian's follower Polidoro Lanzani.[45] On 6 October 1937, Duveen sent a cablegram to New York: 'Mr and Mrs Kenneth Clark seen Giorgione today — first impression picture was not improved by cleaning — evidently had seen Gulbenkian who had similar views. On further study agreed picture entirely by master. Group figures much improved by cleaning but trees [and] landscape should be toned down as now too disturbing and lost some of their poetry'. At the end of that month, the *Allendale Adoration* was framed and shipped to Florence, where it was shown to Georg Gronau at Fiesole and Berenson at Settignano. In July of the following year, it was bought by the Kress Foundation.

Berenson remained convinced that the painting was by Titian and justified it at some length in a letter of 30 October 1937 to Duncan Phillips. When asked for proofs he replied: 'They are in my own head, too many, & the most probing ones, to me, cannot easily go into words for they come from that "sixth sense", the result of fifty years of experience, whose promptings are incommunicable'.[46] Nevertheless, Berenson went on to give as his 'clenching reason' that the 'crackle all over the Allendale picture is rectangular in the main & with a tendency to parallel lines as *always* in Titian's early years, but *never* in Giorgione's whose crackles are invariably *polygonal*'. The morphology of craquelure was a particularly unintelligent argument to pursue. For the American public, Berenson had played such a important role in the creation of their museums that he could do no wrong. To this day, students of Berenson are the sole voices in favour of the attribution to Titian. Berenson finally changed his mind and listed it as a Giorgione, but described the landscape as probably finished by Titian.[47]

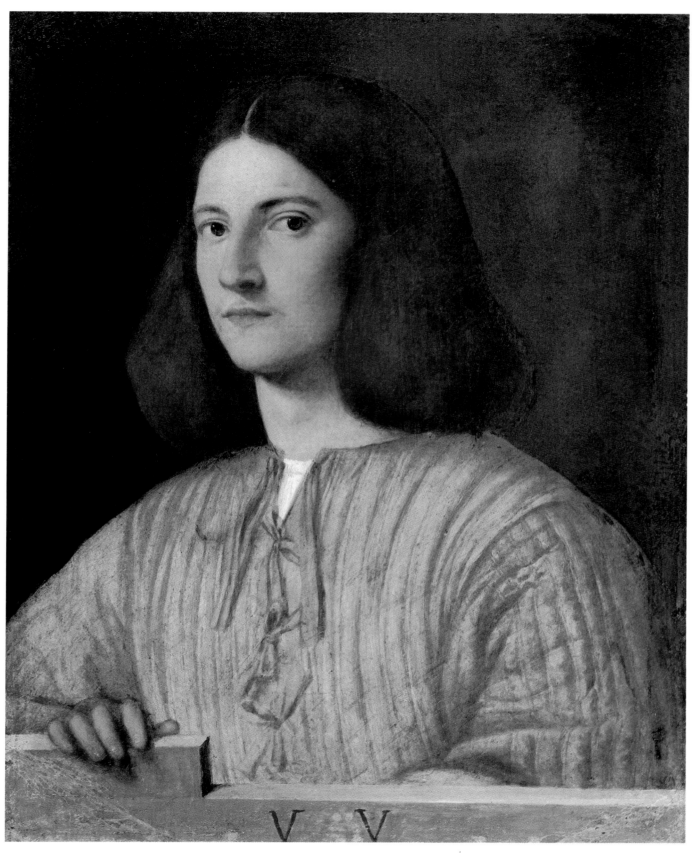

159. GIORGIONE. *Portrait of a Young Man in a Pink Padded Jacket (The Giustiniani Portrait)*.
Canvas. 57.5 x 45.5 cm. Staatliche Museen zu Berlin-Preussischer Kulturbesitz, Gemäldegalerie.

160. The collection of Jean Paul Richter in Padua, 1880.

In the same year, 1937, Kenneth Clark's judgement concerning Giorgione was called into question when, as director of the National Gallery, he acquired four exquisite little furniture panels, *Scenes from an Eclogue*, the eclogue written by the Ferrarese poet Antonio Tebaldeo. The National Art Collections fund assisted with the purchase, but on condition that the works were unconditionally labelled Giorgione, rather than School of Giorgione. The attribution was not believed and in the public outcry that followed the name of Previtali emerged, an attribution which has prevailed. Clark, though he had advanced the attribution cautiously, was inclined to believe that the panels were by Giorgione. He explained his position in a letter to George Martin Richter, the author of a recently published monograph on Giorgione, on 3 November 1937: 'It is naturally disappointing to learn that you don't think our little pictures are by Giorgione's hand, but I must confess I see your reasons. I have always felt that the facture did not tally perfectly with the rest of his early work, though I must say they are very like the *Tempesta*. I think my article in the *Burlington*[48] puts the case for the pictures as fully as possible. Your suggestion of [Andrea] Previtali is most ingenious, and there are certainly resemblances in the details of his backgrounds: but all much more wooden. Could he ever have achieved the beauty of tone of our pictures? Even supposing the compositions are inspired by Giorgione, quality of light and tone are usually impossible to copy. However, I shall think the matter over. At the moment I am anxious to avoid public controversy over the pictures, as the press are all too anxious to start a row which would discredit the Gallery. And the precious value of the pictures as examples of Giorgionismo would be lost sight of in a public discussion. [Tancred] Borenius' letter has done enough harm. Does he think that the cause of scholarship can be advanced by a letter to the *Times* — even supposing his letter had contained a plausible suggestion?'[49]

Borenius' letter to the *Times* of 21 October 1937 was fairly short; he congratulated the National Gallery on the charming acquisition, but attributed the panels to Palma Vecchio, later revising his opinion in accord with Richter's suggestion of Andrea Previtali.[50] Clark, who was then only thirty-four and had been recently appointed director of the National Gallery, was much criticized and felt extremely vulnerable. The depicted scenes, which tell the story of the shepherd Damon's unrequited love for Amaryllis and his subsequent suicide, were tainted by the misattribution,

and have never been fully appreciated. The imagery is individual, closely dependent on Tebaldeo's second eclogue, published in Venice in 1502, and looks very Giorgionesque in the treatment of subject. If they were not in a set, then individual panels would be as difficult to interpret as the *Tempesta*. In his autobiography, Clark later reflected on the episode: 'Politicians must be hardened to episodes of this kind, although I am told that even they grow a trifle uneasy after a time; but for a fortunate young swimmer on the tide of success it was an unnerving experience. I learnt to sympathise with those who, like Rousseau, have suffered from persecution mania'.[51]

162. Lord Joseph Duveen.

In point of fact, the psychic bruise was even darker than Kenneth Clark admitted when writing his autobiography in old age. For Clark in 1931 had bought for himself from a sale of Ruskin's picture collection a very beautiful fragment of a Cupid from Giorgione's fresco cycle on the Fondaco dei Tedeschi (Fig. 173). Clark's early archives were destroyed when bombs fell on his flat in Gray's Inn Road during the Second World War, so there is only one reference to the work in his later correspondence. He must have recognized the fresco fragment as the 'Cupid in the guise of an angel' which had so perplexed Vasari. Bruised by his experience with the four Tebaldeo subjects — a rare public occasion on which his judgement had been called into question — Clark never spoke about his personal acquisition of the Fondaco fragment. If he had ever considered offering it to the National

161. Lord Kenneth Clark.

Gallery, he would have found it an onerous task to convince the trustees, who would only have been cynical about the possibility of another Giorgione. In any case, the condition of the fresco was poor, as was the only other surviving fragment, the *Female Nude* (Fig. 165), which had only been removed from the wall in 1937. Clark never allowed his own Giorgione to go on public exhibition; nor did he talk about it to art historians. His son Alan Clark remembers that it was at their London home, 30 Portland Place, when he was a child, then it was in storage at Oxford during the war, and it was finally hung high in the library at Saltwood Castle, the setting for Kenneth Clark's last lecture in the *Civilisation* series for BBC television, where it loomed in the darkness above his chair. It is published in this volume for the first time.

163. John Ruskin in 1885.

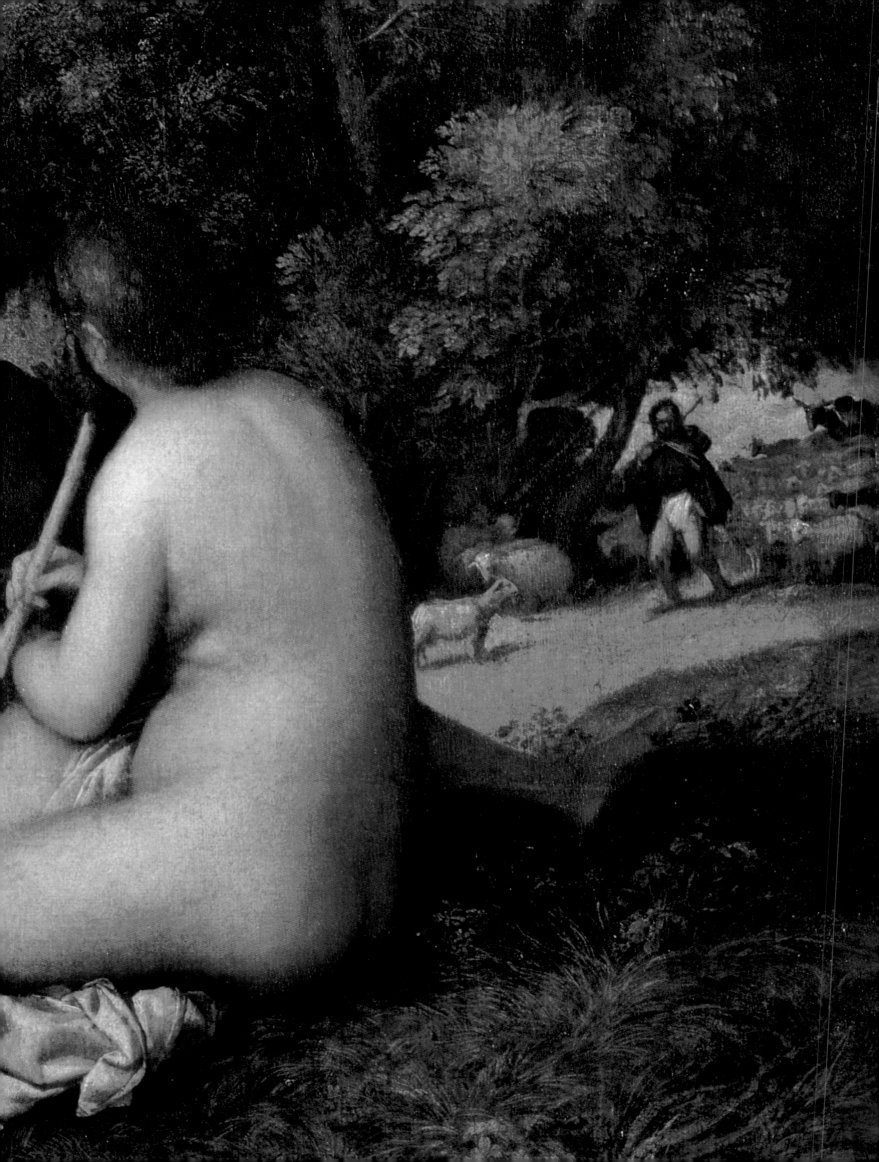

Chapter VII

The Fondaco dei Tedeschi and Afterwards

L ittle remains of one of the most extensive and important of all Venetian Renaissance fresco cycles, which once covered the facades of the Fondaco dei Tedeschi, the German Customs House in Venice. The remaining fragments are now on view at the Galleria Franchetti alla Ca' d'Oro, Venice, in a modern installation, which juxtaposes Giorgione's large flaming red *Female Nude* (Fig. 165) from the Grand Canal facade with other fragments attributed to Titian from the Merceria facade. This one female figure is so far the only Giorgione fresco known to have survived. She was originally between the sixth and seventh windows, counting from the left, on the highest floor. Here published for the first time is a further fragment, which belonged to John Ruskin (Fig. 163) and subsequently to Kenneth Clark, and almost certainly was once on the Fondaco building.[1] It is here interpreted as the *Hesperid Cupid* (Fig. 173) and attributed provisionally to Giorgione.[2] Grouped on one long wall of the Ca d'Oro are Titian's famous *Judith/Justice* (Fig. 176), other disparate scenes of a *Battle between Giants and Monsters*, and coats-of-arms. Seen together, they show a considerable disparity in the quality of the execution, such as to suggest that they are the products of a workshop, rather than the hand of one artist, as is usually argued.[3] The *Judith/Justice* is the outstanding image from the Merceria facade, while the others are less interesting visually and have been little commented upon. The allegorical female figure has been variously interpreted as Justice by Dolce, Judith and Holofernes by Vasari, and as an allegory of Justice defeating a German soldier by Cavalcaselle, Wind and other scholars. Whatever the subtlety of interpretation, the fresco makes a political statement about Venetian supremacy in 1508, the year in which the German Emperor Maximilian threatened Venice. Unlike the *Herperid Cupid*, these frescoes in the Ca d'Ora are not *strappati*, that is, they are not transferred to canvas, but are actually *staccati* on pieces of the Fondaco wall.

If these images are a good indication of what was once visible on the two facades, it is difficult to believe Dolce's story that Giorgione could ever have been jealous of the artist or artists who executed the frescoes on the Merceria facade. For in the present installation, Giorgione's one surviving *Female Nude* has an extraordinary presence (difficult to convey in a photograph) that dominates the small exhibition space, while the fragments attributed to Titian are less imposing. Almost half a century after Giorgione had died, Dolce published a version of events, which few

contemporaries would have been able to contradict, except Titian.

Pietro Aretino, who lived at Rialto, in the Palazzo Bollani at the corner of the Grand Canal and the rio San Giovanni Crisostomo, described, in a celebrated and much quoted letter to Titian of May 1544,[4] a sunset which may have been triggered by the flaming colour of the paintings reflected in the clouds. In all his writings, Aretino never mentioned Giorgione, except indirectly on this one occasion. In 1550 Vasari wrote of the vivacious colours of the Fondaco frescoes, and he did so again in 1568. In the eighteenth century, Anton Maria Zanetti made prints after a few of the frescoes in order to record them for later centuries; some of these were hand-coloured (Figs. 174, 175). The red colour was so strong that even in the nineteenth century Ruskin could write in the *Stones of Venice* of the strong tide beneath the Rialto, which 'is reddened to this day by the reflection of the frescoes of Giorgione'.

Before Giorgione, Venetian houses were frescoed, but not with large-scale figures. Venetian confraternity paintings, such as Gentile Bellino's *Miracle of the Holy Cross* and Carpaccio's *Healing of the Possessed Man*, represent buildings with frescoes and graffiti, hieroglyphs and decoration *all' antica* that extend even to the chimney pots. Carpaccio's *St Jerome and the Lion* in the Scoula degli Schiavoni shows that some churches had religious frescoes on their exteriors.

The Fondaco dei Tedeschi was an attempt to create a commercial style of architecture (which Ruskin found ugly), one that could not be confused with a patrician building, such as the Palazzo dei Camerlenghi opposite. The frescoes were intended as the painted equivalents of sculpture, with the architecture of the building as a backdrop to the frescoes. Given Giorgione's interest in the rivalry between sculpture and painting, attested in the numerous anecdotes about the *paragone* (p. 49 above), he may have been chosen as the most capable artist to create fictive sculpture. German merchants' taste was for the opulent, such as Dürer's *Feast of the Rose Garlands* (Národni Galerie, Prague), which he created in 1506 for an expatriate German confraternity, the Scuola dei Tedeschi. By contrast, the decoration of the Fondaco, although destined for Germans, was controlled by the Venetians, as is demonstrated by the German soldier in the *Judith/Justice*, who is clearly in a subordinate position.

On 6 February 1504, Marino Sanudo reported that the Fondaco building, having been destroyed by fire, had to be rebuilt quickly.[5] Palaces

165. GIORGIONE. *Female Nude*. Detached fresco. 250 x 140 cm.
Venice, Galleria Franchetti alla Ca' d'Oro.

nearby were acquired in order to increase the area of the site, and a competition for the building contract was arranged. Models were exhibited and discussed in the Senate.⁶ The master builder Giorgio Spavento was in charge of the building until September 1505, when he was succeeded by Antonio Scarpagnino. The overall design was said to be by Girolamo Tedescho, a German architect, who is otherwise unknown. In November 1508, a mass was celebrated at the building's completion (Fig. 166). If the project was completed by November 1508, then many artists must have been employed. All the documentation about the commission suggests that the design and decoration were a matter of public concern to the government of Venice, as was, by implication, the imagery on the facades. Giorgione's frescoes were on the prominent facade of the building, the facade that overlooked the Grand Canal near the Rialto bridge. Later sources record that every facade of the Fondaco, both the interior courtyard and the external walls, was frescoed.⁷

It has been suggested purely on stylistic grounds that the frescoes on the Merceria facade are much later than Giorgione's on the front facade, and were completed after the Imperial forces had been defeated, that is, c. 1510–11, closer in time to Titian's frescoes in the Scuola del Santo, Padua. Yet all the documentation states that the Fondaco was completed quickly. (Sanudo records that in August 1508 a mass was sung in the newly rebuilt courtyard of the Fondaco; while the Germans began to enter and perform dances, interior finishing and exterior painting continued.) Conceptually and stylistically, Titian's frescoes in Padua are very different from those on the Merceria facade of the Fondaco. Even though Vasari spoke to Titian about the Fondaco commission, he was still perplexed and complained that he could not find anyone to interpret it for him. He found especially enigmatic a seated woman, near to the head of a dead giant, who looked like a *Judith*, raising her sword and talking to a German beneath her. Surely Vasari must have asked Titian for his interpretation, and if Titian had indeed been totally responsible for the imagery, why was he unable to furnish an interpretation, unless he was executing designs by Giorgione that he did not fully understand.

During Titian's long life, he worked almost exclusively on board or canvas, with three youthful exceptions, when he collaborated on fresco cycles. On the first occasion, it was on the Fondaco dei Tedeschi (1508), and shortly thereafter on three of thirteen frescoes in a large cycle of the

166. The Fondaco dei
Tedeschi before 1836.
Line engraving. Archive of
the Soprintendenza dei
Monumenti, Venice.

life of St Antony of Padua, in the Scuola del Santo (1511). Titian executed
the most moving miracles, when St Antony makes a newborn child speak
(*Miracle of the Speaking Baby*, Fig. 168); when St Antony reattaches a young
man's severed foot (*Miracle of the Irascible Son*, Fig. 167), and when the
saint resuscitates a dead woman (Fig. 169). Titian's technique of executing
fresco was thoroughly Venetian, as Gianluigi Colalucci has shown in his
recent conservation of the frescoes (1982–85).[8] On the third occasion,
Titian painted frescoes on the facade of the Palazzo Grimani, principally
the *Diligenza*, in circumstances about which we can only hypothesize.

Titian's technique was characterized by drawing the whole composi-
tion on a large area in wet plaster, rather than executing it piecemeal,
tiny section by tiny section, from a careful preparatory outline drawing,
day by day, according to the *giornate* of Tuscan tradition. The term *gior-
nata* denotes the amount of fresco painting executed in one long day. Each
day's work materially overlaps the preceding day's and may be detected in
the joinings of the plaster at the edges of sections.

Sections would be determined by the level at which the scaffolding
(*pontata*) was placed, rather than by the *giornate* of Tuscan tradition. This
pontata method was better suited to the Venetian way of roughly outlining
a whole composition, rather than making detailed preparatory drawings of
individual parts. Marco Boschini gives a good description of the difference
between the two methods, when he writes in 1660 that the foreigners (by

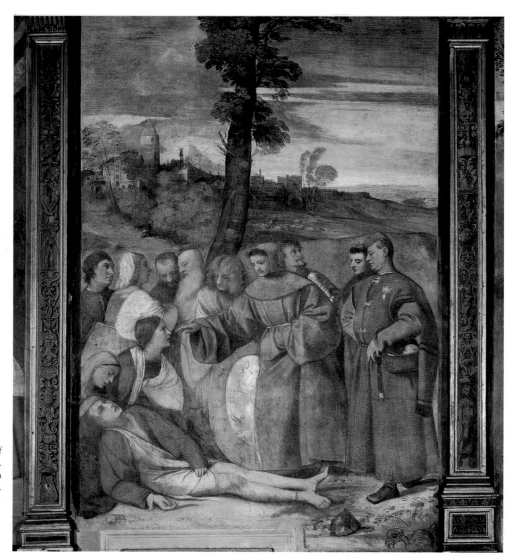

167. TITIAN. *The Miracle of the Irascible Son*, 1511. Fresco. 327 x 220 cm. Padua, Scuola del Santo.

whom he means Tuscans) create figures piecemeal, heads, arms, knees, legs, and toes, but never whole figures (' … i foresti, i fa le cose a parte, a tochi, a pezzi, teste, brazzi, zenochi, gambe e piè, ne mai quelle figure risultano unitarie'), whereas the Venetians roughly sketch their stories with colours, and draw and paint at the same time ('i venetiani i abbozza, le storie con quei colori che ghe vien de tresso, e dessegna e concerta ad un tempo istesso').[9] In the first half of the Cinquecento, Venetian painters used a technique that was partly by *pontata* and partly by *giornata*. Titian worked in this way, as did Giorgione.

Titian's three frescoes in the Santo have horizontal divisions. In the *Miracle of the Speaking Baby*, the upper section consists of an entire *giornata*, whereas the lower half is divided into twelve days, each *giornata* devoted to

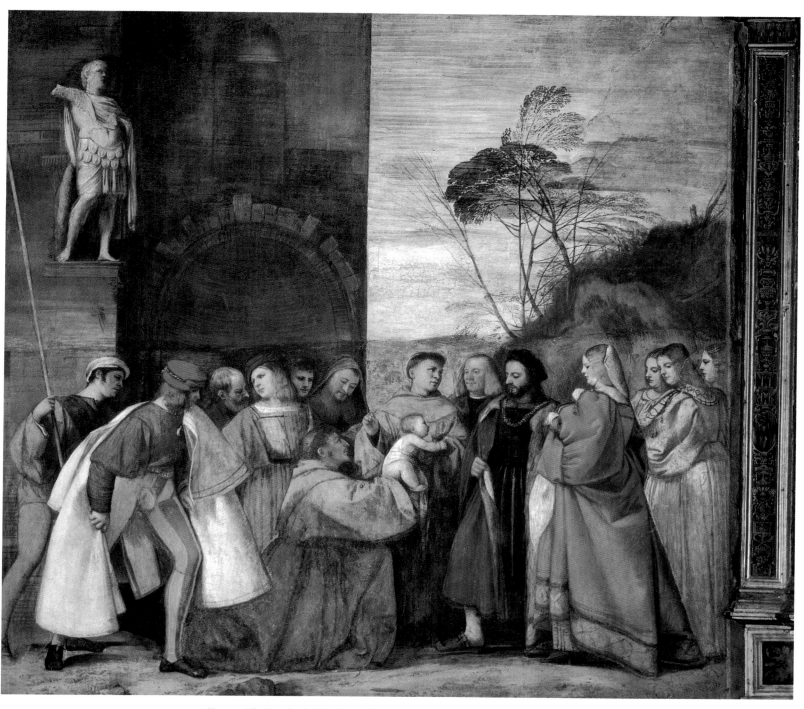

168. TITIAN. *The Miracle of the Speaking Baby*, 1511. Fresco. 315 x 320 cm. Padua, Scuola del Santo.

the depiction of a single head or figure or group of figures. The *Miracle of the Irascible Son* consists of eight *giornate*, while the last scene took six days, one devoted to the depiction of the woman's arm. No traces of a cartoon have been found, but direct incisions were made in the plaster, especially evident in the architecture and the lance in the miracle of the newborn child. Titian inscribed the figures on the fresh intonaco with a Trecento technique, roughly drawing with a brush in yellow ochre and brown. This technique is also to be found close at hand in the basilica of Sant'Antonio in the frescoes by Giusto de' Menabuoi in the Capella del Beato Luca, as well as nearby in the frescoes by Altichiero da Zavio in the oratory of San Giorgio. Unlike Tuscan fresco painters who prepare their colours beforehand, diving each one in three tonalities, Titian painted directly from his palette. Delicate refinements were later added *a secco*.

169. TITIAN. *The Jealous Husband Kills his Wife and the Miracle of her Resuscitation*, 1511. Fresco. 327 x 183 cm. Padua, Scuola del Santo.

In the *Rialto Bridge from the North* (Fig. 171), as in other Canaletto *vedute* that depict the Fondaco, there are clear traces of fresco decoration, denoted by large blue and red patches on the front and side facades of the building (Fig. 170). On the upper left, on the Rio of the Fondaco, there is a blue patch (barely visible in the painting), which could conceivably represent the *Hesperid Cupid*. But the frescoes are shadowy presences in Canaletto's views, the imagery never legible, and this suggestion can only be hypothetical.[10] By the nineteenth century, only some tantalizing fragments remained. When John Ruskin visited Venice he thought that Giorgione was 'to be admired without qualification, but that it was difficult to discover where his works were'. He

wrote to his father on 4 October 1845: 'There is a fragment or two of Giorgione left yet on one place, purple and scarlet, more like a sunset than a painting'.[11] In *Modern Painters*, he was even more precise: 'Two figures of Giorgione's are still traceable on the Fondaco dei Tedeschi, one of which, singularly uninjured, is seen from above and below Rialto, flaming like the reflection of a sunset'.[12] Ruskin considered the Fondaco building 'a huge, blank, five storied pile, on whose walls the first glance detects nothing but the signs of poverty and ruin. They have been covered with stucco, which for the most part is now peeled away from the brick beneath, and stains of rusty red, and sickly grey and black, hang down in dark streams from the cornices, or spread in mossy patches hither and thither between its case-ments. Among this grisly painting where the stucco is still left, the eye may here and there discern other lines, faint shades of that noble grey which nothing can give but the pencil of a great colourist, and subdued fragments of purple and scarlet, dying into rusty wash from the iron bolts that holds the walls together. This is all that is left of the work of Titian and Giorgione'.[13]

In a letter of 1876, Ruskin notices for the first time that there were also frescoes on the Merceria facade when he 'cut through a side alley I never use to go by — and found — a fresco of the Giorgione series left, that I had thought all destroyed, at the side of the Fondaco dei Tedeschi'.[14] By the time Ruskin wrote *St Mark's Rest* (1884), there was only one fresco on the front facade. He instructed the reader to walk across Rialto bridge and look back over the Grand Canal: 'Here standing, if with good eyes, or a good opera glass, you look back, up to the highest story of the blank and ugly building on the side of the canal you have just crossed from, you will see between two of its higher windows, the remains of a fresco of a female figure. It is, so far as I know, the last vestige of the noble fresco painting of Venice on her outside walls; Giorgione's — no less — when Titian and he were house painters'.[15]

When Ruskin acquired his own relic from the Fondaco (Fig. 173) is unknown, but he knew the fabric of the building extremely well and had studied it over many years. In 1845 he described several frescoes, but by 1884 only the *Nude* (Fig. 165) remained. Ruskin reproduced Giorgione's *Nude* in an engraving in volume V, chapter 11, of *Modern Painters* (1888), with the title 'The Hesperid Æglé'. The chapter is mainly concerned with Turner's representation of the *Hesperides*, and Giorgione's fresco may appear to have been introduced as a seemingly accidental flourish in a rather

weird discussion, for which reason no one has ever taken seriously, or even repeated, Ruskin's interpretation of Giorgione's nude as the Nymph Ægle, whose skin was flaming red. Yet Ruskin's interpretation is one of the few that has ever been proposed, and the best to date. He explains that his 'impression is that the ground of the flesh in these Giorgione frescoes had been pure vermilion; little else was left in the figure I saw. Therefore, not knowing what power the painter intended to personify by the figure … I have called her, from her glowing colour, Hesperid Ægle'.[16]

The subject of the three nymphs of the evening, the Hesperides, was popular with nineteenth-century English artists like Turner and Leighton, but stories concerning the golden apples of the Hesperides had been frequently represented from antiquity, especially Heracles' final labour, which was to bring the golden apples from the garden of the Hesperides to Eurystheus. A well-known Roman copy of a Greek relief, which depicts Hercules in the Garden of the Hesperides (Villa Albani, Rome), was frequently copied in the Renaissance and inspired artists from Pisanello to Michelangelo.[17] 'Le Vergine delle Hesperide' are referred to often in Renaissance literature, for example in the *Hypnerotomachia Poliphili* (1499), where their names are invoked in the context of an exotic orchard in a meadow full of rare fruit trees, one of which bears the magical apples. The nymphs of the evening were called Ægle, Erythia and Hesperethusa, their names meaning 'brightness', 'scarlet' and 'sunset glow', all references to the sunset, when the sky is yellow and red, like an apple tree, and the sun is cut by the horizon like a crimson half-apple. The round object held in the standing nude's hand, once tentatively identified as a ball, or globe, is much

Far left: 170. CANALETTO. *The Rialto Bridge from the North*. Detail showing traces of frescoes on the Fondaco dei Tedeschi.

171. CANALETTO. *The Rialto Bridge from the North*. Oil on canvas. 63.5 x 90.5 cm. London, Sir John Soane's Museum.

more likely to have been an apple. The nomenclature of the nymphs may explain the rosy skin of the female nudes, the attribute that delighted all those who described the redness of the frescoes, but which bewildered Vasari and provoked Aretino's description of the sunset above Rialto.

172. Attributed to GIORGIONE. *Putto Bending a Bow*. Red chalk. 15.7 x 6.6 cm. New York, The Metropolitan Museum of Art; Rogers Fund, 1911.

The fragment of a cupid tapping apples from a tree (Fig. 173), which Ruskin had bought himself from the Fondaco, may also have informed his interpretation of the *Female Nude* as Æglé. The tree with golden apples was a gift from mother earth, Gaia, to Hera on her marriage to Zeus. It was guarded by the Hesperides in Hera's orchard on Mount Atlas, until Hera discovered one day that the nymphs were pilfering the apples, whereupon she arranged for the dragon Ladon to coil around the tree as its guardian (Hercules later encountered Ladon in his last labour). Ruskin's fresco fragment depicts the moment when the apples were stolen from the tree. The contrapposto of the cupid, and the way in which the masses of his body are painted, all relate in posture to Giorgione's other figures, known only in Zanetti's eighteenth-century reproductions. A similar composition was recorded in a red chalk drawing of a *Putto Bending a Bow* (Fig. 172). In the eighteenth century, this drawing was in the collection of the great French connoisseur Mariette, who attributed it to Giorgione. The old hypothesis was that the drawing depicted a cupid from the Fondaco. Seen together with the newly discovered fresco, the drawing has an added authority, and may be interpreted as representing a related cupid from the same facade.

Parallels of the *Hesperid Cupid* from the Fondaco may be found in works by Giovanni Bellini and Titian. In one of the most Giorgionesque and problematic of all Bellini's paintings, the *Sacred Allegory* in the Uffizi, the central motif of the composition is a manicured apple tree in a pot. The tree bears

173. GIORGIONE. *Hesperid Cupid*. Detached fresco on canvas. 131 x 64 cm.
Kent, Saltwood Castle, Saltwood Heritage Foundation.

golden apples, which putti knock down, harvest, and roll across the terrace.[18] All the other vegetation in the painting is dead. The scene has a Christian significance and takes place before saints and the Madonna, so that the golden apple tree must have a religious meaning in this context. In Titian's

174. After GIORGIONE. *Female Nude* (*Nymph Æglé?*). Hand-coloured engraving from ANTON MARIA ZANETTI, *Le varie pitture a fresco de' principali maestri veneziani* (1760). Rome, Biblioteca Hertziana.

famous recreation of an ancient painting described by Philostratus, the *Feast of Venus* (Prado, Madrid), made for Alfonso d'Este by October 1519, there is a prominent representation of putti harvesting and playing with apples. The prominence of golden apples in both these pictures, otherwise a rare motif, seems hardly casual.

The theme of the Hesperides was used throughout the Cinquecento in different Medicean political contexts. It was first taken up by Michelangelo as an idea in one of his early projects for the Medici tombs. Recorded in a drawing by Battista Sangallo (1520, Uffizi, Florence), two projected reliefs are shown, one of which was for a scene showing the nymphs plucking apples in the Garden of the Hesperides, the apples being a Medicean impresa.[19] In 1581–82, Alessandro Allori took up the subject in his intriguing fresco for the Salone of the Villa Medici at Poggio a Caiano, made to accompany Pontormo's lunette of *Vertumnus and Pomona* (1521). In Allori's *Ricordi*, he credits the invention of *Hercules in the Garden of the Hesperides* to Vincenzo Borghini. Most of the frescoes at Poggio a Caiano contain references to Medicean politics, and in Allori's case the Garden of the Hesperides has been interpreted as an allusion to a Medicean Golden Age.[20] Such occurrences are evidence of how the myth of the Hesperid nymphs could be adapted to different political contexts.

Ruskin knew Anton Maria Zanetti's publication on Venetian frescoes, *La varie pitture a fresco de' principali maestri veneziani* (1760), which

After GIORGIONE. Left: 175. *Seated Male Nude (Hercules?)*. Right: *Seated Female Nude (Hesperid Nymph?)*.
Hand-coloured engravings from Anton Maria Zanetti, *Le varie pitture a fresco de' principali maestri veneziani* (1760).
Rome, Biblioteca Hertziana.

attempted to preserve something of the remains of Renaissance frescoes in Venice (Fig. 174).[21] But Ruskin did not attempt to interpret the figures in Zanetti's hand-coloured prints as part of the Hesperides theme. Ruskin's original interpretation of the *Female Nude* as the 'Hesperid Æglé', which opens up a new approach to the imagery of the Fondaco, may also help clarify the identity of the two figures recorded by Zanetti of a seated female and seated male figure (Fig. 175). The seated woman, whose skin has a rosy glow in the hand-coloured Zanetti print, could be identified as one of the other nymphs of the evening, while the seated male could be Hercules. Yet another figure that caused Vasari perplexity was a man with a lion's head near to this latter figure ('dove è uno uomo in varie attitudini, chi ha una testa di lione appresso'), perhaps an unusual depiction of Hercules, one of the central characters in the Garden of the Hesperides. Could he be the seated male reproduced in Zanetti's print? These are all questions provoked by Ruskin's reading of the imagery on the Fondaco, although the condition of the fragments is such that the figures are without attributes, and their identities can only be suggested. The geographical home of the nymphs was debated by ancient mythographers, but they were most commonly considered as the guardians to the gate of the Western world, a suitable theme for a trading post in a city that was between East and West. Hespèria, the Western land, was a poetic name given by the Greeks to Italy because it lay west of Greece (Virgil, *Aeneid*, III, 163).

A further copy of another lost figure from the Fondaco is at Burghley House, Stamford, no. 134, where it has been misdescribed as a 'nude Eve standing full length in a landscape' by Lo Scarsellino (see p. 319). The identification, which was suggested to me by Paul Joannides, is based on Jacopo Piccini's well-known engraving of a woman, dating c. 1658, usually identified as a Venus from the Fondaco. The Burghley copy should in my view be attributed to one of the most colourful artists of the Venetian Seicento, Pietro Liberi, on the basis of such characteristic details as the cold tonality of the flesh. There are other paintings by Liberi at Burghley House, and the comparative lack of detail in the woman's form may be explained by the fact that it is a copy of a fresco. Liberi's other paintings at Burghley were brought by John Cecil, the Earl of Exeter (1648–1700), when he was in Venice in 1684, including a set of erotic paintings for his wife's dressing room, and a rather personal commission, an allegorical portrait of his son, the *6th Earl Pulling Fortune by the Hair*.

Liberi's copy — unlike Piccini's summary engraving — depicts a huge golden apple at the feet of the female figure, suggesting that once again another figure from the Fondaco enacts a role in the Garden of the Hesperides. The large-thighed woman may be a copy of the third nymph of the Hesperides. She was certainly never on the Merceria facade, although Piccini attributed her to Titian, and could quite possibly have once been placed with the other nymphs on the front facade. Boschini's *Carta del navegar pitoresco* presents Liberi as a knowledgeable artist who can discuss Renaissance artists, especially Titian. It would have been quite natural for the 5th Earl, when on his Grand Tour, to have commissioned from one of his favourite Venetians a souvenir, a copy of a figure from the fresco cycle before it had deteriorated.

The impact of Giorgione's innovative figure style in the Fondaco frescoes was immediately felt not only in Venice, especially in such paintings as Sebastiano del Piombo's *Judgement of Solomon* (Fig. 78), but also in

176. TITIAN in Giorgione's workshop. *Judith/Justice*. Detached fresco from the Merceria facade of the Fondaco dei Tedeschi. 214 x 346 cm. Venice, Galleria Franchetti alla Ca' d'Oro.

Rome, on Michelangelo's *ignudi* on the Sistine Ceiling.[22] It is unclear how Michelangelo knew of the Venetian figures, but perhaps there were intermediary drawings, or he travelled to Venice from Bologna in 1508, when the frescoes were in the course of execution. There are many formal analogies between Giorgione's nudes and Michelangelo's Sistine athletes, since both series portray seated figures in complex attitudes, on low pedestals in architectural surrounds. What helped the analogy was that in both cases

the figures were regarded as proverbially enigmatic; this attitude may have had the unfortunate effect of inhibiting art historical interpretation of Giorgione's frescoes.

After Giorgione's Fondaco frescoes, the supremacy of Venetian power in Italy was challenged. For many decades, Venice had been adding to her dominions on the mainland, finally attempting to increase her territories in the Romagna in the Papal States. Pope Julius II then organized the famous

177. After GIORGIONE. *Portrait of a Young Soldier with his Retainer (Portrait of Girolamo Marcello).* Engraving by JAN VAN TROYEN, from Teniers' *Theatrum pictorium,* 1658.

European league against Venice, formed at Cambrai, France, in December 1508, when other Italian rulers allied with most European kings against Venice. On 27 April 1509, Julius II excommunicated Venice. After the battle of Agnadello on 14 May 1509, the Venetian army and government were seriously demoralized and the French king and the German emperor repossessed the Venetian empire on the *terraferma.* Town after town submitted to the conquering armies without any pretence of loyalty to Venice. A patriotic and moralistic chronicler, Girolamo Priuli, interpreted these events as a punishment against the Venetian nobility for their immoral way of life, an opinion that was widely believed at the time. Priuli castigated their luxurious and lascivious lifestyle, habits, clothing, entertainments, effeminate dress, sodomy and all manner of sins.[23] On 17 July 1509, Andrea Gritti recaptured Paduo with difficulty, but it was not until 1516 that Venice repossessed essential territory on the mainland. On 24 February 1510, Julius II lifted the ban of excommunication on Venice, following which plague raged in the city, and by the autumn of 1510 Giorgione had died.

In many ways, Giorgione's patrons appear to have been in the very section of Venetian society that Priuli criticized. Giorgione's portraits of men are conspicuously different from any of those patricians painted by Bellini and Titian in their dark togas and official senatorial robes.

All Giorgione's men are dressed in flamboyantly bright colours, pink (*Giustiniani Portrait*, Fig. 159; *Young Boy with an Arrow*, Fig. 17), or purple (*Terris Portrait*, Fig. 68), rather than black; and they are usually represented in allegorical situations, dressed with provocative elegance. With a few works, Giorgione introduced into Venetian painting in the first decade of the Cinquecento a new conception of portraiture. Whereas his predecessors had concentrated on representing a faithful likeness, he and his followers represented their subjects in situations that told you a great deal about the sitter. For this purpose, Giorgione invented a series of portrait motifs that influenced painters both in Venice and Rome. His formal inventions were accompanied by his much discussed painting style *senza disegno*, a method devised perhaps because it was so well-suited to portraiture. Leonardo da Vinci had complained that portrait painters were solely concerned with likeness to the neglect of the general laws of painting. 'Among those who profess to portray faces from life', he wrote, 'he who gives the best resemblance is the worst composer of history paintings'.[24] To remedy this situation, he suggested that portrait painters should observe the principles of decorum and should introduce movement into their compositions indicative of the movement of their minds. Leonardo's concern with the observation and depiction of movement is legendary. As regards the human figure and face, he was involved in defining what later theorists were to call expression, the representation of the motions of the soul as shown in the movement of the body and face. Giorgione's most Leonardesque painting was his *Christ Carrying the Cross* in San Rocco (Fig. 15), a picture commissioned shortly before the Fondaco frescoes.

Giorgione's last picture, the *Concert champêtre* (Figs. 37, 178), is a product of the erotic fantasy of a bachelor culture in Renaissance Venice, a continuation in every morphological detail of the cultural concerns of the Compagnie della Calza and their pastorales in a way similar to the *Tempesta*. Although the attribution of the *Concert* cannot but remain controversial, the conception of the subject and its relation to poetry and music in a pastoral setting is reminiscent of the opening of Bembo's *Gli Asolani*. In an extraordinary compelling interpretation of the painting, Philipp Fehl has argued that the nude women are in fact Muses and invisible to the men, hence their total disregard of one another.[25] Patricia Egan had noted that the allegorical representation of Poetry on one of the tarocchi cards combined the attributes of both female figures, the flute,

and the jug pouring water.[26] Since then, Eric Fischer has gone further and suggested that the indifference between the men and women depicted may be explained in another way: that Giorgione had represented Orpheus and Calais, Orpheus serenading his young male love in a shady wood.[27] According to Fischer's interpretation, such behaviour antagonized the cruel women of Thrace, who then sharpened their swords to kill Orpheus. But at this point the whole theory becomes improbable, for the two nude women, though psychologically divided from the men, do not threaten them or even show signs of despair. Strangely, Fischer does not refer to Giorgione's *Self-Portrait as Orpheus*, as recorded in Teniers' copies (p. 317 below), where Giorgione depicts himself at that crucial moment when Eurydice is torn from him (a tiny scene in the background) and he foregoes woman's love forever, a subject celebrated frequently in Renaissance poetry, but most notably in Poliziano's *Orpheus:* 'E poi che sì crudele è mia fortuna / già mai non voglio amar piú donna alcuna'.

None of Giorgione's sitters is identifiable, except for himself, the young Borghenini and his tutor (Fig. 89), and the confrontational representation of Girolama Marcello and his servant in the sadly ruined portrait in Vienna (Figs. 13, 177). Yet they all represent a *dolce vita veneziana*. Like the Giorgione of tradition, they are handsome, long-haired, elegant, seductive, melancholic, and they all wilfully flaunt the sumptuary laws. The imagery of the portraiture is as provocative in its modernism as the flaming red-coloured frescoes on the facade of the Fondaco at Rialto, which Vasari proved unable to understand, although Ruskin may have. Among the representations on the Merceria facade of the Fondaco were members of the Confraternity of the Sock, the Compagnie della Calza, dramatic clubs exclusively for patricians youths and designed to provide entertainment for a large number of unmarried young men. In the festivals of the Compagnie, the performances were particularly well-prepared and actors interpreted mythological subjects and burlesqued pastoral ones. According to Sanudo's *Diaries*, there were numerous performances of pastoral eclogues and 'comedie di pastroi' in early sixteenth-century Venice. The Venetian patriciate looked at the *terraferma* with curiosity, and the eclogues made all urban society reflect on her dependent relationship with the countryside. The *compagno* always remained a city dweller dressed up as a peasant, and to some degrees elegantly superficial in his interest in the pastoral— as was Giorgione.[28]

Right: 178. GIORGIONE. *Concert champêtre.* Detail of Fig. 37.

Page 288: 179. GIORGIONE. *Education of the Young Marcus Aurelius (Three Ages of Man).* Detail of Fig. 106.

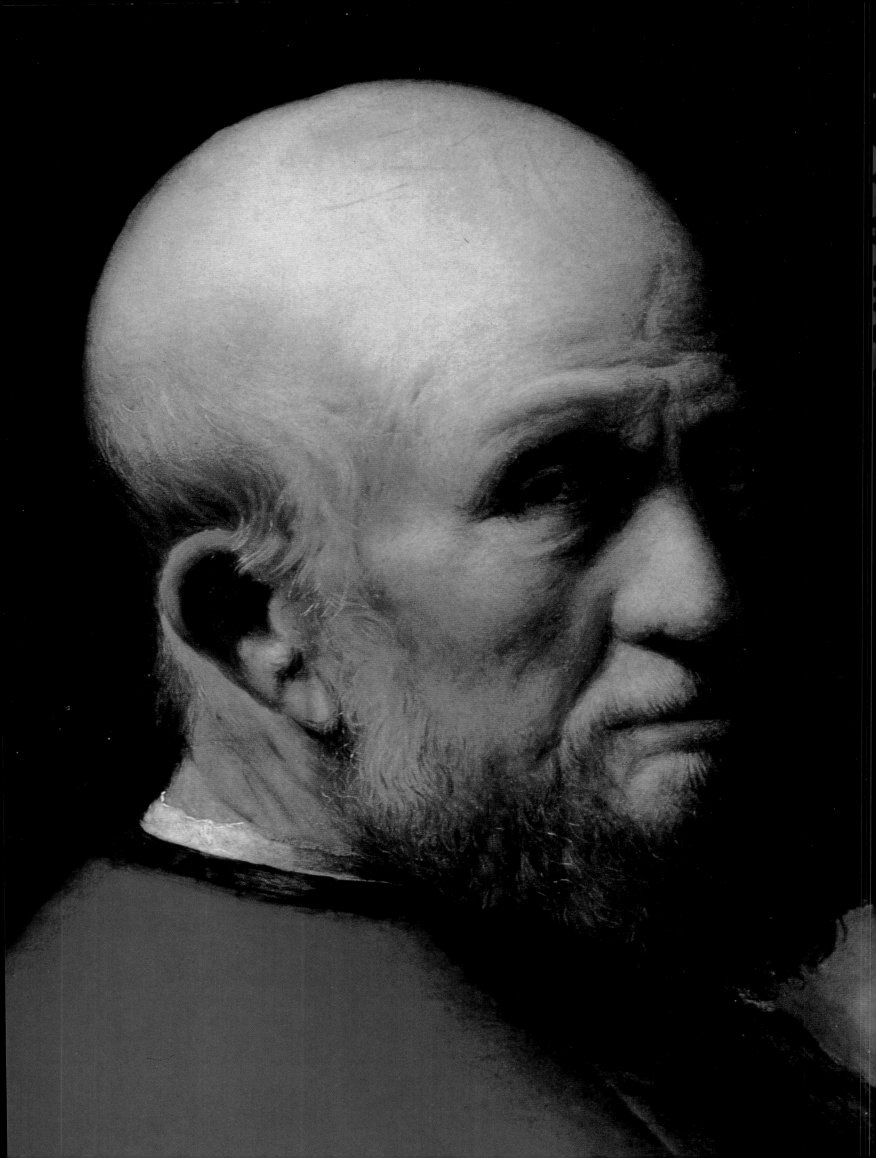

Catalogue
Raisonné

The catalogue raisonné is divided into four sections, beginning with the works accepted as by Giorgione. These are arranged in a chronological order that the author finds convincing. Precise dates are avoided, however; it would be rash to try to create a fixed chronology for individual paintings by an artist who has few secure dates in his œuvre. In determining matters of attribution, documentary evidence and data from the history of conservation are privileged.

The second section consists of controversial attributions, a category of works which for various reasons may not be given outright to Giorgione, as in the case of the *Giovanni Borgherini and his Tutor*, where the original paint surface is obscured by repaint. The works are arranged alphabetically by city of location, as they are in the section on rejected attributions.

ACCEPTED WORKS

FLORENCE, Galleria degli Uffizi, inv. 945 and 947
Trial of Moses and *Judgement of Solomon* (Figs. 6, 7)
Oil on panel, 89 x 72 cm each

Provenance: Grand Duchess Vittoria of Tuscany at the Villa Poggio Imperiale (1692); from 1795 in the Uffizi, where first attributed to Giovanni Bellini.

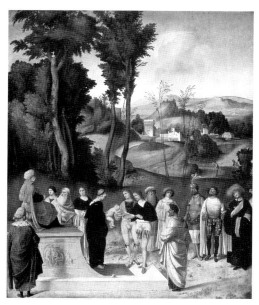

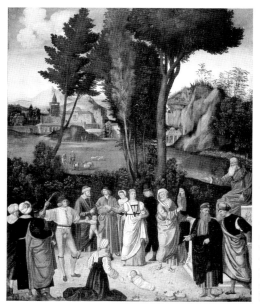

These companion panels, both of unusual iconography, represent religious judicial subjects in a novel pastoral setting. Of all the paintings attributed to the youthful Giorgione, these have the best claim to be considered his earliest works, dating c. 1496, shortly after his apprenticeship with Bellini ended. For if he had followed the traditional rules of apprenticeship, Giorgione would have become an independent painter by about 1498 at the age of twenty. Even so, the panels are of uneven quality in execution and style, which has led to conflicting opinions about their authorship. The most frequently repeated of the theories is that the panels are a collaborative work between Giorgione and a rather heavy-handed assistant, the assistant being more conspicuously present in the somewhat wooden figures represented in the *Solomon* panel. Some art historians (Rearick, 1979) have seen a Ferrarese component in the two panels, suggesting that Giorgione collaborated with Ercole dei Roberti in the late 1490's; others (such as Fiocco, 1915) have seen a parallel to the Paduan frescoes in the Scuola del Santo. Since Fiocco wrote, the Paduan archivist Sartori has revealed that these frescoes are by Giovanni Antonio Corona and date from the end of the first decade of the Cinquecento, suggesting that they are a later imitation of Giorgione. All writers have experienced difficulty in locating the panels chronologically, a range of dates having been proposed from the last years of the Quattrocento (Ballarin, 1979) to the middle of the first decade of the Cinquecento (Pignatti, 1969). If these paintings may be attributed to Giorgione, either in part or wholly, then the best possibility is to see them as the artist's earliest works. Scientific investigation of the panels does not reveal any disjunctures that would be proof of a joint collaboration. Thus the uneven characterization of the figures could reflect the inexperience of a youthful artist. The higher quality of the *Moses* panel, the idyllic beauty of the landscape, comparable to the landscape at the left side in the *Castelfranco Altarpiece* (Fig. 84), and the characterization of some of the figures suggests that they may be plausibly interpreted as a prelude to Giorgione's later pastoral works. Moreover, the meditative quality with which the unusual subject from the infancy of Moses is treated, not unlike Giovanni Bellini's *Sacred Allegory* in the Uffizi, suggests Giorgione's inventive mind, especially in pastorales.

The subject of the *Moses* panel is taken from an apocryphal story told in the *Midrash Rabbah* (Exodus [Shemouth] 1:26), as well as in other Jewish sources (discussed in detail by Haitovsky, 1990). When the infant Moses was brought before Pharaoh, the child seized Pharaoh's crown, an act regarded as an omen of usurpation. The infant was then given the chance to save himself by choosing between two bowls, one containing gold, the other burning coals. He chose the burning coals, which he put in his mouth, scorching his tongue; hence Moses' statement: 'I am slow of speech, and of a slow tongue' (Exodus 4:11). The legend explains why Moses had a stutter, and is one of those stories that represents the precociousness of a child destined for a great future. It was frequently repeated and elaborated upon in medieval Christian writing and illustrated in the *Biblia Pauperum*. One of the earliest depictions of the ordeal of the infant Moses occurs in a mosaic in the thirteenth-century atrium of San Marco, Venice, while the most famous Quattrocento example was Benozzo Gozzoli's fresco of scenes from Moses' childhood (1468-74), formerly in the Campo Santo, Pisa (destroyed 1944).

Giorgione's panel is unusual, in relation to earlier precedents, in that the scene is represented as an isolated incident — not within other scenes from the childhood of Moses — and in a landscape setting, with the principal protagonists dressed as though they were courtiers at an Italian court. Similarly, the *Judgement of Solomon* takes place in a landscape, rather than in a temple, as would be appropriate to the biblical story (I Kings, 3:16-28), while Solomon is elderly with a grey beard, rather than a youthful king, as he is in Sebastiano's *Judgement* at Kingston Lacy (Figs. 77, 78). The relief on Pharaoh's throne in the *Moses* panel has been rarely commented upon. For Tschmelitsch (1975, p. 86) it represents rather implausibly a judgement of Midas, whereas more plausibly for Haitovsky (1990, pp. 28-29), it is Prometheus creating a sculpture, watched by satyrs to the left and Pallas Athena to the right.

The debate taking place in the *Moses* scene between the members of the court has been plausibly interpreted by Haitovsky in relation to the Jewish sources of the story. After the infant Moses seized Pharaoh's crown, three counsellors reacted to the incident in different ways. Balaam (perhaps the man in profile, turbaned and dressed in red in the foreground) calls for Moses' death, which provokes Jethro (the white-bearded man vigorously arguing with Pharaoh) to save the child by suggesting the ordeal, while Job (the bearded man in a turban, partly hidden by the two servants proffering dishes to the infant) remains indifferent. Whatever their identities, the intrigue of an Oriental court translates well into the dialogue of a North Italian court scene, such as Giorgione would have witnessed at the court of Caterina Cornaro in Asolo. The parallel between the two panels is that both depict the miraculous salvation of a child in connection with a judgement, suggesting perhaps a patron who was a judge, or that the function of the panels was related to a judicial space.

Literature: Crowe and Cavalcaselle, 1871, II, pp. 121-27; Fiocco, 1915, pp. 138-56; Pignatti, 1969, pp. 58, 98-99; Ballarin, 1979, pp. 227-29; Rearick, 1979, pp. 189-91; Haitovsky, 1990, pp. 21-29; Torrini, 1993, pp. 16-19.

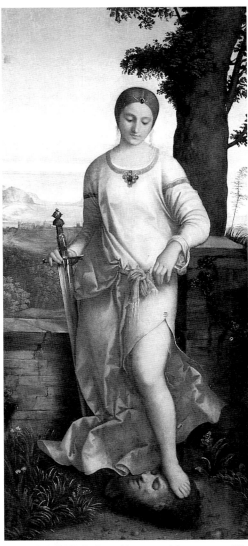

ST PETERSBURG, State Hermitage Museum, inv. 37
Judith with the Head of Holofernes (Fig. 123)
Canvas, transferred in 1893 from panel, 144 x 68 cm

Provenance: M. Bertin; M. Forest; Pierre Crozat; Louis-François Crozat, marquis du Châtel; Louis-Antoine Crozat, baron de Thiers; Catherine II of Russia.

With this small picture, Giorgione introduced the Jewish heroine of the Apocrypha to Venetian painting. He did so with an impressive knowledge of the classicizing sculpture of the Lombardi, but for the composition as a whole adopted the pose of the classical sculpture of Venus standing on a tortoise by Phidias, the *Aphrodite Ourania* (Fig. 120). The work is in good condition, as revealed in the 1969-71 restoration by A. M. Malova. On the right, close to the edge and slightly below centre, a square keyhole has been blocked in and repainted, revealing that the panel was once a cupboard door. Repaint is still evident on Judith's face and neck and on Holofernes' nose and temple. Other damages are on the grass and tree trunk. For many years it was erroneously believed that two long strips of landscape had been cut from either side of the painting on the evidence

of an early engraved copy by Antoinette Larcher, an illustration to Mariette's description of the Crozat collection, *Recueil d'estampes d'après les plus beaux tableaux et les plus beaux dessins qui sont en France dans le Cabinet du Roy, dans celui de Monseigneur le Duc d'Orléans et dans d'autres Cabinets*, Paris (1729). Earlier engravings by 'L. Sa.', Jan de Bisschop, and de Quitter reveal that the side pieces were later additions, made to 'improve' the work when it was in the Crozat collection. The side strips were removed between 1838 and 1863.

The original ground was a light rose colour. Radiographic evidence shows numerous changes in the course of execution. Figures were sketched in by incising the contours and other details were drawn freely with the brush. The size of Judith's head was reduced by about 5 mm. Her hair style was originally more dishevelled, her locks falling loosely on her shoulders like the 'gypsy' in the *Tempesta* (Fig. 108), but finally her hair was severely fitted to the shape of her head and only a few locks allowed to stray. The position of the fingers on Judith's left hand was altered, and originally there were plants on the left side matching those on the right, subsequently painted over. Giorgione's fingerprints survive in the final touches on Judith's diaphanous crimson robe, the wall on the left, and the sky.

Although the picture was commonly attributed to Raphael from the seventeenth century on, the earliest description of the work, by Mariette, notes: 'Les couleurs fortes, vives, les carnations fondues de beaucoup de relief, enfin le paysage qui sert de fond étant précisément dans le goût dans les principes du Giorgion, tout cela a porté quelques connoisseurs àsoutenir qu'il était du Giorgione non de Raphael'. Waagen, in the first catalogue of the Hermitage, 1864, attributed the *Judith* to Moretto da Brescia, under whose name it was exhibited until 1889. In the nineteenth century, Liphart, Richter and Morelli, all independently attributed the painting to Giorgione. On 29 November 1880, Richter wrote to Morelli from Paris about a recent visit to his uncle's house at Châlons, where Larcher's print hung on the walls: 'ich — aber lachen Sie nicht — einen Giorgione entdeckt zu haben glaube. In seinem Salon hängt ein moderner französischer Stich nach einem Bild in Petersburg das Raffael oder "Ecole de Raphael" genannt ist. Ein Weib, *en face* gesehen, ein Schwert haltend, der linken Arm auf eine Mauer gelehnt, den Fuss auf dem Haupt des Holofernes.... Das Petersburger Bild hat den Castelfranco-Typus und ist viel feiner, so scheint es'. Morelli replied that he hoped the Giorgione had been photographed for he would be delighted to add a further Giorgione to his inventory. On 23 January 1881, Richter sent a photograph and three days later Morelli responded: 'Die Photographie, die "Judith", die Sie mir beilegten, machte mir sogleich den Eindruck eines echten Giorgione. So schlecht auch diese Kopie immer sein mag, den Meister erkennt man beim ersten Blicke darin: am Oval des Gesichts, an der Form und Stellung des linken Beines, an den gekniffenen Bruchfalten, und, wenn Sie Wollen, selbst an der Auffassung. Das Original muss herrlich sein, und dies Bild allein machte mir Lust, nach Petersburg zu wallfahrten. Auch Freund Frizzoni gibt zu, dass es ein Giorgione sein durfte'.

Literature: Morelli, 1891, pp. 286, 292; Liphart, 1910, pp. 16-17; J. P. Richter, 1960, pp. 134-35; Pignatti, 1969, p. 96; Steinböck, 1972, pp. 51-62; Fomicieva, 1973, pp. 417-20; Wilde, 1974, p. 83; Freedberg, 1975, pp. 131-32; Tschmelitsch, 1975, pp. 107f; Pignatti, 1979A, pp. 269-71; Hornig, 1987, pp. 177-79; Torrini, 1993, pp. 52-55.

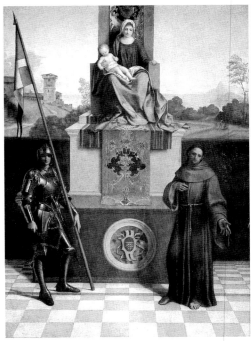

CASTELFRANCO, Cathedral of San Liberale
Virgin Enthroned between St Francis and St George (*Castelfranco Altarpiece*) (Fig. 84)
Panel, 200 x 152 cm

Provenance: painted for the chapel of San Giorgio in the chiesa vecchia of San Liberale, Castelfranco, decorated with frescoes of Christ the Redeemer and four Evangelists, amidst inscriptions and Costanzo tombs (Melchiori, *Castelfranco e territorio ricercato nelle iscrizioni e pitture pubbliche*, Venice, Ms. It. VI, 416 [5972], fol. 19, nos. 24-31, Biblioteca Marciana, Venice); the church was demolished in the mid-eighteenth century, and the work is now installed in a modern setting, together with Mattheo Costanzo's sepulchral monument, in a side chapel in the eighteenth-century church of San Liberale.

The first published reference to the altarpiece occurs in Carlo Ridolfi's *Maraviglie* (1648). Ridolfi relates that Giorgione returned home to Castelfranco, where he painted, for the *condottiere* Tuzio Costanzo, an altarpiece of the Madonna enthroned between St Francis and St George for the church of San Liberale; Ridolfi also introduces the notion of portraiture, claiming that St George is Giorgione's own self-portrait while St Francis bears his brother's features. The earliest references to the chapel and the altarpiece are in the *Visite pastorali*, Archivio della Curia Vescovile, Treviso (Anderson, 1973; Bellinati, 1978; Pedrocco, 1978). They record what local bishops said about the successive restorations of the painting and its ever-deteriorating condition. On 13 May 1564, there is a brief reference to the tomb of Tuzio's son Mattheo Costanzo in the chapel of San Giorgio in the old church of San Liberale ('in cuius cappella reperitur sepultura illorum de Constantiis'); the tomb was placed on the wall of the chapel, according to Tuzio Costanzo's testament, where he also made provision for his own tomb: 'Voglio che quando piacerà al mio Signor Altissimo levarmi de questo mundo, se io serò in questa parte dell'Italia, voglio che corpo mio sia portado et sep-

pelido in Castel Franco ne la giesia de San Liberale ne la nostra capella dove è sepulto el corpo di Matteo mio carissimo fiolo defuncto, cum quelle honesta pompa che parera a ditti mei commissarij, facendo nel muro di detta cappella un altro deposito over sepulcro de marmoro (16 October 1510)'. In 1567 and 1584, visiting bishops comment on the fact that the chapel was not well maintained, and in the pastoral visit of 1603 we have the first reference to the altarpiece, then in a ruinous condition, which provoked the bishop to order a new altarpiece and other furnishings: 'Ordini . . . Che all'altare di S. Giorgio sia della famiglia delli SS.ri Costanzi provisto d'una palla nova . . .'. Fortunately, the order was not instituted, and in 1635 the Trevisan bishop Sylvestro Mauroceno ordered the restoration of the altarpiece, because it was by the famous artist Giorgione: 'Vidit Altare Sancti Georgij cuius Icona, propterea quod est picta manu Zorzonis de Castrofrancho pictoris celeberrimi, difficillime potest reperiri qui eam renovet; et restauranda impossibile ubi est corrupta et deformata. Ordinavit in omnino restaurari eo meliori modo quo possit' (*Visite pastorali antiche*, busta 13, fols. 169v-170r, Archivio della Curia Vescovile, Treviso). Seven years later, bishop Marco Mauroceno, in words of grave severity, demanded that unless Giorgione's painting be restored within a month, mass was not to be celebrated at the altar: 'Vidit altare Sti Giorgij quius Icon est valdo corrosum: jussit in termine unius mensis resarciri aliquo prout meliori modo respectu picturae manu excelentis artificis depictae'. Presumably, shortly thereafter the first of many restorations took place.

Following Ridolfi's citation of the altarpiece, travellers on the Grand Tour made a pilgrimage to Castelfranco, such as John, 3rd Earl of Bute, who in 1769, noted the altarpiece and its 'fine landskip on each end of the Pedestal' in a notebook entitled 'From Venice to Holland thro' Germany', to be published by Francis Russell. Restorations took place in 1643 (unknown); 1674 (Pietro della Vecchia and Melchiore Melchiori); 1731 (Antonio Medi and Ridolfi Manzoni); 1803 (Aniano Balsafieri, possibly assisted by Daniele Marangoni); 1831 (Giuseppe Gallo Lorenzi); 1851-52 (Paolo Fabbris di Alpago); 1934 (Mauro Pellicioli at the Brera; see 'La clinica dei capolavori', *L'Ambrosiana*, 7 March 1934); 1978 (Soprintendenza di Venezia). The altarpiece was originally hung high in the old chapel and exposed to direct sunlight, which meant that on many occasions peeling paint had to be stabilized. Paolo Fabbris' solution to this problem was to paint over the surface and cover what was missing with a Neoclassical temple, the vestiges of which are still disturbingly visible in the upper right landscape of the work. An important amount of data concerning Giorgione's technique was discovered during conservation on the painting for the quincentenary exhibition (Lazzarini, 1978, pp. 45-59; Valcanover, 1978, pp. 60-70). Giorgione began the composition by carefully tracing outlines of the principal forms in the gesso, whereas details such as the landscape backgrounds were painted in by brush, seemingly without underdrawing.

The unusual composition of the altarpiece was not imitated, but the figure of the armoured St George was frequently copied as a single picture, perhaps in the mistaken belief that he was a representation of Gaston de Foix. There is a painting in the National Gallery, London (p. 330 below), perhaps once in the collection of Gabriel Vendramin (Anderson, 1979A, p. 644), which was copied by Philippe de Champaigne for Cardinal Richelieu, and subsequently engraved as a portrait of Gaston de Foix. A variant of this figure occurs in a fresco by Pellegrino da San Daniele in the church of Sant'Antonio, San Daniele, Friuli, and in Bonifazio Pitati's *Adulteress*, Galleria Borghese, Rome.

By the nineteenth century, it was believed that the St George was a portrait of Tuzio's son. An anonymous writer in the *Quotidiano Veneto*, 2 December 1803, first proposed that the commission for the altarpiece occurred when Tuzio was in mourning for his son Matteo, killed in battle, an interpretation that was influenced by the configuration of the altarpiece with Mattheo's tomb (1504), newly placed on the floor in the eighteenth-century church. The reason why this idea has been so hard to disprove is that we always see the altarpiece and tomb in this nineteenth-century installation. The notion that the Madonna originally looked down sadly at Mattheo's tomb is impossible, since Tuzio's will states that Mattheo's tomb was on the wall, where he also wished his own to be placed. The interpretation would have suggested itself to our anonymous author by the new arrangement in the chapel in the new church. Circumstantial evidence about Tuzio's presence in the Trevigiana, discussed above (p. 134), suggests that the altarpiece would have been commissioned shortly before 1500, as part of Tuzio's program to convince the Republic of Venice that he had taken up residence in Castelfranco. More important, the style of the altarpiece, which is Bellinian in its details, recommends such an earlier dating, one which has been accepted by Lucco, 1988, p. 208; Humfrey, 1993, pp. 236-38, 351; Battisti, 1994, p. 257 n. 70 — although others still believe the legend created by the anonymous Venetian newspaper reporter in 1803 (for example, Torrini, 1993, pp. 56-63). Only Charles Hope (1993) has queried the attribution to Giorgione, suggesting instead the engraver Giulio Campagnola. Hope questions the attribution since the documentation dates a century after Giorgione's death. Elsewhere in this volume (p. 70 above) it is shown how Ridolfi could have been acquainted with this tradition when he visited the Trevigana in 1630. There is no known painting by Giulio Campagnola, who, according to early sources such as Michiel, was a printmaker who imitated Giorgione; see especially Keith Christiansen (1994) for his criticism of Hope's article.

Literature: Ridolfi, 1648, ed. von Hadeln, I, pp. 95-97 (see p. 370 below); Crowe and Cavalcaselle, 1871, II, pp. 129-34; Anderson, 1973, pp. 290-99; Bellinati, 1978, pp. 4-5; *Giorgione: La Pala di Castelfranco Veneto*, 1979; Humfrey, 1993, pp. 236-38, 351; Hope, 1993B, pp. 23-24; Battisti, 1994, p. 257 n. 70; Christiansen, 1994, p. 341.

LONDON, NATIONAL GALLERY, inv. 1160
Adoration of the Magi (Fig. 59)
Wood, possibly from a predella, 29 x 81 cm

Provenance: before 1822, acquired by John Philip Miles, Leigh Court, Somersetshire, from Richard Hart Davis, Bristol, Avon, according to the 1822 catalogue; inherited by Sir William Miles (1845-1879) and Sir Philip John William Miles; acquired by the National Gallery from the Miles sale, Christie's, London, 1884.

The *Adoration* in the National Gallery, now almost universally attributed to Giorgione, has provoked some strange controversies in its history, both when it first entered the national collection and more recently when its underdrawing was analyzed (Hope and Van Asperen de Boer, 1991). This is partly because of its association with the Allendale group. In the account of the sale of the Leigh Court Gallery of pictures, on 21 June 1884, the painting was first described in the *Athenaeum* as 'a charming Giovanni Bellini, representing with delicate little figures, *The Adoration of the Magi*, [which] was . . . [exhibited] at the Academy in 1870. It is a predella picture, carefully, elegantly and smoothly finished. The flesh tints are golden and the coloration is bright, and the work is in excellent condition'. Sir Frederick Burton bought the painting for the National Gallery in the belief that it was a Giorgione, and tried unsuccessfully to persuade his friends, Sir Austen Henry Layard, a trustee of the Gallery, and the great connoisseur Giovanni Morelli, of the attribution. As Layard wrote to Morelli in 1884: 'Burton m'écrit qu'il a acheté à la vente des tableaux de Leigh Court un petit tableau qu'il croit être de Giorgione. Crowe et Cavalcaselle en font une description dans leur *North Italy*, vol. II, p. 128, et se montrent disposé à l'attribuer a ce grand maître. Burton me dit que c'est un bijou. Il l'a eu pour très peu' (Add. Mss. 38667, British Library, London). Morelli was to attribute the panel, together with the whole Allendale group, to Catena, who was closely associated with Giorgione. From 1889 onwards, it was catalogued as Giovanni Bellini, then as a Bonifazio, until the middle of this century, when the attribution to Giorgione found increasing favour. The excellence of the condition of the painting was certainly exaggerated by Burton, as there are a considerable number of losses of small pieces of paint caused by flaking. The quality of the original surface is still present in some parts, such as the doublet and belt of the young man on the right.

The panel clearly belongs with the Allendale group, and is accepted as by Giorgione, with the recent exception of Hope and Van Asperen de Boer (1991), who argue that the underdrawing may be by two different hands, one of whom is Giulio Campagnola. An underdrawing on the *Adoration* panel does indeed show another composition, perhaps an alternative earlier idea for the companions of the Magi, which was sketched on the panel when it was the other way up. It shows nude figures and horsemen. It is this preliminary underdrawing that Hope and Van Asperen de Boer claim is by Campagnola. Images revealed by infrared examination are as open to different interpretations as other graphic images. By contrast, Jill Dunkerton (1994, p. 69) was struck by the similarities in detail between the two underdrawings for the *Adoration* and for the *Three Philosophers* (Fig. 49), such as 'the schematic rendering of the lowered eyelids of the central philosopher and of the Christ Child in the National Gallery picture as semicircles, like lunettes and in both paintings the drapery folds are outlined with an angular sequence of linked, only slightly curved strokes of the brush, a linear reduction of Giorgione's style of drapery painting that in the core works, at least, suggests stiffened almost papery fabrics that fall into broad and often interconnected triangular shapes'. Dunkerton's analysis is persuasive, while the search for several personalities beneath the surface can lead to confusion.

The discovery of drawings unrelated to the surface composition is something that appears to be characteristic of Giorgione's picture-making in both the Pitti *Three Ages of Man* (Fig. 106) and the *Terris Portrait* (Fig. 68).

The format of the painting has always suggested that the panel was once part of a predella, but no other panels from the same predella, if they were by Giorgione, appear to have survived. The provenance gives no help as to the work's original location. Predellas were uncommon beneath Venetian altarpieces beginning in the mid-Quattrocento, though they did continue to survive as part of the altarpiece in the *terraferma*. It could be that the predella form is accidental.

Literature: *A Catalogue of the Pictures at Leigh Court, near Bristol, the Seat of P. J. Miles, with Etchings from the Whole Collection by John Young*, London (1822), p. 14, no. 23; Hope and Van Asperen de Boer, 1991, p. 132; Dunkerton, 1994, p. 69.

WASHINGTON, D.C., National Gallery of Art, inv. 1952.2.8
Holy Family (Benson Madonna) (Fig. 57)
Panel transferred to masonite in 1936, 37.3 x 45.6 cm

Provenance: Charles I of England; possibly James II of England; possibly Allaert van Everdingen (sold Amsterdam, 19 April 1709, no. 2); French private collection, where attributed to Cima da Conegliano (Borenius, 1914); anonymous dealer, Brighton, England, until 1887 (according to Benson, who owned the painting in the 1920's, it was discovered in a Brighton curiosity shop about 1887); on death of the purchaser it was sold by auction in Brighton, and bought by Henry Willett; Henry Willett, Brighton, from 1887 until 1894; given in exchange to Robert Henry and Evelyn Benson (née Holford), Buckhurst Park, Sussex, London, where catalogued by Borenius as by Giorgione); bought by Duveen's, New York, in 1927; sold to the Samuel H. Kress Collection in 1952.

In view of its size and subject, the picture could perhaps be identified with a painting in the collection of Giovanni Grimani, Venice, 'Uno quadro de uno prexepio de man de zorzi da Chastel Franco per ducati 10' (p. 365 below), where it was valued by Paris Bordone in 1553-64. The surprisingly low valuation of ten ducats might arise from the small size of the panel. If it were in the collection of Giovanni Grimani, then he may well have inherited it from his relatives, either Domenico or Marino Grimani. But no such painting is recorded in any other Grimani inventory.

The condition of the painting is complex, which helps to explain some of the contradictory views about the attribution, generally located within the Allendale group. The painting was last cleaned in 1936 by William

Suhr, when it was at Joseph Duveen's. Suhr's notes reveal that it had already been transferred, and that it was to be retransferred probably due to extensive flaking. An unpublished photograph of the painting taken when it was stripped during Suhr's restoration reveals that there are numerous scattered losses and that the paint layers are abraded in some areas. There is no original paint along the bottom edge and on the lower right and left edges; there are three horizontal splits along the length of the painting. Most surprisingly, Suhr's photograph reveals damage due to a previously unrecorded act of vandalism in the form of scratched drawn circles, as though made by a compass, in several parts of the picture, especially on the Madonna's robe. There are also scratchings on Joseph's eyes, mouth and nose as well as on the Madonna's features. In his notes, Suhr remarks that Duveen's assistant Bogus 'directed that the Madonna's face be made more complete'. In a recent examination of the painting, David Bull reports that the Virgin's blue cape and red dress are much repainted, the shadows strengthened, although the green and orange lining is in good condition. The head of the infant Christ is well preserved, but the extremities of his limbs are damaged. Despite all this, the undamaged parts of the painting guarantee an attribution to Giorgione. The Northern characteristics of the iconography and the painting's style, often remarked upon, accord with the suggestion of Grimani patronage, but it can only remain a hypothesis that this is the picture valued by Paris Bordone for Giovanni Grimani.

Literature: T. Borenius, *Catalogue of Italian Pictures . . . Collected by Robert and Evelyn Benson*, London (1914), p. 167, no. 83; Pignatti, 1969, pp. 95-96; Shapley, 1979, pp. 211-13; Torrini, 1993, pp. 24-26.

WINDSOR, Windsor Castle, Royal Library, Collection of Her Majesty the Queen, inv. 12803
Adoration of the Shepherds (Fig. 27)
Point of brush with brown ink and wash over black chalk on blue paper, heightened with white body colour, 22.7 x 19.4 cm

The drawing has always been connected with the *Allendale Adoration* in Washington (Fig. 52), with which its critical history is allied. Those who attribute the Allendale group to another artist usually attribute this drawing to the same hand. For Pignatti (1969), however, the drawing was a copy after the *Allendale Adoration* by a painter taught by Carpaccio. But there are a number of significant differences between the drawing and the

painting, which suggest that this is an earlier and simpler idea for the picture. If the drawing were a copy or a free variant, then it would surely have recorded the more innovative aspects of the imagery. In the drawing, only one of the shepherds is represented, the Christ Child is propped up in a seated position rather than reclining, while the background looks more like a wall than a cave. For Johannes Wilde, this was the 'only drawing which can be attributed with some degree of certainty to Giorgione' (quoted in *Drawings by Michelangelo, Raphael & Leonardo and Their Contemporaries*, exh. cat., Queen's Gallery, Buckingham Palace, 1972, p. 48). The underdrawing revealed in the infrared reflectogram, discussed in the following entry, is not dissimilar to the Windsor drawing.

Literature: Baldass and Heinz, 1965, p. 117; Pignatti, 1969, pp. 144-45; *Drawings by Michelangelo, Raphael & Leonardo and Their Contemporaries*, exh. cat., Queen's Gallery, Buckingham Palace, 1972, p. 48.

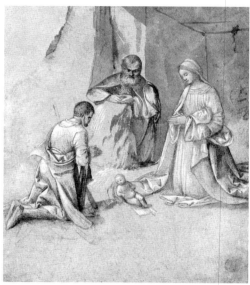

WASHINGTON, D.C., National Gallery of Art, Samuel H. Kress Collection, inv. 1939.1.289
Adoration of the Shepherds (Allendale Adoration) (Fig. 52)
Oil on wood panel, 91 x 111 cm
Inscribed on banner held by angel, at upper left: GLORIA

Provenance: Cardinal Joseph Fesch, Rome (sale catalogue, 1841, lot 644, as Giorgione); sold Palazzo Ricci, Rome, March 17-18, 1845, lot 874, when it was said to have come from France; Claudius Tarral, Paris (sold Christie's, London, 11 June 1847, lot. 55 as Giorgione); Thomas Wentworth Beaumont, Breton Hall, Yorkshire, inherited by his son, Wentworth Blackett Beaumont, 1st Lord Allendale; purchased by Duveen's, New York, 5 August 1937, as Giorgione; sold to the Samuel H. Kress Collection, July 1938.

Various earlier provenances have been proposed. It has been suggested (Luzio, 1888; Baldass and Heinz, 1965) that the *Adoration* may be identified with Giorgione's *Notte*, which Isabella d'Este desired to buy at any price from two Venetian collectors in 1510 (p. 362 below), for the word was used in the sense of Holy Night, rather than the sort of moonlit landscape we might expect. The

independent description of the Vienna variant as a 'Nachtstuckh' in Leopold Wilhelm's inventory (p. 375 below) lends credibility to the suggestion that it was the *Notte* Isabella d'Este wished to buy. It has also been suggested that the *Adoration* may be the *Nativity* by Giorgione appraised by Paris Bordone in his inventory of 1553-64 of the Giovanni Grimani collection (p. 365 below), but it is more likely that the *Benson Madonna* was the painting valued by Paris, in view of its low price. Finally, it has been identified as the *Adoration of the Shepherds* in the collection of James II of England, which is the most difficult provenance to prove.

The condition is excellent, with the following qualifications: splits in the wood joints are apparent at 28 and 62 cm from the bottom; the vertical edges of the panel have minor abrasions; there are paint losses in the sky, especially above the announcing angel, and along the joints, as well as smaller scattered losses on the Madonna's robe, the standing shepherd's face, and in the middle ground just above the small shepherd leaning on the rock. *Pentimenti* are apparent in infrared reflectography and X-ray photographs, which suggest that the painting has been reworked at least once, if not twice. The tree stump in the bottom left corner has been painted over foliage; the rocky edge of the cave has been extended to the left over foliage and sky.

During restoration in 1990-91, David Bull observed that the paint of the announcing angel lies on already cracked paint and is most probably a later addition, a technical observation confirmed by the clumsiness of the lettering of the word GLORIA on the ribbon held by the angel as well as the clumsy execution of paint on the figure. The addition of the angel is an intrusion into the composition and purports to add a contiguous episode. But if Giorgione had intended to represent two episodes from the same story, would he not have dressed the shepherds in the foreground and background similarly? The youth leaning against the rock looks across the stream towards a seated man, but not at the angel, who occupies too lofty a position. The men became shepherds when this rather amateurish angel was added. Bull further observed that at an earlier period — perhaps in the early nineteenth century — a restorer had explored the surface of the painting and had damaged the area between the plateau of stone on which the shepherds stand and the stream adjacent to the tree stump. Here an earlier harsh cleaning has removed something, most likely a bush and/or indications of a pond. Similarly, the contours of the trees above and beneath the angel were once larger and appear to have been skimmed at the edges by the same (nineteenth-century?) restorer when cleaning the sky. The colour of a particularly beautifully painted frond of leaves on the left side of the cave has altered from green to gold. These leaves were once attached to a long vine, later cancelled by Giorgione in order to emphasize the profile of the standing shepherd's head against the rocky cave. A *pentimento* of the thin, vine-like trunk is visible to the eye.

From the time the painting was in the Fesch collection it has almost always been attributed to Giorgione — until 1936, when it came on the art market and Berenson pronounced it to be by the young Titian, a dramatic reattribution that ruined his friendship with Duveen. Since the *Adoration* entered the Kress collection, the attribution to Giorgione has prevailed, with some dissenters, such as Waterhouse (1974) and Freedberg (1975, 1993), who both opt for the young Titian, or those who favour a master of

the *Allendale Adoration*, sometimes giving him a name. For example, Morelli first advanced this alternative solution when he ascribed the *Adoration* and the related group of pictures — the *Benson Madonna* and drawing of the *Adoration* in Windsor — to Catena.

The curious mixture of naïveté and sophistication in the execution of the picture, and its various stages of development have elicited some confusion concerning the authorship. This may in part arise from the curious mixture of Ferrarese and Northern European sources that have been amalgamated into the composition. Following his recent restoration, David Bull suggested the possibility that the painting was executed in several stages, beginning with the landscape. Then changes were made in the left foreground, the tree stump and bush covering an earlier foreground landscape, and finally ending with the figures of the Holy Family and shepherds before the cave. He considered that the picture may even have been left for several years between the time in which the landscape background was executed and the foreground figures begun and completed, which I would suggest, occurred between 1500 and 1502. Bull's hypothesis makes sense of the difficulties that earlier scholars have experienced with the radical changes between parts of the painting, such as the awkward transitions between foreground and background, and where the sky and foliage from the earlier background is discernible, cut at the edge of the cave. After Bull's restoration, the details of the imagery are dazzlingly clear, such as the ultramarine blue of the Madonna's robe and the brilliant red pinpoints of hearth fire in the rightmost building. Many points of comparison with Giorgione's other known works are more easily recognizable than ever before. The figures in the landscape background resemble those in the background of the Uffizi *Trial of Moses* (Fig. 6). The broken tower, as if damaged by war, resembles the broken tower in the *Castelfranco Altarpiece* (Fig. 84), suggesting an early date for the beginning of the picture, somewhere between the altarpiece and the *Moses*. The leaves in the left foreground are morphologically related to those framing the head of *Laura* (Fig. 131).

Delicate brush drawings, similar to the landscape on the surface of the *Tempesta* (Fig. 108), as well as to its underdrawing, were revealed with infrared reflectography using a vidicon camera (Figs. 63-65). The underdrawing consists of both parallel curving lines and washes (Fig. 65). Some compositional elements deviate from the underdrawing, indicating that changes were made during the paint stage. Elements that are not visible in the infrared reflectogram were probably not underdrawn. The left edge of the cave was changed twice, resulting in three contours being visible in the infrared reflectogram. In the first drawn version, the rocks were rounded. Parallel curvilinear lines indicate the volumes and shadows. The second version was in parts painted and in other parts underdrawn. The third version was just painted, not underdrawn. The dark mouth of the cave is much as it appears to the eye, with one edge centred above Joseph's head (Fig. 64). However, this edge was originally curved, with the same parallel curvilinear lines used for the rest of the hill. In later paint stages, dark brown paint was pulled down around Joseph's elbow. Areas were left in reserve for the Virgin's face and for Joseph, but not for the animals. The underdrawing for the Virgin's cloak has different folds, especially those arranged on the ground. The cloak of the shepherd

dressed in blue and red fell in one smooth fold at the underdrawing stage (Fig. 63). The staff on which he leans was slightly longer at the underdrawing stage — it extends through the shoulder of the shepherd in green and blue. The underdrawn head of this shepherd, standing more erect, or a third shepherd was also noted when the painting was examined with a vidicon camera. The cloak of the shepherd in blue and green also had smooth folds: the lining was not folded in a point. A faint shape to the left of his shoes suggests that his shoes were moved, so that the cloak fell in a line parallel with the leg on the shepherd in blue and red. Repeating horizontal lines beneath his leg indicate either ground or that the cloak was spread out on the ground. The tiny male figure at the base of the tree was drawn before the cloak of the shepherd in blue and red was painted. In the landscape, the buildings to the right of the tower were not present at the underdrawing stage. Instead, there were trees in the middle ground. There was no foliage to the right of the mill, so more of the foundation was visible. A tiny building was underdrawn to the right of the mill, but not painted. Once the link between the facture of the *Tempesta* and the underdrawing of the *Allendale Adoration* is made, and by implication the whole Allendale group, then we can make sense of Giorgione's early development.

Literature: Luzio, 1888, pp. 47f.; G.M. Richter, 1937, pp. 257-58; Pignatti, 1969, p. 98; Waterhouse, 1974, p. 13; Wilde, 1974, p. 89; Freedberg, 1975, p. 137; Tschmelitsch, 1975, p. 87; Shapley, 1979, p. 51; Hornig, 1987, pp. 191-92; Places of Delight, 1988, p. 62; Freedberg, 1993, pp. 51-71.

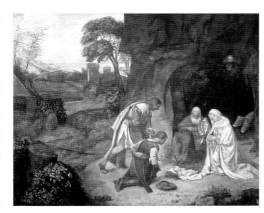

VIENNA, Kunsthistorisches Museum, inv. 1835
Adoration of the Shepherds (variant of the *Allendale Adoration*) (Fig. 28)
Oil on poplar, 92 x 115 cm

Provenance: Bartolomeo della Nave, Venice, 1636, no. 45, as 'our Lady and the Nativity of Christ and the Visitation of the Shepherds Pal 5 & 4 idem'; bought by Lord Basil Feilding, 2nd Earl of Denbigh, when he was the English ambassador in Venice (1634-39), for his brother-in-law, James Hamilton, 3rd Marquis (later first Duke) of Hamilton, d. 1649; inventory of the collection of Archduke Leopold Wilhelm, 1659, no. 217, as 'Ein Nachtstuckh von Öhlfarb auf Holcz, warin die Geburth Christi in einer Landschafft, das Kindtlein ligt auf der Erden auf unser lieben Frawen Rockh, wobei Sct. Joseph und zwey Hierdten undt in der Höche zwey Engelen. In einer glatt verguldten Ramen, hoch 5 Span 4 Finger undt 6 Span 4 Finger braith. Man halt es von Giorgione Original' (p. 375 below).

Despite its excellent provenance, the picture has never been given the critical attention it deserves because of its sorry condition and lack of finish. When compared with the *Allendale Adoration* (Fig. 52), the copy shows marked differences: the Virgin's robe is much lighter, the announcing angel and one of the cherubs across the cave front is absent, and the trees on the left are of a different spindly species. A comparison between this unfinished copy with the X-radiographs of the *Allendale Adoration* reveals similarities that cannot be seen on the picture surface of the Washington painting. The X-ray photograph indicates a significantly greater presence of X-ray opaque (white lead?) paint in the Madonna's robes compared to any of the other garments represented in the picture. In the copy, the Madonna's robes are much lighter, and this may reflect an earlier stage in the painting of the *Allendale Adoration*, when the Madonna's robes were coloured lighter by the use of a relatively X-ray opaque white pigment. In the copy and the radiograph, the structure of the bank of rocks beneath the hut on the left is both similar and different from what is seen on the surface of the *Allendale Adoration*. In the copy, the bank is divided into three masses, thereby creating a much softer and more gradual progression into depth that leads the eye gently back along the stream, whereas in the Washington version two of these masses have been joined together to create an artificial barrier, a too abrupt transition between the detailed foliage of the leafy bush in the foreground and those in the middle distance. Two conclusions are possible. Either this copy was made while the *Allendale Adoration* was unfinished in Giorgione's studio, or a copy was made after the picture was finished, but before a later hand added the angel. From the seventeenth century on, this unfinished copy in Vienna has always been catalogued as having originated in Giorgione's studio, an old tradition confirmed by the evidence here. The traditional title of 'nightpiece' by which it was known brings to mind the *Notte* owned by Taddeo Contarini, mentioned in the Isabella d'Este correspondence.

Literature: Baldass, 1964, p. 164; Pignatti, 1969, pp. 140-41; Torrini, 1993, pp. 118-19.

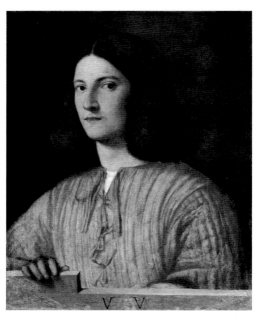

BERLIN, Staatliche Museen zu Berlin-Preußischer Kulturbesitz, Gemäldegalerie, inv. 12A
Portrait of a Young Man in a Pink Quilted Jacket (The Giustiniani Portrait) (Fig. 159)
Canvas, 57.5 x 45.5 cm
Inscribed: V V on the parapet.

Provenance: bought in 1884 by Jean Paul Richter, Florence; acquired in 1891 by the Gemäldegalerie.

The portrait has sometimes been identified with a picture described by Vasari in his life of Titian: 'A principio, dunque che cominciò seguitare la maniera di Giorgione, non avendo più che diciotto anni, fece il ritratto d'un gentiluomo da ca Barbarigo amico suo, che fu tenuto molto bello, essendo la somiglianza della carnagione propria e naturale, sì ben distinti i capelli l'uno dall'altro, che si conterebbono, come anco si farebbono i punti d'un giubone di raso inargentato che fece in quell'opera. Insomma, fu tenuto sì ben fatto e con tanta diligenza, che, se Tiziano non vi avesse scritto in ombra il suo nome, sarebbe stato tenuto opera di Giorgione' (Pignatti, 1969; Rosand, 1978). When the portrait was acquired by Richter, he believed that he had bought a Giorgionesque portrait by the young Sebastiano del Piombo, an attribution later endorsed by Wickhoff. After the painting was restored by Luigi Cavenaghi in 1887, Giovanni Morelli advised Richter not to sell such a wonderful object but to keep it for his own collection ('. . . das Porträt des Sebastiano del Piombo würde ich an Ihrer Stelle, lange Jahre in meinem Arbeitszimmer vor meinen Augen behalten'). The work appears to have been first attributed to Giorgione by Morelli in a conversation concerning the authenticity and possible sale of pictures in Richter's collection with Sir William Gregory, a trustee of the National Gallery, London. On 25 November 1887, Morelli wrote to Richter that he had asked Gregory: 'Und was sagen Sie . . . zu dem wunderschönen Jünglingsporträt des Giorgione?' Gregory retorted: 'Herrlich, very beautiful . . . und halten Sie es wirklich für ein Werk des Giorgione?' 'Welchen anderen Meister wollten Sie es denn geben? Für den Sebastiano kommt es mir fast zu lebendig und geistreich vor', replied

the great connoisseur. Since then, the portrait has always been attributed to Giorgione with the exception of Rosand's proposal of Titian, a proposal in part based on Vasari's testimony, not always a reliable source for Giorgione attributions. The appearance of the portrait after Cavenaghi's restoration is documented by an excellent colour print made by the Photographische Gesellschaft in 1908 prior to Ruhemann's cleaning and less well by a photograph of the portrait as it hung in Richter's collection in Padua (Fig. 160).

The following account of the condition is based on reports by Helmut Ruhemann (1931-33; translation in G.M. Richter, 1937, pp. 125-26) and A. Lobodzinski (1979, unpublished). Paint losses have occurred on each of the four corners, which were all at some time bent down and now show the imprint of longish crease-like folds. The grey background and parapet have been overpainted with a blottesque coarse colour. On the left side of the dark painted background is a later overpaint, which covers the original contour of the youth's own right arm. The parapet's original colours can be seen at the extreme edge of the right side of the picture, and about 2 cm of the original grey ground is still present at the point where the hair touches the right shoulder. The darker areas of shadow on the face and neck have been retouched and there is overpainting on the irises and whites of the eyes and on the eyelashes. The dark line under the left side of the youth's lip, which runs parallel to the mouth, is a *pentimento*. The X-ray photographs show little underdrawing. The craquelure of the hair has been partially closed and consequently damaged. The famous inscription on the parapet, V V, cannot be original in its present state, for close examination reveals that it was painted by a later hand with much heavier brushstrokes. Whether the inscription is based on something that was originally present and can no longer be seen is impossible to determine. The black shadow on the parapet has been retouched by the same heavy hand.

The condition of the flamboyantly painted pink quilted jacket gives an invaluable insight into Giorgione's method of using glazes. Two layers of colour are clearly discernible, a red lake colour under which we may suppose a grey underpainting, and quite distinctly on top of this a bluish grey layer with which the lines of the deep folds at the edges of the quilted padding are partly shown. The ties in the middle are modelled in red. At the edges of the picture the red colour is much richer, while the bluish grey layer is missing. This can be explained by the fact that the picture originally had a frame that was wider by 2 cm. (The wider frame has also left its mark on the upper edges of the grey background.) Bode had the picture reframed at some time between 1891 and 1912. In Ruhemann's report, the discrepancy was explained by the conjecture that the light blue layer or glaze was never applied there, having been covered by a frame from the beginning. In his 1979 restoration report, A. Lobodzinski suggested that the blue layer may be the result of one component of the red glaze, the madder dyes, having faded as a result of exposure to light. In the middle of the jacket, a slightly defective area — on the right side of the middle tied bow and underneath the tied ribbon — shows two original layers of the red colour with which Giorgione modelled the drapery. A disappointing area is the youth's right shoulder, where much of the upper paint layer was removed by Ruhemann in 1931, causing an abrupt transition from clothing to parapet.

The meaning of the inscription V V on the parapet has provoked considerable discussion, as the inscription occurs with quite significant variations in a group of Venetian portraits. The only other occasion in which the inscription occurs precisely in the same form as here is on a rather mediocre portrait, formerly in a private collection, London (Pignatti, 1969, no. A 25). Recently, during restoration of the Goldman portrait in Washington (p. 345 below), the inscription V V O was rediscovered, but the last letter is conjectural. Teniers' copy after Titian's *Lady at the Mirror* in the Prado version of the Archduke's Gallery interior is inscribed V V P in the upper right background. The letter V occurs on the *Broccardo Portrait* (Fig. 158). The only instance of a similar inscription with an acceptable interpretation is to be found on two paintings by Titian, the so-called *Ariosto Portrait* and *La Schiavona*, both in the National Gallery, London, inscribed with the artist's initials, TV, on the parapet (Gould, 1975, pp. 281, 288).

Various explanations of the letters v v on the Berlin portrait have been proposed: that it represents the artist's signature; that it is a portrait of Gabriel Vendramin and means 'Vendramin Venetis', or that it signifies *Vanitas vanitatum* (Schrey, 1915, p. 574; G.M. Richter, 1937, p. 209). The oddity of the letters within any traditional classical or Renaissance epigraphic context is that they stand alone and are not abbreviations within a longer inscription. In the examples cited to support the various theories proposed, such as Thomson de Grummond's supposition of *Vivus vivo* or *Vivens vivo* (1975, p. 352), the comparative classical and Renaissance examples are all taken from longer inscriptions that give a context to the identification. Other alternatives, also to be found in dictionaries of epigraphic abbreviations, are *Votum vovit* and *Ut vouverat*, but which is preferable, or indeed provable? The youth's flamboyant pink quilted jacket, which Giorgione enjoyed painting so much, and which is so conspicuous among the galleries of darkly dressed men and women in Venetian portraits of the period, must have been worn in flagrant violation of the sumptuary laws, and this could lead us to believe any of the following possibilities: *Veniet Venus*, or *Veneris victor* or *Victor vecundus*, but is any one more credible than another?

Literature: Justi, 1936, I, p. 44, II, pp. 181, 185; G.M. Richter, 1937, pp. 124-27, 209; J.P. Richter, 1960, pp. 509, 510, 517; Pignatti, 1969, pp. 100-01; Thomson de Grummond, 1975, pp. 346-56; Tschmelitsch, 1975, p. 122; Rosand, 1978, p. 66; Anderson, 1987B, p. 125; Mündler, 1985, p. 79; Hornig, 1987, pp. 193-95; Torrini, 1993, pp. 40-41.

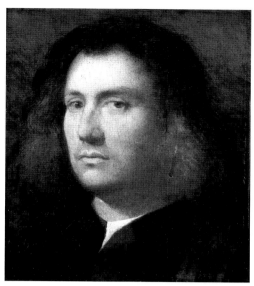

SAN DIEGO, San Diego Museum of Art, inv. 41:100
Portrait of a Man (Terris Portrait) (Fig. 68)
Oil on poplar, 30.1 x 26.7 cm
Inscribed on reverse: *15_di man, de M° Zorzi da Castel fr . . .*

Provenance: David Curror in the nineteenth century; Alexander Terris, London; with T. Agnew & Sons during World War I; c. 1930, David Koester; Lilienfeld Galleries, New York; Misses Anne R. and Amy Putnam, San Diego, who bequeathed it to the museum in 1941.

The panel is about 3 mm thick, with gesso on both sides. While it was in various private collections, the picture was little discussed until Richter's 1937 monograph, when it was accepted as an authentic Giorgione, and the inscription on the reverse perceived as contemporary (Fig. 67). Most found the last two digits of the inscribed date illegible, except that there was definitely a loop visible at the bottom of one, allowing for the possibilities of 1500, 1506, 1508, or 1510. One of the great novelties of Pignatti's monograph (1969) was the confident reading of the date as 1510. Pignatti used this reading as a guideline for what he considered Giorgione's style to have been in the last two years of his life. This allowed him to exclude from Giorgione's œuvre pictures like the *Concert Champêtre*. Hope argued (reported by Hornig, 1987, p. 231), *contra* Pignatti, that the missing third digit could not be '1', since there was no dot in the well-conserved region above the missing number, whereas there is a dot above the first digit. Ballarin (1993) suggested that the date on the reverse was much earlier, 1506. Recent discoveries in conservation have opened up the question of how the inscription on the reverse should be interpreted and suggest an even earlier date.

In 1992, in preparation for the 1993 Paris exhibition, *Le siècle de Titien*, Yvonne Szafran of the paintings conservation department at the J. Paul Getty Museum made an infrared reflectogram of the reverse of the panel in the hope that it would lead to a correct reading of the date (Fig. 69). Instead, she discovered that Giorgione had begun the panel on this side; he had prepared it with a gesso ground, and had then made an ink drawing which he had begun to inpaint on some of the figures. The drawing represents a number of seemingly unrelated fig-

ures, different in relative size, an *Ecce Homo*, and other drawings of the outlines of nudes. Analysis points to the medium of the drawing being probably iron gall ink. At some points on the reverse of the panel where the paint layer has pulled away, it is possible to analyze the drawing. The facial types of two of the drawn figures look like St Joseph and Mary in the *Allendale Adoration*. For some reason, Giorgione abandoned this side of the extremely thin poplar panel, but not before beginning to work it up; and he then made a portrait on the other side.

On the portrait side, most of the first layer of paint is heavy and dark. This black underpainting shows through on the surface of the painting, especially evident in the man's flesh colour, which looks grey and splodged with black, as if the sitter had not shaved properly. This black layer most closely resembles underpainting in the flesh of parts of the Glasgow *Woman Taken in Adultery* (Figs. 41, 44), but is different from the grey primings used by Lorenzo Lotto in his *St Nicholas in Glory* (I Carmini, Venice) and in Titian's *Pesaro Altarpiece* (Lazzarini, 1983, p. 140). There is substantial damage on the nose, and the flesh is heavily abraded, but otherwise the panel is in good condition. The heavy overpainting, removed in 1992, was occasioned by abrasion and craquelure. The X-ray suggests that the subject may have once worn a hat. The colours have changed considerably, most noticeably on the sitter's dress, which now reads black, but which was once a flamboyant purple-blue. It is a mixture of azurite, which has blackened with time, and organic red lake, always a fugitive pigment. The green background is in good condition, but the effect of a purple dress against green must have been once very different, rather like the flamboyant pink quilted jacket of the boy in the *Giustiniani Portrait* (Fig. 159), and manifestly strident in comparison to those sombrely dressed patricians in other Venetian portraits of the period.

This important new data from conservation allows for a new approach to the dating of the picture. The inscription and date on the reverse lie on top of a brown layer of paint, which originally covered the entire reverse. The paint used for the date and inscription are close in date to those used for the portrait on the other side. There is no dirt layer between the layer with the drawing and the paint layer with the inscription, which would have suggested a time interval; it may be contemporary. Giorgione's name in the inscription is given correctly in Venetian dialect, which has always made the attribution acceptable, despite the recent provenance. The underdrawing is very like the underdrawing in ink found on the *Three Ages of Man* in the Pitti (Fig. 106). These two underdrawings are very different from what appears on the surfaces of the pictures. All the indications suggest that the portrait is an early picture, of a similar date to the *Three Ages of Man*. Could the inscription on the reverse be read as being even as early as 1500? The composition of the portrait is simple, the colour scheme very like the *Giustiniani Portrait*. The *Terris Portrait* can no longer be taken as a guideline to Giorgione's style in his last years. The style of the brush drawing dates from the early part of the first decade of the sixteenth century, and the style of the portrait looks as though it is related in colour and composition to the *Giustiniani Portrait*; this would have been even more apparent before the discolouration of the pigments used in the dress. At some stage, a layer of brown paint was applied to protect the reverse of the painting, and the date, now illegible, was added.

In the past, there have been two unsuccessful attempts to identify the sitter, the first by William Schupbach (1978, pp. 164-65), who suggests an Emilian physician and poet, Gian Giacomo Bartolotti da Parma, on the basis of a comparison with a portrait by Titian; the second, by Klara Garas (1972), who suggests Christopher Fugger, an illegitimate son of the house of Fugger, resident in Venice, whom Dürer also portrayed. Both likenesses fail to convince and neither have been accepted. The casual reuse of the panel suggests that this is not a commissioned portrait, but could be that of a friend. In many ways, it bears a close relationship to the three-quarter view of the *Giustiniani Portrait*. If the colour deterioration is borne in mind, the sitter is a somewhat ostentatious personality, robed in purple, in contrast to those soberly dressed patricians in black.

Literature: G.M. Richter, 1937, p. 226; Pignatti, 1969, pp. 110-11; Garas, 1972, pp. 125-35; Ballarin, 1993, pp. 729-32.

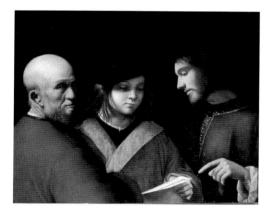

FLORENCE, Palazzo Pitti, inv. 110
Education of the Young Marcus Aurelius (Three Ages of Man) (Fig. 106)
Wood, 62 x 77 cm

Provenance: probably collection of Gabriel Vendramin as 'Un altro quadro con tre che canta con soaze dorade' (inventory of 1567-69, p. 368 below); and with the Vendramin heirs as 'un quadro con tre teste, con un soaze dorade alto quarte cinque et largo cinque e mezza in circa' (inventory of 1601, p. 369 below); probably collection of Niccolò Renieri, 1666, as 'Palma Vecchio. Un Marco Aurelio, quale studia tra due filosofi, mezze figure quanto al vivo, fatto in tavola, largo quarte 5, alto 4, in cornice tutta dorata'; collection of Grand Duke Ferdinand of Tuscany, at least from 1698 — 'un quadro in tavola di maniera buonissima lombarda, che rappresenta tre teste al naturale, che significano le tre età dell'uomo'.

In all probability the painting is described briefly in the above-mentioned inventories of Gabriel Vendramin's collection, which with other works of the same provenance was bought by the artist-dealer Niccolò Renieri. The measurements in the second inventory, given in Venetian *quarte*, are equal to 85.4 x 94.9 cm, which, allowing for a frame of 8.5 at the bottom and top (this minor disparity in the frame size is due to the fact that measurements were given to the nearest half *quarta*), suggest that this is the *Three Ages of Man*, said to have

hung in Gabriel's *camera per notar*. In the Vendramin collection, the painting was unattributed. When it was in Renieri's collection, it was interpreted as a unique representation of the thirteen-year-old Marcus Aurelius, who studied philosophy in a college of priests and surprised them by his liturgical knowledge. In the *Scriptores historiae Augustae* (Marcus Aurelius 2.7-31 to 4.1-4), it is described how Marcus Aurelius as a child became pre-occupied with philosophy, so much so that at the age of twelve he wore philosopher's clothes, and studied with the stoic Apollonius of Chalcedon. Other sources also describe how Emperor Antoninus Pius asked the philosopher to come to Rome for the purpose of instructing his son. Marcus Aurelius became involved in initiation ceremonies, but no one had to teach him the songs, as he knew them by heart. In reality, the title by which the painting became known in the Medici collection, the *Three Ages of Man*, only exists as a subject in the figurative arts, where it is related to an astrological cycle or within the larger context of human life. As Lucco has shown (1989), two men are represented with a youth, one in old age, the other in his early twenties rather than middle age or adulthood, so that this is not really a representation of three ages.

The painting was first attributed to Giorgione on a reproductive engraving by Lambert Antoine Claessens, after a drawing by Jacques Touzé, entitled, 'La leçon de chant', for the Musée Napoléon between 1799 and 1815. Morelli proposed an attribution to Giorgione at the end of the nineteenth century which gained only a limited acceptance. For many years this eloquent and haunting painting concerning a young man's musical education hovered in the limbo of uncertain attributions, until 1989, when Mauro Lucco made it the centre of an exhibition at the Pitti, following Alfio del Serra's restoration. It is the most important attribution to Giorgione proposed in recent years, and has been accepted in a number of exhibitions, where it was shown in good company. Ballarin observed (1979, 1993) that the head of the young man dressed in green, on the right side, was based on a Leonardo drawing of the Apostle Philip for the *Last Supper* (Fig. 11), though it is not necessary to suppose that Giorgione had a direct knowledge of an individual drawing. An underdrawing discovered during Serra's restoration (Figs. 70, 71) reveals a seemingly unrelated composition of a Madonna and Child, who resemble figures in the *Allendale Adoration* (Fig. 52). The underdrawing shows the Virgin worshipping the Christ Child on the ground, as in the Washington painting. All this evidence points to a dating in the first years of the century, shortly after the Allendale group. Similarly the *Terris Portrait* (Fig. 68) shows an analogous underdrawing on the reverse of the panel, similar in character and completely unconnected to the subject of the visible painting.

Literature: Morelli, 1891, pp. 282-83; Anderson, 1979A, pp. 639-48; Garas, 1979, pp. 165-70; Lucco, 1989, pp. 11-29; Brown, in *Leonardo & Venice*, 1992, p. 338; Ballarin, 1993, pp. 702-06; Torrini, 1993, p. 46.

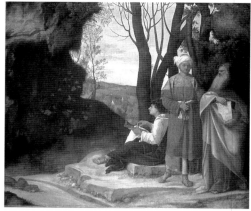

VIENNA, Kunsthistorisches Museum, inv. 551
Three Philosophers in a Landscape (Fig. 49)
Canvas, 123 x 144 cm

Provenance: Taddeo Contarini, Venice, where described by Michiel as 'In casa di M. Taddeo Contarini, 1525. La tela a oglio delli 3 phylosophi nel paese, due riti ed uno sentado che contempla li raggi solari cum quel saxo finto cusi mirabilimente, fu cominciata da Zorzo da Castelfranco, et finita da Sebastiano Veneziano'; his son, Dario Contarini q. Taddeo, S. Fosca, 14 November 1545 (Atti di Pietro Contarini, b. 2567, cc. 84v-100v, Archivio di Stato, Venice), where described as 'Un altro quadro grandeto di tella soazado di nogara con tre figure sopra'; Bartolomeo della Nave, 1638, described as 'A Picture with 3 Astronomers and Geometricians in a Landskip who contemplat and measure Pal 8 x 6 of Giorgione de Castelfranco . . . 400'; bought by Lord Basil Feilding, 2nd Earl of Denbigh, when he was the English ambassador in Venice (1634-39), for his brother-in-law, James Hamilton, 3rd Marquis (later first Duke) of Hamilton, d. 1649; Archduke Leopold Wilhelm, 1659, no. 128: 'Ein Landschaft von Öhlfarb auf Leinwah, warin drey Mathematici, welche die Mase der Höchen des Himmels nehmen . . . Original von Jorgonio'. Described in the first catalogue of the Vienna museum, by Mechel, 1783, as 'Giorgione, Die drei Wesen aus dem Morgenland.'

The manner in which the painting was conceived and developed has been analysed by means of radiographs, published by Wilde (1932), and more recently with infrared reflectograms (Hope and Van Asperen de Boer, 1991, their figs. 67-69; here Fig. 48). The entire composition was first drawn on the ground in a brush drawing before Giorgione began painting, although some parts of the composition are not legible, obscured by the pigment above. The background was first conceived with a castle on top of a hill, replaced in the final version with a mill in a valley. The eldest philosopher was originally depicted in profile, a somewhat monotonous parallel to the youngest man, but this was later altered to a three-quarter view. Instead of the cowl we now see, he originally had a diadem in the form of the rays of the sun attached to his forehead (Fig. 46). As well as the pair of dividers in his left hand, he also held another instrument that is not precisely identifiable, and the sheet of parchment with the astrological signs had a different shape. In the radiographs, the youngest philosopher originally wore a hat, and his features were less sharply delineated — he does not appear in the reflectogram, but this does not mean he was not part of the original conception. Numerous *pentimenti* show that much care was taken with the positioning of his hands holding the pair of dividers and set square. The middle

philosopher was first dressed in a shorter overgarment, and his right hand was placed below the knot of his girdle rather than, as now, in his belt.

The painting was cut in the eighteenth century on the left side by some 17.5 cm (Wilde, 1932), the cave having originally occupied a much more prominent part of the composition, almost half the surface, as we see it in Teniers' copies (p. 316 below, Fig. 148). Despite many attempts to identify where Sebastiano del Piombo may have 'finished' the composition, no consensus has ever been reached, and Michiel may have been mistaken in claiming that the painting was 'finished by Sebastiano'.

Despite the early descriptions of the picture as a representation of philosophers, astronomers, mathematicians, the painting has often been said to represent the Three Magi, beginning with Mechel's catalogue of the Kunsthistorisches Museum in 1783. Mechel's view was revived by Wilde, who maintained that the central philosopher had originally been painted with a dark skin (Wilde, 1932, pp. 145, 150). Wilde misinterpreted the X-ray, which can give no evidence of colour (Fig. 47). Furthermore, the literary source adduced for the painting, the apocryphal Book of Seth, a commentary on St Matthew's Gospel, which describes the Magi before a cave, awaiting the appearance of a star on Mons Victorialis, speaks of twelve Magi rather than three (Wind, 1969, p. 26; see also p. 152 above). The documents discussed above also reveal that Taddeo Contarini, the patron, was a borrower of books on ancient astronomy and philosophy from Bessarion's library (Anderson, 1984A). Of the three Contarini in Venice with the same first name, Battilotti and Franco (1978, pp. 58-61) have established that the patron was Taddeo, son of Niccolò, and the brother-in-law of Gabriel Vendramin. The reaction of certain scholars against a philosophical interpretation of the painting, one which accords with the earliest descriptions of the work, has more to do with debates concerning twentieth-century art historical methodology than with the Renaissance.

A reaction against Neoplatonic interpretations of Renaissance imagery, as proposed for example by Wind, Panofsky, and others, has been fashionable for many years. In Giorgione studies, this reaction is exemplified by Settis (1978, p. 124; English trans., 1990, p. 136), who falls victim to the misinterpretation of the radiographic evidence, when he writes: 'With the *Three Philosophers* in Vienna, Giorgione (and his patron) challenged the wits of his observers first by selecting a single event from the whole story of the magi and then further by choosing one that was very rarely portrayed. But even this was not enough for, as the X-ray shows, he changed the colour of the black king and thus obscured not just an interpretation of the scene but the identity of the characters. According to one scholar (G.M. Richter), the Moor's colour was altered because Giorgione had changed his mind and he wanted to make it clear that the philosophers were not the Magi. Another scholar (C. Gilbert) held that since the figure of the Moorish King was rare in Italian tradition, Giorgione eliminated him because he wanted to make it clear that the three philosophers *were* the Magi. His intention was more probably that only a few observers should be able to identify the three Magi as protagonists, to recognize the story and understand the real meaning of the painting. Just as only the Magi were able to discern the light in the depths of the cave and interpret it

correctly, recognizing the sign of God's presence in the world, so only Giorgione's patron and the most "ingenious" of his friends would be able to perceive the painting's hidden subject. For us the more hurried and careless observers of today, this was revealed by an X-ray'. This lengthy quotation shows how scientific evidence can be misused to support a prevailing orthodoxy, and how X-radiographic images are often misunderstood.

In 1933 Ferriguto (pp. 64-65) proposed the first 'philosophic' interpretation of the painting. Influenced by the prevailing interpretation of Venetian and Paduan Renaissance philosophy as Aristotelian rather than Neoplatonic, he saw the three philosophers as representing three generations of Aristotelian philosophy: the eldest represented Aristotelianism before scholasticism, the turbaned philosopher represented Arabic scholasticism, and the youth humanistic Aristotelianism. Much later, Wind suggested that the painting was about Neoplatonism, the most important new philosophic trend following Cardinal Bessarion's donation to the Venetian Republic of his corpus of Platonic manuscripts in 1468. Cardinal Domenico Grimani then obtained Pico della Mirandola's library, which he brought to Venice. Wind (1969, pp. 4-7) drew attention to the possible philosophic significance of the Platonic cave. Attempts have been made to identify contemporary portraits of philosophers, especially in the face of the youngest philosopher. According to Nardi (1955), he was a portrait of Copernicus, but the comparison with later portraits of the Polish philosopher is unconvincing. Nor is it likely that Taddeo Contarini would have commissioned a portrait of an impoverished foreign scholar, whose heliocentric ideas were unpublished during Giorgione's lifetime. More plausibly, it has been suggested that his features are those of the humanist patrician scholar Ermolao Barbaro (Branca and Weiss, 1963, pp. 35-40), but even this idea is unproven. Giorgione may have intended to represent particular philosophers, but we may never be able to identify who they are. The most convincing interpretation of the painting has been proposed by Peter Meller (1981, pp. 227-47), who argued that the picture represented the education of philosophers according to the famous allegory in Plato's *Republic*. A similar and related interpretation is advanced above (pp. 152ff).

Despite the sophistication of the subject, the painting is stylistically and compositionally fairly simple, and may be located chronologically shortly before the *Laura* portrait, that is, c. 1506. Although it is executed on canvas, there is little of the freedom and responsiveness characteristic of the support, as is shown in the painterliness of the *Tempesta*.

Literature: Wilde, 1932, pp. 141-54; Pignatti, 1969, pp. 105-06; Settis, 1978, pp. 19-45; Hope and Van Asperen de Boer, 1991, pp. 129-31, 135; Torrini, 1993, pp. 86-93.

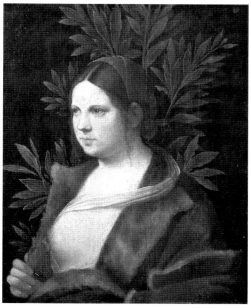

VIENNA, Kunsthistorisches Museum, inv. 219
Portrait of a Woman (Laura) (Fig. 131)
Canvas affixed to spruce panel, 41 x 33.6 cm

Inscription on reverse: *1506 adj. primo zugno fo fatto questo de man de maistro zorzi da chastel fr[ancho] cholega de maistro vizenzo chaena ad instanzia de misser giacomo.*

Provenance: Bartolomeo della Nave, until 1636, as 'Petrarcas Laura' by Giorgione; bought by Lord Basil Feilding, 2nd Earl of Denbigh, when he was the English ambassador in Venice (1634-39), for his brother-in-law, James Hamilton, 3rd Marquis (later first Duke) of Hamilton, d. 1649: 'a Weoman in a red gowne lines with fur with Laurell behind her' (Garas, 1967A, p. 76); Archduke Leopold Wilhelm, 1659, no. 176: 'Von einem vnbekhandten Mahler' (p. 375 below).

In the eighteenth century, the painting was cut to fit an oval frame (Fig. 151), in which form it was exhibited until 1932. Before the reduction in size, the portrait was copied in Teniers' gallery interiors, and the Prado version (Fig. 152), shows Laura with her hand on her stomach, inscribed GIORGION. Wilde (1931, p. 96) assumed that the canvas was originally pasted on the panel (mentioned already in the inventory of 1659). The area cut from the bottom of the painting may be as little as 5 cm (Wilde, 1931, followed by Ballarin, 1993). Whether the inscription dates from the time the work was painted (Wilde, 1931), or whether it is an accurate copy of a text first inscribed on the reverse of the original canvas, later transferred to panel (Baldass, 1955, p. 109), hardly matters since the handwriting is characteristic of the early sixteenth century. The inscription was first deciphered by Dollmayr in 1882, and the portrait subsequently attributed by Justi (1908, pp. 262-63, publishing Dollmayr's findings) to Giorgione. Although the *Laura* appears amongst the most exquisite of the archduke's Venetian treasures in a gallery interior painted as a gift for Leopold Wilhelm's cousin, Philip IV of Spain, the portrait was not engraved for the *Theatrum pictorium* (1658).

Although the earliest description of the painting interprets the laurel wreath as a reference to Petrarch's Laura, it is unlikely that Giorgione intended such a reference, since the woman admired by Petrarch was conspicuously

blonde. The composition of a portrait with laurel leaves framing the sitter's head has always been seen as an act of homage to Leonardo's *Ginevra dei Benci*. Opinion is fiercely divided as to whether the portrait is a marriage portrait, the companion piece then being missing (Noë, 1960, p. 1; Verheyen, 1968, p. 220; Dal Pozzolo, 1993), or whether the woman represented is a courtesan (Anderson, 1979B, pp. 155-56; Pedrocco, 1990; Junkerman 1993, p. 56). The controversy revolves around how to interpret her one bared breast and her clothing. There is comparative material, both in sculpture (Luchs, 1995) and painting, which is used, sometimes irrespective of context, by all the participants in the debate. It could be legitimate to represent a woman partly nude in a portrait composition if she were a heroine such as Diana, Judith, or Lucretia, or if she were a historical personage, one of Boccaccio's famous women for example. There was a known tradition of representing beautiful women so as to display their naked beauty, but Giorgione's *Laura* has no female companions such as are found in these cycles, nor a husband, except for the hidden reference to 'misser Giacomo' on the reverse. She is portrayed actually opening her dress to reveal one bare breast, nestling on the fur lining of her coat dress. She has no *camicia*, or any form of undergarment, which is unusual and contributes to the extraordinary sensuality of the image. According to Cesare Vecellio in his *Habiti* (1590), the winter dress of Venetian courtesans was cloth lined with beautiful fur ('vestida da verno, con veste foderata di bellissime pelli di gran valore'), which for Pedrocco (1990) was a confirmation of her identity as a Venetian courtesan. The whole question of the identity of Giorgione's *Laura* relates to the wider issues concerning the rarity of female portraiture in Venice in this period, discussed above (pp. 211-217).

Literature: Justi, 1908, II, pp. 262-63; Wilde, 1931, pp. 99-100; Justi, 1936, II, pp. 400-03; Baldass, 1955, pp. 103-44; Noë, 1960, pp. 1-35; Verheyen, 1968, pp. 220-27; Anderson, 1979B, pp. 153-88; Pedrocco, 1990, p. 93; Ballarin, 1993, pp. 724-29; Dal Pozzolo, 1993, pp. 257-91; Junkerman, 1993, pp. 49-58; Luchs, 1995, pp. 91-92.

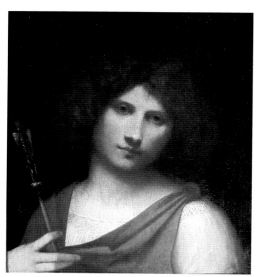

VIENNA, Kunsthistorisches Museum, inv. 323
Young Boy with an Arrow
Poplar, 48 x 42 cm

Provenance: Archduke Sigismund at Innsbruck, 1663, as an Andrea del Sarto, later in the castle at Ambras (inv. 1663); 1773, in the Imperial collections at Vienna as Schedone; transferred to Paris between 1809 and 1815, and subsequently returned.

In 1531 Michiel recorded in the house of a Spanish merchant, Giovanni Ram, resident in Venice at San Stefano, a picture of a boy with an arrow that he described as being by Giorgione. In the following year, Michiel visited the house of Antonio Pasqualigo and noted a similar picture 'La testa del gargione che tiene in mano la frezza, fu de man de Zorzi da Castelfranco, avuta da M. Zuanne Ram', and wrote that Ram only owned a replica, even though he believed it was original ('benchè egli creda che sii el proprio'). Whom are we to believe? Did the Spanish merchant or the Venetian really own the original? Could Michiel recognize a true Giorgione in 1532? Whatever the answer, the painting now in the Kunsthistorisches Museum is certainly an original Giorgione, of exquisite quality, and belonged to either Pasqualigo or Ram.

Research on the Pasqualigo collection suggests that Giorgione's patron may not have been Antonio, but his father Alvise, who was in contact with Gabriel Vendramin, with whom he exchanged the marble antique torso of a 'donna che tien la bocca aperta'. Alvise's portrait was made by Antonello da Messina in 1475, shortly after he entered the Maggior Consiglio on 2 December 1474 (Battilotti and Franco, 1994, pp. 215-16). The collection described by Michiel has the appearance of having been formed in the last years of the Quattrocento and early Cinquecento. It also contained a replica by Giorgione of the head of St James from the painting *Christ Carrying the Cross* in San Rocco (Fig. 15), the sort of variant that Giorgione may have made for a friend.

Giovanni Ram's collection was equally distinguished and also contained an analogous painting of a boy with a fruit by Giorgione, described by Michiel as 'la pittura della testa del pastorello che tiene in man un frutto'. Ram's features are well known from his donor portrait at the bottom of Titian's *Baptism of Christ* in the Capitoline Museum, Rome, also described by Michiel. The Ram family were distinguished Spanish merchants, referred to with respect in Sanudo's *Diaries*, who could boast of illustrious ancestors, among them a Domenico Ram, who was created cardinal by Pope Martin V (Battilotti and Franco, 1994, p. 213). Ram died between 1531 and 1533; he did not refer to his collection in his testament. Nothing in the biographies of the two patrons, in so far as we can reconstruct them, helps explain why they would have commissioned this unusual image of a young boy, which resembles what was described in England in the eighteenth century as a 'fancy-picture' in Reynolds' Fourteenth Discourse. It is a portrait disguised as a pastoral character.

How the painting came from Venice to Vienna is unknown. Once in the Imperial collections it was attributed to various hands — Andrea del Sarto (1663), Schedone (1783) and Correggio (1873), until Ludwig (1903) made the connection with Michiel's text. The marked Leonardesque *sfumato* of the painting clearly created confusion as far as the attribution was concerned, especially since a replica was also documented. It has also led to difficulties in placing the picture within Giorgione's chronology, because he was often interested

in Leonardesque style and motifs. Some scholars (Justi, 1908, p. 189; Venturi, 1913, p. 211) believed that the Vienna picture was the copy. After the painting was shown at the Giorgione exhibition in Venice in 1955, unanimity was reached in favour of an attribution to Giorgione. At this exhibition, the painting was hung next to an equivalent composition of a young boy with a flute, from the Royal Collection at Hampton Court. As John Shearman has demonstrated (1983, pp. 255-56), 'in every non-typological aspect of picture-making they were profoundly different'. At the Paris exhibition in 1993 (*Le siècle de Titien*), it was possible to make the same comparison, though the paintings were on different walls. Even though the Hampton Court painting has suffered a great deal, it is clearly by a different hand, one that imitates the typology of the subject. Whichever patron was responsible for the commission, there is little in their biographies to help explain what the subject is about.

The painting depicts a close-up view of a small, androgynous figure, a child or rustic or pastoral character. He wears a gold-embroidered white *camicia* beneath a loosely draped red garment, his luxuriant long hair slightly disarrayed at the parting. He holds an arrow firmly in his right hand, the tip of which is out of sight, but which is clearly pointed at himself. It has been suggested that he is Eros, but the *camicia* was used for pastoral characters in theatrical productions (Mellencamp, 1969, pp. 174-77) and might suggest that he has assumed the role of Eros or Apollo for a play. Alternatively, in Leonardo da Vinci's studio in Milan in the last decade of the Quattrocento there were a number of representations of young boys dressed up as St Sebastian, such as the painting of St Sebastian by Giovanni Antonio Boltraffio (Fig. 18), which could have suggested the subject. The markedly Leonardesque style and subject has suggested to many a date of c. 1500 (Ballarin, 1993), when Leonardo was briefly in Venice. Alternatively, Giorgione may have seen works by Leonardo, such as the 'quadro testa di bambocio' in the Grimani collection, Venice (Anderson, 1995, pp. 226-27). At the Paris exhibition, the juxtaposition of *Young Boy with an Arrow* and the *Three Ages of Man* (Fig. 106) suggested that the works were different in pictorial handling, and that the *Young Boy with an Arrow* represented a rethinking of Leonardesque ideas of c. 1506, about the time of the *Laura* portrait (Lucco, 1994).

Literature: G.M. Richter, 1937, p. 252; Pignatti, 1969, p. 109; Shearman, 1983, pp. 255-56; Ballarin, 1993, p. 700; Lucco, 1994, p. 47.

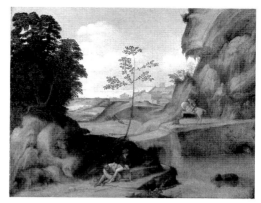

LONDON, National Gallery, inv. 6307
Landscape with St Roch, St George and St Antony Abbot
(*Il Tramonto*) (Fig. 113)
Canvas, 73.3 x 91.5 cm

Provenance: Discovered by Giulio Lorenzetti in 1933 at the Villa Garzoni, Ponte Cassale, previously said to be owned by the Michiel family; collection of Vitale Bloch 1934-57; acquired by National Gallery through Colnaghi's in 1957.

Roberto Longhi invented the title of *Tramonto* in his *Officina Ferrarese* (1934). The picture was exported from Italy, probably around 1934, as a Giulio Campagnola. The attribution to Campagnola, in part suggested by a resemblance to a figure in one of his prints, was also intended to facilitate the export licence. A year earlier, Giorgio Sangiorgi had published the discovery in *Rassegna Italiana* (November 1933), and an English version of the same article was then published in the *Illustrated London News*, 4 November 1933, with photographs of the painting before and after restoration by Vermeeren of Florence. These unflattering photographs were in circulation for many years and contributed to the view that the painting was ruined. Between 1934 and 1955, the picture was kept secretly in London, and was only on public exhibition for the first time in 1955 at the Giorgione exhibition in Venice. Indeed some scholars, such as Augusto Gentili (1981), have been so worried by the extensive repainting on the surface as to consider it close to a forgery. A letter in the dossier at the National Gallery from Vitale Bloch to Philip Hendy recalls that the Roman restorer Theodor Dumler, supervised by Mauro Pellicioli and advised by Roberto Longhi in the 1950s, was responsible for the reconstruction of the damage, in parts conjectural.

Conservation undertaken at the National Gallery after the painting was acquired in 1961 affirms that only twelve percent of the original surface is missing. At this time, part of the figure of St George as well as St Anthony Abbot in his rocky cave were revealed. Prior to 1961, the subject of the painting looked as though it concerned devilish animals in a fantastic landscape, provoking the hypothesis that it might be the lost *Hell with Aeneas and Anchises*, described by Michiel. This hypothesis was subsequently discarded. X-ray photographs reveal many *pentimenti* in the course of execution, particularly in the buildings in middle distance. In the last five years, conservators involved in research on other Giorgione paintings have found the morphological details of the landscape background to be closely related

to parts of the *Allendale Adoration* (Fig. 52), as well as to the hidden landscape of a plane in the central part of the background in the underdrawing of the Dresden *Venus* (Fig. 139).

The subject is a sacred one, with St George fighting the dragon and the bearded St Antony in his cave accompanied by his pig. Pisanello's altarpiece of *St Antony and St George*, also in the National Gallery, shows how both saints allude to a victory of the spirit over an infernal power. It has been suggested that the foreground figures represent a scene of healing, or of pilgrims, such as Gothardus tending the ulcer on St Roch's thigh, or the miracle of the youth's leg performed by St Antony in Padua, but the usual attributes for these figures are lacking. Could the foreground figures be associated with St Antony's reputation for healing? The Antonites were responsible for healing a disease known as St Antony's fire by pouring wine over the infected limbs of sufferers. To the right of the older bearded man, there is a small cask, perhaps containing the medicinal wine, and the young man's leg is bandaged. Much has been made of the fact that the picture was found in a villa once said to have belonged to the Michiel family. Yet the Antonite imagery, and the Bosch-like devils, all suggest Grimani patronage: the Grimani devotion to the monastery of San Antonio in Castello, Venice, was legendary and there were works by Bosch in the Grimani collection.

Literature: *National Gallery Acquisitions, 1953-62*, 1962, pp. 32-35; Pignatti, 1969, p. 107; Gentili, 1981, pp. 12-25; Hoffmann, 1984, pp. 238-44; Ballarin, 1993, pp. 701-02; Torrini, 1993, pp. 84-85.

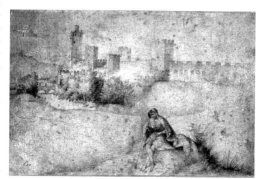

ROTTERDAM, Museum Boijmans Van Beuningen, inv. I 485
View of Castel San Zeno, Montagnana, with a Seated Figure in the Foreground (Fig. 61)
Red chalk, 20.3 x 29 cm
Inscribed: *K 44*.

Provenance: S. Resta; J.W. Marchetti; Lord Somers; J. C. Robinson; G. M. Bohler; F. Koenigs.

This drawing is one of the few graphic works that has been attributed to Giorgione with a degree of certainty. The town represented was for many years erroneously believed to be Castelfranco. In 1978 it was shown by a group of architects at the Centro Studi Castelli that the walled city depicted was the Castel San Zeno di Montagnana, not far from Padua. This discovery has pro-

voked speculation as to what Giorgione was doing there. In the seventeenth century, when Padre Resta discovered this drawing pasted in an old book, he decided to remove it from its mount with warm water, causing some damage. This is apparent in the upper right corner, where an aerial figure, possibly a bird, is barely discernible. The shepherd boy is seated cross-legged, leaning forward on a staff, his gaze animated, as he points to the spectator with the forefinger of his left hand. Only Meijer (1979) has speculated on the interpretation of the subject. He has suggested that it is either a representation of the prophet Elijah near the river Cherith fed by ravens, or the poet Aeschylus in exile. But, as he himself admitted, neither interpretation is satisfactory.

Literature: Centro Studi Castelli, *Antichità Viva*, XVII, nos. 4-5 (1978), pp. 40-52; Meijer, 1979, pp. 53-56; Wethey, 1987, pp. 173-74; Dal Pozzolo, 1991, pp. 23-42.

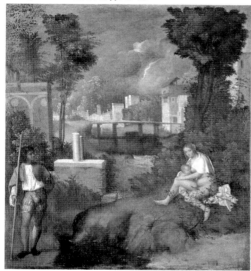

VENICE, Gallerie dell'Accademia, inv. 881
The Tempesta (Fig. 108)
Oil on canvas, 82 x 73 cm

Provenance: Gabriel Vendramin and his heirs until 1601; c. 1800-75, Manfrin collection, Venice, where it was known as 'the Family of Giorgione'; from 1876, Prince Giovanelli; 1932, acquired by the state for the Gallerie dell'Accademia.

The painting was described by Michiel in the house of Gabriel Vendramin in 1530 as 'El Paesetto in tela con la tempesta con la cingana e soldato, fu de man de Zorzi da Castelfranco' (p. 363 below). If Gabriel Vendramin commissioned the painting he would have been in his early twenties when the work was executed. In an inventory of 1569, compiled by Tintoretto and Orazio Vecellio, it is described as 'Un altro quadro de una cingana un pastor in un paeseto con un ponte con suo fornimento de noghera con intagli et paternostri dorati de man de Zorzi da Castelfranco' (p. 368 below). In 1601 it is again described in an inventory of the Vendramin collection composed by lawyers as 'Un quadro de paese con una Dona che latta un figliuolo sentado et un altra figura, con le sue soaze de noghera con filli d'oro altro quarte sie, et largo cinque, e meza incirca' (Anderson, 1979A; p. 369 below). The provenance of the painting is unknown from the early seventeenth century until the early eighteenth century, when it reappears, c. 1800, with

the title of the 'Family of Giorgione' in the Manfrin collection, Venice. In 1817, Jacopo Morelli, librarian of the Marciana, identified the *Family of Giorgione* as the *Tempesta* in his annotations to his own publication of Michiel's text (Archivio Morelliano 73 [=12579], fol. 80, Biblioteca Marciana, Venice; quoted in Holberton, 1995). The painting informed the subject of Byron's *Beppo*, and was copied by artists such as the Swiss Charles Gleyre in 1845 (Hauptman, 1994). Until the end of the nineteenth century, the painting was known as the *Family of Giorgione*, until it became clear that Giorgione never had a family and such a title was nonsense. Whence began a bewildering series of interpretations of the painting's meaning. For the critical history of the painting in the nineteenth century, see pp. 247-54 above.

The young man on the left, identified in the early sources as a soldier, or shepherd, is dressed fashionably, rather like the two men in the foreground of the *Trial of Moses* (Fig. 6), except that his clothes are rendered rather more freely. According to the evidence of radiography (Moschini Marconi, in *Giorgione a Venezia*, 1978), his puffed breeches are added as a refinement in the later layers of the painting. The difference in colour in the legs of his breeches suggests that he is in fact a *compagno* of the Compagnie della Calza, a member of the Confraternity of the Sock who specialized in amateur dramatics for unmarried patrician youths. Gabriel Vendramin never married and could have been about the same age as the youth represented when he commissioned the painting. The man's face is in shadow, as he stares at the woman across a divide of water. To the right of the figure are two broken columns, which were once larger and taller, in the first conception of the painting. They stand on a little broken wall. Behind them, on the left, is a broken colonnade, rather like stage architecture, while to the right is a bridge across a stream. Part of the architecture on the left appears fantastic, while the architecture on the right of the stream resembles a Veneto town, a resemblance born out by the presence of the lion of St Mark and the coat-of-arms of the Carrara family. This last detail, the four wheels of the Carrara family's emblem, is depicted in red, on the tower, at the end of the bridge.

On the right is the figure of a nude woman, who nurses a baby in a strange position, the child resting somewhat uncomfortably on a piece of cloth, rather than in her arms or on her knees, normally the most relaxed position to assume when nursing a child. Her legs are now covered by a plant and leaves, but this may be a later restorer's addition. Further additions may have been made at the same time to the foliage in the upper left and right sides, which appears to have been refreshed. In these small sections, it is a deep brown, somewhat strident in comparison to the other parts. The early reproduction of the *Tempesta* after a drawing by Reinhart in 1866 shows that the additions were not made during Luigi Cavenaghi's restoration work on the painting in 1877. These additions may date back to a restoration of c. 1838.

Following dissatisfaction with the *Family of Giorgione* title, as the painting was known in the Manfrin collection, Wickhoff proposed (1895, pp. 34-43) that the work illustrates the story of Adrastes' discovery of Hypsipyle suckling Opheltes (Statius, *Thebais*, IV, 740). Even Wickhoff realized that the story did not quite fit the

painting — Adrastes should have been accompanied by soldiers and there was no mention of lightning or a storm. Similar difficulties arose in relation to other theories, stories which approximated what was represented in the painting, but which were never quite convincing, such as the birth of Apollo (Hartlaub, 1953, pp. 57-86), Dionysius as the Messiah (Klauner, 1955, pp. 145-68), Jupiter and Io (Battisti, 1960, pp. 145-56), the recreation of a lost painting described by Pliny (XXV, 139) of Danae in Serifo (Parronchi, 1976, p. 3). Other writers suggested an allegorical subject: Ferriguto (1933, pp. 105-27) saw an allegory concerning the forces of nature; Wind (1969, pp. 1-4) thought that the painting was about Strength, Charity and Fortune. According to Wind's theory, the 'gypsy' nursing a child denoted Carità, the truncated columns were emblematic of Strength, and the storm was *fortuna*. Here again there were problems — Charity usually has a number of children, *fortezza* is usually a single broken column. Another category of interpretation held that Giorgione had intentionally created a free fantasy, a picture without meaning (Venturi, 1954, p. 15; Gilbert, 1952, pp. 206-16).

Many of these theories were summarized in Settis' book (1978). Stettis, in turn, proposed a surprisingly weak theory that the painting was a biblical subject, *Adam and Eve*, accompanied by a serpent. The serpent Settis described as a 'tiny snake in the foreground, wriggling into a crevice in the rock'; this tiny line was in an area of the painting where there is a tree root. Like all ultimately venomous snakes, the one that Settis saw in Giorgione's picture had assumed such a perfect form of camouflage as to be invisible to all viewers. Adam had been equally ingenious in acquiring a wardrobe since leaving Paradise, so that he was difficult to identify. In short, all explanations of the *Tempesta* in connection with a story or text have been found to exhibit inexplicable but important divergences from the source.

The painting was X-rayed for the first time in 1939 to reveal a seated female figure on the edge of the stream, beneath the male figure, introducing further complications for the interpretation of the painting (pp. 96-7 above). This hidden female figure was very close to the image of a woman being attacked in the well-known copy by Teniers, entitled *The Rape*, after a lost work by Giorgione (p. 316 below). The many changes in execution, more of which have been revealed in more recent analyses (Moschini Marconi, in *Giorgione a Venezia*, 1978), show that Giorgione worked out the composition on the canvas as he went along, experimenting with the position of the woman in another location, before placing her on the right side. Recently, infrared reflectography (published in the *Quaderni delle Soprintendenza*, 1986) has shown that a substantial square tower with a cupola was once drawn in the middle landscape, above the broken columns; only the top of the cupola is present in the final painting. In the chronology of Giorgione outlined in this volume, the *Tempesta* belongs to those little figures in large landscapes which Michiel described as being among Giorgione's early works, clearly different from the large nudes of the new style that begins in 1507 and continues to his death.

Literature: Reinhart, 1866, pp. 251-54; Rava, 1920, pp. 155-81; Moschini Marconi, in *Giorgione a Venezia*, 1978, p. 104; Anderson, 1979A, pp. 639-48; *Quaderni della Soprintendenza*, XIV (1986), figs. 239-331; Hauptman, 1994, pp. 78-82; Holberton, 1995, pp. 383-403.

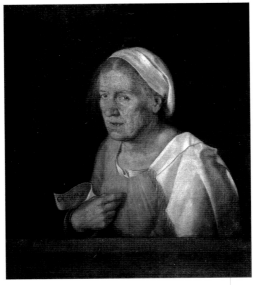

VENICE, Gallerie dell'Accademia, inv. 85
Portrait of an Old Woman (*La Vecchia* or *Col Tempo*) (Fig. 110)
Board transferred to canvas in the nineteenth century, 68 x 59 cm (dimensions with original frame, 96 x 87.5 cm)
Inscribed: COL TEMPO

Provenance: Gabriel Vendramin and his heirs until 1601; seen for sale on the Venetian art market in 1681 in a Medici inventory published here for the first time (p. 376 below); Manfrin Gallery, Venice; 1856, acquired by the Gallerie dell'Accademia.

Although some scholars considered it likely that this painting was described in the 1569 inventory of Gabriel Vendramin's collection as 'il retrato del la madre de Zorzon de man de Zorzon cum suo fornimento depento con l'arma de chà Vendramin' (p. 368 below), there has always been some dissention on the grounds that the shield for the coat-of-arms was never painted. A later, 1601 inventory of the collection gives the measurements of the painting with frame and establishes the provenance: 'Un quadro de una Donna Vecchia con le sue soaze de noghera depente, alto quarte cinque e meza et largo quarte cinque in circa con l'arma Vendramina depenta nelle soaze il coperto del detto quadro depento con un'homo con una vesta di pella negra' (p. 369 below). The sixteenth-century frame in *legno di rovere* has survived surprisingly well, as has its paint, the famous *polvero d'oro* in two tones of gold and black. The shield for the coat-of-arms on this frame was outlined but never painted; yet both inventories describe the Vendramin coat-of-arms as being on the frame. One surprising revelation of the inventory was that the painting had a painted portrait cover with a representation of a man dressed in black fur. Most pictures in the Vendramin collection had *coperti dipinti*, but they were not necessarily by the same artists who had painted the pictures. Some painters, like Lorenzo Lotto, painted their own portrait covers, judging from his *Libro di spese* and the elaborate allegory for the cover of Bernardo de Rossi's portrait, now in the National Gallery, Washington. The cover for Titian's portrait of Sperone Speroni, with the sitter's device of a recumbent lion and cupid (now Alba Collection, Madrid), is of such poor quality that one

wonders if it even came from Titian's workshop (Wethey, 1969-75, II, pp. 140-41).

We now know that *La Vecchia* was later for sale on the Venetian art market from a list of masterpieces, including other works by Giorgione (but not the *Tempesta*), offered to the Medici in 1681: 'Quadro il ritratto di una vecchia di mano di Giorgione che tiene una carta in mano et è sua madre'. It is perhaps significant that again the woman is referred to as Giorgione's mother. Unfortunately, nothing more is known of the painting until it reappears in the Manfrin collection at the beginning of the nineteenth century, then described as the *Madre di Tiziano*.

Before the discovery of the 1601 inventory, the attribution of *La Vecchia* to Giorgione was always resisted, most forcefully by the late Erwin Panofsky in his monograph on Titian (1969). Panofsky claimed that although Giorgione had 'an exquisite taste which recoiled from evil and ugliness . . . he lacked the power to terrify'. Following the discovery of the inventory, scholars have concentrated on integrating *La Vecchia* within Giorgione's works. There is a tear in the canvas across the woman's forehead, from just above her right eyebrow to her left ear. In 1949, much repaint on the parapet and background was removed during restoration (Moschini, 1949). X-ray photographs show that the neck line on the old woman's dress is much lower in the underdrawing, and that the curiously draped shawl was also lower.

La Vecchia speaks to the viewer, her mouth half-open to reveal her few remaining teeth, and she points to herself with a cartellino inscribed COL TEMPO. This phrase occurs as a recurrent refrain in a pastoral eclogue by Cesare Neppi (1508), with reference to the passing of time, the frailty of woman's beauty and the precariousness of existence (Battisti, 1960).

Literature: Moschini, 1949, pp. 180-82; Battisti, 1960, pp. 155-56; Panofsky, 1969, p. 91; Anderson, 1979A, pp. 639-48; Meller, 1979, pp. 109-18; Ballarin, 1993, pp. 712-17; Torrini, 1993, pp. 80-81.

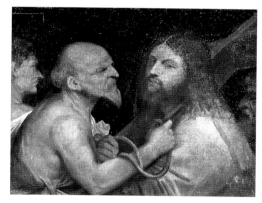

VENICE, Scuola di San Rocco
Christ Carrying the Cross (Fig. 15)
Oil on canvas, 70 x 100 cm

Provenance: formerly in the church of San Rocco, now in the *albergo* of the Confraternity of San Rocco

A document in the early deliberations of the Scuola di San Rocco records that, on 25 March 1508, the venerable Guardian Grande Jacomo de' Zuanne, a wealthy silk merchant, was granted permission to furnish and adorn the small chapel of the Cross in the church of San Rocco with a 'sepoltura, banchi, palia o altar' (Anderson, 1977). It has been accepted that the altarpiece in question was *Christ Carrying the Cross*, a small picture with an appropriate subject for a chapel of that dedication. The furnishing of the chapel was completed by the end of 1509, since Palferius records the dedicatory inscription of that year: 'Iacobi Ioanni mercatori a serico/ et successoribus Dicatum MDIX' (Anderson, 1977). That the picture was executed between April 1508 and the end of 1509 accords well with the traditional dating, but unfortunately these documents do not state to whom the commission was given.

The church of San Rocco was built by Bartolomeo Bon between 1489 and 1508, the consecration taking place on 1 January 1508. By 20 December 1520, Sanudo recalls that 'The great contribution to the church of San Rocco at present is an image of Christ, being pulled by a Judean, part of the altar, which has performed and performs many miracles. Today and every day many people pay homage with donations, which will contribute to the magnificence of the Scuola' (Sanudo, 1496-1533, XXIX, p. 469). An early devotional woodcut (1520), inscribed 'Figura del devotissimo e MiraColoso Christo e nelle Chiesa del San Rocho de Venetia MCCCCCXX', reproduced the painting within a frame. A lunette had been added of God the Father, the Holy Ghost, and four putti holding the instruments of the Passion. This additional lunette has been lost in the course of time. A souvenir pamphlet by Eustachio Celebrino, *Li stupendi et maravigliosi miracoli del Glorioso Christo de Sancto Roccho Novamente Impressa*, c. 1524, exists in three copies, all of different editions. Celebrino describes the image in popular devotional terms, reproduces it in a mediocre woodcut, and mentions some of the miracles performed. The extraordinary fame of the picture a decade after its completion was due to its reputation as a miracle-working image, but these popular pietistic reproductions and pamphlets never mention an artist's name. Throughout the Cinquecento the painting remained in the Zuanne chapel 'dalla destra in entrando', where Francesco Sansovino was to describe it in 1581 (p. 368 below).

In 1532 Michiel saw a painting that copied one of the heads in the altarpiece ('la testa del San Jacomo cun el bordon') in the collection of Antonio Pasqualino, and noted that this head was by Giorgione, or one of his disciples, copied after the Christ in San Rocco. Although ambiguous, for it refers to another painting, his statement suggests that he considered the San Rocco picture to be by Giorgione, otherwise he would have given another name for the original artist. Vasari's later contradictory statements are more problematic. In the first edition of the *Lives* (1550), the painting is attributed to Giorgione: 'Giorgione worked on a painting of Christ carrying the cross with a Judean pulling him, which with time was mounted in the church of San Rocco, and today arouses great devotion performing miracles'. In the second edition (1568), Vasari continues to attribute it to Giorgione in the Giorgione *vita*, whereas in the life of Titian, for which Titian appears to have been Vasari's principal informant, it is also attributed to Titian.

Titian was a member of the Confraternity of San Rocco, a member who was somewhat slow to pay his dues. In September 1553, he is quoted in the proceedings of the confraternity with the following statement: 'Titiano de Cadore pittore di voler lasciar nella schuola nostra memoria dell'incomparabile virtù soa, e far quello quadro grande dell'albergo' (Scuola di San Rocco, Registro delle Parti, II, fol. 140v, Archivio di Stato, Venice). Titian made this statement in the context of his rivalry with Tintoretto, and said that he wished to leave a record of his virtue in the confraternity by making a big painting for the *albergo*. It is strange that Titian would have made this statement if the most famous miracle-working painting were by his hand, even though it was then located in the church of the confraternity. Titian's reported statement raises a further doubt about Vasari's attribution of the work to him.

In the sixteenth and seventeenth centuries, both traditions of authorship survive. Many Venetian writers — Sansovino (1581), the Anonimo di Tizianello (1622) and Boschini (1664) — were impressed by Vasari's second edition and attributed the work to Titian. Two other sources continued the early authoritative tradition of an attribution to Giorgione. On 31 August 1579, Fulvio Orsini writes to Cardinal Alessandro Farnese, and mentions a Giorgione in his possession that depicted half-figures of Christ and Judas with two other Pharisees, which had been bought in Venice years beforehand (Gronau, 1908, p. 434). Alessandro Allori gave two copies of a *Christ Carrying the Cross* to the Grand Duke of Tuscany in 1594, both copied after Giorgione, 'ritratti di quello di Giorgione' (Venturi, 1913, p. 349). Both these examples, concerning copies, show that there was a continuing documentary tradition for the Giorgione attribution.

Giorgione's image is often said to have been inspired by a famous drawing by Leonardo of a head and shoulders of Christ, c. 1490-95 (Marani, in *Leonardo & Venice*, 1992, pp. 344-46). Leonardo's drawing is related to the preparatory studies for the *Last Supper*. The intense expression of pathos on Christ's face stems from the Lombard naturalism of that period. Giorgione appropriated the invention about a decade after Leonardo first created it in order to convey intense devotional feeling. No other Venetian religious image had such a resounding popular success, nor did any other create so much revenue for the institution to which it belonged.

The painting is severely abraded and has much suffered from its function as a miracle-working image. The early copies all suggest that Simon of Cyrene was originally beardless, his present beard an addition from the end of the sixteenth century (G.M. Richter, 1937, p. 246; Puppi, 1961). The paint surface was originally very thin, as we have come to expect with most works by Giorgione. Lazzarini's analysis of pigment samples (1978) shows that the layer structure is very like that of *La Vecchia* (Fig. 110) and other works by Giorgione.

Literature: Lorenzetti, 1920, pp. 181-85; Puppi, 1961, pp. 39-49; Anderson, 1977, pp. 186-88; Nepi-Sciré, in *Leonardo & Venice*, 1992, pp. 350-52.

The existence of two excellent provenances for this fascinating and tragically ruined portrait has only added to its recognition as a Giorgione. Before restoration in 1955, G.M. Richter (1937, p. 254) interpreted the subject as an old woman telling a soldier's fortune, for Jan Van Troyen's engraving for Teniers' *Theatrum pictorium* (Fig. 177) reproduces more of the painting than survives, and interprets the servant as male rather than female. The print shows that the parapet was much deeper and that Marcello held a stick-like object, perhaps a weapon, in his left hand. The servant held a cap and played a more prominent role. It is difficult to understand why the servant holds his master's hand. Is it a gesture of reassurance before or after a heroic deed, or are they making a pact over the weapon, or is the weapon hidden to be used later against the servant? There are dangers in interpreting the picture through Van Troyen's print, as he has dramatized the original in such a way as to make the subject a seventeenth-century genre scene. Pignatti (1969) was hesitant about accepting such a ruined work into Giorgione's œuvre, but following much discussion in articles (Anderson, 1979B; Ballarin, 1979, 1993) and the work's presence in international exhibitions, *Leonardo & Venice* (1992) and *Le siècle de Titien* (1993), its autograph status has gained gradual recognition.

The relationship between Giorgione's double portrait of two contrasting profiles and Leonardo da Vinci's famous drawing of five heads at Windsor (Fig. 12; Anderson, 1979B; Ballarin 1979) has become a frequently made comparison (Holberton, 1985-86; Brown, in *Leonardo & Venice*, 1992). Leonardo's drawing depicts an old man (perhaps a self-portrait), with a wreath on his head, the central figure seen from the back surrounded by mocking and grotesque profiles. It is one of his classic statements of physiognomic contrasts, known perhaps in Venice through copies, of which there were a number. Giorgione's painting isolates the central motif from Leonardo's drawing of a man seen from the back, turning his right arm forward, his classical profile outlined in contrast to that of his ignoble hook-nosed servant. The Leonardesque contrast between age and youth, nobility and commonality, is again reminiscent of *Christ Carrying the Cross* (Fig. 15), and suggests an analogous date of 1508-09. It is also predictive of Giorgione and Titian's fresco of *Judith/Justice* on the Fondaco dei Tedeschi, executed when Titian was in Giorgione's studio (Fig. 176). The subject of the portrait is dressed up in antique armour, as if he were imitating his ancestors. This would suggest that it is the Marcello portrait rather than a Venier commission, as the Marcello were one of the few Venetian families able to trace their ancestry to Roman antiquity, one of their forebears even having been mentioned in the *Aeneid*. Moreover, Sanudo (1496-1533, IX, pp. 144, 206; X, p. 392) informs us of Girolamo's involvement in the defense of Padua in 1509, at which stage he could well have been portrayed by Giorgione as 'armato'; the date seems to chime well with this picture. An alternative interpretation would see the picture as a representation of two half-length figures in conflict, one attacking the other, predictive of the Vienna *Bravo* (Fig. 36), which would explain why seventeenth-century writers like Boschini attributed the *Bravo* to Giorgione.

Literature: Engerth, 1884, I, p. 171; Suida, 1954, p. 165; Pignatti, 1969, pp. 142-43; Garas, 1967A, pp. 59-60; Anderson, 1979B, pp. 154-55; Ballarin, 1979, p. 236; Anderson, 1980, p. 341; Brown, in *Leonardo & Venice*, 1992, pp. 340-41; Ballarin, 1993, pp. 721-24; Torrini, 1993, p. 100.

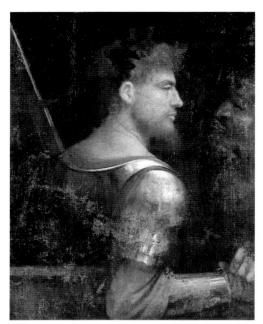

VIENNA, Kunsthistorisches Museum, inv. 1526
Portrait of a Young Soldier with his Retainer (Portrait of Girolamo Marcello) (Fig. 13)
Canvas, 72 x 56.5 cm

Provenance: Two early provenances have been suggested, but neither proven. The painting may be a depiction of Girolamo Marcello, described by Michiel in 1525 as 'lo ritratto de esso M. Ieronimo armato, che mostra la schena, insino al cinto, et volta la testa, fo de mano de Zorzo da Castelfranco' (first proposed by Engerth, 1884; followed by Suida, 1954, and Anderson, 1979B). Alternatively, it represents the portrait of Zuanantonio Venier, described by Michiel in 1528 as 'el soldato armato insino al cinto ma senza celada fu de man de Zorzi da Castelfranco' (Garas, 1967A; Holberton, 1985-86, pp. 186-87); it was certainly engraved by Teniers as a Giorgione when in the collection of Archduke Leopold Wilhelm (1658); Teniers reproduces the composition before about 15 cm was cut from the length and height (Fig. 177); from 1662, Leopold I.

The evidence collected by Garas (1967A, 1968) that a group of pictures — perhaps including this portrait — was sold by the Venier heirs to the procurator Michele Priuli (where some Venier paintings were described by Boschini), and thence from Basil Feilding to his brother-in-law, the 3rd Marquis of Hamilton, finally ending up in the collection of Archduke Leopold Wilhelm, has much to commend it. No such archival documentation has been found to connect the sale of the Marcello pictures to the archduke; however, as Boschini, who acted as an agent for the archduke, describes the Marcello *Venus*, this particular route is not impossible, even if as yet unproven. The only difficulty with the Venier provenance is that this particular picture is not precisely enough described in the various Hamilton inventories — it may be called simply an armed soldier or at times omitted — to be sure of the identification (Ballarin, 1993, p. 722). This is such an unusual portrait composition that one might have expected that the compilers of the Hamilton inventories would have registered the confrontation between the two figures in some way. In the final decision as to which of the two descriptions in Michiel fit the portrait in question, I have a marginal preference for the Marcello picture.

VENICE, Galleria Franchetti alla Ca' d'Oro
Female Nude (Fig. 165)
Detached fresco, 250 x 140 cm

Provance: Originally on the Grand Canal facade of the Fondaco dei Tedeschi, Rialto, between the windows on the upper story. The original position is shown in a photograph (Foscari, 1936, pp. 31-41), before it was detached in 1937.

In January 1504 (*more veneto* 1505), a violent fire destroyed the old German Customs House, and plans for a new building were initiated almost immediately by the Signoria of Venice, who assumed financial responsibility. According to Sanudo in a diary entry of 6 February 1504 (Sanudo, 1496-1533, VI, p. 85), the Signoria was determined that the Fondaco should be rebuilt quickly and beautifully ('lo voleno refar presto e bellissimo'). A number of surrounding palazzi were bought in order to increase the size of the Fondaco. It was unusual to have competitions for building contracts in Venice; nevertheless, Sanudo reports that on 10 June 1505 a competition was held for a design for the new Fondaco dei Tedeschi. Giorgio Spavento, Girolamo Tedesco, and other architects exhibited models in the Senate, and members of the Collegio were obliged to attend meetings of the Senate for a week to discuss the models (Dazzi, 1939-40). It was eventually built under the supervision of two Venetian Protomaestri, Giorgio Spavento, until September 1505, and then Antonio Scarpagnino, but to the design of Girolamo Tedesco ('homo intelligente et practico'), presumably a German architect, who is otherwise unknown. Despite the probable

German nationality of the architect, the appearance of the building was thoroughly Venetian.

By November 1508, a mass was celebrated to give thanks for the completion of the building. It was an elaborate trading complex, a small city according to Francesco Sansovino, where not only German merchants, but traders from all over Europe, came to reside and to exchange merchandise. All the documentation suggests that the project was carefully controlled by the Venetian government, and that it was a matter of concern that everything be executed according to a predetermined design carefully approved by the Signoria. For example, the Senate ordered on 19 June 1506 that the two facades be executed precisely according to the model and not altered ('la faza et riva de la banda davanti non sia in parte alcuna alterada . . . et reducta secondo la forma de esso modelo'). Giorgione's frescoes were a substitute for marble statues, and it seems inconceivable that the subjects were not discussed beforehand, that the painted imagery, like the architectural design, was not subject to rigorous analysis. Moreover, the frescoes that survive as detached frescoes, or in Zanetti's hand-coloured copies, relate to a grander scheme, every facade, internal or external, having been covered with painted decorations. Those on the external facades may have survived better than those in the interior courtyards, perhaps because they were more difficult to reach and restore.

In November 1508, Giorgione's frescoes on the facade facing the Grand Canal were subject to a case brought before the Provveditori al Sal — Hieronimo da Mulla and Alvise Sanudo — in connection with payment. The documents are incomplete and do not record all the developments. Such disputes were rare in Venice, and it is unclear if it was a formality — like the competition for the building contract — or whether the cost was a real issue. Arbitration could occur when a price was disputed, or as a means of ensuring that a work was finished satisfactorily, or sometimes because the price was agreed to after the work was finished. On 8 November 1508, Giovanni Bellini was asked to elect three painters (Lazzaro Bastiani, Carpaccio and Vittore de Matio) as judges; they valued the frescoes at 150 ducats before the Provveditori al Sal, namely Caroso da Ca Pesaro, Zuan Zentani, Marino Gritti and Alvise Sanudo. For some reason Giorgione was paid 130 ducats and declared himself pleased with the decision (Maschio, 1978). In those years, the three heads of the Council of Ten were the legendary Bernardo Bembo, Giorgio Elmo and Francesco Garzoni, who also held responsibility for the Provveditori al Sal. The secretary of the Council of Ten was Nicolò Aurelio, who later commissioned Titian's *Sacred and Profane Love* (Fig. 145) and who therefore appreciated large-scale figure painting. Together these men were ultimately accountable for Giorgione having the commission for the large painting in the Palazzo Ducale and for the Fondaco frescoes (Maschio, 1994, pp. 187-91). Nor is it impossible that Doge Leonardo Loredan himself had something to do with the commission, since there is a prominent inscription to him, and Vasari says that Giorgione painted his portrait.

According to a description by the eighteenth-century archivist of the Fondaco, Giovanni Milesio, work on the frescoes may have begun in March 1508, when the dry weather began. He attributes to Giorgione not only the frescoes on the canal side, but also those which decorated the walls of the interior courtyard: 'Sopra li Archi delle tre piani con bell'ordine si vegono tre gran fregi di Rabeschi, frappostevi con ugual distanza Paesetti, Teste d'antichi Imperatori, Bambini in grande et in piccolo, Mascheroni et

altro. Il tutto a chiaroscuro, fatto dal predetto Giorgione, ma similmente quasi tutto, o si è guasto, o reso poco visibile, dall'ingiuria del Tempo' (Milesio, 1881, p. 45).

The first reference to Giorgione's name in connection with any part of the Fondaco is an ambiguous one, and occurs as late as 1548, when Francisco de Hollanda, in his *Da pintura antigua* (ed. De Vaasconcellos, p. 50) refers to admirable works by Giorgione at the Fondaco.

Whether he was referring to something on one of the facades or whether they were in the art collection of the Fondaco is unclear. Two years later, Vasari published his account of the Fondaco in the first edition of the *Lives*, where he states that Giorgione's fame had grown so much that when the Senate decided to rebuild the Fondaco he was commissioned to fresco the front facade ('ordinarono che Giorgione dipingesse a fresco la facciata di fuori'). In 1550 Vasari had no difficulty describing what was represented: heads and fragmented figures, very brightly coloured, and executed in a totally original style ('che vi sono teste et pezzi di figure molto ben fatte, e colorite vivacissimamente, et attese in tutto quello che egli vi fece, che traesse a'l segno delle cose vive: et non a imitazione nessuna della maniera'). As ambitious a publication as Vasari's *Lives* was bound to provoke a considerable reaction in Italy among contemporary artists. Some wished to rewrite their own biographies, the best-known example being Michelangelo, who instructed Condivi to refashion his own reputation. In Venice, Vasari's sins were perceived as being even greater than in Florence, for he had almost ignored Titian as well as many other Venetians, and considered their achievements inferior to those of Tuscan contemporaries.

The Venetian equivalent to Condivi's *Life* of Michelangelo was Lodovico Dolce's dialogue *L'Aretino*, which purported to represent the views of Titian's greatest popularizer and friend Pietro Aretino, although the dialogue is far too traditional to credibly represent the conversational wit of such a flamboyant personality. Even though Vasari was generous about Giorgione's achievement on the Fondaco in 1550, he had not realized — according to Dolce, presumably echoing Titian's view — that the whole of the Merceria facade was by Titian, 'appena venti anni'. Dolce also writes of Giorgione's jealousy of the talented young Titian, in connection with one fresco on the Merceria side, the *Judith*, which he says was of such excellence that Giorgione was displeased to admit that it was 'di mano del discepolo'. One characteristic of Dolce's dialogue is his subversive attitude to artists earlier than Titian: Gentile Bellini is dismissed as clumsy ('goffo'), while Giorgione is said to have made nothing much besides half-figures and portraits ('non faceva altre opere, che mezze figure e ritratti'); indeed, in Dolce's eyes, Venetian art could scarcely be said to exist before Titian. It is unlikely that Titian was lying about his involvement in the Fondaco, but could he have exaggerated his role in reaction to Vasari? Whatever the truth of the matter, in the second edition of his *Lives*, Vasari amplified his account of the frescoes in the *vita* of Giorgione and also introduced a further discussion of the Fondaco in his new *vita* of Titian.

The Merceria facade, where Titian worked, as many early sources remark, is a narrow and undistinguished space, where anyone in charge of a large workshop could well have let an assistant try his hand. Titian's contribution is defined by Vasari, that is, half a century after the Fondaco frescoes were paid for, and by a critic who was not alive at the time they were executed; nor were any of the others involved in the Fondaco still alive, except Titian. Who could contra-

dict him? Just after the passage where Vasari describes Titian's involvement in the Fondaco, he also mentions a painting by Titian of *Tobias and the Angel* for the church of San Marziliano, Venice, as executed by Titian at the time of the Fondaco frescoes. But this is clearly a mistake, for the painting was executed demonstrably later than 1508 — even as late as 1550. This example reveals that Titian was confused about another work when Vasari visited him in 1566, as Vasari inadvertently reminds us in his life of Titian. Why then should Titian's late testimony about the Fondaco, as recorded by Vasari, be taken as gospel when it is so implausible?

In the second edition of the *Lives*, Vasari increased the section in the *vita* of Giorgione which discusses the frescoes. In this reconsidered version, he describes how Giorgione was first consulted, then commissioned, but confesses that he cannot understand the imagery of either the principal facade or the Merceria facade, both of which he attributes to Giorgione, including the fresco of *Judith*, which he finds incomprehensible. By that date, Vasari also owned and appreciated a portrait sketch in oil by Giorgione of one of the German merchants at the Fondaco, which he kept in his book of drawings. However, in his life of Titian, Vasari returns to the Fondaco, and contradicts himself, by stating that Titian was allocated a few frescoes ('storie') on the Merceria facade. In this section of the *Lives*, Vasari is paraphrasing an interview with Titian. The commission, Vasari claims implausibly, since he has no knowledge of the Venetian committee structure, came from a member of the Barbarigo family. Some gentlemen, he continued, were unaware that Giorgione had not worked on this part of the Fondaco, and thought it the better side. Giorgione became so jealous that 'da indi in poi non volle che mai più Tiziano praticasse, o fusse amico suo'. In 1568 Vasari also mentions that Giorgione had at least one assistant, Morto da Feltre, who helped him with the ornamental details over many months ('. . . con Giorgione da Castelfranco, ch'allora lavorava il fondaco de' Tedeschi, si mise ad aiutarlo, faccendo li ornamenti di quella opera').

What is to be made of Vasari's confused testimony, not only of the contradictions between editions, but of contradictions within an edition? On the basis of this later evidence, some art historians have treated the Merceria facade as purely a commission to Titian (Valcanover, in *Giorgione a Venezia*, 1978); others have more reasonably argued that it seems improbable that a young artist of twenty years of age could be given the responsibility for a complete section, let alone the initiative for creating the imagery on such an important building with a conspicuous political role (Muraro, 1975; Maschio, 1994). The point of comparison in Titian's œuvre is his Paduan frescoes in the Santo (1511; Figs. 167-169), where Titian's abilities in fresco are demonstrably different. Moreover, all the fragments detached from the Merceria facade are of different quality.

In 1760 Anton Maria Zanetti published his *Varie pitture a fresco de' principali maestri veneziani*, the intention of which was to illustrate and preserve for posterity the remains of the ever-deteriorating frescoes on the facades of Venetian palaces by Giorgione, Titian, Veronese, Tintoretto and Zelotti. His book, published anonymously and at his own expense, was a pious act of homage to a great age of Venetian painting. Some of Giorgione's frescoes are represented only in Zanetti's prints, and the appearance of only one fragment that does still exist is recorded at an earlier stage of decay (Fig. 174). A second edition, probably from 1778, the year of Zanetti's death, contains a memoir by his

younger brother Girolamo. (The posthumous edition has a self-portrait of Zanetti, engraved by Giovanni de Pian. The engraved title page of the two editions is the same, but the second edition has been reset, and the opening initial and final tailpiece are relief cuts, instead of the intaglios of the first edition.) The commentary to the twenty-four plates was written by someone who describes himself as 'uno suis-cerato amico dell'autore istesso'. The author-friend continues: 'a cui diè il peso di pubblicar quest'intagli, ch'ei fece, e queste notizie da esso in parte dettate, e in parte da me scritto secondo i di lui pensieri, che io intendo perfetta-mente'. David Brown suggests (1977, p. 32) that this friend was Zanetti's younger brother Girolamo who, in the *Memoria* published in the posthumous edition, claims to have witnessed the entire project.

In his *Della pittura veneziana* (1771, p. 126) Zanetti dis-cusses the Fondaco frescoes and states that 'alcune ne ho disegnate e riportate nel mio libro delle Pitture a fresco', adding that the prints were both designed and engraved by himself. The commentator states that Zanetti made the drawings between June and November 1755; and that he attempted to record the vivid colour of the Fondaco fres-coes by hand-colouring some of the printed copies in his folio volume. Anton Maria noted in *Della pittura veneziana* (p. 536), 'Veggonsi alcuna volta le stampe di questa operetta miniate dall'autore isteso, con le tinte quali appunto sono negli originali. Da altri anche miniate si trovano. Quelle dell'autore sono costantemente in carta fina di Olanda, e non altrimenti; le altre sempre in carta nostra comune'. To my knowledge, three of these hand-coloured copies exist: in the Biblioteca Hertziana, Rome, gr. J. 6990; British Library, London, 61. g. 21; and Houghton Library, Harvard University, Typ. 725. 60. 894 P. Of these, the Houghton Library copy cannot have been coloured by Zanetti's own hand, since it is the second posthumous edition. It is diffi-cult to know what Zanetti meant by 'fine Dutch paper', but one way around the problem is to isolate those copies that are on finer paper with different watermarks. The Hertziana copy has the watermark of a Strasbourg bend and lily, which is unique among the prints, and may accordingly be iden-tified as coloured by Zanetti's hand. The other copies were hand-coloured by the imitators. Some preliminary drawings for the plates have been discovered by David Brown (1977), followed by Karl Parker (1977), and Pignatti (1978). Brown has argued that they are preliminary drawings by Zanetti himself, but Pignatti disagrees. The commentary to Zanetti's *Varie pitture* describes a combination of two techniques, engraving for the figures, etching for the backgrounds.

Both the surviving female figure and Zanetti's prints (Figs. 174, 175) show flaming red sculptural figures in del-icately simulated marble niches, which were along the canal facade. The complex poses and elaborate contrapposto posi-tions of Giorgione's figures invite comparison with Michelangelo's *ignudi* on the Sistine Ceiling, which they predate by a year. They are in fact a remarkable anticipa-tion of Central Italian Mannerism, and to some degree explain why Vasari was so amazed by the imagery of the Fondaco. Giorgione's conception of the nude had devel-oped considerably from his early pictures with small figures like the *Tempesta*. These public frescoes on a conspicuous German monument were executed at a moment when Venice was confronted by the League of Cambrai, an alliance between the Pope Julius II, the Holy Roman Emperor, and the Kings of Spain and France, against the expansionist ambitions, realized and unrealized, of the Venetian Republic. The Merceria facade has seemingly

more contemporary references than the canal facade, and here is to be found the figure of *Judith/Justice*, which Vasari discussed and which was frequently copied. (See, for exam-ple, the anonymous sixteenth-century copy reproduced by P. Rosenberg and A. Schnapper, *Dessins anciens: Bibliothèque municipale de Rouen*, exh. cat., 1970, no. 87.) It has long been recognized that the figure of Judith as Justice on the Merceria facade signifies Venice, and that the German sol-dier near her, holding a sword behind his back, represents betrayal. A similar amalgamation of Judith and Giustizia occurs in Ambrogio Lorenzetti's fresco in the Palazzo Pubblico, Siena, where a female figure of Justice raises her sword above a severed head, 'almost like a Judith' (Vasari). A political interpretation was first suggested by Muraro (1975) and Wind (1969). It has often been erroneously assumed, by Wind and many others, that an engraving by Hendrik van der Borcht of the *Triumph of Peace* represented a lost fresco from the Fondaco. Charles E. Cohen (1980) has revealed that the composition is by Pordenone, and he published a preparatory drawing at Chatsworth.

A contemporary identification of a figure on the Fondaco as a *compagno* of the Calza comes from an unlikely source. An anonymous scribe annotated Michiel's *Diaries* in the early sixteenth century and identified the *compgano* as a cer-tain Zuan Favro (p. 362 below). At the end of the Merceria facade, closest to Campo San Bartolomeo, there are at least four similar figures in striped hose and cloaks that have been identified as *compagni* of the Calza. Between 12 and 15 November 1512, Michiel noted that a certain Zuan Favro had been imprisoned for seven years by the Council of Ten on the charge of smuggling, but that he had managed to escape. The later sixteenth-century annotation to Michiel's *Diaries* reveals that 'This Zuan Favro is portrayed on the Fondaco dei Tedeschi, on the side which faces San Bartolomeo. He was a most admirable man throughout his life'. Sanudo tells essentially the same story about Favro's imprisonment for smuggling, but dates it to 30 October 1512 (Sanudo, 1496-1533, XV, p. 276), and adds that although Favro fled, he voluntarily returned later that year. Cicogna (1861, p. 289) identifies the figure of Zuan Favro as being on the third floor.

One fresco fragment of two female figures engraved by Zanetti (Wind, 1969, fig. 46) invites comparison with the women represented in the *Concert Champêtre* (Fig. 37). What is being communicated between them is mysterious. Further parallels have been seen between the Fondaco fig-ures and Titian's *Sacred and Profane Love* (Fig. 145), but a preparatory drawing by Zanetti, even more than the print, reveals that the jagged edges do not represent clothing on the female figure to the left, but rather the borderline between deteriorating fresco and flesh. This spoils the the-sis that one figure is clothed and the other nude, as pro-posed by Nordenfalk (1952, p. 101) and Wind (1969, p. 39).

Faced with these fascinating fragments of decoration, it is virtually impossible to suggest a program for the whole. One suggestion was proposed by Nepi-Scirè (in *Giorgione a Venezia*, 1978): that Giorgione's nude figure once held a large spherical object, suggesting that she was an allegory of Astronomy or another Liberal Art, within a program that glorified Venice as a perfect state, incorporating Platonic and Neoplatonic ideas, such as are found in the Castello del Bonconsiglio, Trento. One feels that this is the right kind of interpretation for a form of imagery that must have had a political meaning, even if so many years later Vasari, a non-Venetian, found it hard to understand. In chapter VII, I suggest another theory, following Ruskin, that the

nude figure is a Hesperid nymph and once held in her hand a golden apple.

Literature: Hollanda, 1548, ed. Vaasconcellos, p. 50; Milesio, 1881, pp. 183-240; Dazzi, 1939-40, pp. 873-96; Wind, 1969, pp. 11-15; Pignatti, 1969, pp. 14, 102-03, 154; Muraro, 1975, pp. 177-84; Brown, 1977, pp. 31-44; Maschio, 1978, pp. 5-14; Pignatti, 1978, pp. 73-77; Nepi-Scirè, in *Giorgione a Venezia*, 1978, pp. 117-26; Valcanover, in *Giorgione a Venezia*, 1978, pp. 130-42; Cohen, 1980, pp. 601-06; Maschio, 1994, pp. 187-91.

BRAUNSCHWEIG, Herzog Anton-Ulrich Museum, inv. 454
Self-Portrait as David (Fig. 34)
Canvas, 52 x 43 cm

Provenance: probably Cardinal Marino Grimani (1528); proba-bly Giovanni Grimani by inheritance, where described by Vasari; probably Van Veerle collection, Antwerp; Duke of Braunschweig at Salzdahlum from 1737.

Vasari refers to a self-portrait of Giorgione in the col-lection of Giovanni Grimani in his palace at Santa Maria Formosa, which is earlier described in Marino Grimani's inventory of 1528. Justi (1908) identified the portrait as the original that was engraved by Wenzel Hollar (1650; Fig. 125), and proposed that the early provenance had been the Grimani collection. Hollar's engraving is inscribed 'Vero Ritratto de Giorgione de Castel Franco da luy fatto come lo celebra il libro del Vasari', which adds confirma-tion to this provenance. The engraving reproduced the composition before it was cut, with the giant's head visi-ble on a parapet. Despite the credibility of the provenance, the condition of the picture was such that some scholars doubted the attribution, such as Giles Robertson (1955). In 1957, Müller Hofstede published an X-ray photograph of the painting, in which a charming Madonna and Child composition was found underneath the surface. The com-position was of a type associated with Catena, Giorgione's colleague in 1506, according to the inscription on the reverse of the *Laura* portrait. It is impossible to say whether the composition underneath the surface is by Giorgione or Catena, or whether it is a composite venture, dating from the time of their association together. But it makes good sense that Giorgione reused a canvas for his own likeness.

Despite the compelling radiographic evidence, Pignatti rejected the portrait from his monograph (1969, no. C 1). One of his reasons was that Catena's composition in Posnan, which relates to the composition under the surface, had been dated by Robertson in his Catena monograph to 1510-11. Robertson (1971) replied to Pignatti that Müller Hofstede's publication had made him reconsider the evidence. He then argued that the motif of the Madonna and Child was probably conceived by Catena, or even Giorgione, in the light of the radiographic evidence, at a much earlier date than he had supposed. Nevertheless, some scholars are still unconvinced by the attribution, because it would alter their chronology (Ballarin, 1979, p. 243; Torrini, 1993, p. 148). Self-portraiture in Venetian art was rare before Giorgione's representation of himself as the Old Testament hero David, victorious with the severed head of Goliath. The earliest description of the painting in the Grimani inventory of 1528 is the first occasion on which Giorgione's name with the *accessitivo* 'Zorzon' is used, as if in recognition that Giorgione's face and his intellectual stature were as large as the giant whom he vanquished.

Literature: Justi, 1908, I, pp. 199-204; Robertson, 1955, p. 276; Müller Hofstede, 1957, pp. 13-14; Pignatti, 1969, pp. 145-46; Robertson, 1971, p. 477; Anderson, 1979B, pp. 153-54; *Selbstbildnisse und Künstlerporträts von Lucas van Leyden bis Anton Raphael Mengs*, exh. cat., Braunschweig, Herzog Anton-Ulrich Museum, 1980, pp. 38-42.

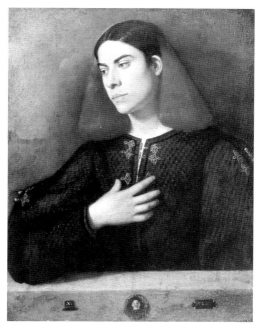

BUDAPEST, Szépművészeti Múzeum, inv. 94 (140)
Portrait of a Young Man (*The Broccardo Portrait*) (Fig. 158)
Canvas, 72.5 X 54 cm
Inscribed: ANTONIVS BRO [KAR] DUS MARE

Provenance: bequeathed by Cardinal Johann Ladislaus Pyrker in 1836 as a work by Orazio Vercelli and said to have been acquired by Pyrker in Venice in the 1820's.

From the time Thausing first suggested Giorgione as the author of this exceptionally fine portrait in 1884, the attribution has been frequently revived, most notably by Pope-Hennessy (1966), but has never gained general acceptance, principally because the sitter is identified as the poet Antonio Broccardo, who was born too late to have been painted at this age by Giorgione. Other attributions have included Pordenone (Frimmel, 1892, pp. 233-34), Licinio (A. Venturi, 1900, pp. 221-23) and Cariani (Morassi, 1942, pp. 102-03). An X-ray photograph reveals that the subject's eyes had been first portrayed in the underdrawing looking upwards akin to those of the spinet player in Titian's *Concert* in the Pitti, but an attribution to Titian has not gained credence.

The youth is dressed in an elaborate black quilted jacket, tied with curious interlaced golden knots. The two side folds of his long hair are painted in a light brown colour, in contrast to the intense black hair on the crown of his head. The change in colour suggests that these luxuriant side pieces are enclosed in a hair net, just as in Titian's *La Schiavona* (National Gallery, London). No traces of a window were apparent on the surface of the painting, although the X-radiograph reveals an oculus in the underpainting. Some scholars have sometimes mistakenly described a window frame on the surface. Instead, there is a delightfully illogical juxtaposition of a parapet portrait with a romantic landscape background of clouds, a tempestuous sky, horizon line and hills. The inscription is scratched into the layers of paint rather like a collector's inscription, in a way analogous to the inscription on Moroni's portrait of Jacopo Contarini, also in Budapest. It is not in any sense an official inscription, such as the one in Gentile Bellini's Budapest portrait of Caterina Cornaro (Fig. 88). The first name has been written twice, once underneath in smaller letters. The three middle letters of the surname are illegible. Late nineteenth and early twentieth-century photographs are misleading, for the incription has been falisifed and the missing letters added. The emblems on the parapet are painted in a much cruder and completely different style from the rest of the painting and appear to be a later addition. The wreath around the triple head is composed of four sections, each denoting one of the four seasons, poppies for spring, wheat for summer, grapes for autumn, nuts for winter. The so-called *tabula rasa* was outlined in white with gold on top. Remnants of a ladder-like shape, painted in gold, can be detected under magnification on the left side of the tablet, as well as traces of an emblem in gold on the right. Thus it does not appear to have been a true *tabula rasa*. The question of the sitter's identity is complicated by the problematical status of the inscription and enigmatic symbols on the parapet.

Literature: Szabó Kákay, 1960, pp. 320-24; Pope-Hennessy, 1966, pp. 135-36, 318; Mravik, 1971, pp. 47-60; Richardson, in *The Genius of Venice*, 1983, p. 171; Brown, in *Leonardo & Venice*, 1992, p. 342; Ballarin, in *Le siècle de Titien*, 1993, pp. 717-21.

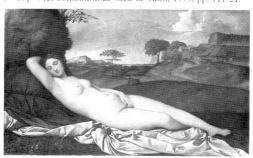

DRESDEN, Gemäldegalerie, inv. 1722
Venus Sleeping in a Landscape (Fig. 139)

Transferred to a new canvas in 1843; 108 x 174 cm (actual canvas size), 103 x 170 cm (paint surface corresponding to original size of canvas)

Provenance: 1525, according to Michiel in the house of Girolamo Marcello, San Tomà, Venice, 'La tela della venere nuda, che dorme in un paese con Cupidine fù de mano de Zorzo da Castelfranco; ma lo paese e Cupidine furono finiti da Tiziano'; heirs of Girolamo Marcello; 1699, acquired by Le Roy, French merchant for August II of Saxony, where it is described as by Giorgione, and after 1722 as a Titian.

As early as 1789, Daniel Chodowiecki noted the poor condition of the painting. By 1837 it was decided to paint over the figure of Cupid and to cover that area of the painting with landscape. In 1843 Martin Schirmer restored the painting, by that date considered to be by an unknown Venetian. He faced many difficult decisions, one of which was to cover up the figure of Cupid, which he had discovered under the surface, because so little of the original was intact in that area of the painting; he also subsequently transferred the picture to a new canvas, a difficult operation at that period (documents concerning Schirmer's restorations are published in Giebe, 1992, 1994). The condition of the painting remained a matter of concern, and it was constantly examined. The picture was recognized as a Giorgione in 1880 by Giovanni Morelli, who identified it as the painting described by Michiel in the Marcello collection, San Tomà. Morelli's friend Karl Woermann, director in Dresden, considered the possibility of restoring the figure of Cupid in 1900, but abandoned the idea. After World War II, it was taken to the Pushkin Museum, Moscow, where it remained until 1956. At this time, Chagall painted a free variant of Giorgione's composition, now in the Musée Marc-Chagall, Nice. Following the return of the historical archives from Russia to the Dresden museum, the conservation history was published by Giebe (1992, 1994), together with new scientific photography.

The original conception of the composition is defined by Giorgione in the earliest layers of the picture, beginning with the confident placing of Venus across the foreground. Except for the position of the figure of Venus, most parts of the painting were modified and developed during the construction of the picture. The original paint surface is very thin. Michiel states that the landscape and Cupid were finished by Titian, but the recent scientific analysis of the layer structure of the pigments reveals that Titian's retouchings were made to an already finished composition, and were more extensive than Michel realized. Titian reworked the extant landscape, invented the red drapery, and increased the rocky area around Venus' head, so that her countenance is framed by the contour of the cave.

Giorgione first defined the position of Venus in the landscape, for a white ground has been used in that part of the painting which corresponds to her body. Small *pentimenti* are apparent in the positioning of her head, which he has minimally moved to turn it towards the spectator. The paint surface is noticeably heavier in the modelling of her breasts, and especially at that point where there is a transition between her left arm and her body. The ground colour has been used to define the details of the landscape, such as the contours of the roofs of the cottages, and the tree at the right hand side. The path which leads to the hill originally came much closer to the figure of Venus, and turned more to the right. It has been obscured with green overpaint. The X-ray

reveals an underdrawing of a different background: a wonderful landscape of a plain is visible, stretching right across the centre between the castle on the right and the mountains on the left, in contrast to the rather wooden execution of the landscape on the surface. It is drawn beautifully with a brush in a paint that has a high metallic content and is easily legible in the X-ray. There is considerable retouching in the area of the fortress and town, as though Titian refined the image. Both artists should be given credit for developing the landscape on the right that we now see. This landscape motif of a winding path leading up to rural houses, some thatched, and bounded by the contour of an abandoned castle was invented by Giorgione for the Dresden *Venus* and then reworked on the same picture by Titian. Titian was to repeat the motif in such works as his *Noli me tangere* (National Gallery, London), to some degree in the *Gypsy Madonna* (Kunsthistorisches Museum, Vienna), and in reverse in *Sacred and Profane Love* (Fig. 145), which has led to the mistaken belief that he, rather than Giorgione, should be credited with the invention. It is surprising that an artist of the calibre of Titian repeatedly used a motif invented by another artist, one who he later claimed was jealous of him. Perhaps there was a personal reason. Titian may, in his youth, have conceived the repetition as a tribute to Giorgione — or was it that he fondly remembered a Veneto village in which something had happened that concerned them both?

Giorgione's original conception of the painting had Venus on a luxurious white sheet, which extended much further to the right, beneath both her feet and probably beneath Cupid as well. Giorgione's original white drapery was like a bed on which Venus lay, placed *before* the landscape, rather than *within* a landscape as we now see her. The head of Venus was originally conceived against a light landscape background, whereas Titian altered the background, so that she appears to nestle her head in a hollow dark cave.

Literature: Morelli, 1880, pp. 161-93; Justi, 1908, ed. 1936, I, pp. 205-22; Posse, 1931, pp. 29-35; Gamba, 1928-29, pp. 205-09; Oettinger, 1944, pp. 113-39; Anderson, 1980, pp. 337-42; Fleischer and Mairinger, 1990, pp. 148-68; Giebe, 1992, pp. 91-108; Giebe 1994, pp. 369-85.

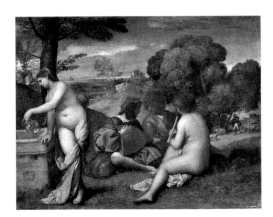

PARIS, Musée du Louvre, inv. 71.
Concert champêtre (Fig. 37)
Canvas, 105 x 136.5 cm

Provenance: Jabach collection, Paris; sold by Jabach to Louis XIV in 1671; collection of Louis XIV, described in Le Brun's 1683

inventory (see below), together with Holbein portraits from the Arundel collection, as 'Un tableau de Georgeon qui représente une Pastoralle, deux hommes assis dont l'un tient un luth, une femme auprès toute nue aussy assise tenant une flute et une autre femme debout nue auprès d'une fontaine tirant de l'eaue'.

In many publications, the early provenance of the *Concert* was erroneously given as the Gonzaga collection in Mantua, subsequently that of Charles I of England. Justi (1908), followed by others, hoped that the Mantuan provenance would suggest that a picture about music, poetry and lovemaking could have been commissioned by Isabella d'Este. Research on the Arundel collection gradually made out a case for the identification of a painting described as 'Giorgion. bagno di donne' as the *Concert*. The identification was first tentatively proposed by M. F. S. Hervey (*The Life Correspondence & Collections of Thomas Howard Earl of Arundel, 'Father of Vertu in England'*, Cambridge, 1921, p. 479). The 1654 inventory of the Countess Arundel's collection in Amsterdam was copied by Johannes Crosse for the litigation concerning her estate (*High Court of Delegates*, DEL. I, Processes, ff. pp. 692-705, Public Record Office, London; published by Cox and Cust, 1911, p. 284). Further supporting evidence was provided by A. Brejon de Lavergnée (*L'inventaire Le Brun de 1683: La collection des tableaux de Louis XIV*, Paris [1987], pp. 254-55), who noted that a group of Arundel pictures, including the *Concert*, entered the French royal collections together, evidence of a common provenance. Furthermore, the earliest copies of the *Concert* were made by Dutch artists, two drawings by Jan de Bisschop (Prentenekabinet, Rijksuniversiteit, Leiden; Lugt collection, Institut Néerlandais, Paris) and a print by Blooteling. Ballarin (1993) was reluctant to accept this circumstantial evidence as being absolute proof that the Countess Arundel owned the painting, but formulated the hypothesis that she could have owned a copy. According to Ballarin, this copy was what de Bisschop and Blooteling copied in their respective drawings and engraving. It is surprising, even improbable, that it never survived, and in what circumstances could it have ever been made?

Although there is no knowledge of the painting's location for several centuries, it emerges in Le Brun's inventory and Blooteling's print with a firm attribution to Giorgione, under whose name it remained until the nineteenth century. If it could be agreed that the Arundel provenance was correct, the Arundels bought their collection in Venice, and attributions in their collection would be based on an early seventeenth-century Venetian source.

It is surprising that such a large and important painting was not recorded before the seventeenth century, and one can only suspect that this is due to the erotic nature of the subject. The *Concert champêtre* was continually thought to be a Giorgione until the nineteenth century, when connoisseurship introduced different minor names, beginning with Waagen's suggestion of Palma Vecchio, and Crowe and Cavalcaselle's implausible suggestion of Morto da Feltre. By contrast, Morelli wrote to his friend Austen Henry Layard on 1 September 1875: 'Le "Concert" du Salon carré, donné à Giorgione me semble vraiment l'oeuvre de lui, mais c'est une peinture dans un état pitoyable'. Layard responded on 30 September 1875: 'C'est très curieux qu'après toutes les critiques que l'on a fait sur le fameux tableau du "Concert", et que les con-

noissseurs se sont trouvées d'accord pour l'attribution au Titien, que vous l'avrez de nouveau donné à Giorgione. Aussi vôtre liste des œuvres de ce grand peintre s'est augmontée d'une autre example'.

Morelli's authority resulted in the picture being reascribed to Giorgione. It was the French scholar Louis Hourticq (1919) who attributed it to Titian, surprisingly in connection with a document of 1530, in which Titian described a painting of a woman in a bath, which he had begun earlier and which he wished to finish and to give as a present to Federico Gonzaga, one of the great patrons of Italian erotic art. From that point on, the attribution of the painting went back and forth between two artists of incomparable stature, Giorgione and Titian, although the date is now generally agreed to be 1509-10, and is not usually an issue. Points of comparison with works by Titian are difficult, as there are few certain dates within his early works, except for his three frescoes of 1511 in the Scuola del Santo, Padua (Figs. 167-169), which are manifestly different in style, even allowing for differences in media. Even the most ardent supporters of the attribution of both the *Concert* and the Paduan frescoes to Titian, such as Freedberg (1975, p. 144), confess that the 'Padua frescoes regress from the accomplishment of the Pastorale'. Freedberg even states (p. 134) that the painting is so like Giorgione's style that it is an intentional attempt on Titian's part to imitate his predecessor so perfectly as to deny Giorgione immortality. In many ways the chronology of early Titian is even more problematic than that of Giorgione.

A new name entered the list of possibilities very recently, when Hope (1993B), followed by Holberton (1993), proposed the name of Domenico Mancini, a minor artist who had signed an altarpiece at Lendinara in 1511, as the author of the *Concert*. The Lendinara altarpiece is well known to Giorgione scholars since it was prominently discussed in 1978 during the Giorgione quincentenary celebrations at Castelfranco, when it was the subject of a restoration by the Soprintendenza del Veneto. Hope argues the case for the attribution on the grounds that one of the women is left-handed, hence an allusion to Mancini's surname, whereas Holberton claims to see parallels in both pictures in the drapery. The introduction of a new name, centuries after the picture was created, on such slight evidence fails to convince. There had been an earlier attempt by Wilde (1933) to establish a corpus of work in Mancini's name, the article appropriately entitled 'Problems about Domenico Mancini', which also failed to convince.

X-radiography has shown a *pentimento* beneath the standing woman, who resembles the ample forms of the female figures on Giorgione's front facade on the Fondaco. In various publications, M. Hours (1976, pp. 30-31) has argued that the painting is closer to Giorgione than Titian on most of the surface, with the exception of the woman at the fountain, who she proposes was repainted by Titian. Whether there is a disjuncture between the two parts of the painting is highly debatable.

About one feature of the *Concert* there is agreement: that the theme of the painting is a pastorale about the nature of poetry. The aspect of the painting that most fascinated artists and critics in the nineteenth century was the combination of female nude figures with men who were clothed. The indifference that the men expressed towards the women was explained by Philipp

Fehl (1957, p. 153) in an influential interpretation of the painting. Fehl proposed that the two women were either women or Muses, invisible to their male companions; hence both women regard their nudity as natural and the shepherd who approaches causes no embarrassment. It was further observed by Patricia Egan (1959, p. 305) that the attributes of the two women are combined on a Ferrarese tarocchi engraving of c. 1465. The playing card which represents the allegory of Poetry depicts a female figure who plays a flute and pours water from a jug. Robert Klein (1967) further developed this interpretation when he associated the tarocchi card with an allegory of Poetry that was painted by Cosimo Tura for the library of Pico della Mirandola at Carpi. The painting was described in a dialogue by L. G. Gyraldus, said to have taken place in 1503. The three central figures, characterized by the lute, singing, and the flute, represent three literary genres — heroic, bucolic and erotic. Even though some of the details may be challenged, it is generally agreed that this is a pastoral eclogue.

My attribution to Giorgione is based on the tradition stemming from the work's provenance, combined with the technical analysis of the facture of the painting. Given Vasari's characterization of Giorgione as a musician and his interest in 'le cose d'amore', the theme of the painting is an appropriate one for his personality and differs considerably in conception from Titian's *Three Ages of Man* (National Gallery of Scotland, Edinburgh). If the *Terris Portrait* (Fig. 68) is removed from Giorgione's post-Fondaco painting, then the attribution of the *Concert* to him becomes a very real possibility.

Literature: Fehl, 1957, pp. 135-59; Egan, 1959, pp. 103-13; Klein, 1967, pp. 199-206; Haskell, 1971, pp. 543-55; Fischer, 1974, pp. 71-77; Benzi, 1982, pp. 183-87; Ballarin, 1993, pp. 340-48; Holberton, 1993, pp. 245-62; Hope, 1993, pp. 22-25.

CONTROVERSIAL ATTRIBUTIONS

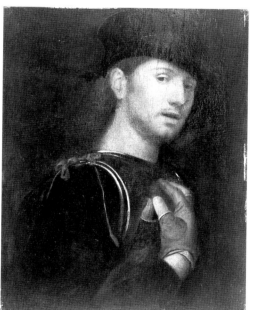

EDINBURGH, National Gallery of Scotland, inv. 690
Sixteenth-century Venetian School
An Archer
Panel, 54 x 41.3 cm

Provenance: Probably described by Ridolfi in 1648 as the portrait 'd'un giovinetto parimente con molle chioma & armatura, nella quale gli riflette la mano di esquisita bellezza', in the collection of Giovanni and Jacopo Van Voert [*sic*], a Venetian approximation of the name Van Veerle, Antwerp; from 1682 until 1697 probably in the collection of the Portuguese jeweller

Diego Duarte, Amsterdam, 'No. 14. Een Mans konterfeytsel half lijf in t'harnas met de hant gehantschoent pp t'harnas. cost 35' (F. Muller, *De Oude Tijd*, Haarlem [1870], p. 398); Christie's, London, 30 June 1827, lot 53: 'Giorgione. Himself as an Officer of the Archers'; Mary Lady Ruthven Bequest, 1885.

The unusual motif of an archer with his hand reflected in his cuirass is without parallel in the repertoire of Venetian painting, and this makes an identification with the picture described by Ridolfi very plausible, even though Brigstocke (1993) may have been reluctant to accept Ridolfi's testimony as evidence of the early provenance, first proposed by Garas (1964). That the painting may have gone from Holland to Christie's in the nineteenth century, as proposed here for the first time, is also feasible. At this time, the portrait was believed to be a Giorgione self-portrait. The provenance is easier to establish than the attribution.

The appearance of this interesting, but badly damaged painting is masked by repainting carried out by A. Martin de Wild, during restoration at The Hague in 1937. The face, hand and body are the best-preserved parts of the composition. An X-ray reveals that considerable changes have occurred in the hair and the hat. In its present state, it is impossible to form a judgement about the author of the work, although many have attempted to do so. Ballarin has suggested on several occasions (1979, p. 234; 1993, p. 288) that it is by Giorgione, while other attributions to Francesco Torbido and Cariani (discussed by Brigstocke, 1993) have proved unacceptable. The subject of an archer is otherwise unknown in Venetian art, and the reflection of his hand (gloved appropriately for archery) in his cuirass brings to mind those paintings attributed to Giorgione in the early sources concerning the *paragone* (pp. 26-27, 49, 66 above).

Literature: G. M. Richter, 1937, pp. 216, 343; Garas, 1964, no. 25, p. 57; Ballarin, 1979, pp. 234, 247 n. 41; Ballarin, 1993, p. 288; Brigstocke, 1993, pp. 194-95.

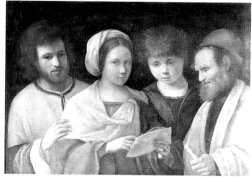

HAMPTON COURT PALACE
Attributed to Giorgione
The Concert
Canvas, 76.2 x 98 cm

Provenance: bought by Jan Reynst in Venice before 1646; acquired by the States of Holland and presented to Charles II, 1660, from which date it has been in the Royal Collection, where it is described in inventories, first as unattributed, 'A Concert of Singing Dutch pr.sent', and subsequently as a Giorgione, 'A piece with four figures to the waste singing'.

This fine Venetian painting has been in conservation since 1981, and hence neglected in recent scholarship. In the last considered discussion of the painting by Shearman in his Hampton Court catalogue (1983, no. 38), he attributes the painting to 'School of Bellini', although he himself convincingly demonstrates that the picture does not resemble late works by Bellini's hand. As all scholars have noted, it belongs to a group of pictures comprising the *Three Ages of Man* (Fig. 106) and *Giovanni Borgherini and his Tutor* (Fig. 89). In this catalogue, the *Three Ages of Man* is accepted as by Giorgione, while the attribution of the Borgherini portrait to Giorgione is advanced cautiously. This group of pictures is increasingly seen as intersecting with other works by Giorgione, although how they may be placed within Giorgione's chronology is problematic.

I last examined the *Concert* together with Viola Pemberton-Pigott in July 1996, at a time when conservation was still in progress. The photograph reproduced here shows the work as it was in 1981, before conservation began. Although there are scattered losses across much of the surface of the painting, the condition is fair. The removal of discoloured varnish has revealed colours that are much fresher than those Shearman described. For example, where he mentions a 'fawn colour' there is now a clear white. On the left side, a man in his thirties is dressed in an orange gown with green sleeves over a white *camicia*, outlined in black. The girl in the centre of the composition has her hair enclosed in a white turban; a white transparent shawl bordered in black is over her shoulders. Tiny pearls are embroidered on the collar of her dress. A young boy, dressed in a blue vest embroidered with gold and a white undershirt, stares down at a sheet of music in her hand. An older bearded man is dressed in a golden garment composed of the pigments realgar and orpiment. He holds a tiny piece of music on a rolled sheet. Musical notation is represented in both sheets of music, but has so far not been legible. The fact that the colour was obscured by discoloured varnish may explain the pejorative judgements previously expressed of the painting, when it was shown in company with the Pitti picture at the 1955 Giorgione exhibition (see, for example, Robertson, 1955, p. 277).

The illusionistic frame at the edge of the painting is shown to be a much later addition and grossly overpainted. With the aid of an infrared vidiocon, *pentimenti* were revealed in the underdrawing such as can be seen in other works by Giorgione. The underdrawing revealed by infrared analysis shows that the central woman was first conceived with her eyes looking in a different direction, that is, towards the music held in her hand. Considerable care was taken with the placement of the central woman's hands. There is another earlier outline drawing for her right hand which has longer fingers. Underdrawing was also detected beneath the hand of the man on the left. It is in such details as these hands that the attribution to Giorgione is most forcefully suggested. A close examination of the painting suggests that it was executed quickly and fluently.

Although traditionally called *The Concert*, no agreement has been reached on the subject represented. For although the presence of music denotes that the figures are musicians, they are not really singing, nor do they hold musical instruments. The term concert suggests a public performance, whereas such a representation seems to be about informal music-making, as Patricia Egan has shown ('"Concert" scenes in Musical Paintings of the Italian Renaissance', *Journal of the American Musicological Society*, XIV [1961], pp. 184-95). Egan also suggests that this particular picture is an allegory about love and music, an interpretation taken further by Shearman (1983, p. 46). Shearman sees the presence of the young girl as denoting 'a distinction between the amorous effects of music upon the Three Ages of Man', similar to Titian's famous painting in Edinburgh. For others, the individuals in the group are so particularized as to suggest that they are portraits of known musicians. Albert Einstein identified them in a caption as Philippe Verdelot, a French musician in Venice, a boy and girl, and Adrian Willaert, the composer of polyphony from Bruges (*The Italian Madrigal*, Princeton, [1949], I, p. 159). Though we know that Verdelot was portrayed by Sebastiano, the evidence for this identification is slim, as it is for Willaert, who only taught in Venice after Giorgione's death.

The central figure of the group is a female musician, which could suggest that she is a *figlia del coro*. It was Venetian custom to teach music to female orphan students in the *ospedali*. That one of them might possibly have been portrayed in an informal music-making situation is suggested in the innovative study by Jane L. Baldauf-Berdes (*Women Musicians of Venice: Musical Foundations, 1525-1855*, Oxford [1993]). Some women became music teachers (*maestre di coro*) or had a career as soloists, so another possibility worth considering is that the painting depicts a *figlia del coro* with music-making companions, executed quickly as a portrait composition. Such a subject would be unusual, but not impossible given Giorgione's interest in novel subjects concerning women.

Literature: Shearman, 1983, pp. 43-46.

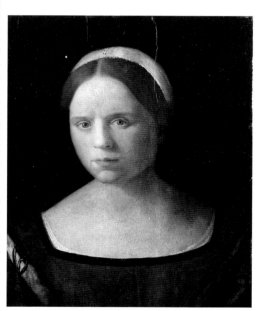

HOLYROOD PALACE, Edinburgh
Attributed to Giorgione
Portrait of a Woman
34.3 x 44.5 cm

Provenance: Charles I of England

This enigmatic, much damaged and repainted portrait of a woman (Shearman, 1983) belongs to the group of paintings associated with the Hampton Court *Concert* and the Pitti *Education of the Young Marcus Aurelius* (Fig. 106). It was formerly in the reserve collection at Hampton Court Palace, but since 1996 it has been on display in the new installation of Mary Queen of Scots' rooms at Holyrood Palace, Edinburgh. In Shearman's catalogue, the portrait is attributed to a 'Disciple of Giovanni Bellini', but is ignored in the Bellini literature. In view of the rarity of portraits of women that may be associated with Bellini, it is surprising that this portrait has been forgotten, especially since no one has managed to identify missing masterpieces, such as the famous portrait of Gabriel Vendramin's sister by Bellini, described by Michiel in the collection of Taddeo Contarini. In Giorgione scholarship, the Edinburgh portrait has only been attributed firmly to the master by Berenson, who realized that it was an early work and closely related to the Pitti painting. Closer examination of the picture reveals that it resembles the *Terris Portrait* (Fig. 68) in its newly restored state. The lack of sentimentality in the representation of the sitter invites a comparison with the *Laura* portrait in Vienna (Fig. 131). This portrait of a woman most resembles the work of Giorgione, among all Bellini's disciples.

Literature: Shearman, 1983, pp. 46-47.

MILAN, Pinacoteca Ambrosiana, inv. 89
After Giorgione
Page Placing his Hand on a Helmet
Panel, 23 x 20 cm

Provenance: Cardinal Federico Borromeo; donated 1618 as Andrea del Sarto.

Despite the high quality of the picture, it has not been as extensively discussed as the variant with Knoedler's, described in the following entry. The attribution to Giorgione was first proposed in the guidebook to the Ambrosiana written by A. Ratti in 1907, and accepted by Suter (1928, p. 23), who dated the work about 1500 on the basis of the boy's loose-sleeved costume, which he found comparable to that worn by a shepherd in the Budapest fragment of the *Finding of the Infant Paris* (p. 323 below). Other scholars, such as Fiocco (1941, p. 32), suggested Domenico Mancini, and the Ambrosiana now considers the panel an old copy after Giorgione by an anonymous artist, c. 1520 (Falchetti, *The Ambrosiana Gallery*, Vicenza [1986], p. 243). The Ambrosiana page belongs to a group of four pictures, all of which may be copies after an original by Giorgione. They have all been variously identified with the 'little shepherd boy who holds a fruit in his hand' ('pastorello che tiene in mano un frutto'), described by Michiel in the house of the Spanish merchant Giovanni Ram in 1531. Yet the object on which the dreamy child rests the fingers of his right hand is too large to be, say, an apple. Nor is it really legible as a melon. It is unlikely that Michiel's generic term 'fruit' was prompted by this perplexing round object. Another doubt arises concerning the fancy costume worn by this youth: is he really a rustic shepherd, or a fancifully attired shepherd in a play? A more credible interpretation of the subject is that he is a little page with his fingers resting on the top of a helmet or a piece of armour — in which his fingers are reflected — a subject represented in Giorgione's circle.

Literature: Suter, 1928, pp. 23-27; G. M. Richter, 1937, p. 231; Pignatti, 1969, p. 131; Falchetti, 1986, p. 243.

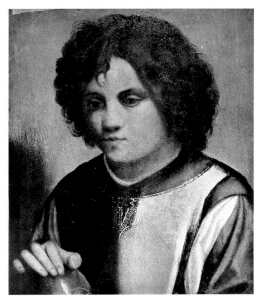

NEW YORK, Knoedler & Co.
After Giorgione
Page Placing his Hand on a Helmet
Pearwood, 24.1 x 20.6 cm

Provenance: 1775-1815, Giovanni Bossi, Milan; 1882, Mason Jackson, London, published by the Arundel Society in 1913; 1926, W. W. Martin, New York; Colonel Arnold Strode-Jackson, reputedly in Oxford but in reality lost in the cloakroom at Knoedler's; Denis and Audrey Strode-Jackson, until 1973.

The fortune of the attribution has closely followed the successive restorations of the picture and its relation to the art market. Following an early twentieth-century restoration by Rougeron, it was first attributed to Giorgione, and the attribution was reaffirmed by George Martin Richter in 1942, following a restoration by Shelden Keck. Keck reported that a large portion of the front of the costume had been damaged and repainted without regard to the original design. Probably the dress is more accurately rendered in the Suida-Manning copy (see following entry), where the youth wears armour. The finely executed head and the hand are intact, although the shadows of the face have been strengthened by stippling. X-rays reveal only the outline of the figure; no internal drawing is revealed, as found in the *Giustiniani Portrait* (Fig. 159). In his monograph of 1969, Pignatti (p. 131, no. A 39) denied the attribution to Giorgione and proposed the name of Domenico Mancini, but he later changed his mind following the restoration by Mario Modestini in 1973 (Pignatti, 1975, p. 314). Pignatti also argued that the painting might be identified with a work recorded in the Grimani collection. It was mentioned both in an inventory of 1528 as a head of a putto ('una testa di puto'), and also by Vasari as 'a putto as beautiful as can be created, with hair like a fleece' ('un putto, bella quanto si può fare, con certi capelli à uso di velli . . .'). Yet it is difficult to accept this adolescent as a putto and his hair is not so roughly groomed as to suggest fleece. The suggestion that he is a page, with his hand resting on the top of a helmet or piece of armour, seems more credible.

From the 1960s to 1973 the painting was inaccessible. A bizarre story explains what happened (Berenbaum,

1977). Colonel Strode-Jackson is said to have lost the picture and its containing briefcase on a visit to New York, where it remained unnoticed for a decade in the cloakroom at Knoedler's. After the colonel's death, an attorney investigating the Strode-Jackson estate managed to relocate it. In *The Golden Century of Venetian Painting*, (1980) Pignatti reaffirmed the attribution to Giorgione and dated the work 1505.

Literature: Richter, 1942; Pignatti, 1969, p. 131; Pignatti, 1975, p. 314; Berenbaum, 1977; Pignatti, 1980, pp. 46-47.

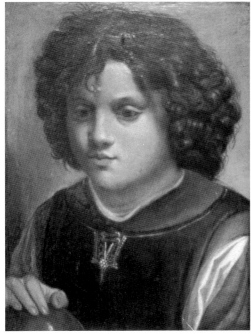

NEW YORK, Suida-Manning Collection
After Giorgione
Page Placing his Hand on a Helmet
Panel, 21.6 x 15.9 cm

Provenance: sold by the Wauchope Settlement Trust, having been removed from Niddrie Marischal House (now destroyed), Edinburgh, at Christie's, London, 12 May 1950, lot 94, to Miss Celia Surgey, as Giulio Romano ('A Boy, in red and blue dress — on panel; and The Infant Saviour reclining on the clouds — [two]'); sold Christie's, London, 27 February 1959, lot 28, to Da Molla ('A Boy, in green and red dress'); acquired by Suida-Manning in 1980.

A previously unpublished variant of the pages associated with Giorgione, the image is much more detailed than the other copies, suggesting that it conveys more information about the original. There are many more curls in the hair, the vest is coloured green and simulates material, whereas in the other versions the boy is dressed in armour. The least worthy of consideration is a copy of the *Page Holding a Helmet* in the museum at Aix-en-Provence (Suter, 1928, p. 24; G. M. Richter, 1937, p. 231).

The existence of so many contemporary copies of high quality of this work all testify that they reproduce a famous lost original by Giorgione.

■

NEW YORK, The Metropolitan Museum of Art, Rogers Fund, 1911, inv. 11.66.5
Attributed to Giorgione
Putto Bending a Bow (Fig. 172)
Red chalk, 15.7 x 6.6 cm (original sheet), increased by Mariette to a sheet of 23.7 x 15.2 cm

Provenance: Pierre-Jean Mariette until the sale of his collection in 1775-76, where described as 'Giorgion. Un Amour ployant son arc'; Count Moritz von Fries; Lord Ronald Sutherland Gower; acquired by the Metropolitan Museum of Art at Christie's, London, 28 January 1911.

The traditional attribution of the New York drawing, when it was in the collection of the great Parisian connoisseur Mariette, was to Giorgione. Whether Mariette recorded an older tradition or whether it was his own attribution is not known. As David Alan Brown has

noted, Mariette mounted the drawing by setting 'the original rectangular sheet into another one, on which is drawn a semicircular niche, suggesting that Mariette associated the foreshortened figure with a wall decoration' (*Berenson and the Connoisseurship of Italian Painting*, pp. 32, 57). In these circumstances, Erica Tietze-Conrat (1940) proposed that the putto might well have been conceived as a preliminary idea for Giorgione's frescoes on the Fondaco dei Tedeschi. The cupid was delineated in such as a way as to suggest a figure seen high on a facade and to prompt an identification with Vasari's mention of an 'angel in the guise of cupid' on the Fondaco.

In his monograph on Giorgione, Pignatti (1969) attributed the New York drawing to Titian, on the grounds that it resembled the Christ Child in Titian's *Gypsy Madonna* in Vienna, although in his subsequent publication on Titian drawings (1979), Pignatti did not refer to the drawing at all. The attribution to Giorgione has been upheld in the Metropolitan's catalogue with a question mark (J. Bean, *Fifteenth and Sixteenth Century Italian Drawings in the Metropolitan Museum of Art*, New York [1982], no. 82).

Subsequently, the drawing was attributed to the little-known Emilian artist Michelangelo Anselmi (W. Griswold and L. Wolk-Simon, *Sixteenth-Century Italian Drawings in New York Collections*, New York [1994], pp. 5-6). Another more detailed drawing by the same hand and of the same subject in a Vienna private collection, in which the putto has wings, was published by the dealer Yvonne Tan Bunzl (*Old Master Drawings* [1987]), also as Anselmi, though the comparisons advanced are not so convincing as to make the attribution valid. One alternative explanation of these drawings would be to see them as copies made by a young Emilian artist after Giorgione's frescoes on the Fondaco — copies of the angel that interested Vasari. It has often been suggested that Emilian artists, like the young Parmigianino and others, visited Venice and that their youthful style was influenced by Giorgione and Titian. However, in no instance can a comparison be made that proves the attribution.

The discovery of the fresco fragment of the *Hesperid Cupid* (Fig. 173) provides new authority for the drawing's subject and for reviving the attribution of the drawings to Giorgione. Seen together as companions, the two putti may represent different episodes from the same story. In the New York drawing, the putto adjusts his bow, or perhaps merely a stick, only to use it later as a baton to knock apples from a tree in the fresco fragment. The use of red chalk was a particularly appropriate medium for working out preliminary ideas for a fresco cycle that was predominantly flaming red. Giorgione may have had recourse to drawing during the Fondaco project because, unlike other projects, here he had a studio. The chubby contrapposto of the putto's thighs, the steep perspective, and the morphology of the forms is particularly close in both examples. Such inventions are remarkably similar to the conception of form in the representation of the women's bodies in the *Concert champêtre* (Fig. 37).

Literature: Tietze-Conrat, 1940, pp. 32ff.; Pignatti, 1969, p. 130; D.A. Brown, *Berenson and the Connoisseurship of Italian Painting*, exh. cat., Wahsington, D.C., National Gallery of Art (1975); *Old Master Drawings*, exh. cat., London, Yvonne Tan Bunzl (1987), no. 4.

SALTWOOD CASTLE, Saltwood Heritage Foundation, Kent

Attributed to Giorgione

Hesperid Cupid (Fig. 173)

Fresco from the Fondaco dei Tedeschi, Venice, transferred to canvas, 131 x 64 cm

Provenance: John Ruskin; bought by Kenneth Clark, 1931, from the sale of paintings and drawings formerly in Ruskin's residences at Brantwood, Coniston, and Warwick Square, London, and sold by the trustees of Joseph Arthur Palliser Severn, Sotheby's, London, 20 May 1931, lot 135a, as: 'Early Italian School. Study of a winged cherub. Fresco transferred to canvas'.

The fresco fragment has no exhibition history, although it hung in the library at Saltwood, above the chair from which Lord Clark delivered his last lecture in the *Civilisation* series for the BBC. Nor is it mentioned in art historical literature, with the exception of the sale catalogue, prepared by the Severn heirs and, according to Ruskin scholars, one of the most imprecise catalogues ever compiled. The solicitors and Sotheby's appear to have relied heavily on Miles Wilkinson, a general factotum at Brantwood, who was notoriously inaccurate in his knowledge and memory of pictures.

The provenance was given by Lord Clark in a letter of 15 July 1971, addressed to Sir Anthony Blunt. 'It is said to have been bought by Ruskin from the Fondaco dei Tedeschi when they were pulling it down, and there is quite a circumstantial story of Ruskin's servant bringing it to him when he was in bed ill. It is, of course, in miserable condition like the other fragments, but it seems to me to be a relic worth preserving. . . . I do not guarantee that it ever was a Giorgione or a Titian, but was certainly of that date' (Tate Gallery archives, Kenneth Clark Papers, TGA8812..1.4). At the end of his life, Clark contemplated leaving the fresco to a British institution, so important did it seem to him. The incident he referred to in his letter to Blunt seems to date from the final years of Ruskin's life. Ruskin suffered from a depressive illness, but was only occasionally bedridden during the last decade at Brantwood, where pictures were sometimes brought to him to contemplate when he was in bed. He had usually travelled with several of his pictures to beautify his hotel rooms, and often moved them around at home, where it would be quite in character for Ruskin's servants Crawley or Baxter to bring a favourite picture to cheer him up when he was ill.

Clark's initial enthusiasm for Ruskin was kindled when he was a schoolboy by people who had known Ruskin directly, for example, Alexander Macdonald, Ruskin's first drawing master in Oxford. Macdonald's son taught Clark at Winchester, where Clark met Alexander Macdonald when the latter was visiting his son. Clark 'frequently went out drawing with him [Alexander], so that I have a living link with the greatest member of my profession', as he recalled in his autobiography (*Another Part of the Wood*, London [1974], pp. 55-56). These were the only two works from Ruskin's collection that Clark bought from the sale; but he also owned drawings by Ruskin acquired at other times. Clark must have known about the Fondaco fragment from someone who had known Ruskin. Ruskin, it would seem, never valued the fragment highly, but then neither were the frescoes in situ valued by the Venetians themselves. It would have been hard for Clark to evaluate his acquisition, given the neglect of the Fondaco. He also may have been inhibited about discussing it since he had experienced a psychic bruise from his brush with the press and public in the late 1930's over his acquisitions of the Previtali panels for the National Gallery (p. 261 above). This may explain his silence over his own Giorgione. Clark's papers, which would have documented the period when he made the acquisition, were destroyed when bombs fell on his flat in Gray's Inn Road during World War II.

Ruskin may have acquired the fresco on one of his many visits to Venice, most likely when he was there for an extended period in 1876-77, as earlier visits are extremely well documented, or even in 1880. One or another of Ruskin's Venetian helpers could have had a hand in the acquisition, such as Giacomo Boni, Director of Works at the Doge's Palace, the dealer Consiglio Ricchetti, who specialized in selling the contents of Venetian palaces, or even Fairfax Murray, who sold Ruskin a number of Italian Renaissance paintings, notably his Verrocchio. During the nineteenth century, there were at least several occasions when fragments were removed from the Fondaco. and their present whereabouts are still unknown. The Fondaco also owned an important collection of Renaissance paintings, described by Ridolfi and other sources. The earliest alien-

ation of the Fondaco's collection occurred in Napaleonic times. In 1841, Waagen acquired a number of paintings by Veronese and Tintoretto, known to have been in the painting collection of the Fondaco dei Tedeschi, from the Lechi collection, Brescia, for the Gemäldegalerie, Berlin. It is unrecorded how General Teodoro Lechi managed to acquire the pictures from the Fondaco, but it was presumably in the Napaleonic period. In 1836, Zanotto recorded that during a restoration the two lateral side towers of the Fondaco were destroyed, as well as two well-preserved figures by Giorgione ('due figure del Giorgione forse le più conservate tra le superstiti'; discussed by Nepi-Scirè, in *Giorgione a Venezia*, 1978, p. 123). Clark's letter to Blunt, quoted above, refers to the destruction of the Fondaco, which could mean this episode in 1836, for in point of fact although the building suffered a great deal in its history, it never actually fell down. In 1895, when the building was converted into the Venetian post office, at least one head in fresco ('una testa') was removed during Leopoldo Vianello's restoration (see the documentation from the archive of the Soprintendenza ai Beni Ambientali ed Architettonici di Venezia, published by Nepi-Scirè, in *Giorgione a Venezia*, 1978, p. 129).

It is also possible that the piece was hoarded by someone from as early as 1836, and that it had been in other collections before reaching Ruskin. Ruskin rescued various architectural fragments in this way. In the nineteenth century, it was habitual for *staccatori*, those who specialized in taking frescoes from the wall, to keep fragments of the fresco cycle that were of secondary importance as a perquisite; they would then be sold by the restorers concerned. Evidence of this common practice is to be found in the fragments of the fresco cycle of *Cephalus and Procris* by Bernardino Luini, from the Casa Rabia, Milan, now distributed between the Staatliche Museen zu Berlin, the National Gallery in Washington, and elsewhere (see Shapley, 1979, pp. 285-88, for an account of the Luini provenances). In other instances, nineteenth-century restorers in Venice sold pieces from buildings they were restoring, such as panels of mosaics from the basilica of San Marco. Ruskin himself owned a piece of masonry from San Marco.

The painting is structully not in good condition. Unlike the other surviving fragments from the Fondaco, the Saltwood piece was removed in the nineteenth century by the *strappato* method and transferred to a fine-weave linen canvas; the fragment was then double-lined on a more medium-weight canvas, attached with an animal glue adhesive. The putto has more original paint than other surviving fragments, since it was removed at least some sixty, or perhaps as many as eighty years earlier, than the other surviving frescoes, now in the Galleria Franchetti alla Ca d'Oro, Venice. There are extensive areas of raised and flaking paint over the surface. There is a thick layer of dirt over the entire surface. The dirt layer is a greyish brown colour, has adhered to the paint layer, and obscures the visual interpretation of the image. Cupid's abdomen, arms and legs are in relatively good condition, while there are losses apparent in the face and wings.

The restoration history of the fresco fragment is as yet unknown, although there were probably two early restorations before Clark acquired the fresco. During Clark's ownership, his son Alan on one occasion attempted to restore the work. On 4 April 1972, Clark wrote to Blunt that he had 'left the fragment in an obscure corner of Saltwood which, as you may know I have given to my son [Alan]. He has just moved into the house and discovered it. Thinking that it must have been left there by Lady Conway and of no value he began to try and clean it, so that a certain amount of it has come away. But there is still enough to be of considerable interest, a little more, I should say, than the fragment in the Accademia'. Active flaking is scattered across the surface, especially on the right side. The surface paint is on a very thin plaster layer, almost wafer thin in part, stuck on primed canvas. The canvas is on a conventional wooden stretcher. Paper and cardboard edging are stuck over the borders of the canvas.

The figure is depicted winged, his head uplifted, as he harvests fruit from a tree, a wooden stick in his left hand. The tree trunk is a long vertical form on the right side of the composition. The twelve fruit are larger than conventional apples. Cupid hops on tip-toe to avoid the falling fruit, which he easily manages to push off the branches. His heavy thighs and large tummy are depicted in a dramatic contrapposto, his elbow turned to the spectator. A little bit of white drapery extends from his arms to beneath his bottom. The depth of the figure would be even more extraordinary if the surface dirt were removed. The contrapposto and the modelling of the thighs and torso compare well with what Zanetti recorded of the other Giorgione figures from the Fondaco — a man and a woman (Fig. 175) — bearing in mind that Zanetti saw the figures with eighteenth-century eyes. Moreover, this cupid is closest in type to the hidden Cupid in Giorgione's Dresden *Venus*. Should we compare the modelling of the eyes and face, both representations are very similar in conception.

Ruskin's fresco fragment may plausibly be identified with an image that caused Vasari considerable perplexity, the famous winged angel in the guise of Cupid, which provoked his often quoted judgement, 'angelo a guisa di Cupido, né si giudica quel che si sia', in the *Life of Giorgione* in the second edition of the *Vite*. Vasari's perplexity before Giorgione's Fondaco frescoes has been much discussed, and there have been very few interpretations of what the cycle was all about. Ruskin, however, was uninhibited by Vasarian prejudices and proposed an interpretation of the surviving *Female Nude* by Giorgione, as one of the nymphs with flaming skin who guards the Garden of the Hesperides. Ruskin's perception of the Giorgione frescoes may have been enhanced by his own acquisition, which he would almost certainly have interpreted as Cupid harvesting the famous magic apples. Ruskin's interpretation, proposed in the last volume of *Modern Painters*, is discussed in greater detail above (p. 278). That this cupid was not just a decorative detail is confirmed by the way in which Giovanni Bellini had earlier used the motif of cupids and an apple tree as the central theme in his *Sacred Allegory* in the Uffizi. Another echo of this Fondaco fragment is to be found in Titian's *Garden of Love* in the Prado, where cupids, children of the nymphs, gather apples, some of the details corresponding to the famous description in Philostratus' *Imagines* (I. 6). Another echo of the fresco may be found in Callisto Piazza's fresco of a putto from the Chiesa dell'Incoronata, Lodi (reproduced in *Bergamo per Lorenzo Lotto*, exh. cat., Bergamo [1980], p. 110).

Literature: Unpublished.

VIENNA, Kunsthistorisches Museum, inv. 21
After Giorgione
David Meditating over the Head of Goliath (Fig. 128)
Poplar, 65 x 74.5 cm (the reproductive print in Teniers' *Theatrum pictorium* [Fig. 127] shows that it has been cut at the top and bottom)

Provenance: 1638, James Hamilton, 3rd Marquis of Hamilton, where described as Giorgione's self-portrait, 'his picture made by himself' (p. 370 below); Archduke Leopold Wilhelm, where listed as a Bordenone, perhaps a bowdlerization of the name Giorgione, as it is engraved in Teniers' *Theatrum pictorium*.

Despite the impeccable provenance, and despite the fact that it is a Giorgione self-portrait composition, this portrait has always been considered a copy by a follower of Giorgione rather than an original. The banal handling of the paint surface has none of the characteristics of any of Giorgione's works, but the condition is poor. David's armour may have been once different and his hand in another position. It is the first example of a type of portrait composition where there is a dialogue between a subject's head and a severed head, or helmet. The sword hilt establishes horizontals and verticals. It was used alternatively for half-length representation of Judith by Giorgione and Catena (Rome, Palazzo Querini-Stampalia). There are also portraits by Dosso Dossi and Romanino of men who are depicted holding swords, but without the severed heads. The boldest interpretation of the composition is in Cavazzola's *Gattamelata Portrait* (Uffizi), where a helmet is substituted for a severed head.

Literature: Waterhouse, 1952, p. 16; Ballarin, 1979, p. 29; Lucco, 1995, p. 28.

VIENNA, Kunsthistorisches Museum, inv. 10
Attributed to Giorgione
Portrait of a Youth with a Helmet, said to be Francesco Maria I della Rovere, Duke of Urbino (Fig. 20)

Transferred in the nineteenth century from wood to canvas, 73 x 64 cm

Provenance: Dukes of Urbino, where recorded c. 1623-24 in the Guardaroba, Pesaro, as '. . . uno mezzano col retratto d'uno de' serr[enissi]mi della Casa d'Urbino da putto con un elmo in mano vestito all'antica et cornici di noce: attorno all'elmo rami di cerque, disse dal duca Guido Baldo' (Sangiorgi, 1976, p. 356); described in the inventory of Bartolomeo della Nave's collection, acquired by Lord Feilding for the Marquis of Hamilton, as: 'A picture of Guido Ubaldi [d]elle Rovere Duke of Urbino 3 palmes square of every side made by Raffael . . . 150' (Waterhouse, 1952, p. 14); subsequently described in the Hamilton inventories as a Correggio portrait of the Duke of Urbino (Garas, 1967A, pp. 72, 75); Archduke Leopold Wilhelm, 1659, first listed as a Correggio, but subsequently engraved by Vorsterman for Teniers' *Theatrum pictorium* as a Palma Vecchio.

The descriptions of the portrait in the early inventories reveal how difficult it has been to agree on the attribution, which ranges from Raphael to Correggio to Palma Vecchio. None of these early attributions was considered valid, and in the early part of this century various Venetian names — Catena, Licinio, Michele da Verona and Pellegrino da San Daniele — were proposed, but none stood the test of time. Giorgione's name was first suggested by Suida (1954, p. 161). He compared this gesture to the hand of the Madonna in the *Castelfranco Altarpiece* (Fig. 84), to the hand of the young page in the Ambrosiana picture (p. 310 above), and to the hand on the parapet in the Giustiniani portrait (Fig. 159). All these parallels are valid. The Urbino inventory mentions only the name of Duke Guidobaldo in relation to the decoration of oak leaves on the helmet. Could he be the person reflected in the helmet and could this large helmet (too big for the boy) be his? In the autumn of 1504, Francesco Maria della Rovere became the adopted son of Guidobaldo. The oak leaves in gold on the helmet are those of the Della Rovere family (D. L. Galbreath, *Papal Heraldry*, Cambridge [1930], p. 86). The helmet could not have been that of Guidobaldo, for a Montefeltro would never have worn the helmet with a Della Rovere *impresa*. The helmet could have been that of Giovanni della Rovere, Francesco Maria's father.

The name of the young boy most frequently proposed is Duke Francesco Maria I della Rovere, born 25 March 1490, son of Giovanni della Rovere and Giovanna da Montefeltro. He is dressed in a black damask outer garment, with a design of oak leaves, and a red crimson cloth is draped over his shoulder. His likeness cannot be disproved or confirmed in relation to other more mature likenesses by Raphael and Carpaccio's *Portrait of Duke Francesco Maria della Rovere* in the Thyssen Collection, Lugano, inscribed 1510 (Ballarin, 1993). Francesco Maria is not documented in Venice, but his uncle Guidobaldo of Montefeltro and his aunt Elisabetta Gonzaga were there in 1502-03, in flight from Urbino, which had fallen into the hands of Cesare Borgia. According to Suida, they could have commissioned the work from an intermediary likeness, their nephew being then in France with his other uncle, Cardinal Giuliano della Rovere, later Pope Julius II.

Suida's hypothesis has found favour with some later scholars, most recently with Ballarin (1993), who has argued the case for an attribution to Giorgione. Ballarin further suggests that the occasion for the commission was when Francesco Maria della Rovere assumed the office of Prefect of Rome. More precisely, Francesco Maria became prefect immediately on his father's death on 6 November 1501 (or perhaps 8 November), because the grant to Giovanni (the father) by Sixtus IV was in perpetuity by the legitimate male line. Since Giovanna da Montefeltro understandably feared for her son's safety if he went to Rome, the pope agreed to hold the conferment in a solemn ceremony in the Duomo of Urbino; this took place on 24 April 1502. Francesco Maria had been sent to the safety of Urbino because his mother feared that Cesare Borgia would attack Senigallia or Mondavio (held in fief), while Sora in the kingdom of Naples was unsafe because of the French occupation and Spanish (Aragonese) threats. Legally, Francesco Maria could not act as prefect or rule his fiefs until his sixteenth birthday; accordingly, his mother became in effect 'prefettessa' and acted on behalf of her son.

Duke Guidobaldo did not want to adopt Francesco Maria, though this had been proposed by Cardinal Giuliano della Rovere at least as early as 1498; he resisted as long as he could until 1504. Hence it is unlikely that he would have commissioned Francesco Maria's portrait in Venice, where he arrived without cash or clothes and was dependent on a grant from the Venetian government. The portrait could not have been painted from life in Venice or in Rome, because Francesco Maria did not visit the former in his youth, and did not reach Rome until 2 March 1504. Cecil Clough has suggested to me in a letter that the portrait may have been commissioned by the sitter's mother, Giovanna della Rovere, who was interested in art and in contact with Giovanni Santi, Raphael, and even perhaps Piero della Francesca, from whom she may have commissioned the *Madonna di Senigallia* for her nuptial journey to Rome (Clough, 1992, p. 136). Giovanna was extremely active in promoting the claims of her son to succeed to the duchy of Urbino, and just the sort of patron to have commissioned likenesses of her son at a crucial moment in his political career from an outstanding artist.

An alternative view (Pignatti, 1969, p. 142) is that the work is a very early portrait by Sebastiano del Piombo, and that the sitter is about sixteen years old, suggesting a date of about 1506. Yet Sebastiano arrived in Rome in 1511, too late to have received the commission there.

The recent conservation of the painting has confirmed that the best preserved parts of the picture are the reflections in the helmet. X-radiography reveals beautiful underdrawing as well as a little piece of paper, once attached to the wall in the background, the writing on which is illegible. It is unclear whether the artist himself cancelled out this inscription or signature, or whether it has been overpainted in earlier restorations. During conservation, the technique was found to be much more consistent with what is known of Giorgione than Sebastiano, justifying the traditional attribution in the museum to Giorgione himself (Ferino-Pagden, 1992).

Giorgione may have been considered particularly adept at portraying children, especially by visitors to Venice: the Florentine Salvi Borgherini commissioned a portrait of his son from Giorgione between 1504 and 1506 (Fig. 89), indicating that the artist had a clientele for portraiture that went beyond the confines of the Venetian Republic. In all likelihood, the Vienna painting is a portrait of Duke Francesco Maria I della Rovere, commissioned by his mother Giovanna, on the occasion when he was made prefect in 1502, but none of this confirms Giorgione's authorship, nor that of Sebastiano.

The later likeness of Francesco Maria della Rovere by Carpaccio (Lugano), dated 1510, is similarly undocumented. In October 1508, Francesco Maria became captain-general of the papal forces; on 23 December, he married Eleonora Gonzaga. In July 1510, he was in command of the papal forces against Modena. It could be that Carpaccio's portrait was executed to commemorate the wedding, or that it was a gift from Venice, eager to soften the pope's support for the League of Cambrai. Lorenzo Costa painted Eleonora around the same time, as is shown by her image in the Currier Gallery, Manchester, New Hampshire.

Literature: Sangiorgi, 1976, p. 356; Ballarin, 1979, pp. 234, 247; Ferino-Pagden, 1992, pp. 17-23; Ballarin, 1993, pp. 695-99; Torrini 1993, p. 124.

WASHINGTON, D.C., National Gallery of Art; Gift of Michael Straight, 1974, inv. 1974.87.1
Attributed to Giorgione

Giovanni Borgherini and his Tutor (Niccolò Leonico Tomeo)
(Fig. 89)

Canvas, 47 x 60.7 cm

Inscription on scroll: NON VALET INGENIVM NISI FACTA VALEBVNT

Provenance: probably Giovanni Borgherini, Florence, and inherited by his sons, in whose possession Vasari described it in 1568; Cavaliere Pier-Francesco Borgherini (d. 1718), whose heirs sold the painting in Milan in 1923; in stock with an anonymous dealer, London, 1923-25; by 1925, Herbert Cook, Doughty House, Richmond, Surrey, until at least 1932; purchased by Michael Straight in 1939, who bequeathed it to Washington in 1974.

The double portrait may plausibly be identified as the painting described by Vasari in 1568 as the portrait of Giovanni Borgherini and his tutor (p. 369 below). The Latin inscription, 'Talent is of no avail if deeds are not going to be effective', sounds like Salvi Borgherini's paternal admonition to his son. It does not have an obvious source and may not be classical, as the syntax is odd, with one verb in the present, the other in the future. Infrared reflectography shows the roughed-in inscription on the scroll.

A definite attribution of this compelling picture to Giorgione is inhibited by the condition, for the work is severely abraded and grossly repainted, especially in the dark background and at the edges. In 1991 and 1994, I examined the painting in conservation, together with David Alan Brown, David Bull, Wendy Stedman Sheard, and Elizabeth Walmsley, upon which this report of the painting's condition is based. Although it is hard to distinguish what is original and what is overpaint, there appear to be three stages apparent in the X-rays: a Giorgione underdrawing in brush, original reworking of the image, and a restoration that looks to have been done in the 1920's, when the painting was in the Cook collection.

Of the original *pentimenti* revealed in the radiographs, the most striking are brush drawings of Giovanni Borgherini's head, which was initially drawn in a different position, turned more to the left, his eyes peering downward. The delicate ovoid shapes of the approximations of his head are very reminiscent of the shape of Judith's head (Fig. 123) and are consistent with Giorgione's way of working with brush underdrawings. Borgherini's mouth may have been more rounded, and he may have worn a different type of hat, or none at all. The hand that we see on the surface holding the armillary sphere once also pointed at himself and held brushes and quills. The thumb was originally more extended, and the astronomical instrument was rendered more accurately in the underdrawing, as Kristin Lippincott has informed me. The inscription has been slightly moved, and the scroll at the right side was much longer in the earlier version. Shapley (1979) argues convincingly that the *pentimenti* show that the work is not a copy, but she suggests the possibility of two hands. However, in our view the discrepancy between the *pentimenti* and the quality of the surface is due to later repaint in restoration, not a second contemporary hand.

Literature: H. Cook and M.W. Brockwell, *Abridged Catalogue of the Pictures at Doughty House*, Richmond (1932), pp. 69f., no. 568; Pignatti, 1969, pp. 144-45; Sheard, 1978, pp. 205-08; Shapley, 1979, pp. 217-18.

COPIES AFTER GIORGIONE

David Teniers the Younger

The collection of Archduke Leopold Wilhelm, Hapsburg Governor of the Spanish Netherlands from 1646 to 1656, contained an important nucleus of paintings by Giorgione. As his early education had been in Spain, the archduke became acquainted from an impressionable age with the collections of Venetian paintings formed by his great-grandfather Charles V and by Philip II. In forming his collection, he was ably assisted by agents in Italy including Marco Boschini and Pietro Liberi — and by David Teniers the Younger, who had become court painter to the archduke in Brussels by 1651, a post that also involved curatorial responsibility for the picture gallery. However, as far as works by Giorgione were concerned, some of Leopold Wilhelm's best acquisitions came via England.

The Venetian collections described by Marcantonio Michiel in the first decades of the sixteenth century seem to have remained in the same families for about a century, after which they changed hands, usually for financial reasons, or perhaps because the children and grandchildren of the original collectors had lost interest. At the end of the sixteenth century, Bartolomeo della Nave formed an important collection, which contained a number of Giorgiones, some of which he probably bought directly from the Contarini heirs. Della Nave, who is a shadowy figure despite his importance,[1] died about 1635, at which point the British ambassador to Venice, Lord Basil Feilding, later 2nd Earl of Denbigh, bought a considerable amount from his collection. On a number of occasions, Ridolfi mentions paintings in the della Nave collection, but always adds that now they are in England. Feilding was buying on behalf of his brother-in-law, James, 3rd Marquis of Hamilton. But he may also have wished to profit commercially from the transaction in the expectation of selling the collection to his sovereign Charles I.[2]

When the collection was eventually shipped to England after May 1638, the king was engaged in a war with Scotland. Both Hamilton and the king lost their lives in 1649, and a decade later the paintings had come into the possession of Archduke Leopold Wilhelm. Feilding had found an alternative buyer. Before his arrival in the Netherlands, the archduke's collection already consisted of 517 pictures, and while as governor he was to acquire some 900 more. Thirteen works by Giorgione are listed in an inventory of 1659, made when the archduke took his collection to Vienna at his retirement. It was then inherited by Emperor Leopold I, and eventually became the nucleus of the Kunsthistorisches Museum.

1. For brief biographical details, see Waterhouse, 1952; Cicogna, 1824-53, VI, p. 33; Bottari, 1754, I, p. 232.

2. Waterhouse, 1952, p. 5, from *Historical Manuscripts Commission, 4th Report*, London (1876), pp. 237-38.

3. Speth-Holterhoff, 1957, pp. 132ff.; *David Teniers, Jan Breughel y los gabinetes de pinturas*, 1992.

MADRID, Museo del Prado
David Teniers the Younger
The Picture Gallery of Archduke Leopold Wilhelm
Canvas, 106 x 129 cm

Like his father, Teniers the Younger specialized in a peculiarly Flemish genre subject — *cabinets d'amateurs* — pictures of collectors among their treasures. For the archduke, he painted at least nine versions of his gallery at the Palais de Coudenbrug in Brussels (now four are in Munich, two in Vienna, one in Madrid, one at Petworth House, Sussex, and one at Woburn Abbey, Bedfordshire), each illustrating a different selection of the paintings.[3] One of the most striking, now in the Prado (Fig. 152), was painted as a present for Leopold Wilhelm's cousin, Philip IV of Spain. The archduke is shown visiting his Gallery, attended by two companions. On the left is Count de Fuensaldana, another collector, next to Teniers, who holds a print in his hand. The largest and most prominent paintings represented are by Titian, but there are also two Giorgiones: at left, second row from top, the so-called *Self-Portrait as David* (p. 313 above); and on the slanting inner left wall, the *Laura* (Fig. 131), both now in Vienna. *The Self-Portrait* (now in Budapest, p. 324 below) is on the back wall, second row, of the Prado version (Fig. 153), represented with slightly larger dimensions than it has at present.

VIENNA, Kunsthistoriches Museum
David Teniers the Younger
The Picture Gallery of Archduke Leopold Wilhelm
Canvas, 123 x 163 cm.

At some stage during the archduke's residence in the Netherlands, the idea of publishing an illustrated cata-

logue of the collection, perhaps in imitation of Roman patrons like the Barberini, was conceived. Teniers painted some 244 *modelli*, described as *pastiches de Teniers*, which a team of engravers reproduced for a book entitled *Theatrum pictorium*, first published in 1658 and reissued in French and Flemish editions. In his *Carta del navegar pitoresco*, Boschini announced the imminent publication of the book, as if to advertise both his patron's greatness and his own expertise as a promoter of Venetian painting. The volume contained engravings only after Italian paintings, and although Teniers had earlier planned another volume for Flemish paintings, it remained unrealized when the archduke's collection was removed to Vienna.

A surprisingly large number of lost Giorgione paintings belonged to Leopold Wilhelm. Teniers' copies also cast light on the original appearance of those that have survived — such as the *Laura* and the *Three Philosophers* — which were cut in the eighteenth century to fit a new system of framing in the Vienna museum. Unlike other seventeenth-century attributions to Giorgione, those preserved in Teniers' copies appear reliable, and he is reputed to have imitated each artist's style so well that he was nicknamed Proteus. The engravings are similar in size to the *modelli*, which sometimes have Teniers notes, usually measurements, in the margins along the bottom edges.

Teniers' *modelli* are first recorded at Blenheim Palace, Oxfordshire, after they were presumably bought by John, 1st Duke of Marlborough. Vertue mentions them in his notebook in 1740: 'in ye Closet about 100 small pictures — coppyd by David Teniers for the Duke Leopold — from his excellent pictures in his Collections and from these small pieces, were done the printed book by Teniers suppose they were all Engraved again — twoud be much better'.[4] They remained virtually undiscussed until 16 August 1868, when Giovanni Morelli visited Blenheim Palace and described them in a letter to his friend Austen Henry Layard: '... toutes les portes nous ont été ouvertes, mêmes celles de l'appartement, où se trouve l'intéressant collection de petites copies faites part D. Teniers d'ouvrages de différents maîtres, la plupart de l'école venitienne. C'est très curieux, sont beaucoup de rapports, de voir cette traduction de l'italien en hollandais'.[5] Morelli was the first art historian to take account of Teniers' *modelli* in a reconstruction of Giorgione's œuvre. Despite attempts to keep the paintings together, the collection was sold at Christie's in July 1886. It had earlier been catalogued by the Reverend Vaughan Thomas. Teniers and his engravers record not only known compositions by Giorgione that are lost, but also the uncut state of extant works. Unlike other attributions to Giorgione in some seventeenth-century inventories, these have great credibility, with only three relating to paintings that we would now attribute to Giorgione's contemporaries.

4. *Vertue Notebooks, V, The Walpole Society*, XXVI (1937), p. 135.
5. Add. Ms. 38963, British Library, London.

MODELLI

CHICAGO, The Art Institute of Chicago
David Teniers the Younger, after Giorgione
Rape of Europa
Oil on panel, 21.5 x 31 cm

Provenance: c. 1740, Duke of Marlborough, Blenheim Palace; Blenheim Palace sale, Christie's, London, 24 July 1886, lot 84; bequeathed by Mrs Charles L. Hutchinson to the Art Institute in 1936.

The original was described in the Hamilton inventory of 1638, as 'One peice of Jupiter carringe away Europa in the shape of a Bull, one mayde crying after her, another tearinge her hayre a shippeard 3 cowes a Bull of Gorioyne' (p. 370 below); and later in the Archduke Leopold Wilhelm's collection as: 'Ein Stückhl von Ohlfarb auf Holcz, warin die Europa auf einem weißen Oxen durch das Waser schwimbt, auf einer Seithen ein Hürrth bey einem Baum, welcher auf der Schallmaeyen spilt, vnd auf der andern zwey Nimpfhen. In einer glatt vergulden Ramen 2 Span 2 Finger hoch vnd 4 Span 4 Finger braith. Original de Giorgione'. It was also engraved with an attribution to Giorgione for the *Theatrum pictorium*, and there seems no reason to doubt the traditional attribution to Giorgione. The expressionist fear on Europa's face appears to be a reflection of Riccio's famous sculpture of Europa in the Budapest museum.

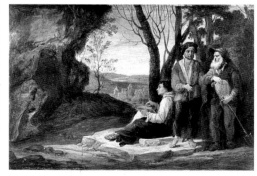

DUBLIN, National Gallery of Ireland
David Teniers the Younger, after Giorgione
Three Philosophers
Oil on oak, 21.5 x 30.9 cm

Provenance: c. 1740, Duke of Marlborough, Blenheim Palace; Blenheim Palace sale, 24 July 1886, Christie's, London, lot 85, sold to Agnew; 1894, acquired by the National Gallery of Ireland, from George Donaldson, London.

This copy initially appears to be a free variant on Giorgione's masterpiece in Vienna (Fig. 49), almost a rustic satire rather than a replica in the true sense of the word. For the seated philosopher here stirs a concoction in a glass bowl; the turbaned philosopher wears trousers torn at the cuffs, an open-necked shirt, and holds a stick; the oldest sage is also dressed in trousers and a raffish peaked cap and holds a spade in his left hand. The mill in the background has been replaced by a castle. They are clearly no longer philosophers, but rustic down-and-outs, a cook, a gypsy and a gardener.

Close inspection of the painting reveals that Teniers repainted his copy, for there is an earlier version underneath which is a more faithful replica of Giorgione's original. This earlier version was initially completed as a *modello* for the engraving by J. Troyen after the *Three Philosophers* in the *Theatrum pictorium*. With the eye alone — no radiographs have been taken — the first outlines of the costumes and the original attributes can clearly be seen to correspond with Giorgione's original. For example, the pair of dividers held by the youngest philosopher is perceptible beneath the glass bowl. The reason for the alterations is unclear, but it has recently been suggested that Teniers might have wished to rework the picture for sale, or — since the repaint is so thin — may have used the composition as a working model for one of his own landscapes with peasants.

Literature: Oldfield, 1992, no. 390, p. 142.

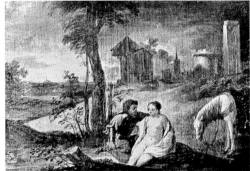

LONDON, formerly Gronau collection
David Teniers the Younger, after Giorgione
The Rape
Oil on wood, 22 x 32 cm

Provenance: probably c. 1740, Duke of Marlborough, Blenheim Palace; but not recorded in Blenheim Palace sale, Christie's, London, 24 July 1886; formerly Georg Gronau collection, London.

The original was described in the Hamilton inventory of 1649 as: 'Une femme qui est outrage par un Soldat avec un paisage' (p. 374 below); and further in the inventory of the archduke's collection (p. 375 below). As has been frequently noted, the female figure is related in posture to the woman revealed in the X-radiograph of the underdrawing on the *Tempesta* (Fig. 54). In neither of the inventories was the subject adequately defined. The present title is unsatisfactory, but the representation does appear to be closer to a twentieth-century conception of a rape than a Renaissance one, in which a god seduces

a mortal for the purpose of begetting children. Several subjects have been proposed, such as Robert Eisler's (unpublished) suggestion of Dinah and Shechem (Genesis 34:1-3), and Georg Gronau's idea that it represents Genoveva, but neither is convincing (G. M. Richter, 1937, p. 219). There is an engraving by Quirin Boel in the *Theatrum pictorium*, based on the painted copy.

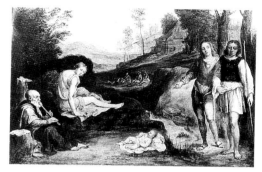

LONDON, private collection
David Teniers the Younger, after Giorgione
Finding of the Infant Paris (Fig. 93)
Panel, 23 x 31.5 cm

Provenance: c. 1740, Duke of Marlborough, Blenheim Palace; Charles Loeser, Florence; Sir Robert Mayer, London; Sotheby's, London, 8 April 1981, lot 99; private collection, London.

The original picture by Giorgione was described by Michiel in Taddeo Contarini's collection (1525) as 'La tela del paese con el nascimento de Paris, con li dui pastori ritti in piede, fu de mano de Zorzo da Castelfranco, e fu delle sue prime opere'. Together with the *Three Philosophers* (Fig. 49), a companion piece of the same dimensions, it passed to the collection of Bartolomeo della Nave, by which time the sense of the subject appears to have been lost, judging by the inventory description: 'the history of the Amazons with 5 figures to the full and other figures in a Landskip of the same greatness made by the same Giorgione' (Waterhouse, 1952, p. 16). Nevertheless, the compiler of the inventory valued the original at 450 ducats higher than any other work in the collection, and to make sense of the subject, ingeniously remembered that the Amazons are said to have exposed their male children. When Basil Feilding wrote to the 3rd Marquis of Hamilton concerning the sale of the della Nave paintings on 9 June 1637, he mentioned that 'those of Giorgione are of his first way, and not comparable to some wch I have seene of his hand', echoing Michiel's description (Shakeshaft, 1986, p. 125). The *modello* was finally acquired by Archduke Leopold Wilhelm as 'Ein Landtschafft von Öhlfarb auf Leinwath, warin zwey Hüerthen vff einer Seithen stehen, ein Kindl in einer Windl auf der Erden ligt, vnd auff der andern Seithen ein Weibspildt halb blosz, darhinter ein alter Mahn mit einer Pfeyffen siczen thuet. In einer vergulden Ramen mit Oxenaugen, hoch 7 Span 11/2 Finger, braith 9 Span 7 1/2 Finger braith. Original von Jorgione'. This small painted copy by Teniers contains much more information about the orig-

inal than the engraving by Theodor van Kessel in the *Theatrum pictorium*. Giorgione's original was a large canvas, approximately 149 x 189 cm, more or less the same size as the *Three Philosophers* in the same collection, painted for one of the richest and most cultivated men in Venice.

In classic accounts of the Paris legend, the hero's early rustic life and musical education is described only briefly (for example, Apollodorus, III, xii, 5, and Hyginus, *Fabulae*, 91). Despite the considerable popularity of the Paris legend in art, the story of his exposure and coming to manhood was hardly ever represented in ancient art, and is extremely rare in any other period. The only other examples from the Renaissance occur in the context of Giorgionesque furniture painting. Giorgione appears to have chosen a rare subject and to have treated it freely even in one of his earliest commissions.

Michiel calls the two standing figures 'shepherds', but only the bare-legged man with a crook is a truly rustic herdsman. His more elegantly clothed companion could be identified as Agelaus, one of Priam's servants, who, rather than kill the infant, exposed him on Mount Ida, where he was found by shepherds, who brought him up. Here Agelaus seems to be introducing the child to a rustic herdsman and persuading him to adopt the boy, an incident that is not, to my knowledge, described in the classical sources, but which is a plausible poetic invention. The shepherd, who is about to take the child, places his hand on a staff very like the saint in the *Castelfranco Altarpiece* (Fig. 84). The infant looks at an ancient rustic, the embodiment of rural wisdom, who will presumably take care of Paris' musical education. In the background, the nymph may possibly be Oenone, daughter of the stream Kebres, with whom Paris lived happily until he was invited to judge the famous competition with the three goddesses. Her strange staring expression may indicate her prophetic gifts; she was said to have inherited second sight from Rhea and warned Paris not to leave his rural paradise to pursue Helen. The youth lying in the middle distance is probably another representation of Paris at ease among the herdsmen.

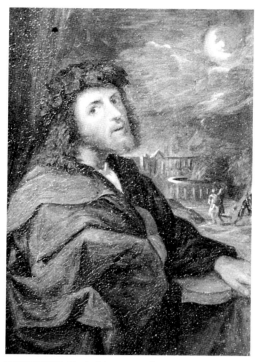

NEW YORK, Suida-Manning collection
David Teniers the Younger, after Giorgione
Self-Portrait as Orpheus
Canvas stretched on board, 16.8 x 11.7 cm

Provenance: c. 1740, Duke of Marlborough, Blenheim Palace; Blenheim Palace sale, Christie's, London, 24 July 1886, lot 82; Wilhelm Suida, Baden near Vienna; Suida-Manning collection, New York.

The original by Giorgione was described in the 1649 inventory of the Hamilton collection as 'Un orphee' (no. 52, p. 374 below) and in the archduke's collection as: 'Ein Stuckh von Öhlfarb auf Leinwath, warin Orphaeus in einerm grünen Kläidt vnd Krancz vmb den Kopf, mit seiner Geigen in der linckhen Handt, vnd auff der Seithen die brennende Höll. In einer vergulten Ramen mit Oxenaugen, hoch 5 Span 4 Finger vnndt 4 Span 2 Finger bräidt. Man hält es von Giorgione Original'. It was engraved by Lucas Vorsterman the Younger for the *Theatrum pictorium*. On the back of the painted copy is a printed label stating that the Reverend Vaughan Thomas called it 'Nero fiddling. Rome burning in the distance'. But the traditional title in the archduke's inventory as Orpheus holding his violin, with Eurydice grasped by a devil in the background, appears correct. One of the primary stories associated with Orpheus has him prevailing upon the infernal powers to release his wife from Hades (Euripedes, *Alcestis*, 357-59; Plato, *Symposium*, 179D). The burning classical buildings in the background and the moon emerging through the cloud reveal the impact of Northern artists on Giorgione, as Suida, who once owned the painting, noted. The position of the eyes is characteristic of a self-portrait, and there is some resemblance to Giorgione's likeness as in the Braunschweig *Self-Portrait* (Fig. 34). It is the only work by Giorgione copied in the *Theatrum pictorium* that is not reversed in the print, suggesting that Vorsterman

recognized the likeness and did not wish to distort the self-portrait. Another picture concerning Orpheus in the underworld was attributed to Giorgione in the collection of Baron Bernard von Imsterad, Cologne (Kurz, 1943, p. 281).

Literature: G. M. Richter, 1937, p. 208; Richter, 1942, p. 34; Suida, 1954, pp. 159-60; Pignatti, 1969, p. 155; Tschmelitsch, 1975, p. 263.

OTHER COPIES

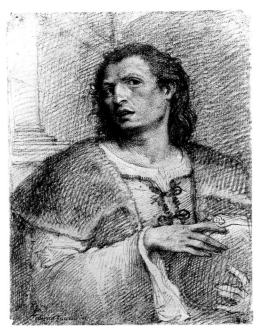

BERLIN, Staatliche Museen zu Berlin-Preußischer Kulturbesitz, Kupferstichkabinett, inv. 23473,51
Federico Zuccaro, after Giorgione
Portrait of a General with a Red Helmet
Black and red chalk, 19.9 x 14.5 cm
Inscribed: *Federico Zuccaro del*; numbered 80 in right-hand corner.

Among Giorgione's earliest works, Vasari described some very beautiful portraits from life in the studio of the Patriarch of Aquilea, Giovanni Grimani. One of these was a self-portrait, while another was a large head, drawn from life, in which the sitter held in his hand a red helmet and was dressed in a long military cloak (with a fur collar), such as to suggest he was a general ('una testona maggiore, ritratta di naturale, che tiene in mano una berretta rossa da comandatore, con un bavero di pelle, e sotto uno di que' saioni all'antica: questo si pensa che fusse fatto per un generale di eserciti').

Matthias Winner first published this drawing in 1973 as a copy after a presumed Bernardo Licinio portrait, made when Zuccaro was working for the Grimani in Venice, during his Venetian journey in 1564. Ballarin (in *Le siècle de Titien*, 1993, p. 291) further suggested that the Berlin drawing was a copy after a lost Giorgione por-

trait of a general, formerly in the Grimani collection. The careful mark-making does indeed suggest a copy of an early sixteenth-century portrait, the sitter's clothing datable to the first decade of the century. The general's cap is drawn only in red chalk, which corresponds pointedly with Vasari's description, as do other details of the sitter's dress. In 1564 Federico worked for Cardinal Grimani in the palace at Santa Maria Formosa, where the portrait was kept, and also in the Grimani chapel at San Francesco della Vigna, where Cosimo Bartoli reported to Vasari that Federico was working on 19 August 1564 (Frey, 1930, II, p. 107). All this evidence suggests that Zuccaro, when working for the Grimani, made a copy of one of the most famous portraits in Venice, which very plausibly is the Giorgione described by Vasari, so close is the description with the image.

Literature: Winner, *Von späten Mittelalter bis zu Jacques Louis David: Neuerworbene und neubestimmte Zeichnungen im Berliner Kupferstichkabinett*, Berlin (1973), no. 62, p. 46; Ballarin, 1993, p. 291.

ENGRAVINGS *after Giorgione* from the *THEATRUM PICTORIUM* (1658)

1. Jan van Troyen, after Giorgione's *Portrait of a Young Soldier with his Retainer (Portrait of Girolamo Marcello)*.

The picture, now at Vienna (Fig. 13), appears in reverse before it was cut down on all sides. The accuracy of the additional details shown in the engraving is confirmed by the description of the portrait in Archduke Leopold Wilhelm's inventory of 1659: 'Ein Contrafait von Oelfarb auf Holz. Ein gewaffneter Mann mit einer Oberwehr in seiner linckhen Handt und neben ihm ein andere Manszpersohn ... Original von Giorgione'. The parapet was originally deeper and Marcello held a stick,

perhaps a weapon, in his left hand, The servant, who wore a cap, played a more prominent role.

2. Lucas Vorsterman, said to be after Giorgione's *St John the Evangelist*.
The original painting now in the Kunsthistorisches Museum, Vienna (inv. 57), is attributed to Palma Vecchio.

3. Lucas Vorsterman, said to be after Giorgione's *Philosopher*.
The original painting, now in the Kunsthistorisches Museum, Vienna (inv. 123), is attributed to Savoldo.

4. Anonymous engraving, said to be after Giorgione's *Resurrection*.
The original painting, now in the Kunsthistorisches Museum, Vienna (inv. 260A), is attributed to Palma Vecchio.

5. Lucas Vorsterman, engraving after Giorgione's *Judith*.
Ridolfi, in his life of Vincenzo Catena (ed. von Hadlen, I, p. 83), mentions that he saw in the collection of Bartolomeo della Nave a painting by Catena with a representation of a 'mezza figura di Giuditta lavorata su la via di Giorgione con spade in mano e'l capo d'Oloferne'. A painted variant by Giorgione's colleague Catena is now in the Pinacoteca Querini-Stampalia, Venice, and differs in minor details of dress and the arrangement of hair. The version engraved by Vorsterman is missing.

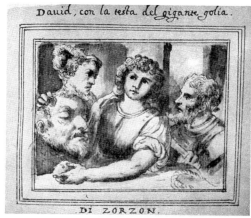

Vincenzo Catena, *Judith with the head of Holofernes*, after Giorgione. Venice, Pinacoteca Querini-Stampalia

Drawings after Pictures by Giorgione in the Collection of Andrea Vendramin, San Gregorio, Venice

In 1615, Vincenzo Scamozzi described the private museums and galleries to be seen in Venice, among which he singled out the collection of Andrea Vendramin (c. 1565-1629), displayed in two rooms in his palace on the Grand Canal, at San Gregorio. There he had assembled statues, torsos, bas-reliefs, vases, medals, and some 140 paintings, both big and small, and of good quality. In 1627, Andrea had an illustrated inventory made of his painting collection, now Sloane Ms. 4004, British Library, London (reproduced in Borenius, 1923). Prominent within the collection were thirteen drawings after pictures attributed to Giorgione. Two years later, Andrea Vendramin died (18 November 1629), and though he asked in his will that the collection remain intact, it was shortly sold abroad. The brothers Gerard and Jan Reynst of Amsterdam, to whom Ridolfi's *Maraviglie* is dedicated, were said to have bought the Vendramin collection intact (Jacobs, 1925, p. 17; Savini Branca, 1964, p. 285; Logan, 1979, pp. 67-74). However, the collection survives only in the manuscript drawings. The thirteen claiming to be after Giorgione record lost works — if the attributions are correct. None of the paintings in the Vendramin collection can be identified today and the collection remains mysterious.

Giorgione's self-portrait was the only painting in Andrea Vendramin's collection that Ridolfi described: 'si ritrasse in forma di Davide con braccia ignude e corsaletto in dosso, che teneva il testone di Golia, haveva da una parte un Cavaliere con giuppa e baretta all'antica e dall'altra un Soldato, qual Pittura cadè dopo molto giri in mano del Signor Andrea Vendramino'. The scene, summarily indicated by background columns, would seem to be Saul's house, where David was welcomed after his victory (I Samuel 18:1-10). The younger man who gazes searchingly at David is probably Jonathan, who grew to love the young hero as his own soul. The older

After Giorgione, *Self-Portrait as David with the Head of Goliath, accompanied by King Saul and Jonathan*

man holding the concealed weapon is Jonathan's father Saul, who became jealous of David's success and misguidedly attempted to kill him. Whether the features of David in this genre scene really represent Giorgione, as Ridolfi stated, has been questioned by Garas (1964, p. 60) and Wind (1969, p. 34), but the many copies after the lost original are variable. A painted replica in Madrid, optimistically attributed to Luca Giordano, is

After Giorgione, *Two Lovers*

After Giorgione, *A Family of Fauns with a Goat*

recorded by Borenius (1923, p. 24), while there are two others at Schloß Nymphenburg and the Národni Galerie, Prague (Garas, 1964, pp. 56-60).

BURGHLEY HOUSE, Stamford, no. 134
Pietro Liberi
A Nymph with a Golden Apple.
Copy after a lost fresco from the Fondaco dei Tedeschi.
Canvas, 186 x 102 cm.
See pp. 282–83

After Giorgione, *Nymph and Faun before an Altar*

After Giorgione, *Portrait of a Man with a Cap*

After Giorgione, *Bust of Christ*

After Giorgione, *'La Divitia', or Allegory of Wealth*

After Giorgione, *Landscape with Small Figures and Goats*

After Giorgione, *Portrait of a Patrician*

After Giorgione, *'Favola di Paride', Judgement of Paris*

After Giorgione, *Youth in a Plumed Hat Holding a Flute*

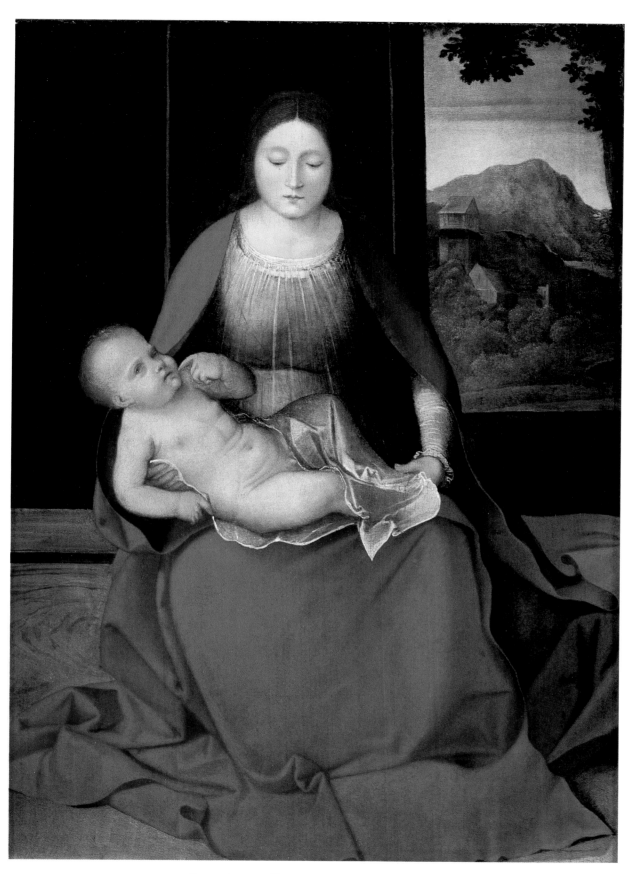

Sixteenth-century Venetian School. *Madonna and Child.*
Canvas, 68 x 48 cm. Private collection, Bergamo.

After Giorgione, *Portrait of a Bearded Man*

After Giorgione, *Man in Armour*

After Giorgione, *Sacrifice*

REJECTED ATTRIBUTIONS

BERGAMO, private collection
Sixteenth-century Venetian
Madonna and Child

Provenance: Sir Herbert Cook, Doughty House, Richmond; private collection, Bergamo.

Although this painting is first recorded in the nineteenth century as a Pseudo Boccaccino in the collection of Sir Herbert Cook — a scholar renowned for his

expansionist view of Giorgione's œuvre — no one dared to attribute the painting to Giorgione until Testori suggested the attribution in 1963. It was elevated to a prominent position in Pignatti's monograph (1969), where it is accepted as a certain early work. Some reviewers of Pignatti's book rejected the attribution (Robertson, 1971, p. 477; Turner, *The Art Bulletin*. LV [1973], p. 457; *Times Literary Supplement*, 30 April 1971, p. 503). The painting itself has never been on public exhibition and its location in Bergamo is strangely unknown. Judging by various reproductions, beginning with photographs in the Cook collection catalogues, it has changed its appearance considerably in restoration on several occasions during the last forty years (Gentili, 1993, pls. 153-55, reproduces them). On each occasion, the photographs indicate that there are significant alterations to the faces of the Madonna and Christ Child. No account of these restorations has ever been published. The X-radiograph published by Mucchi (in *I tempi di Giorgione*, III, 1978) suggests significant changes difficult to estimate without examining the painting itself. In these circumstances, it is difficult to evaluate the attribution; the picture is sometimes reproduced in recent catalogues of Giorgione (Torrini, 1993) and sometimes ignored (Baldini, 1988).

Literature: T. Borenius, *A Catalogue of the Paintings in the Collection of Sir Frederick Cook*, London (1913), no. 153; Testori, 1963, pp. 45-49; Pignatti, 1969, pp. 94-95; Gentili, 1993, p. 291; Torrini, 1993, pp. 22-23.

BERGAMO, collection of Giacomo Suardo
Attributed to Carpaccio
Page in a Landscape
Panel, 13.2 x 27.6 cm

Provenance: in the Abati collection, Bergamo, for several centuries; by inheritance to Giacomo Suardo, Bergamo.

This poetic painting of a page in a landscape was first published in 1955 in the exhibition catalogue *Giorgione e i Giorgioneschi*, where it was attributed by Fiocco to Giorgione. It had earlier been attributed to Giorgione by Gustavo Frizzoni when it was in the Abati collection. It is a panel of lyrical beauty, where a fashionable youth divides a landscape, with a pool of water on one side and a poplar wood on the other. This contrasting landscape appears to mirror the poetry in his thoughts. In 1962 Lauts discovered a Carpaccio drawing in the Hermitage with the figure of a page and one of St Ursula, the latter from his famous painting of *St Ursula Taking Leave of her Father*. The Bergamo panel appears to date from the early years of the Cinquecento, and shows how Carpaccio was influenced by the new Giorgionesque mode of poetic pastoral painting. It is an important painting, which documents Giorgione's early impact on other Venetian artists and deserves to be better known.

Literature: Fiocco, in *Giorgione e i Giorgioneschi*, 1955, pp. 8-9; Lauts, 1962, p. 238; Lilli and Zampetti, 1968, p. 59.

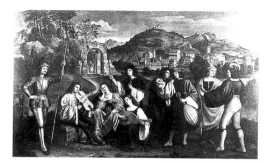

BERWICK, Attingham Park
Concert at Asolo
Oil on canvas, 98.7 x 79.8 cm

Provenance: said to have been acquired by William Hill, 3rd Earl of Berwick, when ambassador to Naples between 1824 and 1833.

The painting was first published by Herbert Cook (1909, pp. 38-43) as an eighteenth-century copy of a lost original by Giorgione. Cook read the subject in the following way: 'We are introduced into the famous society of Caterina Cornaro and her romantic court up at Asolo surrounded by poets, musicians and painters, among them the young Giorgione himself; or here in the centre sits Caterina, listening in a dreamy pose to a duet, no doubt on some love theme, whilst close behind her stands her young protegee the youthful Giorgione of Castelfranco. In the distance behind her to the right are seen the wall and towers of his birthplace, and upon the hill is possibly Asolo itself, her own home. Who shall say who are the others in this group? Can the armoured youth on the left be Matheo Costanzo, the local hero in remembrance of whose early death young Giorgione was so soon to paint the altarpiece at Castelfranco? And is Pietro Bembo, the poet one of those four in the group on the right?'

There can be no doubt that the facture of the painting is entirely nineteenth century, but what of the conception? The fact that it is a pastiche of various motifs from other works by Giorgione and that it presents a sentimental view of Giorgione's life at Asolo suggests that the conception of the picture is also entirely nineteenth century (Anderson, 1973). Moreover, in any age it would be unlikely that an artist would be presented in an amorous relationship with a queen. The painting belongs to that genre of art, so beloved in the nineteenth century, which depicts the early life of an artist; it was during the same period that Robert Browning wrote 'Asolando'.

Literature: Anderson, 1973, pp. 290-92; Chastel, 1978, pp. 100-05.

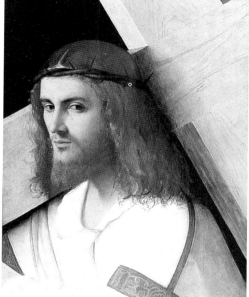

BOSTON, Isabella Stewart Gardner Museum
Attributed to Giovanni Bellini
Christ Carrying the Cross
Oil on nut wood, 52 x 43 cm

Provenance: acquired by Mrs Gardner from Count A. Zileri dal Verme, Palazzo Loschi, Vicenza, in 1898.

For many decades the picture, then said to be a free variation by Giorgione after a Bellini prototype, was examined by nineteenth-century museum directors as a possible acquisition for a national museum. On 10 November 1856 (National Gallery, London, *Minutes of Board Meetings*, IV, fol. 54), Eastlake reported to the trustees of the National Gallery, that '. . . the half figure or rather head, by Giorgione — Christ bearing his cross in the possession of a Lady of rank in Vicenza, is I think a desirable specimen; although I consider that as the picture consists only of a portion of a figure under life size, the estimate of £750 is too high. I should say that £500, should be the limit. The proprietors have, however, as yet, refused to part with it'. In 1898 Mrs Gardner paid at least four times that amount, and she commissioned a painted copy fromm Robert David Gauley for the owner in Vicenza. She was convinced that it was a Giorgione, but her adviser Berenson was less convinced. In 1906 Berenson was summoned to a hearing at the Florence magistrate, when the city of Vicenza protested that the painting had been sold abroad and a copy secretly substituted.

The original Bellini prototype is a painting now in Toledo, Ohio, which could perhaps be the one referred to in the collection of Taddeo Contarini as 'El Quadro del Christo con la croce in spalle, insino alle spalle, fu de mano de Zuan Bellino'. That the Boston version is a high quality variant of the Bellini composition has never been in doubt, though there is no agreement as to who in the Bellini studio may have made it. The idea that Giorgione was the copyist was advanced by Morelli and G.M. Richter (Richter, 1939, p. 95, summarizes earlier views). Pignatti (1969, p. 94) reproposed the work as

one of Giorgione's earliest Bellinian compositions, but in recent years his suggestion has been forgotten, and the painting has been seen as a variant of Bellini's composition from his studio (as in Hendy, 1974, no. 20, or Torrini, 1993).

Literature: Morelli, 1880, p. 188; G.M. Richter, 1937, p. 237; G.M. Richter, 1939, pp. 95-96; Pignatti, 1969, p. 94; Hendy, 1974, p. 164; Hornig, 1987, pp. 179-81; Torrini, 1993, p. 144.

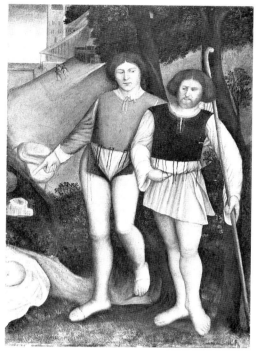

BUDAPEST, Szépmüvészeti Múzeum, inv. 95 (145)
After Giorgione
Finding of the Infant Paris
Canvas, 91 x 63 cm

Provenance: Cardinal Johann Ladislaus Pyrker in the nineteenth century; 1836, bequeathed to the Hungarian National Museum, Budapest, as a Titian.

When the Budapest fragment was first thrust into the critical limelight, it was considered by Morelli (1880) a fragment of the original picture described by Michiel and recorded in Teniers' copy (p. 317 above). The measurements of the height of the original described in the inventory of Archduke Leopold Wilhelm's collection are compatible with this fragment — allowing for the frame and other losses. Significantly, there are many differences in the clothing of the two 'shepherds' in the Budapest fragment and the Teniers' copy, explained by Gombosi (1935), who published an X-ray photograph of the detail of the shepherd holding the staff, as merely the result of later overpainting. Gombosi failed to comment on the interesting differences in the landscape backgrounds of the two works. Instead of the two shepherds watching a flock of sheep which Teniers copied, the Budapest fragment shows the same two shepherds (dressed precisely as those in the foreground) in an earlier episode of the story. They are seen hurriedly leaving a hill town, sum-

marily indicated by a drawbridge, campanile and thatched buildings. In the Budapest version, the shepherd's reluctance to take the child is emphasized. Priam's servant has placed his hand firmly on the shepherd's shoulder, as if pulling him, but the herdsman resists, his left foot pressed firmly on the ground while he glances suspiciously at the baby. When Cardinal Pyrker acquired the painting in Treviso as a Titian, it was then called 'zwei Blinde führen einander', a title that attempted to explain the rustic's tottering stance and hesitant expression. The status of the picture is unlikely to be resolved without further scientific investigation. Either it could be a fragment in very poor condition of the original early work by Giorgione (Justi, 1936) or more likely a fragment of a sixteenth-century copy (Garas, 1964; Pigler, 1968).

Bibliography: Morelli, 1880, p. 190; Gombosi, 1935, pp. 157-64; Justi, 1936, I, pp. 114, 315; Garas, 1964, pp. 62, 72-73; Pigler, 1968, p. 270.

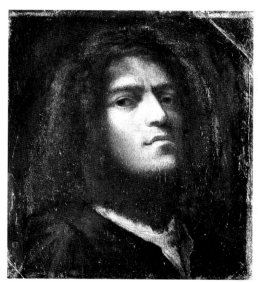

BUDAPEST, Szépmüvészeti Múzeum, inv. 86 (161)
Sixteenth-century Venetian artist, after Giorgione
Self-Portrait
Paper on walnut wood, 31.5 x 28.5 cm

Provenance: until 1636, Bartolomeo della Nave, Venice; bought by Lord Basil Feilding, 2nd Earl of Denbigh, when he was the English ambassador in Venice (1634-39), for his brother-in-law, James Hamilton, 3rd Marquis (later first Duke) of Hamilton, d. 1649; Archduke Leopold Wilhelm, Brussels, when depicted by Teniers in his representation of the archduke's gallery (Fig. 152); 1770, from the Vienna court collection to Schloß Pressburg; 1848, Hungarian National Museum, Budapest.

The novelty of the work is that it is one of the earliest painted sketches on paper, but it has suffered greatly. In the eighteenth century, it was chopped at the edges to fit a display cabinet in Schloß Pressburg, but its earlier appearance is recorded in many of the copies in the representations of Archduke Leopold Wilhelm's collection by Teniers and Prodomus, the latter showing much more of the portrait than survives. It has a good provenance, and was always highly valued as an original work

by Giorgione. It is severely abraded and has suffered from cleaning. There is a disturbing yellowishness on the surface. Only the central part of the face, the scowling mouth and the area around the eyes are in good state. The style and technique of this oil sketch are not consistent with a work from the early Cinquecento; the painting is most likely an early sixteenth-century copy of one of the innumerable likenesses of Giorgione.

Literature: Prodomus, 1735, pl. 12; Pigler, 1968, pp. 266-67.

CASTELFRANCO (Veneto), Casa Marta Pellizzari
Imitator of Giorgione
The Liberal and Mechanical Arts
Fresco in chiaroscuro of yellow monochrome with white highlights and bistre shading, on the first floor of the house, 78 x 1588 cm and 76 x 1574 cm

The earliest attribution of the fresco to Giorgione occurs in the eighteenth-century *Repertorio* by Nadal Melchiori, a local chronicler and indifferent painter (Ms. 163, Biblioteca Comunale, Castelfranco): 'Nella casa della famiglia Marta evi di sua mano [Giorgione] nella sala un fregio rappresentante cose naturali, cioè Istromenti, Libri et Ordegni di tutte le professioni, a chiaro scuro et una testa in particolare finta marmo bellissima'. Melchiori attributed almost every fresco of the Cinquecento he chanced upon in Castelfranco to Giorgione, such as the Hercules frescoes on the facade

of the Casa Bovolini. In view of how ridiculous his proposals were and are, all his attributions should be regarded with great caution. These frescoes were introduced to Giorgione's œuvre by Crowe and Cavalcaselle with the statement that they are 'treated boldly, and certainly in a Giorgionesque spirit (1871, p. 170). Since this publication, they have been, at times, allowed grudgingly into Giorgione's corpus as a possible early work.

The frieze on the east side commences with a still life of books arranged on shelves and an hourglass. There follows a sober *memento mori*: UMBRE TRANSITUS EST TEMPUS NOSTRUM ('Our time is a journey to the shades; Book of Wisdom 2:5); and then a philosopher's head in a medallion with the motto SOLA VIRTUS CLARA AETERNAQUE HABETUR ('Virtue alone is accounted noble and everlasting'; Sallust, *Bellum Catilinae*, I, 4). The next section contains a long series of astronomical diagrams and instruments. An astrolabe is inscribed 'sphera mundi', thus identifying the source for the eclipse of the moon and the sun as Sacrobosco's *Sphera mundi* (1488). To the right of the instruments are two mottoes: QUI IN SUIS ACTIBUS RATIONE DUCE DIRIGUNTUR IRAM CELI EFFUGERE POSSUNT ('Those whose actions are guided by reason can escape the wrath of heaven'), and FORTUNA NEMINI PLUS QUAM CONSILIUM VALET ('To no one is good fortune of more value than good counsel'; an inversion of Publilius Syrus, *Sententiae*, 222). Placed in conjunction with astronomy, the mottoes could be construed as an affirmation of reason against the caprices of fortune and astrological prediction.

There follow more astronomical drawings, weapons and a helmet accompanied by mottoes: FORTIOR QUI CUPIDITATEM VINCIT QUAM QUI HOSTEM SUBIICIT ('He who overcomes cupidity is more valiant than he who vanquishes an enemy'; Publius Syrus, *Proverbia*, 49); and SEPE VIRTUS IN HOSTE LAUDATUR ('Virtue is often praised in an enemy'). Then there is a group of musical instruments and a section that is irretrievably lost which probably once contained the emperor's head now in the Casa Rostirolla-Piccinini, Cittadella. The concluding section on this side of the wall has a representation of painter's equipment, an unfinished painting of St John the Baptist, an open book with vanishing-point perspective diagrams, a painting on an easel with an outline of a satyr and a young boy in a hilly landscape. SI PRUDENS ESSE CUPIS IN FUTURA PROSPECTUM INTENDE ('If you wish to be prudent look to the future') is placed next to the unfinished picture on the easel.

The frieze on the west wall is stylistically different, as is the grouping of objects and *sententiae*, from which the emperors' heads are absent. Only four tablets with the following mottoes are legible: TERRIT OMNIA TEMPUS ('Time brings all things low'); VIRTUS VINCIT OMNIA ('Virtue conquers all'); AMANS QUID CUPIT SIT QUID SAPIAT NON VIDET ('A lover knows his desire, his wisdom is out of sight'; Publilius Syrus, *Sententiae*, 15), next to a picture of Venus and Cupid; the final proverb is incomplete — OMNIUM RERUR RESPICIEN. The *sententiae* occur among arms, trophies, musical instruments, gardening tools, navigational instruments, skulls, and easels seen in juxtaposition to one another. Although the frieze has been interpreted as a representation of the Liberal Arts, the diversity of objects suggests otherwise. A cohesive program or significance for the decoration has still to be found. More than anything else, the frescoes resemble, as Mariuz (1966, p. 61) suggested, the

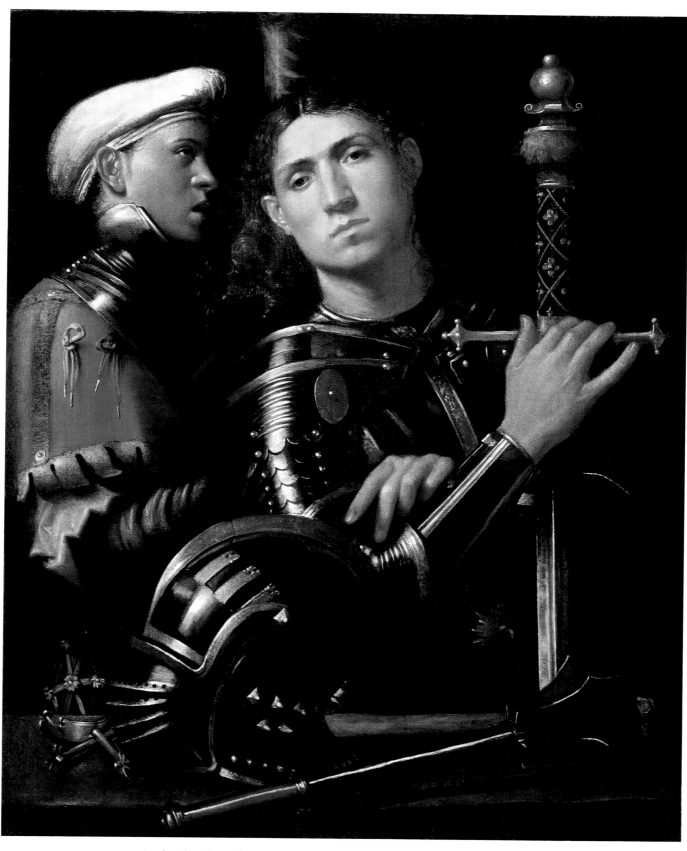

Attributed to Cavazzola. *Portrait of a Man in Armour with his Page (the Gattemelata Portrait)*.
Canvas, 90 x 73 cm. Florence, Galleria degli Uffizi.

wooden *intarsia* decorations in *studioli*, with their still lifes of musical instruments. The playful juxtaposition of text with image relates the frieze to the early study of hieroglyphs and emblems, and makes the room a particularly appropriate setting for an Academy, which Ferriguto (1943, p. 403) argued was its function.

Some scholars have accepted the frescoes as Giorgione's earliest works, exceptions being Ferriguto (1943, pp. 403-18), Muraro (1979, p. 179), and Sgarbi (1979), who date them after Giorgione's lifetime. A prominent characteristic of the frieze are the quotations of virtuous Roman *sententiae*, which all suggest the influence of Erasmus, who published his second edition of the *Adages* in 1508. Some years later, in 1514, an edition of the *Sententiae* of Publilius Syrus, the source most frequently consulted for these frescoes, was first printed. If the Fondaco frescoes are placed next to any of even the most felicitous parts of these frescoes, it is difficult to accept an attribution to Giorgione himself. Rather, they are by a local artist imitating the great man who was born in this charming country town.

Literature: Mariuz, 1966, pp. 49-70; Pignatti, 1969, pp. 103-04; Sgarbi, 1979, pp. 273-80; Torrini, 1993, pp. 12-15; Fortini Brown, 1996, pp. 252-59.

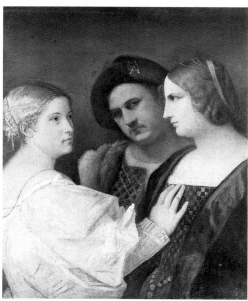

DETROIT, The Detroit Institute of Arts
Sixteenth-century Venetian
Triple Portrait or a Scene of Seduction
Canvas, 84 x 69 cm

Inscribed on reverse: FRA SEBASTIANO DEL PIOMBO — GIORZON — TITIAN

Provenance: Schönborn Gallery, Pommersfelden, where attributed to Giorgione in the nineteenth century; Duke of Oldenbourg; Munich, Böhler, 1923; Lucerne, Fine Arts Company; acquired in 1926 by the Detroit Institute of Arts.

Both the attribution and the emotional sense of this rather weak painting have proved difficult to understand. It is clumsily executed, especially in such details as the prominent hand of the blonde woman in the foreground. The inscription on the reverse was accepted as genuine by some scholars, and seemed to confirm that the three

artists had collaborated together, each figure representative of one of their separate styles, until it was realized that Sebastiano only received the office of the Piombo in 1531, years after Giorgione's death. According to some scholars, this meant that the inscription was apocryphal and added later. For others, it emphasized the ambiguous nature of the composition. The selection of different models whose types span decades may be interpreted as the sign of a pasticheur, which suggests that the painting is an academic exercise from the mid-1540s, or even later. What was the painter's intention? Was it to deceive or was it to illustrate an academic point? What can be the meaning of such a painting?

Some scholars have attributed this inferior painting to great names: Ballarin (1993) believes it to be by Sebastiano, whereas Lucco (1995) considers it to be by Giorgione, and Furlan (1988) believes it to be early Pordenone, certainly the best suggestion so far.

Literature: Furlan, 1988, p. 332; Ballarin, 1993, p. 297; Lucco, 1995, p. 136.

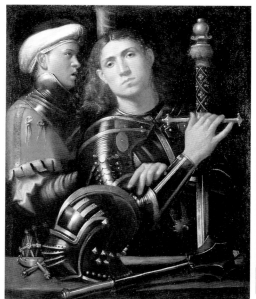

FLORENCE, Galleria degli Uffizi
Attributed to Cavazzola
Portrait of a Man in Armour with his Page (The Gattamelata Portrait)
Canvas, 90 x 73 cm

Provenance: the castle at Prague, first half of the eighteenth century, as school of Titian (Garas, 1965, p. 52); by 1783 transferred to the Imperial collections, Vienna, where described in Mechel's catalogue as Giorgione's portrait of Gattamelata, general of the Venetians, with his son Antonio; 1821, by exchange with the Imperial Museums in Vienna, given to the Uffizi, where exhibited as by Giorgione.

The portrait presents an extraordinarily compelling image of a *condottiere*, a combination of military power and effeminancy. The idea that Giorgione could have portrayed Gattamelata is a historical impossibility. The composition of a knight balancing his hand on the hilt of a large and prominent sword originates with half-figure representations attributed to Giorgione and his circle in painted and engraved copies. In the Gattamelata por-

trait the still life of the helmet replaces the severed head of Holofernes or Goliath in the Giorgione compositions. The critical history of the painting shows that almost all writers, beginning with Morelli (1880, pp. 54-55; J.P. Richter, 1960, p. 110), attribute the work to an artist of the Veronese School, most often Cavazzola, but other Veronese names have been suggested, such as Torbido, Michele da Verona and even Caroto. In the 1940s, Longhi reproposed Giorgione's name, and later changed his mind after the 1955 *Giorgione e i Giorgioneschi* exhibition. Longhi was the culprit who attributed many of Giorgione's works to Titian, and because of his enormous influence in Italian scholarship, many of his views have been repeated without adequate examination. More recently, Ballarin has attempted to revive Giorgione's name, and to question the dating of the helmet, which is usually said to be later than Giorgione's lifetime. There is no historical reason for an attribution to Giorgione, nor does the facture of the painting suggest that he should be credited with the portrait.

Literature: Baldass, 1965, p. 170; Pignatti, 1969, p. 171; Ballarin, 1993, pp. 706-09; Torrini, 1993, p. 122.

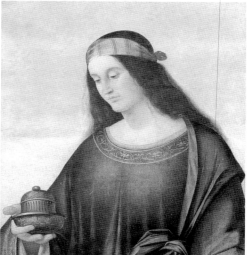

FLORENCE, private collection
Attributed to Lorenzo Lotto
St Mary Magdalen
Tempera and oil on poplar, 54.1 x 49.1 cm

Provenance: unknown, but recorded in the literature as Milan, private collection, 1955; 1995, Florence, private collection; unsold at auction, Pandolfini, Florence, 11 June 1997.

The saint first entered the critical literature as a work by Giorgione, when the attribution was proposed by Roberto Longhi in *Giorgione e i Giorgioneschi* (1955). Longhi believed that this was Giorgione's first work, and that it proved Giorgione's formation took place in the workshop of Carpaccio at the time of the *Ursula* cycle. William Suida and Giuseppe Fiocco agreed with Longhi, whereas Lionello Venturi preferred an attribution to Carpaccio. The painting was inaccessible in a private collection for many years, and little studied. The attribution to Giorgione was rejected by Pallucchini (1955), Pignatti (1969) and Torrini (1993), but accepted by Ballarin (1979) and Lucco (1995). Rearick (1979) was

intrigued since the painting seemed to be in accord with his theories of Giorgione's development, but he nevertheless expressed reserve. The panel is of considerable quality, and in recent conservation was proved to have been a fragment of a larger altarpiece, perhaps the saint on the righthand side of a *Sacra Conversazione* (Lucco, 1995). The faint traces of a nimbus, seen clearly following conservation, reinforced the figure's identification as St Mary Magdalen. In 1993, Achille Tempestini took up a suggestion made by Pignatti: that the artist was someone who undoubtedly had Giorgionesque and Carpaccesque elements in his style, but was Trevisan. Tempestini then proposed that the *Magdalen* was an early work by Lorenzo Lotto. He compared the *Magdalen* with works from Lotto's Trevisan period, such as the altarpiece of the *Madonna and Child with St Peter Martyr*, now in the Capodimonte, Naples, dated 1503. Tempestini's suggestion seems the most credible attribution so far.

Literature: Longhi, in *Giorgione e i Giorgioneschi*, 1955, p. 14, no. 7; Pignatti, 1969, pp. 127-28; Ballarin, 1979, p. 229; Tempestini, 1993, pp. 300-02; Lucco, 1995, pp. 14-15.

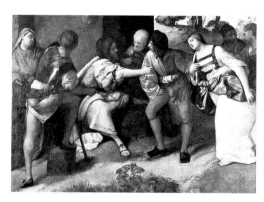

GLASGOW, Corporation Art Gallery and Museum
Titian
Christ and the Woman Taken in Adultery (Fig. 41)
Canvas, 139.2 x 181.7 cm (substantially cut on both sides of the composition)

Provenance: McLellan collection, Glasgow, bequeathed to the Glasgow museum in 1856.

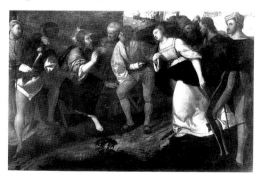

An early copy reproduces the composition before it was cut: Accademia Carrara, Bergamo, inv. 161, measuring 149 x 219 cm (presumably the original dimensions of the Glasgow painting), traditionally attributed to Giovanni Cariani, although with no good reason (Pallucchini and Rossi, 1983, pp. 262-63), but datable to about 1520. The deletion of the two side figures

recorded in the early copy, men of vitality, whose bodies are presented in a dramatically foreshortened manner, affects both the way we read the composition and the attribution. A fragment of the head of the man on the right side, cut from the Glasgow canvas, is now in Glasgow. Other copies, one now in a private collection Berlin (formerly collection of Dr Max Friedeberg, Berlin) and another recorded in the collection of Baron Donnafugata of Ragusa in 1960 (discussed by Ballarin, 1993, pp. 330-31), suggest that this was a famous composition.

Yet nothing is known of the early provenance of this picture. Although there are many seventeenth-century inventories that record half-length compositions of *Christ and the Woman Taken in Adultery* with attributions to Giorgione (Garas, 1965, pp. 33-43), none has been plausibly associated with the Glasgow painting. Ballarin (1993) and others before him have suggested that the subject is Susanna and Daniel, but the man who is supposed to be Daniel has a cross-shaped halo, usually appropriate to Christ. Moreover, he appears too old to be identified as Daniel, for it is said in the Bible that Daniel was still a child when he established Susanna's innocence (as argued by Hope, 1993, p. 24). Those in favour of an attribution to Giorgione, such as Tietze-Conrat (1945, pp. 189-90) suggested an identification with a commission to Giorgione from Alvise de Sesti, but the status of these documents (p. 361 below) is highly dubious and many scholars regard them as fraudulent. In recent decades the majority of scholars have opted for an attribution to Titian, as the composition is comparable with the frescoes in the Scuola del Santo, Padua. Two exceptions are provided by Hornig (1987, pp. 234-36), who is still in favour of Giorgione, and Hope (1993), who attributes the painting to Domenico Mancini. Joannides (1990, p. 23, figs. 15-17) identifies the soldier on the left in a cuirass as a borrowing from an antique statue of Hermes (Louvre), known also to Raphael.

The Glasgow picture was examined in conservation by Helmut Ruhemann together with Joyce Plesters in the early 1950's, when the scientific examination of Venetian painting was in its infancy (Ruhemann, 1955). In correspondence with the author, Joyce Plesters states that she found the use of colours in the Glasgow painting comparable with those in Titian's *Bacchus and Ariadne* (London). She writes: 'there occurs the same dominant realgar/orpiment orange/yellow drapery, the same lilac-purple shade, lavish use of ultramarine in both sky and drapery, rich-coloured crimson lakes, and the use of then available full palette. Ruhemann also pointed out the curious flesh tone, which he used to term "cocoa-colour", a sort of warm, almost uniform pinkish brown (rather like stage pancake make-up). The Glasgow painting is of rather coarse *matière*, with a rough stippled effect on some of the paint. This may be explained merely as a consequence of the size and scale of the picture'. Plesters' analysis of pigment samples has revealed that the bright orange and yellow satin doublet of the man in the foreground was found to have been bright green originally, a brighter and bluer green than the landscape background. This was first painted out with a layer of white lead before the orange paint was applied. The *pentimenti* revealed in the X-ray, especially those showing the difficulties the artist had with the placement of the adulteress's head, are entirely characteristic of Titian, and

the composition is comparable with the Paduan frescoes in the Scuola del Santo (Figs. 167-169). The side figures, especially those recorded in the copies, suggest a sense of unease, almost an anticipation of Mannerism, for which no parallel is found in the work of Giorgione, as it survives.

Literature: Ruhemann, 1955, pp. 278-82; Ballarin, 1993, pp. 328-31; Hope, 1993B, p. 24; Torrini, 1993, p. 146.

HAMPTON COURT PALACE, Collection of Her Majesty the Queen, inv. 101
Titian
Shepherd with Flute
Canvas (relined), 61.2 x 46.5 cm

Provenance: Charles I of England; sold during the Commonwealth to De Critz and Co., 1650; recovered at the Restoration and listed as a 'Shepheard with A pipe' and, in the successive inventories of the Royal Collection, always as by Giorgione (Shearman, 1983, pp. 253-56).

Shearman's account of the condition of the painting reveals that it is complex, and that the best-preserved areas are the white shirt, the blue drapery, and the hand. There are substantial areas painted in an old restoration, especially apparent in the hair and the face. The entire head of the flute is a restoration, and the object in the shepherd's hand could have originally been something entirely different, a staff, for example; the remains are difficult to interpret as a musical instrument.

From the seventeenth century, the picture was attributed to Giorgione. J.P. Richter, in correspondence with his teacher Morelli, 22 February 1881, called attention to this 'wunderbares Bild', which from then on was often considered to be the work described by Michiel as 'la pittura della testa del pastorello che tien in man un frutto, fo de man de Zorzo da Castelfranco'. It was always considered very similar to the so-called self-portrait of Giorgione in the Vienna *David* (Fig. 128 and p. 313 above).

At the 1955 Giorgione exhibition in Venice, the

Hampton Court *Shepherd* was hung next to the Vienna *Young Boy with an Arrow* (Fig. 17), which suggested to John Shearman that, despite the generic similarities, they were by different hands, 'in every non-typological aspect of picture-making they were profoundly different'. At the 1993 Paris exhibition, the same opportunity for comparison was given, and to some scholars, Paul Joannides and myself, Shearman's attribution appeared convincing. Despite its ruined state, the picture has enormous presence. As Shearman noted, there is a vigorous impasto, underdrawing characteristic of Titian revealed in an X-ray, and outlining around the contours of forms with brown pigment, which is also characteristic of Titian's hand.

Literature: Pignatti, 1969, p. 111; Shearman, 1983, pp. 253-56; Ballarin, 1993, p. 739.

HOUSTON, Sarah Campbell Blaffer Foundation
Sixteenth-century Venetian
Pastoral Allegory with Apollo and a Satyr
Panel, 43.1 x 69.8 cm

Provenance: possibly mentioned in the 1681 Medici list of paintings available in Venice as: 'Quadro in tavola di Giorgione con Apolo che suona la lira e con il satiro che suona la zampogna' (p. 377 below); purchased by Sir Frederick Cook in 1912 from Messrs Norman Leaver and Co., Genoa, who said it came from the collection of Professor André Giordan; sold by Thos. Agnew and Son, London, 1951; Capt. V. Bulkeley-Johnson; the Mount Trust collection; purchased from Agnew by the Blaffer Foundation.

When the painting was in the Cook collection, it was catalogued by Borenius as a follower of Giorgione, perhaps Girolamo da Santa Croce, on the basis of a comparison with the *Glory of St Helena* in the Akademie der bildenden Künste, Vienna. Undoubtedly, the painting relates to the imagery of both Giorgione and Lorenzo Lotto around 1508, but as yet neither the artist nor the subject has been adequately explained. The coat-of-arms (as yet unidentified) and the medium suggest that this panel once decorated a *cassone* or piece of furniture. To the left there appears to be a contest between Apollo and a satyr. The fight between a satyr and boy on the right is probably an allegory of reason triumphing over brute force.

Literature: T. Borenius, *A Catalogue of the Paintings in the Collection of Sir Frederick Cook*, London (1913), I, p. 64; T. Pignatti, *Five Centuries of Italian Painting 1300-1800, from the Sarah Campbell Blaffer Foundation*, Houston (1985), pp. 91-92.

KINGSTON LACY, WIMBORNE, DORSET
Sebastiano del Piombo
Judgement of Solomon (Figs. 77, 78)
Canvas, 2.08 x 3.15 cm

Provenance: Described by Ridolfi in the Grimani Calergi collection at Sant'Ermagora in 1648: 'la senza di Salomone lasciando il manigoldo non finito'; also in an inventory of Giovanni Grimani Calergi in 1664 of the Palazzo Vendramin-Calergi: 'Un detto [quadro] grande col Giuditio di Salamone di Zorzon con soaze di pero nere (Levi, 1900, II, pp. 47-48); according to a receipt in the Bankes papers, Dorset Record Office, Dorchester, Bankes bought the painting from Count Carlo Marescalchi for 575 Roman ducats on 11 January 1820; according to the same receipt, it had been acquired by Count Ferdinando Marescalchi in 1811-12 from the Tron collection, Venice, who in turn had bought it from the Grimani. How the painting passed from the Tron family to the Bolognese dealer who sold it to Mareschalchi is explained in a manuscript note of 1834: 'Il quadro di Zorzon rappresentante il Giudizio di Salomone — lasciato al n. h. Nicolò Tron cavaliere e suoi discendenti. Questo quadro di Giorgione non compiuto rappresentante il Giudizio di Salomone nel 1806 fu venduto per talleri quaranta dal n. d. Loredana Tron moglie di Giorgio Priuli di S. Trovaso al patrocinatore e negoziante di quadri Signora Galeazzi da Cadore, il quale dopo averlo fatto ristaurare lo vendette al . . . Manfredino di Bologna per diciotto mila franchi. Dicesi che venduto per maggior prezzo dal Manfredino, già ora passato in Inghilterra, notizia avuta dall' . . . Casoni la cui madre di commissari della n. d. Tron vendette il quadro al Galeazzi' (letter from Cicogna to Moschini, 30 May 1834, Ms. Moschini XIX, Biblioteca Correr, Venice).

For many years, this masterpiece was inaccessible in a private collection, and oscillated between attributions to Giorgione and Sebastiano, until it was bequeathed to the National Trust. Subsequently, it was studied in conservation and lent to exhibitions on Venetian painting, the *Genius of Venice* (1983) and *Le siècle de Titien* (1993), until gradually a consensus has been reached that it is by the young Sebastiano del Piombo. Opinions differ as to how early to place the work. Much repainting was removed in conservation to show that more of the surface was unfinished than ever thought before (Hirst and Laing, 1986). The two babies were outlined in the underdrawing, one held upside down in the executioner's hand, the other lying dead in the central foreground. There was a different architectural composition, reminiscent in form of Sebastiano's organ portals, and on the right there is a large and prominent horseman. Apparent to the eye, but not visible in the infrared reflectography, are the remains of a bodice painted in green and pink with golden edges. Other fragmentary details, such as a loincloth, suggest that the right side of the composition has been extensively repainted, even if unfinished.

Hirst (1981) plausibly suggests that the *Judgement* was commissioned by Andrea Loredan for the Palazzo Loredan (later the Palazzo Vendramin-Calergi), which he had built. The palace was described as finished by 1509, and may have been completed a year or so earlier. Hirst suggests that the painting remained in the Palazzo Loredan at San Marcuola even after the family sold the palace in 1581. It may have remained there until Ridolfi described it in 1648. One interpretation of the changes in figure scale in the underdrawing might be that Sebastiano felt the impact of Giorgione's Fondaco frescoes, and altered his composition accordingly. Lucco (1980) suggests a date as early as 1506-07, whereas Ballarin (1993) opts for 1509, a more reasonable conjecture in view of the relationship with the Fondaco frescoes. The circumstances in which such a large painting was commissioned and left unfinished are still unknown, but it has taken its place within Sebastiano del Piombo's youthful works in Venice, and explains why Alessandro Chigi considered him worthwhile taking to Rome, as the most talented artist of his generation in Venice.

Literature: Lucco, 1980, pp. 91-92; Hirst, 1981, pp. 13-23; Hirst and Laing, 1986, pp. 273-82; Ballarin, 1993, p. 296.

KINGSTON LACY, WIMBORNE, DORSET
Attributed to Camillo Mantovani
A Pergola with Seven Putti Gathering Grapes and Catching Birds
Approximately 200 cm diameter

Provenance: bought by William John Bankes on 6 February 1850 from the Venetian dealer Consiglio Richetti, who was in charge of the dispersal of the paintings from the Palazzo Grimani, Santa Maria Formosa, Venice; Bankes purchased it for the ceiling above the marble hallway at Kingston Lacy.

Before Bankes bought the ceiling from the Palazzo Grimani, it was restored by Giuseppe Lorenzi on 24 September 1843. In a *perizia* among the Bankes papers (Dorset Record Office, Dorchester), Lorenzi declares it among the best works by Giorgione with which he was acquainted (he had restored the *Castelfranco Altarpiece*). The first substantial description of the picture is given by G.M. Richter (1937), who quotes some material from the Bankes papers and accepts the traditional attribution to Giorgione and Giovanni da Udine in 1510, which Bankes believed. Richter's attribution was virtually ignored, except by Pignatti (1969), who suggests that the

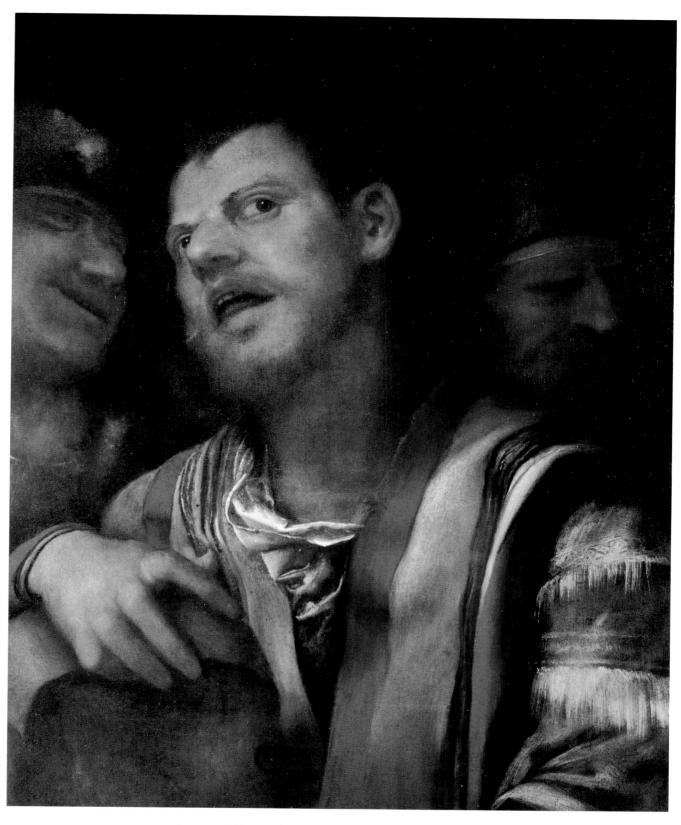

Anonymous. *Three Heads*. Canvas, 86 x 70 cm. Milan, Mattioli Collection.

work is comparable to works of the 1530s by Francesco Vecellio from San Salvador, Venice. Recently discovered documents in the Bankes papers reveal that Bankes had a drawing (now lost) made of the ceiling when it was in situ in the Palazzo Grimani, and that he arranged for a Venetian carpenter, Costante Traversi, to take it down and to transform the octagon into a roundel (February-July 1850), before exporting it to England. The style of the ceiling is Central Italian in origin and informed by an Emilian tradition, as exemplified in Mantegna's Camera degli Sposi and Correggio's Camera di San Paolo. One hypothesis worth considering is that it is an early work by Camillo Mantovani, an artist who is known almost exclusively for his work in the Palazzo Grimani.

Literature: G.M. Richter, 1937, pp. 221-22; Pignatti, 1969, pp. 123-24.

LONDON, private collection
St Jerome in a Moonlit Landscape
Canvas, 81 x 61 cm

Provenance: Guidi, Faenza: sold Rome, Sangiorgi, April 1902; 1912, James Rennell, later 1st Baron Rennell, Rome and London; inherited by his daughter Baroness Emmet of Amberley; Sotheby's, London, 8 July 1981, lot 27 (unsold).

A. Venturi (*Storia dell'arte italiana*, IX, iii, Milan [1928], p. 42, fig. 23) proposed that this might be a copy after Giorgione's lost painting of the same subject, described by Michiel in the house of Girolamo Marcello in 1525. It is generally included in catalogues of Palma Vecchio's works as a copy (A. Spahn, *Palma Vecchio*, Leipzig [1937], p. 6; G. Mariacher, *Palma il Vecchio*, Milan [1968], p. 93).

LONDON, National Gallery, inv. 269
Sixteenth-century Venetian
A Man in Armour
Wood, 39 x 26 cm

Provenance: possibly Gabriel Vendramin, Venice, 1569; 1st duc de Simon; Vigné de Vigny, sale catalogue, 1 April 1773, Remy, Paris; François Louis de Bourbon, prince de Conti, in whose sale catalogue, 4 August 1777, Remy, Paris, it is described; Benjamin West by 1816; bought by Samuel Rogers at West sale, Christie's, London, 24 June 1820; acquired by the National Gallery in 1855 with the Samuel Rogers bequest.

This charming free variation after the armoured saint in Giorgione's *Castelfranco Altarpiece* (Fig. 84) may have been in the collection of Gabriel Vendramin (Anderson, 1979A, p. 644), where it was described in 1569 as a 'quadretto picolo de un homo armado con una soazeta de noghera schieta', and in 1601 as 'Un quadretto con un homo armato con la lanza in spalla cole sue soazette de noghera' (51.2 x 34.2 cm). The dimensions are unusual, and an identification with a picture in the collection of the patron who commissioned Giorgione's *Tempesta* is intriguing. The surface is much damaged and considerably abraded, although the armour is well preserved. It is therefore difficult to attribute it, although the provenance and the fact that it is a free variation have much in its favour. The picture has always enjoyed a certain fame. In the seventeenth century, it was believed to represent Gaston de Foix, and it has sometimes been attributed to great names, to Giorgione himself by Crowe and Cavalcaselle (1912), or to Raphael, with whose name it was engraved by Michel Lasne. The National Gallery catalogues have been somewhat dismissive of it, even going so far as to call it a forgery (Gould, 1975), for which reason it was included in the 1990 exhibition, *Fake? The Art of Deception* as an example of 'the difficulties of deciding when a copy becomes a forgery'.

Venetian collections often contained copies after single figures from more celebrated masterpieces, usually religious paintings. Michiel describes several, the most famous being the lost copy of the figure of St James from Giorgione's San Rocco *Christ Carrying the Cross* (Fig. 15). Another is the Bellinesque *Infant Bacchus* (National Gallery of Art, Washington, D.C.), which is a kind of souvenir painting of the *Feast of the Gods*. In this context, the Vendramin provenance sounds plausible, for it is more than likely that one of Giorgione's patrons would have ordered a copy of a detail of one of his pictures. Ridolfi attempted to identify a portrait in the figure of the armoured saint, as did seventeenth-century collectors in France.

Literature: Crowe and Cavalcaselle, 1912, III, p. 13; Gould, 1975, pp. 107-08; M. Jones, ed., *Fake? The Art of Deception*, exh. cat., London, British Museum, 1990, pp. 51-52.

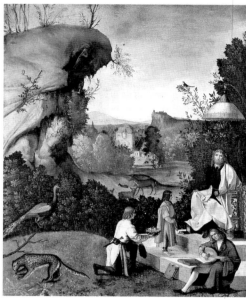

LONDON, National Gallery, inv. 1173
Imitator of Giorgione
Homage to a Poet
Panel, 59 x 48 cm

Provenance: 1603, inventory of the Aldobrandini collection, as 'Un quadro con una poeta coronata di lauro con tre altre figure attorno con un tigro, et un pavone, di mano di Raffaelle da Urbino'; by 1800 in the collection of Alexander Day, who records acquiring it from the Villa Aldobrandini; sold, 21 June 1833 to Edward White as a Raphael; sold Christie's, London, 4 June 1872 in the White sale to Henry George Bohn; bought by the National Gallery through Lesser at the Bohn sale, Christie's, London, 19 March 1885.

Both the subject and the attribution are fascinating and elusive, even if the figures are somewhat stiff in execution. Most art historians agreed that the painting was not by Giorgione himself, until Ballarin (1993) and Lucco (1995) proposed that it was his earliest work, to be dated shortly before the Uffizi panels (Figs. 6, 7). In the gallery catalogues, the painting has been dated far beyond Giorgione's lifetime on the grounds of costume: it was argued that certain details of the poet's dress —

the turned-down white collar, plain front and low set belt — are unprecedented before at least 1540. For Gould (1975), these costume details were incontrovertible evidence for a much later dating; thus he suggested that the curious combination of an archaic style and mode of dressing in the 1540s must mean that the work was a very early imitation or forgery. Such a late dating on costume alone seems highly improbable, whereas to attribute it to Giorgione himself is also debatable.

In the Aldobrandini collection the subject was described as 'Solomon and his attendants in a landscape'; whereas in a later sale catalogue it was 'King David instructing a pious man in his devotions'; Richter, following unpublished work by Eisler, suggested that it was 'the boy Plutus calling on the poet laureate with his brother, Philomelus (with lute), and his father (with bowl)'; Pigler suggested it was 'Children of the Planet Jupiter' on the basis of a similar scene of the children of the moon in a Florentine engraving of c. 1460, which depicts a youth beneath a baldacchino, receiving homage from another youth with a leopard and a stag ('Astrology and Jerome Bosch', *The Burlington Magazine*, LXXXXII [1950], p. 135). Stella Mary Newton suggested the anodyne title by which it is now known, 'Homage to a Poet', (*The Metropolitan Museum of Art Bulletin* [August-September 1971], pp. 33-37). The painting has always appeared to me to be Ferrarese in its handling and poetic subject. Much of the Aldobrandini collection was formed in Ferrara, a circumstance which also suggests a Ferrarese origin.

Literature: Gould, 1975, p. 109; Ballarin, 1979, pp. 228-29; Ballarin, 1993, p. 268; Lucco, 1995, pp. 46-49.

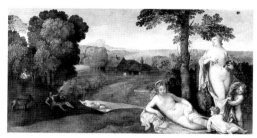

LONDON, National Gallery, on loan from the Victoria and Albert Museum since 1900
Mid-sixteenth-century imitator of Giorgione
Nymphs and Children in a Landscape with Shepherds
Wood, 46.5 x 87.5 cm

Provenance: bequeathed by Mitchell in 1878.

This is a puzzling picture that imitates various characteristics of Giorgione's better-known works, but appears to date from the mid-sixteenth century. As Gould noted (1975), the oval face of the recumbent nymph is comparable to the Hermitage *Judith* (Fig. 123), the hands with an index finger crooked are characteristic of the gypsy in the *Tempesta* (Fig. 108) and the *Courtesan* in the Norton Simon Foundation, Pasadena (p. 335 below). The landscape appears earlier than the figure painting. The children in particular are executed in a very coarse manner. Gould argued that these pastiche-like motifs meant that the picture was an early forgery. More likely it was made c. 1540 for a patron who wanted an old-fashioned Giorgionesque painting. The

Vienna fragment of a cupid (p. 342 below) was conceived for a similar patron (as argued by Fleischer and Mairinger, 1990, pp. 148-68), which suggests that this kind of art market existed.

Literature: Gould, 1975, pp. 110-11.

LONDON, Collection of Nicholas Spencer
Early sixteenth-century Venetian
Ecce Homo
Curved panel, 63.9 x 55.9 cm

Provenance: according to a printed label on the reverse: 'The collections of the Royal House of France, removed from Schloss Frohsdorf in Lower Austria, H.R.H. Princess Beatrix de Bourbon-Massimo', an inventory number, '500', also on the reverse; private collection, London; Sotheby's, London, 8 December 1993, lot 72, as Palma Vecchio; 1993, Nicholas Spencer, London.

The panel has been cut at the bottom, and perhaps on the left. There is damage in the upper left corner, some overpainting on the upper right landscape and above Christ's right shoulder. An X-ray taken in 1994 reveals a smaller head in the top left, presumably an earlier and smaller version of Christ. The picture has only once been on public exhibition, at Johns Hopkins University in 1942, where it was recognized as an important addition to the known corpus of Venetian painting, but the attribution to Giorgione was questioned (by Tietze in 1947). There is a tradition that Giorgione painted an *Ecce Homo*, for a painting of this subject is recorded in various inventories and sale catalogues. Such a composition is first recorded in the Venetian collection of the famous artist-dealer Niccolò Renieri (1590-1667), as 'No 11. Christo Ecce Huomo di Titiano, overo di Giorgion -40', in List C of paintings in the Casa del Gobbo, made for Basil Feilding when he was ambassador in Venice, as possible acquisitions for his brother-in-law James Hamilton (Waterhouse, 1952, p. 22). Pictures on List C were not among those sent to England. Shakeshaft (1986, p. 124 n. 15) dates this particular list to 1637. An *Ecce Homo* by Giorgione is recorded in the collec-

tion of the Marchese del Carpio (Don Gasparo de Haro y Guzman), a Spanish collector who bought pictures in Italy (M. B. Burke, *Private Collections of Italian Art in Seventeenth-Century Spain*, Ph.D. diss., New York University [1984], II, p. 289): 'Giorgione, half-length Christ, tied at the column with his hands behind, 3 x 2 Roman palmi'; the inventory was made when Don Gasparo left Rome to take up his appointment as Viceroy at Naples, on 7 September 1682. The same or another variant is recorded in the sale of the Earl of Bessborough's collection, Christie's, London, 5 February 1801, lot 51, as 'Giorgione — The Ecce Homo — capital'.

Christ is seen against an open window with a Giorgionesque landscape, characteristic of a group of paintings from about 1510. Christ's face, beard and type of moustache conform with the fashionable appearance of the period. The naturalistic rendering of Christ's body suggests observation from the live model, unusual in Venetian art. A 1994 X-ray of the painting shows underdrawing that would not be inconsistent with Palma Vecchio. A later reflection of this composition of an *Ecce Homo*, attributed to Caprioli, was sold at Sotheby's, London, 7 July 1982, lot 287.

Literature: G. de Batz, *Giorgione and his Circle*, exh. cat., Baltimore, The Johns Hopkins University, 1942, pp. 19, 30 (where misdescribed as on canvas); H. Tietze, 'La mostra di Giorgione e la sua cerchia a Baltimore', *Arte Veneta*, I (1947), pp. 140-42; Pignatti, 1969, no. A 24, as Palma Vecchio.

MADRID, Museo del Prado, inv. 288
Attributed to Titian
Madonna and Child between St Antony of Padua and St Roch
Canvas, 92 x 133 cm (unfinished)

Provenance: Duca de Medina de Las Torres, Viceroy of Naples; 1650, given to Philip IV of Spain, who placed it in the Escorial; transferred to the Prado, 1839.

The oldest source to describe the painting (P. Santos, *Descripcion breve del Monasteria de S. Lorenzo el Real dell'Escorial*, 1657) attributes it on Velázquez's authority to 'mano de Bordonon', a bowdlerization of Giorgione, like 'Pordon', Francisco de Hollanda's version of the same name. Similarly, the self-portrait of Giorgione as *David Meditating over the Head of Goliath* (Fig. 128) was listed in the collection of Archduke Leopold Wilhelm as both 'Bordonone' and 'Giorgione'. In 1880, Morelli reproposed the old attribution to Giorgione, and even ordered a copy of the picture by a Spanish artist for himself, now in the Accademia Carrara, Bergamo. Many

Attributed to Sebastiano del Piombo. *Virgin and Child with a View of the Piazzetta di San Marco, Venice (The Tallard Madonna)*. Wood, 76 x 61 cm. Oxford, Ashmolean Museum.

scholars in the first part of the twentieth century still attributed the work to Giorgione, such as Justi (1908) and G.M. Richter (1937, pp. 228-29), as do even some recent ones (Hornig, 1987), but the majority have maintained that it is by the young Titian. Despite the fact that the painting is often grouped with the *Concert champêtre* and the Dresden *Venus* (Figs. 37, 139), it exhibits a slightly different style, more analogous to Titian's *Gypsy Madonna* (Kunsthistorisches Museum, Vienna) and *Noli me Tangere* (National Gallery, London). In the 1993 Paris exhibition, it was placed in the context of Titian's early works, where the attribution made sense.

Literature: Morelli, 1880, p. 189; Justi, 1908, pp. 108, 140-41; Venturi, 1913, pp. 134-35, 358; Baldass and Heinz, 1965, pp. 160-61; Hornig, 1987, pp. 228-31; *Le siècle de Titien*, 1993, pp. 348-51.

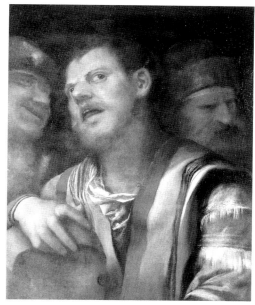

MILAN, Mattioli collection
Sixteenth-century Venetian
Three Heads
Canvas, 86 x 70 cm

Provenance: 1944, Mattioli collection, Milan.

It is difficult to understand how this study of three heads, a reflection of the style of Dosso Dossi, can be accepted as a painting by Giorgione. The attribution was proposed by Longhi (in an unpublished letter to the owner, 30 March 1944), who suggested an identification with a picture by Giorgione of *Samson Mocked* in the collection of Niccolò Renieri (1666): 'Un quadro mano di Giorgione da Castel Franco, ove è dipinto Sansone mezza figura maggior del vivo, quale s'apoggia con una mano sopra d'un sasso, mostra rammaricarsi della Chioma tagliata, con dietro due figure, che si ridono di lui, alto quarte 5. e meza, largo 5. in Cornice di noce toccata d'oro'. Acquired in circumstances that remain obscure by one of the most important patrons of Futurism, the picture has no proven provenance before 1944, although attempts have been made to identify it as a painting mentioned in the Vendramin inventories (Bora, in *Leonardo & Venice*, 1992; Ballarin, in *Le siècle de Titien*, 1993). When I discovered the inventory of Gabriel Vendramin's collection (Anderson, 1979A), I considered the possibility that the painting was described in it.

The painting was restored by Giovanni Rossi in 1985, under the supervision of Pietro Marani of the Soprintendenza of Milan. Marani (oral communication) is unconvinced that the restoration confirmed an attribution to Giorgione. Torrini (1993, p. 132) is also doubtful, as were Pignatti (1969) and Hornig (1987, omitted from catalogue). However, the attribute held by the central figure was shown not to be a stone, but a *lira da braccio*, and for Ballarin and Bora this was enough to identify the work as the one described in the successive inventories of the Vendramin collection as three singers: 'Quadro de man de Zorzon de Castelfranco con tre testoni che canta' (1569)', and decades later as 'Quadro con una testa grande e doi altre teste una per banda in ambra [ombra] come par con le sue soaze de noghera' (1601, with measurements of c. 102.5 x 85.4 cm). Though the central man has his mouth open, and he is accompanied by two men with sniggering derisory expressions, it is rather difficult to identify the protagonists as 'Three big heads ("testoni") singing'. The second description is so generic that it is difficult to believe that it can only refer to this painting; nor are the measurements precise enough. Of all the inventory descriptions that have been associated with the Mattioli heads, that of the Renieri collection corresponds most closely to the mocking mood of the picture. Boschini advised Renieri on acquisitions, and one wonders whether this is not one of those later imitations of Giorgione's style, discussed by Boschini.

Literature: Bora, in *Leonardo & Venice*, 1992, pp. 378-79; Ballarin, in *Le siècle de Titien*, 1993, pp. 733-36; Lucco, 1995, pp. 128-31.

MILAN, Museo Poldi-Pezzoli, inv. 4579
Sixteenth-century Venetian
Portrait of a Man
Canvas, 71 x 61 cm

Provenance: Bonomi collection, Milan; bequeathed to the museum in 1987 by Eva Sala.

A graceful young man with long hair is dressed in a coat with a large fur collar, one of his hands encased in a gorgeous glove, elegantly cut and beribboned on the forefinger. The condition of the painting is poor and nothing is known of its early history, except that it was in the Bonomi collection, where it was usually attributed to Giorgione or Titian. The young man is a powerful player among fashionable youthful patrician men in Venice. On the grounds of costume, the hairstyle and the cut of the fur lapel, the portrait is datable to the last years of Giorgione's lifetime, but an attribution is precluded by the condition. It belongs to the tradition begun by Giorgione of psychological portraiture of attractive young men.

Literature: *Giovanni Gerolamo Savoldo tra Foppa, Giorgione e Caravaggio*, exh. cat., Brescia, Gallerie del Monastero di Santa Giulia, 1990, p. 244.

MONTAGNANA (Padua), Cathedral
Attributed to Buonconsiglio
David and Goliath and *Judith and Holofernes*
Frescoes

Since the discovery that the Rotterdam drawing represented the Castel San Zeno at Montagnana (p. 301 above), scholars have tried to find other evidence of Giorgione's presence in Montagnana. These two frescoes, previously attributed to Montagna or Buonconsiglio, have been attributed by Puppi and Dal Pozzolo to Giorgione, a view that has been ignored by other scholars, such as Torrini (1993), and rejected by Lucco (1995).

Literature: L. Puppi, in *Mattino di Padova*, 27 October 1991; Dal Pozzolo, 1992, pp. 23-42; Lucco, 1995, p. 13.

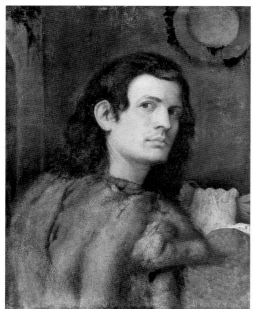

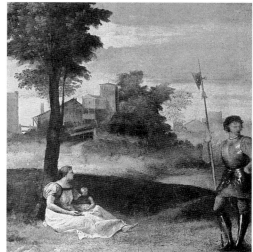

MUNICH, Bayerischen Staatsgemäldesammlungen, Alte Pinakothek, inv. 524
Sixteenth-century Venetian
Portrait of a Young Man in a Wolf Fur Coat
Poplar, 69.4 x 53.6 cm

Inscribed on reverse in a late sixteenth-century hand: *Giorgion. De Castel Franco. F/Maestro De Ticiano*

Provenance: Van Veerle collection, Antwerp, where engraved by Hollar, 1650; from 1748 in the Munich ducal collection; from 1789 to 1836 in the Hofgartengalerie, and thereafter in the Alte Pinakothek.

The portrait is identified as Giorgione's likeness of a Fugger, described by Vasari in his *Libro dei Disegni*, and later also described by Ridolfi as 'un Tedesco di casa Fuchera con pellicia di volpe in dosso, in fianco in atto di girarsi'. Certainly the romantic invention of a portrait with the sitter viewed from the back but turning frontwards seems to have been devised by Giorgione. In the Munich inventories, the portrait was always ascribed to Giorgione, until Otto Mündler produced the first serious catalogue of the Munich gallery and attributed the portrait to Palma Vecchio. Most art historians from then on have attributed the work to Palma, although recently Hornig (1987) and Ballarin (1993) have reproposed Giorgione's name, and Lucco (1980) has argued the case for Sebastiano del Piombo. In Kultzen and Eikemeier's catalogue of the museum (1971), the attribution is to a sixteenth-century Venetian. The literature reveals how art historians have grappled to give a name to this felicitous image, without a consensus having been reached. My own view is that despite the seventeenth-century tradition it is closest to Palma Vecchio.

Literature: Kultzen and Eikemeier, 1971, pp. 202-05; Hornig, 1987, pp. 232-34; Ballarin, 1993, p. 291.

NEW YORK, collection of Seiden and de Cuevas
Attributed to Sebastiano del Piombo
An Idyll, or *Mother and Child Watched by a Halberdier in a Wooded Landscape*
Oil on wood panel, 46.4 x 43.8 cm

Provenance: Alexander Baring, 1st Lord Ashburton, until c. 1848; Marquis of Northampton, Lord Spenser Compton, Compton Wynyates, Warwickshire; Seiden and de Cuevas, New York.

It cannot be doubted that this is by an artist who had seen Giorgione's *Tempesta* (Fig. 108) shortly after it was executed (Wind, 1969), for it depicts a clothed — rather than nude — woman with an infant, watched by a soldier in a Venetian landscape. It is also related in theme to Jacopo Palma's *Woman in a Meadow with Two Infants Watched by a Halberdier*, in the Wilstach Collection, Philadelphia Museum of Art (*Places of Delight*, 1988, no. 41). This haunting panel has been attributed to one of Giorgione's followers, Titian (Goldfarb, 1984), or more plausibly to Sebastiano del Piombo (Lucco, 1980). The attribution to Sebastiano is argued on the grounds of a close morphological correspondence between the clothing of these figures and the saints on the San Bartolommeo organ shutters and the powerful atmospheric detailing of the landscape, which suggests Sebastiano's hand before 1508. There is considerable paint loss from the surface. One change in execution is visible to the eye: the woman was originally seated slightly more to the left so that her figure covered the base of the tree. The light colours used to paint the child have been subsumed into the dark green underpainting of the bank that divides the foreground figures from the sunset landscape. The handling of the foliage and the architectural detailing is very fluffy in contrast to similar areas on the *Tempesta*.

Literature: Wind, 1969, p. 3; Lucco, 1980, no. 5; Goldfarb, 1984. pp. 419-23.

OXFORD, Ashmolean Museum of Art and Archaeology
Attributed to Sebastiano del Piombo
Virgin and Child with a View of the Piazzetta di San Marco, Venice (The Tallard Madonna)
Wood, 76 x 61 cm

Provenance: sale of Marie-Joseph Tallard, duc de Paris, Remy, Glomy, Paris, 22 March 1756; bought by Bernard at Tallard sale; described in catalogue of collection of Alan Cathcart, Christie's, London, 13 May 1949, as a Cariani; bought by Colnaghi's from Cathcart sale, who sold it to the Ashmolean.

There is a *pentimento* at Christ's right heel, and X-rays show a change in the position of the cushion. It does not seem likely that the lack of depth in the folds of the Madonna's robes is due to the attrition of a final layer of paint. While it is an attractive possibility to explain the negative judgement occasionally passed on this picture as due to a possible technical imperfection, there are other problematic features. Among them are the harsh colouring, the awkward construction of the composition and the crudity of the brushstrokes, evident not only in the view of the piazzetta, especially at the point where the water laps against the base of the stone, but also in the lines outlining the Madonna's drapery, and the shadow following underneath the contour of her yellow veil and of her left hand.

The *Tallard Madonna* was first attributed to Giorgione when the painting was acquired by Sir Karl Parker for the Ashmolean in 1949, and was then accepted by a group of scholars—Gronau, Hendy, Morassi, Pallucchini, Venturi and Zampetti—as an early work. As such, it had a degree of plausibility because the baby, the one beautiful part of the painting, is comparable to the Christ Child in the *Castelfranco Altarpiece* (Fig. 84), and the other manifest weaknesses of the painting could be excused as youthful errors. An alternative hypothesis concerning the date was suggested by Puppi (Puppi and Olivato-Puppi, 1979, and 1994, pp. 52-53): that the clocktower on the

piazza is represented at the moment it was remade in 1506. Pignatti (1969) dated the work to c. 1508 on the basis of the freedom of the handling of the paint. In a review of Pignatti, published in 1971, Giles Robertson reviewed the problem perceptively: 'It is very difficult to accept a date of about 1508 for so primitive and constructionally incompetent picture as the Oxford Madonna, though there are very obvious difficulties in integrating it into the series as a very early work'.

Giorgione, even in works as early as the *Castelfranco Altarpiece*, had resolved the problems of foreshortening involved in the representation of a seated figure, whereas the painter of the *Tallard Madonna* has infinite difficulties, exemplified by the Virgin's knees, overly tiny beneath a tautly stretched dress. Giorgione's landscape style, even as a young man, is refined and delicately harmonious in detail, and it is hard to believe that he could have painted freely impressionistic passages, such as where the water laps up against the piazza. That the *Tallard Madonna* is the work of a young painter trained in the Bellini studio, but also acquainted with the new and fashionable style of Giorgione, c. 1506, as Puppi may well be right about the date, seems the best solution. The painting most resembles Sebastiano's *Sacra Conversazione* in the Accademia, Venice, and seems like a youthful study — perhaps his earliest work. Nevertheless, Hirst (1981) would attribute the works to different artists, the Ashmolean painting to Giorgione and the Accademia *Sacra Conversazione* to Sebastiano.

Literature: Pignatti, 1969, p. 105; Freedberg, 1975, pp. 141, 687; Robertson, 1971, p. 276; Wilde, 1974, p. 85; Tschmelitsch, 1975, p. 94; Torrini, 1993, p. 36.

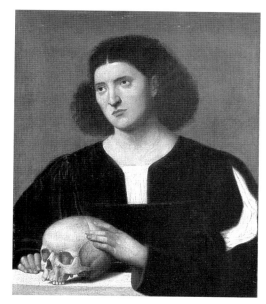

OXFORD, Ashmolean Museum of Art and Archaeology
Bernardino Licinio
Portrait of a Young Man with a Skull
Canvas, 75.7 x 63.3 cm

Provenance: posthumous inventory, no. 276, of Cardinal Ludovico Ludovisi in 1633; possibly the same item as 'una dama tenendo una testa de morte piccolo' in the posthumous inventory of Aletheia, Countess of Arundel, 1654; by 1871 exhibited as 'A Lady Professor at Bologna' in the collection of Baroness Louisa Caroline Mackenzie Baring Ashburton, Grange Park, Hampshire; sold at the Ashburton sale, Christie's, London, 8 July 1905, as a Giorgione, to Bates, buying for Sir William James Farrer, in whose collection it remained until 1911, when inherited by Mr. O. Gaspard Farrer; bequeathed to the Ashmolean in 1946.

Although the attribution to Bernardino Licinio is no longer controversial, the painting is included here as it has often been confused with a lost self-portrait of Giorgione holding a skull.

PADUA, Museo Civico, inv. 162 and 170
Leda and the Swan and *Rustic Idyll*
Panels, 12 x 19 cm

Provenance: possibly mentioned in a Venetian dealer's inventory of 1681 (p. 377 below), enclosed in letter from Matteo del Teglia to Apollonio Bassetti; bequeathed in 1864 to the museum from the Emo Capodilista collection, Padua, where previously described as coming from the 'dimora Asolana dei Falier'.

These two tiny panels may have once decorated a box, perhaps for a Falier villa at Asolo, as the provenance suggests. They relate to the Venetian taste for small furniture paintings for a domestic context, supplied by minor artists when in need of money, as described by Ridolfi (p. 370 below). They should be interpreted as a popular reflection of Giorgione's imagery. The panel with the unsatisfactory title of *Rustic Idyll* is a popular derivative version of the *Tempesta* (Fig. 108), but the sexual confrontation between the two figures has been treated in an anodyne manner. The woman holding her baby is clothed and the role of the young boy holding flowers is trivialized. The attribution literature, which describes the panel as 'workshop' or 'imitator', reflects the uncertainty generated by Ridolfi's statement that Giorgione made furniture paintings with subjects taken from Ovid's *Metamorphoses*.

Literature: Coletti, 1955, p. 52; Pignatti, 1969, pp. 131-32.

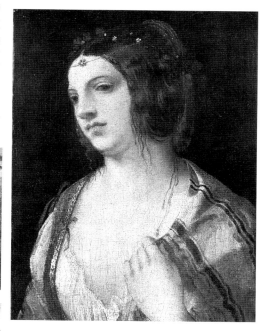

PASADENA, Norton Simon Foundation
Attributed to Titian
Portrait of a Courtesan (fragment of a larger work)
Canvas, 31.7 x 24.1 cm

Provenance: James Howard Harris, 3rd Earl of Malmesbury, London, 1876; William Graham, London, 1886; Prince Karl von Lichnowski (German Ambassador in London, 1912-14), Kuchelna, Hultschin, Czechoslovakia; Sir Alexander Henderson, 1914; Paul Cassirer, Berlin; Sir Alfred Mond, 1st Baron Melchett, Romsey, Hampshire; 1930, Sir Henry Mond, 2nd Baron Melchett, Sharnbrook, Bedfordshire; Duveen Brothers, New York, 1928; purchased by Norton Simon from Duveen, 1964.

Despite the illustrious provenance, the picture's reputation has suffered because it is reputed to be considerably damaged. For example, even though Pignatti (1969) considered that 'the vibrant application of paint is distinctly Titian', two years later, John Pope-Hennessey maintained that he had observed a recent restoration and declared that the paint surface was largely new and the work unattributable. The subject has provoked less controversy. Everyone agrees that the woman's provocative glance, combined with the languid manner in which she loosens her *camicia*, already in disarray, makes her a courtesan. Despite the adverse criticism, the fragment is characteristic of many early works by Titian, and there seems to be no reason to doubt the attribution. David Bull, who restored the work, considers the condition fair. No less an authority than Valcanover (1969, p. 93, no. 21) gives it full autograph status.

Literature: Pignatti, 1969, no. A 14; J. Pope-Hennessey, *Times Literary Supplement*, 30 April 1971.

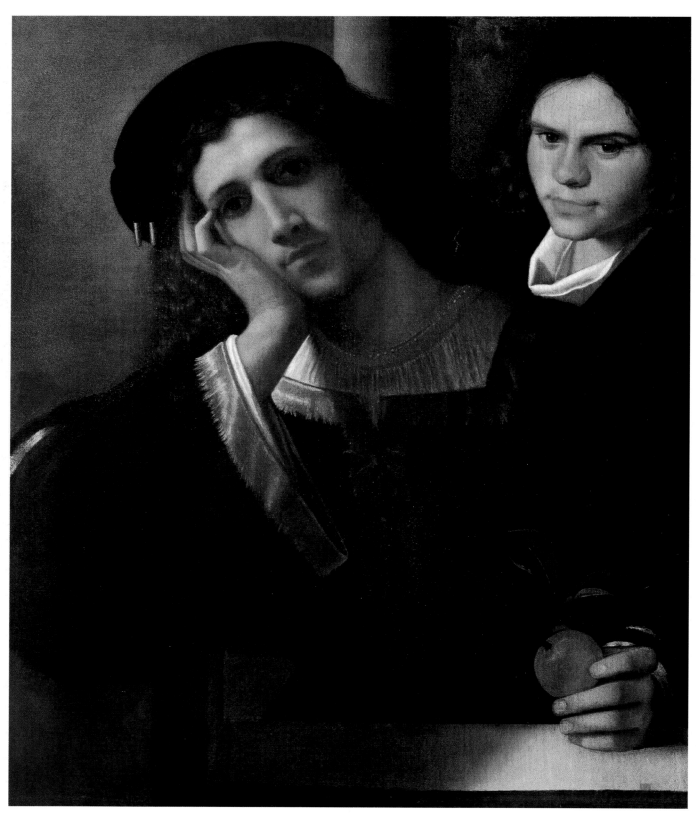

Double Portrait or Portrait of a Young Patrician Holding a Seville Orange with his Servant in the Background.
Canvas, 77 x 66 cm. Rome, Palazzo Venezia.

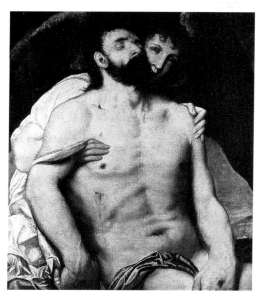

PRINCETON, collection of Barbara Piasecka Johnson
Workshop of Titian
Dead Christ Supported by an Angel
Canvas, 77.7 x 64.4 cm

Provenance: Polcenigo collection, Venice; Pier Maria Bardi, New York; Gaetano Miani collection, Brazil; from 1982, collection of Barbara Piasecka Johnson.

The painting has frequently been connected with a work described by Michiel in the collection of Gabriel Vendramin: 'El Christo morto sopra el sepolcro, cun l'anzolo che el sostenta, fo de man de Zorzi da Castelfranco, reconzato da Tiziano', despite the fact that the 'sepolcro' is conspicuously absent. Michiel's description had earlier been related to a series of *Pietàs* in Treviso, Lovere, and elsewhere, but each identification failed to convince. In this case, the former owner, Count Polcenigo, stated that he had bought the painting from the Palazzo Vendramin, Santa Fosca, but produced no evidence. Strangely, the painting described by Michiel is not mentioned in the later inventories of the Vendramin collection made in 1567-69 and 1601. This is a curious omission since Gabriel's heirs sold his antique coins, but not the paintings. One of the compilers of the 1567-69 inventory was Titian's son, and it is unlikely that he would have failed to describe a work by his father. By 1601 the Vendramin paintings were no longer together at Santa Fosca, but dispersed among various members of the family; they were reassembled at the Santa Felice palazzo for the purpose of making the inventory. All of this raises doubts about the provenance that has been proposed by Polcenigo.

Moreover, the condition of the painting is problematic. A restoration by Mario Modestini has been mentioned in the literature, but never properly published. It is said that there was a figure of a shepherd underneath the present composition and painted crosswise to what we now see (Grabski, 1990). The underdrawing discernible in the radiographs is broadly brushed in, as would be characteristic of a much later work of the kind associated with Titian. There is an uneven quality in the execution which has led Pignatti and others to suggest the possibility of two hands, as might be consistent with a Giorgione

remade ('reconzato', as Michiel put it) by Titian. In the absence of a really thorough analysis of the media and technique of the painting, these suggestions remain speculative. For the present writer, the picture is consistent with a product from Titian's studio in the 1520s, but not of a quality to warrant an attribution to Titian himself, a reservation held by other Titian scholars, such as Wethey and Valcanover. Other scholars propose an even later dating and an attribution to Lambert Sustris.

Literature: Pignatti, 1969, pp. 109-10; Wethey, 1969-75, I, p. 171, no. X-10; Anderson, 1979A, p. 643; Grabski, 1990, pp. 130-34; Gentili, 1993, p. 290.

PRINCETON, The Art Museum, Princeton University
Infant Paris Abandoned on Mount Ida
Wood, 38 x 57 cm

Provenance: Clyde Fitch; gift of Professor Frank Jewett Mather, Jr, to Princeton, 1948.

The picture was first attributed to Giorgione by Martin Conway (1928), and it undoubtedly belongs to a group of furniture paintings that imitate a Giorgionesque style. The painting is in poor condition and a large part of the surface is lost. It represents the first scene from the Paris legend, a story that is often associated with Giorgione (Fig. 93 and p. 149 above).

Literature: Pignatti, 1969, p. 134.

RALEIGH, North Carolina Museum of Art, inv. GL. 60.17.41
Attributed to Titian
Adoration of the Christ Child
Panel, 19 x 16.2 cm

Provenance: Mont's Gallery, New York, 1952; on loan from the Samuel H. Kress Foundation, from 1961.

This charming panel painting reflects the unusual iconography of the Allendale group, but is not of the same quality of execution. More plausibly, it relates to a subgroup of images that depict the Madonna and St Joseph worshipping the Christ Child, including a painting attributed to Romanino in the Hermitage, a rather crude pen and ink drawing in the Albertina, as well as a print by the Master F.N. of the same subject, also in the Albertina (Bartsch XIII, 367). The technique is much freer and the application of paint much thicker than in any paintings attributed to Giorgione. Pignatti (1969) believed that he had discovered an old inscription on the lower left side of the panel reading ZORZON, but even under a microscope the squiggly lines are difficult to read. The technique of the painting suggests that it is attributable to Titian around 1510 or even earlier.

Literature: Shapley, 1968, p. 185; Pignatti, 1969, pp. 134-35.

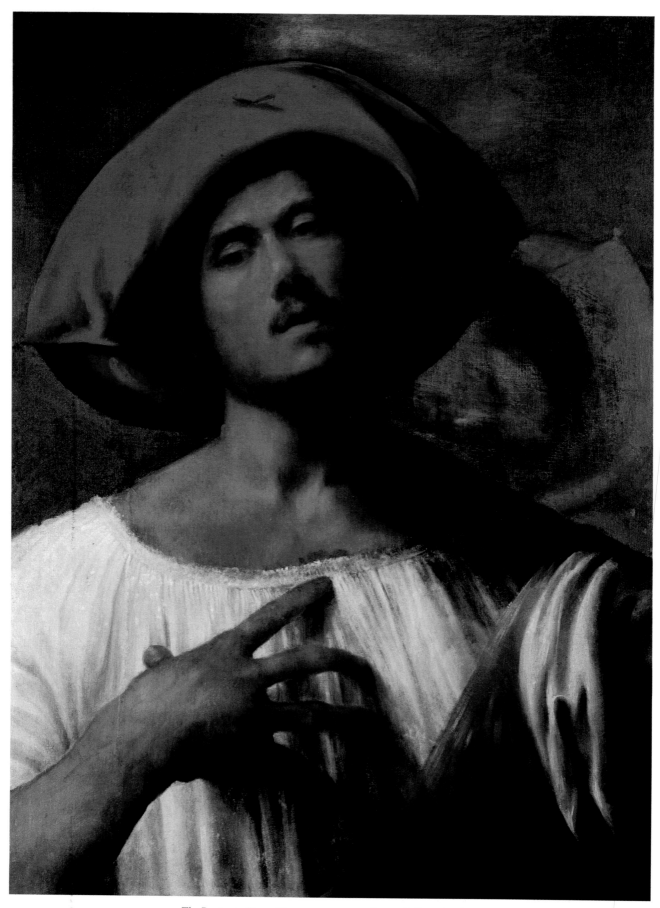

The Passionate Singer. Canvas, 102 x 78 cm. Rome, Galleria Borghese.

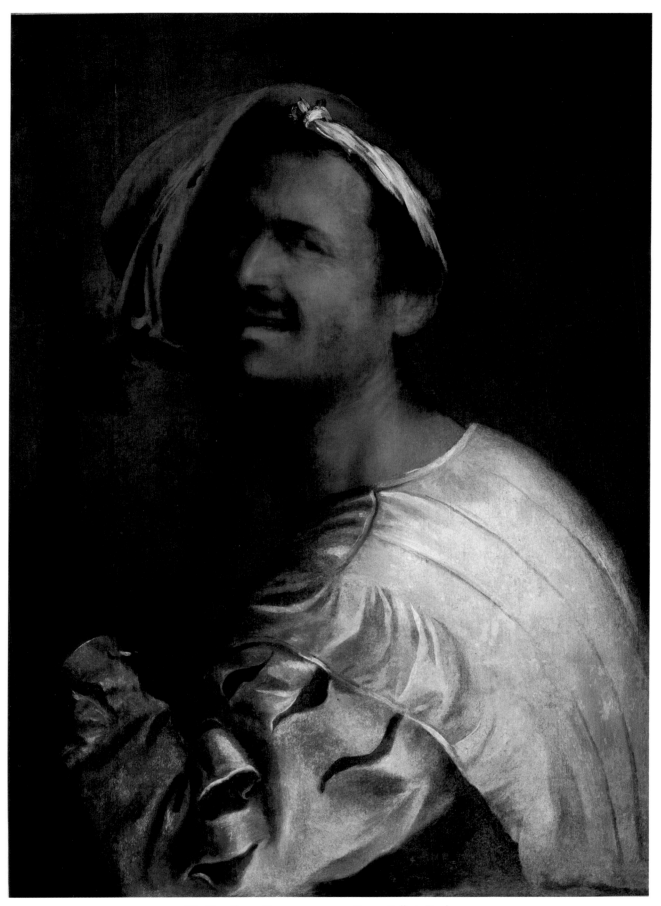

The Flute Player. Canvas, 102 x 78 cm. Rome, Galleria Borghese.

In the earliest manuscript catalogue of the Borghese collection, written by Manilli in 1650, these two heads were attributed to Giorgione, but by the end of the nineteenth century they were firmly attributed to Domenico Capriolo. In 1954 Della Pergola identified the musicians as two of three fragments from a painting described in the Vendramin inventory of 1567-69 as 'quadro de man de Zorzon de Castelfranco con tre testoni che canta'. In a later inventory of the Vendramin collection (Anderson, 1979A), this painting of 'testoni' is further described as 'Quadro con una testa grande e doi altre teste una per band in ambra come par con le sue soaze de noghera con filli d'oro alto quarte sei, et largo quarte cinque in circa'. The measurements, given in Venetian *quarte*, equal 102.5 x 85.4 cm, a canvas size considerably smaller than the combined area of both Borghese musicians. Ballarin supposed that this description could be associated with the Mattioli painting in Milan (p. 333 above). Another painting also in the Vendramin collection of three heads has dimensions which correspond with the *Three Ages of Man* in the Pitti (Fig. 106). An expert within the Galleria Borghese, Hermann Fiore (oral communication), described them as seventeenth-century copies after lost works by Giorgione, of which Garas (1979) had found other copies in the Dona delle Rose collection, Venice. Fiore's explanation resolves the contradiction between the sixteenth-century costumes and the early seventeenth-century style of the painting, expressed in the firm bold modelling of the hand and the bravura of the paint surface. Perhaps this discrepancy best explains the widely divergent views that have always been held of the paintings.

Literature: Della Pergola, 1955, I, pp. 111-13; Anderson, 1979A pp. 643-44; Garas, 1979, pp. 165-66; Ballarin, 1993, pp. 736-39

First proposed as a Giorgione by Ridolfi when describing Roman collections: 'Il Signor Prencipe Aldobrandino in Rorna, hà una figura del detto Santo à mezza coscia & il Signor Prencipe Borghese un Davide'. The painting is in a mediocre state of conservation, and most scholars have considered it an imitation of Dosso Dossi. Morelli interpeted the subject in relation to *Orlando Furioso*, while Schlosser and Lionello Venturi thought it depicted Astolfo and Orrile. Recently, Ballarin (1993) has reproposed the idea that it is a copy after a lost Giorgione, but the painting has not been seen in the context of a major exhibition, where it would fail to be acceptable, even as a copy after Giorgione.

Literature: Della Pergola, 1955, I, pp. 34-35; Ballarin, 1993, p. 291.

ROME, Galleria Borghese, inv. 142 and 130
The Passionate Singer and *The Flute Player*
Canvas, each 102 x 78 cm

Provenance: Cardinal Scipione Borghese, 1618-19.

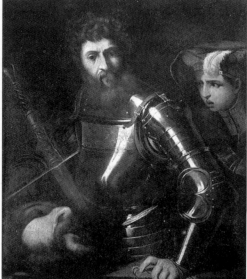

ROME, Galleria Borghese, inv. 181
Replica after Dosso Dossi
David with the Head of Goliath and a Page
Board, 98 x 83 cm

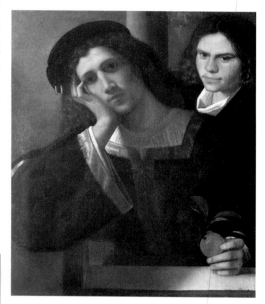

ROME, Palazzo Venezia
Portrait of a Young Patrician Holding a Seville Orange with his Servant in the Background
Canvas, 77 x 66.5 cm

Provenance: Cardinal Ludovisi, Rome, dispersed in 1600, when described as by Giorgione: 'Un quadro di due ritratti mezze figure uno tiene la mano alla guancia e nell'altra tiene un melangolo' (Garas, 1965, p. 51); Cardinal Ruffo, 1734, where described as by Dosso Dossi; 1915, acquired from the Ruffo collection by the Palazzo Venezia.

For many years this haunting portrait was identified as the famous lost picture by Sebastiano del Piombo of two musicians, Verdelot and Obrecht. Following Garas' discovery of the Ludovisi inventory, an attribution to Giorgione was reproposed (Ballarin, 1979, 1993). But the Ludovisi inventory was compiled a century after Giorgione's death by someone who had little idea of his true style. At the 1993 Paris exhibition, it was apparent that the style of the portrait was much later than those certain portraits by Giorgione's hand, the *Laura*, the *Terris Portrait* and the *Girolamo Marcello* (Figs. 13, 68, 131). Consequently, it has been removed from his certain works in recent catalogues (Torrini, 1993). One would hope for an appreciation of the exquisite quality of this double portrait, which has a unique configuration of two figures, a

fashionable young man, or a love-sick courtier (?), with his manservant in the background.

Literature: Ravaglia, 1922, pp. 474-77; Pignatti, 1969, pp. 136-37; Garas, 1965, pp. 48-57; Ballarin, 1979, pp. 243-45; Ballarin, 1993, pp. 721-24; Torrini, 1993, pp. 126-27.

TREVISO, Monte di Pietà
Sixteenth-century Venetian
The Dead Christ
Canvas, 135 x 203 cm

Provenance: said to have been painted for the Spinelli family, Castelfranco; inherited from the Spinelli by the Bishop of Treviso, Alvise Molin; by the seventeenth century in the Monte di Pietà, Treviso.

First attributed to Giorgione by Ridolfi in the *Maraviglie* (1648), followed by Marco Boschini in *La carta del navegar pitoresco* (1660) in a lengthy and rapturous passage (p. 375 below). In the nineteenth century, the painting was restored by Gallo Lorenzi, famous for his additions to Renaissance pictures and it was the only work by 'Giorgione' that was always on the art market, seen by every international museum director, and recorded in their travel diaries, but rejected as ineligible (pp. 250-53 above). G.M. Richter (1937) was probably the only scholar to accept it as a Giorgione. The composition and style all suggest that this is a painting from c. 1530 or later.

Literature: G.M. Richter, 1937, p. 239.

ST PETERSBURG, State Hermitage Museum, inv. 38
Sixteenth-century Venetian
Madonna and Child in a Landscape
Canvas, transferred from board in 1872, 44 x 36.5 cm

In the earliest catalogues of the Hermitage, the picture was given to Garofalo (1817), Giovanni Bellini (1864), Cariani (1915), Bartolomeo Veneto (1916), and finally attributed to Giorgione by the pan-Giorgionesque English scholars, Phillips (1895, p. 347) and Cook (1900, pp. 102, 136). Thereafter, opinion was divided, but those accepting the painting wished to see it as youthful picture, hence excusing its weaknesses. The conception of a figure in a landscape and many of the details, such as the trees and the small town, seem comparable to more certain works by Giorgione, as in the background of the *Castelfranco Altarpiece* (Fig. 84). The figure of the Virgin is considerably retouched, and it is difficult to evaluate the condition of the painting in the absence of a scientific report. In recent years, the picture has been exhibited in Paris and has been accepted by Torrini (1993), while for others it is of such poor quality and execution that it is difficult to admit within the catalogue of Giorgione's works.

Literature: Ballarin, 1993, pp. 693-95; Torrini, 1993, pp. 64-65.

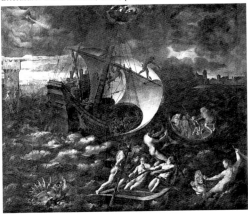

VENICE, Biblioteca dell'Ospedale Civile, formerly Scuola di San Marco (Gallerie dell'Accademia, inv. 37)
Attributed to Palma Vecchio and Paris Bordone
St Mark, St George and St Nicholas Save Venice from the Storm
Canvas, 360 x 406 cm

In 1550 Vasari was deeply impressed by the *Storm* and discussed it enthusiastically twice, once in Giorgione's life and again in the *proemio* to the third part of the *Lives*. In 1568 he says that it is by Palma Vecchio. And in 1581 Francesco Sansovino also attributes it to Palma

(p. 368 below), but with the aside that 'altri dicono' is by Paris Bordone. The story depicted records how three saints saved Venice from a storm. Until 1829, the canvas was in the location for which it was painted in the Sala dell'Albergo of the Scuola di San Marco. The archive of the confraternity has documentation from 1492 to 1530 relating to a series of paintings they commissioned from Gentile and Giovanni Bellini, Mansueti and Bordone, all of whom were members of the Scuola. Neither Giorgione nor Palma Vecchio is mentioned.

The painting is extremely damaged, as revealed in restoration in 1955. The monster in the lower left has been inserted on a rectangle of modern canvas, probably at the time of Sebastiano Santi's restoration in 1833. The rowers and the waves are completely repainted, perhaps during the restoration of Giuseppe Zanchi in 1733. In the left background, the big tower on the lagoon and the clouds are characteristic of Palma, whereas Paris Bordone's style is recognizable in the boat with saints (Moschini Marconi, 1962). Whenever the painting has been examined in conservation, it has always been hoped that some light would be thrown on whether Giorgione could have played any part in the picture's conception, in view of Vasari's statements. The most reasonable hypothesis seems to be that Palma began the painting, but after his death in 1528 Paris Bordone was asked to finish it, perhaps at the same time he was working on the *Presentation of the Ring*, also for the Scuola.

Literature: Moschini Marconi, 1962, p. 165; Pignatti, 1969, pp. 138-39.

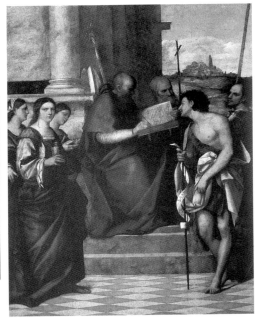

VENICE, San Giovanni Crisostomo
Sebastiano del Piombo
St John Chrysostom between Sts Catherine of Alexandria, Mary Magdalen, Lucy, John the Evangelist (?), John the Baptist and Theodore (?) (Fig. 19)
Canvas, probably transferred from panel, 200 x 165 cm

The controversy over the attribution was provoked by Vasari, who attributed the altarpiece to both Sebastiano

and Giorgione; debate was refuelled by Francesco Sansovino, who said the painting was begun by Giorgione, but finished by Sebastiano: 'Giorgione da Castel Franco famosissimo Pittore, il quale vi cominciò la palla grande con le tre virtù theologiche, & fu poi finita da Sebastiano, che fù Frate del piombo in Roma, che vi dipinse à fresco la volta della tribuna' (p. 368 below). Sansovino misdescribed the saints as Theological Virtues, for which reason his testimony has not been taken seriously. Sebastiano's departure for Rome in the late spring or early summer of 1511 has always provided a firm date for the completion of the altarpiece.

A significant discovery was made by Rodolfo Gallo (1953), who published the will of Caterina Contarini, wife of Nicolò Morosini, 13 April 1509, in which she leaves a bequest — a mere 20 ducats — for the San Giovanni Crisostomo altarpiece, with the strange stipulation that it must be paid only after the death of her husband. From her husband's will of 13 March 1510, it is clear that she predeceased him, as he requests burial near to his spouse. The existence of two codicils to Nicolò Morosini's will, dated 4 and 18 May 1510, when he was still living, suggests that the altarpiece may not have been commenced before that date. Thus it would have been begun at the earliest in June 1510 and finished by summer of 1511. The chronology of these events almost excludes Giorgione as the author, although it is just possible he could have been alive when the altarpiece was first conceived, or designed. Lucco (1994) has attempted to dismiss the documentation, and to propose an earlier date, but this seems imprudent in the circumstances. The extraordinarily imaginative composition of the figure of a saint seen in profile and surrounded by asymmetrical companions was unprecedented in Venetian art, and is the sort of revolutionary composition that might be associated with Giorgione. The book held by St John Chrysostom has a word inscribed in Greek, *aghíon*, meaning 'saints' (Bertini, 1985). Why this particular combination of saints was chosen is unclear, except that St Catherine of Alexandria was probably included in homage to one of the donors.

The altarpiece was in conservation in preparation for the 1993 Paris exhibition, and the results were published by Alessandra Pattanaro (in *Le siècle de Titien*, 1993). Gross nineteenth-century repaints were removed, but even so certain saints' heads are abraded—those of St Catherine, St John Chrysostom and his elderly companion. The false architectural perspective and colonnade were found to be nineteenth-century additions and removed. The restoration eliminated the possibility of any collaboration between Giorgione and Sebastiano in the execution of the altarpiece, for there was no evidence of joint work.

Literature: Gallo, 1953, p. 152; Hirst, 1981, pp. 23-29; Bertini, 1985, pp. 1-30; Pattanaro, in *Le siècle de Titien*, 1993, pp. 301-03; Lucco, 1994, pp. 43-49.

VIENNA, Akademie der bildenden Künste, inv. 466
Attributed to Titian, c. 1530-40
Cupid in a Loggia
Canvas, 79 x 77 cm (fragment)

Provenance: Graf Lamberg-Sprinzenstein, where in 1821 described as 'Amore Quadro Bell.mo di Tiziano. N. B. èuna porzione essendo il quadro stato tagliato'.

Cupid is seated somewhat precariously on a balcony between two partially visible columns as he leans back to release a bow from his shoulder. The long outline of a leg in the left corner reveals that he once accompanied a reclining Venus. The landscape behind Cupid is a further variation of a group of farm buildings that occurs in the background of Giorgione's Dresden *Venus* (Fig. 139) and Titian's *Noli me tangere* in London. The group of houses, together with the barn and trees that are absent in the London picture, might suggest that this landscape is based on the Dresden *Venus*. One imagines that the fragment is part of a composition with Venus reclining on a coach, while Cupid adjusts his bow; beyond him there is a vista through a window. But surprisingly, a minor detail, the arrangement and shape of the windows in the furthest house to the left, is much closer to the same part of the London painting (G.M. Richter, 1933, p. 218).

The configuration of an interior scene with a reclining figure and a landscape seen through a window might indicate a date within the second decade of the sixteenth century, an interim stage in the development from the Dresden *Venus* to Titian's *Venus of Urbino*. However, Fleischer and Mairinger (1990) date the fragment much later. They emphasize the disparity between the old-fashioned elements of the composition, as in the fine delineation of the drapery, and the technique, with a heavy impasto in the painting of the Cupid, which most closely resembles Titian's *Mystic Marriage of St Catherine* (National Gallery, London) and *Madonna with the Rabbit* (Louvre), both datable to about 1530. When the canvas was in conservation, Fleischer and Mairinger found that there was a grey imprimatur over the surface, as found in works by Palma Vecchio and Lorenzo Lotto (Lazzarini, 1983, p. 138). The painterly style of the fragment and the type of the child resemble two Titian workshop pro-

ductions, the *Mystic Marriage of St Catherine* (Hampton Court Palace) and the *Sacra Conversazione between St John and a Donor* (Alte Pinakothek, Munich). All of this suggests a date of c. 1530, and that this is a Titian workshop variation of Giorgione's *Sleeping Venus* in Dresden, one of the most discussed paintings in Renaissance Venice.

Literature: Baldass and Heinz, 1964, p. 178; Poch-Kalous, 1968, p. 24; Fleischer and Mairinger, 1990, pp. 148-68.

VIENNA, Kunsthistorisches Museum, inv. 51
Polidoro Lanzani
Christ and the Magdalen
Canvas, 68 x 94 cm

Provenance: Bartolomeo della Nave, Venice; 1638-49, bought by Lord Basil Feilding, 2nd Earl of Denbigh, when he was the English ambassador in Venice (1634-39), for his brother-in-law, James Hamilton, 3rd Marquis (later first Duke) of Hamilton, d. 1649; Archduke Leopold Wilhelm.

Although engraved for Teniers' *Theatrum pictorium* as a Giorgione, the attribution has never been taken seriously.

Literature: Klauner, 1979, pp. 263-67.

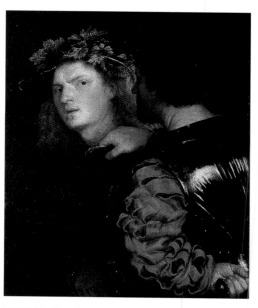

VIENNA, Kunsthistorisches Museum, inv. 64
Titian
The Bravo, c. 1515-20 (Fig. 36)

Sixteenth-century Venetian School. *Madonna and Child in a Landscape*. Canvas, transferred from board in 1872, 44 x 36.5 cm. St Petersburg, State Hermitage Museum.

Canvas, 77 x 66.5 cm

Reverse has a sketch of the *Entombment of Christ*

Provenance: Bartolommeo della Nave, Venice; 1638-49, bought by Lord Basil Feilding, 2nd Earl of Denbigh (as by Varotari), when he was the English ambassador in Venice (1634-39), for his brother-in-law, James Hamilton, 3rd Marquis (later first Duke) of Hamilton, d. 1649; Archduke Leopold Wilhelm, as 'Ein Bravo, Original von Giorgione'.

Of all the paintings attributed to Giorgione in the collection of Archduke Leopold Wilhelm, *The Bravo* was the most famous, partly because of its fame in the writings of Boschini, and partly because the bravura of the execution pleased. It is represented prominently in several of Teniers' painted gallery interiors, as well as twice in the *Theatrum pictorium*. In the seventeenth century, this painting epitomized what was most attractive in Giorgione's style, whereas in the twentieth century scholars have found it increasingly difficult to place among Giorgione's certain works.

An attribution to Titian was first proposed by Engerth (1884), though he identified *The Bravo* as a painting by Giorgione described by Michiel in 1528: 'Le due mezze figure che si assaltano', despite the fact that there is really only one attacker. Various alternative names were proposed among Giorgione's followers—Cariani (Crowe and Cavalcaselle, 1871, II, p. 152), Palma Vecchio (Wickhoff, 1895, pp. 34-43), and Domenico Mancini (Wilde, 1933, pp. 121-23). In recent decades the attribution to Titian has been revived and found persuasive. Of the many seventeenth-century copies, one rather cursory sketch by Van Dyck of 1625 (in his *Italian Sketchbook*, British Museum), has provoked speculation that there is an earlier version by Giorgione himself. X-rays reveal that the head of the attacker was originally seen in profile, as in Van Dyck's sketch, and the position of the assassin's hand on the young man's shoulder is in a different position in Van Dyck's sketch and in the underdrawing. This suggests a lost prototype, also recorded in the drawn inventory of the Andrea Vendramin collection (p. 319 above).

Ridolfi's rather muddled account of the subject was reinterpreted by Wind (1969), who identified the episode as the lecherous assault of Caius Lusius on Trebonius, one of his troops. To counter this homosexual advance, Trebonius drew his sword and killed his antagonist. At his trial, Trebonius was awarded the garland which he already wears in the painting, in recognition, according to Wind, of his future victory (Plutarch, *Vita Marii*, xiv). A more recent interpretation by Bruce Sutherland in a letter to the Kunsthistorisches Museum, 9 October 1989, discussed by Sylvia Ferino-Pagden, may be more convincing (Ferino-Pagden, in *Titian: Prince of Painters*, 1990-91). Sutherland suggests that Titian has represented Pentheus, King of Thebes, attempting to arrest Bacchus in order to prevent his cult from spreading in the Theban kingdom. The episode is described in Euripides' *Bacchae* and alluded to in Ovid's *Metamorphoses* (III, 515f.). If Sutherland is right, then the expression on the man's face could represent anger at the presumption of a mortal who attempts to arrest a god. Pentheus was later punished—torn apart limb by limb by his mother and sisters, all maenads—because he had witnessed the secret revelry of Bacchic women.

Literature: Engerth, 1884, pp. 168-70; Wind, 1969, pp. 7-10; Ferino-Pagden, in *Titian: Prince of Painters*, 1990-91, pp. 178-80.

WASHINGTON, D.C., National Gallery of Art, Samuel H. Kress Collection, inv. 253

Giorgionesque furniture painter

Venus and Cupid in a Landscape (Fig. 75)

Wood, 11 x 20 cm

Provenance: Contessa Falier, Asolo; acquired from Conte Alessandro Contini-Bonacossi; Samuel H. Kress collection, 1932-39.

Attributed by Darcos and Furlan to the young Giovanni da Udine, at the time he told Vasari he was a pupil of Giorgione (*Giovanni da Udine 1487-1561*, Udine [1987], pp. 96-100), together with the Paduan paintings of *Leda* and the *Idyll*. The composition is taken from Andrea Riccio's *Allegory of Glory* (Fig. 76). The zigzagging path is not in the underdrawing, revealed in infrared reflectography. In conservation, a keyhole was discovered above the centre of the panel, suggesting that it was designed as the lid of a jewel case (Shapley, 1979). Infrared reflectography, to be published in the forthcoming catalogue of the National Gallery, reveals an underdrawing in the bold calligraphy of an artist like Pordenone. It does not resemble the well-known drawing style of Giovanni da Udine, but suggests a date at the end of the first decade of the sixteenth-century. The infrared reflectogram does not clarify what Cupid is giving to Venus. However, the artist has made the surface painting conspicuously Giorgionesque, suitable as a fashionable decoration for a casket.

Literature: Shapley, 1979, pp. 216-17.

WASHINGTON, D.C., National Gallery of Art, Widener Collection, inv. 1942.9.2

Attributed to Giovanni Bellini

Orpheus

Wood, transferred to canvas in 1929, 39.5 X 81.3 cm

Provenance: possibly Charles I of England; Stefano Bardini, Florence; Hugo Bardini, Paris; Agnew's, London; sold by Arthur J. Sulley, London, in 1925, to Joseph E. Widener, who bequeathed it to Washington in 1942.

Frequently misidentified as a picture of a gazelle in the collection of Giovanni Cornaro, Venice, mentioned by Jacomo Tebaldi in a letter to Alfonso d'Este in 1520 (Shapley, 'Giovanni Bellini and Cornaro's Gazelle', *Gazette des Beaux-Arts*, XXVIII [1945], pp. 27-30). Tebaldi had been sent by Alfonso to show Titian a gazelle, but the animal had died, the carcass was thrown into a canal, and all that remained was a representation 'ritratta in piccola proporzione con altre cose dalla mano di Giovan Bellini in un quadro che si teneva in casa'. The lost gazelle picture that Titian was to copy can hardly be identifiable as this enigmatic allegory with subsidiary animals, among which there are feline beasts vaguely resembling gazelles in the background. More plausible is the connection with Richard Symonds' description of a painting in the collection of Charles I of England: 'Dec. 1652. Orpheus & a Woman & a Paes [meaning landscape], naked figures. Bellini's manner', further described in an inventory of the King's Goods at Greenwich, as 'a peece of Orpheus' (*Walpole Society*, XLIII [1970-72], p. 63).

The picture is in poor condition, the surface extensively abraded and repainted. It may once have been a furniture painting or box cover. Many scholars, such as Berenson, have believed in its quality, and have suggested an attribution to Bellini, and others to Giorgione. There are scattered paint losses across the surface and a very large loss in the lower right corner in the area that is retouched as an isosceles triangle of grass. There is much discoloured retouching throughout, particularly disturbing in areas such as the uniform blue stream. Horizontal depressions in the paint film originally corresponded to the joints of the panel; the regular craquelure should also be associated with the original support. Possibly the original panel was cut on both sides, suggested by the cut-off animals at the right and left edges. A *pentimento* of Circe's upper body shows that she was originally conceived turning slightly less to her left. The extensive discoloured retouching and condition of the painting (last cleaned in 1919, the bloom removed and varnish refreshened by H. N. Carmer in 1930) inhibits an attribution.

Infrared reflectograpy reveals extensive and very beautiful brush underdrawing, in a style which is characteristic of Giovanni Bellini himself. Preliminary indications in the landscape suggest that Circe and Orpheus were originally conceived as in a glade. The woodland background was always an important part of the original composition. The artist began by drawing the landscape, and then improvised the details. The figures were worked up later. The tender sensual expression on the satyr's face is very like Riccio in the underdrawing. X-rays are far less indicative of what is going on in the painting.

Were it not for the existence of this picture, Bellini's *Feast of the Gods* might appear to have made little impression on Venetian artists. Here the general tree-lined composition echoes Bellini's masterpiece and the figure of Orpheus is a reflection of Bellini's drunken Mercury, suggesting a date shortly before or after 1514. Nevertheless, the prudish decorum with which the figures are painted, the way in which Pan's arm rather awkwardly covers his companion's nipple, and the draping of his genitals with a white cloth, all suggest a very different mind from that of Giovanni Bellini when he painted the *Feast of the Gods*. Wendy Stedman Sheard has revealed that there is an intelligent design to the invention of the canvas rooted in Neoplatonic philosophy.

Literature: Kurz, 1943, p. 279; Hartlaub, 1951, pp. 129-31; Schapiro, 'The Widener *Orpheus*', *Studies in the History of Art*, VI (1974), pp. 23-36; Sheard, 1978, pp. 189-219; Shapley, 1979, pp. 47-50; *Places of Delight*, 1988, p. 258.

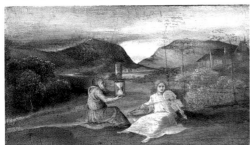

WASHINGTON, D.C., Phillips Collection, inv. 0791
Sixteenth-century Venetian
Father Time and Orpheus (The Astrologer) (Fig. 72)
Panel, 12 x 19.5 cm

Provenance: Pulszky collection, Budapest, until 1937; possibly in the Galerie Sanct Lucas, Vienna, 1937-39 (falsely reported as having been in the Thyssen collection, Lugano); purchased by Duncan Phillips in 1939 from Arnold Seligmann, Rey and Co., New York.

Few scholars would attribute this charming poetic invention to Giorgione himself, but it is closely related to his style. Pignatti (1969) tried to solve the attribution problem by grouping the panel together with the furniture panels in Padua, under the heading of the Phillips Astrologer, but this hardly seems convincing. Underdrawing revealed by infrared reflectography (Figs. 73, 74) shows a very different style underneath, different also from the underdrawings in the group of furniture panels to which it is related. The subject has never been explained but the prominent hourglass held by the old man as well as his advanced age are usually associated with Father Time in his role as the harbinger of death. The viol player could well be Orpheus, similarly represented in the Widener *Orpheus* (see preceding entry). For poets and artists in Renaissance Italy, such as Poliziano and Giorgione, Orpheus was a fascinating figure. Apollo and Chronos may denote the opposition of time and music. As Wendy Stedman Sheard has suggested, Orpheus, the musician, is playing in defiance of the hourglass, indicating that by virtue of his music he will survive death and time.

Literature: Pignatti, 1969, no. A 66; Sheard, 1978, pp. 189-219.

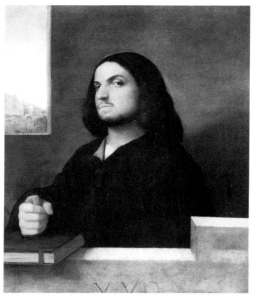

WASHINGTON, D.C., National Gallery of Art, Samuel H. Kress Collection, inv. 369
Attributed to Giovanni Cariani
Portrait of a Venetian Gentleman (The Goldman Portrait)
Canvas, 76 x 64 cm
Inscribed on parapet: VVO

Provenance: Robert P. Nichols, London; William Graham sale, Christie's, London, 10 April 1886, as 'Portrait of a Lawyer'; 1886, in stock with Colnaghi's, London; Henry Doetsch sale, 22 June 1895, Christie's, London, as Licinio; by 1897 and at least until 1905, in the collection of Lt. Col. George Kemp, Lord Rochdale, Beechwood Hall, Rochdale, Lancashire; in stock with Duveen in the 1920's; Henry Goldman collection, New York, by 1920, as a Titian; bought from Duveen Brothers for the Samuel H. Kress collection in 1937.

Given the unfortunate condition of this portrait, it is difficult to understand why it has been attributed to Giorgione or to Titian. The entire surface of the paint layers has been severely abraded. Concentrations of larger-sized losses are present in the sky, water, and building tops viewed through the window, the background, the parapet, the book cover and in the dark areas of the gentleman's garment, but not on his face. During the 1962 restoration, the letters VVO were discovered on the parapet, but the O is conjectural. X-radiography reveals various *pentimenti*. Originally, the man's right hand held a sword hilt or dagger, later changed to a scroll and finally to a handkerchief or a folded glove.

Following the restoration of 1962 (Pallucchini, 1962), the picture was sometimes attributed to Titian (Morassi, 1967; Shapley, 1968) on the basis of a comparison with two early parapet portraits of much higher quality, *La Schiavona* and the *Ariosto* portrait. Yet the radiographic evidence for the Washington portrait suggests an incompetent first design. The restoration of Titian's portrait of his father, in the Ambrosiana, Milan (Garberi, in *Omaggio a Tiziano*, 1977, no. 4), reveals that this is probably Titian's earliest portrait, very reminiscent of the style of Gentile Bellini. Titian's portrait of his father is painted on a finely weaved canvas and the style of his father's red velvet jacket is very similar to the youth in

Giorgione's *Giustiniani Portrait* (Fig. 159), suggesting a similar date. There are slight hesitancies in the modelling of the hand and lower lip of the father, but these are more than surpassed by the marvellous texture of the old velvet and cuirass. If Titian were capable of such excellence as a portrait painter in his earliest works, how can he be given such a work as the *Goldman Portrait*?

Pignatti (1969) gave the *Goldman Portrait* to Giorgione at the end of his career, a sad and unbelievable finale. The attribution has been ignored by other scholars (for example Torrini, 1993). The 'unpleasant' and 'uncomfortable' feeling of this portrait (Wethey, 1969-75) is hard to ignore, and it is not entirely due to its condition, but also to the ineptitude of the composition and organization of the forms. The radiographic evidence for the Washington portrait suggests an inept first design, incomparable with what is known of either Giorgione or Titian. As the surface of the painting is so severely abraded, an attribution cannot be based on the handling of the paint. It has to be decided on the basis of the design and the aggressive stance and expression of the sitter. David Alan Brown has suggested to me that the author may well be Cariani, who uses similar poses for many of his male sitters, such as the central figure in the Lugano *Concert of Musicians* from the Heinemann collection (now in the National Gallery of Art, Washington, D.C.) and the portraits in the North Carolina Museum of Art, Raleigh.

Literature: Pallucchini, 1962, p. 234; Morassi, 1966, p. 19; Shapley, 1968, pp. 178-79; Pignatti, 1969, pp. 114-15; Wethey, 1969-75, II, p. 185; *Le siècle de Titien*, 1993, pp. 323-27.

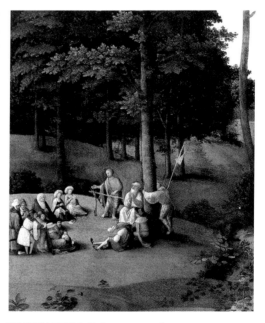

WASHINGTON, D.C., private collection
Early sixteenth-century Venetian
St John the Baptist Preaching in the Wilderness
Panel, 34.3 x 27.9 cm

Provenance: Piero Corsini Gallery, New York; private collection, Washington.

The painting depicts a religious scene in a landscape background, imitative of the approach to religious

iconography in Giorgione's Uffizi panels (Figs. 6, 7). It is a recent discovery, and has only been on public exhibition once, in 1988. The rather optimistic attribution to Giorgione hardly stands up to scrutiny before the Uffizi panels.

Literature: *Places of Delight*, 1988, no. 5.

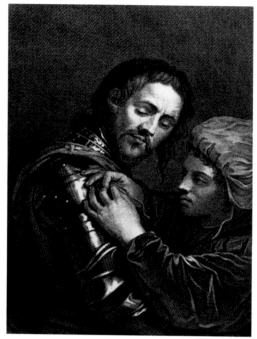

YORKSHIRE, Castle Howard
After Giorgione
A Knight and his Page
Paper or vellum stuck on panel with lead white adhesive, 21 x 18 cm

Provenance: described as no. 419, 'Portrait d'un homme illustre', by Giorgione in the 1671 inventory of Madame Henriette d'Angleterre, Duchess of Orléans; by descent to the duc d'Orléans (engraved by Besson, 1786); sold 1792 to the Earl of Carlisle (engraved by A. Cardon, 1811); thence by descent to Simon Howard.

From the seventeenth century, the picture was traditionally said to be Giorgione's *Portrait of Gaston de Foix (Duc de Nemours) with his Page Removing his Armour*—although, as the compiler of the Orléans collection catalogue noted, Gaston de Foix died at the age of twenty-four and the man depicted is much older (*Galerie du Palais Royal*, Paris [1786], II, pl. 3). Despite a persistent tradition that Giorgione painted the French lieutenant, repeated especially insistently in French inventories, Gaston is not known to have visited Italy before February 1511, when he received the title 'lieutenant du Roi dans le Milanais', that is, after Giorgione's death. Nor does the likeness resemble the effigy of Foix on Bambaia's tomb, now in the Castello Sforzesco, Milan. In 1854, when Waagen (*Treasures of Art in Great Britain*, London [1854], II, p. 278) described the painting at Lord Carlisle's town residence, the identification was no longer believed: 'Giorgione. A warrior, apparently wounded; a youth in the act of taking off his armour. A

small picture, of noble feeling; golden and transparent in the flesh-tones, and very harmonious in the full and powerful colouring of the drapery'.

The conservation department at the National Gallery, London, examined the picture in 1992. It was thought to be of very high quality, though an attribution to Giorgione was excluded on the grounds of the handling, the impasto of the highlights on the armour suggesting a later date. The X-ray suggests that it is painted with a freedom which does not look like the work of a copyist; the edges were overpainted when the paper or vellum was placed on panel. A pattern on the back of the panel may indicate that it was once used for furniture. Sebastiano del Piombo's knight in the Wadsworth Atheneum, Hartford, Connecticut, records a similar composition, a page having been covered on the left side of the painting, thus adding weight to the old tradition that this records a lost original by Giorgione, as does the recorded copy by Pencz.

Copies: Kunsthistorisches Museum, Vienna; Staatsgalerie, Stuttgart; Casa Alfieri di Sustengo, Turin; Spanio collection, Venice; a larger copy, signed by George Pencz, recorded by Waagen in the collection of Count Redern, Berlin (*Die vornehm-sten Kunstdenkmäler in Wien*, Vienna [1866], p. 45), subsequently Kauffmann collection, Berlin; variant sold Sotheby's, London, 13 October 1976.

Literature: Crowe and Cavalcaselle, 1912, III, p. 32 (as Flemish); C. Stryienski, *La Galerie du Régent*, Paris (1913), pp. 9, 39, 148; Justi, 1936, II, p. 346; G.M. Richter, 1937, pp. 229-30; *Italian Art in Britain*, exh. cat., London, Royal Academy of Arts, 1960, p. 16; Pignatti, 1969, p. 147 (as Paris Bordone).

VENICE, facade of the Palazzo Loredan (later Vendramin-Calergi) at Sant'Ermagora, San Marcuola
After Titian
Allegorical Figure of Diligence

The figure is known in several copies, the earliest the red chalk drawing reproduced here by Alessandro Varotari, called Il Padovanino (Stockholm, Statens Konstmuseer, inv. NMH 1515/1863, 40.4 x 27 cm). Another red chalk drawing is in the University Library, Salzburg (Tietze-Conrat, 1940); and there is an engraving by Zanetti, in *Le varie pitture* (1760). The lost original fresco has frequently been ascribed to Giorgione, although in the first recorded reference, the 1550 edition of Vasari's *Lives*, it is said to be by Titian. Ridolfi (1648, ed. von Hadeln, p. 155) followed Vasari's attribution, but Boschini, who had no confidence either in Vasari or Ridolfi as far as Venetian subjects were concerned, attributed the fresco to Giorgione, as well as other painted frescoes of *huomini maritimi* on the same facade: 'dello stesso Giorgione, sopra una porta si vede una figura di Donna rappresentante la Diligenza, e di sopra l'altra corrispondente, la Prudenza, cose rare' (*Le ricche minere*, ed. Pallucchini, p. 483). Zanetti, who always respected and followed Boschini, attributed the fresco to Giorgione. Among modern writers most have preferred to attribute the fresco to Giorgione with the exception of Valcanover (1969). In the absence of the original fresco, it seems best to keep to Vasari's attribution, which is the earliest, especially since Padovanino's copy suggests the massive forms of Titian's compositions.

Andrea Loredan presumably commissioned the frescoes on the facade of his Palazzo Loredan, a building completed by 1509. It has also been shown that this was probably the palace for which Sebastiano del Piombo's *Judgement of Solomon* was painted (see p. 122 above). The subjects on the facade of his palace, Diligence and Prudence, and a large painting of Justice inside are appropriate signals for Andrea Loredan's political career, which seemed always to be in jeopardy. In 1505 he had been a *savio* of the Council of Ten, then he was elected head of the Council in early 1506. In August 1509, after spending time in the Friuli, he was again elected to that office. Almost immediately he was sent to Burano in disgrace, but by November 1510 he was *capo* once more. The image of his patronage seems very carefully calculated to show his political virtue. What made Boschini attribute the fresco to Giorgione, and why did Zanetti call it Giorgione's 'best extant work'? Boschini may have attributed the *Diligenza* to Giorgione because *La Vecchia* was then on the art market, for sale on a Medici list of 1681 (p. 376 below).

Literature: Tietze-Conrat, 1940, p. 32, fig. 17; Valcanover, 1969, no. 10; Pignatti, 1969, p. 159; P. Bjurström, *Italian Drawings*, Nationalmuseum, Stockholm, Stockholm, 1979, no. 149; Hirst, 1981, p. 20.

NOTES

CHAPTER I

1. This exchange of letters and other documents relating to Giorgione is reproduced below, p. 362.

2. For the earlier orthodoxy, see Pignatti, 1969. But his view has been questioned by Anderson, 1972; Ballarin, 1979; Rearick, 1979; Hirst, 1981; and, most recently, Maschio, 1994.

3. Hope, 1993A, p. 195.

4. A. Quondam, 'Sull'orlo della bella fontana: Tipologie del discorso erotico nel primo Cinquecento', in *Tiziano: Amor sacro e amor profano*, 1995, pp. 65-81.

5. The fundamental study remains A. Serena, *La cultura umanistica a Treviso nel secolo decimoquinto* (Miscellanea di Storia Veneta, serie 3, III), Venice, 1912. Serena defines the third quarter of the Quattrocento as the period when humanistic studies flourished in the Trevigiana.

6. For the best critical edition of the text, see that of Giovanni Pozzi and Lucia A. Ciapponi, 1964, Padua, 2 vols. The author's real identity has been the subject of much speculation. The editors of this edition are committed to the idea that it was written by one of the many Dominican friars with the name Francesco Colonna at the convent of San Giovanni e Paolo in fifteenth-century Venice. For a contrary view, see Lamberto Donati, 'Il mito di Francesco Colonna', *Bibliofilia*, LXIV (1962), pp. 247-53. A seventeenth-century theory that the author is a Trevisan Servite, Frate Eliseo, first proposed in 1618 by a historian of the Servite order, has recently been proposed again by Piero Scapecchi in a series of articles; see, for example, '"L'Hypnerotomchia Poliphili" e il suo autore', *Accademie e biblioteche d'Italia*, LI (1983), pp. 286-98. An overview of recent literature on the subject, including Scapecchi's work, is provided by Emilio Lippi, *Studi Trevisani*, II, no. 4 (1985), pp. 159-62.

7. E. D. MacDougall, 'The Sleeping Nymph: Origins of a Humanist Fountain Type', *The Art Bulletin*, LVII (1975), pp. 357-65.

8. See, for example, Marcon, 1994, pp. 107-31.

9. On the biography of Crasso, see G. Biadego, 'Intorno al *Sogno di Polifilo*', *Atti del Reale Istituto Veneto di Scienze, Lettere ed Arti*, LX (1900-01), pp. 699-714.

10. For recent theories relating to the vexed question of the authorship of the book, see *Aldo Manuzio*, 1994, pp. 36-37; P. Fortini Brown, *Venice and Antiquity*, New Haven and London (1996), pp. 287-90.

11. Gauricus, ed. Chastel and Klein, 1969, pp. 254-55; the passage is discussed in Sheard, 1971, p. 209, and Luchs, 1995, pp. 37-38.

12. Sanudo, 1496-1533, I, p. 96.

13. This important document was first published in its entirety by Sheard, 1977, pp. 219-68.

14. Rearick, 1979, pp. 187-93.

15. A connection with this area and Giorgione's patron Girolamo Marcello has been suggested by Dal Pozzolo, 1991, pp. 36-37.

16. *Leonardo & Venice*, 1992.

17. First noted by Ballarin, 1979, pp. 227-52.

18. First proposed by Anderson, 1979B, p. 156, a derivation that has gained general acceptance; see, for example, David Alan Brown's catalogue entry in *Leonardo & Venice*, 1992, p. 340.

19. First proposed by Anderson, 1979B, p. 156, and then generally accepted, as in David Alan Brown's catalogue entry in *Leonardo & Venice*, 1992, p. 340.

20. See Pietro Marani's catalogue entry in *Leonardo & Venice*, 1992, p. 346.

21. Paschini, 1926-27, p. 174.

22. Pietro Marani has drawn attention to the importance of the Grimani collection of antiquities for Leonardo, and has proved that dancers sculpted on the bases of two marble candelabra inform Leonardo's late drawing of *Three Dancing Nymphs*. Marani also suggests, following others (cf. Padoan, in *Leonardo & Venice*, 1992), that Leonardo knew the Grimani since someone wrote the address of Cardinal Domenico's secretary, now identified as Stefano Ghisi, in the Arundel codex, on a sheet of studies of canals on the Arno, in about 1503-04; see Marani, 'The "Hammer Lecture" (1994). Tivoli, Hadrian and Antinöus: New Evidence of Leonardo's Relation to the Antique', *Achademia Leonardi Vinci: Journal of Leonardo Studies & Bibliography of Vinciana*, VIII (1995), pp. 216-17.

23. 'Uno quadro una testa con girlanda di man de lunardo vinci'.

24. 'Uno quadro testa di bambocio di lunardo vinci'.

25. J. Shell and G. Sironi, 'Salaì and Leonardo's Legacy', *The Burlington Magazine*, CXXXIII (1991), pp. 95-109.

26. P. Marani, *Leonardo e i Leonardeschi a Brera*, Florence (1987), pp. 11-65.

27. Some scholars have tried to identify the sitter, for example, Malaguzzi Valeri, who proposed the name Gerolamo Casio. His and other proposals are discussed by V. Markova, 'Il "San Sebastiano" di Giovanni Antonio Boltraffio e alcuni disegni dell'area Leonardesca', in *I Leonardeschi a Milano: Fortuna e collezionismo*, eds. M. T. Fiorio

and P. Marani (Atti del Convegno Internazionale, Milan, 25-26 September 1990), Milan (1991), pp. 100-07.

28. In the recent exhibition catalogue, there were attempts to suggest that Giorgione could have become acquainted with Leonardo's inventions through the works of a minor figure, Giovanni Agostino da Lodi; see P. Humfrey, in *Leonardo & Venice*, 1992, pp. 358-59. While no scholar would deny that Giovanni Agostino da Lodi represents another interesting example of how closely Leonardo was imitated in the Veneto, Giorgione's interest in Leonardo is independent.

29. See chap. III, pp. 114-17 above.

30. These famous documents were frequently published, but without the names of the signatories, until Maschio's impeccable transcriptions (1978), although even he failed to draw attention to Aurelio's name.

31. For a summary of the literature on Aurelio and his much discussed career, see M. G. Bernardini, 'L "Amor Sacro e Profano" nella storia della critica', in *Tiziano: Amor sacro e amor profano*, 1995, pp. 35-39.

32. The text is best read in a modern edition: P. Barocchi, *Trattati d'arte del Cinquecento*, I, Bari (1960), pp. 95-139; Gilbert, 1946, pp. 87-106; Puttfarken, 1991, pp. 75-95, where Venetian theorists are analyzed in connection with the debates of eighteenth-century writers.

33. Adapted literally from Aristotle's definition of knowledge in the *Metaphysics*, 981A.

34. For further discussion of Titian's borrowings from Central Italian artists, see Gilbert, 1980, and especially Joannides, 1990.

35. Perugino's painting was referred to both as a 'fantasia' and as 'la poetica nostra invenzione' in the correspondence between Isabella and Perugino; see W. Braghirolli, 'Notizie e Documenti inediti intorno a Pietro Vannucci detto il Perugino', *Giornale di Erudizione Artistica*, II (1873), pp. 159-63.

36. 'E perchè la pittura è propria poesia, cioè invenzione, la qual fa apparere quello che non è, però util sarebbe osservare alcuni ordini eletti dagli altri poeti che scrivono, i quale nelle loro comedie et altre composizioni vi introducono la brevità: il che deve osservare il pittore nelle sue invenzioni, e non voler restringere tutte le fatture del mondo in un quadro, n'anco disegnare le tavole con tanta istrema diligenza come usava Giovan Bellini, perch'è fatica gettata, avendosi a coprire il tutto con li colori, e men e utile oprare il velo over quadrature, ritrovata da Leon Battista [Alberti] cosa inscepida e di poca costruzione'; Barocchi, *Trattati d'arte*, pp. 115-16.

37. L. Curtius, *European Literature and the Latin Middle Ages*, New York (1963), chap. 13, discusses 'Brevity as an Ideal of Style'.

38. P. Fortini Brown, *Venetian Narrative Painting in the Age of Carpaccio*, London (1988), p. 4.

39. 'La poesia per la invention de le hopere, la qual nase de grammatica e retorica ancor dialetica. E de istorie convien esser pittor copiosi'. For the text of the letter, see L. Servolini, *Jacopo de' Barbari*, Padua (1944), pp. 105-06.

40. *Ibid.*, p. 115.

CHAPTER II

1. The Michiel texts relevant to Giorgione are given below, p. 363. Michiel's notes were first transcribed and edited by Jacopo Morelli, librarian of the Marciana, Venice, 1800. A later edition by T. Frimmel, 1888, gives a slightly improved transcription, but for these two editors the author's identity remained a mystery. An unsurpassed biography of Michiel was written by Emmanuele Cicogna, 1861, pp. 359-425. With his unrivalled knowledge of Venetian sources, Cicogna proposed Michiel as the author of the Marciana manuscript on the basis of a comparative analysis of the handwriting of the letters by Michiel's hand, now in Biblioteca Correr, Mss. Cicogna 368/9. Furthermore, the published text of Michiel's description of Bergamo, *Agri, et Urbis Bergomatis descriptio Marci Antonii Michaelis patricii Venetii* (1532), corresponds with his description of paintings in Bergamo, contained in the *Notizia*, in such matters as the choice of monuments and paintings to be discussed and their attributions. For example, these are the only two sources that ascribe the Colleoni Chapel to the sculptor Gianantonio Amadio Pavese. On Michiel's biography, see also F. Nicolini, *L'arte napoletana del Rinascimento e la lettera di Pietro Summonte a Marcantonio Michiel*, Naples (1925); also J. Fletcher, 1981, pp. 453-66, 602-08.

2. Cicogna, 1861, pp. 362-63.

3. For example, see Donato Giannotti's letter to Marcantonio Michiel, asking him for information on Venice to be included in Giannotti's dialogue, *Della Repubblica de' Veneziani*, 30 June 1533, in L. A. Ferrai, *Atti del Reale Istituto Veneto di Scienze, Lettere ed Arti*, III, serie 7 (1884-85), pp. 1570-84. Testimonies from Michiel's friends about their admiration for him are reported in Cicogna, 1861, pp. 379-87.

4. Rava, 1920; transcribed below, p. 368.

5. Anderson, 1979A; transcribed below, p. 369.

6. I. Favaretto, 'Inventario delle antichità di Casa Mantova Benavides', *Bollettino Museo Civico, Padova*, LXI, 1972 (1978), pp. 35-164.

7. Clifford Brown, 'An Art Auction in Venice in 1506', *L'Arte*, XVII-XX (1972), pp. 121-36.

8. An omission discussed by Luchs, 1995, pp. 17-20.

9. It has often been suggested that the Mercury statue had a horoscope represented on a plaque at the side of the figure, con-

nected with the year 1527, the year of Michiel's marriage, but it has recently been shown that the plaque is merely an astronomical attribute of Mercury; see J.C. Eade, 'Marcantonio Michiel's Mercury Statue: Astronomical or Astrological', *Journal of the Warburg and Courtauld Institutes*, XLIV (1981), pp. 207-09.

10. Fletcher, 1973.

11. Michiel's enthusiastic description reads: 'El quadretto del S. Ieronimo che nel studio legge in abito Cardinalesco, alcuni credono che el sii stato de mano de Antonello da Messina: ma li più, e più verisimilmente, l'attribuiscono a Gianes, ovvero al Memelin pittor antico Ponentino: e cussì mostra quella maniera, benchè el volto è finito alla Italiana; sicchè pare de man de Iacometto. Li edificii sono alla Ponentina, el paesetto è naturale, minuto, e finito, e si vede oltra una finestra, e oltra la porta del studio, e pur fugge: et tutta l'opera per sottilità, colori, disegno, forza, e rilevo è perfetta. Ivi sono ritratti uno pavone, un cotorno, e un bacil da barbiero espressamente. Nel scabello vi è finta una letterina attaccata aperta, che pare contener el nome del maestro; e nondimento, se si riguarda sottilmente appresso, non contiene lettera alcuna, ma è tutta finta. Altri credono che la figura sii stata rifatta da Iacometto Veneziano.' Jacometto Veneziano is an artist documented only in Michiel's notes, and to whom may be credited the double portrait in the Lehman Collection, The Metropolitan Museum of Art, New York, also described by Michiel.

12. Ms. Cicogna 2848, Biblioteca Correr, Venice; see p. 362 below. It is surprising that Marcantonio's diaries have never been published, despite the extremely interesting references to the Roman art world contained in them.

13. The literature on Michiel's Roman sojourn is discussed in Fletcher, 1981, pp. 455ff.

14. 'Li Filosofi coloriti nella fazzata sopra la piazza, e li altri Filosofi a chiaro e scuro nella Sala, furono de man de Donato Bramante'. The remaining frescoes are now in a museum in Bergamo. See Frizzoni, 1884, pp. 125-26, where the commentary for Bergamo is especially interesting since he was a native of that town.

15. A grotesque bust of a man in profile, black chalk drawing, Christ Church, Picture Gallery, Oxford, dated c. 1503, and connected with a black chalk head, described by Vasari as 'quella di Scaramuccia capitano de' Zingari'.

16. In the vast interpretative literature summarized by Settis, 1978, there have been few attempts to make much sense of the word 'cingana'. Recently it has been claimed that the whole debate is really very simply resolved (Holberton, 1995), and that the painting is nothing other than a family of

gypsies — just as Michiel said. Yet Michiel did not say this; he only described the woman as a gypsy. In support of his claim, Holberton reproduces many representations of exotic peripatetic families, but in no instance is it clear that they represent gypsies, for they have frequently been named families of Orientals, or Turks, or exotic foreigners. Moreover, they are all clothed, unlike the woman in the *Tempesta*. Holberton's article, contrary to his premise, is a demonstration of how difficult Michiel's description is to understand.

17. See P. Rubin, *Giorgio Vasari: Art and History*, London (1995), esp. pp. 135-37, 244-45, for an analysis of why Vasari disapproved of Venice.

18. Hope, 1994, p. 195 n. 124, is reluctant to accept Vasari's birthdate for Giorgione, and argues that Vasari's informant was Titian, and Titian could not even remember his own age. How could he have remembered the age of an older artist? However, this passage with the corrected date of Giorgione's birth does not occur in Titian's life, and could easily have come from another informant.

19. For the most recent discussion of the painting, see Lucco, 1994.

20. G.M. Richter, 1937, pp. 207-08, discusses what is known about portraits of Gonzálvo, and argues that since Gonzálvo visited Venice in 1501, this should be the date of the lost portrait. See also the exchange of letters between Richter and E. Panofsky (*The Art Bulletin*, XXIV [1942], pp. 199-201), where agreement is reached that a portrait of Gonzálvo, then in the Brocklesby collection, is from the circle of Hans Burgkmair, and has nothing to do with Giorgione.

21. That Titian gave different information about himself to different writers has been shown by Hope, 1994, pp. 178-82.

22. *Rime alla rustica di Magagnò*, Venice (1568), fol. 19v.

23. *La quarte parte delle rime alla rustica di Menon, Magagnò e Begotto*, Venice (1583).

24. D. von Hadeln, 'Sansovinos Venetia als Quelle für die Geschichte der venezianischen Malerei', *Jahrbuch der königlichen preußischen Kunstsammlungen*, XXXI (1910), pp. 149-58.

25. Transcriptions of the relevant sections of Ridolfi's and Boschini's texts appear below, pp. 370-74 and 375-76, respectively. Ridolfi's text is most easily studied in D. von Hadeln's edition, 1914-24, now somewhat out of date, while Boschini is best read in A. Pallucchini's edition, 1966.

26. Discussions of Boschini tend to see him as either a greedy dealer, as in J. Fletcher, 'Marco Boschini and Paolo del Sera: Collectors and Connoisseurs of Venice', *Apollo*, CX (1979), pp. 416-24, or as a theoretician with serious views and theories concerning Venetian art, as in Merling, 1992.

Both interpretations convey something that is true of this interesting hybrid personality.

27. A.-M. Logan, *The 'Cabinet' of the Brothers Gerard and Jan Reynst*, New York (1979).

28. Ms. Sloane 4004, British Library, London. The other drawings are reproduced below, pp. 319-22; see also Borenius, 1923.

29. 'Me ne andai dunque à Spineda villaggio del Trivigiano, proveduta la casa delle bisognevoli cose, inviato da un'amico di casa Stefani soggetto di buone qualità, e che si dilettava del disegno, mà sopramodo fisso ne' suoi pensieri. Ivi trapassai il rimanente dell'anno 1630, dove si provarono molti disagi lungi da' commodi della Città, che nondimeno erano soavi in riguardo delle afflittioni di Venetia, crescendo ogni giorno il numero de' feriti e de' morti; si che in breve gionsero al numero di 600 e più'; Ridolfi, 1648, ed. von Hadeln, II, p. 299.

30. For the texts of these visits, see pp. 292-93 below; also Anderson, 1973.

31. The inscription is given in N. Melchiori, *Cronaca di Castelfranco*, Ms. Gradenigo-Dolfin 205, Biblioteca Correr, Venice, fol. 71, and P. Coronelli, *Viaggi*, Venice (1697), I, p. 67:

OB PERPETUUM LABORIS ARDUI
MONUMENTUM IN HANC FRA
TRIBUS OBTINENDO PLEBEM SU
SCEPTI VIRTUTISQUE PRAECLARAE
IACOBI ET NICOLAI SENIORUM AC
GEORGIONI SUMMI PICTORIS MEMO
RIAM VETUSTATE COLLAPSAM PIE
TATE RESTAURANDAM MATHEUS
ET HERCULES BARBARELLA FRA
TRES SIBI POSTERISQUE CONSTR
VI FECERUNT DONEC VENIAT
ULTIMA DIES ANNO DNI MDCXXXVIII
MENSE AUG⁰

Internal inconsistencies (the Barbarella died well before the date of the inscription, Matthew in 1600 and Hercules in 1608) suggest that the epitaph was reported incorrectly (G. Gronau, 'Zorzon da Castelfranco: La sua origine, la sua morte e tomba', *Nuovo Archivio Veneto*, VII, pt. II, anno IV [1894], pp. 447-58). Only one scholar, G. Chiuppani, attempted to substantiate Ridolfi's claim ('Per la biografia di Giorgione da Castelfranco', *Bollettino del Museo Civico di Bassano* [1909]). Chiuppani found notarial documents concerning a certain Giorgio, son of a notary, Johannes Barbarellus in Vedelago, who was in Venice in 1489. Gronau objected that Giorgione's birthdate would have to be changed to 1470, and found it strange that the notary did not refer to Giorgio's profession if he were a painter ('Il Cognome di Zorzi da Castelfranco', *Bollettino del Museo Civico di Bassano* [1904]).

32. See von Hadeln's introduction to Ridolfi, 1648, I, pp. xiii-xliii. For assessments of Ridolfi as a historical biographer, see Puppi, 1974, and Hope, 1994.

33. Hope, 1994, p. 171.

34. K. Pomian, 'Le collezioni venete nell'epoca della curiosità', in *Collezionisti, amatori e curiosi*, Milan (1989), pp. 129-46.

35. 'Per quanto si è da noi potuto, si sono registrate quelle pitture, che da privati ci sono state fatte vedere ò venuteci à notitia, le quali non essendo permanenti, può cagionar ancora, che lo scrittore riesca tal'hor fallace per le vicende, che fanno; oltre che non si può tutti pienamente sodisfare, essendo spesso le opere predicate per quegli Autori, che giamai non videro, & ogn'vn vorrebbe, che le cose degli eccellenti Artefici pullulassero nelle case loro, come il grano ne' campi, si che lascieremo ogn'uno nella sua opinione, essendoche: *Ciascun del suo saper par, che si appaghi*'; Ridolfi, 1648, ed. von Hadeln, I, p. 202.

36. Wethey, 1987, pp. 245-47. A certain Tomio Renieri, perhaps related to the artist Niccolò Renieri, was a studio assistant to Ridolfi, who inherited all the drawings at his death. Could he have sold the drawings to General Guise (1682-1765), whose collection was bequeathed to Christ Church? See Muraro, 1968, p. 434.

37. For Pietro della Vecchia's relation to Giorgione, see Aikema, 1990, pp. 37-56.

38. See the correspondence published by the Procacci, 1965, pp. 92, 97-98. See also Mitchell Merling's catalogue entry on Pietro della Vecchia's *Imaginary Self-Portrait of Titian* (National Gallery of Art, Washington, D.C., inv. 1960.6.39). I quote the translation from Merling's entry in the forthcoming catalogue of the seventeenth-century Italian paintings in the National Gallery.

39. 'L'Idee di questo Pittore sono tutte gravi, maestose e riguardevoli, corrispondenti appunto a quel nome di Giorgione, e per questo si vede il suo genio diretto a figure gravi, con Berettoni in capo, ornati di bizzare pennacchiere, vestiti all'antica, con camicie che si veggono sotto a'giupponi, e questi trinciati, con maniche a buffi, bragoni dello stile di Gio. Bellino, ma con più belle forme; i suoi panni di Seta, Velluti, Damaschi, Rasi strisciati con fascie larghe; altre figure con Armature, che lucono come specchi; e fu la vera Idea delle azioni umane'; Boschini, 1674, ed. Pallucchini, p. 709.

40. 'A gloria di Giorgione e di Pietro Vecchia, Pittor vivente Veneziano, e a intelligenza de'Dilettanti, devo dire che abbino l'occhio a questo Vecchia, perché incontrerano tratti di questo pennello trasformati nelle Giorgionesche forme in modo, che resterano ambigui se siano parti di Giorgione, or imitazioni di quello: poiché anco alcuni dei più intendenti hanno colti de'frutti di questo, stimandoli dall'Arbore dell'altro'.

41. Waterhouse, 1952; Shakeshaft, 1986.

42. The full text of the 1681 Medici docu-

ment is printed below, p. 376-77. The letter from Matteo del Teglia to Apollonio Bassetti is in *Mediceo del Principato*, fol. 1575, cc. 623-24, Archivio di Stato, Florence. Part of the inventory was published by Gualandi, 1856, xii, no. 433, pp. 268-69.

43. See Joannides' discussion (1991) of the lack of precision in inventories, especially when relating to pastoral subjects, in his article on Titian's *Three Ages of Man*, where he plausibly suggests that the subject is *Daphnis and Chloe*.

44. National Gallery of Art, Washington, D.C., Samuel H. Kress Collection, inv. 1939. 1. 156. No early provenance has previously been proposed for the panel, nor for the others discussed below.

CHAPTER III

1. On the early history of the application of X-radiography to painting, see the informative article by C.F. Bridgman, 'The Amazing Patent on the Radiography of Paintings', *Studies in Conservation*, IX (1964), pp. 135–39; also the annotated bibliography by Joyce Plesters, for H. Ruhemann, *The Cleaning of Paintings*, London (1968), pp. 476–81.

2. Posse, 1931, pp. 29–35.

3. Giebe, 1994, pp. 369–84.

4. In my own interpretation of the painting, 1980, I was misled by Posse's reconstruction and discussed at some length the erotic symbolism of the bird, which now seems irrelevant.

5. Discussed p. 342 above.

6. Wilde, 1932.

7. Settis, 1978, p. 23: 'Che Giorgione intendesse dipingere, nelle tre figure di un giovane che "contempla", un Moro e un vecchio che si volgono a "misurare" e a parlare, i Magi, non può essere dubbio'.

8. Gombrich, 1986, goes so far as to accept the 1783 inventory description of the picture as 'The three magi who await the appearance of the star'.

9. Hirst, 1981, p. 8.

10. Letter from John Walker to Guy Emerson, 15 April 1949, dossier on the *Allendale Adoration*, archives, National Gallery of Art, Washington, D.C.

11. J. Walker, *Bellini and Titian at Ferrara: A Study of Styles and Taste*, London (1966).

12. D. Bull and J. Plesters, '"The Feast of the Gods": Conservation, Examination, and Interpretation', in *Studies in the History of Art*, XL (1990).

13. Fletcher, 1988, p. 173.

14. Morassi, 1939, pp. 567-70.

15. S. Moschini Marconi, in *Giorgione a Venezia*, 1978, p. 108; Lorenzo Lazzarini, in *Giorgione: La pala di Castelfranco*, 1978, pp. 45ff.

16. *Riflettoscopia all'infrarosso computerizzata. Quaderni della Soprintendenza ai Beni Artistici e Storici di Venezia*, Venice (1984); discussed by Plesters, 1987.

17. Mucchi, in *I Tempi di Giorgione*, 1978, III. He had earlier arranged a similar exhibition of the radiographs of Titian's portraits at Milan in 1976, where the problems of attribution were less complex; see M. Garberi, 'Tiziano: I Ritratti', in *Omaggio a Tiziano: La cultura artistica milanese nell'età di Carlo V*, exh. cat., Milan, Palazzo Reale (1977), pp. 11-37.

18. Lazzarini, 1978, pp. 45-58.

19. *Ibid.*, pp. 48-49.

20. *Ibid.*, p. 49.

21. Lazzarini, 1983, pp. 135-44.

22. On Suhr's practice as a restorer, see J. Hill Stoner, 'Pioneers in American Museums: William Suhr', *Museum News*, LXI (1981), pp. 31-35.

23. As has been realized by A. Luchs, 'Duveen, the Dreyfus Collection, and the Treatment of Italian Renaissance Sculpture: Examples from the National Gallery of Art', *Studies in the History of Art*, XXIV (1990), pp. 31-38.

24. Dunkerton, 1994, pp. 70-71.

25. 'Quasi che non si possino porre in più modi differenti su la tavola, e da questa cassarle e rifarle, come su la carta, ma mi manca di provar la coglioneria di quel goffo del Vasari'; first published by H. Bodmer, 'Agostino Carracci's Marginilia', *Il Vasari*, X (1939), pp. 25-26. The Venetians found another champion in the Zuccari brothers, who also annotated their copy of Vasari; see M. Hochmann, 'Les annotations marginales de Federico Zuccaro à un exemplaire des *Vies* de Vasari: La réaction anti-vasarienne à la fin du XVIe siècle', *Revue de l'Art*, LXXX (1988), pp. 64-69. However, Federico's comment on Giorgione thoroughly endorsed Vasari's view, and represents the first realization that Giorgione's oeuvre was small: 'É Giorgione in particolare che fu il primo che dipinse con maesta, forza e rilievo grandissimi con tenerezza di carne e tinte mirabile; se poche cose fece ma di molta perfettione e gratia'.

26. The camera was operated by Elizabeth Walmsley and her colleagues in the conservation department of the National Gallery of Art, Washington, D.C. I am grateful for their cooperation.

27. Yvonne Szafran and Holly Witchey are preparing a publication on the *Terris Portrait* and Szafran's conservation discoveries, which they showed me in draft.

28. Lucco, in '*Le tre età dell' uomo*', 1989, pp. 29-32.

29. Sheard, 1978, pp. 189-213.

30. Bottari, 1754-83, III, pp. 285-301.

CHAPTER IV

1. The first biographies of these Venetians were provided by the editors of Marcantonio Michiel's text: Jacopo Morelli, 1800; Gustavo Frizzoni, 1884; Theodor von Frimmel, 1888 (a commentary was only partly published in *Blätter für Gemäldekunde*, 1907, supplement); G. C. Williamson, 1903; Paola Barocchi (Verona, 1977, a partial edition). On Michiel himself, the fundamental study remains Cicogna, 1861, pp. 359-425. The best profiles of these patrons, with new data from archival sources concerning their careers, is given in two excellent studies by Battilotti and Franco, 1978, 1994. References to studies concerning individual patrons will be given in the following notes.

2. The reasons for the Venetian reluctance to write *ricordanze* are considered in a study by J.S. Grubb, 'Memory and Identity: Why Venetians Didn't Keep *ricordanze*', *Renaissance Studies*, VIII (1994), pp. 375–87.

3. Much of the archival material in this section was first published in an earlier article, Anderson, 1973; also see Battilotti and Franco, 1978, 1994.

4. G. Bordignon Favero, *La Cappella Costanzo di Giorgione*, Vedelago (1955); *idem*, *Le opere d'arte e il tesoro del Duomo di Castelfranco*, Castelfranco (1965).

5. The Costanzo also commissioned frescoes of St Francis for the convent of Sant'Antonio, Castelfranco, as recorded in the inscription, 'Costanzo e Fratelli F. F. per sua devozione', in the bell tower; see N. Melchiore, *Castelfranco e territorio ricercarto nelle iscrizione e pitture publicche*, Ms. It. VI. 416 (5972), fol. 47, no. 45, Biblioteca Marciana, Venice. The convent was suppressed in 1771, and fell into ruin.

6. Tuzio's brother and one of his sons were Knights of the Order of St John. His third son, known as Bruto Muzio, eventually became captain of the Tongue of Italy and Admiral of his religion, the highest office possible to hold in the Maltese Knights. Tuzio mentions him with these titles in his testament, *Testamenti di G. Francesco dal Pozzo*, Archivio Notarile, busta 765, no. 246, Archivio di Stato, Venice.

7. The identity of the military saint has proved puzzling. He holds the flag of the Knights of Malta, which is closely related to, but not identical with, the different flags of St Liberale, the titular saint of the church, and St George, the titular saint of the chapel. In 1973 I proposed that the name of the saint was St Nicasius, a saint of the Order of the Knights of St John. But St Nicasius was unknown in the Veneto; and I now think that the saint is the titular saint of the chapel holding the flag of the Order of the Knights of St John.

8. Ferriguto, 1933, pp. 165-66, tried to identify the landscape as the Lago di Garda

because he reasoned it was the only lake in the Veneto, and Tuzio had fought at Castello di Ponti. But Ferriguto and others confused the distant blue of aerial perspective with the depiction of a lake.

9. B. Aldimari, *Memorie historiche di diverse famiglie nobile così napoletane, come forastiere*, Naples (1691); H. Ruscelli, *Le imprese illustri con espositioni et discorsi del Ser Ieronimo Ruscelli*, Venice (1572); Sansovino, 1582; *Storia della famiglia Costanzo*, Ms. C. 4, Misc 27, Biblioteca Comunale, Castelfranco.

10. Sansovino, 1582, p. 293; Hill, 1940-52, III, pp. 574ff.

11. Letters granting these fiefs to Muzio are reprinted in Mas de Latrie, 'Documents nouveaux servent de preuves à l'histoire de l'île de Chypre', *Mélanges Historiques*, IV (1872), no. XIV, p. 415.

12. The most interesting accounts of Caterina's life are those by Pietro Bembo, *Della historia vinitiana . . . volgarmente scritta*, Venice (1552); and A. Colbertaldo, *Breve compendio della vita di Caterina Cornaro Regina di Cipro scritto da Antonio Colbertaldo di Asolo*, Ms. It. VII, 8 (8377), Biblioteca Marciana, Venice. Andrea Navagero's funeral oration on Caterina's catafalque, referred to by Bembo, does not survive. For the most recent analysis of the documentary sources, see Puppi, 1994.

13. Hill, 1940-52, III, chap. XI, gives the best account of the negotiations for the marriage, which took place by proxy in 1468.

14. The dowry of 3,000 ducats was contested by Tuzio's heirs, *Archivio dei Giudici del Proprio, Testimoni*, 47, fol. 102v, Archivio di Stato, Venice.

15. Between 1475 and 1488 there is an indication that Tuzio was employed by the Venetian Republic in Lombardy, as he received a stipend from the Senato Terra, from the paymaster Piero Michiel in 1483 in Lombardy, *Codex Cicogna*, 3281, III, fasc. 19, Biblioteca Correr, Venice.

16. A copy is in the Costanzo codex, fol. 2r, cited in note 18 below.

17. S. Luisignano, *Histoire contenant une sommaire description des généalogies de tous les princes qui ont jadis commandés royaumes de Hierusalem, Cypre, etc.* Paris (1579), fol. 71; Hill, 1940-52, III, p. 731.

18. *Liber instrumentorium clarissimi Equitis Dn. Clariss (imi) Equitis Dn. Tutti de Constantio* (Costanzo codex), Miscellanea Codici II, diversi no. I, Archivio di Stato, Venice. It was begun by Tuzio on 2 January 1488, and continued by his descendants. The codex was discovered and discussed by Anderson, 1973. An inventory of family documents, *Commissaria della famiglia Costanzo*, is preserved in the parish archive of San Vito, Asolo.

19. Sansovino, 1582, p. 294.

20. Sanudo, 1496-1533, I, pp. 194, 765; II, pp.

84, 92, 99, 126, 162, 205, 222-23, 309, 392, 875, 888, 939, 953, 1177; III, p. 7; IV, p. 33; V, p. 86; VIII, pp. 167, 231, 341, 373, 401, 434; IX, p. 70; X, p. 669.

21. See the intriguing interpretation by G. Liberali, 'Lotto, Pordenone e Tiziano a Treviso', *Memorie dell'Istituto Veneto*, XXXIII (1963).

22. G. Biscaro, 'Il dissidio tra Gerolamo Contarini Podestà e Bernardo de Rossi Vescovo di Treviso e la congiura contro la vita del vescovo', *Archivio Veneto*, VIII (1929), p. 42.

23. In Lotto's *Libro di spese*, a portrait of Tomaso Costanzo is described as 'grande quanto il naturale armato a tute arme et su una tavola el saio d'armar et l'elmeto senza altro de sotto la guarda de l'arnese in suso'; ed. Zampetti, 1969, p. 174. Yet the sitter always refused to pay for it, 'qual signor thomaso sempre mi dete bone parole, ma che aspettase la sua comodità'. After Tomaso's death, his son Scipio gave Lotto a small payment, but refused to give him the full price as the portrait did not resemble his father; ed. Zampetti, pp. 175, 218, 229-30. The portrait is also mentioned in Lotto's possessions in his testament, p. 301.

24. L. Puppi, 'Il Barco di Caterina Cornaro', *Prospettive*, XXV (1962), p. 53.

25. J. Anderson, 'The "Casa Longobarda" in Asolo: A Sixteenth-Century Architect's House', *The Burlington Magazine*, CXVI (1974), pp. 296-303.

26. 'Free are such poems', Bembo wrote, 'as are not bound either to a set number of lines or to a prescribed rhyme scheme but each forms them as he thinks best; they are generally called madrigals (they are so named), either because they were originally used to sing rude and simple matters in a likewise simple and rude form of rhyme; or else because in this manner rather than in any other those people discussed loves and other rustic events in the same way in which the Latins and Greeks discussed them in their eclogues taking the names and designation of the songs from the herds'; trans. A. Einstein, *The Italian Madrigal*, Princeton (1949), I, p. 117.

27. V. Cian, 'Pietro Bembo e Isabella d'Este Gonzaga', *Giornale Storico della Letteratura Italiana*, IX (1887), p. 107.

28. First noted by G. Pauli, 'Dürer, Italien und die Antike', *Vorträge der Bibliothek Warburg*, I (1921-22), pp. 51-68.

29. Chastel, 1978, followed by Puppi, 1994.

30. Anderson, 1973.

31. There is a lost portrait of Caterina in widow's clothing by Titian, the best known being in the Uffizi, Florence.

32. Costanzo codex, fol. 3r (see note 18 above). Pyrgoteles, who was a member of the Lombardi workshop, was responsible for a famous statue, now lost, of *Venus Chastising Cupid*, described in Gauricus, ed. Chastel

and Klein, p. 255; other works are discussed in Paoletti, 1893, II, pp. 217-18.

33. Described in a 'Copia de una lettera venuta di Brexa, che narra la intrata di la majestà di la regina e li tronfi facti, scripta a domino Nassino de Nassinis, era orator di quella communità a la Signoria nostra', in Sanudo, 1496-1533, I, p. 765.

34. See my article, 'Rewriting the History of Art Patronage', in *Renaissance Studies*, X, 2 (1996), pp. 1-10. On Agnesina's patronage, see D. Lewis, 'The Sculptures in the Chapel of the Villa Giustinian at Roncade, and their Relation to those in the Giustinian Chapel at San Francesco della Vigna', *Mitteilungen des Kunsthistorischen Institutes in Florenz*, XXVII (1983), pp. 307-52.

35. Varchi, *Della storia fiorentina*, ed. Florence (1838-41), II, p. 46; the context in which Varchi's judgement was made is discussed by R. Starn, *Donato Giannotti and his 'Epistolae'*, Geneva (1968), p. 106.

36. As first noted by James O'Gorman, 'An Interpretation of Andrea del Sarto's *Borgherini Holy Family*', *The Art Bulletin*, XLVII (1965), pp. 502-05. Further analysis of the 'republican' iconography was given by F. Gilbert, whose interpretation is followed here, in 'Andrea del Sartos *Heilige Familie Borgherini* und florentinische Politik', *Festschrift für Otto von Simson zum 65 Gesburtstag*, eds. Lucius Grisebach and Konrad Renger, Frankfurt-am-Main, 1977, pp. 284-88.

37. For the most recent edition, see Donato Giannotti, *Opere politiche*, ed. F. Diaz, Milan (1974), pp. 29-151.

38. F. Gilbert, 'The Date of the Composition of Contarini's and Giannotti's Books on Venice', *Studies in the Renaissance*, XIV (1967), pp. 172-84.

39. Giannotti, *Lettere a Piero Vettori*, eds. R. Ridolfi and C. Roth, Florence (1932), p. 6.

40. Starn, *Donato Giannotti and his 'Epistolae'*, pp. 17, 20, 21, 106.

41. See Daniela de Bellis, 'La vita e l'ambiente di Niccolò Leonico Tomeo', *Quaderni per la Storia dell'Università di Padova*, XIII (1980), for the facts of Leonico's life. Some account of Leonico's library, left to Fulvio Orsini, is given in P. de Nolhac, *La bibliothèque de Fulvio Orsini*, Paris (1887), pp. 171-72. For a profile of Leonico, see King, 1986, pp. 432-34.

42. Giannotti, *Opere politiche*, I, p. 150.

43. Pietro Bembo, *Lettere*, ed. E. Travi, Bologna (1992), II (1508-28), p. 553; III (1529-36), pp. 26-27.

44. I. Favaretto, 'Appunti sulla collezione rinascimentale di Niccolò Leonico Tomeo', *Bollettino del Museo Civico di Padova*, LXVIII (1979), pp. 15-29; see also the commentary on Michiel's account of the collection in Barocchi, 1977, pp. 2868-69.

45. Leonico was the recipient of a famous

Latin letter, written in the early sixteenth century, by the learned artist Giulio Campagnola, concerning Paduan artists of the Quattrocento. This important source, which is now lost, was used by Michiel and Vasari. For Vasari's considerable use of the letter, see W. Kallab, *Vasaristudien*, Vienna (1908), pp. 347-57.

46. See Gauricus, eds. Chastel and Klein, pp. 17ff.

47. Vasari refers to it in the lives of no less than six artists: Andrea del Sarto, Granacci, Pontormo, Baccio d'Agnolo, Aristotle di San Gallo and Perugino.

48. Settis, 1978, pp. 139-42; Battilotti and Franco, 1978, pp. 58-61, and *idem*, 1994, pp. 205-07. Marco Barbaro's *Genealogia*, II, fols. 304, 308, and 345, Biblioteca Correr, Venice, lists three distinguished patricians with the name Taddeo Contarini, all from the Santi Apostoli branch of the family. The two who do not qualify as Giorgione's patron are Taddeo, son of Andrea, and Taddeo, son of Sigismondo. Jacopo Morelli thought that Taddeo, son of Andrea, was the most likely candidate (see his edition of Michiel, p. 199 n. 112), while Ferriguto, 1933, pp. 186-92, thought it was Taddeo, son of Sigismondo, because, although impoverished by warfare, he was related to a famous philosopher. By eliminating the others, Settis suggested the right one on the grounds that he was rich and that the others were less likely candidates. But definitive evidence that Taddeo, son of Niccolò, is really the collector described by Michiel, is presented here for the first time by the publication of extracts from a 1556 inventory of his son Dario's collection (p. 365 below), which shows that he had inherited some of the principal pictures described by Michiel, including the Giorgiones.

49. The tax return of Federico Vendramin, 28 August 1524, states that Contarini lived in one of their houses at Santa Foscha: 'In Santa Foscha una caxa da statio in la qual sta messer Tadio Contarini per lui fabrichada, paga de fito cum el mezado de soto in tuto ducati setanta'; quoted in Battilotti and Franco, 1978, p. 60, from Savi alle Decime, b. 76-82, Archivio di Stato, Venice.

50. 'Una caxeta la qual tien messer Tadio Contarini nostro cugnado per andar a solazo nè da lui havemo mai havuto cosa alguna'; *ibid*.

51. Mentioned in the will of his son Dario Contarini, Notarile, Atti Marcon, b. 1203, c. 59, Archivio di Stato, Venice, 'altar di marmori con una immagine in pittura de messer San Jeronimo', but no longer in situ and unidentifiable.

52. I am grateful to Charles Hope for having given me the citation.

53. There is also a replica in the collection of Stanley Moss, New York, discussed in *Tiziano: Amor sacro e amor profano*, 1995, pp. 242-43.

54. Other paintings described in different rooms in the inventory of Dario Contarini's collection were: 'Uno quadretto scieto con la figura del nostro signor messer Jesu Christo'; 'Do quadri con la figura della nostra Donna'; 'Uno altro quadro piccolo con diverse figure in la quale e depinto una donna con una lira in man, et un homo appesso'; 'Una figura della nostra Donna in un quadro piccolo in dorado'; 'Un quadro grandeto con la figura della nostra Donna, it di sui Zuanne con le sue soazze de nogara sorfilado d'oro'; 'Uno altro quadro grande soazo vecchio con la figura della nostra donna'; and 'Un quadro grandeto con la figura del nostro Signor et altre figure con sue soazze dorade intorno'.

55. On Musurus, see E. Legrand, *Bibliographie Hellénique*, I (1885), pp. CVIII-CXXIV.

56. Taddeo di Niccolò had four sons, Pierfrancesco, Andrea, Dario and Girolamo.

57. Identified as Mg. 453 and Mg. 454, now in the Biblioteca Marciana, Venice, in L. Labowsky, *Bessarion's Library and the Biblioteca Marciana: Six Early Inventories*, Rome (1969), pp. 139-41.

58. C. Castellani, 'Il prestito dei codici manoscritti della biblioteca di San Marco in Venezia ne' suoi primi tempi e le conseguenti perdite de' Codici stessi', *Atti del Reale Istituto Veneto di Scienze, Lettere ed Arti*, serie 7 (1896-97), pp. 367-70.

59. There were sixteen codices of Ptolemy in Bessarion's library.

60. C. Castellani, 'Pietro Bembo, bibliotecario della libreria di S. Marco de Venezia', *Atti del Istituto Veneto di Scienze, Lettere ed Arti*, serie 7 (1895-96), pp. 868-69, 888-89.

61. For an analysis of the sources for the book of Seth, see A.F.J. Klijn, *Seth in Jewish, Christian and Gnostic Literature*, Leiden (1977), pp. 57-60.

62. As noted by Wind, 1969, p. 26. The theory was in danger of becoming an orthodoxy when Klauner identified the leaves on the cave as ivy, and the nearby tree as a fig, noticing for the first time a stream in the grotto. Klauner argued that the Three Magi, by contemplating the fig and ivy, the *arbores electi*, learnt in symbolic fashion about the Redeemer's birth, which according to tradition took place in the cave; see Klauner, 1955, pp. 145-68. It is difficult to agree that the foliage can be so precisely identifiable, as for example, in the laurel behind *Laura*. Apart from the misreading of the X-ray, there are important general objections to the theory — the absence of a star, and the absence of any direct reference to Christ's birth.

63. For an account of lunar volvelles, see R. T. Gunther, *Early Science in Oxford*, London (1967), II, pp. 234-44.

64. There were many lunar eclipses visible in Venice in Giorgione's lifetime, and without a legible date it is hard to identify which one may be intended. On lunar eclipses, see T. Oppolzer, *Canon of Lunar Eclipses*, New York (1962).

65. Kristin Lipincott has told me that she came to the same interpretation independently.

66. Meller, 1981, pp. 227-47.

67. P. Verdier, 'Des mystères grecs à l'âge baroque', *Festschrift Ulrich Middeldorf*, eds. A. Rosengarten and P. Tigler, Berlin (1968), pp. 376-91.

68. For further discussion of the iconography of the *Antrum Platonicum*, see J. L. McGee, 'Cornelis Corneliszoon van Haarlem (1562-1638)', *Biblioteca Humanistica et Reformatorica*, XLVIII (1991), pp. 239-49.

69. In 1933 Arnaldo Ferriguto proposed an interpretation of the *Three Philosophers* as standing for three successive ages of Aristotelian philosophy. He differentiated between three modes of seeing: the eldest philosopher's eyes are narrowed, half-closed; the Eastern philosopher's are preoccupied; while the young man's eyes are fully open in contemplation of the natural world (pp. 64-66, 87).

70. Meiss, 'Giovanni Bellini's *Saint Francis*', *Saggi e Memorie di Storia dell'Arte*, III (1963), pp. 11-30; see also J. Fletcher, 'The Provenance of Bellini's Frick "St. Francis"', *The Burlington Magazine*, CXIV (1972), p. 206, who identifies the Frick picture with a stigmatized St Francis by Bellini, described by Boschini.

71. R. Turner, *The Vision of Landscape in Renaissance Italy*, Princeton (1966), p. 59.

72. For further parallels between Platonism and Franciscan imagery, see C. Mitchell, 'The Imagery of the Upper Church at Assisi', in *Giotto e il suo tempo*, Rome (1971), pp. 133-34.

73. For my earlier discussion of Gabriele's collection, see Anderson, 1979A.

74. 'Un quadro grando nel qual li retrazo le crose miracolose con ser Andrea Vendramin con sette fioli et mesier Gabriel Vendramin con suo adornamento d'oro fatto de man de sier Titian'; Rava, 1920, p. 117.

75. As argued by C. Gould, *National Gallery Catalogues: The Sixteenth-Century Venetian School*, London (1961), pp. 117-20.

76. The will of Andrea Vendramin, copied in Ms. PD. C 1302/16, Biblioteca Correr, Venice, from the acts of Michiel Rampano, 20 January 1546.

77. P. Pouncey, 'The Miraculous Cross in Titian's Vendramin Family', *Journal of the Warburg and Courtauld Institutes*, II (1938-39), pp. 191ff.

78. Suggested by Pouncey, *ibid*.

79. For these documents and others, see Battilotti and Franco, 1978, pp. 64-68.

80. Doni, *I Marmi*, Venice (1552), parte III, fols. 40f.

81. 'Un cupido che pesta sopra un lion di bronzo apresso alla testa'; Rava, 1920, p. 163.

82. The following citation shows that it cannot have represented a real gem: '[Fortuna] già la viddi io in un Cammeo antico nello studio del Magnifico M. Gabriel Vendramino, molto diligentemente scolpita. Una femina senz'occhi in cima d'uno albero la quale con una lunga pertica batteva i suoi frutti, come si fanno le noci. I quali non erano peri, o pine, ma libri, corone, gioghi, lacci, scarselle, travoccanti d'ore & borse piene di danari, & gioei, pietre di gran valuta in anelli . . .'; *Pitture del Doni academico pellegrino. Nelle quali si mostra di nuova inventione: Amore, fortuna, tempo, castità, religione, sdegno, riforma, morte, sonno & sogno, huomo, republica, & magnanimità*, Padua (1564), fol. 10r.

83. Mentioned in Aretino's letter to Luca Contile, discussed in G. Falaschi, *Progetto corporativo e autonomia dell'arte in Pietro Aretino*, Messina and Florence (1977). On Aretino's religious writings, see Anderson, 1984D, pp. 275-90.

84. The documents concerning their evaluation were first published by F. Malaguzzi Valeri, 'La chiesa della Madonna di Galliera in Bologna', *Archivio Storico dell'Arte*, VI (1893), pp. 32-48; and republished in B. Boucher, *The Sculpture of Jacopo Sansovino*, New Haven and London (1991), pp. 149, 195-98.

85. Sertio, *Il terzo libro nel quale si figuravano, e descrivano le antiquità di Roma, e le altre che sono in Italia*, Venice (1540), in a postscript to readers, 'A li littori'.

86. Goltz, *Iulius Caesar, sive historiae imperatorum Caesarrumque Romanorum ex antiquis numismatibus restituatae*, Bruges (1556), fol. bbʲ; Vico, *Discorsi sopra le medaglie de gli antichi*, Venice (1555), p. 88.

87. First published by G. Gronau, 'Archivalische Beitrage zur Geschichte der venezianische Kunst', *Italienische Forschungen*, IV (1911), pp. 72-74; among subsequent publications, see Battilotti and Franco, 1978, pp. 66-67.

88. Although there may be some doubt as to how this picture is listed in the Vendramin inventories, no one would disagree that it was there; see p. 298 below.

89. S. Chojnacki, 'Subaltern Patriarchs: Patrician Bachelors in Renaissance Venice', in *Medieval Masculinities: Regarding Men in the Middle Ages*, ed. C. A. Lees, *Medieval Cultures*, VII (1994), pp. 73-90.

90. G. Boerio, *Dizionario del dialetto veneziano*, Venice (1856), s.v. 'cingano'.

91. In *Giorgione a Venezia*, 1978, p. 104.

92. L. Venturi, 'Le compagnie della Calza (sec. XV-XVI)', *Nuovo Archivio Veneto*, N.S. VIII (1908), pp. 161-221, and IX, 1909, pp. 140-233. The fundamental, stimulating study on Venetian theatre is by G. Padoan, *La commedia rinascimentale Veneta (1433-1565)*, Venice (1982).

93. Fritz Saxl, *Lectures*, London (1957), p. 162.

94. L. Stefanini, 'La Tempesta di Giorgione e la Hypnerotomachia di F. Colonna', *Memorie dell'Accademia Patavina*, XX, 58 (1941-42).

95. On the question of authorship, see G. Biadego, 'Intorno al "Sogno di Pilifilo"', *Atti del Reale Istituto Veneto di Scienze, Lettere ed Arti*, LX (1900-01), pp. 699-714, and the edition by G. Pozzi and L. A. Ciapponi, *Hypnerotomachia Polifili*, Padua (1964), 2 vols.

96. Some of the documentary material about the dispersal of the collection was published in my article on the Vendramin collection, Anderson, 1979A.

97. This documentation is in the *Libri Antiquitatem*, I, Bayerisches Hauptstaatsarchiv, Munich.

98. All the documentation concerning the inventories is in the archives of the Casa Goldoni, Venice, Archivio Vendramin, sacco 62, 42 F 16/5.

99. Published in Anderson, 1979A.

100. *Dell'architettura*, Venice (1615), pp. 305f.

101. A catalogue of a lottery of the Renieri pictures is reprinted in Savini Branca, 1964, pp. 97-107.

102. Although there is a series of excellent articles by Marilyn Perry and others on the Grimani sculpture collection, the *Quadreria* of the various members of the Grimani family has been little studied. For example, Perry, 'The Statuario Pubblico of the Venetian Republic', *Saggi e Memorie di Storia dell'Arte*, VIII (1972), pp. 75-150; idem, 'Wealth, Art, and Display: The Grimani Cameos in Renaissance Venice', *Journal of the Warburg and Courtauld Institutes*, LVI (1993), pp. 268-74; idem, 'A Renaissance Showplace of Art: The Palazzo Grimani at Santa Maria Formosa, Venice', *Apollo*, CXIII (1981), pp. 215-21.

103. There is an excellent biography by Paschini, 1943.

104. *Ibid.*, p. 80.

105. *Opvs Epistolarvm Des. Erasmi Roterodami*, ed. P. S. Allen, Oxford, 1963, IX, pp. 204-24.

106. C. Limentani Virdis, 'La Fortuna dei fiamminghi a Venezia nel Cinquecento', *Arte Veneta*, XXXII (1978), identifies some of the Flemish pictures; R. Gallo, 'Le donazioni alla Serenissima di Domenico e Giovanni Grimani', *Archivio Veneto*, L-LI (1952), pp. 34-77.

107. Letter from Bartolommeo Angelini to Michelangelo, 27 June 1523, *Il Carteggio di Michelangelo*, eds. G. Poggi, P. Barocchi, and R. Ristori, Florence (1967), p. 376.

108. *Ibid.*, pp. 381-83.

109. '[. . .] tra le altre cose erano due antiporte d'oro a ago soprarizzo, fu del Cardinale Grimano; item altre d'oro e di seda, pur del detto Cardinal; e tra le altre alcuni quadri fatti a Roma di man di Michiel Angelo bellissimi, pur del detto olim Cardinal: e vidi do ritratti come el vivo, dal busto in su, de bronzo, videlicet il Serenissimo M. Antonio Grimani & il suo fiol Cardinal Grimani'; Sanudo, 1496-1533, XL, p. 758.

110. The editors of Michelangelo's correspondence do not identify what the Grimani commission may have been, but if, as Sanudo says, it was a Roman work, perhaps Michelangelo sent something from an earlier stage in his career. Paul Joannides has suggested to me that it may have been one of the paintings of the Madonna and Child, attributed to Michelangelo by G. Fiocco, 'La data di nascita di Francesco Granacci e un' ipotesi Michelangiolesca', *Rivista d'Arte*, II (1930), pp. 193ff. In this case, one would assume that Michelangelo sent something that was by an assistant to fulfil Grimani's request. The existence of works by Michelangelo in a Venetian collection at this date would have had a stimulating effect on the young Tintoretto.

111. The inventory is in the Biblioteca Vaticana, Cod. Rossiano 1179, and is inscribed: 'Card. Marino Grimani inventario di sue cose scritto da lui medesimo il 22 Nov. 1528 con aggiunte posteriori fattivi da lui stesso in tempi posteriori'. It was published by Paschini, 1926-27, pp. 149-69.

112. P. Marani, 'The "Hammer Lecture" (1994). Tivoli, Hadrian and Antinöus: New Evidence of Leonardo's Relation to the Antique', *Achademia Leonardi Vinci: Journal of Leonardo Studies & Bibliography of Vinciana*, VIII (1995), pp. 207-27.

113. Castelfranco, 1955, p. 305.

114. Frey, 1930, II, p. 107.

115. The first substantial description of the picture is in G.M. Richter, 1937, pp. 101-02, 221-22, 345, who quotes some material from the Bankes papers, and accepts the traditional attribution to Giorgione and Giovanni da Udine in 1510. Most scholars ignored the ceiling, but subsequently Pignatti, 1971, p. 124, suggested that it is comparable to works of the 1530s by Francesco Vecellio from San Salvador, Venice. In the most recent guide to Kingston Lacy, Alistair Laing (in Mitchell and Laing, 1994, p. 74) attributes the ceiling to Giovanni da Udine, c. 1537-40, an attribution that is difficult to accept for two reasons. First, Giovanni da Udine's activities in the Palazzo Grimani are precisely documented in his own account books, and this ceiling is not mentioned; second, the way in which the foliage is rendered is incompatible with his hand.

116. Dorset Record Office, Dorchester:

D/BKL: HJ/1/898: 'Ho ricevuto io sotto-scritto dal Signore Guglielmo Gio. Bankes una Cambiale in Prima e Seconda di #100 e dico cento Lire Sterline sopra il Sig. Childs a Londra à 3 mesi data d'oggi — essendo il sudetto convento per un soffitto vendutogli col relativo quadro nel centro — Venezia li 6 Febbraio 1850. Consiglio Ricchetti'.

117. Dorset Record Office, D/BKL:HJ 1/1015: 24 September 1843, 'Dichiaro io sot-toscritto di avere ripulito al Sig⁶ Consiglio Ricchetti un quadro in tavola di forma ottangolare, la di cui circonferenza è di circa due metri di diametro, rappresentante l'Autunno. Esso quadro raffigura una bal-austrata, che contorna l'ottangolo, e for-mava base ad una pergola carica di uova, e sette putti i dissementi mosse, che s'aggrup-pano a quella per cogliere la grupoli d'uva, ed osservare una colomba ed un pavone. La invenzione del concetto, le bellissime fres-che e sanguigne carni dei putti, li scorci, la facilità di pennello che dipinge e disegna nello stesso punto d'intreccio, verità di tinte e conciata luce delle foglie mi determinaranno a dichiare detto quadro fra le migliori opere di Giorgio Barabarelli di Castelfranco, detto il Giorgione, e stimato del valore per lo meno di Napoleoni da 20° franchi att. 800 ottocento. In fede di che Giuseppe G° Lorenzi'.

118. A. Bristot Piana, *Il Palazzo Grimani di Santa Maria Formosa a Venezia e le sue deco-razioni: Giovanni da Udine e Camillo Mantovano*, Ph.D. diss., University of Padua, 1986-87.

119. M. Stefani Mantovanelli, 'Giovanni Grimani Patriarca di Aquileia e il suo Palazzo di Venezia', *Quaderni Utinensi* (1984), pp. 34-54.

120. See p. 365 below.

121. Sheard, 1978, pp. 199-201.

122. Paschini, 1926-27, p. 182.

123. F. Cornaro, *Notizie istoriche delle chiese e monasteri di Venezia*, Padua (1758), pp. 67-70; Cicogna, 1824-53, l, pp. 157ff. esp. p. 188.

124. For the interpretations of Marcantonio Raimondi's print, see F. Gandolfo, *Il 'Dolce Tempo': Mistica, eremetismo e sogno nel Cinquecento*, Rome (1978), pp. 77ff.

125. *Ibid.*, pp. 78-83.

126. This view has been challenged recently by M. Hochmann in a series of publications, but principally in an article on Giacomo Contarini (1987) and a book on patronage (1992). See also I. Palumbo-Fossati, 'Il collezionista Sebastiano Erizzo e l'inventario dei suoi beni', *Ateneo Veneto*, CLXXI (1984).

127. Lorenzi, 1868, p. 599.

CHAPTER V

1. A rare exception is the painting of *Doge Pietro Orseolo and his Wife at Prayer*, Museo Correr, Venice, attributed to the studio of Giovanni Bellini.

2. Anderson, 1979B.

3. James S. Grubb, 'Memory and Identity: Why Venetians Didn't Keep *ricordanze*', *Renaissance Studies*, VIII (1994), pp. 375-87.

4. Fomicieva, 1973, pp. 417-20. I am grate-ful to Dr B. Piotzrovskj, who allowed me to study the painting in conservation in 1971.

5. On the lost bronze attributed to Donatello's workshop, see Smith, 1994, who provides an extensive account of the history of the attribution and the iconography of decapitation.

6. The description of the statue of *Aphrodite Ourania* most frequently quoted in the Renaissance — as in Andrea Alciati, *Emblematum liber*, ed. 1531, F, b — was in Plutarch's *Coniugalia praecepta* (142, 30), where he states that 'Phidias made the Aphrodite of the Eleans with one foot on a tortoise to typify for womankind keeping at home and keeping silence'.

7. The significance of the inscription — 'Kingdoms fall through licence; cities rise through virtue. See the proud neck struck by the humble hand' — is discussed by E. Wind in 'Donatello's *Judith*: A Symbol of Sanctimonia', in *The Eloquence of Symbols: Studies in Humanist Art*, ed. J. Anderson, Oxford (1983), pp. 37-38. The first reference to Donatello's *David* occurs in 1469, in the description of the wedding celebrations for Lorenzo de' Medici and Clarice Orsini found on a column in a Medici palace courtyard; see C. M. Sperling, 'Donatello's Bronze *David* and the Demands of Medici Patronage', *The Burlington Magazine*, CXXXIV (1992), pp. 218-24, for a discussion of recent literature. Another, slightly later interpretation of Judith as a heroine of civic virtue and the triumph of faith is provided by the French Huguenot poet Guillaume de Salluste du Bartas, who was commissioned by Jeanne d'Albret, Queen of Navarre, to write an epic poem, *Judit*, first published in 1574 but written a decade earlier, when the author was only twenty; see the edition by A. Baiche, Toulouse (1971).

8. R. Borghini, *Il Riposo*, 1584, ed. Florence (1730), p. 286.

9. Bialostocki, 1981, pp. 193-220.

10. The suggestion was made independently by Pignatti, 1979, and by J. Shearman, 'Cristofano Allori's *Judith*', *The Burlington Magazine*, CXXI (1979), p. 9, who argues against the Vasarian tradition and the evi-dence of the Grimani inventories, claiming that Giorgione represented himself as the severed head of the giant Goliath in the late self-portrait rather than as David. This sug-gestion appears implausible, not only because it is against the literary tradition (dismissed by Shearman as unhelpful) and Vasari's *Lives*, but, more important, because David's eyes are those of the artist's tradi-tional self-portrait, seen gazing to the right as if reflected in a mirror.

11. P. de Winter, 'Recent Accessions of Italian Renaissance Decorative Arts, Part I: Incorporating Notes on the Sculptor Severo da Ravenna', *Bulletin of the Cleveland Museum of Art*, LXXIII (1986), p. 106.

12. Gauricus, eds. Klein and Chastel, pp. 262-63. A lost bronze of *Judith with the Head of Holofernes*, also by Severo da Ravenna (reprod. in Smith, 1994, fig. 7, p. 67), shows that Severo initially imitated and knew Giorgione's *Judith*, for his sculpture repeats some details, such as the draped dress and pose of the figure.

13. Baldinucci, ed. Florence (1974), pp. 732-33; here given in the translation of R. and M. Wittkower, *Born under Saturn. The Character and Conduct of Artists: A Documented History from Antiquity to the French Revolution*, New York (1963), pp. 160-61.

14. H. Hibbard, *Caravaggio*, London (1983), pp. 256-67.

15. On Artemisia, see R. Ward Bissell, 'Artemisia Gentileschi: A New Documented Chronology', *The Art Bulletin*, L (1968), pp. 153-68; also Bissell's mono-graph, *Orazio Gentileschi and the Poetic Tradition in Caravaggesque Painting*, University Park and London (1981), *passim*; and M. Garrard, *Artemisia Gentileschi: The Image of the Female Hero in Italian Baroque Art*, Princeton (1989), pp. 303-36.

16. On Fede Galizia, see A. S. Harris and L. Nochlin, *Women Artists: 1550-1950*, exh. cat., Los Angeles County Museum of Art (1977), pp. 115-17, who discuss Galizia's *Judith with a Maidservant*, c. 1596, now in the Ringling Museum, Sarasota, Florida. *Ibid.*, pp. 147-50, for Sirani. Versions of Sirani's *Judith* are now in the collection of the Marquis of Exeter, Burghley House, and at the Walters Art Gallery, Baltimore.

17. Discussed by D. A. Brown in *Andrea Solario*, Milan (1987), pp. 161-73, 206-08.

18. That Lotto's *Judith* has the feautres of a contemporary woman was suggested by A. Gentili, *I giardini di contemplazione: Lorenzo Lotto, 1503-1512*, Rome (1985), pp. 200-05.

19. The Doria portrait was interpreted as Salome by Panofsky, 1969, pp. 42-47, in a classic study.

20. Joannides, 1992, pp. 163-70.

21. See Ballarin's catalogue entry in *Le siè-cle de Titien*, 1993, pp. 724-29, and Dal Pozzolo, 1993, for a summary of diverse views.

22. Teniers' copies of the picture are docu-mented in Justi, 1936, p. 402.

23. As noted by Ballarin, 1993, II, p. 725.

24. Dal Pozzolo, 1993, has argued that it is too moralistic to insist on the nudity of a single breast as denoting a courtesan, and yet

all the examples he brings to the argument are concerned with allegorical women and hence irrelevant in the context of portraiture (e.g., Pisanello's *Allegory of Chastity*, on the reverse of Cecilia Gonzaga's medal, his fig. 13). Moreover, he reproduces portraits that are overpainted, on the art market, and of dubious condition and authenticity; see, for example, his figs. 3, 4, 8, 16, 18, 21. Similarly, the portraits of three men holding laurel leaves (figs. 9-11) are also of uncertain status, and two are homeless.

25. For the interpretation of one bared breast in the context of Venetian Renaissance sculpture, see A. Markham Schulz, 'Two New Works by Antonio Minello', *The Burlington Magazine*, CXXXVII (1995), p. 808 n. 26.

26. As argued by Gentili, 1995. More convincing is the account of the iconography of Flora in the Renaissance given by J. Held, 'Flora, Goddess and Courtesan', in *De artibus opuscula XL: Essays in Honor of Erwin Panofsky*, ed. M. Meiss, New York (1961), pp. 201-18.

27. Fletcher, 1989.

28. This criticism of Fletcher's article was first made by Garrard, 1994, pp. 59-85, who also questions whether Bembo had adopted the emblem of the laurel and palm as a personal device at this date, since it is only found on two manuscripts in his possession.

29. E. Cropper, 'The Beauty of Women: Problems in the Rhetoric of Renaissance Portraiture', in *Rewriting the Renaissance: The Discourses of Sexual Difference in Early Modern Europe*, Chicago (1986), pp. 175-90.

30. Quoted by M. Kemp, 'Leonardo da Vinci: Science and the Poetic Impulse', *Royal Society of Arts Journal*, CXXXIII (1985), p. 203; Garrard, 1994, pp. 63, 81.

31. Garrard, 1994, p. 63.

32. Quoted from a letter, *ibid.*, pp. 63, 81.

33. Junkerman, 1993, pp. 49-58, argues that Laura is a courtesan wearing a man's fur coat, (improbably) suggesting that it resembles the fur coat worn by one of the Magi in the *Adoration of the Magi*, National Gallery, London.

34. A point first made by Pedrocco, 1990, p. 93 n. 12.

35. Veronica Franco exemplifies this change. Her mother was an eminent courtesan in Venice, described in the 1535 list of courtesans, but Veronica was the friend of princes, intellectuals, and artists, among whom one at least, Tintoretto, painted her portrait. She was also a patron of artists of the calibre of Correggio, from whom she commissioned a Magdalen reading, described in a letter to Isabella d'Este. Her collected works, letters, sonnets and poetry were printed in 1575. And her poetry was often frankly about lovemaking:

Così dolce e gustevole divento,

quando mi trovo con persona in letto,
da cui amata e gradita mi sento,
che quel mio piacer vince ogni diletto,
sì che quel, che strettissimo parea,
nodo de l'altrui amor divien più stretto.

Franco, *Terze rime*, in *Poesia del Quattrocento e Cinquecento*, eds. C. Muscetta and D. Ponchiroli, Turin (1957), p. 1283.

36. For recent literature on the problematic iconography of Venetian women, see J. Habert, *Véronèse: Une dame vénitienne dite la Belle Nani*, Paris, 1996.

37. The Medici inventory is published on pp. 376-77 below. Marinoni, in the preface to *Leonardo & Venice*, 1992, made the comparison between Giorgione's *La Vecchia* and a drawing of an old woman by Leonardo on fol. 72 of the pocket-sized Codex Forster II, in the Victoria and Albert Museum.

38. Saxl, 'Titian and Aretino', *Lectures*, London (1957), I, p. 162.

39. Meiss, 'Sleep in Venice: Ancient Myths and Renaissance Proclivities', *Proceedings of the American Philosophical Society*, CX (1966), pp. 348-62.

40. 'Epithalamium dictum Palladio V.C. tribuno et notario et Celerinae', *Carmina minora*, XXV, 1-10. On the circumstances of the composition of the poem, see A. Cameron, *Claudian: Poetry and Propaganda at the Court of Honorius*, Oxford (1970), p. 401. Frequent Renaissance editions of Claudian's poetry (Vicenza, 1482; Parma, 1493; Venice, 1495; Venice, 1500; Vienna, 1510) testify to how popular he was. On Claudian's epithalamia as a source for Politian, see A. Warburg, '"Geburt der Venus" und "Frühling"', *Die Erneuerung der heidnischen Antike*, Leipzig and Berlin (1932), I, pp. 15f.

41. On early epithalamia and *hymenaioi*, see A. L. Wheeler, 'Tradition and the Epithalamium', *American Journal of Philology*, LI (1930), pp. 205ff.; also E. Fraenkel, 'Vesper Adest', *Journal of Roman Studies*, XLV (1955), pp. 1ff.

42. For the epithalamium in late antiquity, see C. Morelli, 'L'epitalamio nella tarda poesia latina', *Studi Italiani di Filologia Classica*, XVIII (1910), pp. 319-42.

43. *Silvae*, I, ii, 51-60. See also Z. Pavlovskis, 'Statius and the Late Latin Epithalamium', *Classical Philology*, LX (1956), pp. 164ff.

44. 'Epithalamium', *Carmina*, XI, 47-61.

45. *Carmina*, I, iv, 29-52.

46. Ennodius, *Carmina*, I, iv, 1-24.

47. *Carmina*, XI, 48ff.

48. Posse, 1931; Giebe, 1992, p. 95.

49. This particular example is discussed by A. Furtwängler, *Beschreibung der geschnittenen Steine im Antiquarium*, Berlin (1896), I, p. 72.

50. A term used by Pliny to describe a picture by Aristides, *Historia naturalis*, XXXV,

99; see E. D. MacDougall, 'The Sleeping Nymph: Origins of a Humanist Fountain Type', *The Art Bulletin*, LVII (1975), p. 361.

51. Marco Barbaro, *Genealogia*, IV, fol. 475, Archivio di Stato, Venice. The bride's first name is not given by Barbaro but by G. Giomo, *Indice dei matrimoni patrizii per nome di donne*, II, fol. 238, Archivio di Stato, Venice.

52. E. Cicogna, *Della famiglia Marcello Patrizia Veneta*, Venice (1841). I am grateful to Count Alessandro Marcello, a direct descendant of Giorgione's patron, who allowed me to consult the family archive and library, which contains many books and documents that belonged to Girolamo.

53. In the collection of the Earl of Crawford and Balcarres, discussed in E. Wind, *Pagan Mysteries in the Renaissance*, rev. ed., London (1967), p. 143 n. 7, pls. 44-45.

54. *Balla d'oro*, III, fol. 264v, Archivio di Stato, Venice.

55. Sanudo, 1496-1533, IX, pp. 144, 206; X, p. 392.

56. Segretario alle Voci, Registro 11, 1523-1556, fol. 75, Archivio di Stato, Venice.

57. *Dieci Savi sopra le decime in Rialto, ditte della Redecima 1514*, registro 1471, fol. 492, Archivio di Stato, Venice. See also Girolamo's will, Atti Ciprigni, busta 208, no. 113, which does not, however, mention his collection of paintings.

58. *De auctoritate summi Pontificis, et his quae ad illam pertinent, adversus impia Martini Lutheri dogmata*, Florence (1521). On Cristoforo, see Cicogna, 1824-53, II, pp. 79ff.

59. *Oratio ad Iulium II*, Rome (1513); see L. Pastor, *History of the Popes*, London (1898), VI, p. 429.

60. *Ritum ecclesiasticorum sive sacrarum cerimoniarum SS. Romanae ecclesiae*, Venice (1516).

61. Sanudo, 1496-1533, XLV, 28 June 1527, p. 362; also Cicogna, 1824-53, II, p. 80f.

62. Sanudo, 1496-1533, LIII, p. 229.

63. *Paraphrasi nella sesta satira di Giuvenale: nella qualle si ragiona delle miserie de gli huomini maritati. Dialogo in cui si parla di che qualita si dee tor moglie, & del' modo, che vi si ha a tenere. Lo epithalamio di Catullo nelle nozze di Peleo e di Theti*, Venice (1538). I am indebted to Charles Hope for this reference.

64. See, for example, Ballarin's attribution of the painting to Titian, in *Le siècle de Titien*, 1993, pp. 307, 310.

65. See p. 86 above and Fig. 45. I accepted this in early writing, as did R. Goffen in her interpretation of Giorgione's *Venus* in 'Renaissance Dreams', *Renaissance Quarterly*, XL (1987), pp. 682-705.

66. The reason for the inclusion of Venus has been questioned by D. Sanminiatelli, *Domenico Beccafumi*, Milan (1967), p. 84, but

once Venus' epithalamic role has been understood her presence is logical.

67. K. Christiansen, 'Lorenzo Lotto and the Tradition of Epithalamic Paintings', *Apollo*, CXXIV (1986), pp. 166-73; S. Béguin, in *Le siècle de Titien*, 1993, p. 494.

68. This was the subject of a notable exhibition at the National Gallery, London, *Goya's Majas at the National Gallery*, May-July 1990. The scholarly discussion of these Pordenone variants of Giorgione's nudes was published by E. Harris and D. Bull, 'The Companion of Velázquez's *Rokeby Venus* and a Source for Goya's *Naked Maja*', *The Burlington Magazine*, XC (1964), pp. 19-30.

69. Kurz, 1943, pp. 279-82. The Imstenraedt collection was also described in a verse poem, *Iconophylacium sive Artis Apelleae Thesaurarium*. It contained three other works by Giorgione, a shepherd with his wife in a landscape with their little children ('Un pastore con la moglie nel paese, con alcuni piccioli figlioli'), an Orpheus, and a small version of the 'Inferno', which may be related to *Hell with Aeneas and Anchises*, which Michiel described in the Contarini collection; see G.M. Richter, 1937, p. 352.

70. On the development of the theme in Cranach's work, see D. Koepplin and T. Falk, *Lukas Cranach*, exh. cat., Basel, Kunstmuseum (1974), pp. 421-31.

71. A notable discussion of the problems of interpreting Titian's erotic paintings was held at the Titian conference, *Tiziano e Venezia: Convegno Internazionale di Studi, Venezia, 1976*, Venice (1980). At the session entitled 'La donna, l'amore e la morte', Charles Hope proposed Titian's *Sacred and Profane Love* as a representation of *Laura Bagarotto at the Fountain of Venus*; see Hope, 'Problems of Interpretation in Titian's Erotic Paintings', pp. 111-24. Previously, Titian's paintings had been interpreted as Neoplatonic allegories in classic studies by Panofsky, 1969 (his final statement on the subject), and E. Wind, *Pagan Mysteries in the Renaissance*, London (1958). Recently, the subject was discussed at an international symposium arranged by Claudie Balavoine, Tours, 'Le mariage à la Renaissance', 6-8 July 1995, Centre d'Études Supérieures de la Renaissance, Université François Rabelais, Tours.

72. Wethey, 1969-75, III, pp. 22, 177. Mrs Alice Wethey, a genealogist accompanying her husband, first claimed to perceive the coat-of-arms, which was then published in her husband's catalogue of Titian's works, and its presence has been accepted ever since.

73. Hope, 'Problems of Interpretation in Titian's Erotic Paintings', pp. 111-24.

74. Goffen, 1993, pp. 121-44.

75. Sanudo's descriptions of Venetian brides and their wedding dresses have been gathered together by A. C. Junkerman, *Bellissima donna: An Interdisciplinary Study of Venetian Sensuous Half-length Images of the Early Sixteenth Century*, Ph. D. diss., University of California, Berkeley (1988), p. 349.

76. C. Strinati, 'Una donna in attesa delle nozze', in *Tiziano: Amor sacro e amor profano*, 1995, p. 19.

77. For a full account of the story, see Goffen, 1993, pp. 121-44.

78. *Ibid.*, p. 132.

79. See A. Quondam's convincing and subtle analysis of the *Sacred and Profane Love* in relation to Bembo, 'Sull'orlo della bella fontana: Tipologie del discorso erotico nel primo Cinquecento,' in *Tiziano: Amor sacro e amor profano*, 1995, pp. 65-81.

CHAPTER VI

1. Storffer, *Gemaltes Inventarium der Aufstellung der Gemäldegalerie in der Stallburg*, three Pergamon volumes in the archives of the Kunsthistorisches Museum, 1720, 1730, 1733.

2. *Verzeichnis der Gemälde der Kaiserlich Königlichen Bilder Galerie in Wien verfaßt von Christian von Mechel*, Vienna (1783). For a full discussion of these problems, see Garas, 1969.

3. Algarotti, *Opere*, Cremona (1781), VII, p. 51: 'Io non so che sia de' Tiziani che sono nello Escuriale in Ispagna. So bene il governo che si è fatto di quelli, che sono nella Galleria di Vienna. Crederebb' ella che per accomodargli alla forma di certe loro bizzarre cornici qua si sieno aggiunti dei pezzi al quadro, là tagliati degli altri? *quaque ipsa miserrima vidi*'.

4. For further examples, see A. Conti, *Storia del restauro e della conservazione delle opere d'arte*, Milan (1988), pp. 89-93.

5. *Ibid.*

6. Ridolfi describes the Widmann collection on a number of occasions, but these pictures by Giorgione do not appear in the inventories compiled by Niccolò Renieri and Pietro della Vecchia and others, published by F. Magani, 'Il collezionismo e la committenza artistica della famiglia Widmann, patrizi veneziani, dal seicento all'ottocento', *Memorie dell'Istituto Veneto di Scienze, Lettere ed Arti*, XLI (1989).

7. The anecdote is told by Canova's biographers; see V. Malamani, *Canova*, Milan 1911, pp. 50-51; discussed in Manners and Williamson, 1924, p. 99.

8. The collection is described in an *opuscolo* by E. Cicogna, *Cenni intorno a Giovanni Rossi*, Venice (1852). It was housed in dei Rossi's villa at Sant'Andrea di Barbarana, but sold by his widow in 1858. The most famous paintings in his collection were Gaspard Dughet's *Storm: Moses and the Angel*, National Gallery, London, and Pontormo's *Joseph and Jacob in Egypt*, also in the National Gallery.

9. Anderson, 1973.

10. Urbani di Gheltof, 1878, II, pp. 24-28, suggested that it was the Palazzo Valier, on the Riva dell'Olio, San Silvestro, now no. 1022. Whereas Ridolfi located Giorgione's house within the Campo, meaning perhaps any of the surviving fifteenth-century buildings, now nos. 1087-1089. It is a hopeless task to identify the presumed location of Giorgione's house.

11. First suggested by Hauptman, 1994; followed by Anderson, 1994; and Holberton, 1995. I am grateful to William Hauptman for corresponding with me on these matters.

12. Stendhal, one of the most remarkable of all French travellers, noted in his journal, 25 July 1815, that he had visited the Manfrin Gallery; see *Oeuvres complètes*, eds. Del Litto and E. Abravanel, Paris (1969), V, XXI, p. 156.

13. H. Christmas, *The Shores and Islands of the Mediterranean including a Visit to the Seven Churches of Asia*, London (1851), II, pp. 160-61.

14. Bankes papers, Dorset Record Office, Dorchester, quoted p. 328 above. On the Marescalchi gallery, see M. Proni, 'Per la ricostruzione della Quadreria del Conte Ferdinando Marescalchi (1753-1816)', *Antologia di Belle Arti*, XXXIII-XXXIV (1988), pp. 33-41.

15. The receipt for the ceiling is dated 6 February 1850. Earlier, on 24 September 1843, the restorer Giuseppe Girolamo Lorenzi wrote a *perizia*, declaring that he had cleaned an octagonal painting depicting *Autumn* and measuring some 2 metres in diameter for the dealer Consiglio Ricchetti. Without reservation, he states that the painting, which depicts a balustrade around the edges of an octagon, with seven putti gathering bunches of grapes and observing a dove and a peacock, is definitely among 'the best works of Giorgione' (see chap. IV, note 117). Lorenzi, who came from Soligo, was a notable restorer for the Accademia di Venezia, and had indeed restored a number of Giorgione's 'better works', namely the *Castelfranco Altarpiece* in 1831, as well as some less credible pictures purporting to be by Giorgione, such as the *Dead Christ* in the Monte di Pietà, Treviso. No less an observer of the Venetian scene than Count Cicogna records in his diary that in 1852 Lorenzi added some bits and pieces he presumed were missing to the *Dead Christ* (Cicogna, *Diario*, Biblioteca Correr, Venice, fol. 6550, quoted by F. Fapanni, in his *La città di Treviso esaminata negli edifici pubblici e privati*, Ms. 1355, Biblioteca Civica, Treviso). On Lorenzi as a restorer, see M. Lucco, 'Note sparse sulle pale bellunesi di Paris Bordon', in *Paris Bordon e il suo tempo* (Atti del Convegno Internazionale di Studi), Treviso (1985), p.

168. Lorenzi's other restorations include an altarpiece by Palma Vecchio at Oderzo, between 1823 and 1828, now in the Accademia, Venice; the *Pentecost* of Palma il Giovane in the Cathedral, Oderzo, before 1833; Pordenone's altarpiece at Susegana in 1836; Giovanni Bellini's *Baptism of Christ*, Santa Corona, Vicenza, in 1840. He seems as well to have illicitly removed two of the medallions in the Casa Pellizzari, Castelfranco, one to a private collection; see G.M. Richter, 1937, p. 213.

16. The *Triple Portrait*, now at Alnwick Castle, was purchased by Alexander Barker, a London dealer, from the Manfrin collection, and sold to the Duke of Northumberland in 1874. Drawings by a London artist of Barker's stock, including the pictures from the Manfrin collection, now in the National Portrait Gallery, London, show that he was the middleman. Andrew Geddes copied the portrait in the mistaken belief that it was Giorgione's *Family*; his copy is reproduced in Hauptman, 1994, p. 81 and is in the Victoria and Albert Museum. It was described in his wife's comments to the *Memoirs of the Late Andrew Geddes Esq.*, London (1844), p. 18, where she noted that her husband had copied 'the celebrated picture sometimes said to be Giorgione's family, three heads, mentioned by Lord Byron'.

17. Hauptman, 1994, pp. 80-82, quotes the various opinions. Studies by literary historians include I. Scott-Kilvert, 'Byron and Giorgione', *The Byron Journal*, IX (1981), pp. 85-88; H. Gatti, 'Byron and Giorgione's Wife', *Studies in Romanticism*, XXIII (1984), pp. 237-41; S. Whittingham, 'Byron and the Two Giorgiones', *The Byron Journal*, XIV (1986), pp. 52-55.

18. Mündler's description of the Manfrin collection, March 1858: 'no. 225. "The family of Giorgione;" attributed to the same. The landscape certainly does not look so, & there is a presumption of its being altogether by the hand of Girolamo Savoldo. Yet it is unquestionably a picture of great charm. 0.74 by 0.83 c. h. C.'; O. Mündler, *Travel Diary*, *The Walpole Society*, LI (1986), p. 213. In the Zentralarchiv, Staatliche Museen zu Berlin-Preußischer Kulturbesitz, the *Nachlaß* of Julius Meyer contains Mündler's catalogue of the Manfrin Gallery, written in an Italian hand, with Mündler's annotations: *Pinacoteca Manfriniana, catalogo copiato in Venezia, 1855, Nachlaß 96*. The original and much more detailed German volumes of Mündler's diaries have been also rediscovered in Meyer's *Nachlaß*, Zentralarchiv, Berlin.

19. The text of the following letter was given to me by Tilmann von Stockhausen, who modernized the texts and is preparing a study of Waagen's correspondence and collecting, entitled *Gustav Friedrich Waagen, Reise nach Italien, 1841-1842: Ein Bericht in Briefen*. The

letter, addressed from Waagen to Olfers, is dated 25 October 1841: 'Der Galeriedirektor von Manfrin, den ich bald ganz für mich zu gewinnen wußte, sagte mir, daß die Freunde der Besitzerin, einer Gräfin [Julie-Jeanne Manfrin] Plattis, ihr jetzt dringend geraten hätten, keine Bilder einzeln zu verkaufen, daher sie auch erst kürzlich dem Prinzen von Oranien den Ankauf einer Magdalena verweigert habe. Da er in ärmlichen Umständen ist und ein Italiener vom gewöhnlichsten Schlage, so brachte ich ihn durch das Versprechen einer Gratifikation in den regsten Eifer, so daß er versprach, bei der Gräfin sein äußerstes zu tun, ich müßte aber mehrere Bilder nehmen. Ich bezeichnete daher neben dem Tizian noch zwei Bilder des Giorgione und einen trefflichen Ostade. Das Glück wollte, daß die Gräfin zwei Tage darauf eines Geschäfts wegen auf einige Tage nach der Stadt kam. Leider sagte er mir, daß er ungeachtet aller Vorstellungen sie nicht habe bewegen können, auf den Verkauf der Bilder für irgendeine Summe einzugehen, daß sie entweder die ganze Galerie oder nichts hergeben wolle. Für diese aber wird die lächerliche Forderung von 650,000 Gulden K[on]ventionsgeld begehrt, während ich mich nach einem sehr genauen Examen der Galerie sehr bedenken würde, dafür die Summe von 100,000 Gulden zu geben. Die alte, sehr reiche Frau kann allem Ansehen nach nicht mehr lange leben, und die Erben, sagte mir der Galeriedirektor, dächten über diesen Punkt ganz anders'; Gustav Friedrich Waagen to Ignaz von Olfers, 25 October 1841, Geheimes Staatsarchiv, Preußischer Kulturbesitz, Akte, Rep. 137 I, no 18. See also Locke, 1996, for references to the *Tempesta* in German guidebooks.

20. 'Dieses traurige Resultat hätte ich Ihnen schon vor 8 Tagen melden können, doch ließ mich mein dringender Wunsch nicht ohne alles Resultat vor Ihnen zu erscheinen nach Treviso eilen, um dort das Bild des Giorgione im Monte di Pietà zu gewinnen, wovon mir Passavant mündlich und schriftlich eine begeisterte Schilderung gemacht hatte. Wie unangenehm war ich daher überrascht, ein Werk zu finden, welches zwar für die Kunstgeschichte sehr interessant ist, aber unsere Galerie nur um ein neues [illegible word] bereichert hätte. Es ist ein mißlungener Versuch, aus der einfachen Kunstweise des Bellini in eine breitere Behandlung der Form, in starke Wendungen und kühne Verkürzungen überzugehen'.

21. Hauptman, 1994.

22. F. Haskell, *Rediscoveries in Art*, London (1976), p. 15.

23. Layard to Sir William Gregory, a fellow trustee of the National Gallery, London, after he had visited the Manfrin collection on 20 November 1870, Add. Mss. 38949, British Library, London: 'There is no doubt that a number of admirable pictures might

have been bought by us from the Manfrin collection after [Alexander] Barker had carried off those which had a reputation but which were really not the most important for a National Gallery. The Mantegna you mention is a gem, also the Canaletto in the Gallery and one or two others which were bought from Manfrin after Barker had his pick. The National Gallery has got one or two excellent things from the same source, I bought my Bramantino (for which I have been offered L.500), my Carpaccio and one or two others (the signed early Sebastiano del Piombo among them) and picked out fourteen very valuable pictures for Ivor Guest. I never could make out why Eastlake did not take a whole lot, including those which I have mentioned. They were offered to him in my presence at a very moderate price — one fifth of their real value. This and allowing the splendid Lochis collection to slip through his fingers, were the greatest mistakes he ever made'.

24. 'Il quadretto in tela dal Giorgione (dai conoscitori almeno ritenuto tale) si trova tuttora invenduto nella raccolta Manfrin di Venezia. . . . É una gran bella cosa, nè lo stato di conservazione parvemi cattivo, ma il prezzo, che se mi chiede — di 30 000 Lire — è esagerato. L'argomento però parmi troppo labrico per quella gente, e poi è un quadretto che non sarà mai gustato, se non da' veri conoscitori d'arte'; Morelli to Hudson, Archivio della Fondazione Cavour, Santena.

25. Wilhelm von Bode, *Mein Leben*, Berlin (1930), I, p. 125.

26. The importance of Julius Meyer in the formation of the Berlin collections is discussed in Tilmann von Stockhausen, *Geschichte der Berliner Gemäldegalerie und ihrer Erwerbungspolitik, 1830 bis 1914*, Hamburg, 1997, and will also appear in the commentary to Bode's autobiography that is being prepared for publication under the direction of Thomas W. Gaehtgens. I am grateful to von Stockhausen for generously giving me transcriptions of the documents in the Berlin archives.

27. The following documentation is from the Zentralarchiv, Staatliche Museen zu Berlin-Preussischer Kulturbesitz.

28. Zentralarchiv, I/GG 59, letter from Wilhelm von Bode to the general director of the royal museums, Guido Graf von Usedom, 11 May 1875: 'Verehrter Herr Graf, wenn ich Ew. Exzellenz während meiner Anwesenheit hier in Italien noch keine Nachricht gegeben, so bitte ich mich mit dem Wunsche zu entschuldigen, nur mit einer Anzahl bestimmter Offerten oder einigermaßen sicheren Aussichten auf Kunstwerke ersten Ranges Ew. Exzellenz entgegenzutreten. Und dies ist jetzt, nachdem ich länger als eine Woche im oberen Toskana und in Umbrien mich aufgehalten habe, allerdings der Fall. . . . Heute werde

ich den bekannten Giorgione im Palazzo Manfrin ("G's Familie in Landschaft"), der bisher wegen seiner starken Übermalung noch immer nicht gekauft ist, mir wieder einmal genau ansehen. Es ist trotz allem ein köstliches Bild und vielleicht ist das Alte noch mehr oder weniger darunter. Es soll jetzt etwa für 25 000 Lire zu haben sein, während man früher 1500 £. St. forderte. Für Dresden steht vielleicht der Ankauf in naher Aussicht, da man — wie ich schon in Berlin hörte — Prof. Große den Auftrag nach seinem künstlerischen Ermessen gegeben hat'.

29. Zentralarchiv, I/GG 60, letter from Wilhelm von Bode to Guido Graf von Usedom, from Bologna, 9 October 1875: 'Während ich in Brescia und Mailand mich zu erholen suchte, reiste Dr. Meyer von Brescia direkt nach Venedig, namentlich um sich dort nach dem kleinen Giorgione bei Manfrin umzusehen, welcher angebl. in diesem Sommer an einen russischen Grafen verkauft sein sollte (mit anderen Bildern der Sammlung für 150,000 Lire, die der ganze Rest nicht mehr wert ist.) Wie mir aber Dr. Meyer heute schrieb, befindet sich der Giorgione an Ort und Stelle u. wird nach wie vor zu haben sein: Die Forderung von 1500 £ St. in diesem Frühjahr war er aber angeblich für 25,000 Lire zu haben — für einen Giorgione wenig, für eine Ruine aber jedenfalls ziemlich viel'.

30. Meyer's letter is so important that it deserves quoting in full (Meyer to Usedom, 23, 25 October 1875, Zentralarchiv, I/GG 60): 'Der bekannte Giorgione-Manfrin ist, wie ich Euer Exzellenz schon telegraphierte, nicht verkauft: Der Vertrag, der über den Erwerb des Bildes (nebst zwei anderen) im Juni von einem Russen eingegangen worden, hat die vorbehaltene Zustimmung des betr. Familienhauptes nicht erhalten und ist also zurückgegangen. Bei neuer Prüfung und Besichtigung bin ich in dem Wunsch, unsere Galerie möge in den Besitz des Bildes gelangen, auf's Neue bestärkt worden: auch Baron v. Liphart, der sich gerade in Venedig befand, war derselben Meinung. Dr. Bodes Brief hat Euer Exzellenz schon vorgelegen; ich füge hier hinzu, was Crowe und Cavalcaselle (*North Italy* II 135-137) über dasselbe aussagen (in Auszügen): "The second picture . . . in the surrounding scenery." Leider gibt die beiliegende Photographie (durch einen Irrtum Nayas erst gestern hier eingetroffen), bei dem ziemlich tiefen Ton des Bildes eine ganz ungenügende Vorstellung, doch ist die Luftperspektive, die schöne Wirkung der Landschaft auch in der Photogr. noch erkennbar. Größe: Über H. 0,83, Br. 0,74. In der *Zeitschrift für bildende Kunst* 1866 findet sich im Holzschnitt nebst Text von Reinhart: doch, wenn ich nicht irre, auch ein Stich des Bildes in derselben Zeitschrift, in den Jahrgängen 73-75. Der Preis ist nicht mehr der exorbitante, der meines Wissens (bei dem Zustande der

Erhaltung) dem Verkaufe des Bildes früher entgegenstand. Allerdings hatte das Gemälde nicht durch Reinigung, denn durch teilweise Restauration gelitten — man würde es jetzt wohl im Ganzen lassen müssen, wie es ist, so würde es seinen Käufer sicher zu 60-80,000 Fr. finden, um so mehr als es der einzige Giorgione ist, der je in den Handel kommen wird. Ich habe mich diesmal mit dem (bevollmächtigten) Verwalter des Besitzers selber in Verbindung gesetzt: die Forderung ist 40,000 Lire, doch mit der Andeutung, daß man auf 35,000 wohl herabgehen würde. Wäre es zu 20,000-25,000, was nicht unmöglich scheint, zu haben, so könnte man sich doch zu dem Erwerb Glück wünschen. Die Erhaltung könnte wohl bei höherem Preise einiges Bedenken erregen; aber wie bedauerlich wäre es andererseits, wenn das Bild nicht in eine Galerie überginge. Zudem ein Gemälde, das jene lebendig allgemein menschliche Schönheit hat, die Jedem zugänglich ist'.

31. Zentralarchiv, I/GG 60, letter from Friedrich Nerly from Venice, to Guido Graf von Usedom, 2 April 1876: 'Ew. Exzellenz, wertes Schreiben vom 27. März erhielt ich vor einigen Tagen und glaubte nicht so bald als es mir gelungen ist, Aufschluß über die gestellten Fragen geben zu können, indem ich vor einigen Jahren dem Marchese Sardegna gegenüber, mich in ähnlicher Lage, wegen dem Verkauf des Tizians (Grablegung) nach Köln, befand und seitdem diesen Herrn recht gerne auszuweichen suchte.

Glücklicherweise fand ich im Palast Manfrin, den mir von damals her sehr wohl bekannten Kustoden Pinpelli ganz allein, der mir dann, ohne daß ich danach frug, wie aber die Rede auf den nicht mehr vorhandenen Giorgione kam, alles haarklein erzählte. Zur Zeit als die Verhandlungen wegen diesem Bild von Berlin aus schon abgeschlossen waren, hatte der hier als bester Kunstkenner geltende Signor Morelli davon Kenntnis bekommen und in seinem italienisch patriotischen Eifer nichts Eiligeres zu tun für nötig gehalten, als jenen Verkauf ins Ausland auf alle mögliche Weise zu verhindern, wozu ihm außerdem der hiesige Prinz Giovanelli, mit dem er sich damals zusammen in Rom befand, die Hand bot.

Die hiesige Regierung hat bekanntlicher Weise das Vorkaufsrecht, was hierbei nun geltend gemacht werden sollte; bekanntlicher Weise hat die Regierung, obgleich man auf alle mögliche Weise mit Taxen und Abgaben gezwickt und gezwackt wird, aber auch niemals Geld, am allerwenigsten für Kunstgegenstände. Es wurde demnach der Prinz Giovanelli mit in diese Angelegenheit hineingezogen, um die 27,000 Francs wie Pinpelli mir es sagte, vorzuschießen, was geschehen ist.

Er — Pinpelli — glaubte nun gar, daß der Prinz noch hier in seinem Palaste das Bild (vorsichtigerweise) beherberge. Prinz und

Prinzessin sind beide verreist, ich ging also nach dessen Palast und erfuhr von der Dienerschaft, daß das Bild nach Mailand abgegangen sei, ob vielleicht in die Brera oder Königl. Palast wußte man mir nicht zu sagen. gez. Nerly'.

At the end of the month Nerly wrote again to Usedom about Morelli and the *Tempesta*, 29 April 1876: 'Euer Exzellenz, Erst jetzt komme ich zur Beantwortung Dero letzten Schreibens, indem ich dem Faktotum der Galerie Manfrini absichtlich daselbst nicht aufsuchen wollte, sondern ihn per Caro, so zufällig auf der Straße abzufassen suchte. Unter dem Vorwand nach den Preisen der noch verkäuflichen Gegenstände fragend, brachte ich dann das Gespräch auf den fraglichen Punkt. Der Abschluß jener Angelegenheiten mit Morelli-Giovanelli und der Regierung fand also im Januar statt und zwar gegen Ende des Monats.

Auf Anraten Morellis ist das Bild dann auch von Giovanelli zum Restaurieren nach Mailand geschickt worden, wo es gegenwärtig noch ist und wahrscheinlich, wie obgenanntes Faktotum sicher zu vernehmen glaubt, von dort auch wiederum in den hiesigen Palast des Prinzen kommen wird. Denn ehe ihm die Regierung nicht das ausgelegte Geld ersetzt, dürfte er es wohl nicht ausliefern. — Natürlich kann einen der Gang dieser Geschichte auf ganz sonderbare Gedanken bringen, und erst nach Verlauf vieler Monate könnte es sich vielleicht herausstellen, ob das Bild nicht durch den patriotischen Fürsprecher, der, da er wohl, um es im Inlande zu erhalten, keinen anderen Ausweg wußte, als den Prinzen erstens dafür zu interessieren, und dann das Ausfuhrverbot vorschob, um den Signor [illegible name] allen, Unannehmlichkeiten der nicht eingehaltenen Verpflichtungen zu entheben.

Über diese meine Ideen bitte ich weiter nichts verlauten zu lassen, die Zeit wird uns aber lehren, wie die Sache sich in Wirklichkeit verhält'.

32. There are two selective accounts of the Giovanelli collection: G. Lafenestre and E. Richtenberger, *Venise*, Paris (1896), pp. 313-17, and N. Barbantini, 'La Quadreria Giovanelli', *Emporium* (1908), pp. 183-205. Part of the Giovanelli collection was later sold in the sale of G. de Cresenzo, Rome, 17-22 May 1954. The nucleus of the collection, some several hundred pictures, had already been formed by the beginning of the eighteenth century, according to the family inventories consulted by Barbantini. It is interesting to compare Mündler's account of the collection in the 1850's, *Travel Diary*, pp. 77, 138.

33. Add. Mss. 38963, British Library, London: 'Mon gouvernement ayant appris par M. Barozzi que la Prusse traitait l'achat de tableaux de Giorgione de la collection Manfrin, a prié le Prince Giovanelli de prevenir les délegués prussians, et de s'emparer du tableau pour la Pinacotheque de Venise.

Giovanelli a donc acheté le petit tableau pour la somme de trente mille livres — à présent il se trouve dans les mains de Cavenaghi qui l'a déjà nettoyé et l'a trouvé beaucoup plus conservé qu'on ne s'y attendait. Mais le prix est très fort'!

34. *Ibid.*: 'Le Gouvernement Italien a acheté le petit Giorgione du Palais Manfrin, quoique vous l'avez payé trop chère. Sous l'habile restoration de M. Cavenaghi il en sortira quelque chose et les tableaux de ce grand maitre sont si rares que l'Italie a bien fait de ne pas laissir passer dans d'autres mains un example du peintre dont l'authenticité pourrait etre admise par tous les meilleurs juges'.

35. *Ibid.*: 'Il a souffert assez et je suis content de le savoir mort. C'était un homme bon qui a fait beaucoup de bien à son pays. Les pauvres de Venise en sentiront la perte. J'espère qu'il aura laissé sa collection de tableaux à l'Académie de Venise, dont il était le Président'.

36. *Ibid.*: 'Le testament du Prince Giovanelli est un vrai scandale, et tout le monde ici s'en est indigné. L'avez-vous lu? Il défend à tous ceux qui ne sont pas de sa religion d'assister à ses funérailles; il laisse tous ses biens à son fils adulterin; rien a ses amis qui lui ont soigné dans sa dernière maladie, aucune pension àses dependants, rien à l'Académie . . . une somme très mesquines aux pauvres. . . . Je n'aurais pu connu que le Prince était tellement bigot et méprisable'.

37. Mrs Gardner to Berenson, 4 November 1896, *The Letters of Bernard Berenson and Isabella Stewart Gardner 1887-1924*, ed. R. Van N. Hadley, Boston (1987), p. 69.

38. Pyrker, *Mein Leben*, ed. A. P. Czigler, Vienna (1966), esp. chap. 1, where he discusses his friendship with the Capello family, an ancestor of whom has sometimes been identified in the *Broccardo Portrait*, and chap. 5, where he discusses the artists he knew in Venice.

39. Robinson wrote an account of the collection, *Art Journal*, London (1885), pp. 133-37.

40. For a defence of Robinson as a connoisseur, see Helen Davies, *Sir John Charles Robinson (1824-1913): His Role as a Connoisseur and Creator of Public and Private Collections*, Ph.D. diss., Oxford (1992).

41. The discussion regarding Duveen and the *Allendale Adoration* in the following paragraphs is based on material in the Duveen archives.

42. G. Gronan, 'The *Allendale Nativity* by Giorgione', *Art in America*, XXVI (1938), pp. 95ff.

43. G.M. Richter, 1937, pp. 257-58.

44. G.M. Richter, 'Lost and Rediscovered Works by Giorgione', *Art in America*, XXX (1942), pp. 142f.

45. K. Clark, 'Die Londoner italienische Ausstellung', *Zeitschrift für bildende Kunst*, LXIII (1929-30), p. 137.

46. Berenson's letter is in the dossier on the *Allendale Adoration*, archives, National Gallery of Art, Washington, D.C.

47. Berenson, *Italian Pictures . . . Venetian School*, London (1957), I, p. 85.

48. Clark, 'Four Giorgionesque Panels', *The Burlington Magazine*, LXXI (1937), p. 199, where he attributed the scenes to Giorgione with reserve.

49. Letter from Clark to Richter, 3 November 1937, George Martin Richter papers, Photo Archive, National Gallery of Art, Washington, D.C.

50. Richter, 'Four Giorgionesque Panels', *The Art Bulletin*, LXXII (1938), pp. 33-34.

51. Kenneth Clark, *Another Part of the Wood: A Self-Portrait*, London (1974), pp. 262-64.

CHAPTER VII

1. My thanks to Gabriele Finaldi for alerting me to the existence of the fresco. James Dearden has generously shared with me his enviable knowledge of Ruskin scholarship.

2. I am grateful to the Rt. Hon. Alan Clark and the Saltwood Heritage Foundation for permission to publish the fresco, and to David Bomford, David Alan Brown, Gianluigi Colalucci, Paul Joannides, Alessandra Moschini Marconi, Roger Rearick, Francesco Valcanover, and others for helpful discussions about the discovery. It is hoped that more information will emerge now the fresco is in conservation at the Hamilton Kerr Institute, Cambridge.

3. The frescoes were first published by F. Valcanover, 'Gli affreschi di Tiziano al Fondaco dei Tedeschi', *Arte Veneta*, XXI (1967), pp. 266-68. For the most recent account, see Valcanover, in *Titian, Prince of Painters*, 1990-91, pp. 135-40; A. Moschini Marconi, *Galleria G. Franchetti alla Ca' d' Oro Venezia*, Rome (1992), pp. 73-76.

4. *Lettere sull' arte di Pietro Aretino*, ed. E. Camesasca, Milan (1957), II, pp. 16-18; English trans. 1976, pp. 225-26. The text reads: 'I fell to gazing at the marvellous spectacle presented by the countless number of barges, crammed by no fewer strangers than townspeople, which were delighting not only the onlookers but the Grand Canal itself, the delight of all who navigate her . . . And after all these various streams of humanity applauded happily and went their way, you would have seen me like a man sick of himself and not knowing what to do with his thoughts and fancies, turn my eyes up to the sky; and ever since God created it, never had it been so embellished by such a lovely picture of lights and shades . . . Also consider my wonder at the clouds made up of condensed moisture; in the principal vista they were partly near the roofs of buildings, and partly on the horizon, while to the right all was in a fused shading of greyish black. I was awestruck by the variety of colours they displayed: the nearest glowed with the flames of the sun's fire; the furthest were blushing with the brightness of partially burnt vermilion. Oh, how beautiful were the strokes with which Nature's brushes pushed the air back at this point, separating it from the palaces in the way that Titian does when painting his landscapes!'

5. Sanudo, 1496–1533, VI, p. 85. For the full documentation see pp. 304-06 below, the catalogue entry on the *Female Nude* from the Fondaco.

6. Dazzi, 1939–40, pp. 873–96.

7. For a modern view of the architectural history, see J. McAndrew, *Venetian Architecture of the Early Renaissance*, Cambridge (1980), pp. 434–48.

8. The following account is based on Colalucci's observations and unpublished report.

9. Boschini, 1660, ed. Pallucchini, pp. 376–77.

10. According to Justi, 1936, II, pp. 264–65, Canaletto's views of the Rialto in Amsterdam and the Mielzynski Museum, Poland, give the best indications of the lively red colours of the frescoes.

11. Ruskin, eds. Cook and Wedderburn, III, p. 212. Many decades late, Ruskin recalled in a footnote to his lecture on 'The Relation between Michael Angelo and Tintoretto' that 'I saw the last wrecks of Giorgione's frescoes on the outside of it in 1845'.

12. *Ibid.*

13. From *The Stones of Venice*, ibid., X, p. 378.

14. *Christmas Story: John Ruskin's Venetian Letters of 1876–1877*, ed. Van Akin Burd, Newark (1986), pp. 254, 261.

15. Ruskin, eds. Cook and Wedderburn, XXIV, p. 233.

16. *Ibid.*, VII, p. 440; see pl. 79 for 'The Hesperid Æglé', also reproduced in *Modern Painters*, V.

17. A list of Renaissance representations after this famous relief is given in P. P. Bober and R. Rubinstein, *Renaissance Artists and Antique Sculpture*, London and New York (1968), p. 174. Michelangelo as a source for various subjects, notably the *Fall of Man* on the Sistine Ceiling; see A. Ronen, 'An Antique Prototype for Michelangelo's *Fall of Man*, *Journal of the Warburg and Courtauld Institutes*, XXXVII (1974), pp. 356–58.

18. In his full discussion of the iconography, Philippe Verdier considered the possibility that Bellini's apples were those of the Hesperides; see 'L' allegoria della misericordia e della giustizia di Giambellino agli Uffizi', *Atti del Reale Instituto Veneto di Scienze, Lettere ed Arti*, CXI (1952–53), p. 114.

19. As described by P. Joannides, 'A Newly Unveiled Drawing by Michelangelo and the Early Iconography of the Medici Tombs', *Master Drawings*, XXIX (1991), pp. 255–62.

20. J. Cox Rearick, *Dynasty and Destiny in Medici Art: Pontormo, Leo X, and the Two Cosimos*, Princeton (1984), pp. 143–53; also S. Lecchini Giovannoni, *Alessandro Allori*, Turin (1991), pp. 249–50.

21. 'I saw the last traces of the greatest works of Giorgione yet glowing like a scarlet cloud on the Fondaco dei Tedeschi. And though that scarlet cloud ("sanguigna e fiammeggiante, per cui le pitture cominciarono con dolce violenza a rapire il cuoro delle genti", Zanetti) may, indeed, melt away into paleness of night, and Venice herself, waste from her islands as a wreath of wind-driven foam fades from their weedy beach; that which she won of faithful light and truth shall never pass away'; Ruskin, eds. Cook and Wedderburn, VII, pp. 438–39.

22. The relationship between the *ignudi* and the Fondaco has provoked much comment; see Smyth, 1979.

23. G. Priuli, *Rerum italicarum scriptores*, 2nd. ed., Bologna (1938), XXIV, iii.

24. Leonardo, *Treatise on Painting*, ed. A. P. McMahon, Princeton (1956), I, pp. 58f.

25. Fehl, 1957.

26. Egan, 1959.

27. Fischer, 1974.

28. L'Venturi, 'Le Compagnie della Calza', *Nuovo Archivio Veneto*, N.S., XVI, ii (1908), pp. 161–221; XVII, i (1909), pp. 140–233; P. Molmenti, *La storia di Venezia nella vita privata*, Bergamo (1928), II, pp. 381–87; G. Padoan, *Momenti del rinascimento veneto*, Padua (1978), pp. 35–93.

DOCUMENTS
AND SOURCES

1506 adj. primo zugno fo fatto questo de man
de maistro zorzi da chastel fr[ancho] cholega
de maistro vizenzo chaena ad instanzia de
misser giacomo.
Wilde, 1931, p. 100.

COMMISSION FOR THE PALAZZO
DUCALE, VENICE
1507
Nos Capita Consilii X dicimus or ordinamus
vobis Magnifico Domino Francisco Venerio
Provisori Salis ad Capsam Magnam deputato
che numerar dobiate aconto dila fabricha
dila Cancellaria et del loco dil Conseglio di
X a Maistro Zorzi Spavento protho ducati
trenta, et a Maistro Zorzi da Chastel franco
depentor per far el teller da esser posto alau-
dientia delo prefato Illustrissimo Conseglio
ducati vinti. Suma ducati 50. Datum die 14
Augusti 1507. Videlicet ducati cinquanta.
Ducati 50
Franciscus Thiepulo cc. X
Zacharias Delphinus cc. X
Hieronimus Capello cc. X
Nicolaus Aurelius III.ᵐⁱ Consilij Secretarius
mandato subscripsi.
*Archivio di Stato, Venice, Notatorio Provved-
itori al Sal, Registro n. 3, cc. 114v; 119r; 121r.
Maschio, 1978, p. 6; Maschio, 1994, p. 200.*

Nos Capita Illustrissimi Consilij X Dicimus

et ordinamus vobis Domino Alovisio Sanuto
Provisori Salis ad Capsam magnam che dar
et numerar dobiate a maistro Zorzi da
chastelfranco depentor per el teller el fa per
laudientia novissima di Capi di esso
Illustrissimo Conseio ducati vinticinque
videlicet /25/ di quel instesso denaro fu dep-
utato et speso in la fabricha di la audientia
per deliberation dil prefato Illustrissimo
Conseglio. Datum Die 24 Januarii 1507.
Aloisius Arimundus cc. X. Ducati 25
Nicolaus Priolus cc. X
Aloisius da Mula cc. X
Nicolaus Aurelius Illustrissimi Consilii
Secretarius
*Archivio di Stato, Venice, Notatorio dei
Provveditori al Sal, Registro n. 3, c. 119r
Maschio, 1978, p. 8; Maschio, 1994, p. 200.*

1508
Nos Capita Illustrissimi Consilii x Dicimus
et ordinamus vobis Domino Alovisio Sanuto
Provisori Salis ad Chapsam magnam, che dar
et numerar dobiate a maistro Zorzi Spavento
protho per la tenda di la tella facta per
Camera di la audientia nuova, monta in
tutto come appar per il suo conto Lire 35
Soldi 18 di pizoli videlicet Lire trentacinque
Soldi 18. Datum die 23 Maij 1508.
Bernardus Barbadico Caput Xᵐ
Lire 35 Soldi 18
Marcus Antonius Laurendanus cc. X
Franciscus Foscaris cc. X
Nicolaus Aurelius Illustrissimi Consilij
Secretarius

*Archivio di Stato, Venice, Notatorio dei
Provveditori al Sal, Registro n. 3, c. 119r.
Lorenzi, 1868, pp. 141, 144, 145; Maschio,
1978, p. 9; Maschio, 1994, p. 200.*

CONTRACT BETWEEN ALVISE DE
SESTI AND GIORGIONE REGARDING
FOUR PICTURES OF THE STORY OF
DANIEL
1508
El se dichiara per el presente come el claris-
simo messer Aluixe di Sesti die a fare a mi
Zorzon da Castel francho quatro quadri in
quadrato con le geste di Daniele in bona pic-
tura su telle, et li telleri sarano sominestrati
per dito m. Aluixe, il quale doveva stabilir
la spexa di detti quadri quando serano com-
pidi et di sua satisfatione entro il presente
anno 1508. Io Zorzon de Castelfrancho di
mia man scrissi la presente in Venetia li 13
febrar. 1508.
Published by Molmenti, 1878-79, from a
text that G. M. Urbani di Gheltof, deputy
director of the Museo Correr, had copied
in 1869, when the document was for sale
with a Venetian dealer. It has never
reappeared, and some scholars consider it
fraudulent.

DOCUMENT FOR THE COMMISSION
OF CHRIST CARRYING THE CROSS,
SAN ROCCO (Fig. 15)
1508
Adì 25 Marzo al Nomi de Dio alla Bancha.
Et se Supplicha alii Signorie Vostre a Voi

Signori della Bancha della Schuola de Missier S. Roccho per parte del suo humil e devoto Servo Ser Jacomo de' Zuanne al prexente Nostro Guardian Grando, chi cum sit che el sia ormai Vecchio, et bona parte della sua età habbi per devocion sua Consuma in questa vostra Sancta Schuola, oltra che' sempre in ogni impresa la sua borsa è stata all'honor, et utile de questo Sancto loco aperta, come a bona parti delle Signorie Vostre pol esser ben notto, me hasse sparagna la sua persona ad ogni faticha per grande sia state piantonche la sia d'eta, e d'anni piena, vorria piasendo Corp' alle Signorie Vostre, et de' gratia rechiede attento l'Amor, è la devocion che sempre ha havuto et ha a questo glorioso Sancto sotto el nexillo del qual siamo uniti in charità, et Amor, che li sia concesso poter nella Capella picola della Croxe della Nostra Giexia far per si, et Posteri suoi, et suo Fradello el suo monumento perpetuo; osservandosi all honor de Dio, et augumino della Schuola donar a essa Schuola in primij ducati Cento deinde a sue spexe ad hornar ditta Capella de' pitture, pavimento, banchi, et altri adornamenti che li parerà conveniente, et necessarij et mettergli etiam del suo in capellan che' celebri Messa in detta Giexia ogni zorno et in perpetuo promettendo, che ne per si ne successori, et posteri suoi mai remettera, overo promettera che se metti la sua Arma, et questo domandi de' Grazia, et accio el possi dimostrar el suo bon animo, et voler che li ha a questo devoto luogo et che la devocion sua transcendo nella sua posterità a questo glorioso Santo.

Vista, et ben Considerata la sopraditta Supplicatione porta davanti a nui della Bancha del glorioso Missier San Roccho. Mandando fiora dell'Albergo el nostro Guardian Grande cioè el ditto Missier Jacomo acciò cadaun liberamente possi dir l'animo suo; Dicemo l'Opinion Nostra esser accostandossi al dover, et ali honestà, e maxime vista una Parte prexa nel Nostro Capitolo Zeneral. Adì 2 Decembris 1498 del dar della ditta Capella, come in questo appar, et ex quo questo Concession cede in evidentissimo honor, utile et ornamento della nostra Santa Giexia: Che al prefato Messer Giacomo de' Zuanne et Fradello, Fioli et heredi suoi sia Concesso quanto humilmente el domanda et supplica et tanto più quanto la Confraternità Nostra puol sperar de grandissimo ben, et proficuo et da esso supplicante et dalla caxa sua, oltra l'ampia offerta, et tanto più siamo raxenivolmente inclinadi à Compiaxergli quanto nella Capella predetta el non domanda per loro uso altro, che al Sepoltura; et accio, che el desiderio suo habbi votivo, et dexiderato effecto con questo che' oltre la sepoltura, banchi, palio, ò altar non possi metter sopra i Muri o in alguno altro luogo di essa Capella la sua Arma.

Archivio di Stato, Venice, Archivio della Scuola di San Rocco. Libro + Seconda consegna, busta 44. Anderson, 1977, pp. 186-88.

DOCUMENTS REGARDING THE FONDACO DEI TEDESCHI
1508

Die 8 Novembris 1508 Riferì sier marco Vidal di ordene dela Illustrissima Signoria ali magnifici Signori Provedadori al Sal che sue magnificentie che sula causa de maistro Zorzi da chastelfrancho pel depenzere del fondego di todeschi sue magnificentie ministrar debano justitia et fu riferito al magnifico messier Hieronimo da mulla et missier Aloixe Sanudo et omnibus aliis.

Archivio di Stato, Venice, Notatorio dei Provedditori al Sal, Registro n. 3, c. 123v. Maschio, 1978, pp. 9-10; Maschio, 1994, p. 198.

Die XJ decembris 1508, Die dicta Ser Lazaro bastian, ser vettor Scarpaza, et ser vethor di mathio per nominati da ser zuan belin depentori constituidi ala presentia di magnifici Signori missier Caroso da cha da pesaro, messier zuan zentani, messier marin griti, et messier Alvise Sanudo dignissimi provedadori al Sal, come deputadi ellecti dipintori aveder quello pol valer la pictura facta sopra la faza davanti del fontego di todeschi, et facta per maistro zorzi da Castel francho et zurati dachordo dixeno a juditio et parer suo meritar el dicto maistro per dicta pictura ducati cento e cinquanta intuto. Die dicta. Li prefati Magnifici Signori dignissimi provedadori al Sal Aldido el prefato maistro Zorzi richiedendo el resto di quanto lui diceva dover haver per la depenctura per lui facta sopra la fabricha del fontego di thodeschi sula faza davanti reportandossi al juditio de Sue Magnificentie, dove li presenti aldidi et justa la deposition de deputadi pictori, per dicto lavor termenarono el ditto maistro habia et haver debia per il lavor ditto ut supra facto jntuto ducati cento et trenta, di quali fin hora haver auto ducati cento. Si che per suo resto habia, et haver debia ducati trenta per resto. Et a questo intervenendo el Consensso del prefato maistro Zorzi, el qual romaxe contento de quanto volesse et fo dechiarato per sue Magnificentie.

Archivio di Stato, Venice, Notatorio dei Provveditori al Sal, Registro n. 7, c. 95r. Gaye, 1839-40, II, p. 137; Gualandi, 1856, III, p. 90; Maschio, 1978, p. 10; Maschio, 1994, p. 198, whose transcription is followed here.

MARINO SANUDO, *The Diaries*
1508

Dil mese di avosto 1508. A di primo, marti. Fo cantà una messa, preparato in corte dil fontego di todeschi, fabricato novamente . . .et li todeschi comenzano a intrar et ligar balle, e tutavia dentro si va compiando et depenzendo di fuora via.

Sanudo, 1496-1533, VII, p. 597.

CORRESPONDENCE BETWEEN ISABELLA D'ESTE AND TADDEO ALBANO
1510

25 October, Isabella d'Este a Taddeo Albano. Thadeio Albano. Spectabilis Amice noster charissime. Intendemo che in le cose et heredità de Zorzo da Castelfrancho pictore se ritrova una pictura de una nocte, molto bella e singulare. Quando cossì fusse, desideraressimo haverla. Però vi pregamo che voliati essere cum Lorenzo da Pavia, et qualche altro che hanno iudicio et disegno, et vedere se l'è cosa excellente, et trovando de sì operiati il megio del m.co m. Carlo Valerio, nostro compare charissimo, et de chi altro vi pareria per apostar questa pictura per noi, intendendo il precio et dandone aviso. Et quando vi paresse de concludere il mercato, essendo cosa bona, per dubio non fusse levata da altri, fati quel che ve parerà; chè ne rendemo certe fareti cum ogni avantagio e fede e cum bona consulta. Offeremo a vostri piaceri ecc. Mantuae XXV oct. MDX.

1510, 8 November, Taddeo Albano a Isabella d'Este:

Ill.ma et Exc.ma M.a mia obser.ma Ho inteso quanto mi scrive la Ex.V. per una sua de XXV del passato, facendome intender haver inteso ritrovarsi in le cosse et eredità del q. Zorzo de Castelfrancho una pictura de una notte, molto bella et singulare; che essendo cossì si deba veder de haverla. A che rispondo a V. Ex. che detto Zorzo morì più di fanno da peste, et per voler servir quella ho parlato cum alcuni mei amizi, che havevano grandissima praticha cum lui, quali mi affirmano non esser in ditta heredità tal pictura. Ben è vero che ditto Zorzo ne feze una a m.Thadeo Contarini, qual per la informatione ho autta non è molto perfecta sichondo vorebe quella. Un'altra pictura de la nocte feze ditto Zorzo a uno Victorio Becharo, qual per quanto intendo ède meglior desegnio et meglio finita che non è quella del Contarini. Ma esso Becharo al presente non si atrova in questa terra, et sichondo m'è stato afirmatto nè l'una nè l'altra non sono da vendere per pretio nesuno, però che li hanno fatte fare per volerli godere per loro; sichè mi doglio non poter satisfar al dexiderio de quella ecc. Venetijs VIII novembris 1510. Servitor Thadeus Albanus.

Archivio di Stato, Mantua, Fondo Gonzaga, Copialettere particolare di Isabella d'Este, n. 2996, 1. 28, c. 70 r. Luzio, 1888, p. 47; Maschio, 1994, p. 203.

MARCANTONIO MICHIEL, *Diarii*
Between 12 and 15 November 1512

Item in Cons. di X fu da taglia a Zuan Favro el qual confinato in preson per 7 anni per el Cons. di X per contrabandier, era fuggito di giorno, facendosi le cerche da li guardiani. *Sixteenth-century marginal annotation:* Questo Zuan Favro è depento sopra il fontego de todeschi sopra il canton che guarda verso San Bortolomio. Era valentissimo homo della sua vita.

Biblioteca Correr, Venice, Ms. Cicogna 2848. Cicogna, 1861, p. 389.

MARCANTONIO MICHIEL, *Pittori e pitture in diversi luoghi*
1525-43
In Padoa. In casa di Misser Pietro Bembo. Li dui quadretti di capretto inminiati furono di mano di Julio Compagnola; luno è una nuda tratta da Zorzi, stesa e volta, et l'altro una nuda che da acqua ad uno albero, tratta dal Diana, cun dui puttini che zappano.
Ed. Frimmel, p.22.

1525
Opere in Venezia
In casa de M. Taddeo Contarino, 1525.
La tela a oglio delli 3 phylosophi nel paese, dui ritti et uno sentado che contempla gli raggii solari cun quel saxo finto cusì mirabilmente, fu cominciata da Zorzo da Castelfranco, et finita da Sebastiano Venitiano.
La tela grande a oglio de linferno cun Enea et Anchise fo de mano de Zorzo da Castelfranco.
La tela del paese cun el nascimento de Paris, cun li dui pastori ritti in piede, fu de mano de Zorzo da Castelfranco, et fu delle sue prime opere.
Ed. Frimmel, pp. 86, 88.

In casa de M. Hieronimo Marcello. A. S. Thomado, 1525.
Lo ritratto de esso M. Hieronimo armato, che mostra la schena, insino al cinto, e volta la testa, fo de mano de Zorzo da Castelfranco.
La tela della Venere nuda, che dorme in uno paese cun Cupidine, fo de mano de Zorzo da Castelfranco, ma lo paese et Cupidine forono finiti da Titiano.
El S. Hieronimo insin al cinto, che legge, fo de mano de Zorzo da Castelfranco.
Ed. Frimmel, pp. 88, 90.

1528
In casa de M. Zuanantonio Venier, 1528.
El soldato armato insino al cinto ma senza celada, fo de mano de Zorzi da Castelfranco.
Ed. Frimmel, p. 98.

1530
In casa de M. Chabriel Vendramin, 1530.
El paesetto in tela cun la tempesta, cun la cingana et soldato, fo de mano de Zorzi da Castelfranco.
El Christo morto sopra el sepolcro, cun lanzolo chel sostenta, fo de mano de Zorzi da Castelfranco reconzata da Titiano.
Ed. Frimmel, p. 106.

1531
In casa de M. Zuan Ram, 1531, A. S. Stephano.
La pittura della testa del pastorello che tien in man un frutto, fo de man de Zorzi da Castelfranco.
La pittura della testa del garzone che tien in man la saetta fo di man di Zorzo da Castelfranco.
Ed. Frimmel, p. 104.

1532
In casa di M. Antonio Pasqualigo 1532, 5 Zener.
La testa del gargione che tiene in mano la frezza, fu de man de Zorzi da Castelfrancho, havuta da M. Zuan Ram, della quale esso M. Zuane ne ha un ritratto, benche egli creda che sii el proprio.
Ed. Frimmel, p. 78.
La testa del S. Jacomo cun el bordon, fu de man de Zorzi da Castelfrancho, over de qualche suo discipulo, ritratto dal Christo de S. Rocho.
Ed. Frimmel, p. 80.

1532
In casa de M. Andrea di Oddoni, 1532.
El San Hieronimo nudo che siede in un deserto al lume della luna fu de mano de. . .ritratto da una tela de Zorzi da Castelfrancho.
Ed. Frimmel, p. 86.

1543
In casa de M. Michiel Contarini alla Misericordia, 1543 austo.
Il nudo a pena in un paese fu di man di Zorzi, et è il nudo che ho io in pittura del istesso Zorzi.
Biblioteca Marciana, Venice, Ms. Classe XI, Cod. LXVII (=7351).

BALDASSARE CASTIGLIONE, IL CORTEGIANO
1524
Eccovi che nella pittura sono eccellentissimi Leonardo Vincio, il Mantegna, Raffaello, Michelangelo, Georgio da Castelfranco: nientedimeno, tutti son tra sè nel far dissimili; di modo che ad alcun di loro non par che manchi cosa alcuna in quella maniera, perchè si conosce ciascun nel suo stil essere perfettissimo.

INVENTORY OF THE COLLECTION OF CARDINAL MARINO GRIMANI
1528
Una testa di puto ritrato di man di Zorzon Ritratto di Zorzon di sua man fatto per david e Golia
Paschini, 1926-27, p. 171.

PAOLO PINO, DIALOGO DI PITTURA
1548
Lauro. Voglio che sappiate, che'oggidì vi sono de' valenti pittori. Lasciamo il Peruggino, Giotto fiorentino, Rafaello d'Urbino, Leonardo Vinci, Andrea Mantegna, Giovan Bellino, Alberto Duro, Georgione, l'altro Perugino, Ambrosio Mellanese, Giacobo Palma, il Pordonone, Sebastiano, Perin dal Vago, il Parmeggiano, messer Bernardo Grimani, et altri che sono morti, ma diciamo del vostro Andrea del Sarto, di Giacobo di Pontormo, di Bronzino, Georgino Aretino, il Sodoma, don Giulio miniator, Giovan Gierolomo bresciano, Giacobo Tintore, Paris, Dominico Campagnolla, Stefano dall'Argine giouane

Padovano, Giosefo il Moro, Camillo, Vitruvvio, et altri poi, come Bonafacio, Giovan Pietro Silvio, Francesco Furlivese, Pomponio. Non vi pongo Michel Angelo, ne Titiano, perché questi duo li tengo come dèi e come capi de' pittori, e questo lo dico veramente senza passione alcuna. . . .
Lauro: Voi m'hauete sodisfatto benissimo, e se la memoria mia conserua il ragionamento vostro, chiuderò la bocca a questi, che voranno diffendere la scultura, come per un'altro modo furno confusi da Georgione da Castel Franco, nostro pittor celeberrimo e non manco degli antichi degno d'honore. Costui, a perpetua confusione degli scultori, dipinse in un quadro un San Georgio armato, in piedi, appostato sopra un tronco di lancia, con li piedi nelle istreme sponde d'una fonte limpida e chiara, nella qual transverberava tutta la figura in scurzo sino alla cima del capo; poscia avea finto uno specchio appostato a un tronco, nel qual riflettava tutta la figura integra in schena et un fianco. Vi finse un altro specchio dall'altra parte, nel quale si vedeva tutto l'altro lato del San Georgio, volendo sostenare ch'uno pittore può far uedere integramente una figura a un sguardo solo, che non può così far un scultore; e fu questa opera, come cosa di Georgione, perfettamente intesa in tutte le tre parti di pittura, cioè disegno, invenzione e colorire.
Fabio: Questo si può facilmente credere, perch'egli fù (come dite) uomo perfetto, e raro, et è opera degna di lui e atta d'aggrandire l'ali alla sua chiara fama.

ANTON FRANCESCO DONI, DISEGNO PARTITO IN PIÙ RAGIONAMENTI
1549
Among letters at the end of the treatise, one addressed to Simon Carnesecchi lists the most important works of art that he should see in Venice:
. . .a Vinegia Quattro cavalli divini, le cose di Giorgione da Castel Franco Pittore, la storia di Titiano (huomo eccellentissimo) in palazzo, la facciata della casa dipinta dal Prodonone sopra il Canal grande, una tavola d'altare d'Alberto Duro in San Bartolomeo; in particolarte v'è lo studio del Bembo e di M. Gabriel Vendramino Gentilhuomo Venetiano alquale io son servidore con molti altri & infinite antichità poi miracolose come è l'Apollo di Monsignor de Martini, che vi saranno mostrate.
Venice (Giolito), ff. Giiiᵛ-Giiii.

GIORGIO VASARI, LE VITE DE' PIÙ ECCELLENTI ARCHITETTI, PITTORI, ET SCULTORI ITALIANI DA CIMABUE INSINO A' TEMPI NOSTRI
1550
VITA DI GIOVANNI BELLINI
Dicesi che ancora Giorgione da Castelfranco attese a quella arte seco ne' suoi primi principii, e molti altri del Travisano e Lombardi, che non iscade farne memoria.

PROEMIO DELLA TERZA PARTE DELLE VITE

Seguitò dopo lui [Lionardo], ancora che alquanto lontano, Giorgione da Castelfranco, il quale sfumò le sue pitture et dette una terribil movenzia a certe cose, come è una storia nella scuola di San Marco a Venezia, dove è un tempo torbido che tuona, e trema il dipinto, et le figure si muovono et si spiccano da la tavola, per una certa oscurità di ombre bene intese.

VITA DI GIORGIONE DA CASTEL FRANCO PITTOR VENIZIANO

Quegli che con le fatiche cercano la virtù, ritrovata che l'hanno, la stimano come vero tesoro e ne diventano amici, né si partono già mai da essa; con ciò sia che non è nulla il cercare delle cose, ma la difficoltà è, poi che le persone l'hanno trovate, il saperle conservare et accrescere. Perché ne' nostri artefici si sono molte volte veduti sforzi maravigliosi di natura nel dar saggio di loro, i quali per la lode montati poi in superbia, non solo non conservano quella prima virtù che hanno móstro e con difficoltà messo in opera, ma mettono, oltra il primo capitale, in bando la massa de gli studî nell'arte da principio da·llor cominciati, dove non manco sono additati per dimenticanti, ch'e' si fossero da prima per stravaganti e rari e dotati di bello ingegno. Ma non già così fece il nostro Giorgione, il quale imparando senza maniera moderna, cercò nello stare co' Bellini in Venezia, e da sé, di imitare sempre la natura il piú che e' poteva; né mai per lode che e' ne acquistasse, intermise lo studio suo, anzi quanto più era giudicato eccellente da altri, tanto pareva a·llui saper meno quando a paragone delle cose vive considerava le sue pitture, le quali, per non essere in loro la vivezza dello spirito, reputava quasi nonnulla. Per il che tanta forza ebbe in lui questo timore, che lavorando in Vinegia fece maravigliare non solo quegli che nel suo tempo furono, ma quegli ancora che vennero dopo lui.

Ma perché meglio sí sappia l'origine e il progresso d'un maestro tanto eccellente, cominciando da' suoi principii, dico che in Castelfranco in sul Trevisano nacque l'anno MCCCCLXXVII Giorgio, dalle fattezze della persona et da la grandezza dell'animo, chiamato poi col tempo Giorgione; il quale, quantunque egli fusse nato di umilissima stirpe, non fu però se non gentile e di buoni costumi in tutta sua vita. Fu allevato in Vinegia, et dilettossi continovamente delle cose d'amore, e piacqueli il suono del liuto mirabilmente, anzi tanto, che egli sonava et cantava nel suo tempo tanto divinamente che egli era spesso per quello adoperato a diverse musiche et onoranze e ragunate di persone nobili.

Attese al disegno et lo gustò grandemente, et in quello la natura lo favorì sì forte, che egli, innamoratosi di lei, non voleva mettere in opera cosa che egli dal vivo non la ritraessi; e tanto le fu suggetto e tanto andò

imitandola, che non solo egli acquistò nome di aver passato Gentile et Giovanni Bellini, ma di competere con coloro che lavoravano in Toscana et erano autori della maniera moderna. Diedegli la natura tanto benigno spirito, che egli nel colorito a olio e a fresco fece alcune vivezze e altre cose morbide et unite e sfumate talmente negli scuri, ch'e' fu cagione che molti di quegli che erano allora eccellenti confessassino lui esser nato per mettere lo spirto nelle figure et per contraffar la freschezza della carne viva, più che nessuno che dipignesse, non solo in Venezia, ma per tutto.

Lavorò in Venezia nel suo principio molti quadri di Nostre Donne e altri ritratti di naturale, che son e vivissimi e belli, come ne può far fede uno che è in Faenza in casa Giovanni da Castel Bolognese, intagliatore eccellente, che è fatto per il suocero suo: lavoro veramente divino, perchè vi è una unione sfumata ne' colori, che pare il più dipinto. Dilettossi molto del dipignere in fresco, et fra molte cose che fece, egli condusse tutta una facciata di Ca' Soranzo' in su la piazza di S. Polo, nella quale oltra molti quadri et storie che sui fantasie, si vede un quadro lavorato a olio in su la calcina: cosa che ha retto alla acqua, al sole e al vento e conservatasi fino ad oggi. Crebbe tanto la fama di Giorgione per quella città, che avendo il Senato fatto fabricare il Palazzo detto il Fondaco de' Todeschi al ponte del Rialto, ordinarono che Giorgione dipignesse a fresco la facciata di fuori; dove egli messovi mano, si ac[c]ese talmente nel fare, che vi sono teste e pezzi di figure molto ben fatte e colorite vivacissimamente, et attese in tutto quello che egli vi fece, che traesse al segno delle cose vive et non a imitazione nessuna della maniera. La quale opera è celebrata in Venezia e famosa non meno per quello che e' vi fece che per il comodo delle mercanzie e utilità del publico. Gli allogata la tavola di San Giovan Grisostimo di Venezia, che è molto lodata, per avere egli in certe parti imitato forte il vivo della natura e dolcemente allo scuro fatto perdere l'ombre delle figure. Fugli allogato ancora una storia, la quale, quando l'ebbe finita, fu posta nella Scuola di San Marco in su la piazza di San Giovanni et Paulo, nella stanza dove si raguna l'Offizio, in compagnia di diverse storie fatte da altri maestri; nella quale una tempesta di mare, et barche che hanno fortuna, e un gruppo di figure in aria e diverse forme di diavoli che soffiano i venti, e altri in barca che remano. La quale per il vero è tale e sì fatta che né pennello né colore né immaginazion di mente può esprimere la più orrenda e più paurosa pittura di quella, avendo egli colorito sí vivamente la furia dell'onde del mare, il torcere delle barche, il piegar de' remi et il travaglio di tutta quell'opera, nella scurità di quel tempo, per i lampi e per l'altre minuzie che contraffece Giorgione, che e' si vede tremare la tavola e scuotere quell'opera come ella fusse vera. Per la qual cosa

certamente lo annovero fra que' rari che possono esprimere nella pittura il concetto de' loro pensieri, avvengaché, mancato il furore, suole addormentarsi il pensiero, durandosi tanto tempo a condurre una opera grande. Questa pittura è tale per la bontà sua, e per lo avere espresso quel concetto difficile, che e' meritò di essere stimato in Venezia e onorato da noi fra i buoni artefici.

Lavorò un quadro d'un Cristo che porta la croce e un giudeo lo tira, il quale col tempo fu posto nella chiesa di Santo Rocco, et oggi, per la devozione che vi hanno molti, fa miracoli, come si vede. Lavorò in diversi luoghi, come a Castelfranco e nel Trevisano, e fece molti ritratti a varî prìncipi italiani, e fuor di Italia furon mandate molte de l'opere sue come cose degne veramente, per far testimonio che, se la Toscana soprabbondava di artefici in ogni tempo, la parte ancora di là vicino a' monti non era abbandonata e dimenticata sempre dal Cielo.

Mentre Giorgione attendeva ad onorare e sé et la patria sua, nel molto conversar che e' faceva per trattenere con la musica molti suoi amici, si innamorò di una madonna, e molto goderono l'uno et l'altra de' loro amori. Avvenne che l'anno MDXI ella infettò di peste; non ne sapendo però altro, et praticandovi Giorgione al solito, se li apicò la peste di maniera, che in breve tempo nella età sua di XXXIIII anni, se ne passò a l'altra vita, non senza dolore infinito di molti suoi amici che lo amavano per le sue virtù; e ne increbbe ancora a tutta quella città. Pure tollerarono il danno et la perdita con lo essere restati loro duoi eccellenti suoi creati: Sebastiano Viniziano, che fu poi frate del Piombo a Roma, et Tiziano da Cador, che non solo lo paragonò, ma lo ha superato grandemente, come ne fanno fede le rarissime pitture sue e il numero infinito de'bellissimi suoi ritratti di naturale, non solo di tutti i principi cristiani, ma de' più belli ingegni che sieno stati ne' tempi nostri. Costui dà, vivendo, vita alle figure che e' fa vive, come darà e vivo e morto fama e alla sua Venezia e alla nostra terza maniera. Ma perché e' vive e si veggono l'opere sue, non accade qui ragionarne.

VITA DI MORTO DA FELTRE

Perché, venutogli a noia lo stare a Fiorenza, si trasferì a Vinegia. E con Giorgione da Castelfranco, ch'allora lavorava il Fondaco de' Tedeschi, si mise ad aiutarlo, faccendo li ornamenti di quella opera. Et in quella città dimorò molti mesi, tirato da i piaceri e da i diletti che per il corpo vi trovava.

LODOVICO DOLCE, DIALOGO DELLA PITTURA INTITOLATO L'ARETINO
1557

Aretino: [Giambellino] Ma egli è stato dipoi vinto da Giorgio da Castelfranco, e Giorgio lasciato a dietro infinite miglia da Titiano, il quale diede alle sue figure una eroica maestà,

e trovò una maniera di colorito morbidissima, e nelle tinte cotanto simile al vero, che si può ben dire con verità, ch'ella va di pari con la natura.

. . . .

Aretino: [La Signoria di Venezia] Fece ancora, ma molto a dietro, dipinger dal di fuori il fondaco de' Tedeschi a Giorgio da Castelfranco, et a Tiziano medesimo, che alora era giovanetto, fu allogata quella parte, che riguarda la Merceria; di che dirò al fine alquante parole. . . .

Aretino: Fu appresso pittor di grande stima ma di maggiore aspettazione Giorgio da Castelfranco, di cui si veggono alcune cose a olio vivacissime e sfumate tanto, che non si scorgono ombre. Morì questo valente huomo di peste, con non poco danno della Pittura. . . .

Aretino: Per questo Tiziano, lasciando quel goffo Gentile, ebbe mezzo di accostarsi a Giovanni Bellino; ma né anco quella maniera compiutamente piacendogli, elesse Giorgio da Castelfranco. Disegnando adunque Tiziano e dipingendo con Giorgione (che così era chiamato) venne in poco tempo così valente nell'arte, che, dipingendo Giorgione la faccia del fondaco de' Tedeschi che riguarda sopra il Canal grande, fu allogata a Tiziano, come dicemmo, quell'altra che soprastà alla Merceria, non avendo egli alora a pena venti anni. Nella quale vi fece una Giudit mirabilissima di disegno e di colorito, a tale che, credendosi comunemente, poi che ella fu discoverta, che ella fosse opera di Giorgione, tutti i suoi amici seco si rallegravano come della miglior cosa di gran lunga ch'egli avesse fatto. Onde Giorgione, con grandissimo suo dispiacere, rispondeva ch'era di mano del discepolo, il quale dimostrava già di avanzare il maestro, e che è più, stette alcuni giorni in casa, come disperato, veggendo, che un giovanetto sapeva più di lui.

Fabrini: Intendo che Giorgione ebbe a dire, che Tiziano insino nel ventre di sua madre era pittore.

Aretino: Non passò molto che gli fu data a dipingere una gran tavola all'altar grande della chiesa de' Frati minori, ove Tiziano pur giovanetto dipinse a olio la Vergine che ascende al cielo fra molti angioli che l'accompagnano, e di sopra lei raffigurò un Dio Padre attorniato da due angioli. . . . E tuttavia questa fu la prima opera pubblica, che a olio facesse: e la fece in pochissimo tempo, e giovanetto. Con tutto ciò i pittori goffi, e lo sciocco volgo, che insino alora non avevano veduto altro che le cose morte e fredde di Giovanni Bellino, di Gentile e del Vivarino (perché Giorgione nel lavorare a olio non aveva ancora avuto lavoro pubblico; e per lo più non faceva altre opere, che mezze figure e ritratti), le quali erano senza movimento e senza rilevo, dicevano della detta tavola un gran male. Dipoi, raffreddandosi la invidia e aprendo loro a poco a poco la verità gli occhi, cominciarono le genti a stupir della nuova maniera trovata in

Venezia da Tiziano, e tutti i pittori d'indi in poi s'affaticarono d'imitarla; ma, per esser fuori della strada loro, rimanevano smarriti. E certo si può attribuire a miracolo che Tiziano, senza aver veduto alora le anticaglie di Roma, che furono lume a tutti i pittori eccellenti, solamente con quella poco favilluccia ch'egli aveva scoperta nelle cose di Giorgione, vide e conobbe l'idea del dipingere perfettamente.

VALUATION BY PARIS BORDONE OF THE COLLECTION OF GIOVANNI GRIMANI
1553-64

Made after the death of Giovanni's father Antonio, when the collection was divided between Giovanni and his brother Girolamo, in which an inexpensive *presepio* by Giorgione is recorded:

Uno quadro de uno prexepio de man de zorzi da Chastel Franco per ducati 10.

Biblioteca Correr, Venice, Libro crose di me Zuane Grimani dil Clarissimo messer Antonio fu di ser Hieronimo. . .Laus Deo 1553 in Venetia adì 15 Luglio anni 1553-1564, Ms. Autografo D. c. 471.

Paris Bordon, 1984, pp. 138-39.

PAINTINGS BY GIORGIONE IN THE INVENTORY OF THE COLLECTION OF DARIUS CONTARINI, SON OF TADDEO CONTARINI
1556

Un quadro grande con do figure depente in piedi pusadi a do arbori et una figura de un homo sentado che sona de flauto. . . .[Finding of the Infant Paris, Fig. 93]

Un quadro grande di tela soazado sopra il qual e depento l'inferno [Hell with Aeneas and Anchises]

Un altro quadro grandeto di tella soazado di nogara con tre figuri sopra [Three Philosophers, Fig. 49]

Archivio di Stato, Venice, Archivio Notarile, Atti di Pietro Contarini, b. 2567, cc. 84v-100v.

LODOVICO DOLCE, DIALOGO NEL QUALE SI RAGIONA DELLE QUALITÀ, DIVERSITÀ E PROPRIETÀ DE I COLORI
1565

Ti potrei dir di molti: ma ti dirò dei più eccellenti. Questi sono, Michel'Agnolo, Rafaello d'Urbino, Titiano, Giorgio da Castelfranco, Antonio da Correggio, il Parmegianino, il Pordonone, e simili.

INVENTORY OF VENETIAN PAINTINGS PROPOSED TO THE BAVARIAN COURT BY JACOPO STRADA
1567

Gemalte lustige Tücher von kunstfertigen Malern zu Venedig und sonst in Italien gemacht, alle in Oelfarbe

1 altes Quadro von Giorgio da Castelfranco gemacht mit 2 Figuren

J. Stockbauer, Wien, 1874, p. 43.

INVENTORY OF GABRIEL VENDRAMIN'S PAINTINGS IN THE CAMERINO DELLE ANTIGAGLIE, COMPILED BY TINTORETTO AND ORAZIO VECELLIO.
1567

Die x Septembris 1567

Uno quadreto con do figure dentro de chiaroscuro de man de Zorzon de Castelfranco.

GIORGIO VASARI, LE VITE DE' PIÙ ECCELLENTI PITTORI, SCULTORI E ARCHITETTORI
1568

PROEMIO

Soggiungono ancora, che dove gli scultori fanno insieme due o tre figure al più d'un marmo solo, essi ne fanno molte in una tavola sola, con quelle tante e si varie vedute, che coloro dicono che ha una statua sola, ricompensando con la varietà delle positure, scorci ed attitudini loro, il potersi vedere intorno intorno quelle degli scultori: come già fece Giorgione da Castelfranco in una sua pittura, la quale, voltando le spalle ed avendo due specchi, uno da ciascun lato, ed una fonte d'acqua a' piedi, mostra nel dipinto il dietro, nella fonte il dinanzi, e negli specchi i lati; cosa che non ha mai potuto far la scultura.

PROEMIO ALLA PARTE TERZA

Seguitò dopo lui, ancora che al quanto lontano, Giorgione da Castelfranco, il quale sfumò le sue pitture, e dette una terribil movenzia alle sue cose, per una certa oscurità di ombre bene intese.

VITA DEL GIORGIONE DA CASTEFRANCO

Ne' medesimi tempi che Fiorenza acquistava tanta fama per l'opere di Lionardo, arrecò non piccolo ornamento a Venezia la virtù et eccellenza [d'] un suo cittadino, il quale di gran lunga passò i Bellini, da loro tenuti in tanto pregio, e qualunque altro fino a quel tempo avesse in quella città dipinto. Questi fu Giorgio, che in Castelfranco in sul Trevisano nacque l'anno 1478, essendo doge Giovan Mozenigo, fratel del doge Piero, dalle fattezze della persona e da la grandezza de l'animo chiamato poi col tempo Giorgione; il quale, quantunque egli fusse nato d'umilissima stirpe, non fu però se non gentile e di buoni costumi in tutta sua vita. Fu allevato in Vinegia, e dilettossi continovamente de le cose d'amore, e piacqueli il suono del liuto mirabilmente e tanto, che egli sonava e cantava nel suo tempo tanto divinamente che egli era spesso per quello adoperato a diverse musiche e ragunate di persone nobili. Attese al disegno e lo gustò grandemente, e in quello la natura lo favorì si forte, che egli, innamoratosi delle cose belle di lei, non voleva mettere in opera cosa che egli dal vivo non ritraesse; e tanto le fu suggetto e tanto andò imitandola, che non solo egli acquistò nome d'aver passato

Gentile e Giovanni Bellini, ma di competere con coloro che lavoravano in Toscana, ed erano autori della maniera moderna. Aveva veduto Giorgione alcune cose di mano di Lionardo molto fumeggiate e cacciate, come si èdetto, terribilmente di scuro: e questa maniera gli piacque tanto che mentre visse sempre andò dietro a quella, e nel colorito a olio la imitò grandemente. Costui gustando il buono de l'operare, andava scegliendo di mettere in opera sempre del più bello e del più vario che e' trovava. Diedegli la natura tanto benigno spirito, che egli nel colorito a olio e a fresco fece alcune vivezze ed altre cose morbide et unite e sfumate talmente negli scuri, ch'e' fu cagione che molti di quegli che erano allora eccellenti confessassino lui esser nato per metter lo spirito ne le figure e per contraffar la freschezza de la carne viva più che nessuno che dipignesse, non solo in Venezia, ma per tutto.

Lavorò in Venezia nel suo principio molti quadri di Nostre Donne et altri ritratti di naturale, che sono e vivissimi e belli, come se ne vede ancora tre bellissime teste a olio di sua mano nello studio del reverendissimo Grimani patriarca d'Aquileia (una fatta per Davit — e per quel che si dice, è il suo ritratto —, con una zazzera, come si costumava in que' tempi, infino alle spalle, vivace e colorita che par di carne: ha un braccio e il petto armato, col quale tiene la testa mozza di Golia; l'altra è una testona maggiore, ritratta di naturale, che tiene in mano una berretta rossa da comandatore, con un bavero di pelle, e sotto uno di que' saioni all'antica: questo si pensa che fusse fatto per un generale di eserciti; la terza è d'un putto, bella quanto si può fare, con certi capelli a uso di velli), che fan conoscere l'ecc [ellenza] di Giorgione, e non meno l'affezzione del grandissimo Patriarca ch'egli ha portato sempre, a la virtù sua, tenendole carissime e meritamente. In Fiorenza è di man sua, in casa de'figliuoli di Giovan Borgherini, il ritratto d'esso Giovanni, quando era giovane in Venezia, e nel medesimo quadro il maestro che lo guidava, che non si può veder in due teste né miglior macchie di color di carne né più bella tinta di ombre. In casa Anton de' Nobili èun'altra testa d'un capitano armato, molto vivace e pronta, il qual dicano essere un de' capitani che Consalvo Ferrante menò seco a Venezia, quando visitò il doge Agostino Barberigo; nel qual tempo si dice che ritrasse il gran Consalvo armato, che fu cosa rarissima e non si poteva vedere pittura più bella che quella, e che esso Consalvo se ne la portò seco. Fece Giorgione molti altri ritratti, che sono sparsi in molti luoghi per Italia, bellissimi, come ne può far fede quello di Lionardo Loredano fatto da Giorgione quando era doge, da me visto in mostra per un'Assensa, che mi parve veder vivo quel serenissimo principe; oltra che ne è uno in Faenza in casa Giovanni da Castel Bolognese, intagliatore di camei e cristalli ec [cellente], che è fatto per il suocero suo:

lavoro veramente divino, perchè vi è una unione sfumata ne' colori, che pare di rilievo più che dipino. Dilettossi molto del dipignere in fresco, e fra molte cose che fece, egli condusse tutta una facciata di Cà Soranzo in su la piazza di San Poio, ne la quale, oltra molti quadri e storie et altre sue fantasie, si vede un quadro lavorato a olio in su la calcina: cosa che ha retto all'acqua, al sole et al vento, e conservatasi fino a oggi. Écci ancora una Primavera, che a me pare delle belle cose che e' dipignesse in fresco, ed è gran peccato che il tempo l'abbia consumata sì crudelmente; et io per me non trovo cosa che nuoca più al lavoro in fresco che gli scirocchi, e massimamente vicino a la marina, dove portono sempre salsedine con esso loro.

Seguì in Venezia l'anno 1504 al ponte del Rialto un fuoco terribilissimo nel Fondaco de' Tedeschi, il quale lo consumò tutto con le mercanzie e con grandissimo danno de' mercatanti: dove la signoria di Venezia ordinò di rifarlo di nuovo, e con maggior commodità di abituri e di magnificenza e d'ornamento e bellezza fu speditamente finito; dove essendo cresciuto la fama di Giorgione, fu consultato ed ordinato da chi ne aveva la cura che Giorgione lo dipingesse in fresco di colori secondo la sua fantasia, purché e' mostrasse la virtù sua e che e' facesse un'opera eccellente, essendo ella nel più bel luogo e ne la maggior vista di quella città. Per il che messovi mano Giorgione, non pensò se non a farvi figure a sua fantasia per mostrar l'arte; ché nel vero non si ritrova storie che abbino ordine o che rappresentino i fatti di nessuna persona segnalata, o antico o moderna; et io per me non l'ho mai intese, né anche, per dimanda che si sia fatta, ho trovato chi l'intenda, perché dove èun donna, dove è uno uomo in varie attitudini, chi ha una testa di lione appresso, altra con un angelo a guisa di Cupido, né si giudica quel che si sia. V'è bene sopra la porta principale che riesce in Merzeria una femina a sedere, c'ha sotto una testa d'un gigante morta, quasi in forma d'una Iuditta, ch'alza quel testa con la spada e parla con un Todesco quale è abasso: né ho potuto interpretare per quel che se l'abbi fatta, se già non l'avesse voluta fare per una Germania. Insomma e' si vede ben le figure sue esser molto insieme, e che andò sempre acquistando nel meglio; e vi sono teste e pezzi di figure molto ben fatte e colorite vivacissimamente, et attese in tutto quello che egli vi fece che traesse al segno de le cose vive e non a imitazione nessuna de la maniera. La quale opera è celebrata in Venezia e famosa non meno per quello che e' vi fece che per il commodo delle mercanzie e utilità del pubblico.

Lavorò un quadro d'un Cristo che porta la croce ed un giudeo lo tira, il quale col tempo fu posto nella chiesa di San Rocco, et oggi, per la devozione che vi hanno molti, fa miracoli, come si vede. Lavorò in diversi luoghi, come a Castelfranco e nel Trivisano,

e fece molti ritratti a varî principi italiani, e fuor d'Italia furono mandate molte dell'opere sue come cose degne veramente, per far testimonio che se la Toscana soprabbondava di artefici in ogni tempo, la parte ancora di là vicino a' monti non era abbandonata a dimenticata sempre dal Cielo.

Dicesi che Giorgione ragionando con alcuni scultori nel tempo che Andrea Verrocchio faceva il cavallo di bronzo, che volevano, perché la scultura mostrava in una figura sola diverse positure e vedute girandogli a torno, che per questo avanzasse la pittura, che non mostrava in una figura se non una parte sola, Giorgione — che era d'opinione che in una storia di pittura si mostrasse, senza avere a caminare attorno, ma in una sola occhiata tutte le sorti delle vedute che può fare in più gesti un uomo, cosa che la scultura non può fare se non mutando il sito e la veduta, talché non sono una, ma più vedute —, propose di più, che da una figura sola di pittura voleva mostrare il dinanzi et il dietro et i due profili dai lati: cosa che e' fece mettere loro il cervello a partito. E la fece in questo modo. Dipinse uno ignudo che voltava le spalle e aveva in terra una fonte d'acqua limpidissima, nella quale fece dentro per riverberazione la parte dinanzi; da un de' lati era un corsaletto brunito che s'era spogliato, nel quale era il profilo manco, perché nel lucido di quell'arme si scorgeva ogni cosa; dall'altra parte era uno specchio che drento vi era l'altro lato di quello ignudo: cosa di bellissimo ghiribizzo e capriccio, volendo mostrare in effetto che la pittura conduce con più virtù e fatica, e mostra in una vista sola del naturale più che non fa la scultura. La qual opera fu sommamente lodata e ammirata per ingegnosa e bella. Ritrasse ancora di naturale Caterina regina di Cipro, qual viddi io già nelle mani del clarissimo messer Giovan Cornaro. É nel nostro libro una testa colorita a olio, ritratta da un todesco di casa Fucheri, che allora era de' maggiori mercanti nel Fondaco de' Tedeschi; la quale è cosa mirabile, insieme con altri schizzi e disegni di penna fatti da lui.

Mentre Giorgione attendeva ad onorare e sé e la patria sua, nel molto conversar che e' faceva per trattenere con la musica molti suoi amici, si innamorò d'una madonna, e molto goderono l'uno e l'altra de' loro amori. Avvene che l'anno 1511 ella infettò di peste; non ne sapendo però altro e praticandovi Giorgione al solito, se li appiccò la peste di maniera, che in breve tempo nella età sua di 34 anni se ne passò a l'altra vita, non senza dolore infinito di molti suoi amici che lo amavano per le sue virtù, e danno del mondo che [lo] perse. Pure tollerarono il danno e la perdita con lo esser restati loro due eccellenti suoi creati: Sebastiano Viniziano, che fu poi frate del Piombo a Roma, e Tiziano da Cadore, che non solo lo paragonò, ma lo ha superato grandemente; de' quali a suo luogo si dirà pienamente l'onore e l'utile che hanno fatto a questa arte.

VITA DI JACOPO, GIOVANNI E GENTILE BELLINI

Dicesi che anco Giorgione da Castelfranco attese all'arte con Giovanni, ne' suoi primi principj.

VITA DI GIOVANNI ANTONIO LICINIO DA PORDENONE

Costui nacque in Pordenone, castello del Friuli, lontano da Udine 25 miglia; e perchè fu dotato dalla natura di bello ingegno inclinato alla pittura, si diede senza altro maestro a studiare le cose naturali, imitando il fare di Giorgione da Castelfranco, per essergli piaciuta assai quella maniera da lui veduta molte volte in Venezia.

VITA DI MORTO DA FELTRE

Perchè venutogli a noia lo stare a Fiorenza, si trasferì a Vinegia: e con Giorgione da Castelfranco, ch'allora lavorava al Fondaco de' Tedeschi, si mise a aiutarlo facendo gli ornamenti di quella opera; e così in quella città dimorò molti mesi, tirato dai piaceri e dai diletti che per il corpo vi trovava.

VITA DI JACOMO PALMA

Fece oltre ciò il Palma, per la stanza dove si ragunano gli uomini della Scuola di San Marco, in su la piazza di San Giovanni e Paulo, a concorrenza di quelle che già fecero Gian Bellino, Giovanni Mansueti, ed altri pittori, una bellissima storia, nella quale è dipinta una nave che conduce il corpo di San Marco a Venezia; nella quale si vede finto dal Palma una orribile tempesta di mare, ed alcune barche combattute dalla furia de' venti, fatte con molto giudicio e con belle considerazioni; sì come è anco un gruppo di figure in aria, e diverse forme di demonj che soffiano a guisa di venti nelle barche, che andando a remi e sforzandosi con vari modi di rompere l'inimiche ed altissime onde, stanno per somergersi. Insomma quest' opera, per vero dire, è tale e sì bella per invenzione e per altro, che pare quasi impossibile che colore o pennello, adoperati da mani anco eccellenti, possino esprimere alcuna cosa più simile al vero o più naturale; atteso che in essa si vede la furia de' venti, la forza e destrezza degli uomini, il muoversi dell'onde, i lampi e baleni del cielo, l'acqua rotta dai remi, ed i remi piegati dall'onde e dalla forza de' vogatori. Che più!? Io per me non mi ricordo aver mai veduto la più orrenda pittura di quella; essendo talmente condotta e con tanta osservanza nel disegno, nell'invenzione e nel colorito, che pare che tremi la tavola, come tutto quello che vi èdipinto fusse vero: per la quale opera merita Iacopo Palma grandissima lode, e di essere annoverato fra quegli che posseggono l'arte, ed hanno in poter loro facultà d'esprimere nelle pitture le difficultà dei loro concettti; conciosiachè, in simili cose difficili, a molti pittori vien fatto nel primo abbozzare l'opera, come guidati da un certo furore, qualche cosa di buono e qualche fierezza, che vien

poi levata nel finire, e tolto via quel buono che vi aveva posto il furore: e questo avviene, perchè molte volte chi finisce considera le parti e non il tutto di quello che fa, e va (raffreddandosi gli spiriti) perdendo la vena della fierezza; là dove costui stette sempre saldo nel medesimo proposito, e condusse a perfezione il suo concetto, che gli fu allora e sarà sempre infinitamente lodato.

VITA DI LORENZO LOTTO

Fu compagno ed amico del Palma Lorenzo Lotto pittor veneziano, il quale avendo imitato un tempo la maniera de' Bellini, s'appiccò poi a quella di Giorgione, come ne dimostrano molti quadri e ritratti che in Vinezia sono per le case de' gentil'uomini. Essendo anco questo pittore giovane, ed imitando parte la maniera de' Bellini e parte quella di Giorgione, fece in San Domenico di Ricanati la tavola dell'altar maggiore, partita in sei quadri.

VITA DI FRANCESCO TORBIDO

Francesco Torbido, detto il Moro, pittore veronese, imparò i primi principii dell'arte, essendo ancor giovinetto, da Giorgione da Castelfranco, il quale immitò poi sempre nel colorito e nella morbidezza. Ma è ben vero, che sebbene tenne sempre la maniera di Liberale, immitò nondimeno nella morbidezza e colorire sfumato Giorgione suo primo precettore, parendogli che le cose di Liberale, buone per altro, avessero un poco del secco.

VITA DI SEBASTIANO DEL PIOMBO

Venutagli poi voglia, essendo anco giovane, d'attendere alla pittura, apparò i primi principj da Giovan Bellino allora vecchio. E doppo lui, avendo Giorgione da Castelfranco messi in quella città i modi della maniera moderna più uniti, e coll certo fiameggiare di colori, Sebastiano si partì da Giovanni e si acconciò con Giorgione; col quale stette tanto, che prese in gran parte quella maniera. . . . Fece anco in que'tempi in San Giovanni Grisostomo di Vinezia una tavola con alcune figure, che tengono tanto della maniera di Giorgione, ch'elle sono state alcuna volta, da chi non ha molta cognizione delle cose dell'arte, tenute per di mano di esso Giorgione: la qual tavola è molto bella, e fatta con una maniera di colorito, ch'ha gran rilievo.
Andatosene dunque a Roma, Agostino lo mise in opera; e la prima cosa che gli facesse fare, furono gli archetti che sono in su la loggia, la quale risponde in sul giardino, dove Baldassarre Sanese aveva nel palazzo d'Agostino in Trastevere tutta la volta dipinta: nei quali archetti Sebastiano fece alcune poesie di quella maniera ch'aveva recato da Vinegia, molto disforme da quella che usavano in Roma i valenti pittori di que' tempi. Dopo quest'opera avendo Rafaello fatto in quel medesimo luogo una storia di Galatea, vi fece Bastiano, come volle Agostino, un Polifemo in fresco a lato a

quella; nel quale, comunche gli riuscisse, cercò d'avanzarsi più che poteva, spronato dalla concorrenza di Baldasarre Sanese, e poi di Raffaello. Colori similmente alcune cose a olio, delle quali fu tenuto, per aver egli da Giorgione imparato un modo di colorire assai morbido, in Roma grandissimo conto.

VITA DI BENVENTUO GAROFOLO

Fu amico di Giorgione da Castelfranco pittore, di Tiziano da Cador, e di Giulio Romano, ed in generale affezionatissimo a tutti gli uomini dell'arte.

VITA DI GIOVANNI DA UDINE

Questa inclinazione (al disegno) veggendo Francesco suo padre, lo condusse a Vinezia, e lo pose a imparare l'arte del disegno con Giorgione da Castelfranco; col quale dimorando il giovane, sentì tanto lodare le cose di Michangelo e Raffaello, che si risolvè d'andare a Roma ad ogni modo. E così, avuto lettere di favore da Domenico Grimano, amicissimo di suo padre, a Baldassarri Castiglioni, segretario del duca di Mantoa ed amicissimo di Rafaello da Urbino, se n'andò là. Giovanni adunque essendo stato pochissimo in Vinezia sotto la disciplina di Giorgione, veduto l'andar dolce, bello e grazioso di Raffaello, si dispose, come giovane di bell'ingegno, a volere a quella maniera attenersi per ogni modo.

VITA DI PIERO DI COSIMO

Mentre che Giorgione et il Correggio con grande loda e gloria onoravano le parti di Lombardia, non mancava la Toscana orafo et allievo di Cosimo Rosselli, e però chiamato sempre e non altrimenti inteso che per Piero di Cosimo.

VITA DI TIZIANO DA CADORE

Ma venuto poi, l'anno circa 1507, Giorgione da Castel Franco, non gli piacendo in tutto il detto modo di fare, cominciò a dare alle sue opere più morbidezza e maggiore rilievo con bella maniera; usando nondimeno di cacciar sì avanti le cose vive e naturali, e di contrafarle quanto sapeva il meglio con i colori, e macchiarle con le tinte crude e dolci, secondo che il vivo mostrava, senza far disegno, tenendo per fermo che il dipignere solo con i colori stessi, senz'altro studio di disegnare in carta, fusse il vero e miglior modo di fare et il vero disegno; ma non s'accorgeva, che egli è necessario a chi vuol bene disporre componimenti e accomodare l'invenzioni, ch'e' fa bisogno prima in più modi differenti porle in carta, per vedere come il tutto torna insieme. Con ciò sia che l'idea non può vedere nè imaginare perfettamente in sé stessa l'invenzioni, se non apre e non mostra il suo concetto agli occhi corporali che l'aiutino a farne buon giudizio; senzachè pur bisogna fare grande studio sopra gl'ignudi a volergli intendere bene: il che non vien fatto, né si può, senza mettere in carta: et il tenere, sempre che altri colorisce, persone ignude innanzi

ovvero vestite, è non piccola servitù! Là dove, quando altri ha fatto la mano disegnando in carta, si vien poi di mano in mano con più agevolezza a mettere in opera disegnando e dipignendo: e così facendo pratica nell'arte, si fa la maniera et il giudizio perfetto, levando via quella fatica e stento con che si conducono le pitture, di cui si è ragionato di sopra: per non dir nulla che, disegnando in carta, si viene a empiere la mente di bei concetti e s'impara a fare a mente tutte le cose della natura, senza avere a tenerle sempre innanzi, o ad avere a nascere sotto la vaghezza de' colori lo stento del non sapere disegnare, nella maniera che fecero molti anni i pittori viniziani, Giorgione, il Palma, il Pordenone, ed altri che non videro Roma né altre opere di tutta perfezione.

Tiziano dunque, veduto il fare e la maniera di Giorgione, lasciò la maniera di Gian Bellino, ancorché vi avesse molto tempo consumato, e si accostò a quella, così bene imitando in brieve tempo le cose di lui, che furono le sue pitture talvolta scambiate e credute opere di Giorgione, come di sotto si dirà. Cresciuto poi Tiziano in età, pratica e giudizio, condusse a fresco molte cose, le quali non si possono raccontare con ordine, essendo sparse in diversi luoghi. Basta che furono tali, che si fece da mlti periti giudizio ch'e' dovesse, come poi èavenuto, riuscire eccellentissimo pittore.

A principio, dunque, che cominciò seguitare la maniera di Giorgione, non avendo più che diciotto anni, fece il ritratto d'un gentiluomo da Ca' Barbarigo, amico suo, che fu tenuto molto bello, essendo la somiglianza della carnagione propria e naturale, e sì ben distinti i capelli l'uno dall'altro, che si conterebbono, come anco si farebbono i punti d'un giubone di raso inargentato che fece in quell'opera. Insomma, fu tenuto sì ben fatto e con tanta diligenza, che, se Tiziano non vi avesse scritto in ombra il suo nome, sarebbe stato tenuto opera di Giorgione. Intanto, avendo esso Giorgione condotta la facciata dinanzi del fondaco de' Tedeschi, per mezzo del Barbarigo furono allogate a Tiziano alcune storie che sono nella medesima sopra la Merceria. . . .

Nella quale facciata non sapendo molti gentiluomini che Giorgione non vi lavorasse più, né che la facesse Tiziano, il quale ne aveva scoperto una parte, scontrandosi in Giorgione, come amici si rallegravano seco, dicendo che si portava meglio nella facciata di verso la Merceria, che in quella che èsopra il Canal Grande; della qual cosa sentiva tanto sdegno Giorgione, che infino che non ebbe finita Tiziano l'opera del tutto, e che non fu notissimo che esso Tiziano aveva fatta quella parte, non si lasciò molto vedere, e da indi in poi non volle che mai più Tiziano praticasse, o fusse amico suo. . . .

Appresso, tornato a Vinezia, dipinse la facciata de' Grimani; e in Padoa nella chiesa di Sant'Antonio, alcune storie, pure a fresco,

de' fatti di quel Santo; e in quella di Santo Spirito fece in una piccola tavoletta un San Marco a sedere in mezzo a certi Santi, ne' cui volti sono alcuni ritratti di naturale, fatti a olio con grandissima diligenza: la qual tavola molti hanno creduto che sia di mano di Giorgione. Essendo poi rimasa imperfetta, per la morte di Giovan Bellino, nella sala del Gran Consiglio una storia, dove Federigo Barbarossa alla porta della chiesa di San Marco sta ginocchioni innanzi a papa Alessandro Terzo, che gli mette il piè sopra la gola, la fornì Tiziano, mutando molte cose e facendovi molti ritratti di naturale di suoi amici ed altri; onde meritò da quel Senato avere nel Fondaco de' Tedeschi un uffizio che si chiama la Senseria, che rende trecento scudi l'anno. . . .

Per la chiesa di Santo Rocco fece, dopo le dette opere, in un quadro, Cristo con la croce in spalla e con una corda al collo tirata da un Ebreo; la qual figura, che hanno molti creduta sia di mano di Giorgione, è oggi la maggior divozione di Vinezia, ed ha avuto di limosine più scudi, che non hanno in tutta la loro vita guadagnato Tiziano e Giorgione.

VITA DI PARIS BORDONE

Ma quegli che più di tutti ha imitato Tiziano, èstato Paris Bondone, il quale, nato in Trevisi di padre trivisano e madre viniziana, fu condotto d'otto anni a Vinezia in casa alcuni suoi parenti. Dove, imparato che ebbe gramatica e fattosi eccellentissimo musico, andò a stare con Tiziano: ma non vi consumò molti anni; perciò che vedendo quell'uomo non essere molto vago d'insegnare a' suoi giovani, anco pregato da loro sommamente et invitato con la pacienza a portarsi bene, si risolvé a partirsi, dolendosi infinitamente che di que' giorni fusse morto Giorgione, la cui maniera gli piaceva sommamente, ma molto più l'aver fama di bene e volentieri insegnare con amore quello che sapeva. Ma poi che altro fare non si poteva, si mise Paris in animo di volere per ogni modo seguitare la maniera di Giorgione. E così datosi a lavorare ed a contrafare dell'opere di colui, si fece tale che venne in bonissimo credito; onde nella sua età di diciotto anni gli fu allogata una tavola da farsi per la chiesa di San Niccolò de' frati Minori.

INVENTORY OF THE COLLECTION OF GABRIEL VENDRAMIN (CONTINUATION OF 1567 INVENTORY)
1569 Die 14 Martii 1569

Un quadro de man de Zorzon de Castelfranco con tre testoni che canta.
Un altro quadro de una cingana un pastor in un paeseto con un ponte con suo fornimento de noghera con intagli et paternostri doradi de man de Zorzi de Castelfranco.
Una nostra Dona de man De Zorzi de Castelfranco con suo fornimento dorado et intagiado.

Un quadreto con tre teste che vien da Zorzi con sue soazete de legno alla testa de mezo ha la goleta de ferro.
Il retrato della Madre de Zorzon de man de Zorzon con suo fornimento depento con l'arma de chà Vendramin.
Archivio della Casa Goldoni, Venice, Archivio Vendramin, Sacco 62, 42F 16/5, Scritture diverse attinenti al Camerino delle antichaglie di ragione di G. Vendramin.
Rava, 1920, p. 155.

MARCANTONIO MICHIEL, *PITTORI E PITTURE*
1575
In a later hand.
In casa di M. Piero Servio, 1575.
Un ritratto di Suo padre di mano di Giorgio da Castelfranco.
Ed. Frimmel, p. 110.

FRANCESCO SANSOVINO, *VENEZIA CITTÀ NOBILISSIMA*
1581

S. Giouanni Chrisostomo. Fù parimente restaurato San Giouanni Chrisostomo sul modello di Sebastiano da Lugano, ò secondo altri del Moro Lombardo, amendue assai buoni Architetti. Et nobilitato poi da Giorgione da Castel Franco famosissimo Pittore, il quale vi cominciò la palla grande con le tre virtù theologiche, & fu poi finita da Sebastiano, che fù Frate del piombo in Roma, che vi dipinse à fresco la volta della tribuna.
San Rocco. Dalla destra in entrando, Titiano vi dipinse quella palla famosa di Christo, per la quale s'è fatta ricca la Fraterna, & la Chiesa.
Ed. Martinioni, 1663, p. 288.
Scuola di San Marco. Il quadro alla destra doue è espressa quella fortuna memorabile per la quale S. Giorgio, San Marco, & San Nicolò, usciti, come dicono l'antiche scritture, dalle Chiese loro, saluarono la Città, fu di mano di Iacomo Palma, altri dicono di Paris Bordone.
Palazzo Vendramin. Et poco dicosto sono i Vendramini, il cui Palazzo con faccia di marmo, fu già ridotto de i virtuosi della Citta. Percioche viuendo Gabriello amantissimo della Pittura, della Scultura, & dell'Architettura, vi fece molti ornamenti, & vi raccolse diuerse cose de i più famosi artefiici del suo tempo. Percioche vi si veggono opere di Giorgione da Castel Franco, di Gian Bellino, di Titiano, di Michel Agnolo, & d'altri conseruate da suoi soccessori.
Ed. Martinioni, 1663, p. 387.
Feste. Belle & honorate parimente furono, le dimostrationi singolari di allegrezza, che si fecero l'anno 1571. per la Vittoria che si hebbe del Turco. . . . S'adornò poi partitamente ogni bottega d'armi, di spoglie, di trofei de nemici presi nella giornata nauale, & di quadri marauigliosi di Gian Bellino, di Giorgione da Castel Franco, di Raffaello da Urbino, di Bastiano dal Piombo, di Michelagnolo, di Titiano, del Pordonone, & d'altri eccellenti Pittori.
Ed. Martinioni, 1663, p. 415.

RAFFAELLO BORGHINI, IL RIPOSO
1584

Libro Primo: Sicome allegano hauer fatto Giorgione da Castel Franco in una sua pittura, doue appariua una figura, che dimostraua le spalle rimirando una fontana, e da ciascun de lati haueua uno specchio, talmente che nel dipinto mostraua il di dietro, nell'acqua chiarissinia il dinanzi, e nelli specchi ambidue i fianchi, cosa che non può fare la scultura.

Libro Terzo. Giorgione da Castelfranco: Nel medesimo tempo che Firenze per le opere di Lionardo s'acquistaua fama, Vinegia parimente per l'eccellenza di Giorgione da Castel Franco sul Treuigiano facea risonare il nome suo. Questi fu alleuato in Vinegia, e attese talmente al disegno clie nella pittura passò Giouanni, e Gentile Bellini, e diede una certa viuezza alle sue figure che pareuan viue. Di sua mano ha il Reuerendissimo Grimani Patriarca d'Aquileia tre bellissime teste à olio, una fatta per un Dauit, l'altra è ritratta dal naturale, e tiene una berretta rossa in mano, e l'altra è d'un fanciullo bella quanto si possa fare co'capelli à vso di velli, che dimostrano l'eccellenza di Giorgione. Ritrasse in vn quadro Giouanni Borgherini quando era giouane in Vinegia, & il maestro, che il guidaua, e questo quadro è in Firenze appresso à figliuoli di detto Giouanni, sicome ancora è in casa Giulio de' Nobili una testa d'un Capitano armato molto viuace, e pronta. Fece molti altri ritratti, e tutti bellissimi, che sono sparsi per Italia in mano di più persone. Dilettossi molto di dipingere in fresco, e fra l'altre cose dipinse tutta una facciata di cà soranzo su la piazza di San Polo in Vinegia, nella quale oltre à molti quadri, & historie, si vede un quadro lauorato à olio sopra la calcina, che hà retto all'acqua, & al vento, e si è conseruato infino à hoggi: e dipinse etiandio à fresco le figure, che sono à Rialto, doue si veggono teste, e figure molto ben fatte, ma non si sa che historia egli far si volesse. Fece in un quadro Christo, che porta la Croce, e un Giudeo, che il tira, il quale fu poi posto nella Chiesa di San Rocco, e dicono che hoggi fà miracoli. Disputando egli con alcuni, che diceuono la scultura auanzar di nobiltà la pittura; percioche mostra in vna sola figura diuerse vedute, propose che da vna figura sola di pittura voleua mostrare il dinanzi, il di dietro, & i due profili da i lati in una sola occhiata, senza girar attorno, come è di mestiero fare alle statue. Dipinse adunque uno ignudo che mostraua le spalle, & in terra era una fontana di acqua chiarissima, in cui fece dentro per riuerberatione la parte dinanzi, da un de' lati era un corsaletto brunito, che si era spogliato, e nello splendore di quell'arme si scorgeua il profilo del lato manco, e dall'altra parte era uno specchio, che mostraua l'altro lato, cosa di bellissimo giudicio, e capriccio, e che fu molto lodata, & ammirata. Molte altre cose fece, che per breuità tralascio, e molte più per auentura ne harebbe fatte, e con maggior sue lode, se morte nell'età sua di 34 anni non

l'hauesse tolto al mondo con dolore infinito di chiunque lo conoscea.

Libro Quarto

Titiano da Cador della famiglia, non degli Vcelli, come dice il Vasari, ma de' Veccelli, essendo di età di dieci anni, e conosciuto di bello ingegno, fu mandato in Vinegia, e posto con Giambellino pittore; accioche egli l'arte della pittura apprendesse, col quale stato alcun tempo, & intanto essendo andato à stare in Vinegia Giorgione da Castelfranco, si diede Titiano ad imitare la sua maniera, piacendoli piu che quella di Giambellino: e talmente contrafece le cose di Giorgione, che molte volte furono stimate le fatte da Iui quelle di Giorgione stesso. Molte, e molte son l'opere, che fece Titiano, e particolarmente fu eccellentissimo ne' ritratti, e chi di tutti volesse fauellare lungo tempo ne bisognerebbe; però delle cose sue piu notabili brieuemente farò mentione. In Vinegia di sua mano sono queste opere, nella sala del gran Consiglio l'historia, che fu lasciata imperfetta da Giorgione, in cui Federiao Barbarossa stà ginocchioni innanzi a Papa Alessandro quarto, che gli mette il piè sopra Ia gola.

Nella Chiesa di San Rocco, un quadro entroui Christo, che porta la croce con una corda al collo tirata da un'hebreo, la qual opera è hoggi la maggior diuotione, che habbiano i Vinitiani: laonde si può dire, che habbia piu guadagnato l'opera che il maestro.

G. LOMAZZO, TRATTATO DELL'ARTE DELLA PITTURA
1585

Compositione dal dipingere & fare i paesi diuersi....è stato felicissimo, Giorgione da Castelfranco nel dimostrar sotto le acque chiare il pesce, gl'arbori i frutti, & ciò che egli voleua con bellissima maniera.

INVENTORY OF THE COLLECTION OF FULVIO ORSINI, ROME
1600

11. Quadro corniciato di noce, con due teste d'una vecchia et un giovine, di mano dal Giorgione.

12. Quadretto corniciato d'hebano, con un San Giorgio, di mano dal medemo.

Biblioteca Ambrosiana, Milan, Fondo L.-V. Pinelli.

Nolhac, 1884, p. 431.

INVENTORY OF THE COLLECTION OF GABRIEL VENDRAMIN, MADE BY HIS HEIRS ON 4 JANUARY
1601

Un quadro de paese con una Donna che latta un figliuolo sentado et un'altra figura, con le sue soaze de noghera con filli d'oro alto quarte sie, et largo cinque, e meza incirca (*Tempesta*)

Un quadro de una Donna Vecchia con le sue soaze de noghera depente, alto quarte cinque e meza et largo quarte cinque in circa con l'arma Vendramina depenta nelle soaze il coperto del detto quadro depento con

un'homo con una vesta di pella negra. (*La Vecchia*)

Un quadro con tre teste, con un soaze dorade alto quarte cinque et largo cinque mezza in circa (*Three Ages of Man*, Pitti)

Archivio della Casa Goldoni, Venice, Archivio Vendramin, Sacco 62, 42 F 16/5, Scritture diverse attinenti al Camerino delle antichaglie di ragione di G. Vendramin.

Anderson, 1979A, pp. 639-48.

CAMILLO SORDI, LETTER FROM VENICE TO DUKE FRANCESCO GONZAGA, MENTIONING PICTURES WHICH HAVE BEEN OFFERED TO THE DUKE
1612

L'Adultera, di Giorgione, duc. 60.

Venere, di Giorgione, duc. 50.

Luzio, 1913, p. 110.

ANONIMO DEL TIZIANELLO, BREVE COMPENDIO DELLA VITA DEL FAMOSO TITIANO VECELLIO DI CADORE
1622

Fù dunque d'anni dieci in circa mandato (Titiano) à Venetia in casa d'un suo Zio materno, & accomodato da lui con Gio: Bellino Pittore famosissimo in quell'età, dal quale per alcun tempo apprese i termini della Pittura, & aprì in modo l'ingegno alla cognitione di quella, che stimando più grave, e più delicata maniera quella di Giorgione da Castel Franco, desiderò sopramodo d'accostarsi con lui, & favorì la Fortuna il suo generoso pensiero perchè guardando spesso Titiano l'opere di Giorgione, cavandone il buono di nascosto, mentre erano in una Corte ad asciugarsi al Sole, fu più volte osservato, & veduto da lui, che perciò comprendendo l'inclinatione del giovane, quasi un'altro Democrito, che scoprì l'ingegno di Protagora, à se lo trasse, et affettuosissimamente gl'insegnò i veri lumi dell'Arte, onde non solo potè in pochi anni ugguagliare il maestro, ma poscia di gran lunga superarlo, come seguì, quando hebbe Giorgione il carico di dipingere il Fondaco della Natione Alemanna in Venetia, posto appresso il Ponte di Rialto, l'opera del quale conoscendo l'ingegno, & sufficienza di Titiano compartì con lui, & egli fece quella parte, che è sopra il Canal grande, come quella, che in sito più riguardevole era esposta à gli occhi d'ognuno, & l'altra verso Terra, diede al sudetto Titiano, & se ben il Maestro vi pose ogni studio, fù però da Titiano superato, come l'opera medesima ne fà chiara fede, & confermò l'universale consenso di tutti, che si rallegravano con Giorgione particolarmente per l'opera della facciata verso Terra, stimandola fatta da lui; non fu però egli invidioso della gloria del suo buon discepolo, anzi confermando la realtà del fatto si gloriò d'haverlo ridotto à tal perfettione, che l'opere di lui fussero stimate uguali, & maggiori delle sue medesime.

Anonimo del Tizianello, 1622, n.p.

INVENTORY OF THE GOODS OF
ROBERTO CANONICI IN FERRARA
1632

Due Figure dal mezo in sù di Giorgione da
Castelfranco, cioè un huomo con un gran
capello in testa, et una donna paiono
Pastori, che siano in viaggio, ha la cornice
con fili d'oro, scudi cento.
*Campori, 1870, p. 115. First published, together
with Canonici's will, in Testamento solene e
codicilli, Ferrara, 1632.*

INVENTORY OF THE LUDOVISI
COLLECTION, ROME
1663

43. Un quadro di due ritratti mezze figure
uno tiene la mano alla guancia, e nell'altra
tiene un melangolo con cornice nera profi-
lata a Rabescato d'oro mano di Giorgione
45. Un huomo, che tocca il polse ad una
femina in un quadro alto pmi cinque lungo
pmi sei cornice dorata, et intagliata di mano
del Giorgione
259. Un quadro d'una cascata di Xro con la
croce sopra un Monte con soldati alto pmi
sei in circa, e largo dieci in circa cornice
dorata di mano di Giorgione
276. Un quadro d'un Ritratto alto palmi sei
in circa con una Testa di morto sopra un
tavolino, habito antico, cornice dorata,
mano di Giorgione
*Archivio Vaticano, Archivio Boncompagni-
Ludovisi, Arm. IX, Protoc. 325 no. 1, 1633.
Garas, 1967B, pp. 339-48.*

DUKE OF BUCKINGHAM'S
COLLECTION, YORK HOUSE
1635

Georgione. A little picture of a man in
armour.
*R. Davis, 'An Inventory of the Duke of
Buckingham's pictures, etc., at York House
in 1635,' The Burlington Magazine, (1907), X,
p. 380.*

HAMILTON INVENTORY OF
PAINTINGS (INTENDED FOR
CHARLES I)
1636

A Geometrician by Geo Jone	£0250
A nativity by him	£0250
A Bravo by Geo Jone	£0150

*Hamilton Archive, Lennoxlore.
Shakeshaft, 1986, p. 134.*

PRESUMED INVENTORY OF
BARTOLOMEO DELLA NAVE'S
COLLECTION, BOUGHT BY BASIL
FEILDING FOR THE MARQUIS OF
HAMILTON
1638

42. A picture with 3 Astronomers and
Geometricians in a Landskip who contem-
plat and measure Pal 8 & 6 of Giorgione de
Castelfranco. . . .400
43. Another picture of the history
of the Amazons with 5 figures to the full
and othyer figures in a Landskip of the
same greatnes made by the same Giorgione.

. . .450
44. A boy playing upon a Cimbal Pal 2 1/2
idem. . . .160
45. Our Lady and the Nativity of Christ and
Visitation of the Shepherds Pal 5 & 4 idem.
. . .300
46. A Lucrece with Tarquine or any other
Naked Woman forced by a soldier pal 3 &
2 idem. . . .60
50. Petraces Laura pal 2 & 1 1/2 idem. . . .70
51. A faire head idem. . .30
52. his picture made by himself idem. . .70
*Hamilton Archive, Lennoxlore.
Waterhouse, 1952, p. 16.*

HAMILTON INVENTORIES
1638

Inventory no 15. No. 211. One peice of
Jupiter carringe away Europa in the shape of
a Bull, one mayde crying after her, another
tearinge her hayre a shippeard 3 cowes a Bull
of Gorioyne.
*Hamilton Archive, Lennoxlore.
Garas, 1967A, p. 68.*

INVENTORY OF PICTURES IN THE
HOUSE OF NICCOLÒ RENIERI 'IN
CASA DEL GOBBO'
c. 1638

1. Sto Sebastiano de Giorgione Meza figura
al Natural. . . .100
11. 1 Christo Ecce Huomo di Titiano, overo
di Giorgion. . . .40
12. 1 Madonna Picciola del Giorgion. . . .10
13. 1 Testa d'un Pastor del sudetto. . . .5
23. 1 Christo che apar alla Madelena
nel'horto del Giorgion. . . .30
31. 1 Ritratto di un Nobile Anticha di
Giorgion. . . .40
40. 1 Madonna tenuta di Man del Correggio
overo Giorgion. . . .400
43. 1 Ritratto di donna, habito Anticho di
Pordenon overo Giorgion. . . .50
*Hamilton Archive, Lennoxlore.
Waterhouse, 1952, pp. 22-23.*

CARLO RIDOLFI, LE MARAVIGLIE
DELL'ARTE
1648

*VITA DI GIORGIONE DA CASTEL FRANCO
PITTORE*
Haueua di già la Pittura nel Teatro del
Mondo per il corso di più d'vn secolo, disp-
iegato le industriose fatiche de suoi favoriti
Pittori, li quali con la bellezza, e nouità delle
opere dipinte haueuano recato diletto, e
merauiglia à mortali: quando cangiando il
prospetto in più adorna e sontuosa scena
diede à vedere più deliciosi oggetti, e più
riguardeuoli forme nella persona di Giorgio
da Castel Franco, che per certo suo decoroso
aspetto fù detto Giorgione. Hor questi
facendo vn misto di natura, e d'arte, com-
pose vn così bel modo di colorire, che io non
saprei, se si douesse dire vna nuoua Natura
prodotta dall'arte, ò vn'arte nouella ritrouata
dalla natura per gareggiare con l'arte sua
emulatrice, come cantò quel famoso Poeta:

*Di Natura arte par, che per diletto
L'imitatrice sua scherzando imiti.*

Tasso cant. 16.

Contendono Castel Franco Terra del
Triuigiano, e Vedelago, Villaggio non guari
lontano, chi di loro fosse Patria di
Giorgione, come fecero le Città della Grecia
per Homero, come trasse dal Greco Fausto
Sabeo:

*Patriam Homero vni septem contenditis Vrbes,
Cumæ, Smyrna, Chios, Colophon, Rhodos,
Argos, Athenæ.*

La Famiglia Barbarella di Castel Franco si
vanta havervi dato l'essere, e se ne può con
ragione vantare, havendo Giorgio recato à
quella Patria i più sublimi honori; così i Fabi
Patritij Romani si pregiarono, che nella loro
prosapia fosse uscito Fabio chiarismo Pittore.
Affermano alcuni però, che Giorgione
nascesse in Vedelago d'una delle più com-
mode famiglie di quel Contado, di Padre
facoltoso, che veduto il figliuolo applicato al
disegno, condottolo à Venetia il ponesse con
Giovanni Bellino, dal quale apprese le regole
del disegno dando egli poi in breue tempo
manifesti segni del vivace suo ingegno nel
colorire: il che cagionò alcuna puntura di
gelosia nel Maestro, vedendo con quanta
felicità fossero dispiegate le cose dallo
Scolare: e certo che fù maraviglia il vedere,
come quel fanciullo sapesse aggiungere alla
via del Bellino, (in cui parevano addunate
le bellezze tutte della Pittura) certo, che di
gratia e tenerezza nel colorire, come se
Giorgio partecipasse di quella virtù, con la
quale suol la natura comporre le humane
carni col misto delle qualità degli elementi,
egli accordando con somma dolcezza le
ombre co'i lumi, e col far rosseggiare con del-
icatezza alcune parti delle membra, oue più
concorre il sangue, e si esercita la fatica in
modo, che ne compose la più grata, e gio-
conda maniera, che giamai si vedesse: onde
con ragione se gli deue il titolo del più ingeg-
noso Pittore de' moderni tempi, hauendo
inuentato così bella via di dipingere: Mà non
essendogli conceduti dal Cielo, che pochi
anni di vita, non puote in tutto dar à vedere
le bellezze del ingegno suo, mancato nel
fiorire delle sue grandezze.

Uscito dalla Scuola del Bellino si trattenne
per qualche tempo in Venetia, dandosi à
dipingere nelle botteghe de Dipintori, lavo-
randovi quadri di divotione, recinti da letto
e gabinetti, godendo ogn'vno in tali cose
della bellezza della Pittura.

Desideroso poscia di veder i parenti, se
n'andò alla Patria, ove fù da quelli, e dal vic-
inato accolto con la maggior festa del
Mondo, vedutolo fatto grande, e Pittore.
Dipinse poi à Tutio Costanzo, condottiere
d'huomini d'armi, la tauola di nostra Donna
con nostro Signore Bambinetto per la
Parocchiale di Castel Franco, nel destro lato
fece San Giorgio, in cui si ritrasse, e nel sin-
istro S. Francesco, nel quale riportò l'effegie
d'vn suo fratello, e vi espresse qualunque cosa
con naturale maniera, dimostrando l'ardire
nell'invitto Caualiere, e la pietà nel Serafico

Santo. Fece ancora qualche ritratto de que' Cittadini; la figura di Christo morto con alcuni Angeletti, che lo reggano, conservasi nelle camere del monte di Pietà di Trevigi, che in se contiene elaborato disegno, & un colorito così pastoso, che par di carne.

Dopo qualche dimora in Castel Franco, ritornò Giorgio à Venetia, essendo quella Città più confacente al genio suo, e presa casa in Campo di San Silvestro, traeva con la virtù, e con la piacevole sua natura copia d'amici, co' quali trattenevasi in delitie, dilettandosi suonar il Liuto e professando il galant'huomo, onde fece acquisto dell'amore di molti.

Dipinse in tanto lo aspetto della casa presa, acciò seruir potesse d'eccitamento à coloro, che hauessero mestieri dell'opera sua, accostumandosi all'hora per pompa il far dipingere le case da galant'huomini, nella cui cima fece alcuni ouati entroui suonatori, Poeti, & altre fantasie, e ne corsi de camini, gruppi di fanciulli, techi à chiaro oscuro, & in altra parte dipinse due mezze figure, credesi vogliono inferire, Federico 1. Imperadore & Antonia da Bergomo, trattogli il ferro dal fianco in atto d'vccidersi, per conservar la virginità, del cui avveninimento è divulgato un dotto elogio del Signor Iacopo Pighetti, & un poema celebre del Signor Paolo Vendramino; e nella parte inferiore, sono due historie, che mal s'intendono, essendo danneggiate dal tempo.

Piaciuta l'opera à quella Città furono date àdipingere le facciate di casa Soranza sopra il Campo di San Paolo, oue fece historie, fregi de' fanciulli, e figure in nicchie, hor à fatto divorate dal tempo, non conseruandosi, che la figura d'una donna con fiori in mano, e quella di Volcano in altra parte, che sferza Amore.

Seguiva in tanto Giorgio à dipingere nella solita habitatione, ove dicesi, che aperta havesse bottega dipingendo rotelle, armari, e molte casse in particolare, nelle quali faceva per lo più favole d'Ouidio, come l'aurea età divisandovi liete verdure, rivi cadenti da piaceuoli rupi, infrascate di fronde, & all'ombra d'amene piante si stauano dilitiando huomini e donne godendo l'aura tranquilla: qui vedevasi il Leone superbo, colà l'humile Agnellino, in vn altra parte il fugace Cervo, & altri animali terrestri.

Appariuano in altre i Giganti abbattuti dal fulmine di Gioue, caduti sotto il peso de dirupati monti, Pelio, Olimpo, & Ossa; Decalione e Pirra, che rinovavano il Mondo col gettar de' sassi dietro alle spalle, da quali nasceuano groppi di fanciullini.

Haveva poi figurato Pitone serpente ucciso da Apolline & il medesimo Deo seguendo la bella figlia di Peneo, che radicate le piante nel terreno, cangiaua le braccia in rami & in frondi d'alloro; e più lungi fece lo tramutata in Vacca, data in custodia dalla gelosa Giunone ad Argo, & indì addormentato dalla Zampogna di Mercurio, venivagli da quello tronco il Capo, versando il sangue per molte vene, poiche non vale vigilanza d'oc-

chio mortale, dove asiste la virtù d'un Nume del Cielo.

Vedeuasi ancora il temerario Fetonte condottiere infelice del carro del Padre suo fulminato da Gioue, gli assi, e le ruote sparse per lo Cielo; Piroo, e Flegonte, e Eoo, che rotto il freno correvano precipitosi per i torti sentieri dell'aria; e le sorelle del sfortunato Auriga sù le ripe del Pò cangiate in Pioppi, e'l Zio addolorato vestendo di bianche piume gli homeri, tramutauasi in Cigno.

Ritrassè il oltre Diana con molte Ninfe ignude ad una fonte, che della bella Calisto le violate membra scoprivano; Mercurio rubatore degli armenti di Apolline e Gioue convertito in toro, che riportava oltre il mare la bella Regina de' Fenici: così puote la forza d'Amore di trasformare in vile animale un favoloso Nume benche principale fra tutti.

Finse parimente Cadmo, fratello d'Europa, che seminaua i denti dell'ucciso serpente, da quali nascevano huomini armati, e di lontano ergeva le mura alla Città di Tebe; Atteone trasformato in Cervo da Diana, Venere, e Marte colti nella rete da Vulcano; Niobe cangiata in sasso; & i di lei figliuoli saettati da Diana, e da Apolline; Gioue, e Mercurio alla mensa rusticale di Bauci e Filomene, & Arianna abbandonata da Teseo sopra una spiaggia arenosa.

Lungo sarebbe il raccontar le favole tutte da Giorgio in più casse dipinte, di Alcide, di Acheloo e della bella Deianira rapita da Nesso Centauro saetato nella fuga dall'istesso Alcide; degli amori di Apollo, e di Giacinto, di Venere e di Adone: e tre di queste favole si trouano appresso de' Signori Vidmani; in una èla nascita d'Adone, nella seconda, vedesi in soavi abbracciamenti con Venere, e nella terza vien ucciso dal Cinghiale: & altre delle descritte furono ridotte parimente in quadretti poste e in vari studij.

Mà di più degne cose favelliamo. Avanzatosi il grido di Giorgio, hebbe materia in tanto di far opere di maggior consideratione, onde ritrasse molti Personaggi, tra quali il Doge Agostin Barbarigo, di Caterina Cornara Regina di Cipro, di Consalvo Ferrante detto il Gran

Capitano, e altri Signori. Tre ne fece ancora in una medesima tela, posseduti dal Signor Paolo del Sera Gentil-huomo Fiorentino di costumi gentili, e che si fà conoscere di bello ingegno nella Pittura. Quel di mezzo èd'un Frate Agostiniano, che suona con molta gratia il clavicembalo e mira un altro Frate di faccia carnosa col rochetto e mantellina nera, che tiene la viuola; dall'altra parte è un giovinetto molto viuace con beretta in capo e fiocco di bianche piume, quali per la morbidezza del colorito, per la maestria & artificio usatovi vengono riputati de i migliori dell'Autore: ne sia vanità il dire, che Giorgio fosse il primiero ad approssimarsi con mirabile industria al naturale, confermandosi questa verità in que' rari esemplari. Lavorò in questo tempo la facciata di Casa

Grimana alli Serui; e vi si conseruano tuttavia alcune donne ignude di bella forma e buon colorito. Sopra il Campo di Santo Stefano' dipinse alcune mezze figure di bella macchia. In altro aspetto di casa sopra un Canale à Santa Maria Giubenico colorì in un'ovato Bacco, Venere, e Marte sino al petto, e grotesche à chiaro scuro dalle parti, e bambini.

Rinovandosi indì à poco il Fondaco de' Tedeschi, che si abbrugiò l'anno 1504, volle il Doge Loredano, di cui Giorgio fatto haueua il ritratto, che à lui si dasse l'impiego della facciata verso Il Canale (come à Titiano fù allogata l'altra parte verso il ponte) nella quale divise trofei, corpi ignudi, teste à chiaro scuro; e ne cantoni fece Geometri, che misurano la palla del Mondo; prospettive di colonne e trà quelle huomini à cauallo & altre fantasie, doue si vede quanto egli fosse pratico nel maneggiar colori à fresco.

Hor seguitiamo opere sue à oglio. In quadro di mezze figure quanto il naturale, fece il simbolo dell'humana vita. Ivi appariva una donna in guisa di Nutrice, che teneua trà le braccia tenero bambino, che à pena apriva i lumi alla diurna luce provando le miserie della vita direttamente piangeua: alludendo à quello cantò Lucretio dell'huomo nascente in questi versi

Lucret. lib. 5.

> *Tum porro puer, vt sæuis proiectus ab vndis*
> *Nauita, nudus humi iacet, infans, indigus omni*
>
> *Vitai auxilio; tum primum in luminis oras*
> *Nixibus ex alueo Matris Natura profudit:*
> *Vagitumque locum lugubri complet, vt æquum est*
> *Qui tantum in vita restet transire malorum.*

E l'istesso concetto fù poscia maravigliosamente e con più numerose forme dal Marino nel seguente Sonetto dispiegato:

I. delle morali.

> *Apre l'huomo infelice all'hor, che nasce,*
> *In questa vita di miserie piena,*
> *Pria ch'al Sol, gli occhi al pianto, è nato apena*
> *Và prigionier fra le tenaci fasce.*
> *Fanciullo poi, che non più latte il pasce,*
> *Sotto rigida sferza i giorni mena:*
> *Indi in età più fosca che serena,*
> *Trà fortuna, & Amor more, e rinasce.*
> *Quante poscia sostien tristo e mendico,*
> *Fatiche, e morti in fin che curuo e lasso*
> *Appoggiato à debil legno il fianco antico.*
> *Chiude al fin le sue spoglie angusto sasso*
> *Ratto così, che sospirando io dico,*
> *Dalla cuna, alla tomba è un breue passo.*

Nel mezzo eravi un huomo di robusto aspetto tutto armato, inferendo il bollore del sangue dell'età giouanile, pronto nel vendicare ogni picciola offesa e preparato negli aringhi di Marte à versar il sangue per lo desio della gloria, il quale punto non ralenta il furore, benche altro gli rechi innanzi il simolacro di morte, òvolesse ingegnosamente dimostrare il Pittore (secondo il detto del pacientissimo) la vita dell'huomo altro non essere,

che una specie di militia sopra la terra, & i giorni suoi simili à quelli de' mercenari. Poco lungi vedeuasi un giovinetto in dispute co' Filosofanti; e tra negotiatori; e con una vecchiarella, per dinnotare le applicationi varie della gioventù, e finalmente vedevasi un vecchio ignudo curvo per lo peso degli anni, ondeggiante il crine di bianca neue, che meditava il'teschio d'vn morto, considerando come tante bellezze, virtù, e gratie del Cielo, all'huomo compartite, divenghino in fine esca de vermi entro ad un'oscura tomba, qual Pittura dicesi essere in Genova appresso de' Signori Cassinelli.

Si videro ancora in Venetia due mezze figure, l'una rappresentava Celio Plotio assalito da Claudio, che lo afferraua pel collare del giubbone, tenendo l'altra mano al fianco sopra il pugnale; e nel volto di quel giouinetto appariua il timore et l'impietà nell'assalitore, che finalmente rimase da Plotio ucciso, la cui generosa ressolutione fù commendata da Caio Imperadore, Zio del morto Claudio; & vn altro ritratto in maestà all'antica.

Ma consideriamo un gentil pensiero gratiosamente dispiegato dal penello di Giorgio. In capace tela haueua fatto il congresso d'una famiglia, standoui nel mezzo un vecchio castratore con capellaccio, che gli adombraua mezzo il volto, e lunga barba ripiena di molti giri in atto di castrare un gatto, tenuto nel grembo da una donna, la quale dimostrandosi schiffa di quell'atto, altrove rivolgeua il viso: eravi presente una fantesca con la lucerna in mano & un fanciullo teneua il tagliere con empiastri, & una fanciulla recaua un altro gatto, che defendendosi con le unghie le stracciaua il crine.

Fece ancora vna donna ignuda, & con essa lei un Pastore, che suonava il zufolo, et ella mirandolo sorrideva; e si ritrasse in forma di Davide con braccia ignude, e corsaletto in dosso, che teneva il testone di Golia: haueua da una parte un Cavaliere con giuppa, e beretta all'antica, e dall'altra un Soldato, qual Pittura cadè dopo molti giri in mano del Signor Andrea Vendramino.

Una deliciosa Venere ignuda dormiente è in casa Marcella, & à piedi è Cupido con Augellino in mano, che fù terminato da Titiano.

Altra mezza figura di donna in habito Cingaresco, che del seno dimostra le animate nevi co' crini raccolti in sottil velo, e con la destra mano si appoggia ad un libro di vari caratteri impresso, è nelle case del Signor Gio. Battista Sanuto; e gli Signori Leoni da San Lorenzo, conservano due mezze figure in una stessa tela di Saule, che stringe ne' capelli il capo di Golia recatogli dal giouinetto Davide, ed in questi ammirasi l'ardire, in quello la regia maestà; & in altra tela Paride con le tre Dee in picciole figure; & in casa Grimana di Santo Ermacora, è la sentenza dl Salomone, di bella macchia, lasciandovi l'Autore la figura del ministro non finita.

Il Signor Caualier Gussoni grauissimo Senatore ha una nostra Donna, San

Girolamo, & altre figure di questa mano. Il Signor Domenico Ruzzini Senatore amplissimo, possiede il ritratto d'un Capitano armato. I Signori Contarini da San Samuello, conseruano quello d'un Cavallere in arme nere, & i Signori Malipieri San Girolamo in mezza figura molto naturale, che legge vn libro; ed il Signor Nicolò Crasso il ritratto di Luigi Crasso celebre Filosofo Avo suo posto à sedere con occhiali in mano.

Io vidi ancora dell'Autore in mezzani quadri dipinta la fauola di Psiche, della quale, descrivendo il modo tenuto da Giorgio nel divisarla, toccheremo gli avvenimenti.

Nel primo quadro appariva quella fanciulla, il cui bel viso era sparso del candore dei gigli, e del vermiglio delle rose, formaua tra le labra di rubino un soave soriso, e co' bei lumi saettava i cuori; nell'aureo crine spuntavano à gara i fiori, formando quasi in dorata siepe un lascinetto Aprile. Stavasi quella in atto modesto, sostenendo con la destra mano il cadente velo, e con l'altra stringendo l'estremità di quello nascondevasi il morbido seno; e dinanzi le stavano ossequiosi molti popoli, che le offerivano frutti, e fiori, tributandola come novella Venere.

Nel secondo l'amorosa Dea priva de' dovuti honori, asisa sopra à gemmato carro tirato da due placide Colombe, imponeva al figlio Amore, che della sua riuale prendesse vendetta, facendo d'un huomo vile ardere in amorosa fiamma: ma questa fiata il bel Cupido preda rimase di bellezza mortale, provando de' begli occhi di Psiche le amorose punture.

Nel terzo il Rè Padre (conforme la risposta dell'Oracolo di Mileto) accompagnava Psiche con lugubre pompa alla foresta (si prepari sempre il cataletto, chi nella cima delle grandezze si ritroua) ove attender doveva lo sposo suo ferino sprezzatore degli Dei, & era accompagnata dalla Corte, e dal popol tutto con faci accese, e rami di cipresso: in mano in segno di duolo.

Appariva nel quarto la sconsolata fanciulla portata da leggieri zefiri al Palagio d'Amore, dove lavata in tepido bagno, stavasi poi ad una ricca mensa tra musicali suoni, & in rimota stanza, vedeuasi più lungi corcata sotto padiglione vermiglio appresso il bello Amore.

Nel quinto quadro desiderosa Psiche di riveder le sorelle (benche ammonita delle sue disaventure da Amore) portato anch'elleno da Zefiri, si vedetiano in gratiose attitudini nel reale palagio in ragionamenti con le sorelle, le quali maravigliate delle ricche supelletili, e dello stato suo felice, punte da invidioso veleno la fan credere, ch'ella ad un bruto serpe ogni notte si accompagni, a cui deue attender la morte in breue, persuadendola, che di notte tempo, qual'hor dorme l'vccida, sottraendosi in tale guisa dalla di lui tirannia.

Poi nel sesto stauasi la credula amante col ferro, e la lucerna in mano sopra l'addormentato fanciullo, e vagheggiando il bel viso, l'oro de' crini, le ali miniate di più col-

ori, soprafatta dallo stupore non pensa al partire. Spiccasi in tanto dall'ardente lucerna insidiosa fauilla, avida anch'ella di toccare le morbide carni, e cadendo sopra l'homero d'Amore, turba ad un tratto i piaceri di Psiche.

Così le gioie han per confine i pianti.

Onde Cupido riscuotendosi dal sonno, mentre quella tenta ritenerlo, rapidissimo in altra parte si vedeva fuggire, riprendendo la di lei ingratitudine.

Nel settimo Giorgio haueua rappresentato il pellegrinaggio dell'infelice amante, come incontravasi in Pane tinto di color sanguigno, dal cui fianco pendeuano sorati bossi, che la consola; e di lontano si vedeuano le inique sorelle ingannate da Psiche (fatta scaltra nelle proprie disaventure) precipitarsi dal monte, credendo divenir spose d'Amore.

E nell'ottauo era Venere cinta di sbara celeste, accompagnata dalle Gratie sopra conchiglia di perle, che adirata riprendeua il figliuolo per gli amori di quella fanciulla; & in altre sito appariua la sfortunata Psiche, pervenuta dopo molti disagi al Tempio di Cerere, à cui limitati erano fasci di spiche, rastri, e vagli: èspargendo amare lagrirne, pregava quella Dea della sua protettione: la quale per non dispiacere all'amica Venere (anteponendosi spesso l'interesse alla pietà) non ode d'un cuor orante le affettuose preghiere: e di la partita (dopò lungo camino) stavasi di nuovo nel Tempio di Giunone, divenuta sorda anch'ella alle di lei preghiere, poiche ad un rubelle del Cielo, hà turate le orecchie ogni Deità.

In così misero stato agitata da tanti pensieri, che farà l'infelice amante, in odio al Cielo à gli Dei, & allo sposo suo? doue si nasconderà da Venere sua fiera nemica? (ò con quanto disavantaggio contende l'huomo col Cielo?) gli sarà forza in fine ridursi in braccio alla potente sua nemica, la quale per ogni luogo fattala bandire da Mercurio, promette baci, e doni à chi di quella novelle le rechi. Onde nel nono vedeuasi la meschina presa per le chiome da Venere, e battuta con miserabile scempio, e dopò molte ingiurie, e rampogne, in dividere gran cumulo di confusi semi l'impiega, assignandole quel di tempo, che alla cena del gran Giove si trattenghi, quali in virtù d'Amore venivano dalla nera e sollecita famiglia divisi.

Nel decimo la Dea del terzo Cielo vie più incrudelita, desiderosa della morte di Psiche, l'invia ad un folto bosco, ove pascevano fatali pecore, perche di quelle un fiocco di aurata lana le porti (così per la via delle afflittioni si purgano le colpe,) & esequito l'ordine imposto, dinanzi à quella Dea la povera Psiche si presenta. Poi con l'aiuto dell'augel di Gioue le acque di stigie le riporta; e per ultimo delle fatiche scesa per comissione di Venere all'inferno, e ricevuto da Proserpina il creduto unguento per abbellire il viso: stimolata dalla vanità, scoprendo il letale sonnifero cadè tramortita, onde risvegliatala Amore col dorato strale, e

rimessole il sonnifero nel vase la rimandaua alla madre sua.

Nell'undecimo (non potendo il bel Cupido più sofferire gli stratij della sua donna, ottenuto in fine, che gli diuenghi sposa, vedeuasi Gioue nel mezzo al Concistoro degli Dei, decretare il matrimonio di quella con Amore, mentre dalla bassa terra veniua la bella fanciulla da Mercurio portata al Cielo. E nell'ultimo Giorgio finto haueua belle, e sontuose nozze, ove ad una ricca mensa imbandita d'aurei vasi, di fiori, e d'altre vaghezze, sedevano nel più sublime luogo Amore, l'amorosa Psiche, e gl'altri Dei di mano in mano; le Gratie somministrauano al diuino conuito laute viuande; Ganimede d'aria, di crespi, e d'aurei crini, e di rosate vesti adorno serviua di coppiere co' nettari divini. Le Muse anch'elleno formando due lieti cori co' stromenti loro riempivano di celeste armonia le beate stanze, e'l Dio di Delo sul canoro legno intuonaua soavi canzoni, mentre le hore veloci dibattendo le ali d'ogni intorno ricamavano di rose bianche, e vermiglie il Cielo.

In tale guisa Giorgio figurati haveua gli avvenimenti della famosa Psiche, la quale dopò molte fatiche gionse à godere il desiato suo sposo. E sotto questo nome intesero quegli antichi saggi, l'anima humana della quale inuaghitosi il diuino Amore, l'abbellisce d'ogni virtù: mà perseguitata dall'appetito con nome di Venere cerca d'accopiarla all'habito vitioso, quindi stimolata dall'irascibile e concupiscibile potenze, deviando da diuini precetti, cade negli errori: alla fine per sentieri delle fatiche, mediante l'uso degli habiti morali si riduce di nuovo in gratia dello sposo suo, partorendo quel diletto, ch'è la fruitione della celeste Beatitudine; alle quali inuentioni Giorgio reso haveua tale gratia, e naturalezza nelle forme, nelle attitudini, e negli affetti, che ogn'uno fisandovi lo sguardo non istimava vanità la fauola; mà uera è naturale.

Ma ricerchiamo altre pitture dell'Autore. Dicesi essere in Cremona nella Chiesa dell'Annunciata una tavola con San Sebastiano, che hà legato alle spalle un panno, & vi è tratta per terra una celata, e ne frontespitio dell'Altare sono due Angeletti, che tengono una corona.

Il Signor Prencipe Aldobrandino in Roma, hà una figura del detto Santo à mezza coscia & il Signor Prencipe Borghese un Davide.

Li Signori Christoforo e Francesco Muselli in Verona hanno un giovinetto con pelliccia tratta bizzaramente àtraverso le spalle stimato singolare.

Si vide ancora di questa mano un quadro in mezze figure quanto il naturale di Christo condotto al Monte Caluario da molta sbirraglia, un de quali lo tirava con fune & altro con cappello rosso di lui ridevasi; lo accompagnauano le pietose Marie e la Verginella Veronica porgeuagli un panno lino per raccorre del cadente sangue le pretiose stille.

Dipinse in oltre vn gran testone di Polifemo con cappellaccio in capo, che gli formaua ombre gagliarde sul viso, degna fatica di quella mano per l'espressione di si gran volto. Ritrasse molte donne con bizzarri ornamenti e piume in capo, conforme l'uso di quel tempo.

Fece Giorgio di nuouo il rittrato di se medesimo in un Dauide con lunga capigliatura, e corsaletto in dosso e con la sinistra mano afferraua ne' capegli il capo di Golia, e quello d'un Comandatore con veste e giubbone all'antica, e Beretta rossa in mano, creduto d'alcuni per vn Generale, & altro d'un giovinetto parimente con molle chioma & armatura, nella quale gli riflette la mano di esquisita bellezza, & vno d'un Tedesco di casa Fuchera con pelliccia di volpe in dosso, in fianco in atto di girarsi, & una mezza figura d'un ignudo pensoso con panno verde sopra à ginocchi, & corsaletto à canto in cui egli traspare, nelle quali cose diede à vedere la forza dell'Arte, che hà virtù di dar vita alle imagini dipinte; che sono nelle case degli Signori Giouanni e Iacopo Van Voert in Anversa.

Vogliono alcuni, che il medesimo ancora hauesse dato principio ad una historia per la Sala del maggior Consiglio di Papa Alessandro III, à cui l'Imperadore Federico I. baciaua il piede (che altri han detto fosse incominciata da Gio. Bellino), che fù poscia terminata da Titiano, con qual fatica haverebbe conseguito la pienezza della lode, intervenendovi molte figure, che formar potevano un degno componimento: ma piacque à Dio leuarlo dal Mondo d'anni 34 il 1511 infetandosi di peste, per quello si dice, praticando con una sua amica; benche altrimenti il fatto si racconti, che godendosi Giorgio in piaceri amorosi con tale donna da lui ardentemente amata, le fosse sviata di casa da Pietro Luzzo da Feltre detto Zarato suo Scolare, in mercè della buona educatione & insegnamenti del cortese Maestro, perloche datosi in preda alla disperatione (mischiando sempre Amore trà le dolcezze lo assentio) terminò di dolore la vita, non ritrovandosi altro rimedio alla infettatione amorosa, che la morte, e lo disse Ouidio:

Nec modus, & requies, nisi mors reperitur Amoris.

Così restò privo il Mondo d'huomo cosi celebre e d'un Nume della Pittura, à cui si convengono perpetue lodi & honori, hauendo seruito di lumiera à tutti coloro, che vennero dietro di lui. E certo, che Giorgio fù senza dubbio il primo, che dimostrasse la buona strada nel dipingere, approssimandosi col mischie de' suoi colori ad esprimere con facilità le cose della natura; poiche il punto di questo affare consiste nel ritrouar vn modo facile, e non stentato, celandosi quanto più si può le difficoltadi, che si provano nell'operare: quindi è, che nelle mischie delle carni di questo ingegnoso Pittore non appaiono le innumerabili tinte di bigio di rancio, d'azzurro, e di si fatti colori, che si accostumano inserirui da alcuni moderni, che si credono con tali modi toccar la cima dell'Arte, allon-

tanandosi con simili maniere dal naturale, che fù da Giorgio imitato con poche tinte adequate al soggetto, che egli prese ad esprimere, il cui modo fù ancora osservato trà gli antichi (se prestiamo fede à gli Scrittori) da Apelle, Echione, Melantio, e Nicomaco chiari Pittori, non vsando eglino, che quattro colori nel comporre le carni; quali termini, però non si possono basteuolmente rappresentare in carte, e che più si apparano dall'esperienza, che si fà sopra le opere de' valorosi Artefici, che dal discorso: e come che da pochi Professori sono intesi, così mal vengono osseruati da coloro, che men sono istrutti nell'arte; ingannandosi molti ancora dalla vaghezza de' colori, quali soverchiamente usati, apportano nocumento alle carni: ne già come alcuni si credono il dipingere dipende dal capriccio, ma dalle osseruationi della natura e dalle regole fondate sopra la simmitria de'corpi più perfetti, da quali trassero rarissimi docunmeti ne' scritti loro, fra gli antichi, Apelle, Eufranore, Ischinio, Antigono, e Senocrate; e tra moderni Alberto Durero, Leon Battista Alberti, il Lomazzo & altri, che ne prescrissero parimente accurate regole; non douendosi meno imitare ogni natural forma: ma quelle solo, che più si appressano alla perfettione, di che esser deve giudice l'ingegnioso Pittore, ch'eleger sempre deve le più belle, & eccellenti.

Mà ritornando à Giorgio dico, che gli Artefici, che sono dopò lui seguiti, con gli esempi delle opere sue, hanno apparata la facilità, e'l vero modo del colorire, onde si sono avanzati nella maniera, che dipoi si èveduto.

La fama nondimeno nell'immatura sua morte appese nel Tempio dell'Eternità la tabella dell'effigie sua, che con gentile prosopopea così di se ragiona.

Pinsi nel Mondo, e fù si chiaro il grido
Della mia fama in queste parti e in quelle,
Che glorioso al par di Zeusi e Apelle,
Di me rissona ogni rimoto lido.
In giouanile etade il patrio nido,
Lasciai per acquistar gratie novelle ;
Indi al Ciel men volai frà l'auree stelle.
Oue hò stanza migliore, albergo fido.
Qui frà l'eterne, & immortali menti,
Idee più belle ad emulare io prendo
Di gratie adorne, e di bei lumi ardenti.
Et hor del mio pennel l'opre riprendo,
Che vaneggio con l'ombre trà viventi,
Mentre nel Ciel forme divine apprendo.

I. 95-108

VITA DI GIOVANNI BATTISTA CIMA DA CONEGLIANO

Mà frà tutti i Scolari del Bellino i più famosi & eccellenti furono Giorgione da Castel Franco e Titiano da Cadore, i quali col sublime ingegno loro fecero conoscere, quanto la Pittura sia frà le humane operationi Grande & eccellente.

VITA DI JACOPO DA PONTE DA BASSANO

Il Signor Francesco Bergontio hà di questa

mano il ritratto d'un Contadino singolare & uno di donna di mano di Giorgione, & altro dipinto dal Morone, d'un Poeta, ambì rarissimi.

VITA DI TITIANO VECELLIO DA CADORE
Alterò poscia la maniera all'hor, che vide il miglioramento, che fatto haveva Giorgione. Errando nondimeno il Vasari, facendolo suo Discepolo, e che d'anni 18 facesse un ritratto su la maniera di quello, poiche Titiano era di pari età & alleuato con esso lui nella casa di Gio. Bellino.
E però vero, che piacendo à Titiano quel bel modo di colorire, posto in uso dal Condiscepolo, e praticando seco, ne divenne ad un tempo imitatore & emulo.
Titiano emulo di Giorgione.
Non prevaleva all'hora ne' studenti, benche adulti l'albagia, havendo eglino per solo fine l'avanzarsi in perfettione col seguir la via più lodata; il cui bel modo di colorire fù per molto tempo practicato da passati Pittori Veneti, fin tanto, ch'è rimasto perduto tra miscugli delle maniere introdotte in quella Città, non essendo lodato il dipingere à capriccio, ma il seguir la natura con que' modi, che ci vengono prescritti dall'Arte; poiche essendo gli humani corpi composti della mistione degli elementi non appaiono già di cosi viuaci colori, come da alcuni si costuma di dipingerli, partecipando eglino d'un mezzano colore, che più e meno tira all'opaco, conforme la qualità del suo misto, quali termini quanto bene fossero intesi da Giorgione e da Titiano, non è da farne digressione, onde quelli, che hanno caminato per le orme loro, sono arrivati con facilità alla perfettione dell'Arte.
Ma seguendo il discorso, trasformossi Titiano in guisa nella maniera di Giorgione, che non scorgeuasi tra quelli differenza alcuna. Quindi è, che molti ritratti vengono confusamente tenuti senza distintione hor dell'uno, hor dell'altro; e col medesimo stile dipinse la facciata verso terra del Fondaco de' Tedeschi (essendo la parte verso il canale locata à Giorgione, come nella vita sua dicemmo). Nel cantone, che mira il Ponte di Rialto collocò una donna ignuda in piedi delicatissima, e sopra alla cornice un giouinetto ignudo in piedi, che stringe un drappo in guisa di vela, & un bamboccio lograto dal tempo; e nella cima fece un'altro ignudo, che si appoggia à grande tabella, oue sono scritte alcune lettere, che mal s'intendono.
Mà più fiera è però la figura di Giuditta, collocata sopra la porta dell'entrata, che posa il piè sinistro sul reciso capo d'Oloferne, con spada in mano vibrante tinta di sangue, & à piedi vi è un servo armato con berettone in capo, di gagliardo colorito; errando ancora in questo luogo il Vasari, facendola di Giorgione. Sopra la detta cornice diuise altre figure, e nel fine un Suizzero e un Leuantino, & un fregio intorno à chiaro scuro ripieno di varie fantasie.
Titiano supera Giorgione

Dicesi, che così piacquero quelle Pitture àVenetiani, che ne riportò comunemente la lode, e che gli amici suoi fingendo non conoscere, di chi si fossero, si rallegrauano con Giorgio della felice riuscita dell'opera del Fondaco, lodandolo maggiormente dalla parte verso terra, à quali con sentimento alterato rispondeua loro, quell'essere dipinta da Titiano, e così puote in lui lo sdegno, che più non volle, che praticasse in sua casa.
S. Marcuola
Con l'intrapresa maniera lauorò nel porticale di Casa Calergi hor Grimana, à Sant'Ermacora alcune armi e due figure di virtù. Circa lo stesso tempo oprò Titiano il Christo del capitello di San Rocco, posto dal Vasari nella vita di Giorgio, tirato con fune da perfido hebreo, che per esser piamente dipinto, hà tratto à se la diuotione di tutta la Città.

VITA DI DOMENICO RICCIO DETTO IL BRUSASORCI
Ma auuanzando in poco tempo Domenico il sapere del maestro, si risolse il padre mandarlo à Venetia, acciò con la veduta delle opere di Titiano e di Giorgione potesse maggiormente erudirsi, tenendo la via del Carotto della vecchia maniera, doue studiando per qualche tempo, apprese certo che di grandezza e miglior modo nel colorire.

PITTURE DI VARIJ AUTORI PRESSO IL SIG. CORTONI, VERONA
Di Giorgione: Nostro Signore con gli Apostoli e la donna Cananea con la Egliuola indemoniata di manierose forme eccedenti il viuo; un viuace ritratto con paese & architetture; Achille saetato da Paride.

VITA DI JACOPO PALMA IL GIOVINE PITTORE
Varie pitture di eccellenti Autori in Casa del Signor Bortolo Dafino.
Un Bachetto con vase in mano di Giorgione.

INVENTORY OF HAMILTON PAINTINGS
1649
GERGION
47. Un paisage avec 3 Astrologiens, h. 6 la. 8 pa.
48. Une Histoire avec un paisage, h. 6 la. 8 pa.
49. La naissance de nostre Seigneur, h. 4 la. 5 pa.
50. Une femme qui est outrage par un Soldat avec un paisage, h. 2. la 4.
51. St. Jerome, 2 pa. quarree
52. Un orphee, h. 3 la 4 pa.
53. Un Moyse trouve par la fille de pharoah avec quantitez de figures h. 5 la 7 pa.
54. Un Brave qui va assisiner un homme, h. 4 quarree
55. Un homme armee a toutes pieces h. 5. la 3 pa.
56. Le pourtrait de Madame Laura de Petrarcha, 2 pa. quarree

Hamilton Archive, Lennoxlore.
Garas, 1967, pp. 68, 76.

INVENTORY OF PICTURES IN THE POSSESSION OF ALETHEA, COUNTESS OF ARUNDEL, AT HER DEATH, AMSTERDAM
1654
Giorgion. Una testa di homo con Beretino.
Paese con un Cavaglier et una Donna & homini che tengono gli cavalli. Giorgion.
Giorgion. Un homo a Cavallo.
Giorgion. bagno de Donne.
Giorgion. Resurrectione de Lazaro.
Giorgion. Una dama tenendo Una testa de morte piccola.
Gior: Hercules & Achelous.
Giorgion. David con la testa de Gollah.
Giorgion. fuga di Egipto.
Orpheo. Giorgion.
Giorgion. Christo nel horto.
Giorgion. un homo & Donna Con Una testa In Mano.
Public Record Office, London, Delegate's Processes, *VII.*
Cox and Cust, 1911, pp. 282-86.

INVENTORY OF THE COLLECTION OF GIOVANNI PIETRO TIRABOSCO IN HIS HOUSES AT SAN CANCIANO AND SAN AGOSTINO, VENICE
1655, 30 November
Di Giovanni Pietro Tirabosco nelle case di S. Canciano e S. Agostino.
Un quadro antico maniera di Giorgion con la Madona, S. Antonio, San Giov. Evangelista.
Un retratto armato, maniera di Giorgion.
Un ritratto Con una testa di morte, maniera di Giorgion.
Un S. Girolamo di Giorgion.
Levi, 1900, II, pp. 16-18.

COLLECTION OF MICHELE SPIETRA AT SANTI APOSTOLI, VENICE
1656, 5 April
Un quadro copia di Zorzon.
L'Historia dell'adultera vien da Zorzon.
Tre musichi che vien da Zorzon.
Levi, 1900, II, pp. 20, 23.

INVENTORY OF THE COLLECTION OF GASPAR CHECHEL AT SAN LIO
1656, 5 April
Un quadro sopra tela con cornice mezze dorate con
3 figure, una pare del Tintoretto e l'altra di Zorzon e la 3ª di Titiano.
Un ritratto armato maniera del Giorgion.
Un ritratto Con una testa di morte maniera Giorgion.
Levi, 1900, II, pp. 33, 38-39.

INVENTORY OF THE COLLECTION OF ARCHDUKE LEOPOLD WILHELM OF AUSTRIA
1659
13. Ein Contrafait von Öhlfarb auf Holcz.
Ein gewaffneter Mahn mit einer Oberwehr

in seiner linckhen Handt vnd neben ihme ein andere Manszpersohn. In einer glatt vergulden Ramen, 4 Span 5 Finger hoch vnd 5 Span 7 Finger braidt. Original von Gorgonio. [*Portrait of Girolamo Marcello*, Figs. 13, 177]

37. Ein Stuckh von Öhlfarb auf Holcz, die Judit mit des Holofernis Kopf vor ihr auff einem Tisch, auf ihr rechten Achsel ein rothen Belcz, in der rechten Handt ein Schwerth, vnd den linckhen Arm bloß. In einer vergulden, außgearbeithen Ramen, 5 Span 1 Finger hoch vndt 3 Span braidt. [*Judith*, lost]

95. Ein Stückhl von Öhlfarb auf Holcz, warin die Europa auf einem weißen Oxen durch das Waser schwimbt, auf einer Seithen ein Hürrth bey einem Baum, welcher auf der Schallmaeyen spilt, vnd auf der andern zwey Nimpfhen. In einer glatt vergulden Ramen 2 Span 2 Finger hoch vnd 4 Span 4 Finger braith.
Original de Giorgione. [*Rape of Europa*, Fig. 150]

123. Ein Stuckh von Öhlfarb auf Holcz: der Dauidt gewaffent, in der rechten Handt ein Schwert vnd in der linckhen desz Goliats Kopf. In einer glatt gantz vergulden Ramen, die Höche 5 Span vndt die Braidte 4 1/2. Man hält es von Bordonon. [*Self-Portrait as David*, Fig. 34]

128. Ein Landtschafft von Öhlfarb auf Leinwand, warin drey Mathematici, welche die Maß der Höchen des Himmels nehmen. In einer vergulden Ramen mit Oxenaugen, 7 Span hoch und 8 Span 81 Finger braidt.
Original von Jorgonio. [*Three Philosophers*, Fig. 49]

132. Ein Landtschafft von Öhlfarb auf Leinwath, warin zwey Hüerthen vff einer Seithen stehen, ein Kindl in einer Windl auf der Erden ligt, vnd auff der andern Seithen ein Weibspildt halb blosz, darhinter ein alter Mahn mit einer Pfeyffen siczen thuet. [*Finding of the Infant Paris*, Fig. 93]

176. Ein klein Contrefait von Öhlfarb auff Leinwath vnd auff Holcz gepabt einer Frawen in einem rothen Klaidt mitt Pelcz gefüettert, mit der rechten Brusst gancz blosz, auf den Kopf ein Schlaer, so bisz über die Brusst herunder hangt, hinder ihr vndt auf der Seithen Laurberzweig. In einer ebenen Ramen vnd das innere Leistl verguldt, 2 Span 4 Finger hoch vnd 2 Span 1 Finger braith. Von einem vnbekhandten Mahler. [*Laura*, Fig. 127]

215. Ein Landtschafft von Öhlfarb auf Leinwath, warin ein Schloss vndt Kirchen, wie auch ein grosser Baum, dabey siczt ein gewaffneter Mahn mit einem blossen Degen neben einer gancz nackhendten Frawen, auf der Seithen ein weisz Pferdt mit einer Waltrappen, so grassen thuet. In einer gantz verguldten Ramen mit Oxenaugen, hoch 3 Span 7 Finger vnd 4 Span 3 Finger braidt. Man halt es von dem Giorgione Original. [*The Rape*]

217. Ein Nachtstuckh von Öhlfarb auf Holcz, warin die Geburth Christi in einer Landtschafft, das Kindtlein ligt auf der Erden auf unser lieben Frawen Rockh, wobei Sct. Joseph und zwey Hierdten undt in der Höche zwey Englen. In einer glatt vergulten Ramen, hoch 5 Span 4 Finger undt 6 Span 4 Finger braith. Man halt es von Giorgione Original. [*Adoration of the Shepherds*, Fig. 28]

237. Ein Stuckh von Öhlfarb auff Leinwath, warin ein Bravo. In einer schmallen, auszgearbeithen vndt verguldten Ramen, die Höche 4 Span vnd die Braidte 3 Span 3 Finger. Original von dem Giorgione. [*The Bravo*, Fig. 37]

Fürstlich Schwarzenberg'sches Zentralarchiv, Vienna.

Berger, 1883.

MARCO BOSCHINI, LA CARTA DEL NAVEGAR PITORESCO
1660

Vento primo.
ARGOMENTO.

Tician, Zan, e Sentil fradei Belini,
 Zorzon, Carpacio, e'l Basaiti hà laude;
 Ai quadri d'Austria, e al Venetian se aplaude,
 Che del human sauer passa i confini.

ZORZON INGANA LA NATURA

Zorzon con muodi più vivi del vivo
 Mostrerà la maniera del dasseno;
 E troverà quel, che hà ceruelo, e seno
 Assae de più de quel, che mi descrivo.

QUADRO MARAVEGIOSO DE ZORZON
SUL MONTE DE PIETÀ A TREVISO

Porta la spesa andar fina a Treviso,
 Per veder la dotrina de Zorzon;
 Ghe xe una Istoria pia de devocion,
 Che par che la sia fata in Paradiso.

Se vede là sul Monte di Pietà
 El Dio dela Pietà, morto per nu;
 Cosa se puol rapresentar de più,
 Che insieme col divin l'umanità?

Zorzon, ti ha abù giudicio a farlo morto:
 Sì sì, perchè, si ti 'l volevi far
 In ato forsi de resussitar,
 L'andava al Ciel; dar no te posso torto.

Bisogna che ti fussi bon Cristian
 A far con i peneli chi t'ha fato;
 Voi dir, formar sì belo el so retrato.
 Benedete sia sempre le to man!

Ma rende gran stupor tre bei Putini,
 Che xe vivi, e del quadro no se parte.
 Questa fu del Pitor certo grand'arte!
 Si mi no falo, questi fu i so fini.

El disse: ghe voi dar spirito e vita,
 Né vogio che i se parta de qua via
 Fin che 'l Signor ressussità no sia;
 Ché Gesù Cristo è la so calamita.

Signor, la senta si xe granda questa!
 Un de quei che xe in scurzo, in verità
 El xe tuto dal quadro destacà;
 Solamente el lo toca con la testa.

Quela è Pitura de tanto decoro,
 Che chi volesse dar el condimento
 A Venezia, che xe tuta ornamento,
 Bisogneria portarla int'el Tesoro.

E far un epitafio là sul Monte,

In memoria del quadro sì ben fato,
 E dir, che'l Serenissimo Senato
 El custodisse là con le man zonte.

Eccellenza

Ve digo el vero, che in conscienza mia
 Mi no ve posso dir d'averlo visto;
 Ma da sto dir ho fato un tal aquisto,
 Che a dir de sì no la sari busia.

Me avé fata la copia assae galante,
 Che, per non aver qua l'original,
 Per quel'istesso quasi la me val,
 Restando molto pago in un istante.

Compare

No debo certo far sto mancamento,
 De no narar un altro gran stupor,
 Che fa parer crudel quasi el Pitor:
 Ché l'empietà ghe xe depenta drento.

Però questa è virtù, no l'è defeto,
 Rapresentar l'istorie in viva forma;
 La Pitura è modelo, esempio e norma,
 Perché la mostra al vivo el vero efeto.

Ho visto de Zorzon una pitura,
 Ma megio è il dir de la Natura un spechio,
 Con un Zovene drento e un quasi Vechio,
 Quelo tuto timor, questo bravura.

Celio xe là, con impeto assalio
 Da Claudio, che ha la man sora un pugnal,
 E l'altra int'el cavezzo a questo tal,
 Sì che 'l par veramente tramortio.

In verità che l'è una azion sì fiera,
 Che a chi la vede ghe vien volontà
 De petar man e de dir: ferma là,
 Tanto la par dasseno e più che vera

Cusì, come se vede l'atencion
 De Claudio, armà d'un lustro corsaleto,
 Che d'incendio sdegnooso ha colmo el peto,
 Cusì quel Celio muove a compassion.

Se ghe vede la fazza tuta smorta,
 Da mezo vivo, senza sangue adosso.
 Quanto el sia natural dirlo non posso:
 Par che la Morte ghe bata ala porta.

Zorzon, ti è stà el primo, che'l se sa,
 A far le marvegie in la Pitura;
 E, fin che el mondo e le persone dura,
 Sempre del fato too se parlerà.

Fina ai to zorni tuti quei Pitori
 Ha fato de le statue, respetive
 A ti, che ti ha formà figure vive;
 L'anima ti gh'ha infuso coi colori.

Eccellenza

Dove de gratia adesso è sto tesoro?

Compare

No l'è più in stà Città, che chi hebe inzegno
 El portè via, lassando un grosso pegno
 In cambio soo, che fù un profluvio d'oro.

Vero è ben che à San Boldo in Cà Grimani
 Ghe xé una copia del gran Varotari,
 Che anche ela val montagne de danari:
 La viste che'l poul esser sie, ò set'ani.

. .

Ma vegne fuora un spirito imortal,
 Che fu el nostro Zorzon da Castel Franco,
 che coi peneli el fè né più né manco
 Quele figure come el natural.

Al'ora la Pitura fù dasseno;
 Al'ora tuto el Mondo se stupiva:
 Perchè i vedeva la pitura via,

Fata con gran giudicio, e con gran seno.
Eccellenza
Perdoneme Compare, che'l Vasari
　Dise che'l primo fusse in morbidezzA
　Lunardo Vinci; e'l dise con franchezza,
　Che a Zorzon l'insegnasse i colpirari.
Compare
Dove el Vinci xè stà, no xé stà mai
　Zorzon, ne'l Vinci dov'è stà Zorzon:
　Sta so' busssia no ghè farò mai bon:
　Sti conti in sù le prime è stà falai.
La se compiasa a lezer el Borghini,
　Pur anca Fiorentin, che con maniera
　Contese el fà sentir l'Istoria vera:
　Perchè d'ingenuità giera i so fini.
El dise ben che al tempo per aponto,
　Che Fiorenza aquistava per LUnardo
　Gran Fama, anche Zorzon no giera tardo
　A dar su'l Venetian de lù bon conto.
E che arlevado el fusse stà a Venetia,
　Dove studio sì grando el fè in dessegno,
　Che dei Belini el superè l'insegno.
　Questa xè verità; no l'è facetia.
Ma diro megio: la leza più avanti,
　Che l'istesso Borghin fà fede come
　Un Venetian, Domenego de nome
　Insegnè a i Fiorentini tuti quanti.
Parlo però de la Pitura a ogio:
　E per tanto el Vasari no donfonda
　La verità: ma è ben che'l corisponda
　Con cortesia, senza nissun'imbrogio.
No digo che Lunardo no sia stà
　(Per cusi dir) el Dio dela Tosacana:
　Ma anche Zorzon la strada venetiana
　Con eterna so'gloria hà caminà.
Vegne Tician, fù visto el Pordenon,
　E'l Palma vechio con sì rari trati,
　Che l'Universo i fè stupir in fati,
　Per quele so' ecelente operation.
. .
Vento Quinto
ZORZON GRAN COLORITOR
Milita in sto bel far medemamente
　Quel gran Zorzon, l'honor de Castel
　　Franco;
　Quel, che col colorir ne più ne manco
　Ha fato cose da incantar la zente.
E una minima parte, che se vede
　A fresco, de so man, sula fazzada
　De Cà Soranzo, vien molto laudada.
　Chi va a San Polo quel stupor fa fede.
Gh'è un nudo, che xe carne che la vive,
　E viverà, se ben che da quel muro
　La se smarisse; l'è pensier seguro.
　Cusì in concerto molti Autori scrive.
L'illustrissimo Gozi, mio Signor,
　Ben Prospero de nome e de Fortuna,
　Ma prospero e fecondo assae più d'una
　Virtù, che ecede el termine mazor,
Ha de quela Virtù vivo un retrato
　D'un Omo, ecelentissima fatura,
　Dove gariza insieme Arte e Natura,
Me par che sto mio dir sarave indarno,
　E che gran torto ala virtù se fasse,
　Quando un retrato de Zorzon lassasse,
　che gode l'illustrissimo Lucarno.
Oh che vivo retrato, e tuto brilo,
　Grave de positura e vestimento!
　Puol ben, per causa tal, viver contento

Quel mio Signor de stima, Andrea
Camilo.
. .
Eccellenza
El Signor Baron Tassis l'è mio Amigo;
　Ma l'ha un Studio famoso. . .
Gh'è una Madona de Zorzon ben fata
　Gh'è n'è un'altra pur bela del Belin;
　Gh'è un gran Retrato del Calegherin,
　E un altro del Bordon, che fa a regata.
Ghè un quadro con tre Dee de quel gran
　　Palma,
　Digo del Palma vechio, sì ecelente,
　Che'l fa maragegiar tuta la zente
　E tra le bele cose el tien la palma.
De Tician, del Belin e de Zorzon
　Ghe xe ancora, e ghe xe del Tentoreto.
　Gh'è i Licini, el Malombra, e gh'è 'l
　　Moreto;
　Gh'è 'l Pozzo da Treviso e 'l Pordenon.

Galeria del Signor Paulo del Sera capità in
　mano del Serenissimo Leopoldo di
　Toscana
Se vede in prima de Zorzon un quadro,
　Dove se osserva alcuni Religiosi,
　Con diversi istrumenti armoniosi
　Far un concerto musico legiadro.
Ghè'l retrato vesin del Monteverde,
　De man del Strozza, pitor genoese,
　Penel, che hà fate memorande imprese;
　Si che Fama per lù mai no' se perde.
Par giusto, che'l sia là, per ascoltar
　Quei madrigali aponto, e quei moteti.
　L'è là tuto atention. Più vivi afeti
　No' se podeva veramente far.
O che'l componimento elo g'ha fato;
　O che Zorzon ghè insegna quel tenor!
　Par vivo in sù quel quadro ogni Cantor,
　E, per reflesso, vivo anche il retrato.
Zorzon ti è quel che fa de sti stupori,
　Infondendo ai to' quadri el moto istesso;
　E cusì a quei, che se te trova apresso.
　Gran virtù, gran penel, degni colori!
. .
Quel Cesare Tebaldi, mio Signor
　Dela Pitura centro, eCalamita,
　Che è un vero Mecenate ben l'imita,
　Per esser de virtù gran protetor,
Lu tra le cose bele e singular
　Tien de sto Vechia pitura moderna,
　Che al vechio la tien certo la lanterna,
　E ghe mostra de l'arte el vero far.
Con un pugnal là una figura tresca,
　E tien bizaro in testa un bareton:
　De raso bianco la vest un zipon:
　Figura in suma aponto zorzonesca.
Stago per dir, né la me par busia,
　Che se Zorzon istesso la vedesse,
　Che anche lu tra de lu se confondesse,
　Col dir: l'ho fata mi; questa xe mia.
. .
In Ca'Marcelo pur, con nobil'arte,
　M'ha depenta Zorzon da Castel Franco,
　Che, per retrarme natural un fianco,
　Restè contento e amirativo Marte.
Per compiaser su questo ai mii Morosi;
　Ma, quando me ho volesta far retrar,
　Da Paulo son recorsa, che imitar

L'ha sapù megio i trati mii vezzosi.
Né cosa è più dificile al Pitor
　Che retrar una Dona, anzi una Dea,
　Perchè ghe vuol finissima monea;
　Né xe facil cusì darghe in l'umor.
Ma chi vorà formar cosa più viva
　De quel, che int'el depenzer el penelo
　Guidà de quando in quando in muodo
　　belo
　Vien dale man dela più bela Diva?
Pitura, dela statua assae più degna,
　Che Prassitele in Gnido fè de piera:
　Perché Paulo ala fin fece la vera
　Efigie, e con quel più, che l'aarte insegna.
E, come in Gnido tuti quanti alora
　Quel simulacro a vaghizar coreva,
　Così è rason che ognun qua corer deva,
　A vaghizar quel bel che ve inamora.

LA VECCHIA AND OTHER WORKS BY
GIORGIONE ON A MEDICI LIST 1681
Quadro di Ticiano in tavola con la vergine,
il Bambino in braccio Santa Caterina S.
Giovanni con lagnelo e Pastor in paese: di
lunghezza braccia 2 3/4 e di altezza braccia 2
Quadro di Giorgione con un Pastor con una
lira e doi donine in paese al naturale
Quadro di Giorgione in tavola con due
donine nude una dorme e l'altra vigila con
un pastore che suona un flauto al natural et
dele pecore in paese
Quadro il ritrato di Giorgione di sua mano
al naturale con un cranio di cavalo.
Quadro il ritrato di una vecchia di mano di
Giorgione che tiene una carta in mano et è
sua madre.
Quadro di Paolo Veronese con Marte e
Venere che si stringono con le mani con un
amorino che tiene la briglia una testa di cava-
llo al natural
Quadro di Pordenone con ritratto al natu-
rale di un frate francescano che tiene una
testa di morte qual è fra Sebastiano del
Piombo
Quadro di Ticiano con una Dona al natural
che si pone una mano al petto et un uomo
dietro
Quadro in tavola di Giorgione, con una
dona sedente che guarda il cielo tiene un
drapo nelle mani qual sono Danae in piogia
d'oro
Quadro del Bassan Vecchio con Susana ten-
tata da Vecchi al naturale
Quadro in tavola di Giorgione, con la con-
version di S. Paolo.
Quadro di Giorgione con un ritrato di un
Giovane che accorda una lira al naturale
Quadro di Ticiano con un ritratto di un sen-
ator con una carta in mano al natural
Quadro del Pordenon con ritratto di dona
con romana in doro et un gunto in mano al
naturale
Quadro di Bonifacio in tavola con la trovata
di moise nel fiume con molte figure
Quadro di Giorgione con una dona in piedi
con un compaso in mano in tavola d'altezza
de Bracca 2 1/2
Quadro del Pordenone con San Marco che
a un libro aperto al natural in tavola

Quadro del Bassan Vecchio con la Vergine il bambino e san giovanino in paese
Quadro tondo di Bonifacio con Moise che adora il serpente con molte figure in tavola
Quadro di Giorgione con l'Europa in paese in tavola
Quadro del Civeta con la conversion di S. Paulo in tavola
Quadro di chiaroscuro di Paulo Veronese con una figurina che rapresenta la Fede
Quadro in tavola di Giorgione con Apolo che suona la lira e con il satiro che suona la zampogna
Quadro di Giorgione con Leda e il Cigno in paese in tavola

Archivio di Stato, Florence, Miscellanea medicea, Filcia 368, c. 456.
Partly published by Gualandi, 1856, xii, no. 433, pp. 268-69.

FILIPPO BALDINUCCI, NOTA DEI RITRATTI VEDUTI IN ROMA
1685
In casa del signor Ambasciatore di Spagna. . . .Un bel ritratto di Giorgione, che dicono di sua mano, a me pare assai più fresco di quello dovesse essere dopo tant'anni dal tempo che viveva questo pittore.
Gualandi, 1856, ix, p. 264.

INVENTORY OF BERTUCCI CONTARINI
1714
No 23. Orfeo con la lira della scola di Giorgion soaza nera.
No 32. Un ritratto di huomo armato con altra figura di giovine che tiene diverse armi di Giorgion soaza nera.
No 45. Un David armato con la testa del gigante Golia viene da Giorgione soaze nera.
Hochmann, 1987, p. 475.

SELECTED BIBLIOGRAPHY AND ABBREVIATED CITATIONS

EXHIBITION CATALOGUES AND CONFERENCE PROCEEDINGS

1942

Giorgione and his Circle (exh. cat.), ed. G. M. Richter, The Johns Hopkins University, Baltimore.

1955

Giorgione e i Giorgioneschi (exh. cat.), ed. P. Zampetti, Venice, Palazzo Ducale, 1955.

1977

Omaggio a Tiziano: La cultura artistica milanese nell'età di Carlo V (exh. cat.), Milan, Palazzo Reale, 1977.

1978

Antichità Viva, Omaggio a Giorgione, ed. L. Puppi, XVII, nos. 4-5, 1978.

Giorgione a Venezia (exh. cat.), eds. A. Ruggeri, F. Valcanover, et al., Venice, Gallerie dell'Accademia, 1978.

I tempi di Giorgione (exh. cat.), ed. P. Carpeggiani, Castelfranco Veneto, 1978.

I tempi di Giorgione, III: Caratteri radiografici della pittura di Giorgione, ed. L. Mucchi, Florence, 1978.

1979

Giorgione (Atti del Convegno Internazionale di Studi per il 5° Centenario della Nascita, 29-31 May 1978), ed. F. Pedrocco, Venice, 1979.

Giorgione: La Pala di Castelfranco Veneto (exh. cat.), with contributions by L. Lazzarini, F. Pedrocco, T. Pignatti, P. Spezzani, and F. Valcanover, Castelfranco Veneto, 1979.

The Golden Century of Venetian Painting (exh. cat.), ed. T. Pignatti, Los Angeles County Museum of Art.

1981

Giorgione e la cultura veneta fra '400 e '500: Mito, allegoria, analisi iconolgica, Rome, 1978, ed. M. Calvesi, Rome, 1981.

Giorgione e l'umanesimo veneziano (acts of a conference at the Fondazione Giorgio Cini, Venice), ed. R. Pallucchini, Florence, 1981.

1983

The Genius of Venice 1500-1600 (exh. cat.), eds. J. Martineau and C. Hope, London, Royal Academy of Arts, 1983.

1984

Paris Bordon (exh. cat.), Treviso, Palazzo del Trecento, 1984.

1985

Paris Bordon e il suo tempo (Atti del Convegno Internazionale di Studi, Treviso, 28-30 October 1985), Treviso, 1987.

1987

La letteratura, la rappresentazione, la musica al tempo e nei luoghi di Giorgione, Castelfranco-Asolo, 1-3 September 1978, ed. M. Muraro, Rome, 1987.

1988

Places of Delight: The Pastoral Landscape (exh. cat.), ed. R. C. Cafritz, L. Gowing, D. Rosand, Washington, D.C., Phillips Collection, 1988.

1989

'Le tre età dell'uomo' della Galleria Palatina (exh. cat.), ed. M. Lucco, Florence, Palazzo Pitti, 1989.

1990-91

Titian: Prince of Painters (exh. cat.), Venice, Palazzo Ducale, and Washington, D.C., National Gallery of Art, 1990-91.

1992

David Teniers, Jan Breughel y los gabinetes de pinturas (exh. cat.), ed. M. Diaz Padrón and M. Royo-Villanova, Madrid, Museo del Prado, 1992.

Leonardo & Venice (exh. cat.), Venice, Palazzo Grassi, 1992.

1993

Le siècle de Titien: L'âge d'or de la peinture à Venise (exh. cat.), Paris, Grand Palais, 1993.

Titian 500 (symposium, Center for Advanced Study in the Visual Arts, National Gallery of Art, Washington, D.C., October 1990), *Studies in the History of Art*, XLV, ed. J. Manca, Washington, D.C., 1993.

1994

Aldo Manuzio e l'ambiente veneziano 1494-1515 (exh. cat.), eds. S. Marcon and M. Zorzi, Venice, Libreria Sansoviniana, 1994.

I tempi di Giorgione, ed. R. Maschio, Rome, 1994.

La terra di Giorgione, essays by F. Rigon, T. Pignatti, and F. Valcanover, Cittadella, 1994.

1995

Tiziano: Amor sacro e amor profano (exh. cat.), Rome, Palazzo delle Esposizioni, 1995.

BOOKS AND ARTICLES

Full references to abbreviated citations of exhibition catalogues and proceedings volumes can be found in the first part of this bibliography.

AIKEMA, B., *Pietro della Vecchia and the Heritage of the Renaissance in Venice*, Florence, 1990.

ANDERSON, J., *The Imagery of Giorgione*, Ph.D. dissertation, Bryn Mawr College, Pennsylvania, 1972.

————, 'Some New Documents Relating to Giorgione's *Castelfranco Altarpiece* and his Patron Tuzio Costanzo', *Arte Veneta*, XXVII, 1973, pp. 290-99.

————, 'Christ Carrying the Cross in San Rocco: Its Commission and Miraculous History', *Arte Veneta*, XXXI, 1977, pp. 186-88.

————, 'A Further Inventory of Gabriel Vendramin's Collection', *The Burlington Magazine*, CXXI, 1979, pp. 639-48 (1979A).

————, 'The Giorgionesque Portrait: From Likeness to Allegory', in *Giorgione* (Atti del Convegno Internazionale), 1979, pp. 153-88 (1979B).

————, 'Giorgione, Titian and the Sleeping Venus', in *Tiziano e Venezia* (Convegno Internazionale di Studi, Venezia, 1976), Venice, 1980, pp. 337-42.

————, 'Mito e realtà di Giorgione nella storiografia artistica: Da Marcantonio Michiel ad Anton M. Zanetti', and 'Mito e realtà di Giorgione nella storiografia artistica: Dal Senatore Giovanni Morelli ad oggi', in *Giorgione e l'umanesimo veneziano*, 1981, II, pp. 615-35, 637-53.

————, 'La contribution de Giorgione au genie de Venise', *Revue de l'Art*, LXVI, 1984, pp. 59-68 (1984A).

————, 'Dosso Dossi, "Venus Awakened by Cupid"', in *From Borso to Cesare d'Este: The School of Ferrara, 1450-1628* (exh. cat.), Matthiesen Fine Art, London, 1984, pp. 88-89 (1984B).

————, 'The Genius of Venice, 1500-1600', *Art International*, XXVII, no. 2, 1984, pp. 15-22 (1984C).

————, 'Pietro Aretino and Sacred Imagery', in *Interpretazioni veneziani: Studi di storia dell'arte in onore di Michelangelo Muraro*, ed. D. Rosand, Venice, 1984, pp. 275-90 (1984D).

————, 'Il collezionismo e la pittura del Cinquecento', in *La pittura in Italia: Il Cinquecento*, eds. F. Zeri and M. Natale, Milan, 1987, II, pp. 559-68 (1987A).

————, 'Morelli and Layard', in *Austen Henry Layard tra l'Oriente e Venezia*, eds. F.

M. Fales and B. J. Hickey, La Fenice, VIII, Rome, 1987, pp. 109-37 (1987B).

———, 'The Head-hunter and Head-huntress in Italian Religious Portraiture', in *Vernacular Christianity: Essays in the Social Anthropology of Religion Presented to Godfrey Lienhardt*, eds. W. James and D. H. Johnson, Oxford, 1988, pp. 60-69.

———, 'Collezioni e collezionisti della pittura veneziana del Quattrocento: Storia, sfortuna, e fortuna', in *La pittura nel Veneto: Il Quattrocento*, ed. M. Lucco, I, Milan, 1989, pp. 271-94 (1989A).

———, Review of Hornig, *Giorgiones Spätwerk*, Kunstchronik, XLII, 1989, pp. 432-36 (1989B).

———, 'The Provenance of Bellini's *Feast of the Gods* and a New/Old Interpretation', in *Titian 500*, 1993, pp. 265-88.

———, 'Byron's *Tempesta*', The Burlington Magazine, CXXXV, 1994, p. 316.

———, 'Leonardo and Giorgione in the Grimani Collection', *Achademia Leonardi Vinci: Journal of Leonardo Studies & Bibliography of Vinciana*, VIII, 1995, pp. 226-27.

ANONIMO DEL TIZIANELLO, *Breve compendio della vita del famoso Titiano Vecellio di Cadore*, Venice, 1622.

AUNER, M., 'Randbemerkungen zu zwei Bildern Giorgiones und zum Broccardo Porträt in Budapest', *Jahrbuch der Kunsthistorischen Sammlungen in Wien*, LIV, 1958, pp. 151-68.

BALDASS, L. 'Die Tat des Giorgione', *Jahrbuch der Kunsthistorischen Sammlung in Wien*, LI, 1955, pp. 103-44.

———, with notes on the plates by G. Heinz, *Giorgione und der Giorgionismus*, Vienna and Munich, 1964; English ed., *Giorgione*, London, 1965.

BALDINI, U., ed., *Giorgione: Tutta la pittura*, Florence, 1988.

BALLARIN, A., 'Una nuova prospettiva su Giorgione: La ritrattistica degli anni 1500-1503', in *Giorgione* (Atti del Convegno Internazionale), 1979, pp. 227-52; republished in French as 'Éléments du catalogue reportés en fin d'ouvrage: Une nouvelle perspective sur Giorgione', in *Le siècle de Titien*, 1993, pp. 687-88; and a catalogue of works attributed to Giorgione, pp. 689-743.

BAROCCHI, P., partial edition of Marcantonio Michiel's *Notizia*, in *Scritti d'arte del Cinquecento*, III (*La letteratura italiana: Storia e testi*, XXXII, iii), pp. 2865-91.

BAROLSKY, P., and N. E. LAND, 'The "Meaning" of Giorgione's Tempesta', *Studies in Iconography*, IX, 1983, pp. 57-65.

BATTILOTTI, D., and M. T. FRANCO, 'Regesti di committenti e dei primi collezionisti e dei primi collezionisti di Giorgione', *Antichità Viva*, XVIII, nos. 4-5, 1978, pp. 58-86.

———, 'La committenza e il collezionismo privato', *I tempi di Giorgione*, 1994, pp. 204-29.

BATTISTI, E., *Rinascimento e barocco*, Turin, 1960.

———, *Antirinascimento*, Milan, 1962.

———, 'Quel che non c'è in Giorgione', in *I tempi di Giorgione*, 1994, pp. 236-59.

BELLINATI, C., 'Per l'identificazione del santo guerriero nella Pala di Castelfranco', *Antichità Viva*, XVIII, nos. 4-5, 1978, pp. 4-5.

BENZI, F., 'Un disegno di Giorgione a Londra e il Concerto Campestre del Louvre', *Arte Veneta*, XXXVI, 1982, pp. 183-87.

BERENBAUM, L., 'Giorgione's Pastorello, Lost and Found', *Art Journal*, XXXVII/1, Fall 1977, pp. 22-27.

BERGER, A., 'Inventar der Kunstsammlung des Erzherogs Leopold Wilhelm von Österreich', *Jahrbuch der Kunsthistorischen Sammlungen des allerhöchsten Kaiserhauses*, I, 1883, part II, pp. LXXXVI-CLXXVII.

BERTINI, C., 'I committenti della pala di S. Giovanni Crisostomo', *Storia dell'Arte*, LIII, 1985, pp. 23-31.

BIALOSTOCKI, J., 'La gamba sinistra della Giuditta: Il quadro di Giorgione nella storia del tema', in *Giorgione e l'umanesimo*, 1981, pp. 193-226.

BORENIUS, T., *Catalogue of the Paintings at Doughty House, Richmond*, London, 1913.

———, *The Picture Gallery of Andrea Vendramin*, London, 1923.

BOSCHINI, M., *La carta del navegar pitoresco* . . . (1660) and the *Breve istruzione* preceding *Le ricche minere della pittura veneziana* (1674); ed. A. Pallucchini, Venice and Rome, 1966.

BOTTARI, G., *Raccolta di lettere sulla pittura*, Rome, 1754-83.

BRANCA, V., and R. WEISS, 'Carpaccio e l'iconografia del più grande umanista veneziano', *Arte Veneta*, XVI, 1963, pp. 35-40.

BRIGSTOCKE, H., *Italian and Spanish Paintings in the National Gallery of Scotland*, Edinburgh, 1993.

BROWN, D. A., 'A Drawing by Zanetti after a Fresco on the Fondaco dei Tedeschi', *Old Master Drawings*, XV, 1977, pp. 31-44.

———, letter to the editor, *Old Master Drawings*, XVI, 1978, pp. 67-68.

BÜTTNER, F., 'Die Geburt des Reichtums und der Neid der Götter', *Münchner Jahrbuch der bildenden Kunst*, XXXVII, 1986, pp. 113-30.

CAMPORI, G., *Raccolta di cataloghi ed inventarii inediti di quadri, statue, disegni, bronzi, dorerie, smalti, medaglie, avorii, ecc., dal secolo XV al secolo XIX*, Modena, 1870.

CASTELFRANCO, G., 'Note su Giorgione', *Bollettino d'Arte*, XL, 1955, pp. 298-310.

CHASTEL, A., 'Le mirage d'Asolo', *Arte Veneta*, XXXII, 1978, pp. 100-05.

CHRISTIANSEN, K., 'A Proposal for Giulio Campagnola Pittore', in *Hommage à Michel Laclotte: Études sur la peinture du Moyen Age et de la Renaissance*, Paris, 1994, pp. 341-45.

CICOGNA, E. A., *Delle inscrizioni veneziane*, 6 vols., Venice, 1824-53.

———, 'Memorie intorno la vita e le opere di Marcantonio Michiel Patrizio veneto della prima metà del Cinquecento', *Memorie dell'Istituto Veneto*, IX, 1861, pp. 359-425.

CLARK, K., *Landscape into Art*, London, 1949.

CLOUGH, C., 'Federico da Montefeltro and the Kings of Naples: A Study in Fifteenth-Century Survial', *Renaissance Studies*, VI, no. 2, 1992, pp. 113-63.

COHEN, C. E., 'Pordenone, not Giorgione', *The Burlington Magazine*, CXXII, 1980, pp. 601-06.

COHEN, S., 'A New Perspective on Giorgione's *Three Philosophers*', *Gazette des Beaux-Arts*, CXXVI, 1995, pp. 53-64.

COLETTI, L., *Tutta la pittura di Giorgione*, Milan, 1955.

CONWAY, M., 'Giorgione Again', *The Burlington Magazine*, LII, 1928, pp. 259-60.

COOK, H., *Giorgione*, London, 1900.

———, 'Notes on Various Works of Art: "The Concert at Asolo" after Giorgione', *The Burlington Magazine*, XV, 1909, pp. 38-43.

COX, M. L., and L. CUST, 'Notes on the Collections formed by Thomas Howard, Earl of Arundel', *The Burlington Magazine*, XIX, 1911, p. 278.

CROWE, J. A., and G.B. CAVALCASELLE, *A New History of Painting in North Italy*, 3 vols., 1st ed. London, 1871; 2nd ed. London, 1912.

DACOS, N., and C. FURLAN, *Giovanni da Udine 1487-1561*, Udine, 1987.

DAL POZZOLO, E. M., 'Giorgione a Montagnana', *Critica d'Arte*, LVI, no. 8, 1991, pp. 23-42.

———, 'Il lauro della Laurae delle "maritate veneziane"', *Mitteilungen des Kunsthistorischen Institutes in Florenz*, XXXVII, 1993, pp. 257-91.

DAZZI, M., 'Sull'architetto del Fondaco dei Tedeschi', *Atti del Reale Istituto Veneto di Scienze, Lettere ed Arti*, XCIX, 1939-40, pp. 873-96.

DÉDÉYAN, C., *Giorgione dans les lettres françaises*, Florence, 1981.

DELLA PERGOLA, P., *Galleria Borghese*, 2 vols., Rome, 1955.

———, *Giorgione*, Milan, 1957.

DENUCÉ, J., *Na Peter Pauwel Rubens: Documenten uit den Kunsthandel te Antwerpen in de XVIIe eeuw Van Matthijs Musson*, Antwerp, 1949.

DISTILBURGER, R., 'The Hapsburg Collections in Vienna during the Seventeenth Century', in O. Impey and A. MacGregor, *The Origins of Museums*, Oxford, 1986, pp. 39-46.

DUNKERTON, J. 'Developments in Colour

and Texture in Venetian Painting of the Early 16th Century', in *New Interpretations of Venetian Renaissance Painting*, ed. F. Ames-Lewis, London, 1994, pp. 63-75.

EGAN, P., 'Poesia and the Fête Champêtre', *The Art Bulletin*, XLI, 1959, pp. 303-13.

ENGERTH, E. R. VON, *Kunsthistorische Sammlungen des allerhöchsten Kaiserhauses. Gemälde, 1: Italienische, spanische und französische Schulen*, Vienna, 1884.

FEHL, P., 'The Hidden Genre: A Study of the Concert Champêtre in the Louvre', *Journal of Aesthetics and Art Criticism*, XVI, 1957, pp. 135-59.

FERINO-PAGDEN, S., 'Neues in alten Bildern', *Neues Museum*, III-IV, 1992, pp. 17-21.

FERRIGUTO, A., *Attraverso i 'misteri' di Giorgione*, Castelfranco-Veneto, 1933.

———, 'Ancora dei soggetti di Giorgione', *Atti del Real Istituto Veneto di Scienze, Lettere ed Arte*, CII, 1943, pp. 403-18.

FIOCCO, G., 'La giovinezza di Giulio Campagnola', *L'Arte*, XVIII, 1915, pp. 138-56.

———, *Giorgione*, Bergamo, 1941.

FISCHER, E., 'Orpheus and Calaïs: On the Subject of Giorgione's *Concert Champêtre*', in *Liber Amicorum Karel G. Boon*, Amsterdam, 1974, pp. 71-77.

FLEISCHER, M., and F. MAIRINGER, 'Der Amor der Akademiegalerie in Wien', in *Die Kunst und ihre Erhaltung: R. E. Straub zum 70 Geburtstag*, Worms, 1990, pp. 148-68.

FLETCHER, J., 'Marcantonio Michiel's Collection', *Journal of the Warburg and Courtauld Institutes*, XXXVI, 1973, pp. 382-85.

———, 'Marcantonio Michiel: His Friends and Collection', *The Burlington Magazine*, CXXIII, 1981, pp. 453-67; also part II, 'Marcantonio Michiel, "che ha veduto assai"', *ibid.*, pp. 602-08.

———, 'Harpies, Venus and Giovanni Bellini's Classical Mirror: Some Fifteenth-Century Venetian Painters' Responses to the Antique', in *Venezia e l'archeologia: Un'importante capitolo nella storia del gusto dell'antico nella cultura artistica veneziana, Rivista di Archeologia*, 1988, supplement VII, pp. 170-76.

———, 'Bernardo Bembo and Leonardo's Portrait', *The Burlington Magazine* CXXX, 1989, pp. 811-16.

FOMICIEVA, T., 'The History of Giorgione's *Judith* and its Restoration', *The Burlington Magazine*, CXV, 1973, pp. 417-20.

FORTINI BROWN, P., *Venice and Antiquity: The Venetian Sense of the Past*, New Haven and London, 1996.

FOSCARI, L., *Affreschi esterni a Venezia*, Milan, 1936.

FREEDBERG, S. J., *Painting in Italy, 1500-1600*, Harmondsworth, 1975.

———, 'The Attribution of the *Allendale Nativity*', in *Titian 500*, 1993, pp. 51-71.

FREY, K., *Vasaris literarischen Nachlaß*, I, Munich, 1923, II, 1930.

FRIMMEL, T. VON, *Der Anonimo Morelliano*, Vienna, 1888.

———, *Kleine Galerie Studien, I*, Bamberg, 1892.

FRIZZONI, G., ed., Marcantonio Michiel, *Notizia d'opere di disegno*, Bologna, 1884.

FURLAN, C., *Il Pordenone*, Milan, 1988.

GALLO, R., 'Per la datazione della Pala di San Giovanni Crisostomo di "Sebastiano Viniziano"', *Arte Veneta*, VII, 1953, p. 152.

GAMBA, C., 'La Venere di Giorgione rintegrata', *Dedalo*, IX, 1928-29, pp. 205-09.

GARAS, K., 'Tableaux provenant de la collection de l'Archiduc Léopold-Guillaume au Musée des Beaux-Arts', *Bulletin du Musée Hongrois des Beaux-Arts*, II, 1948, pp. 22-27.

———, 'Giorgione e giorgionisme au XVIIe siècle, I', *Bulletin du Musée Hongrois des Beaux-Arts*, XXV, 1964, pp. 51-80.

———, 'Giorgione e Giorgionisme au XVIIe siècle, II', *Bulletin du Musée Hongrois des Beaux-Arts*, XXVII, 1965, pp. 33-58.

———, 'Giorgione e Giorgionisme au XVIIe siècle, III', *Bulletin du Musée Hongrois des Beaux-Arts*, XXVIII, 1966, pp. 33-58.

———, 'Die Entstehung der Galerie des Erzherzogs Leopold Wilhelm', *Jahrbuch der Kunsthistorischen Sammlungen in Wien*, LXIII, 1967, pp. 39-80 (1967A).

———, 'The Ludovisi Collection of Pictures in 1663', *The Burlington Magazine*, CIX, 1967, pp. 287-89, 339-48 (1967B).

———, 'Das Schicksal der Sammlung der Erzherzogs Leopold Wilhelm', *Jahrbuch der Kunsthistorischen Sammlungen in Wien*, LXIV, 1968, pp. 181-278.

———, 'La collection de tableaux du Château royal de Buda au XVIIIe', *Bulletin du Musée Hongrois des Beaux-Arts*, XXXII, 1969, pp. 91-120.

———, 'Bildnisse der Renaissance', *Acta Historiae Artium*, XVIII, 1972, pp. 125-35.

———, 'Giorgione e il Giorgionismo: Ritratti e musica', in *Giorgione* (Atti del Convegno Internazionale), 1979, pp. 165-70.

GARRARD, M., 'Leonardo da Vinci: Female Portraits, Female Nature', in *The Expanding Discourse: Feminism and Art History*, ed. N. Broude and M. Garrard, New York and London, 1994, pp. 59-85.

GAURICUS, P., *De sculptura*, ed. A. Chastel and R. Klein, Paris, 1969.

GAYE, G., *Carteggio inedito d'artisti dei secoli XIV, XV, XVI*, Florence, 1839-40.

GENTILI, A., 'Per la demitizzazione di Giorgione: Documenti, ipotesi, provocazione', in *Giorgione e la cultura veneta*, 1981, pp. 12-25.

———, 'Giorgione non finito, finito, indefinito', *Studi per Pietro Zampetti*, ed. R. Varese, Ancona, 1993, pp. 288-99.

———, 'Amore e amorose persone: Tra miti Ovidiani, allegorie musicali, celebrazioni matrimonali', in *Tiziano: Amor Sacro e Amor Profano*, 1995, pp. 82-105.

GIEBE, M., 'Die Schlummernde Venus von Giorgione und Tizian. Bestandaufnahme und Konservierung—neue Ergebnisse der Röngenanalyse', *Jahrbuch der Staatlichen Kunstsammlungen Dresden*, 1992, pp. 91-108; reprinted in Italian, in *Tiziano: Amor Sacro e Amor profano*, 1995, pp. 369-85.

GILBERT, C., 'Antique Frameworks for Renaissance Art Theory: Alberti and Pino', *Marsyas*, III, 1943-45, pp. 87-106.

———, 'On Subject and Non-Subject in Italian Renaissance Pictures', *The Art Bulletin*, XXXIV, 1952, pp. 202-16; reprinted in Gilbert, *Piero della Francesca et Giorgione: Problèmes d'interprétation*, Paris, 1994.

———, 'Some Findings on Early Works of Titian', *The Art Bulletin*, LXII, 1980, pp. 36-75.

GOFFEN, R., 'Renaissance Dreams', *Renaissance Quarterly*, XL, 1987, pp. 682-705.

———, 'Titian's Sacred and Profane Love: Individuality and Sexuality in a Renaissance Marriage Picture', in *Titian 500*, 1993, pp. 121-44.

GOLDFARB, H., 'An Early Masterpiece by Titian Rediscovered and its Stylistic Implications', *The Burlington Magazine*, CXXVI, 1984, pp. 419-23.

GOMBOSI, G., 'The Budapest Birth of Paris X-rayed', *The Burlington Magazine*, LXVII, 1935, pp. 157-64.

GOMBRICH, E., 'A Note on Giorgione's *Three Philosophers*', *The Burlington Magazine*, CXXVIII, 1986, p. 488.

GOULD, C., *National Gallery Catalogues: The Sixteenth-Century Italian Schools*, London, 1975.

GRONAU, G., 'Kritische Studien zu Giorgione', *Repertorium für Kunstwissenschaft*, XXXI, 1908, pp. 403-36, 503-21.

———, *Giorgione*, Berlin, 1911.

GRABSKI, J., *Opus Sacrum* (exh. cat.), Warsaw, 1990.

GUALANDI, M., *Memorie originali italiane riguardanti le belle arti*, Bologna, 1840.

———, *Nuova raccolta di lettere sulla pittura, scultura ed architettura scritte dai più celebri personaggi dei secoli XV a XIX*, III, Bologna, 1856.

HAITOVSKY, D., 'Giorgione's *Trial of Moses*: A New Look', *Jewish Art*, XVI, 1990, pp. 20-29.

HARTLAUB, G. F., *Giorgiones Geheimnis: Ein kunstgeschichtlicher Beitrag zur Mystik der Renaissance*, Munich, 1925.

———, *Zaueber der Spiegels*, Munich, 1951.

————, 'Zu den Bildmotiven des Giorgione', *Zeitschrift für Kunstwissenschaft*, VII-VIII, 1953-54, pp. 57-84.

HASKELL, F., 'Giorgione's *Concert Champêtre* and its Admirers', *Journal of the Royal Society for the Encouragement of Arts, Manufactures and Commerce*, CXIX, 1971, pp. 543-55.

HAUPTMAN, W. , 'Some New 19th-Century References to Giorgione's *Tempesta*', *The Burlington Magazine*, CXXXVI, 1994, pp. 78-82.

HENDY, P., *European and American Paintings in the Isabella Stewart Gardner Museum*, Boston, 1974.

HILL, G., *A History of Cyprus*, 3 vols., Cambridge, 1940-52.

HIND, G. F., 'Early Italian Engravings from the Lichtenstein Collections at Feldsburg and Vienna', in *Studies in Art and Literature for Bella da Costa Greene*, Princeton, 1954, pp. 199-201.

HIRST, M., 'The Judgement of Solomon at Kingston Lacy', in *Giorgione* (Atti del Convegno Internazionale), 1979, pp. 257-62.

————, *Sebastiano del Piombo*, Oxford, 1981.

HIRST, M., and K. LAING, 'The Kingston Lacy Judgement of Solomon', *The Burlington Magazine*, CXXVIII, 1986, pp. 273-82.

HOCHMANN, M., 'La collection de Giacomo Contarini', *Mélanges de l'École Française de Rome*, IC, 1987, pp. 448-89.

————, *Peintres et commanditaires à Venise (1540-1628)*, Paris, 1992.

HOFFMANN, J., 'Giorgione's "Three Ages of Man"', *Pantheon*, XLII, 1984, pp. 238-44.

HOLBERTON, P., 'La bibliotechina e la raccolta d'arte di Zuanantonio Venier', *Atti dell'Istituto Veneto di Scienze, Lettere ed Arti*, CXLIV, 1985-86, pp. 173-93.

————, 'Ten Years after 500 Years: A Postscript to Giorgione's Quincentenary', *Bulletin of the Society for Renaissance Studies*, VI, 1988, pp. 28-31.

————, *Poetry and Painting in the Time of Giorgione*, Ph.D. dissertation, Warburg Institute, University of London, 1989.

————, 'Giorgione's *Tempest*: Interpreting the Hidden Subject', *Art History*, XIV, 1991, pp. 125-29.

————, 'The *Pastorale* or *Fête Champêtre* in the Early Sixteenth Century', in *Titian 500*, 1993, pp. 245-63.

————, 'Giorgione's *Tempest* or "little landscape with the storm with the gypsy": More on the Gypsy, and a Reassessment', *Art History*, XVIII, 1995, pp. 383-403.

HOLLANDA, FRANCISCO DE, *Da pintura antigua*, 1548, ed. J. de Vaasconcellos, *Vier Gespräche über die Malerei*, Vienna, 1899.

HOPE, C., *Titian*, London, 1980.

————, 'The Early Biographies of Titian', in *Titian 500*, 1993, pp. 167-97 (1993A).

————, 'Tempest over Titian', *New York Review of Books*, 10 June 1993, pp. 22-26 (1993B).

HOPE, C., and J. R. J. VAN ASPEREN DE BOER, 'Underdrawings by Giorgione and his Circle', in *Le dessin sous-jacent dans la peinture*, eds. H. Verougstraete-Marcq and R. van Schoute, Louvain-la Neuve, 1991, pp. 127-40.

HORNIG, C., 'Is It a Giorgione or Not — With Index of Copied Paintings of the "Tramonto" Painting', *Pantheon*, L, 1980, pp. 46-54.

————, 'Underpainting in Giorgione *Heiligen Markus, Petrus und Venedig vor dem Sturm*', *Pantheon*, XLII, 1984, pp. 94-95.

————, *Giorgiones Spätwerk*, Munich, 1987.

HOURS, M., 'Contribution à l'étude de quelques œuvres de Titien', *Laboratoire de Recherches des Musées de France — Annales*, 1976, pp. 7-31; reprinted in *Tiziano: Amor sacro e amor profano*, 1995, p. 368.

HOURTICQ, L., *La jeunesse de Titien*, Paris, 1919.

HOWARD, D., 'Giorgione's *Tempesta* and Titian's *Assunta* in the Context of the Cambrai Wars', *Art History*, VIII, 1985, pp. 271-89.

HUMFREY, P. *Cima da Conegliano*, Cambridge, 1983.

————, *The Altarpiece in Renaissance Venice*, London, 1993.

————, *Painting in Renaissance Venice*, London, 1995.

JACOB, S., 'From Giorgione to Cavallino: Works by Italian Artists in the Herzog Anton-Ulrich Museum', *Apollo*, CXXIII, 1986, pp. 184-89.

JACOBS, E., 'Das Museo Vendramin und die Sammlung Reynst', *Repertorium für Kunstwissenschaft*, XLVI, 1925, pp. 15-38.

JOANNIDES, P., 'On Some Borrowings and Non-borrowings from Central Italian and Antique Art in the Work of Titian, c. 1510-1550', *Paragone*, XLI, 1990, pp. 21-45.

————, 'Titian's *Daphnis and Chloe*: A Search for the Subject of a Familiar Masterpiece', *Apollo*, CXXXIII, 1991, pp. 374-82.

————, 'Titian's *Judith* and its Context: The Iconography of Decapitation', *Apollo*, CXXXV, 1992, pp. 163-70.

————, 'Titian's Century Is Louvre Director's Farewell', *The Art Newspaper*, no. 28, May 1993.

JUNKERMAN, A.C., 'The Lady and the Laurel: Gender and Meaning in Giorgione', *Oxford Art Journal*, XVI, 1993, pp. 49-58.

JUSTI, L., *Giorgione*, 2 vols., Berlin, 1908; 2nd ed. Berlin, 1936.

KAPLAN, P., 'The Storm of War: The Paduan Key to Giorgione's *Tempesta*', *Art History*, IX, 1986, pp. 405-27.

KING, M., *Venetian Humanism in an Age of Patrician Dominance*, Princeton, 1986.

KLAUNER, F., 'Zur Symbolik von Giorgiones "Drei Philosophen"', *Jahrbuch der Kunsthistorischen Sammlungen in Wien*, LI, 1955, pp. 145-68.

————, 'Uber die Wertschätzung Giorgiones', in *Giorgione* (Atti del Convegno Internazionale), 1979, pp. 263-67.

KLEIN, R., 'Die Bibliothek von Mirandola und das Giorgione zugeschriebene "Concert champêtre"', *Zeitschrift für Kunstgeschichte*, XXX, 1967, pp. 199-206; reprinted in Klein, *La forme et l'intelligible*, Paris, 1970, pp. 193-203.

KULTZEN, R., and P. EIKEMEIER, *Venezianische Gemälde des 15. und 16. Jahrhunderts*, Munich, 1971.

KURZ, O., 'Holbein and Others in Seventeenth Century Collections', *The Burlington Magazine*, LXXXII-LXXXIII, 1943, pp. 279-82.

LAUTS, J., *Carpaccio*, Greenwich, 1962.

LAZZARINI, L., 'Lo studio stratigrafico della Pala di Castelfranco e di altre opere contemporanee', in *Giorgione: La Pala di Castelfranco*, 1978, pp. 45-58.

————, 'Il colore nei pittori veneziani tra il 1480 e il 1580', *Studi Veneziani*, V, 1983, pp. 134-44.

LEVI, C. A., *Le collezioni veneziane d'arte e d'antichità dal secolo XIV ai nostri giorni*, 2 vols., Venice, 1900.

LHOTSKY, A., 'Die Geschichte der Sammlungen. Erste Hälfte: Von den Anfängen bis zum Tode Kaiser Karls VI. 1740', *Festschrift des Kunsthistorischen Museums zur Feier des Fünfzigjährigen Bestandes*, II, ed. F. Dworshak, Vienna, 1941.

LILLI, V., and P. ZAMPETTI, *Giorgione*, Milan, 1968.

LIPHART, E. K., 'Imperatorsky Ermitage', *Starye Gody*, January-March, 1910, pp. 16-17.

LOCKE, N., 'More on Giorgione's *Tempesta* in the Nineteenth Century', *The Burlington Magazine*, CXXXVIII, 1996, p. 464.

LOGAN, A. M., *The 'Cabinet' of the Brothers Gerard and Jan Reynst*, Amsterdam, Oxford, and New York, 1979.

LONGHI, R., *Officina ferrarese* (1934), reprinted in *Opere commplete di Roberto Longhi*, V, Florence, 1956.

LORENZETTI, G., 'Per la storia del *Cristo portacroce* della chiesa di San Rocco', *Studi di arte e storia a cura della direzione del Museo Correr*, Venice, 1920, pp. 181-85.

LORENZI, G., *Monumenti per servire alla storia del Palazzo Ducale di Venezia*, Venice, 1868.

LOTTO, L., Il 'Libro di Spese diverse' con aggiunta di lettere e d'altri documenti (Fonti e Documenti per la Storia dell'Arte), ed. P. Zampetti, Venice, 1969.

LUCCO, M., L'opera completa di Sebastiano del Piombo, Milan, 1980.

———, 'Venezia fra Quattro e Cinquecento: La parabola di Giorgione', Storia dell'Arte Italiana, II, I, Turin, 1983, pp. 447-77.

———, 'La pittura a Venezia nel primo cinquecento', in La pittura in Italia: Il Cinquecento, ed. M. Lucco, Milan, 1988, pp. 149-54 (1988A).

———, 'La pittura nelle provincie di Treviso e Belluno nel Cinquecento', in G. Briganti, La pittura in Italia: Il Cinquecento, Milan, 1988, I, pp. 208-18 (1988B).

———, Le tre età dell'uomo, 1989.

———, 'Some Observations on the Dating of Sebastiano del Piombo's S. Giovanni Crisostomo Altarpiece', in New Interpretations of Venetian Painting, ed. F. Ames-Lewis, London, 1994, pp. 43-49.

———, Giorgione, Milan, 1995.

LUCHS, A., Tullio Lombardo and Ideal Portrait Sculpture in Renaissance Venice, 1490-1530, Cambridge, 1995.

LUDWIG, G., 'Archivalische Beiträge für Geschichte der venezianischen Malerei', Jahrbuch der Preussischen Kunstsammlungen, XXIV, 1903, pp. 1-154.

LUZIO, A., 'Isabella d'Este e due quadri di Giorgione', Archivio Storico dell'Arte, I, 1888, pp. 47ff.

———, La Galleria dei Gonzaga venduta all'Inghliterra nel 1627-28, Milan, 1913.

MANNERS, LADY VICTORIA, and G. C. WILLIAMSON, Angelica Kauffmann, R.A.: Her Life and her Works, London, 1924.

MARCHI, R. DE, 'Sugli esordi veneti di Dosso Dossi', Arte Veneta, XL, 1986, p. 20.

MARCON, S., 'Una Aldina miniata', in Aldo Manuzio, 1994, pp. 107-31.

MARIUZ, A., 'Appunti per una lettura del fregio giorgionesco di Casa Marta Pellizzari', in Liceo Ginnasio Giorgione, Castelfranco Veneto, 1966, pp. 49-70.

MARTIN, G., Giorgione negli affreschi di Castelfranco, Milan, 1993.

MASCHIO, R., 'Per Giorgione. Una verifica dei documenti d'archivio', Antichità Viva, XVII, nos. 4-5, 1978, pp. 5-11.

———, 'Per la biografia di Giorgione', in I tempi di Giorgione, 1994, pp. 178-210.

MEIJER, B., 'Due proposte iconografiche per il Pastorello di Rotterdam', in Giorgione (Atti del Convegno Internazionale), 1979, pp. 53-56.

MEIJER, B., and B. AIKEMA, eds. Disegni veneti di collezioni olandesi (exh. cat.), Venice, Fondazione Cini, 1985.

MELLER, P., 'La "Madre" di Giorgione', Giorgione (Atti del Convegno Internazionale), 1979, pp. 109-18.

———, 'I Tre Filosofi di Giorgione', in Giorgione e l'umanesimo, 1981, I, pp. 227-47.

MELLENCAMP, E. H., 'A Note on the Costume of Titian's Flora', The Art Bulletin, LI, 1969, pp. 174-77.

MERLING, M., Marco Boschini's 'La carta del navegar pitoresco': Art Theory and Virtuoso Culture in Seventeenth-Century Venice, Ph.D. dissertation, Brown University, Providence, 1992.

MICHIEL, MARCANTONIO, Notizia d'opere di disegno nella prima metà del XVI esistenti in Padova, Cremona, Milano, Pavia, Bergamo, Crema e Venezia, ed. J. MORELLI, Bassano, 1800; ed. G. FRIZZONI, Bologna, 1884; ed. T. VON FRIMMEL, Der Anonimo Morelliano, Vienna, 1888; partial ed. BAROCCHI, 1977.

MILESIO, G. B., in G. M. THOMAS, 'Zur Quellenkunde des venezianischen Handels und Verkehres', Abhandlungen der Königlich Bayerischen Akademie der Wissenschaften, XV, 1881, pp. 183-240.

MITCHELL, A., and A. LAING, The National Trust: Kingston Lacy, Dorset, London, 1994.

MOLMENTI, P., 'Giorgione', Bolletino di Arti, Industrie e Curiosità Veneziane, II, 1878-79, pp. 17-23.

MORASSI, A., 'Esame radiografico della Tempesta di Giorgione', Le Arti, I, 1939, pp. 567-70.

———, Giorgione, Milan, 1942.

———, in Encyclopaedia universale dell'arte, Venice and Rome, 1966, XIV, s.v. 'Tiziano Vecellio'.

———, 'Giorgione', in Rinascimento europeo e Rinascimento veneziano, ed. V. Branca, Florence, 1967, pp. 187-205.

MORELLI, G. (Ivan Lermolieff). Die Werke italienischer Meister in den Galerien von München, Dresden und Berlin. Ein kritischer Versuch von Ivan Lermolieff. Aus dem Russischen übersetzt von Dr Johannes Schwarze, Leipzig, 1880.

———, Italian Masters in German Galleries. A Critical Essay on the Italian Pictures in the Galleries of Munich, Dresden, Berlin, by Giovanni Morelli, Member of the Italian Senate, trans. L. M. Richter, London, 1883.

———, Doria Pamphili in Rom von Ivan Lermolieff. Leipzig, 1890.

———, Kunstkritische Studien über italienische Malerei. Die Galerien zu München und Dresden von Ivan Lermolieff, Leipzig, 1891.

———, De la peinture italienne. Les fondements de la theorie de l'attribution en peinture à propos de la collection des Galeries Borghese et Doria-Pamphili. Edition établie de Jaynie Anderson, trans. N. Blamoutier, Paris, 1994.

MOSCHINI, V., '"La Vecchia" di Giorgione ne suo spetto genuino', Arte Veneta, III, 1949, pp. 180-82.

MOSCHINI MARCONI, A., Gallerie dell'Accademia di Venezia, Rome, 1962.

MRAVIK, L., 'Contribution à quelques problèmes du portrait de BROKARDVS de Budapest', Bulletin du Musée Hongrois des Beaux-Arts, XXXVI, 1971, pp. 47-60.

MÜLLER HOFSTEDE, C., 'Untersuchungen über Giorgiones Selbstbildnis in Braunschweig', Mitteilungen des Kunsthistorischen Institutes in Florenz, VIII, 1957, pp. 13-34.

MÜNDLER, O., The Travel Diaries of Otto Mündler 1855-1858, ed. C. Dowd, introd. J. Anderson, The Walpole Society, LI, 1985.

MURARO, M., 'Studiosi, collezionisti e opere d'arte veneta dalle lettere al Cardinale Leopoldo de' Medici', Saggi e Memorie di Storia dell'Arte, IV, 1965, pp. 65-83.

———, 'Di Carlo Ridoli e di altre "fonti" per lo studio del disegno veneto del Seicento', Festschrift Ulrich Middeldorf, eds. A. Rosengarten and P. Tigler, Berlin, 1968, pp. 429-33.

———, 'The Political Interpretation of Giorgione's Frescoes on the Fondaco dei Tedeschi', Gazette des Beaux-Arts, CXVII, 1975, pp. 177-84.

———, 'Giorgione e la civiltà delle ville venete', in Giorgione (Atti del Convegno Internazionale), 1979, pp. 171-80.

NARDI, P., 'I tre filosofi di Giorgione', Il Mondo, 23 August 1955.

NOE, N.A., 'Messer Giacomo en zijr Laura', Nederlands Kunsthistorisches Jaarboek, II, 1960, pp. 1-35.

NOLHAC, P. DE, 'Une galerie de peinture au 16e siècle: Les collections de fulvio Orsini', Gazette des Beaux-Arts, XXIX, 1884, pp. 427-36.

NORDENFALK, C., 'Titian's Allegories on the Fondaco de' Tedeschi', Gazette des Beaux-Arts, XL, 1952, pp. 101-08.

NOVA, A., 'Savoldo, Giovanni, Gerolamo between Foppa, Giorgione and Caravaggio', The Burlington Magazine, CXXXII, 1990, pp. 431-34.

OETTINGER, K., 'Die wahre Giorgione-Venus', Jahrbuch der Kunsthistorischen Sammlungen in Wien, XIII, 1944, pp. 113-39.

OLDFIELD, D., Later Flemish Paintings in the National Gallery of Ireland, Dublin, 1992.

PADOAN, Giorgio, 'Il mito di Giorgione intellettuale', in Giorgione e l'umanesimo, 1981, I, pp. 425-55.

PALLUCCHINI, R., Giorgione, Milan, 1955.

———, 'Il restauro del ritratto di gentiluomo veneziano K 475 della National Gallery di Washington', Arte Veneta, XVI, 1962, pp. 234-37.

PALLUCCHINI, R., and F. ROSSI, Giovanni Cariani, Bergamo, 1983.

PANOFSKY, E., *Problems in Titian, Mostly Iconographic*, London, 1969.

PARRONCHI, A., 'La *Tempesta* ossia *Danae in Serifo*', *La Nazione*, 1976, p. 3; reprinted in Parronchi, 1989, pp. 37-43.

———, *Giorgione e Raffaello*, Bologna, 1989.

PAOLETTI, P., *L'architettura e la scultura del Rinascimento a Venezia*, Venice, 1893.

PASCHINI, P., 'Le collezioni archeologiche dei prelati Grimani del Cinquecento', *Atti del Pontificia Accademia Romana di Archeologia*, serie III, *Rendiconti*, V, 1926-27, pp. 149-90.

———, *Domenico Grimani Cardinale di S. Marco*, Rome, 1943.

PAULI, G., 'Dürer, Italien und die Antike', *Vorträge der Bibliothek Warburg*, 1921-22, pp. 51-68.

PEDRETTI, C., 'Leonardo a Venezia', in *I tempi di Giorgione*, 1994, pp. 96-119.

PEDROCCO, F. 'La Pala di Castelfranco attraverso i secoli', in *Giorgione: La Pala di Castelfranco*, 1978, pp. 9-22.

———, 'Iconografia delle cortigiane di Venezia', in *Il gioco dell'amore: Le cortigiane di Venezia dal Trecento al Settecento* (exh. cat.), Venice, Ca' Vendramin Calergi, 1990, pp. 81-107.

PHILLIPS, C., 'A Probable Giorgione', *The Burlington Magazine*, XVI, 1895, p. 347.

PIGLER, A., *Katalog der Galerie alter Meister [Budapest]*, Tübingen, 1968.

PIGNATTI, T., *Giorgione*, Venice, 1969; English trans. London, 1971. All page references cited are to the 1971 edition.

———, 'Il Paggio di Giorgione', *Pantheon*, XXXIII, 1975, pp. 314-18.

———, 'Anton Maria Zanetti Jr. da Giorgione', *Bollettino dei Musei Civici Veneziani*, XXIII, 1978, pp. 73-77.

———, 'La Giuditta diversa di Giorgione', in *Giorgione* (Atti del Convegno Internazionale), 1979, pp. 269-71 (1979A).

———, *Tiziano: Disegni*, Florence, 1979.

PLESTERS, J., '"Scientia e Restauro": Recent Italian Publications on Conservation', *The Burlington Magazine*, CXXIX, 1987, pp. 172-77.

POCH-KALOUS, M., *Akademie der bildenden Künste: Katalog der Gemäldegalerie*, Vienna, 1961.

POPE-HENNESSY, J., *The Portrait in the Renaissance*, London, 1966.

POSSE, H., *Die Staatliche Gemäldegalerie zu Dresden*, Dresden and Berlin, 1929.

———, 'Die Rekonstruktion der Venus mit dem Cupido von Giorgione', *Jahrbuch der Preußischen Kunstsammlungen*, LII, 1931, pp. 29-35.

PROCACCI, L., and U. PROCACCI, 'Il Carteggio di Marco Boschini con il Cardinale Leopoldo de' Medici', *Saggi e Memorie di Storia dell'Arte*, IV, 1965, pp. 87-110.

PRODROMUS, *Prodomus seu Praeamulare Lumen Reserati Portentosae Magnificentiae Theatri Quo omnia Ad Aulam Caesaream in Augustissinae Suae Caesareae e Regiae Catholicae Majestatis nostri gloriossissime Regnantis Monarchae Caroli VI Metropoli et Residentia Viennae recondita Artificiorum et Pretiositatum Decora*, Vienna, 1735; also reproduced in H. Zimerman, 'Franz v. Stamparts und Anton v. Prenners Prodromus zum Theatrum Artis Pictoriae...', *Jahrbuch der Kunsthistorischen Sammlungen des allerhöchsten Kaiserhauses*, VII, 1888, n.p.

PULLAN, B., *Rich and Poor in Renaissance Venice*, Oxford, 1971.

PUPPI, L., 'Une ancienne copie du "Cristo e il manigoldo" de Giorgione au Musée des Beaux-Arts', *Bulletin du Musée Hongrois des Beaux-Arts*, XVIII, 1961, pp. 39-49.

———, 'Fortuna delle *Vite* nel Veneto dal Ridolfi al Temanza', in *Il Vasari storiografo e artista* (Atti del Congresso Internazionale nel IV Centenario della Morte, Arezzo, 1974), Florence, 1974, pp. 405-37.

———, 'La corte di Caterina Cornaro e il Barco di Altivole', in *I tempi di Giorgione*, 1994, pp. 230-35.

PUPPI, L., and L. OLIVATO-PUPPI, *Mauro Codussi*, Milan, 1977.

———, 'L'architettura a Venezia: 1480-1510', in *I tempi di Giorgione*, 1994, pp. 40-54.

PUTTFARKEN, T., 'The Dispute about *Disegno* and *Colorito* in Venice: Paolo Pino, Lodovico Dolce and Titian', *Wolfenbütteler Forschungen. Kunst und Kunsttheorie 1400-1900*, XLVIII, 1991, pp. 75-95.

RAVA, A., 'Il "Camerino delle antigaglie" di Gabriele Vendramin', *Nuovo Archivio Veneto*, XXXIX, 1920, pp. 155-81.

REARICK, W. R., 'Chi fù il primo maestro di Giorgione?', in *Giorgione* (Atti del Convegno Internazionale), 1979, pp. 187-93.

REINHART, H., 'Castelfranco und einige weniger bekannte Bilder Giorgiones', *Zeitschrift für bildenden Künste*, I, 1866, pp. 251-54.

REPETTO CONTALDO, M., 'Francesco Torbido detto il Moro', *Saggi e Memorie della Storia dell'Arte*, XIV, 1984, pp. 43-76.

RICHTER, G. M., 'Landscape Motifs in Giorgione's *Venus*', *The Burlington Magazine*, LXIII, 1933, pp. 211-32.

———, *Giorgio da Castelfranco called Giorgione*, Chicago, 1937.

———, 'Christ Carrying the Cross by Giovanni Bellini', *The Burlington Magazine*, LXXV, 1939, pp. 95-96.

———, 'Lost and Rediscovered Works by Giorgione,' *Art in America*, XXX, no. 3, July 1942, pp. 141-57.

RICHTER, J. P., *Italienische Malerei der Renaissance im Briefwechsel von Giovanni Morelli und Jean Paul Richter*, Baden-Baden, 1960.

RIDOLFI, C., *Le Maraviglie dell'arte* (1648); ed. D. von Hadeln, 2 vols., Berlin, 1914-24.

ROBERTSON, G., review of *Giorgione e i Giorgioneschi*, 1955, *The Burlington Magazine*, XCVII, 1955, p. 276.

———, 'New Giorgione Studies', *The Burlington Magazine*, CXIII, 1971, pp. 475-77.

ROSAND, D., *Titian*, New York, 1978.

———, 'In Detail: Giorgione's *Concert Champetre*', *Portfolio*, III, no. 5, 1981, pp. 72-77.

———, 'The Genius of Venice', *Renaissance Quarterly*, XXXVIII, 1985, pp. 290-304.

———, 'Giorgione's *Tempest*: Interpreting the Hidden Subject' (review of Settis, 1978), *Renaissance Quarterly*, XLVI, 1993, pp. 368-70.

RUHEMANN, H., 'The Cleaning and Restoration of the Glasgow Giorgione', *The Burlington Magazine*, XCVII, 1955, pp. 278-82.

RUSKIN, J., *The Works of John Ruskin*, eds. E. T. Cook and A. Wedderburn, 39 vols., London, 1903-12.

RYLANDS, P., *Palma il Vecchio*, Cambridge, 1992.

SALERNO, L., 'The Picture Gallery of Vincenzo Giustiniani', *The Burlington Magazine*, CII, 1960, pp. 21-27, 93-104, 135-48.

SANGIORGI, F., *Documenti urbinati: Inventari del Palazzo Ducale (1582-1631)*, Urbino, 1976.

SANSOVINO, F., *Venezia città nobilissima et singolare descritta* (1581); ed. G. Martinioni, Venice, 1663.

———, *Della origine et de' fatti delle famiglie illustri d'Italia*, Venice, 1582.

SANUDO, M., *I Diarii (1496-1533)*, eds. R. Fulin et al., 58 vols., Venice, 1879-1903.

SAVINI BRANCA, S., *Il collezionismo veneziano nel '600*, Florence, 1964.

SCAPECCHI, P., 'L'*Hypnerotomachia Poliphili* e il suo autore', *Accademie e Biblioteche d'Italia*, LI, 1983, pp. 68-73; LIII, 1985, pp. 68-73.

SCHULZ, J., 'Jacopo de' Barbari's View of Venice: Map Making, City Views, and Moralized Geography before the Year 1500', *The Art Bulletin*, LX, 1978, pp. 425-74.

SCHUPBACH, W., 'Doctor Parma's Medicinal Macaronic: Poem by Bartolotti, Pictures by Giorgione and Titian', *Journal of the Warburg and Courtauld Institutes*, XLI, 1978, pp. 147-91.

SETTIS, S., *La 'Tempesta' interpretata: Giorgione, i committenti, il soggetto*, Torino, 1978; English trans. Chicago, 1990.

SGARBI, V., 'Il Fregio di Castelfranco e la cultura bramantesca', in *Giorgione* (Atti del Convegno Internazionale), 1979, pp. 273-84.

SHAKESHAFT, P., '"To much bewitched with thoes intysing things": The letters of James, third Marquis of Hamilton and Basil, Viscount Feilding, concerning collecting in Venice 1635-1639', *The Burlington Magazine*, CXXVIII, 1986, pp. 114-34.

SHAPLEY, F. R., *Paintings from the Samuel H. Kress Collection (Italian Schools XV-XVI Century)*, New York and London, 1968.

———, *Catalogue of the Italian Paintings, National Gallery of Art, Washington*, 2 vols., Washington, D.C., 1979.

SHEARD, W. S., *The Tomb of Doge Andrea Vendramin in Venice by Tullio Lombardo*, Ph.D. dissertation, Yale University, New Haven, 1971.

———, 'Sanudo's List of Notable Things in Venetian Churches and the Date of the Vendramin Tomb', *Yale Italian Studies*, I, 1977, pp. 219-68.

———, 'The Widener Orpheus: Attribution, Type, Invention', *Collaboration in Italian Art*, eds. W. S. Sheard and J. T. Paoletti, New Haven and London, 1978, pp. 189-232.

———, 'Giorgione and Tullio Lombardo', *Giorgione* (Atti del Convegno Internazionale), 1979, pp. 201-11.

———, Giorgione's Portrait Inventions c. 1500: Transfixing the Viewer (with Observations on Some Florentine Antecedents)', in *Reconsidering the Renaissance: Papers from the Twenty-Sixth Annual Conference* (Medieval and Renaissance Texts and Studies, LXXXXVIII), 1992, pp. 141-76 (1992A).

———, 'Titian's Paduan Frescoes and the Issue of Decorum', in *Decorum in Renaissance Art*, eds. F. Ames-Lewis and A. Bednarek, London, 1992, 89-100 (1992B).

SHEARMAN, J., *The Early Italian Pictures in the Collection of Her Majesty the Queen*, Cambridge, 1983.

SMITH, S. L., 'A Nude Judith from Padua and the Reception of Donatello's Bronze David', *Comitatus: A Journal of Mediaeval and Renaissance Studies*, XXV, 1994, pp. 59-80.

SMYTH, C. H., 'Michelangelo and Giorgione', in *Giorgione*, (Atti del Convegno Internazionale), 1979, pp. 213-20.

SPETH-HOLTERHOFF, S., *Les peintres flamands de cabinets d'amateurs au XVIIe siècle*, Brussels, 1957.

STEINBOCK, W., 'Giorgiones Judith in Leningrad', *Jahrbuch des Kunsthistorischen Institutes des Universität Graz*, VII, 1972, pp. 51-62.

STOCKBAUER, J., *Die Kunstbetrebungen am bayerische Hofe unter Herzog Albert V und seinem Nachfolger Wilhelm V: Nach den im K. Reichsarchiv vorhandenen Correspondenzacten zusammengestellt von J. Stockbauer* (Quellenschriften für Kunstgeschichte und Kunsttechnik des Mittelalters und der Renaissance, VIII), Vienna, 1874.

SUIDA, W., 'Spigolature giorgionesche', *Arte Veneta*, VIII, 1954, pp. 153-66.

SUTER, K. F., 'Giorgiones *Testa del Pastorello che tiene in man un frutto*', *Zeitschrift für bildenden Künste*, VIII, 1928, pp. 23-27.

SZABÓ KÁKAY, G., 'Giorgione o Tiziano', *Bolletino d'Arte*, XLV, 1960, pp. 320-24.

TEMPESTINI, A., *Giovanni Bellini: Cataloge completo dei dipinti*, Florence, 1992.

———, 'Una "Maddalena" tra Venezia e Treviso', *Studi per Pietro Zampetti*, ed. R. Varese, Ancona, 1993, pp. 300-02.

TENIERS, D., *Theatrum pictorium*, Brussels, 1658.

TESTORI, G., 'Da Romanino a Giorgione', *Paragone*, CLIX, 1963, pp. 45-49.

THAUSING, M., *Wiener Kunstbriefe*, Leipzig, 1884.

THOMSON DE GRUMMOND, N., 'VV and Related Inscriptions in Giorgione, Titian and Dürer', *The Art Bulletin*, LVII, 1975, pp. 346-56.

TIETZE-CONRAT, E., 'Decorative Paintings of the Venetian Renaissance Reconstructed from Drawings', *The Art Quarterly*, III, 1940, pp. 32ff.

———, 'The So-Called "Adultress" by Giorgione', *Gazette des Beaux-Arts*, XXVII, 1945, pp. 189-90.

TORRINI, A., *Giorgione: Catalogo completo dei dipinti*, Florence, 1993.

TSCHMELITSCH, G., *Zorzo, genannt Giorgione: Der Genius und sein Bannkreis*, Vienna, 1975.

URBANI DI GHELTOF, G. M., 'La Casa di Giorgione a Venezia', *Bollettino di Arti, Industria e Curiosità Veneziane*, II, 1878, p. 24.

VALCANOVER, F., *L'Opera completa di Tiziano*, Milan, 1969.

———, 'Conclusione sugli esami tecnico-scientifici', in *Giorgione: La Pala di Castelfranco*, 1978, pp. 60-70.

VENTURI, A., 'I quadri di scuola italiana nella Galleria Nazionale di Budapest', *L'Arte*, III, 1900, pp. 185-240.

VENTURI, L., *Giorgione e il Giorgionismo*, Milan, 1913.

———, *Giorgione*, Rome, 1954.

VERHEYEN, E., 'Der Sinngehalt von Giorgiones *Laura*', *Pantheon*, XXVI, 1968, pp. 220-27.

WAAGEN, G. F., *Die Gemäldesammlung in der Kaiserlichen Ermitage zu St. Petersburg*, Munich, 1864.

WATERHOUSE, E., 'Paintings from Venice for Seventeenth-Century England: Some Records of a Forgotten Transaction', *Italian Studies*, VII, 1952, pp. 1-23.

———, *Giorgione*, Glasgow, 1974.

WETHEY, H., *The Paintings of Titian*, 3 vols., London, 1969-75.

———, *Titian and his Drawings with some Reference to Giorgione and his Contemporaries*, Princeton, 1987.

WICKHOFF, F., 'Giorgione Bilder zu römischen Heldengedichten', *Jahrbuch der königlichen Preußischen Kunstsammlungen*, XIX, 1895, pp. 34-43.

WILDE, J., 'Wiedergefundene Gemälde der Erzherzogs Leopold Wilhelm', *Jahrbuch der Kunsthistorischen Sammlungen in Wien*, V, 1930, pp. 245ff.

———, 'Ein unbeachtetes Werk Giorgiones', *Jahrbuch der Preußischen Kunstsammlungen*, LII, 1931, pp. 91-100.

———, 'Röntgennaufnahmen der "Drei Philosophen" Giorgiones und der Zigeunermadonna Tizians', *Jahrbuch der Kunsthistorischen Sammlungen in Wien*, VI, 1932, pp. 141-54.

———, 'Die Probleme um Domenico Mancini', *Jahrbuch der Kunsthistorischen Sammlungen in Wien*, VIII, 1933, pp. 97-135.

———, *Venetian Art from Bellini to Titian*, Oxford, 1974.

WILLIAMSON, G. C., trans. P. Mussi, *The Anonimo: Notes on Pictures and Works of Art in Italy (Notizia d'opere del disegno) Made by an Anonymous Writer in the Sixteenth Century*, London, 1903.

WIND, E., *Giorgione's 'Tempesta' with Comments on Giorgione's Poetic Allegories*, Oxford, 1969; revised Italian trans. in *L'eloquenza dei simboli [e] La Tempesta: Commento sulle allegorie poetiche di Giorgione*, ed. J. Anderson, Milan, 1992.

WOERMANN, K., *Katalog der Königlichen Gemäldegalerie zu Dresden*, Dresden, 1905.

ZANETTI, A. M., *Della pittura veneziano*, Venice, 1771.

INDEX

All numbers in bold refer to illustrations; those not preceded by 'Fig.' refer to pages in the Catalogue Raisonné.

GREYSCALE

BIN TRAVELER FORM

Cut By _Taylor of Jimmy_ Qty _18_ Date _11/9/24_

Scanned By _____ Qty _____ Date _____

Scanned Batch IDs _____

Notes / Exception

PICTURE CREDITS

DATE DUE

MAY 0 7 2001			